Long Strange Journey

ON MODERN
ZEN, ZEN ART,
AND OTHER
PREDICAMENTS

Long Strange Journey

GREGORY P. A. LEVINE

UNIVERSITY OF HAWAI'I PRESS | HONOLULU

22 21 20 19 18 17 6 5 4 3 2 1

Library of Congress Cataloging-in-Publication Data

Names: Levine, Gregory P. A., author.
Title: Long strange journey : on modern Zen, Zen art, and other predicaments
 / Gregory P.A. Levine.
Description: Honolulu : University of Hawai'i Press, [2017] | Includes
 bibliographical references and index.
Identifiers: LCCN 2016058319 | ISBN 9780824858056 (cloth ; alk. paper)
Subjects: LCSH: Zen art. | Zen Buddhism.
Classification: LCC N8193.3.Z4 L48 2017 | DDC 704.9/48943927—dc23
LC record available at https://lccn.loc.gov/2016058319

Jacket art: Maruyama Shin'ichi (1968–). *Kusho #1,* 2006. Archival pigment print.
© Shinichi Maruyama, courtesy of Bruce Silverstein Gallery, NY.

DESIGNED BY MARDEE MELTON

To the memory of
Elizabeth Epling Twombly
(1929–2015)

CONTENTS

List of Illustrations ix

Acknowledgments and Note to Readers xiii

INTRODUCTION:
WALKING THE ZEN-SCAPE 1

1 ZEN ART BEFORE NOTHINGNESS 25

2 MAKING ZEN MODERN: D. T. SUZUKI 42

3 DANXIA BURNS A BUDDHA:
ZEN AND THE ART OF ICONOCLASM 54

4 THE LOOK AND LOGOS OF ZEN ART 75

5 ZEN-BOOM "CULTURE WARS" 97

6 ZEN INFLUENCE, INHERENCE, AND DENIAL:
RECONSIDERING POSTWAR ZEN AND ART 130

7 WHAT'S SO FUNNY? ZEN CARTOONS, ZEN HUMOR,
AND BODHI-CHARACTERS 158

8 ZEN SELLS 195

CODA 239

Notes 245

Glossary 279

Bibliography 285

Index 319

Color plates follow page 178

ILLUSTRATIONS

FIGURES

1. Daidō Bunka, *Ensō.*
2. Liang Kai, *The Sixth Patriarch Chopping Bamboo,* Southern Song dynasty.
3. South Garden, Ryōanji, Kyoto.
4. Cover, *Tricycle: The Buddhist Review* (Winter 2013).
5. *Daruma.* In Edward Greey, *The Wonderful City of Tokio or Further Adventures of the Jewett Family and their Friend Ota Nambo* (1883).
6. Muqi, *Six Persimmons,* 13th century.
7. Bunsei (Japanese, active mid-15th century), *Landscape.*
8. D. T. Suzuki in Cambridge, Massachusetts, 1958.
9. Sengai Gibon (1750–1837), *Danxia Burning a Buddha.*
10. Okamoto Ippei (1886–1948), *Danxia Burns a Buddha.*
11. "Danxia and the Wood Buddha," in *Japanese-Chinese Expanded Precious Mirror of Painting* (*Wakan zōho Ehon hōkan,* 1688).
12. Nam June Paik performing *Zen for Head.* 1962.
13. John Cage and D. T. Suzuki (1962).
14. Donald Reilly, "I imagine serenity is pretty much the same, one season to the next." *The New Yorker,* July 7, 1977.
15. Gahan Wilson, "Swami Ananda has *also* discovered the secret of life." *The New Yorker,* March 13, 1978.
16. William A. Briggs, "Have zabuton—Will Travel." *Zen Notes* 6, 8 (August 1959).
17. Ed Subitzky, "Zen street sign."
18. Mark Thompson, "Zen hoarder." *The New Yorker,* August 27, 2012.
19. Sidney Harris, "Frankly I'm all meditated out."
20. Gahan Wilson, "Nothing happens next. This is it." *The New Yorker,* August 25, 1980.
21. Gahan Wilson, "None of this seems to be doing me any good at all." *The New Yorker,* October 24, 1994.

22. Pat Byrnes, "Are you not thinking what I'm not thinking?" *The New Yorker,* January 15, 2001.

23. Dan Piraro, "Zen Crossword Puzzle." June 5, 2000.

24. Gahan Wilson, "Enough Yin. More Yang." *The New Yorker,* April 12, 1976.

25. Sidney Harris, "As Jerry Brown says . . ." *The New Yorker,* July 30, 1979.

26. Warren Miller, "Zen and the Art of Bankruptcy." *The New Yorker,* July 22, 1991.

27. Gahan Wilson, "You notice how these telephone pitches always come just when you're about to achieve satori?" *The New Yorker,* June 10, 1996.

28. Gahan Wilson, "You can't handle the meaning of life!" *The New Yorker,* February 12, 2001.

29. Pat Byrnes, "Zenboni." *The New Yorker,* September 23, 2013.

30. Matthew Diffee, Untitled. *The New Yorker,* December 17, 2007.

31. Dan Piraro, "Nothing spices up a Zen garden like digital cable." July 30, 2007.

32. Nonaka Toshihiko, "Komaru (Trouble)." Published in *Yomiuri shinbun,* January 1, 2007.

33. Bruce Eric Kaplan, "My Zen garden has been a total nightmare." *The New Yorker,* July 9, 2007.

34. Dave Coverly, "Zen Kitties." *Speed Bump,* February 6, 2009.

35. Pat Byrnes, "Zen Litter Box." *The New Yorker,* September 16, 2015.

36. John Cox, "Make Me One with Everything."

37. Shiseidō, *Zen.* Advertisement, *New York Times,* December 21, 1966.

38. Nature's Path, "Optimum Zen."

39. Viktor & Rolf Fall 2013 Couture look 21.

40. Screen shot. "Mercedes-Benz Japan." From *Mercedes-Benz A 45 AMG X Zazen.*

41. EEG monitoring of meditating Japanese Zen monks.

42. Statues and Books. The Monastery Store, Zen Mountain Monastery, Mount Tremper, NY, 2015.

43. Meditation cushions. The Monastery Store, Zen Mountain Monastery, Mount Tremper, NY, 2015.

44. Orders ready for shipment. The Monastery Store, Zen Mountain Monastery, Mount Tremper, NY, 2015.

45. *The Sixth Patriarch Chopping Bamboo,* tattoo.

COLOR PLATES *(following page 178)*

1. Sesshū Tōyō. *"Splashed Ink" Landscape* (*Haboku sansui zu*), 1495.
2. Hakuin Ekaku. *Giant Daruma.*
3. Yintuoluo. *Danxia Burning a Buddha,* Yuan dynasty, 14th century. Inscribed by Chushi Fanqi.
4. Maruyama Shin'ichi. *Kusho #1,* 2006.
5. Yamamoto Shunkyo. *Discarding the Bones, Gathering the Marrow* (*Shakaku shūzui*). 1927.
6. Zhou Jichang. *The Rock Bridge at Mount Tiantai.* Southern Song dynasty, second half, 12th century.
7. Katsushika Hokusai. *Danxia Burning a Buddha.* Edo period, mid-Bunka era (1804–1818).
8. Murakami Takashi. *That I may time transcend, that a universe my heart may unfold.* 2007.
9. Dan Piraro, with Victor Rivera. "First Day of Zen Garden School." July 22, 2012.

ACKNOWLEDGMENTS

Family, friends, colleagues, Zen teachers and communities, artists, and others made this book possible and better. Many of them had no idea I was writing it. Neither did I at first. But my book on the Zen Buddhist monastery Daitokuji left me with questions that nagged, and living in the San Francisco Bay Area made them local.

Stephanie Chun at University of Hawai'i Press was marvelous from inquiry to publication, and for meticulous copyediting my thanks to Barbara Folsom. I thank two exceptionally supportive reviewers. For suggestions, enthusiasm, and good company I thank Laura Allen, Patricia Fister, Christine M. E. Guth, Nakajima Izumi, Richard M. Jaffe, Thomas Yūhō Kirchner, Susette S. Min, Mia M. Mochizuki, Noriko Murai, John K. Nelson, James Robson, Janet and Michael Rodriguez, Todd A. Roe, Robert H. Sharf, Shimao Arata, Aileen Tsui, Ryosuke Ueda, Andrew M. Wasky, Bert Winther-Tamaki, and Yamada Shōji. Vanessa Zuisei Goddard, Nathan Lamkin, and Shoan Ankele at Zen Mountain Monastery responded graciously to far too many questions. Chapter 3 is dedicated to Yoshiaki Shimizu and Chapter 4 to Jay Fliegelman (1949–2007). Behind the scenes Jennifer N. Hackney wandered with me into the Zen-scape and convinced me the book would get done; my love to you.

Individual chapters invite specific acknowledgment. The Isabella Stewart Gardner Museum graciously allowed me to revise "Zen Art before Nothingness," published in *Inventing Asia: American Perceptions around 1900* (2014). Chapter 4 began as a paper for the panel "Patterns of Inattention: Taxonomic and Lexical Forces in Japanese Art History," organized by Miriam Wattles for the 2007 meeting of the Association for Asian Studies. Chapter 7 got its start at Yamada Shōji's panel "Affection and Rejection? The Inflections of Zen in Modern and Contemporary Popular Culture" for the Association for Asian Studies meeting in 2008. Part of Chapter 8 originated at the conference "Speaking for the Buddha: Buddhism and the Media," organized by Robert H. Sharf at UC Berkeley in 2005.

Several readers of chapter drafts limned them "very Berkeley," a compliment as far as I'm concerned, but I also like to think the book finds good company with the work of, among others, Christine M. E. Guth, Jane N. Iwamura, Richard M. Jaffe, David L. McMahan, Bert Winther-Tamaki, and

Yamada Shōji. Fussing with revisions, I referred gratefully to, among other books, R. John Williams, *The Buddha in the Machine: Art, Technology, and the Meeting of East and West* (2014); Andrea R. Jain, *Selling Yoga: From Counterculture to Pop Culture* (2015); and Sharon A. Suh, *Silver Screen Buddha: Buddhism in Asian and Western Film* (2015). I could go on at great length about the importance of UC Berkeley's libraries and their staff, and I relied upon dozens of interlibrary loans. Jason Hosford, Senior Digital Curator of the Visual Resource Collection in Berkeley's History of Art department, did wonders with images and rights, and I am immensely grateful to those who granted me permissions, including Brad Plumb and Kaikai Kiki, New York; Tom Haar, Honolulu; the Ishibashi Museum of Art; Jundo Cohen of Treeleaf Zendo; Kobori Geppo, abbot of Ryōkōin; Nature's Path Foods; Nonaka Toshihiko; the Kyoto temple Ryōanji; and Zen Mountain Monastery, Mt. Tremper, NY. Generous research and subvention funding came from the Arts and Humanities Division of the College of Letters and Science, and Center for Japanese Studies, both UC Berkeley.

NOTE TO READERS

I use "Zen" when referring to the Japanese Zen Buddhist tradition or the modern collapse of Chan/Sŏn/Zen/Thiền into the catch-all Japanese pronunciation of the Chinese character Chan 禅. I employ Chan/Zen for more specific reference to the Sino-Japanese tradition. I use standard Romanization systems following Robert E. Buswell Jr. and Donald S. Lopez Jr., eds., *The Princeton Dictionary of Buddhism* (2014). I stick with the latter for most conventions. For words in English usage (e.g., Mahāyāna and kōan), I leave off diacritical marks unless the term appears in a title.

INTRODUCTION:
WALKING THE ZEN-SCAPE

If he'd grown up doing Zen calligraphy and going on horse rides with Leonard Cohen, things might have been different.

—Hari Kunzru, *Gods without Men*[1]

These chapters are like a handful of pebbles I once picked up at the Point Reyes National Seashore, north of San Francisco. Each had a distinctive hue and tumbled contour, but all were pieces of a common, changing landscape. Zen art and aesthetics are parts of a particular, perhaps peculiar landscape, that of Zen Buddhism or simply Zen. Worked by monastic and lay practitioners in Asia for centuries and then, more recently, in Europe, North America, and globally, the Zen-scape—now seemingly deterritorialized—is home to teachers and followers of all sorts, some unaffiliated with specific denominations and lineages who adopt Zen as a personal, spiritual, life-belief system, and some for whom Zen is fashion or fun.

The Zen-scape catches the eye with paintings of Chinese vistas, real or imagined, sometimes in "splashed ink" (Plate 1); calligraphy circles (J. *ensō*), imperfect marks of perfection that convey the gap "between all conceptualizations or descriptions of reality and the way things 'really are'" (fig. 1);[2] "eccentric" Zen patriarchs (Plates 2, 3; fig. 2); and landscape gardens (fig. 3). These sorts of genera have spread from religious biomes into diverse artistic, spiritual, and popular habitats—for the most part avoiding scorn and removal as "invasive species." One also encounters new sorts of Zen-inspired creative work that has no direct relationship to "old Zen art" but which is roused nevertheless by encounters with Zen-associated East Asian brush arts and Zen as mysticism, philosophy, or a way to deal with the dehumanizing impacts of modernity and capitalism. Avant-garde works such as John Cage's (1912–1992) famous, and for some Zen-inspired, "silent" musical composition *4'33* (1952) are now monuments to, even clichés of, the postwar Zen boom and its radical energies. Here and

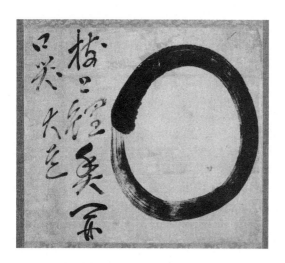

FIGURE 1. Daidō Bunka (1680–1752), *Ensō*. Hanging scroll. Ink on paper. 45.0 x 51.9 cm. Gitter-Yelen Foundation. Image courtesy of Manyo'an Collection, Gitter-Yellen Foundation.

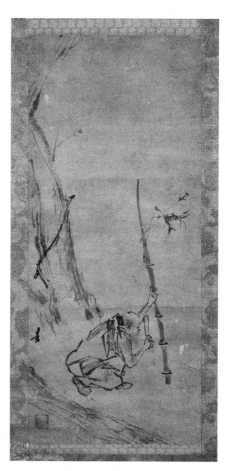

FIGURE 2. Liang Kai, *The Sixth Patriarch Chopping Bamboo* (*Rokuso zu*). Chinese, Southern Song dynasty. Hanging scroll. Ink on paper. 72.7 x 31.5 cm. Tokyo National Museum. Important Cultural Property. Image: TNM Image Archives.

there, present-day artists take up traditional Zen art iconographies in new media, styles, spaces, and markets, begging the question "Is it Zen art?" Sometimes Zen comes with popcorn, when films "idealize Zen Buddhist iconoclasm," with Zen-styled characters to admire, laugh at, and even imitate.[3] Scattered across this landscape (sometimes literally in post-consumer waste) are mass-produced Zen-themed products, with capitalism and "disposable culture" in full effect.

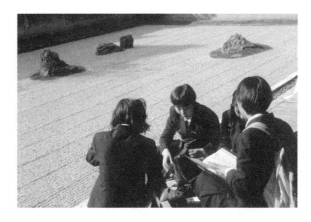

FIGURE 3.
South Garden.
Ryōanji, Kyoto.
Photograph by
the author.

It has been on my mind for some time to walk this landscape along unfamiliar paths that provoke a sense of estrangement, not looking askance but looking anew, resisting both essentialism and cynicism. Can we see Zen as translocative and intersectional rather than as simply *over there* (Japan/Asia) or only *right here* (North America, for instance)?[4] Might we better acknowledge the fact that the Chan, Sŏn, Zen, and Thiền Buddhist traditions have throughout their histories both endured and transformed? By the same token, how might we more fully identify and acknowledge the changes that have accompanied modernity—creating nearly too many sorts of Zen to keep track of let alone reconcile. Perhaps, too, we should not allow "Zen" to function so easily as a convivial floating signifier capable, as James Faubion puts it, "of bearing any meaning, operating within any given linguistic system as the very possibility of signification itself."[5] Given the Japan and Asia-referential exoticism that continues to color Zen, it may not float entirely untethered. And it is probably fair to say that many recent changes taking place with Zen have little to do with the "deep structures" of contestation and transformation found throughout premodern Chan/Sŏn/Zen/Thiền and more to do with the forces and complexities of transnational modernities.[6]

To begin to strange-ify the modern-contemporary landscape of Zen and Zen art and aesthetics, we might think in terms of what Friedrich Nietzsche (1844–1900) referred to as "weightless" periods in bourgeois culture marked, as T. J. Jackson Lears puts it, "by hazy moral distinctions and vague spiritual commitments" in which "individual will and action were hemmed in." How has Zen—different sorts of Zen, in fact—enabled liberation from "a weightless culture of material comfort and spiritual blandness" and offered "some definition, some distinct outline and substance to . . . vaporous lives"?[7] Or, we might employ a counter-poetics, to borrow

from Yunte Huang, that allows us to "do different kinds of cultural work" outside the normative Zen "perimeter."[8] Whatever tool we take in hand, it is high time to muddy up Zen and Zen art and aesthetics with questions that concern contention, ambiguity, dis/relocation, race, gender, and ideology, making the Zen-scape more difficult but also more rewarding to traverse.

That my present focus falls on Zen's modern-contemporary history implies that there is more than simply a deep past that determines outright our understanding of where Zen comes from and what Zen art and aesthetics look like, do, and mean. A perspective of this sort sets off this book from the bulk of art historical, museum, and general audience writing on Zen art and related aesthetics, which tends to fix on masterworks and the biographies of artists of late medieval and early modern periods in China and Japan, gush over putatively timeless visual qualities and metaphysical states, or promote with ahistorical, trend-spotting flair Zen's global design appeal and therapeutic values. Here, in contrast, I explore spectacles of Zen and Zen art modernism and globalism and their networks of exchange that link, uncomfortably at times, temples and centers, the art world, the academy, museums, and popular culture. I examine Zen as "both object *and* agent" of modernization and globalization.[9] I seek out modern campaigners for and critics of Zen, specific terms tied to Zen art and aesthetics, and works of visual culture associated in various ways with Zen that vibrate with modern energy. If this book therefore treats Zen as a "researchable problem" of modernity, it should come as no surprise that it explores a history imbricated with Euro-American imperialism, Japanese nationalism and pan-Asianism, Cold War ideology, capitalism, and racial-cultural identity politics.[10] Zen art and aesthetics, meanwhile, are also tangled up in related conditions and ambitions of collection and exhibition, art making and criticism, and personal belief and self-fashioning.[11]

Many voices can be heard across the Zen-scape, certainly that of D. T. Suzuki (Suzuki Daisetsu Teitarō, 1870–1966)—"the apostle of Zen to the West"—to whom I turn in Chapter 2 and thereafter, but also those of institution-based, transnationally engaged Zen monastics; less widely recognized intellectuals and scholars shuttling between Zen communities and the general public; popular writers of varied ilk; as well as those expressing Zen affinity without trappings of religion or spirituality. Where Zen has spread, restlessly and anxiously at times, it has put down roots, transformed lives, and upended discourses on religion, spirituality, and creative work. True, there have been not-in-my-backyard complaints, but Zen has also been euphorically welcomed and avidly appropriated and reappropriated. Zen has kept going; it has not sat still.

A LONG, STRANGE JOURNEY

Zen is by no means the only religio-cultural topos of Asia (in colonial, quasi-colonial, and nationalist circumstances) to gain prominence in Europe and North America during the nineteenth and twentieth centuries and find an enduring place in varied modernisms and postmodernisms.[12] Nor is it the only non-Western tradition singled out by virtue of specific sorts of visual presence arising from particular techniques, materials, and forms suggestive of the transcendent or mystical preindustrial, precontact other, that were then appropriated into Euro-American avant-garde art. That being said, Zen has covered a considerable amount of ground over the course of the past century or so, a bit more than a blink of an eye for Buddhism but at the same time a surprisingly long and strange journey. That's a corruption of Robert Hunter's lyric to The Grateful Dead's 1970 song "Truckin'": "Lately it occurs to me: What a long, strange trip it's been."[13] Not that I wish to fixate on this counterculture anthem, and admittedly, Zen did not figure largely in 1960s–1970s psychedelic art, with its intense colorations, optical densities, kaleidoscopic patterns, and biomorphic forms. But it is nevertheless true that Zen was part of the ego-dissolving mystical-chemical scene and sacred-transcendental explorations of postwar "nirvanic times," and the phrase "Zen and drugs" is but one of several pairings of postwar Zen.[14] To trace a bit of this phenomenon, then, is one way to get one's footing in the Zen-scape.

In 1964, the clinical psychologist Arthur H. Rogers proclaimed, in *Psychologia: An International Journal of Psychology in the Orient,* that "For five years, I had read about Zen and thought about Zen. With LSD as the facilitating agent, I knew Zen directly."[15] Visitors to Zen temples and centers dropped acid, causing problems for communities of people who sought "altered states" through meditation; being "under the influence of Zen" was in some cases partly or largely chemical. Varied writers and visual and performance artists with an affinity for Zen, and whose work explored concepts of emptiness (Skt. *śūnyatā;* Ch. *kong;* J. *kū*), the aleatoric, and so forth, participated in the drug scene and had experiences that resemble those attained through meditation.[16] For its part, the mainstream press warned that "The craze for 'instant-Zen' (hallucination-producing drugs) among undergraduates has reached dangerous proportions."[17]

Zen teachers and observers of the Zen scene denounced the equation of LSD *kenshō* (insight in to one's true nature) with Zen *kenshō,* dismissed those "ready to exchange Zen for LSD as soon as a pill is within reach," and warned that psychotropic enlightenment was a "world of illusions."[18] In his eighties, D. T. Suzuki considered taking LSD in order to respond to it in an informed manner but was dissuaded due to his blood pressure.[19]

One Zen teacher who apparently did try it is said to have characterized it as "spiritual masturbation." Mary Farkas (1911–1992), writing in the newsletter of the First Zen Institute of America, was comparatively mild: "During the last few years the publicity given to the experimental use of drugs in psychotherapy and education—and the association of what now seems to be coming to be called neo-Zen with this development—has provided us at the Institute with considerable food for thought on the subject of habit formation and the use of alcohol and drugs."[20] Others rejected the outright condemnation of psychedelics and Zen, leading to turf battles in certain Zen communities.[21] Eventually, however, chemical explorers concerned about addiction, bad trips, and neurological damage, sought out Zen teachers for instruction in formal Zen practice as a "way of continuing their search without using drugs," thereby following Buddhist precepts against intoxication.[22]

That LSD and related entheogenic use would become an impetus for serious, traditional Zen practice is one of the Zen-scape's many twists and turns. Equally striking are the diverse and dispersed modern spaces in which the promise or peril of Zen—of one sort or another—was fought over rhetorically. Moreover, if Zen and Zen art and aesthetics became vectors of modern Japanese cultural exceptionalism, creating offshore sites of the Japanese nation, they also became transnational and noninstitutional ways to practice, belong, believe, and create, in some instances challenging nationalism and empire. More than simply a topical, trippy reference, therefore, "long, strange journey" might serve to evoke Zen's geographical and temporal traverse and situational flux. This book reflects on this journey "at large and at small."[23]

"'ZEN' IS A LOVELY WORD—CRISP YET MUSICAL"

Referring to his use of the word "Zen" in his 1958 essay, "Zen in the Art of Writing," Ray Bradbury (1920–2012) observed that "The variety of reactions to it should guarantee me some sort of crowd, if only of curious onlookers, those who come to pity and stay to shout. The old sideshow Medicine Men who traveled about our country used calliope, drum, and Blackfoot Indian, to insure open-mouthed attention. I hope I will be forgiven for using ZEN in much the same way, at least here at the start. For, in the end, you may discover I'm not joking after all."[24]

"Zen": three letters with heft and magnetism and, though not always, a bit of bait and switch. But if Zen is no longer esoteric, its meaning is not always clear. Perhaps it qualifies as an "elevator word," working at different

levels of facticity and knowledge yet sufficiently familiar to raise the level of discourse.[25] Or perhaps it is best treated as a marked term, along with "Buddhism" and "religion," with a target on its back.

"Zen" is also, first, the Japanese pronunciation of the Chinese character 禅 (*chan*), itself shorthand for the Chinese transliteration of the Sanskrit term *dhyāna,* which refers generally to mental concentration or meditation (Ch. *channa*).[26] The term is an ancient one and part of the remarkable processes of transliteration, translation, debate, and re-enunciation that have accompanied premodern flows of Buddhism across the Asian continent over the last millennium. To generalize a bit wildly, these processes generated a shift from "small zen (*chan*)" to "big Zen (Chan)," moving from "meditative absorption" as a first-order truth of Buddhism associated with the Buddha Śākyamuni's awakening and multidenominational practice, to a practice claimed by Song dynasty (960–1279) Buddhist masters and communities that developed into and defended Chan Buddhist lineages, histories, and orthodoxies.[27] In Japan, "zen" became "Zen" more or less from the twelfth century and by the seventeenth had consolidated into three principal lineages—Rinzai (Ch. Linji), Sōtō (Ch. Caodong), and Ōbaku (Ch. Huangbo)—that wielded power (miraculous, political, economic, and cultural) but also drew the wrath of other Buddhist denominations.[28]

This oversimplifies a complex history and its polysemy, and by no means was premodern Chan uniform or stable.[29] But however remarkable the premodern development of Chan/Sŏn/Zen may have been in East Asia—in soteriological, ideological, economic, and cultural terms—the modern era witnessed the appearance of newfangled and scaled-up sorts of Zen (global, meta), based on premodern lineages, teachings, and institutions but forming in the midst of transnational political, interfaith, and intercultural encounter and conflict. This new and eventually global Zen included not only formal monastic (J. *shukke Zen*) and lay (J. *zaike Zen*) communities, linked by lineage and charismatic teachers, but also counterculture movements (and admiring wannabes); artists of varied ilk; practicing academics, doctors, sports coaches, social critics, and politicians; and the variously Zen-curious.

This is the "Zen" that the cultural anthropologist Ernest Becker (1924–1974) referred to as lovely, crisp, and musical, the "Zen" that emerged in the postwar Zen boom decades.[30] Becker was not a fan of Zen, as I note later, and by eliciting the word's incantatory potential, exploited by Bradbury among others, he sought to underscore Zen's danger. Others turned to satire. "Zen," the writer J. D. Salinger (1919–2010) wrote in 1959, "is rapidly becoming a rather smutty, cultish word to the discriminating ear."[31] Becker and Salinger's observations suggest Zen's postwar allure, unruliness, and

refusal to stay put doctrinally, philologically, and socially. "Indeed," Joshua A. Irizarry writes, "the struggle of the Japanese Zen clergy to balance Zen's traditional ritual and social roles while attempting to embrace the surge of international popular interest in *zen* is evidence that, despite their best efforts, the centrifugal force of semiosis was ultimately too powerful." Drawn into the "'post-Fordist' shift in commodification and consumption patterns during the 1970s and 1980s," he adds, "Zen" became a "strange semiotic animal."[32]

It is no wonder, then, that "Zen" beckons explanation, a task on which Zen teachers have expended considerable energy. But one need not turn only to clergy for answers. An online "Buddhism expert" begins her "Zen 101" with the hook, "You've heard of Zen. You may have had moments of Zen. But what the bleep *is* Zen? The popular idea of Zen is that it's, like, Japanese Dada, with kung fu monks."[33] Note the implication that Zen is familiar, even personally experienced, but more than what it seems. Notice too the colliding orientalist tropes (Zen and martial arts). We then receive a "nerdy answer" (Zen is a school of Mahayana Buddhism) and a concise tutorial on Zen history, the importance of *zazen,* and Zen's use of language—all good basic modern Zen, if lacking follow-up on Dada and Gongfu. Not infrequently, however, popular explanations circle back onto themselves in performances of stereotypical Zen-ness. *The Daily Show* host Jon Stewart, who immortalized the phrase "your moment of Zen," invited Jeff Bridges to discuss his 2012 publication with the ordained Zen teacher Bernie Glassman, *The Dude and the Zen Master.* Stewart admitted, "For someone who introduces a Moment of Zen everyday I know very little about it." He therefore asked Bridges, famous for playing The Dude in Joel and Ethan Coen's film, *The Big Lebowski* (1998): "How do you become a Zen master? Is it a philosophy, a religion, a way of life?" Bridges replied, in good-natured schoolyard lingo, that "to be a master you've got to study with a master and then he says, tag, you're it." Fair enough, but how, Stewart wondered, does one identify a Zen master. Bridges—eschewing explanation of institutional Zen training and transmission—shouted, "Hah!" pinned a red rubber clown's nose on Stewart, put on his own clown's nose, and exclaimed: "Boom man. That's it. Now you're done." What about the meaning of Zen, Stewart asked? Bridges referred his host to the idea of interconnectedness, put on his clown's nose again, and uttered, "We are one."[34]

Of course, not everyone is enamored of Zen (the term or what it may signify), but some of us take it seriously in personal religious practice, spiritual belief, and art and design work. It may be a "taste culture,"[35] lifestyle preference, and social justice framework. It may be "inauthentic" to monastic and lay Zen (neither singular in their own right) and at the same

time very real and significant in personal and social ways. Others find Zen
alien and, from fundamentalist standpoints, heathen. Some find the Zenny
appropriations of popular culture orientalist and fatuous.[36] A few are frus-
trated that Zen is not a valid word in Scrabble.[37]

To judge from one (hardly comprehensive or objective) data-min-
ing tool, the Ngram Viewer for Google's digitized books, "Zen" rose overall
in English publication usage by approximately 450 percent between 1900
and 2000 with notable spikes. During the same period, "Zen art" grew by
about 160 percent, peaking in 1976 and dropping off thereafter.[38] Argu-
ably, "Mindfulness" has now replaced Zen as the top "Buddhist buzzword,"
becoming, as Bhikkhu Bodhi put it, "so vague and elastic that it serves
almost as a cipher into which one can read virtually anything we want."[39]
But "Zen" continues to lend itself rather well to urban culture portman-
teau and colloquialism, in some instances designating a form of Zen iden-
tity, as in "Zenthusiast" or "Zenologist."[40] Alternatively, Zen is linked with
behaviors and spaces having no intrinsic connection to monastic and lay
Zen that are nevertheless recognized as having a certain Zen quality or
vibe. There is Zen parking, Zen slap, Zen Slacker, Zentertainment, Zen-
nis, Zenterfield, Zentomologist, Zenovate, Zensual, and so on. There is
even "Zenphobia," a "[d]isorder where one gets frustrated with the 'let's be
zen culture' and express [sic] negative emotion at the sight of zen Buddhist
(often misrepresented) ideals, and attitudes that has [sic] spread all over
the Western culture. May also include a strong reaction of disgust towards
yoga doing, Lululemon wearing hipsters who think they act like they are
all 'zen' and peaceful but in actuality they are just doing it cause all their
friends are doing it."[41] This definition appears to satirize those who indulge
in Zen fad affectations as well as those who abhor Zen's ubiquity and find
affected Zenny behaviors offensive. Simultaneously, the "Zenphobia" coin-
age reflects the very sort of Zen-spreading culture creation that produced
the "pathology" in the first place. This may be about as involuted as one can
get with Zen neologism.

If there is "Zen-this" and "Zen-that," as well as "this-Zen" and "that-
Zen," many of these coinages seem rather "vanilla" these days, suggesting
that we may be moving from the Zen exotic to the Zen banal.[42] Needless to
say, few if any of these buzzwords find their etymological origin in premod-
ern Zen or, arguably, have any essential relevance to present-day medita-
tion, ritual, training, and devotion (although Zen teachers and practitioners
are familiar with this sort of vocabulary and may use it). Nevertheless,
these mashups suggest the fecundity of "Zen"—a phonetically fertile, allur-
ing, go-to sign. As I suggest in Chapter 4, meanwhile, the Zen-ness of art
in the modern and contemporary world depends upon a relational litany

of aesthetic terms, so much so that to use such terms as "simplicity" and "nothingness" is tantamount to speaking of Zen art.

Indeed, how often one hears Zen name-dropped in relation to spontaneity, absurdity, and detachment, be it in creative work or socially heterodox antics. "Get your Zen on." "That's so Zen!" Zen prompts tweets and drives memes. However enchanting the monosyllabic "Zen" may be, it is therefore malleable, appropriated, and networked, and it is easy to succumb to wordplay. But perhaps such behavior might be thought of as "world play," in which the lingo seeks to represent lives, communities, cultures, spaces, and desires, albeit in heterogeneous and potentially hegemonic manners. It is with a tinge of trepidation, then, that I employ the seriocomic term "Zenny zeitgeist." In its defense, I would note that "zeitgeist" was itself a topic in modern discourse about Zen. In 1939, the Japanese layman and Zen advocate Hisamatsu Shin'ichi (1889–1980) argued that, in contrast to Zen, the Western mystical tradition "did not become the *Zeitgeist* of any specific age . . . did not reach the point of creating out of itself a unique art or culture."[43] I also think we need a framing expression for the postwar permeation of Zen into late capitalist society and its establishment as (nearly) a global spiritual, cultural, and consumer given. This is a Zen that can leave behind what many Zen authorities and followers have deemed Zen's sine qua non, seated meditation (J. *zazen*) leading to religious awakening.[44] "Zenism," another available term, seems preferable for understandings and practices of Zen in transnational encounter during the late nineteenth to early twentieth century—echoing the Japanese art historian, educator, and curator Okakura Kakuzō's (1863–1913) use of "Zenist" and the contemporaneous Euro-American cultural movement of "Japonisme/Japanism."[45] The less formal-sounding Zenny zeitgeist, meanwhile, may better capture the spirited, elastic, and sometimes over-the-top discourses and popular perceptions of postwar Zen and beyond. As zeitgeists go, however, it is arguably less consequential than international modernism, postmodernism, and smart-tech, even if it is partly constitutive of or at least has been utilized in all three while emerging from what certain Zen advocates presented as the Japanese volksgeist.

The Zenny zeitgeist, in my use of it, includes institutional Zen religious teachings and practices but also the sort of Zen noted by Sharon A. Suh: "Whether projected as a palliative tonic for a mass-mediated, time-bound (meaning bigger, better, faster, more) U.S. American culture or an Edenic utopia in rapidly post-industrialized Asian nations, the global appetite for Zen exoticism has arguably gone viral."[46] The Zenny zeitgeist may thus be discerned in practice communities as well as in literature, film, music, stand-up comedy, psychology, self-help culture, sports, graphic

design, architecture, home décor, and more. Some of its behaviors are far from those of formal Zen practice, if not far-fetched. And for some the Zenny zeitgeist may simply confirm Slavoj Žižek's suggestion that Western Buddhism reinforces the "fetishist mode of ideology in our allegedly 'post-ideological' era," and enables one "to fully participate in the frantic pace of the capitalist game while sustaining the perception that you are not really in it."[47]

I myself am as much consumer as critic, and my coinage is intended not to disparage but to investigate a history whose inception period extended more or less from the 1950s to the 1970s. Though it is sometimes overlooked, the history of popular Zen formations and representations intersects and at times collides with the history of formal Zen practice and Zen communities, especially in the West, as all have been drawn into twentieth- and twenty-first-century globalization. Meanwhile, without denying the many meaningful impacts of Zen and Zen-associated cultural production in the modern and contemporary world, it would be best not to exaggerate its significance. Thinking of the postwar Zen boom in particular, we should not overlook the contemporaneous wars in Northeast and Southeast Asia, civil rights struggles, protests in Japan against the 1951 Treaty of Mutual Cooperation and Security between the United States and Japan (J. "Anpo jōyaku"), feminism, Black Power, and so forth. We should not forget that multiple Buddhisms (Theravāda and Mahayana, conservative and reform) have gone global over the course of the past century, and that global Zen has remained to some extent bounded by racial-ethnic categories and privilege.[48]

In any case, many things have been going on with Zen—the word, the religion, the attitude, the art, the product, what have you. Since the late nineteenth century, Zen art and Zen-inspired cultural phenomena in particular have been adored, studied, dismissed, and the subject of claims and counterclaims. Such wide-ranging response to visual and material presences is due partly to the rapid geographical movement and transcultural mutations of modern and contemporary Zen itself, as well as to the fact that the matter of "what Zen really is" has been and remains a bone of contention (partly a ruckus over the "relics" of premodern Zen), leaving us to ask, in the words of Steven Heine, "Will the Real Zen Buddhism Please Stand Up?"[49]

TYPOLOGY ZEN

Accompanying the modern spread of Zen have been repeated efforts to classify multiple varieties of doctrine and adherence or identity and, more often than not, to argue for the authenticity of one or another. Indeed, the

question of who teaches, practices, produces, consumes, and admonishes Zen has occasioned multiple typologies, which emerge within the larger category-making processes of modern Buddhism.[50] This is not entirely unreasonable given the diversity of Zen's who, what, and where during the twentieth century. A Zen demographic map might help us walk the undulating landscape of Zen. As is to be expected, however, every classification or mapping effort observes the world according to selective points of reference and with particular skills and goals. Thus, while it may come as no surprise that a list of Zen identities may be predisposed toward one type or group over another, it is more notable that many typologists propose an evolution from nascent or mistaken Zen to ultimate and true Zen. This typological urge is not uniquely modern, but efforts to classify Zen communities or forms of practice and belief during the twentieth century reveal the complex character of modern Buddhism as well as the ideological tenor of modern Zen. Before I turn to several examples, and in the spirit of full disclosure, here is my own back-of-the-napkin list.

There are ordained Zen monastics in institutional lineages who perform rituals at monasteries, churches, centers, and private homes and provide instruction in Buddhist teachings and practices including meditation. There are those who meditate under their guidance. They may live as Zen center residents, participate in intensive meditation periods (J. *sesshin*), and become formal dharma successors to their teachers. There are also lay members of Zen Buddhist temples or churches who participate in annual Buddhist observances and mortuary rites in addition to or exclusive of meditation.

Then there are those who explain Zen to non-monastic audiences, offer instruction, and are admired as "lay Zen masters." Some of their followers self-identify as Zen in personal, spiritual, or cultural terms, but have no contact with monastics and institutional contexts of Zen. They may practice meditation on their own, if at all, and may be "promiscuous" with various Asian and non-Buddhist spiritual traditions.

Many learn about Zen through books and other media, do not identify as Zen, Buddhist, or religious, and do not practice meditation. This has long been referred to as a bookish Zen, or, as the Vipassana teacher Jack Kornfield describes it, "couch potato Zen."[51] Writers and artists of varied ilk, meanwhile, have been drawn to philosophical principles and visual techniques and forms associated with Zen, often derived from books, lectures, exhibitions, and travel, and often alongside their explorations of other religious and visual traditions and configured in relation to radical politics.

Then there are those of us who use Zen-associated words as daily "guiding terms," perhaps for the re-enchantment of the mundane, or drop

Zen-inspired slang into our conversations for flavor or fashion. We may consume Zen-associated products, often without meditation or Buddhist belief, contact with Zen communities, or even Zen book learning. We may study and write about Zen from various academic disciplinary perspectives and may or may not have a practice relationship with Zen. We may also practice a Zen that is not the Zen of our parents or grandparents, whatever that may be, or combine several of the above-mentioned sorts of Zen.

Not all of these categories are strictly modern, including the differentiation between those practicing "book Zen" and those engaged in "meditation Zen," a topic of early discourse in Chan, present in the teachings of the Tang dynasty master, Guifeng Zongmi (780–841), who sought to harmonize the two. No doubt there are additional categories, but my purpose here is "re-performance" rather than definition, of putting my hand to the task of clarifying who and what Zen is—part of the labor of modern Zen. One of the best-known instances appears in the Zen advocate Alan Watts' (1915–1973) oft-cited 1958 article, "Beat Zen, Square Zen, and Zen." Watts, neither a formally trained Zen master nor an academic Buddhologist, sought to identify three sorts of Zen practice and knowledge that had emerged in North American Zen. He was skeptical of the "Bohemian affectations," "protestant lawlessness," and stridency of the Beat Zen crowd, who he claimed appropriated Zen for anarchist mischief. Watts therefore found that the "self-proclaimed Daddyo of Beat Writers" Jack Kerouac's (1922–1969) novel *The Dharma Bums* confused "'anything goes' at the existential level with 'anything goes' on the artistic and social levels."[52] That said, Watts nevertheless admired Kerouac's "generous enthusiasm for life," which saved him from being classed with the "fake-intellectual hipster searching for kicks, name-dropping bits of Zen and jazz jargon to justify a disaffiliation from society which is in fact just ordinary, callous exploitation of other people."[53] Watts also took issue with the "Square Zen" of Westerners who trained in temples in Japan and became entranced with hierarchy, authenticity, and orthodoxy—arguably what the counterculture West sought to dismantle or drop away from. Both Beat and Square Zen were just so much fuss for Watts; both missed the *real* Zen, which he argued is devoid of affectation, the need to justify unconventional behavior, and anything special.[54]

In 1960, the Sōtō Zen scholar Masunaga Reihō (1902–1981) doubled down on the categories. There is Beat Zen, whose "proponents rebel against convention and tradition. Seeking freedom, they try to model their actions on those of the monks in Sung China. But most of them lack creativity and moderation. They represent, however, a phase of the process toward deeper understanding." Those who derive their Zen from books fall into the category of Conceptual Zen: "It tries to grasp Zen conceptually and fails—because

Zen is a practice and not a concept. But the concept can serve as a starting point." Masunaga defines Square Zen much as Watts did and singles out for criticism those who emphasize "solving koans and receiving the certification of the Zen masters." Zen, he counters, "stresses vital freedom," so that there is "no need to be so strictly enslaved by form." Then there is Suzuki Zen, which, because of its emphasis on koan, deprives Zen of its "original 'abrupt' flavor" and makes it "step-like." Masunaga then acknowledges followers of a Native Zen, based on the West's "native philosophical tradition," which has the potential to enhance "understanding of Zen in Europe and America." But then there is real Zen, which for Masunaga is based on the teachings of Dōgen Kigen (1200–1253), the founder of the Japanese Sōtō Zen denomination, "especially in his intuition of the self-identity of original enlightenment and thorough practice." Dōgen's Zen "requires a deep philosophical ground, understanding Zen's historical development, and the guidance of a true Zen master. From these will come an authentic transmission. But of course this transmission should be creative; the disciple should not cling to the teachings of his master but should transcend them. This is the Zen beyond Zen."[55] Masunaga's classifications lead from rebellion to authentic Zen, critique the contemporary Zen scene, and present a sectarian scheme emphasizing the Sōtō Zen transmission—in opposition to the better-known Rinzai Zen presented by D. T. Suzuki. Masunaga allows that Beat and Conceptual Zen may be starting points and opens the door to an adapted Zen in the West, but the latter will be authentic only if its "creativity" arises from Dōgen's teachings.

In 1967, the scholar of comparative religions R. J. Zwi Werblowsky (1924–2015), who had observed monastic Zen in Japan, consolidated the range and volume of publications related to Zen into three groups: "scholarly studies (philological, philosophical, historical and physiological); journalism—either Zen propaganda, or Zen debunking, or relatively objective attempts at describing Zen in its cultural and religious setting; and finally discussions of Zen as a spiritual way by authors with very definite views on the nature of the spiritual life." This tripartite scheme holds up fairly well today, although there are also literary renderings of the Zen life, autobiography, and satire.[56] Werblowsky is careful to add that his division is "not for the sole pleasure of labeling, but for the sake of the methodological problem which it helps to highlight."[57] Categorization is therefore a platform for getting at questions: What is Zen and how should one study it, as religion or as something else? Ultimately he concludes that the question "is not whether Zen is Japanese—of course it is—but rather whether the arbitrary selections made by modern devotees are meant to tickle the jaded palates of tired Westerners in search of a non-committal exoticism or whether they contain

the promise of a new *Lebensgefühl* [life awareness or attitude].”[58] For Werblowsky, Zen therefore has a true source and national-ethnic identity, and the key problem that typology may help solve is whether or not Japanese Zen will lead to meaningful spiritual awareness in the West.

When Werblowsky was writing, there were indeed plenty of books on Zen, which were shelved in a broad number of categories established by modern library science.[59] Wandering from call number to call number, one might well conclude that Zen became as much, if not perhaps more, print than practice, more representation than ritual. What the modern library adumbrates, too, is the preponderance of publications in particular areas, the upsurge of writing at certain moments, and the expenditure of funds on multiple copies and editions of best-selling volumes (such as D. T. Suzuki’s *Essays in Zen Buddhism*). Most of my university students today rarely venture into the stacks (print graveyards to some) and have limited interest in their organization of knowledge. That said, they are avid curators of online resources and adept at categorizing different forms of Zen as they are blogged, streamed, tweeted, pinned, and so forth.

Zen typology is alive and well, therefore, but the problem with all of the preceding lists is their desire to fix and authenticate it rather than allowing for modern Zen’s labile and blurring presences. Given the ongoing controversy surrounding the typologies that have been proposed for North American Buddhism generally, I suspect that just about any classification model for Zen in particular will fail to accommodate demographic change, hybridization, and creolization; account for spectrums of adherence and affinity; acknowledge gradients of intensity, overlaps in affiliation, and movement from one sort of Zen to another; and adequately take into account race, gender, and class. Ultimately, we might entertain for Zen what Thomas A. Tweed proposes for Buddhism in general, namely that we should “use self-identification as the standard.”[60] This, he argues, allows us to explore the processes of Buddhism’s spread and hybridization and the multiplicity of Buddhist subjectivities. In turn we may better negotiate the rougher paths of transmission, acculturation, distortion, and dispute that have led to the capacious diversity, and occasional perversity, of modern-contemporary Zen.[61]

WHAT IS ZEN ART?

Once we head off in this direction, questions such as “Who is a Zen artist?” and “What is a Zen —?” (painting, sculpture, garden, film, performance, take your pick) require a bit of agility. Indeed, assumptions tend to snag and

tear in the thickets of visual form, creative subjectivity, and transnational discourses on art. Take the artist Maruyama Shin'ichi's (b. 1968) gripping "splashed" work, *Kusho #1* (2006) (Plate 4). Is this photographic work Zen art? Is Maruyama a Zen artist? Is this not a renewal of an esteemed Zen visual form—the complete-but-incomplete Zen ink calligraphic circle (*ensō*)—and the "splashed ink" (J. *haboku*) landscape painting technique associated with the Zen monk painter Sesshū Tōyō (1420–1506) (fig. 1, Plate 1)?[62]

Like traditional ink *ensō, Kusho #1* is vigorously geometric, seducing the eye toward closure only to preclude it, in whirling spray and exiting droplets. As a picture it holds together but discloses its airborne liquidity and lack of surface. Forcefully *there* for the camera shutter in a humanly imperceptible moment, it then falls out from itself in gravity's grip into, perhaps, nothing.[63] Does its suspended liquid instant not force us to acknowledge Zen's oft-mentioned emphasis on impermanence? If so, *Kusho #1* would seem to fit the bill of Zen art. Or perhaps we get Zen inklings from the title—its Chinese characters for "sky" or "empty" 空 and "writing" 書—and Maruyama's recollection of childhood calligraphy practice: of the "decisive moment" of ink-saturated brush touching paper and of committing "your full attention and being to each stroke."[64] Is this not, therefore, a visual manifestation of the unflinching, no-thought-just-action and in-the-moment spirit of Zen materialized in a new sort of calligraphy? Might capturing the "decisive moment" for the art market run afoul of true Zen, or does it point to new artistic work as meaningful Zen practice?[65]

Were they alive to see *Kusho #1,* twentieth-century Zen advocates such as D. T. Suzuki and Hisamatsu Shin'ichi, discussed in the chapters that follow, might caution that real Zen art requires the Zen experience of *mushin* (no-mind). Does Maruyama possess or profess *mushin*? If not, what then? Does Maruyama even practice Zen? What sort of Zen might that be? Is his Zen of a sort that differs from that of Suzuki and Hisamatsu, his art a different Zen art? Maruyama offers us an oblique answer to such questions in a comment on Zen gardens, which he characterizes as "expressions of the spirit of high priests who have achieved enlightenment," and embodiments of "boundless cosmic beauty in a physical environment created through intense human concentration, labor and repeated action." Such gardens empower the visitor to "resist temptation, eliminate negative thought, and sever the continuous stream of inessential information emanating from the outside world." And then he adds:

> I have tried to represent this feeling I get from Zen gardens in my art-
> work. Although I am still far from those enlightened monks who labor

in nature, my actions of repeatedly throwing liquid into the air and photographing the resulting shapes and sculptural formations over and over—endlessly—could be considered a form of spiritual practice to find personal enlightenment.[66]

This would seem to seal the Zen deal. In *Kusho #1,* we appear to have a photographic work in a traditional Zen calligraphic form inspired by Zen gardens and "enlightened monks who labor in nature," and an embodiment of personal Zen spiritual practice.

There is no need to disparage Maruyama's explanation, and what instead invites attention is the question of how we might historicize the artist's effort to relate his work to a specific visual past and to articulate a relationship between monastic Zen and a "spiritual practice to find personal enlightenment." Moreover, how might we understand the photographic technology and "various actions and devices" necessary to create the work's sensationally acrobatic encircling ink and water, separate from the artist's bodily actions? How might Maruyama's citation of Zen play in his cosmopolitan, New York City art environment? What might the display of *Kusho #1*—in a Zen temple, gallery, museum, or private residence—do for its potential Zen-ness and Maruyama's status as a Zen artist (should he desire it)?

These sorts of questions may lead us to wonder if *Kusho #1* is less self-evidently or exclusively Zen, and to consider its place downstream from an unruly discourse on Zen and art arising from the postwar period in which, as I suggest in Chapter 6, Zen form, expression, and intention may be affirmed or denied or simply absent. In the case of *Kusho #1,* we might note the response of the critic Maurice Berger, who describes the work and its larger series as a penetrating "meditation on the material properties of photography," one that elicits from Berger not a Zen workup but a turn to Alfred Stieglitz' (1864–1946) *Equivalents* series (1925–1931), Symbolist art, and a "shared investment in the modernist ideal of representation as a form of 'radical absence.'"[67] Some will argue that such modernist ideals were themselves influenced by Zen concepts of form and emptiness, and there is reason to explore this, but we need not stop at such general notions. Does the precisely staged, high-speed, technical marvel of *Kusho #1* not in fact confirm, more specifically, the legacy of postwar "*technê*-zen," as R. John Williams puts it, a rejection of the "failed Luddism of the sixties" and a "new 'Zen' effort to live *with* (rather than rage against) machines," promoted in works such as Robert Pirsig's best-selling novel, *Zen and the Art of Motorcycle Maintenance: An Inquiry into Values* (1974)?[68] In this sense, Maruyama is perhaps not simply a contemporary artist nostalgic for

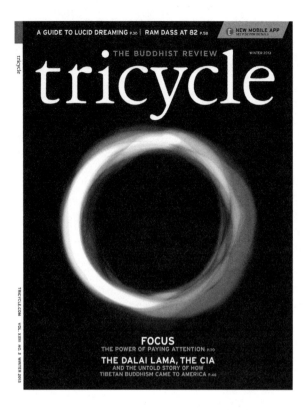

FIGURE 4. Cover, *Tricycle: The Buddhist Review* (Winter 2013), with artwork by Andreas Nicolas Fischer.

his childhood calligraphy practice and fond of Zen gardens but a new-tech descendant of Nam June Paik (1932–2006), the Korean American artist renowned for his installations merging video and Buddhist sculpture (*TV Buddha*).

As it turns out, however, the *ensō* form is remarkably multifarious in modern-contemporary art and visual culture, and we might juxtapose Maruyama's *Kusho #1* not simply with heirloom works of Zen monastic calligraphy—as inspiration or touchstone—but postwar, perhaps Zen-like, *ensō-*esque works, such as the painter Yoshihara Jirō's (1905–1972) *White Circle on Black* (1965) or Isamu Noguchi's (1904–1988) marble sculpture *White Sun* (1966).[69]

But why stop there, when there are the many *ensō* and *ensō*-like "enlisted" artworks used by Buddhist groups and found in Buddhist practitioner magazines, such as *Tricycle: The Buddhist Review* (fig. 4). Then there is the "Interactive Brushpainting Activity" on the website of the Asian Art Museum, San Francisco, in which one can use a digital "brush" to trace or replicate an *ensō* by the Rinzai Zen monk Nakahara Nantenbō (1839–1925).[70] What about the kitsch Zen circles seen so often in spa and boutique logos and in commercial product design? Let us not forget body art, including at least one tattoo based on *Kusho #1*.[71] Down the rabbit hole of Zen art we go.

ZEN MODERNITY AND BEYOND

My conviction in writing this book is that we should know a great deal more about what was at stake with Zen and what was claimed and fought over in the name of Zen and Zen art before we claim full rights to its analysis and interpretation. This book therefore elects to wade through and reflect on the lexicon, episodes, debates, and representations of Zen and Zen art and aesthetics in the modern and recent world. Doing justice to this

requires several things, the first being that we not simply pass judgment on past essentialisms, and that we resist the desire for "ultimate solutions."[72] Even so, those essentialisms and our inclination to find those solutions as they relate to Zen are, in my view, part of the history that I explore. Second, to borrow from Andrea Jain's study of Yoga, we should probably treat Zen as "polythetic-prototypical": "polythetic because it is radically heterogeneous . . . and prototypical because people use it to refer to a particular idealized construct."[73] Third, and this from Leigh Eric Schmidt, we should refrain from rebuking the "SBNR crowd" (spiritual but not religious) for its "flighty tastes" and instead take seriously the "American invention and hallowing of 'spirituality,'" even in some of its popular forms.[74] If we should therefore take to heart the diversity of Zen in its practices, belief systems, and audiences (remembering that Buddhism has always had multiple forms and goals), we might also apply a counterweight of suspicion regarding willful misrepresentation, insensitive appropriation, and what David Loy and Jonathan Watts refer to as the "religion of consumption."[75]

The notion that modern-contemporary Zen is post-nationalist, post-racial, post-gender, or post-religious, meanwhile, may feel good to some and ease certain anxieties, but the history says otherwise and may point to the need to decolonize Zen and decenter the discourses of privileged communities.[76] Whatever one's view of D. T. Suzuki's efforts to champion Zen may be, his contributions to Asian and religious studies occurred during a period in which, as Richard M. Jaffe points out, these fields were "dominated by white, male Europeans and Americans."[77] Moreover, any history of modern and global Zen cannot ignore the roles of Zen nuns and women lay teachers and practitioners, and their participation in modern debates on Zen.[78] Nor can we discount the agency of artists of Asian heritage and multiracial and cultural identity and their responses *on their own terms* to varied visual and religious traditions, national and local debates over art and modernity or postmodernity, and global movements and politics.

Moreover, as will become abundantly clear in the pages that follow, not all has been ecumenical and content in modern and contemporary Zen. If a case can be made that Zen and Buddhism generally have been constantly changing and debated, then it is arguably true that the adaptations have not all been necessarily expected, compatible, or accepted. Independently from premodern sectarianism, modern and present-day Zen cliques and factions take each other to task in collegial discourse as well as fiery argument. One Zen constituency may deem another heretical, superstitious, dogmatic, racist, misogynist, neo-Orientalist, or merely irrelevant. More than narrow affinity-group fuss, the issues raised are significant:

the relationship between mystical perception and historical inquiry; the role of Zen and its cultural works in Orientalist representation and nationalism; the appropriation of religious imageries and beliefs into consumer culture; race, gender, and power in Zen teaching and training contexts; and so forth. The conversations and quarrels play out within—and in the intersections of—Zen spaces, art spaces, academic spaces, commercial spaces, and virtual spaces.[79]

I do not wish to overstate emulousness, for there have been countless meaningful exchanges and collaborations. That a Chan Buddhist nun took several of my lecture courses on Buddhist art and architecture raised into view different kinds of knowledge and subject positions as well as the potential to enrich learning through a refusal to make assumptions based on identity categories (nun and professor). What should therefore engage us now, I think, is less a process of discerning "who was or is right" about Zen or efforts to simply differentiate true Zen art and aesthetics from false, than an attempt to discern the multifariousness or palimpsest-like quality of modern Zen—or perhaps crisscross, for what happened with Zen in Japan during the late nineteenth and early twentieth century had direct impact upon the West in the following decades. The postwar Zen boom in Europe and America—inspired by globetrotting Japanese intellectuals such as D. T. Suzuki as well as Europeans and Americans who trained in Japan—reverberated back to Japan, transforming Japanese culture and Zen.[80]

Religious and cultural authenticities are, it seems fair to say, political questions, and if pushed to take a side, I have come to believe that the "authenticity" of modern-contemporary Zen is to be found in its contentions and collisions, heteroglossia, and multi-visuality. We must deal with the issues of discourse and representation, in small and large-scale encounters and entanglements, in local, national, and transnational contexts, that present us with productive predicaments for the study of human religion and culture. Moreover, while it is quite true, as Richard M. Jaffe states, that Buddhism has always "had multiple functions and goals targeting different audiences" and that "this multiplicity is baked in the cake of Buddhism and is not a sign of its diminution in transmission beyond Asia," an "anything goes" attitude may silence the critical observations of particular participants and overlook the need to call out at times egregious behaviors that may, in the end, work against inclusion as well as Buddhist goals of release from suffering, wisdom, and compassion.

Meanwhile, if it is fair to say that Zen and Zen art and aesthetics inspire, or haunt, certain dreams of modernity and postmodernity, this does not mean we have adequately considered the histories abiding in alluring objects, concepts, styles, behaviors, and spaces deemed Zen. Indeed, some

of us want our Zen free of history's encumbrances, critical inquiry, and the institutional contexts, hierarchies, and trappings of orthodox Zen Buddhist religion (such desires being symptomatic of Zen and Buddhist modernity itself). It may be more appealing to look for smoothly connecting global Zen circulations or flows rather than collisions. Perhaps this is why it has taken some time for Zen art to come under scrutiny within critical studies of modernity and postcolonial and cultural studies. Fortunately, there is now a surfeit of counter-narratives in the academy about Zen, as well as a growing body of new work on Zen art, film, and branding, though the impact of these writings on wider educational, intellectual, and art worlds, not to mention consumer spaces, remains unclear.[81]

One instance in which this sort of gap opened up before me—on the page, as it were—occurred as I reviewed the manuscripts of college-level art history and humanities textbooks that referred to Zen's importance to Japanese premodern culture and its saturation of Japanese art. My critique of the authors' essentialist explanations no doubt came across as those of a Zen art curmudgeon, but this sort of tension between American academic and generalist representations of non-Western cultures is a manifestation of the sort of modernity this book considers. The museum space also opens up interpretive distances that may be widened by museum marketing departments and donor relations. The cultural programming paired with exhibitions of Zen art, particularly in Europe and North America, often reveals perceptions of Zen art's past, present, and future that may diverge from those held by historians of religion and art and also by monastics. Whether or not museums should be concerned with "honest historiography" and should address the issue of who benefits from ahistorical and sectarian presentations of Zen art are important (if infrequently asked) questions.[82]

With that said, I should lay a few more cards on the table, the first being my own position in relation to Zen. I tell students that I do not consider myself to be Buddhist or Zen, though I have done *zazen* in Japanese Zen temples and with groups in the United States, and I have studied the art and architecture of Zen temples and monasteries for more than two decades. At home I meditate in an unorthodox manner without the formal guidance of a Zen teacher or affiliation with a Zen community. My posture is absurdly informal (one cat tends to sit in my lap, another sits on my cushion when it is not in human use). I have read far too many books, articles, blog posts, and so forth about Zen, Zen art, Zen design, and Zen business. I mention all this because it puts me in one or more constituencies of modern Zen noted earlier—the non-monastic, non-devotional, non-denominational, academic and bookish, and individualist sorts. Which is to say that I do not

stand apart from what I write about in "subject-object distinction," to borrow from Dipesh Chakrabarty, or hover in a "safe space" between putatively disinterested academic Zen observers and partisan Zen advocates, makers, and consumers.[83]

Second, this book may be linked to the recent academic trend of "unmasking" Buddhism, an effort that seeks to resist essentialist, ahistorical, and nationalist claims and to situate (mis)conceptions in relation to Buddhism's complex development in particular places and moments, notably within modernity.[84] In a smaller way these chapters may contribute to rethinking modernism, at least as Zen and Zen art enter into discussion. To the extent that my goal is to write anew about these topics without attempting to claim them and fence them off, I am, to borrow from Tomoko Masuzawa, "more inquisitive about the marvelously loquacious discourse" on Zen and Zen art and aesthetics than about what this discourse asserts per se are the meanings and visualities of Zen.[85] Thus, the trail blazed through this book is historiographical, and its proposals work from discourse analysis. This is partly by preference, but it is also based on my study of modern Zen itself. Any modern Zen monastic or lay Zen practitioner worth their salt, one might assume, would take it as a given that Zen was meditation, not primarily discourse. But public explanations of and discussions about Zen during the postwar period became in a certain sense more of what Zen was for most people than meditation or other rituals. In their efforts to bring Zen out of the meditation hall, Suzuki, Hisamatsu, Watts, and other campaigners made public discourse about Zen a modality of modern Zen itself, treading as they did so between the ineffable and the empirical, the means and the end.[86]

Many people therefore talked a great deal about Zen, and for some it was the discussion—and its distinctive language—that became Zen: a Zen of talking, not sitting. This is arguably not entirely a modern phenomenon, and European and North American observers caught on to the fact that modern "discourse Zen" ruffled the feathers of certain Zen advocates. "Some strictly orthodox Zen masters," the American music critic Winthrop Sargeant (1903–1986) remarked in his 1957 profile of D. T. Suzuki, "may have grumbled at his temerity in attempting to explain the unexplainable mystery of their doctrine, but even they had to admit that he had become Zen's most successful and most widely respected missionary outside Japan."[87] Winthrop joins in the fun of Zen-boom reporting here, leveraging the wordy aura of Zen, and his phrases "strictly orthodox Zen masters" and "explain the unexplainable" invite readers to discern Suzuki as a modern master unfettered from fusty tradition and also to enjoy a taste of Zen's purportedly timeless, paradoxical aura.

To the extent that postwar Zen had the potential to become more a matter of discourse than of meditation, it concerned the particularities of modern reception and representation (often naïve to centuries of Zen discourse on practice, precepts, concepts, and so forth). And after all, it was hard (purposefully so, from a monastic perspective) to do more: pursue serious meditation with a qualified Zen teacher, grapple with koan, and bring Zen awareness and wisdom into one's life generally. In any case, as a suggestive aspect of the Zen scene, "discourse Zen" points to constitutive predicaments facing modern Zen advocates: how to merge "old school" Zen and new forms of Zen for new groups of practitioners and how to weed out false Zen from the true in unruly transnational exchange. The fact that Zen changed as dramatically as it did during the 1950s and 1960s meant that centuries' old concerns over authenticity and positions of authority were re-enunciated. But postwar management of orthodoxy and orthopraxy may have been distinctively messy. Zen authorities had not only to sharpen their skills at introducing Zen, with greater or lesser degrees of hybridization and adaptation for new audiences, but also to strengthen their abilities at debunking what in their view was not Zen—sorts of Zen that they had never before encountered. Meanwhile, the turn by Suzuki and other Japanese Zen campaigners to increasingly emphasize meditation and koan practice with a teacher, may not have been simply a "traditionalist" response to inappropriate sorts of Zen but a strategy to "own" the means to authoritative Zen in opposition to Western access to and presumption to define Zen, often through books.[88]

Let me be clear on another point: I did not write these chapters as a "Zen-bashing" polemic. I believe that there are different sorts of valid knowledge and belief about Zen. I am genuinely interested in these diverse kinds of knowledge, and we should pay attention to the disjunctive teachings, practices, experiences, communities, and histories that abide within the multifarious tradition we call Zen. I am intrigued by the grip Zen has on the modern imagination, and I am curious not only about the arts of Zen monastic environments but also about postwar avant-garde works said to arise from, embody, or demand a "Zen mind" or "Zen gaze."[89]

But to repeat, I resist the lure of authenticity, the project of defining what is true and false Zen and Zen art and aesthetics. To pursue such an end would be like trying to define or assert what the "real Japan" is, an exercise many of us have long ago abandoned. Indeed, like any religious, spiritual, and cultural meta-phenomenon, Zen in its varied manifestations deserves to be reconsidered, even fiercely, and to do so requires that we complicate the effort to write its history. Not that I wish to take all the enjoyment out of Zen; I am susceptible to the Zen aesthetic and laugh at Zen cartoons. But not everything said to be Zen is necessarily all in good fun. Ultimately, to

seek inner and global change, to find peace within and without, to come to terms with "the big questions" of life and death; these are surely part of what the Mahayana tradition and Zen have long termed the "Great enterprise" (Ch. *dashi;* J. *daiji*).[90]

Third, this book could hardly be said to map the entire landscape of modern Zen and Zen art and aesthetics, and some readers will cry out at its blank spaces. There are notable teachers, writers, and artists who do not appear, countless pictures, things, and spaces passed by. For instance, I do not address Zen and Japanese tea cultures or, in a sustained manner, Zen gardens.[91] Indeed, there is too much ground to cover and, as Thomas A. Tweed puts it, too much to know.[92] There is also thin ice, as when I venture across the surface of postwar art, film, and Zen. My bargain with the reader, however, is that my selection—of particular moments, spaces, and actors; artworks and artefacts; and patterns of practice and consumption—will help us to begin seeing this landscape in new ways. Let me emphasize, too, that this book is neither intrinsically a comparative study of modern Zen in Japan and North America nor a survey of Zen art and artists. If the book is generally chronological it is also omnivorous and sometimes panoramic.[93] For this reason, I leave unfulfilled certain assumed obligations, including robust artist biography, minute formal analysis of art masterpieces, and a comprehensive theoretical model for Zen art. Some may regret the book's attention to popular visual culture, but we catch important glimpses of Zen concepts, perceptions, and desires in operation when we move away from the canon, even as pop culture draws at times from canonical works and has its own "canonical" tropes. Taking a cue from David Morgan, therefore, this is just the sort of imagery and stuff that may be important to thinking through the fuller modern-contemporary development of Zen and Zen art and aesthetics.[94] More often than not it returns us to big-scale questions concerning religion, belief, culture, and consumption.

To the extent that Zen and Zen art and aesthetics have become cherished yet often taken-for-granted presences of modernity and postmodernity, the time is ripe for new questions and productively tentative responses. I hope readers will take a few steps off the beaten path and keep moving through the Zen-scape. There is much more of it out there to explore, more pebbles to pick up and turn in the hand, at least for a moment—some to hold on to, others to toss back.

1

ZEN ART BEFORE NOTHINGNESS

Pictures of Nothing: Abstract Art since Pollock (2006) comprises the art historian Kirk Varnedoe's (1946–2003) 2003 Andrew W. Mellon Lectures.[1] In the spring of 2009 a scholar of Chinese art commented to me, with nearly a growl, that despite Varnedoe's use of "Nothing" in the title, the book contains scant reference to Zen.[2] This omission came as a surprise given the many comments on Zen and nothingness found in writings on postwar art. The novelist and writer on Asian religions Nancy Wilson Ross, for instance, reported in 1958 that everyone was "talking about Zen," which has exerted a "curious influence on . . . writers, painters, musicians and students."[3] Indeed, in certain art circles, Zen was "it" during the 1950s and 1960s and "nothing," "nothingness," and "emptiness" de rigueur. If so, why doesn't Varnedoe give Zen its due?

There are good reasons for Varnedoe's "thunderous silence."[4] Twentieth-century art was hardly a colony of Zen, which does not explain fully Abstract Expressionism, Pop Art, and so forth. The idea of "nothing," at least in one reading of postwar art, is concerned with the rejection of mimesis, among other aspects of modern Euro-American representational theory. As the art historian Bert Winther-Tamaki reminds us, meanwhile, the complex intercultural context and rhetoric surrounding Zen at this time included the "striking pattern of denying the relevance of Asian culture to American art."[5] There were thus different sorts of "nothing," and I am inclined to view Varnedoe's sort as refreshing.

Indeed, the arts of Japan and Asia, especially in the European and North American gaze, have not always been so narrowly pinned to Zen, and Zen-associated concepts such as nothingness (J. *mu*), emptiness (J. *kū*), and no-mind have not always held art-world cachet. Whereas these concepts come to the fore from the 1920s and 1930s, notably through the efforts of D. T. Suzuki, Nishida Kitarō (1870–1945), and other Zen campaigners,

there was a time before the West "got Zen." This is not to suggest that turn-of-the-century European and North American collectors and scholars were unaware of or disinterested in Zen Buddhism and the arts associated with Zen temples and painters. Many were familiar with the writings of Okakura Kakuzō, whose 1906 *Book of Tea* gushes over Zen and Zen art.[6] Still, the Gilded Age was relatively Zen free, preceding the ensuing age of the "Zen-nist" and Romantic-Transcendental taste for Zen art.

This chapter is a genealogical sketch, moving from ambivalence during the mid-to-late nineteenth century to fixation in the early twentieth. Some may be surprised to learn that the horizon of Zen and Zen art in Western perception appears first within sixteenth-century Christian missionary accounts of China and Japan. That said, Zen art—as a particularized object of visual interest and philosophical interpretation—was largely absent from Western affection for the arts of Asia until the early twentieth century. Groundwork was laid during the 1893 World's Parliament of Religions and Columbian Exposition in Chicago. By this time Japanese monks and lay practitioners had begun to explain Zen to Europeans and Americans more explicitly. Japanese scholars and officials began to emphasize the art of the Zen sect within the canon of Japanese art, interpret "Zen-influenced" Chinese and Japanese culture, and disseminate a lexicon and metaphysical register for understanding Zen art. Some of these intellectuals, Okakura and D. T. Suzuki in particular, would become nearly household names in the West. Much of their work was indebted to nation-building efforts in Japan, including domestic surveys of temple treasures that fed heirloom works into Japan's imperial museums and helped produce official histories of the arts of Japan that promoted the nation to the West.[7] Their articulation and promotion of Zen Buddhism during the first decades of the twentieth century were also profoundly intercultural and voiced as a challenge to Western philosophy, religious studies, and art. By 1920, a fair number of white Europeans and North Americans were practicing Zen meditation, and Zen art had become part of collections and discussions of art.[8] By the 1930s, Zen art had attracted the sort of adulation that seems more in keeping with the postwar period and the Zen boom avant-garde's fascination with Zen's visual forms, which for many embodied nothingness. I shall turn to the postwar decades in later chapters, but before the 1920s and 1930s the fortunes of Zen art seem, in retrospect, less assured.

FIRST CONTACTS

In Goa, prior to arriving in Japan in 1549, the Jesuit priest Francis Xavier (1506–1552) heard a description of a Zen monastery and Zen meditation

from a Japanese expatriate, Anjirō. Upon arriving in Japan Xavier met the Japanese Zen master Ninshitsu (d. 1556) at the Kagoshima monastery Fukushōji. Urs App, discussing these encounters, suggests that for Xavier this was a meeting not with a monk the Jesuit understood to be a master of the Zen school but "a representative of a yet unknown but apparently well-developed idolatrous cult," namely Buddhism.[9] Xavier concluded that "the members of this sect are evil; they have no patience to hear it said that there is a hell."[10] The earliest reference directly to the Zen school, App adds, appears in a 1551 letter written by Father Cosme de Torres (1510–1570), in which Zen is distinguished from other Buddhist denominations and is said to have two branches. Thereafter, Jesuit writings on Japan refer to the Zen school, Zen monks, monasteries, and meditation halls, as well as seated meditation, koan, eremitism, and awakening (J. satori). There is likewise the case of Cristóvão Ferreira (1580–1650), a Portuguese missionary in Japan who, after his apostasy in 1633 during the Tokugawa shogunate's prohibition of Christianity, was obliged to register as a parishioner at a Zen temple.[11]

Was there a Jesuit discourse on "Zen art," one we would recognize today? It seems unlikely. Still, there are indications of Jesuit awareness of the principle of "nothing" and intimations in their dispatches of works we would consider today Zen art. Cosme de Torres, App notes, reported that Zen monks taught that "what has been created out of nothing (crió de nada) returns to nothing (se convierte en nada)."[12] The *Vocabvlario da Lingoa de Iapam* (*Nippō jisho*, 1603–1604), meanwhile, includes entries for "Ienpit" (J. *Zenpitsu*, "Zen brush") and "Ienno fude" (J. *Zen no fude*, "Zen brush"), referring, it would appear, to Zen painting and calligraphy, though the dictionary eschews aesthetic or philosophical comment. Moreover, the Jesuit Luis Frois (1532–1597) described what was likely an ink painting of a tree and figures inscribed with verses probably by Zen monks that suggest Buddhist teachings on emptiness and nonduality: "Who planted thee, O withered tree? I, whose origins was [*sic*] nothing and into nothing must needs return" and "My heart has neither being, nor no-being. It neither comes, nor goes, nor stands still." Europeans also encountered Zen iconography in paintings of Bodhidharma (J. Daruma) and were struck by the pictorial effects of ink monochrome. The Jesuits were especially avid commentators on Chanoyu, one variety of Japanese tea culture, which they associated with Zen. João Rodrigues (1561–1633), for instance, reported that "pagan followers of this art belong to the Zen sect, or else join it" and follow "the solitary philosophers of the Zen sects who dwell in their retreats in the wilderness," where "they give themselves up to contemplating the things of nature, despising and abandoning worldly things."[13]

So far so good, but what may have caught the fullest attention of the Jesuits were, instead, the exquisitely designed and richly appointed buildings and landscape gardens of Japan's Zen monasteries, which rivaled the religious centers of Europe. "Let it suffice to say, dear brothers," Frois observed, "that they possess all this only for their happiness and renown in this life."[14] Frois writes, it appears, of colorful worldliness rather than monochrome, abstraction, mysticism, and nothingness.

CURIOS AND OLD MASTERS

If initial contacts did not yield the sorts of encounter with Zen art we might expect, how did Zen art figure in the perceptions of vanguard foreign visitors at the "opening" of Japan in the mid-nineteenth century and of travelers and residents in the ensuing decades? For foreign globe-trotters and residents during the second half of the nineteenth century, Japan presented an art world with relatively little Zen in it. In most Anglophone books and essays, Zen was but one of many Buddhist denominations, albeit one distinguished by some Western writers for its discipline and belief in "annihilation" and "meditative doctrine."[15] Zen art does not leap off the page at this time, however, and there are only brief discussions of ink painting (J. *sumi-e*) and Zen monk painters such as Minchō (1352–1431) and Sesshū Tōyō, who were lauded not for their Zen abilities but their Chinese painting skills. Certain commentators refer to simplicity and directness, but they make no reference to chance, nothingness, or emptiness—Zen's postwar keywords par excellence.[16]

Instead, this was a period for the "study of Japanese Art and its applications to industrial purposes," as Sir Rutherford Alcock (1809–1897) put it in 1878, a time to appreciate the wonders of Japanese design and decoration, the moment of Katsushika Hokusai's (1760–1849) apotheosis, and the era of Japonisme.[17] The taste of the times favored "Aesthetic Orientalism," and Japan was described as a paradise of curios.[18] Thus, while visitors may have exclaimed that "everything in Japan is *so* artistic!" most were drawn to lacquer, cloisonné, porcelain, woodblock prints, and paintings of literary and historical subjects, landscapes, flowers, and birds—among them, "*kakemonos* [hanging scrolls] by good artists" of the Kano and Tosa schools.[19] Guidebooks and travel accounts offer descriptions of picturesque Zen monasteries, their golden "idols," and treasures locked away in formidable storehouses, but their authors attend chiefly to sliding-door paintings by professional artists, not ink paintings or calligraphies by Zen monks.[20]

Even commentators who offered more elaborate interpretations of artistic practice in Japan were generally silent regarding the nexus of painting and Zen philosophy. James Jarves (1818–1888), writing in 1876, presents a patently Romantic view of what the Japanese artist does: "Mind takes two forms of consciousness in apprehending art; one primary, recognizing its material semblance to its objects, the other its capacity of an inward suggestiveness, or manifestation of the fundamental spirit, or ruling thought of its motives."[21] With regard to painting subjects that might occasion explanation of "fundamental spirit" as a specific product of Zen, Jarves is silent. Hotei (Ch. Budai), for example,

DARUMA.

FIGURE 5.
Daruma. In Edward Greey, *The Wonderful City of Tokio or Further Adventures of the Jewett Family and their Friend Ota Nambo* (1883).

a core figural subject in medieval Chan/Sŏn/Zen painting, is introduced strictly as one of the seven gods of good fortune (J. Shichifukujin), "neither more nor less than an obese, dirty mendicant Buddhist friar, of great sanctity, self-taught, affable, jovial, generous, sleeping on the ground outdoors in all weathers, and always carrying with him his sack of begged victuals."[22] Hotei is thus a quixotic character but not an embodiment of Zen, let alone the postwar "dharma bum" he became.

Indeed, some of us may scratch our heads at the British attaché Edward Greey's (1835–1888) description of Bodhidharma accompanied by an illustration based on a premodern painting (fig. 5):

> Daruma was a very holy saint, and it is a shame to make toys, snow-men, and tobacconists' signs in his image. He came from the land of Shaka, therefore wore a beard and moustache. When he crossed from Corea he had no boat, but rode over on an *ashi* (rush) leaf. Before venturing on this perilous voyage, he prepared himself by making a retreat that lasted nine years, during which time he knelt with his face turned to the wall. It is said that he thus wore off his lower limbs, so he is represented as having only head, arms, and body. Ah, my daughter, if we could all be like him.

Greey refers (with notable mistakes) to two famous episodes in the Bodhidharma hagiography—"Crossing the Yangtze River on a Reed" and "Wall-gazing at the Shaolinsi"—but he makes no reference to meditation

per se, Bodhidharma's status as the first Chan patriarch, or any feature of the accompanying illustration that reveals Zen artistry.[23] Nor does Greey cite the famous aphorism attributed to Bodhidharma that would soon become the standard definition of Zen: "A special transmission outside the scriptures. / Not establishing words and letters. / Point directly to the mind. / See one's nature and become buddha."[24] We might note, too, that Greey's description of Daruma appears in a chapter titled "Among the Porcelain-Makers," suggesting that Zen art had yet to achieve the sort of synecdochic/metonymic capacity for Japan it would by the mid-twentieth century.[25]

Individual Zen masters, painters, and pictorial subjects thus existed within the range of knowledge of Euro-Americans, but not necessarily as "Zen art."[26] Indeed, one finds a string of writings continuing into the early twentieth century that virtually ignores the Zen in the paintings of monks such as Minchō, Josetsu (active late fourteenth to early fifteenth century), Shūbun (active mid-fifteenth century), and Sesshū.[27] Basil Hall Chamberlain (1850–1935) may have invited readers of his *Handbook for Travellers in Japan* (1891) to admire Sesshū for "The grand simplicity of his landscape compositions, their extraordinary breadth of design, the illusive suggestions of atmosphere and distance, and the all-pervading sense of poetry," but he gave these qualities priority over Sesshū's possible expression of Zen mysticism or philosophy.[28] Moreover, despite the virtues of Sesshū's paintings, Chamberlain doubts their appeal in the West:

> The synthetic power, the quiet harmonious colouring, and the free vigorous touch of these Japanese "old masters" have justly excited the admiration of succeeding generations of their countrymen. But the circle of ideas within which the Sesshūs, the Shūbuns, the Kanos, and the other classical Japanese painters move, is too narrow and peculiar for their productions to be ever likely to gain much hold on the esteem of Europe. . . . Grant the ideals of old Japan, grant Buddhism and Chinese conventions, and you must grant the claims of the worshippers of the old masters. But the world does not grant these things.[29]

The "world" here is the West, and these old masters, many lauded today as quintessential Zen painters, were apparently too esoteric for audiences in Europe and North America, who favored instead Ukiyoe and the "decorative" in Japanese art. Even an explanation for Sesshū's famous *Splashed Ink Landscape* (Plate 1), published in the 1917 bilingual *Wakan meigasen* (Selection of Famous Japanese and Chinese Paintings), remains chaste regarding Zen metaphysics and philosophy:

Here is one of Sesshū's landscape masterpieces. In this case we are con-
fronted with a super example of the *P'o-mo* [pomo] style, a style of ink
sketching characterized by the utmost economy of strokes. See what a
marvelous effect has been here brought out by a few indifferent dashes
and strokes; yet with these few dashes there has been produced a land-
scape complete in all essentials. The phrase "artistic triumph" seems
most appropriate for describing a work of this order.[30]

It would take a decade or more for such paintings to garner attention and
acclaim in Europe and North America specifically for their relationship to
Zen.[31]

 That said, Chamberlain and other writers brought attention to the
"directness, facility, and strength of line" in Japanese ink painting, "a sort of
bold dash due probably to the habit of writing and drawing from the elbow,
not from the wrist." In this mode, Chamberlain explained, the Japanese art-
ist "paints the feelings evoked by the *memory* of the scenes, the feelings
when one is between waking and dreaming."[32] Such attention to ink line
would be sustained in later writings about painting in Japan and would fig-
ure in art pedagogy in the West. Arthur Wesley Dow (1857–1922), in his
"Course in Fine Arts for Candidates for the Higher Degrees," would teach
the "Quality in Drawn Line" through the works of Jean-François Millet
(1814–1875), Rembrandt van Rijn (1606–1669), "and Japanese brush work,
preferably by Sesshu."[33] Meanwhile, descriptions of the Japanese painter
working unfettered from natural detail and omitting what is "irrelevant
to the particular emotion which he himself feels" echo Romantic ideals of
artistic expression and presage later descriptions of the Oriental *sumie* (ink)
painter expressing Zen consciousness.[34] This is a topic that, from the 1920s
and 1930s, D. T. Suzuki and others would write about with great verve.[35]

ON DISPLAY TO THE WORLD

Exhibits representing Japan at the world's fairs during the second half
of the nineteenth century for the most part reinforce the impression that
European and North American perceptions of Japan's cultural past did not
in this period incorporate Zen art. Presentations at the 1876 Philadelphia
Exposition included porcelain, lacquerware, textiles, metalwork, wood and
ivory carving, and painting.[36] The *Official Catalogue of the Japan Section,*
drawn up by the Japanese commissioners, introduced the history of the
fine arts in Japan in relation to Korea and China and to Buddhism, traits
of national character, a "predilection for the quiet and harmonious scenes of

nature," and the use of ink monochrome in painting—but not a word about Zen-inspired art. The United States report on the 1889 Exposition Universelle in Paris, meanwhile, commented that, "The paintings on silk furnished by nine Japanese exhibitors have all the rich and quaint features, with the harmonious coloring that we were accustomed to expect from that interesting empire." Joining these works were paintings in oil and watercolor and "a very full display of ingenious Japanese work in bronze, enamel, lacquer, ivory, wood, faience, iron, and silver, including vases, censers, boxes, plates, panels, tables, etc."[37]—nothing here explicitly Zen either. Zen art had yet to grab hold of the Western imagination as part of the "Japan effect" famously described by Oscar Wilde (1854–1900).[38]

Things were a bit different at the 1893 World's Columbian Exposition in Chicago. Emphasis was placed firmly on "decorative" painting and ceramics and lacquerware shimmering with color and gold. The dominance of this visual and material register was evident in two of the three rooms of the Hōōden (Phoenix Pavilion), an architectural replica of the eleventh-century Amida Hall at the Byōdōin, Uji. As Judith Snodgrass points out, Okakura Kakuzō decorated the pavilion in large measure to accommodate prevailing Western tastes for color and ornament.[39] Still, the imperial commissioners incorporated into the building's south wing a new visual order associated with Zen. Hanging in one room designed in the Shoin architectural style (J. *Shoin zukuri*) were copies of paintings of the Zen ox-herding theme by the Ashikaga- or Muromachi-period (1336–1573) painter Sesshū, completed by the modern painter Tsuruzawa Tanshin (1834–1893), which were surrounded by sliding-door paintings of landscape in ink monochrome by Kawabata Gyokushō (1842–1913).[40] The introduction of this architectural style and decoration was linked partly to the Ashikaga period's temporal relationship to Columbus' discovery of the Americas, but Snodgrass suggests that it aimed to appeal to "new tastes for elegant simplicity and appreciation of natural materials."[41] Not coincidentally, Japanese intellectuals were beginning to characterize the Ashikaga period of warrior rule as the golden age of Zen art, just as Zen was being promoted by figures such as the Rinzai Zen lineage master Shaku Sōen (1860–1919), a prominent participant at the 1893 Chicago World's Parliament of Religions, through reference to the "samurai spirit."[42]

Nevertheless, a gap remained between Japanese art and Zen at the 1910 Japan-British Exhibition in London. The *Times* and other papers paid considerable attention to paintings from the Heian (794–1185) to Edo (1615–1868) periods, many national treasures of Japan borrowed from temples and shrines, the imperial museums, and private collectors. By exhibiting these works Japanese officials sought to generate recognition of ancient

achievements in the fine arts separate from the works of porcelain and uki-yoe that captivated many in the West. Among the exhibits were figural and landscape scrolls by Minchō, Shūbun, and Sesshū, including a *Splashed Ink Landscape* attributed to the latter.[43] Lauded later as "Zen paintings," at the time these works were described not in terms of Zen but through compar-ison (oftentimes unfavorable) to paintings by artists such as Fra Angelico, Michelangelo, and Whistler.[44]

But change was clearly afoot, and by the publication in 1900 of *L'his-toire de l'art du Japon,* written under the direction of Kuki Ryūichi (1852–1931) for the Exposition Universelle de Paris, strong links had been forged between Zen, art, and Japan. Indeed, *L'histoire* presents an extended nar-rative on Zen art and reproduces many of its now-familiar "greatest hits," including Muqi Fachang's (active second half 13th c.) *Guanyin, Gibbons, and Crane* and Josetsu's *Catfish and Gourd.* We read that the expansion of the Zen sect during the rule of the Ashikaga shoguns shifted elite art away from the court tradition. As the most important painters were Zen adepts, the text informs us, painting at this time became "Zénesque." The Zen-ness of such art was due, meanwhile, to the sect's "propagation of the contemplative spirit and the taste for seclusion and solitude. It introduced to the arts a simplicity that is somewhat rustic and ascetic in nature. In all ways it preferred the somber paintings in Chinese ink in the style of the Song and Yuan [dynasties]. It eschewed the decorative."[45] Moreover, "just as the basis of this [Zen] doctrine affirms that in order to achieve aware-ness of the heart it is necessary to practice meditation, it is natural that the paintings influenced by it must show a character that is simple and elevated."[46] In other words, eremitic rusticity, monochrome, simplicity, and loftiness, aesthetic and philosophical aspects that establish both the quality and greatness of Zen painting, which, it is implied, arises from the spiritual awareness achieved through meditation. Great painting, which is ink painting, *sumiyé,* is, in short, Zen painting, which in turn manifests aesthetic qualities born of and indexical to Zen awakening.[47] Although *L'histoire* may not be the "smoking gun" of global Zen art's appearance, it constructed a national metaphysical-aesthetic matrix and ushered in new possibilities for Zen and art.

OKAKURA'S ZENNISM, FENOLLOSA'S ART HISTORY

For many Victorians and Gilded Age Americans the arts of Japan were seen as products of an inferior race whose achievements could not surpass those of Europe with its Classical and Renaissance heritage. Even so, collectors

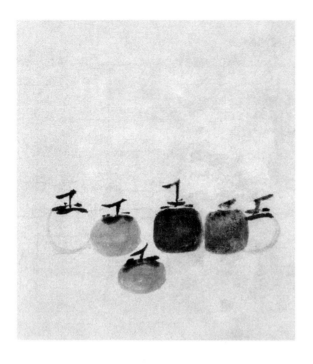

FIGURE 6. Muqi (active mid-to-late 13th c.). *Six Persimmons.* Chinese, 13th c. Hanging scroll. Ink on paper. 35.1 x 29.0 cm. Important Cultural Property. Ryōkōin, Kyoto.

did not hesitate to acquire the sort of Japanese art they enjoyed and revel in their visions of Japan, leading to Oscar Wilde's famous assessment of Japonisme: "the whole of Japan is a pure invention."[48] Part of this "invention" was white Euro-American understandings of Buddhism, in which, from the 1910s and 1920s, Japanese Zen became increasingly prominent.[49]

Growing interest in Zen in the West was spurred by the efforts of globe-trotting Zen teachers such as Shaku Sōen, who were simultaneously active in Japanese domestic discourses on modernity and religion, reform of the Zen institution towards greater lay participation, and the development of exceptionalist ideology within the expanding Japanese empire. Debates on art and nation taking place in Japan during the late Meiji and Taishō (1912–1926) periods, meanwhile, paid increasing attention to the artistic cultures associated with Zen, drawing them into modernizing strategies, art historical examination, mechanical reproduction, museum exhibition, and the international art market. This was the larger process underlying the creation of the panoptic narrative of the arts of Japan presented in the 1900 *L'histoire,* which in a material sense began with the art surveys conducted by the Meiji government in the 1870s to 1890s. Identifying ancient paintings and calligraphies produced by Chan and Zen monks, these surveys led to the designation as National Treasures of Japan of works such as Muqi's *Guanyin, Gibbons, and Crane* and *Six Persimmons,* the latter perhaps the most frequently reproduced work identified as Zen painting (fig. 6).[50]

Newly established national museums regularly displayed these and other Zen-associated works to demonstrate intrinsic aesthetic qualities and narrate the development of Oriental art (*Tōyō bijutsu*). Art treatises, journals, popular texts, and lavish art reproduction volumes published in Japan (the latter frequently graced with English captions and explanations), disseminated premodern Chan/Zen painting and calligraphy domestically and abroad. By the 1930s the international modern canon of Zen painting and calligraphy was by and large established.[51]

Moreover, during the first decades of the twentieth century, Japanese intellectuals, writers, and artists, including D. T. Suzuki, the novelist Natsume Sōseki (1867–1916), the philosophers Nishida Kitarō and Watsuji Tetsurō (1889–1960), the poet Nagai Hyōsai (1882–1945), and the writer Okamoto Kanoko (1889–1939) became lay practitioners of Zen under the guidance of modern masters, wrote about Zen for general audiences, and dabbled in Zen pictorial themes and calligraphy.[52] Collectors from among Japan's new business and industrialist class, including Masuda Takashi (1848–1938), Nezu Ka'ichirō (1860–1940), and, later, Masaki Takayuki (1895–1985), sought out works of Chinese and Japanese art of the Song and Yuan dynasties and Kamakura, Muromachi, and Momoyama periods associated with Chan/Zen, often for their importance to Chanoyu.[53] Idemitsu Sazō (1885–1981), meanwhile, was drawn to paintings by Edo-period (1615–1868) monks such as Hakuin Ekaku (1685–1768) and Sengai Gibon (1750–1837), presaging the postwar valorization of their works as "Zenga."[54] Zen-associated pictorial subjects were not uncommon in modern Japanese painting (J. Nihonga, Yōga) (Plate 5), while Zen rock gardens (J. *karesansui; sekitei*) were increasingly part of modern discourses on Japan's old art and inspiration for modernist design (fig. 3).[55]

As Zen art came into vogue in early twentieth-century Japan, this domestic process turned towards the West, contemporaneously with Japan's military victories and colonial expansion in Asia. This was due partly to the world's fairs and the English-language writings of Japanese intellectuals. Okakura Kakuzō's books *The Ideals of the East* (1903) and *The Book of Tea* (1906), which were part of a larger nation/empire-building genre, introduced "Zennism" with effusive lyricism and identified Zen as *the* religion of the samurai in what Okakura characterized as the great military-cultural synthesis of the Ashikaga period.[56] The followers of Zen, Okakura explained, "aimed at direct communion with the inner nature of things, regarding their outward accessories only as impediments to a clear perception of Truth."[57] The great age of Zen painting in Song dynasty China is embodied, Okakura added, in the scrolls of Ma Yuan (ca. 1190–1225), Liang Kai (fl. 1st half 13th c.), and the monk Muqi preserved in Japan. Not merely did Zen painting reach its culmination in Japan, in Okakura's view, "Life and art, as influenced by these teachings [of Zen], wrought changes in Japanese habits which have now become second nature."[58] From Okakura we learn, in sum, that Chinese Chan was surpassed by Japanese Zen, and that Zen and Zen art are part of, if not predominant in, the "national essence" (*kokusui*) of Japan, a sentiment echoed in the later writings of D. T. Suzuki and others.[59]

Okakura's writings provided a vocabulary for describing Zen art and explained the subjectivity and aesthetic preferences of the Zen artist. The

artists of the Ashikaga period, he asserts, "were all Zen priests, or laymen who lived almost like monks," and their art, "pure, solemn, and full of simplicity," discarded "the high-toned drawing and colouring, and the delicate curves of Fujiwara and Kamakura [period painting]" in favor of "simple ink-sketches and a few bold lines" to "make expression as simple and direct as possible."[60] The conventional symbols of Buddhist imagery were dispensed with, we read, and Zen painters, eschewing mimesis, sought in brushwork and composition "direct communion with the inner nature of things" and "clear perception of Truth."[61] In the work of the painters Sesshū and Sesson Shūkei (ca. 1504–ca. 1589), "Each stroke has its moment of life and death; all together assist to interpret an idea, which is life within life. Sesshū owes his position to that directness and self-control so typical of the Zen mind. . . . To Sesson, on the other hand, belong the freedom, ease, and playfulness which constituted another essential trait of the Zen ideal."[62]

Okakura's Zennism was explicitly juxtaposed with the European tradition and sought to intervene in European and North American perceptions of East Asian art. That which appears in Western eyes to fail, at least in terms of the principles of European art, Okakura argues, is the ultimate aesthetic achievement in art:

> The absence of symmetry in Japanese art objects has often been commented on by Western critics. This, also, is a result of a working out through Zennism of Taoist ideals. . . . True beauty could be discovered only by one who mentally completed the incomplete. . . . Since Zennism has become the prevailing mode of thought, the art of the extreme Orient has purposely avoided the symmetrical as expressing not only completion, but repetition. Uniformity of design was considered as fatal to the freshness of imagination.[63]

Okakura's pronouncements on Zennism and art were masterful in their way. Romantic, exotic, and nationalist, they seem to rhetorically and ideologically overwhelm the descriptions of Zen temples and largely a-philosophical commentary on Zen art found in the writings of Europeans and North Americans in preceding decades. Arguably, Okakura's efforts were strategically "self-Orientalizing, projecting an image of Japanese cultural practice long past as the essence of the present."[64] The early twentieth-century present was acutely important to Japanese officials and intellectuals, and Okakura was not alone in his efforts to promote Japan through its past traditions, including and especially that of Zen. Although it did not have the breadth of readership that Okakura's *Book of Tea* achieved, Anesaki Masaharu's (1873–1949) *Buddhist Art in Its Relation to Buddhist*

Ideals, based on lectures given in 1914 at the Museum of Fine Arts, Boston, emphatically promoted Zen in Japanese culture. Anesaki, a prominent writer on Japanese religions and visiting professor at Harvard University from 1913 to 1915, had no specific affiliation with the Zen institution. He nevertheless focused an entire chapter—"Buddhist Naturalism and Individualism: The Transition from Religious to Secular Arts"—on Zen and its diffusion into Japanese culture, illustrating his explanation with more than a dozen figure and landscape paintings almost exclusively in ink monochrome.[65] Like Okakura, Anesaki presents a Zen devoid of monastic ritual, devotion, social class, history, and ideology, and centered solely on individual meditation and intuition leading to realization of the absolute.[66] This is what differentiates Zen from other forms of Buddhism, he proposes; Zen art is distinctly and directly the product of this Zen intuitive realization.

Anesaki's explanation suggests a Zen-Transcendentalist hybrid, and in this he echoes Okakura's writings and lectures—especially those composed and presented in Boston—that took up Emersonian thought in the transnational promotion of traditional Japanese culture as a means to achieve re-sacralization amid the vexations of modernity.[67] For Anesaki, the "union of the individual soul with the cosmic spirit," which the Zenist attains, is manifest in "art of a transcendental kind. Naturalism and intuitionism enabled the Zenist not only to absorb the serenely transient beauty of nature, but also to express it, distinct from human passions and interests, in placid dignity and pure simplicity." In turn, "a picture should be the soul of nature brought to a focus before the purified, spiritual eyes of man,—the cosmic spirit embodied in a little space through a mind in full grasp of the cosmos."[68] Thus, while paintings of the Buddha, bodhisattvas such as Kannon, and other members of the pantheon personify Zen enlightenment, "All deities [as they appear in the Zen context] are deprived of their traditional glories and decorations, of their golden light and brilliant colors, and appear simply as human figures, semi-naked or clad in white robes, abiding in the midst of nature." Such paintings, he adds, "are not meant to be worshipped, but to give pleasure,—the pleasure of serene composure, of pure simplicity, of the beauty of slender human figures." Zen art, in other words—words that undoubtedly resounded in the minds of Gilded-Age Boston audiences—is all the better and more significant for having left the monastery, separated itself from ritual, and transformed into a universal "religion of simple beauty" for all humanity rooted in the soul's union with the cosmic spirit.[69]

Although Anesaki may have partly tailored his explanations to his Boston audiences, his Zen-Transcendentalist hybrid is one expression of the sincere and strategic engagement of modern Japanese intellectuals and Zen

advocates with European philosophy and religion, a matter I address in the next chapter. In this sense, Anesaki's "Transcendental Zen" was not merely a fabrication designed to beguile American audiences or strictly a means to reclaim from Western intellectuals the prerogative to represent Japan. It was, perhaps, part of a transnational modern conversation about "humanity," the "individual," and the "soul"—a conversation of high ideals that was nevertheless situated amid the encounters of empire (European, American, and Japanese) in which, in the view of Okakura, Anesaki, and others, Zen had a role to play.[70]

As it turned out, European and North American scholars were highly susceptible to Romantic-Transcendental Zen as they engaged in their own transcultural and often orientalist representations of Asia. In *Painting in the Far East* (1908), for instance, Laurence Binyon (1869–1943) wrote in a now familiar vein that Zen painters during the Ashikaga period pushed beyond form to the transcendental: "To find one's own soul, the real substantial soul, beyond and behind not only the passions and unruly inclinations of nature, but also the semblances with which even knowledge, even religion, may cloud reality by imagery, form, ritual—this was the aim of Ashikaga culture; liberation, enlightenment, self-conquest."[71] In Binyon's telling, a Zen painting not only expresses its maker's inner spiritual grasp of the outwardly pictorialized subject, it offers the viewer an opportunity to "summon an interiorized experience."[72] Going further, he proposes that a Zen painting communicates a "spark between mind and mind"; the ideally attuned viewer who catches this spark, and completes the painter's allusive composition, achieves a form of awakening.[73] With this statement Binyon deftly knotted into the interpretation of Zen painting the much commented upon spiritual-ideological framework of mind-to-mind dharma transmission of monastic Zen, bringing forth a conception of Zen painting that, echoing Okakura and others, helped to enable a discourse on Zen art that could operate outside monastic and lay contexts in Europe and North America.

If Binyon appears to have fallen partly under Okakura and Anesaki's spell, Ernest F. Fenollosa's (1853–1908) vision of Zen art was of a somewhat different visual ilk and art historical order. In *Epochs of Chinese and Japanese Art* (1912), he singled out works already canonized as Zen art including the "Muqi Triptych." Rather than their Zen simplicity and asymmetry, however, what seems to have captivated Fenollosa was what he referred to as the Oriental harmony of line, the poetic nuances of *nōtan* (dark and light), vivid coloring, and evocative spacing. If Zen painting had a spiritual aura for Fenollosa, meanwhile, it seems to have been primarily about the transubstantiation of the soul and more in keeping with his interests in

Tendai Buddhism, occultism, Theosophy, and Spiritualism than with Zen meditation and metaphysics or Emersonian thought per se. This outlook informed Fenollosa's exhibition of scrolls from the *500 Luohan* borrowed from the Zen monastery Daitokuji and displayed at the Boston Museum of Fine Arts in 1894–1895 (Plate 6).[74] Forty paintings from the hundred-scroll set, produced in Ningbo, China, between 1178 and 1188, were exhibited in the "Japanese corridor" of the museum's Copley Square building. Fenollosa deemed the scrolls rare treasures of Song-period Buddhist art, the Song being, in his words, the "golden period of art for the Zen sect in China." Fenollosa was deeply impressed with the paintings' stunning visual forms, and his florid descriptions rejoice in the powerful aesthetic effects of undulating lines and whirls of color within dramatic figural, architectural, and landscape compositions.[75]

Given the unprecedented loan of these paintings by a prominent Zen monastery to the Museum of Fine Arts, perhaps the premier venue for Japanese art in North America, one might describe this as the grand debut of Zen art in the West. One cannot help but note, however, that these paintings display little that resonates with Okakura's explanations regarding simplicity and suggestion or, for that matter, postwar conceptions of Zen painting as consisting of abstract circles or quirky Zen eccentrics in ink monochrome. Be that as it may, Fenollosa was assertive in his efforts to define Zen art. His writings give the art of Zen a particular valence: it is "idealistic" rather than "mystical." This is because the Zen doctrine, "certainly the most aesthetic of all Buddhist creeds," "holds man and nature to be two parallel sets of characteristic forms between which perfect sympathy prevails."[76] Fenollosa sees the shift from esoteric mysticism to Zen idealism as epochal, "for it implied no less a change in Buddhist and in social contemplation than the substitution of the natural for the supernatural. If I call it Idealistic contemplation, it is because it regards nature as more than a jumble of fortuitous facts, rather as a fine storehouse of spiritual laws. It thus becomes a great school of poetic interpretation."[77] Landscape painting in Asia was transformed, therefore, through the "Zen-like recognition that something characteristic and structural in every organic and inorganic form is friendly to man, and responds gladly to the changing moods and powers of his spirit. . . . to make, in short, nature the mirror of man—this is completed [*sic*] Zen system; this gives vast vitality to landscape art."[78] Showing his Western philosophical colors, he adds that the Zen-painter-adept achieved "a sort of independent discovery of Hegelian categories that lie behind the two worlds of object and subject." "Possibly," he added, "the telepathic power of the teacher, and of the whole Zen enlightenment, worked through the perceptions of the neophyte, to bring him to this general unity of plan."[79]

Fenollosa seems to be on his way to a heady, full-blown discourse on Zen art, non-duality, nothingness, and mind-to-mind transmission, but in the end such statements are arguably secondary to the biographies of painters and the formal and aesthetic features of their work. He writes of "priestly artists" (such as Li Longmian, 1049–1106, Muqi, and Sesshū) but does not elaborate on their specific mental and spiritual states or the sorts of qualities posited by Okakura. Instead, great Zen painters achieve marvelous form—bold outline strokes, misty effects, accents of light and dark, and so on—and become part of a grand lineage and transmission of pictorial types and innovations from China to Japan.[80] Note his eulogy for Sesshū:

> Sesshu is the greatest master of *straight line and angle* in the whole range of the world's art. . . . We may say that Sesshu's line combines the broken edge and the velvety gloss of a dry-pointist's proof, with the unrivalled force and resource of a Chinese calligrapher's brush— Godoshi [Wu Daozi] and Whistler rolled into one. But though Sesshu's line dominates mass and color, his notan taken as a whole . . . is the richest of anybody's except Kakei's [Xia Gui]. . . . One other greatest quality Sesshu possesses in large measure, and that is "spirit." By this first of the Chinese categories is meant the degree in which a pictured thing impresses you as really present and permeated with a living *aura* or essence.[81]

Fenollossa may have deemed Sesshū a "great Zen seer"[82] and his painting full of "spirit," but all great art should have this quality, and Zen art per se was not Fenollosa's endgame. Rather, it was to impress upon the West the magnificence of Oriental art within a universal, world art and promote a utopia of visual form, fusing East and West.[83]

◎ ◎ ◎

Fenollosa wrote in *Epochs* about Zen art in ways that differ considerably from Okakura's *Book of Tea,* but there is no question that both wrote at considerable length, helping to usher in new worlds of Zen art. Western collectors and scholars became entranced by their accounts, and it bears mention that in the span of only a half-century general comments about the Zen sect and treasures found in Zen temples gave way to particular explanations of Zen painting and other arts and to effusive descriptions of the spiritual consciousness of the Zen artist and resulting aesthetic achievements. Romantic conceptions of artistic creativity are prominent in this shift, and the transcendental aura surrounding the Zen-influenced arts is striking partly by

virtue of its distinction from the positivist anal-
ysis of many art historians of the time whose
allegiances generally resided with artistic biog-
raphy, formal analysis, and cultural history.

There were other figures whose publi-
cations in the 1910s and 1920s helped inject
Zen art further into scholarly and popular dis-
cussions of the arts of Asia, including Garrett
Chatfield Pier's *Temple Treasures of Japan*
(1914), which reproduces numerous works of
painting from Japanese Zen monasteries and
praises their somber monochrome and the Zen
feeling for nature. Arthur Waley (1889–1966)
weighed in with his book, *Zen Buddhism and
Its Relation to Art* (1922), discussed in Chap-
ter 4. The same year the historian of Japanese
painting Fukui Rikichirō (1886–1972) wrote
for the *Burlington Magazine* on the well-
known ink *Landscape* by the Zen-associated
painter Bunsei (mid-15th c.) in the Museum of
Fine Arts, Boston (fig. 7). Fukui, who noted that
"This landscape leads me far away to my native
land, and appears to me like a dream here in
bustling Boston," was of a new generation of
art historians in Japan who would sustain the
intercultural efforts of Okakura and others and
their perceptions of Zen and ink painting as
revealing the truth of nature beyond its out-
ward forms while bringing to Zen art a more
"scientific" mode of art historical inquiry.[84]

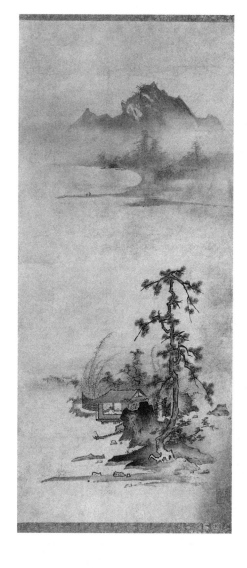

FIGURE 7.
Bunsei, Japanese,
active mid-15th
century. *Land-
scape.* Latter half
of the 15th c.
Hanging scroll. Ink
on paper. 73.2 x
33 cm. Museum of
Fine Arts, Boston.
Special Chinese
and Japanese
Fund, 05.203.
Photograph
© Museum of
Fine Arts, Boston.

The Zen art beat would go on, therefore, and the stage was well set
for D. T. Suzuki and other Japanese Zen campaigners whose performances
across the following decades would emphasize new concepts and terms and
imprint upon audiences the mystical and aesthetic registers that contrib-
uted greatly to postwar understandings of Zen and art. At that point, Zen
and Zen art could be unabashedly about "nothing," leading the scholar of
religious studies Huston Smith to observe in the midst of the postwar Zen
boom that "The West does not understand, but the Nothingness of which
it hears from across the sea sounds like something it may have to come to
terms with."[85] As I suggest in the following chapters, such "coming to terms
with" was by no means easy.

2

MAKING ZEN MODERN

D. T. SUZUKI

FIGURE 8.
D. T. Suzuki in
Cambridge, Mas-
sachusetts, 1958.
© Francis Haar.

That there have been remarkable modern efforts to explain Zen and Zen art and aesthetics to the world and motivated modern raconteurs is clear from the published writings, lectures, letters, and journals of D. T. Suzuki, "whose name is all but coterminous with Zen as known and practiced in the West" (fig. 8).[1] My turn to Suzuki here will come as no surprise to many, but for those unfamiliar with him, Suzuki acquired a larger-than-life presence as an indefatigable advocate for Zen in transnational discourses on religion and humanity. There were other earnest Zen campaigners, but Suzuki's writings are a good place to begin exploring the process by which Zen became modern, bearing in mind, of course, that, for all his prolific writing, Suzuki emphasized time and again that language could not fully convey the experience of, or substitute for, individual awakening to one's true nature.[2]

To imagine what was at stake for Suzuki, we might begin with his prefatory comments to his *Essays in Zen Buddhism, First Series* (1927), wherein he writes:

> The Zen masters so called are unable to present their understanding in the light of modern thought. Their most intellectually-productive years are spent in the Meditation Hall, and when they successively graduate from it, they are looked up to as adepts thoroughly vested in the kō-ans. So far so good; but, unfortunately from the scholarly point of view, they remain contented with this, and do not show any lively intellectual interest in the psychology and philosophy of Zen. Thus Zen is left to lie

quietly sealed up in the "Sayings" of the masters and in the technical study of the kō-ans; it is thus incapacitated to walk out of the seclusion of the cloisters.[3]

"Unfortunately," Suzuki writes, suggesting the need for new modes and voices of explanation so that Zen is no longer cloistered and can contribute actively to modern thought and life, leading toward a better future for all humanity. Not everyone would agree that Zen held the key to such a future, but in this and other declarations Suzuki purposefully positioned himself not as an advocate for a hidebound Zen but as a determined Zen reformer, and even, we might say, a missionary for Zen modernity. It might be said, too, that the ambition to bring Zen out of the "seclusion of the cloisters" was neither strictly modern nor exclusive to Suzuki.[4] But for Suzuki to advocate Zen with reference to psychology and philosophy, as he does in the preceding excerpt, is to reveal the effort's particular capacities and ambitions.

Suzuki was by no means anti-tradition, for certain aspects of premodern Zen were to be staunchly defended and sustained. And even if in his view Zen was ultimately timeless and universal, formidable and ultimately formless, it would be salvific in the face of modern conflicts and conundrums because of its rootedness in the past. An ordained Zen layman, Suzuki would champion as indispensable to true Zen the disciplined practice of meditation, and ultimately the orthodox training of the Japanese Zen monastery and meditation hall (J. Zendō).[5] The latter, for Suzuki, was based on centuries-old conventions that had passed to the present through the early modern reform efforts associated with the Rinzai Zen master Hakuin.[6] Reformist, and partly antimodernist, Suzuki's intervention worked its magic, we might say, with a traditional Japanese Zen touchstone, and for certain modern audiences the exotic aura of this putatively pure and unequivocal religious past confirmed the re-enchanting power of Suzuki's explanations.

Even a brief review of Suzuki's writings from the 1920s through the 1950s makes it clear that he sought tirelessly—though not without intellectual and sectarian preferences and complex relationships to Japanese nationalism and militarism—to transform traditional Japanese Zen into a modern religion for Japan and the world.[7] In the process, he would advocate in particular for the Rinzai Zen tradition while differentiating himself from traditionalist Zen masters (J. Zenji) who appeared stubbornly stuck in the past. "Not being one of those Zen masters, deeply imbued in the traditional pattern," Suzuki would write, "I follow my own method. There will be no kicking, no beating, no name-calling, but a 'logical' presentation of Zen philosophy."[8] Suzuki was in fact deeply indebted to such Zen masters for his early Zen training and ongoing practice, specifically Imakita Kōsen

(1816–1892) and Kōgaku (Shaku) Sōen (1860–1919), and it may be debated whether or not there has ever been quite as much literal kicking, beating, and name-calling in the Zen tradition as popular impressions suggest.[9] Noteworthy in Suzuki's statement, however, and arguably rather modern, is his unhesitant assertion that he will follow his own method of Zen. This was a method that took up the classical Chan/Zen textual and ritual tradition as the basis for a new, revitalized Zen practice that was valid in philosophical terms, could be explained logically, and could in turn be meaningful to modern society and discourses on the self, religion, and humanity. Without reading too much more into Suzuki's Zen self-determination, it seems in retrospect to explain later characterizations in the West of him and other Japanese layman such as Hisamatsu Shin'ichi as bona fide Zen masters and global representatives of authentic Zen, despite their relative autonomy from the monastic establishment and lack of full lineage transmission.[10] However much Suzuki may have rejected such characterizations, choosing instead a career as a "public Buddhist intellectual," as Richard M. Jaffe puts it, the attention Suzuki drew in Europe and North America as a Zen authority seems to have fostered, as I later note, modern extra-monastic Zen lineages, especially in the arts, in which the American composer John Cage (1912–1992) could be deemed a "Zen master" partly by virtue of his association with Suzuki.[11] In any case, for Zen to become modern—and this was critically important to Suzuki—it had to change in a variety of ways, some applicable to Japan and others specific to Europe and North America, while remaining based in the Rinzai tradition and Japanese Mahayana Buddhism.

MODERN ZEN HYBRIDITY, NATIONALISM, AND UNIVERSALISM

Suzuki wrote and lectured relentlessly about Zen for Japanese and non-Japanese audiences seeking to convince them of its benefits for the modern world. Zen offered release from the suffering brought on by excessive individualism and materialism as well as the mechanized, scientific world, and, especially, by dualistic apprehensions of reality.[12] Suzuki was by no means the only Japanese intellectual to advocate for Zen, to engage Zen teachings in relation to Western thought, or—as Steve Bein puts it in terms of the philosopher Watsuji Tetsurō's writings on the Sōtō Zen patriarch, Dōgen—to perform CPR on important Zen figures and bring them into the modern limelight.[13] Moreover, a number of Europeans and Americans took up the promotion and revitalization of Zen alongside these figures. Dwight

Goddard (1861–1939), for instance, whose perspectives on Zen were indebted to Suzuki and the Zen abbot Yamazaki Taikō (1876–1966), opined in 1932:

> Today, when Christianity seems to be slipping, [Zen] is the most promising of all the great religions to meet the problems of European civilization which to thinking people are increasingly foreboding. Zen Buddhism, with its emphasis on mind-control, its dispassionate rationality, its cheerful industry, not for profit but for service, its simple-hearted love for all animate life, its restraint of desire in all its subtle manifestations, its subjection of desire to wisdom and kindness, its practical and efficient rule of life, its patient acceptance of karma and reincarnation, and its actual foretaste of the blissful peace of Nirvana, all mark it out as being competent to meet the problems of this materialistic and acquisitive age.[14]

Unfortunately for Goddard and other advocates writing in the interwar period, Zen did not cure what ailed the modern world as quickly as they undoubtedly hoped. If anything it would be the violence and trauma of the Second World War and Cold War era conflicts, the threat of nuclear annihilation, as well as the alienation, social injustices, and environmental destruction accompanying postwar capitalism, that accelerated Zen's global acculturation, manifest in the "Zen boom" of the 1950s to 1970s.

Be that as it may, Suzuki's efforts constituted more than the mere introduction of Zen practices and Buddhist teachings as such. In recent years Robert H. Sharf, David L. McMahan, and Richard M. Jaffe have drawn attention to Suzuki's determined comparative engagement with European and American thought and belief, medieval to modern—from religion to philosophy to psychology and beyond—leading to what we might refer to as his hybridized formulation of Zen. In a process of sustained intercultural discourse, Suzuki (and other modern Zen campaigners) reshaped Japanese Zen into something that could be eminently congenial to the Western tradition through widespread reference to the mysticism of the medieval theologian Meister Eckhart (ca. 1260–ca. 1328), the Transcendentalist thought of Ralph Waldo Emerson (1803–1882), William James' (1842–1910) *The Varieties of Religious Experience: A Study in Human Nature* (1902), John Dewey's pragmatism, and the writings of Henry David Thoreau (1817–1862), among others.[15]

This is now well-trodden territory in Suzuki studies, even if it is in some senses unexceptional. For it is perhaps fair to say that comparative and hybridizing efforts—some in search of the ultimate sameness of East

and West, at least as the West presumed to find it, and others engaged in Asian nationalist resistance against Euro-American imperialism—may be "genetic" to modern discourses on Buddhism and the art histories of Asia.[16] In the Zen case, a pattern of fusing, grafting, and transplanting persisted into and beyond the postwar period (in some instances creating dubious farragoes). "They are all saying the same thing," the composer John Cage wrote concerning Sri Ramakrishna (1836–1886), Zen, and Aldous Huxley (1894–1963).[17] The poet Gary Snyder, whose style of Zen was quite different from that of Cage, would in part base his "Buddhist anarchism," with its eco-activism and social justice efforts, on his formal Zen training in Japan.[18] For Suzuki, Snyder, and others, hybrid Zen carried with it a serious responsibility to the Buddhist and Zen traditions, and to the very act of sitting down to meditate amid the rush of the world.

In any case, Suzuki's turn to European and American thinkers and writers in the cause of Zen—James' writing on religious experience providing Suzuki, in Jaffe's words, "a jumping off point for the development of his own Buddhist-centered theory of the nature of religion and mysticism"—did not go unnoticed in Japan, where multiple Zen modernizing and reform movements were under way.[19] Nor was Suzuki's strategy merely a ploy to convince the West. Rather, as Jaffe points out, his comparative mode emerged from his early personal and intellectual formation, including encounters with the rush of westernization in modern Japan, study of European thought at Tokyo Imperial University, experiences while accompanying Shaku Sōen to the World's Parliament of Religions in Chicago in 1893 and on other visits to the United States, and work for the editor and writer on comparative religions Paul Carus (1852–1919).[20] Indeed, Suzuki dove headfirst into contemporary discussions of religion and philosophy taking place in Japan, Europe, and North America. Over time, his transcultural explorations of mysticism and religious experience widened, taking in new intellectual debates and vocabularies. His goal seems to have grown ever more clear: to, in McMahan's words, "bring Zen into the conversations of modernity—in both Japan and the West."[21]

Arguably, it is Suzuki's success in bringing Zen to the high table of global interreligious, philosophical, and social discourse more than any citation of a particular Western writer and tradition, however rhetorically useful this may have been, that distinguishes Suzuki's Zen as eminently modern. Moreover, at the root of his evolving formulation of modern Zen, including his braiding of Rinzai Zen practice (its koan training system in particular) with strands of European and American religious, philosophical, and psychological thought, was that of personal mystical experience as the basis of true Zen, surpassing all intellectual, historical, and philosophical

discourses.[22] However eloquent Suzuki's philosophical rhetoric may have been at times, and however much such rhetoric came to be understood as the heart of Zen, Suzuki believed that understanding engendered by meditation—experiential, nonrational—was imperative. Indeed, he was critical of Western philosophers and others who wrote about Zen but did not engage in meditation.[23]

For some time, scholars have also reconsidered Suzuki's modern Zen in terms of its nationalistic ambitions and contributions to Japanese militarism. Although opinions diverge precipitously on the latter issue, it may be fair to identify a deep exceptionalist strain in Suzuki's assertions of Zen's status as the unique achievement of Japanese religion—Chinese Chan, in Suzuki's view, had long since died out—in fundamental distinction from Western religion, dualistic logic, and culture.[24] Here is Jaffe on this point: "Although Suzuki frequently wrote about common ground between 'East' and 'West,' pointing to the Romantics, Transcendentalists, and such Christian mystics as Swedenborg and Eckhart, Suzuki also asserted the ultimate superiority of Zen and, hence, Japanese culture."[25] Thus, at stake for Suzuki and other Japanese Zen campaigners during the 1930s and 1940s and thereafter was, in part, a sort of epistemological marking, a claiming of authority to define authentic Zen in order to control the emerging trans-Pacific/Atlantic presences and uses of it.

In *Japanese Spirituality* (a translation of *Nihonteki reisei* published in 1944), Suzuki argued that Japanese spirituality "exists in its purest form in Jōdo (Pure Land [Buddhism]) and in Zen," neither of which, despite having been transmitted to Japan from China, "possesses a foreign nature." On the surface this is an odd statement. But what arrived from China, Suzuki explains, was merely "Buddhist ritual and its trappings." Foreign Buddhism—"a historical accident"—served only as a catalyst for the expression of inherent Japanese spirituality. In that Zen "typifies Japanese spirituality," it was not the case that Zen developed deep roots in Japan. Instead, Suzuki argues that the roots were already there: "From the beginning there has been something in Japanese spirituality that could be regarded as 'Zen-like.' Since this was awakened by the chance appearance of Zen, it would be confusing cause and effect to say that Zen is foreign." Thus, in Suzuki's explanation, Zen—which accomplishes "directly, without any difficulty" a "connection to the highest reality without the intervention of some intermediate condition"—is neither beholden to nor in spiritual terms akin to Chinese Chan. Indeed, the imported character of Chinese Chan "altogether vanished following its introduction, and it became Japanese."[26] We therefore find an initial role for Chan in Japanese Zen, through processes of migration and ritual, literary, and material transmission; but the emergence

of Japanese Zen (and, in turn, its putative permeation of every aspect of traditional Japanese culture, a topic discussed in Chapter 4) depended on something already innately, uniquely present. *This* is the Zen that Suzuki wishes to introduce: *the* Zen that can engage the world's mystical and spiritual traditions and heal the damages of modernity.

Needless to say, Suzuki glides over the East Asian interregional, patriarchal mytho-history, interphilosophical and intertexual discourses, as well as lived human experiences of pilgrimage and migration characteristic of the remarkable development and spread of premodern Chan/Sŏn/Zen. But historical or ethnographic explication is not his primary aim, which is instead to distinguish Japanese Zen as the principal expression of Japanese spirituality—"spirituality," meanwhile, being a topic of critical importance, in his view, to Japanese national identity in distinction from other parts of Asia and the West and to modern efforts to counter scientism and materialism. Lest one read his exegesis as being flatly ideological, Suzuki adds: "There are no political connotations whatsoever attached to the Japanese spirituality of which I speak. It just happens that Japanese spirituality is Japanese. It has no wish to excel, politically or in any other way, or to rise above any other spirituality with its particular characteristics. It does not want to subjugate other elements of any kind."[27] Given that Suzuki's text was written in the early 1940s, during the height of Japan's Holy War (J. Seisen) in Asia and in the midst of heavy surveillance and censorship, and noting the wartime rhetoric of Japanese Buddhist ultranationalists, Suzuki's avowed apolitical but nevertheless exceptionalist stance may be more complex than it appears.[28]

In any case, Japanese Zen exceptionalist rhetoric as it emerged in the 1930s and 1940s was more ambitious or dimensional than an argument concerned strictly with Japanese uniqueness. Instead, it was deployed in some instances as a form of (anti-Western) universalism. In Suzuki's view, the Zen mystical experiences of *kenshō* (seeing into one's true nature) and satori (awakening), achieved through serious Zen practice and leading to the attainment of non-duality, were not only identical with the mystical experience of the Buddha Śākyamuni in India, they likewise constituted "the ultimate fact of all philosophy and religion."[29] Such arguments did not go over well with every observer, however, and R. J. Zwi Werblowsky noted that Suzuki

> Proclaimed Zen to be the universal message of salvation—*semper, ubique et pro omnibus* [always, everywhere, and for all]. In spite, or perhaps because of its oriental roots "Zen is . . . extremely flexible in adapting itself to almost any philosophy and moral doctrine as long as

its intuitive teaching is not interfered with. It may be found wedded to anarchism or fascism, communism or democracy." Dr. Suzuki forgot to add to the list of possibilities also Nazism with its gas chambers (as annoying Mr [Arthur] Koestler has rudely pointed out) and carefully refrained from referring to that particular aspect of Eugen Herrigel's career. . . . If Zen presents a challenge to the West, it is because the encounter with the East and West should set the West re-examining its attitudes and cultural assumptions, and by re-examining them deepen its humanity and discover, and possibly integrate, new dimensions of existence. This is a far cry from Suzuki's universal validity of Zen, and far more sophisticated.[30]

Bravura or hyperbole as it may now appear, the promotion of Japanese Zen's universalism as a "cosmopolitan" discourse enabled, among other interpretive behaviors, the detection of Zen in varied non-Japanese, non-Buddhist cultural works. This is evident in the writings of, for example, the poet and Zenophile R. H. Blyth (1898–1964), notably his *Zen in English Literature and Oriental Classics* (1942). In his preface, Blyth identifies Japan as the endpoint of Zen's development in Asia and attributes to it outsized authority in Japanese cultural production. He then argues for Zen a pan-cultural inherence predicated simultaneously on its Japanese apotheosis:

> Zen is the most precious possession of Asia. With its beginnings in India, development in China, and final practical application in Japan, it is today the strongest power in the world. Wherever there is a poetical action, a religious aspiration, a heroic thought, a union of the Nature within a man and the Nature without, there is Zen. Speaking generally, in a world culture we find Zen most clearly and significantly in the following: in the ancient worthies of Chinese Zen, for instance, Enō and Unmon; in the practical men of affairs of Japan, Hōjō Tokimune, for example, and in the poet Bashō; in Christ; in Eckhart, and in the music of Bach; in Shakespeare and Wordsworth.[31]

Not only did Blyth believe that Zen naturally underlies and infuses Western religion, thought, and culture, a perspective adopted by a variety of later writers in Japan and abroad, he sought to represent his belief in Zen's transhistorical/-cultural presence by pairing premodern Japanese ink paintings already set into the modern canon of Zen and Japanese art with poems by English authors. Sesshū's *Splashed Ink Landscape* (see Plate 1), for instance, is paired with an excerpt from William Collins' (1721–1759) poem

"Ode to Evening": "Wilds and swelling floods, / And hamlets brown, and dim-discover'd spires; / And hears their simple bell; and marks o'er all / Thy dewy fingers draw / The gradual dusky veil."[32] An appealing match, perhaps, though it ignores the poetic content inscribed by Zen monks above Sesshū's painting. One may also sense in Blyth's writing a bit of euphoria over the discovery of the unifying source and cause of cultural creation, no less one from the classical Orient.

Blyth was not alone or especially original in making such modernist Zen mash-ups, indebted as he was to Suzuki, but this universalist mode of Romantic criticism has remained active in philosophical writing on Zen and in popular criticism and marketing that search out and valorize individuals, texts, and objects that are, we might say, Zen without their even knowing it.[33] My "Zen Desktop Page-a-day Calendar," for instance, includes sound bites from classical Chan texts, Suzuki, Alan Watts, and other modern Zen advocates, as well as aphoristic phrases from, among others, the Pharaoh Akhenaten, Diogenes, Rumi, William Wordsworth, John Muir, and Emily Dickinson.[34] That Zen can be found in religious traditions, places, cultures, statements, and representations that have no intrinsic relationship or even proximity to Zen—a Zen *avant la lettre*, anywhere, anytime worldview—is part of a broader, modern interpretive matrix, one that produces claims for Zen's inherence in or permeation into all creative acts and art forms in Japan as well as any achievements outside Japan that are said to arise from what is deemed Zen awakening.

SLIPPING OUT OF CONTROL

In hindsight, Suzuki appears both inside modern Zen and outside it as well: a Japanese insider to the Rinzai Zen monastic and textual tradition as it had emerged during the late nineteenth and early twentieth century, and a modern, globe-trotting professor-philosopher-social critic and interlocutor for the West on Buddhism, Japan, and Asia. He had it both ways, emic and etic, as it were, as he traveled and wrote in the cause of Zen and Buddhism. Not that Suzuki was without his critics. As early as 1908, Jaffe points out, Suzuki's *Outlines of Mahāyāna Buddhism* was deemed by Louis de La Vallée Poussin (1869–1938) as overly susceptible to Vedantism and German philosophy, and therefore impure in its representation of Buddhism (as La Vallée Poussin preferred to understand it).[35] Half a century later, in 1959 and 1960, English-language reviews of Suzuki's oft-cited book *Zen and Japanese Culture* were noticeably mixed. Although Nancy Wilson Ross (1913–1986) gushed in the *New York Times* about the "delightful book" and

its description of the "inexpressibly soothing . . . old Japanese virtues of *wabi* and *sabi*," various critics were irked by its history and art history.[36] One reviewer noted that *Zen and Japanese Culture* had been written for the lay public and might therefore be excused for its lack of a "consistently historical scheme" and "technical presentation of Zen," while another noted that "Occasionally [Suzuki] descends to pure nonsense or to unbearable repetition."[37] There was praise for the book's copious plates but concern over Suzuki's inattention to works of art themselves: "This book seems at first sight to promise enlightenment on the relation of Zen to Japanese painting. In this the reader will be disappointed. Dr. Suzuki dwells at length on Zen and swordsmanship, Zen and the samurai, Zen and the art of tea, but his remarks on painting are meager in the extreme."[38] The art historian Alexander Soper (1904–1993), meanwhile, was perturbed by Suzuki's emphasis on the samurai and unconvinced by his treatment of the visual arts:

> The book is generously illustrated, chiefly with reproductions of Chinese and Japanese paintings and calligraphy. By no means do all of these have any connection with Zen: some provide pictorial footnotes to Japanese history . . . and others summarize the interests of rival sects of Japanese Buddhism. At the same time one finds no chapter with a title like "Zen and the Art of Painting"; and the one entitled "Love of Nature" makes no use at all of the whole *sumi-e* tradition.[39]

However one judges these responses, their pointedness is indicative of the impact Suzuki's ideas had in transnational exchange. They reveal too the competing authorities that emerged to speak for Zen and the arts, a topic to which I return time and again.

To become modern, therefore, Zen would have to enter and prevail in the arena of public discourse, not simply in the meditation hall, in Japan, or in new Zen communities abroad. Its advocates would have to engage the academic disciplines, with their particular debates and theories on human history, culture, and experience, and respond to public intellectuals and social critics concerned with the past, present, and future. As I discuss in Chapter 5, the conversations were not always convivial. Moreover, Suzuki, "the apostle to the non-Japanese gentiles of the universality of Zen," as Werblowsky described him, would find himself conversing with unlikely (from the orthodox Japanese Zen perspective) Western gurus of Zen—Alan Watts, Jack Kerouac, John Cage, and others—leading David W. Patterson to observe that Suzuki "could well be classified as an unwilling adoptee of the Western avant-garde."[40] Making Zen modern was therefore a matter not merely of inculcation but of negotiation, with the conservative

Zen institution in Japan, with religion, philosophy, and political-social contexts in the West, and then with the counterculture, avant-garde, and wider popular Zen boom.

In many respects Suzuki's efforts were well rewarded, but the transnational and intercultural opportunities that empowered his project may have thwarted its tidy management. Indeed, Suzuki would find that his labors were not entirely successful or were "successful" in unintended ways. In 1958, he wrote of his concerns with European and North American receptions of Zen:

> Zen is at present evoking unexpected echoes in various fields of Western culture: music, painting, literature, semantics, religious philosophy, and psychoanalysis. But as it is in many cases grossly misrepresented or misinterpreted, I undertake here to explain most briefly, as far as language permits, what Zen aims at and what significance it has in the modern world, hoping that Zen will be saved from being too absurdly caricatured.[41]

Suzuki's aside, "as far as language permits," echoes his frequent declaration that language is insufficient to the task of understanding Zen, which comes only through personal realization brought forth by meditation. That he would write of misrepresentation and unexpected echoes, meanwhile, suggests not only that he believed that there was a true, authentic Zen to be understood but that he may not have fully anticipated the places Zen would go and what it would become in the modern world.

Indeed, over the course of only a decade or so (the 1950s) different sorts of Zen split off from formal meditation and koan training, adopted meditation in idiosyncratic or marginal ways, if at all, and emerged as book-based, philosophical, visual-performative, as well as attitudinal and fashion-affected. We might perhaps locate this in the term, "Zen-like." For although Suzuki would claim that "From the beginning there has been something in Japanese spirituality that could be regarded as 'Zen-like,'" the concept of the "Zen-like" would itself become an embodiment, even a barometer, of Zen's labile nature in global exchange and its vulnerability to all manner of appropriation, defying Japanese exceptionalism in the process and opening Zen up to new possibilities, both serious and silly. Suzuki was partly responsible for some of this slippage given his presentations of Zen in philosophical and cultural terms that at times overshadowed his exhortations about meditation, but Zen got swept up in postwar circumstances well beyond his control. In retrospect, the slippage appears to some extent to have become the norm.

Or perhaps we might say that, corrupting a term of biology, modern Zen as formulated by Suzuki and others worked through a process of exaptation, putting old traits to new uses: traditional Zen, as defined by its Japanese advocates, was important, not only for domestic responses to modernity and the question of religion, but also for transnational self-representation and soft-power engagement with the West.[42] If that holds true, it bears equal mention that the modern Zen promoted by Suzuki and others ("Occidentalist Zen," as the American studies scholar James P. Brown terms it) was in turn exapted by Beat poets and artists and others in their anarchist challenge to the postwar American order.[43] Beat Zen would in turn be valorized and become nostalgic among certain segments of the baby boom generation and, then, neo-hip to some of their children and grandchildren. Put differently, modern Japanese Zen would mutate from its identity as a reform movement and touchstone of Japanese theories and rhetoric of uniqueness (Nihonjinron) to become a transnational theory of counterculture ideology and action lived by political and artistic avant-gardes in Europe, America, Japan, and elsewhere and espoused by "disaffected youth," hippies, and so on. Later, it would split off from the countercultural political, artistic, and spiritual, to become a mode of attitudinal and material consumption, and then a corporate social-engineering method for efficiency and profit; Zen would come "under new management." In any case, making Zen modern involved more than the mere rehearsal of timeless tradition, updated approaches befitting the new world, and benevolent intercultural and "unitarian" spiritual and cultural flows. Situated and implicated in the conditions and ambitions of modernity itself, including Japanese response to Euro-American empire and the fertile yet fraught circumstances of American spirituality, Zen could hardly sit still across the twentieth century.

3

DANXIA BURNS A BUDDHA
ZEN AND THE ART OF ICONOCLASM

Since Zen denounced . . . the scriptural authority, it is quite reasonable to have . . . set at naught those statues and images of supernatural beings kept in veneration by the orthodox Buddhists.

—Nukariya Kaiten, *The Religion of the Samurai* [1]

Let us test drill into the Zen-scape at specific coordinates: Zen iconoclasm. As we inspect our core sample, we find evidence suggesting that, for eons it seems, Zen masters—at play in the fields of non-duality—routinely violated normative conduct with unorthodox couture, inscrutable comments, scatological acts, ribald outbursts, icon desecration, and even killing. Since the mid-twentieth century, meanwhile, and especially in the West, Zen seems to have been predicated on acts that are jarring, antiauthoritarian, and antisocial. In the "ecology" of modern and contemporary cultural production, far from the ritual contexts and sophisticated pedagogical gestures and hermeneutical strategies of institutional Zen, these sorts of acts are alternately celebrated and condemned as Zen. To put it one way, if "getting in your zone" can be Zen, as the late twentieth-century colloquialism goes, shocking behaviors and naughty rebellion are equally, essentially Zen.

Who doesn't wish, at some point or other, to break the rules, and how reassuring or useful it is to find (apparent) validation in ancient Zen? Is this something that all of us might partake of and, in turn, be Zen? But why in the first place did Zen masters get away with brazen and scandalous deeds?[2] A short, normative answer might suggest that however shocking such actions may be, and even though they break the "taming" monastic regulations of the Buddhist monastic *vinaya* (Ch. *lu*; J. *ritsu*), they manifest orthodox Zen by virtue of their ability to provoke realization. Like other aspects of modern

Zen, moreover, there are fertile precedents, including ancient Buddhist discourses on rule breaking situated in relation to teachings on the emptiness of mental and material phenomenon and provisional and ultimate truths. One may cite the cases of premodern and modern Buddhist monks and nuns in various traditions known (and sometimes excoriated) for controversial teachings and actions.[3] Specific Chan lineages such as the Hongzhou school and masters such as Linji Yixuan (d. 867), meanwhile, were noted for iconoclastic methods, including shouting and beating, and the Chan "Lamp Histories" (Ch. *chuandeng lu*) and other hagiographical texts contain more than a few instances of "deviant" behavior and "anarchic" performances that skewered attachments to language, perception, hierarchy, representation, and so on.[4]

The explosive scenarios and language of such tales have long provided rich material for re-enunciation by later Chan/Sŏn/Zen monastics in figural paintings inscribed with poems that praise and comment upon such behaviors in transhistorical, virtual communion. The well-known Chan iconoclast iconography includes the sutra-tearing Six Patriarch Huineng (638–713); Nanquan Puyuan (748–835), who killed a cat; the quixotic monk-poet Han Shan (9th c.); the laughing, rotund Budai (10th c.); and the "shrimp eater" Xianzi (early 10th c.). With regard to incendiary acts, we read that Deshan Xuanjian (780/782–865) set fire to his collection of commentaries on the *Diamond Sutra* (Ch. *Jingang jing*), and Dahui Zonggao (1089–1163) burned his master Yuanwu Keqin's (1063–1135) copy of *The Blue Cliff Record* (Ch. *Biyan lu*; J. *Hekigan roku*) out of concern that his disciples would become attached to its cases and commentaries.[5] Episodes of icon abuse, which challenged conventional understanding of form, turn up in the *Blue Cliff Record* and other texts such as the discourse record (Ch. *yulu*; J. *goroku*) of the Chinese master Xutang Zhiyu (1185–1269):

> Once there was a monk who accompanied a Buddhist priest to a Buddhist temple. There the monk spat at the statue of Buddha. The priest said, "You have little sense of propriety! Why do you spit at Buddha?" The monk said, "Show me the place where there is no Buddha so that I can spit there." The priest was speechless. [Xutang's response] A fierce fellow indeed![6]

In Japan, the (allegedly) carousing Zen monk Ikkyū Sōjun (1394–1481) is associated with numerous outrageous acts, including his "consecration" of an icon of the bodhisattva Jizō by urinating on it.[7] That some of these brazen acts were taking place in some manner and with some frequency is suggested by criticisms of "anything goes" in Chan, notably that

issued by Guifeng Zongmi (780–841), who, Peter N. Gregory notes, felt that the Hongzhou School of Chan's practice of "'entrusting oneself to act freely according to the nature of one's feelings' had dangerous antinomian implications."[8]

In the modern world, one can trace the retelling of Zen iconoclast stories with little difficulty to the late nineteenth century and early twentieth centuries, when the curious and "radical" exploits of Zen masters were recounted outside the Zen institution by teachers such as Shaku Sōen and Sōkei'an Sasaki Shigetsu (1882–1945) as well as Zen advocates such as Okakura Kakuzō, D. T. Suzuki, and Alan Watts. Once we enter the second half of the twentieth century, the "tall tales" of the Zen masters—in circulation for centuries in East Asia—caught the attention of those engaged in counterculture practices and creative work in which Zen "radicality" could function in new ways and produce new Zen-identified actors and antics. We see this in Jack Kerouac's (1922–1969) novels, notably in the "crazy famous bhikkus Japhy and Ray" in *The Dharma Bums* (1958). A later version of it appears in the film *The Big Lebowski* (1998), whose protagonist, the Dude, is now the iconic Zen iconoclast-as-slacker-hipster, and in the illustrated biography *The Zen of Steve Jobs* (2012), wherein we read that the Zen master Otogawa Kōbun Chino (1938–2002) "was to Buddhism what Steve was to computers and business: a renegade and maverick."[9] Perle Besserman and Manfred Steger's adoring *Zen Radicals, Rebels, and Reformers* (2011), meanwhile, packages it up concisely, explaining that "Many Zen practitioners [in medieval China] stopped meditating and started to pray to these 'superhuman' beings [i.e., buddhas and bodhisattvas] to intercede for them and create a miracle. To counter this, Zen masters had to resort to radical means."[10] Such radical means were, in this account, Zen's wake-up call for a Buddhism that had displaced its attentions. Perhaps this is simply an updating of much older hagiography, but it seems rather close to branding and fashion; be a "Zen rebel," and purchase a limited-edition logo shirt.[11] Then there are the more recent "punk" and "hardcore" Zen teachers writing in irreverently confessional modes about their Zen training and offering advice for Zen practice amid the sufferings of the present world.[12]

When reviewing the postwar scene and its legacies one can hardly miss comments and even full-scale expositions on Zen-associated or -inspired iconoclastic acts taking place in art. Modern art iconoclasm à la Zen is often thought of as being conceptually impetuous in its ruptures of the European visual tradition and unflinching in its material, factural, bodily, and situational liberations from mimesis. In conventional Zen-affirmative accounts, such artistic acts (usually associated with white male artists) are born of Zen's unfettering power, even when there are notable

interrelationships with other modernist modes of rebellion. If undoing art visually, materially, aurally, performatively, and politically could be an iconoclastic Zen thing to do, the modern Zen iconoclast artist has perhaps provoked as much myth-making as the *artiste maudit*.

But why in the first place is it the Zen iconoclast, rebel, or radical, rather than other possible Zen figures, who so frequently distinguish Zen from other sorts of Buddhism and other religions in the modern world and who stands out in the crowd of spiritual role models? Perhaps rebels are simply more exciting than the comparatively nonsensational Zen parish priest, cook, hospice caregiver, and even the mildly quirky Zen teacher, who may be too plain or redolent of religion to capture our spiritual, countercultural, and entertainment culture imaginations. Perhaps the contrarian Zen masters are the perfect guides for those fleeing "the alienating features of hardened institutions and over-bearing traditions," even when these honored ancestors were themselves more often than not institutional leaders.[13] They may be the ideal surrogate performers for those in search of individualist social heterodoxy—hipsters "whose Zen makes them savvy, iconoclastic arbiters of cool."[14] At the very least, acting out, as it were, would seem to be a more visible and seemingly active response to the pains of existence than cloistered acts of renunciation. And such is the modern-contemporary flow of Zen that Zen iconoclasm seems to float effortlessly into spaces far from institutional and religious Zen and can be identified in individuals who have a taste for Zen and do Zen-like things. Rather than secularization, this may be an instance of enchantment, in which a Zen aura cloaks and exoticizes the refusal or rejection of social norms and otherwise nonsoteriological efforts toward disruption.[15]

Meanwhile, even if medieval Zen iconoclasm is not a modern fantasy, it is notable that we do not often find modern and contemporary Zen masters destroying religious icons and texts and performing other actions akin to the more outrageous behaviors represented in the premodern Zen literature. Nevertheless, the sensational accounts of Zen hagiography seem to have taken on a particular force of the "real," spurring Zen's global appeal while at the same time encouraging the growth of perceptions and uses of Zen that in fact threaten Zen orthodoxy. Thus, echoing Zongmi's criticisms leveled centuries earlier, modern Zen campaigners spoke out against the self-indulgent affectation of Zen as a license for misbehavior and to emphasize the importance of discipline and meditation. In his 1932 *An Outline of Zen Buddhism,* Alan Watts included "A Warning," in which he urged readers to undertake meditation under the guidance of a qualified master, and added: "The motives of the Zen student must be absolutely unselfish, and it is essential that he be living an absolutely pure life, otherwise his efforts will

result in libertinism or antinomianism. . . . In all Zen monasteries the discipline is almost militaristic in order that strict morality may be ensured."[16] In 1958, he cautioned against the use of Zen "to justify a very self-defensive Bohemianism." A real Zen practitioner, he emphasized, "has no need to say 'To hell with it,' nor to underline with violence the fact that anything goes."[17]

R. J. Zwi Werblowsky likewise sounded the alarm when he noted, in his 1967 review of recent Western-language writings on Zen, that Zen has "a vast body of what may be called literary Zen-folklore, most of which is Chinese in origin: masters furiously slapping and pushing their disciples, Buddha-statues used as firewood, sutras being kept in the outhouse, and contempt for ritual as the supreme expression of perfect spontaneity." However interesting this folklore may be, Werblowsky cautioned, this does not "alter the fact that it has no reality in actual life. As for spontaneity—it is a culturally stereotyped spontaneity, achieved at the end of an arduous and rigid training. In fact, Zen training can be very much like that given in a military barracks. Also the beatings administered by the supervising monks are anything but spontaneous; on the contrary, they are highly ritualized."[18]

From the 1990s the academy's challenges have come fast and furious. Bernard Faure has argued that Chan actors performed a "theoretical iconoclasm, following the spirit not the letter."[19] Robert H. Sharf has warned that "traditional Zen monastic training did not countenance spontaneous outbursts, but rather taught forms of speech and action that ritually *denoted* spontaneity and freedom. . . . the denotative force of Zen activity depends largely on how the active is 'framed,' i.e., the social role of the protagonist and the ritual context in which his performance takes place."[20] As Ronald L. Grimes has put it, *zazen* "is so heavily structured that expressions of spontaneity usually violate its decorum."[21]

In other words, the old Zen tales of spontaneous outbursts and flagitious acts were heuristic, ritual, and ideological rather than strictly literal or mimetic. Even if certain masters performed radical actions, their point was not principally infraction or destruction outright, and occurring as the urge arose, but rather actions, literal or symbolic, that ideally shoved the practitioner (or potential convert) smack-dab into the center of nonattachment and non-duality. Moreover, when texts and images appear to have been destroyed by monastics, there was surely in each case an important mise en scène, specific relationships between the iconoclast and the particular textual or visual-material things, and perhaps, too, the creative imagination as it is brought to the representation of embodied awakening. In Hakuin's autobiographic *Wild Ivy* (J. *Itsumadegusa,* 1765–1766), for instance, the master recounts an act of fiery destruction that comes with

revealing provisos. Invited to view a calligraphy by the monk Daigu Sōchiku (1584–1669) owned by a warrior in Matsuyama, Hakuin later wrote that the scroll was

> the product of truly enlightened activity. That calligraphy meant far more to me than any of the other scrolls. . . . As soon as I got back to the temple, I went to my quarters and assembled my small collection of inscriptions and paintings—about a score in all—some copybooks of calligraphy that had been made for me, drawings and calligraphies others had done at my request (which I had always treasured), as well as a few specimens of my own brushwork. Bundling them up, I took them out into the cemetery, put them in front of one of the egg-shaped tomb-stones, and set fire to them. I watched until they were completely consumed by the flames.[22]

By "a product of truly enlightened activity," Hakuin was presumably referring to Daigu's particular use of language and its calligraphic materialization to express his awakening directly and charismatically, which in turn startled Hakuin and diminished his estimation of his own collection of scrolls. That Hakuin "cremated" these lesser objects in a mortuary context suggests an abandonment of inadequate form and expression, but also a deliberate, symbolic disposal whose return to emptiness of particular things was predicated on a superlative calligraphy and evaluative criteria for what to destroy and what to keep—namely, that which is "just as it should be," excels in presencing awakened identity, and is to be preserved as an authentic patriarchal trace relic. If my reading of this episode has something to it, we may want to keep our eyes peeled for the distinctive circumstances of iconoclasm and the back-and-forth between form and emptiness that takes place in the environs of destruction.

But if we are to scrutinize Zen's modern and contemporary presences as such, we need to do more than simply indicate how traditional Zen made use of iconoclasm and then trace it forward and outward. In this regard we may turn to David L. McMahan, who situates modern Zen iconoclasm in relation to Romanticism and Transcendentalism and their emphasis on "the inner depths of the person, and the spontaneous expression of one's true nature through both artistic creation and everyday life in its immediacy."[23] In this sensibility (noted already in the previous chapter), Zen and the art of iconoclasm has had a great deal going for it as a vital animating force in modernity. That said, scholarly admonition regarding literal perceptions of Zen iconoclasm and emphasis on its modern formation tends to matter little in spiritual, popular, and avant-garde Zen cultures.

The modern image of the Zen master as exemplar of anti-institutional, antisocial, and anticapitalist rebellion and perpetrator of outrageousness has a life of its own.

DANXIA BURNS A BUDDHA

What sort of traverse does an ancient tale of iconoclasm and its representation make as it comes into a modern surround? Take, for instance, Danxia Tianran (literally, the monk "Spontaneous [or natural]" of Mount Danxia; 739–824), a Chinese master who, along with other exploits, is celebrated for having burned a statue of the Buddha at the temple Huilinsi in Luoyang.[24] This is a venerable incident often cited in premodern Chan texts that found a place in the writings of modern teachers that were directed at lay audiences in Japan and Western converts and likewise came to be cited in Japanese nationalist and Western orientalist writings.[25] Danxia the iconoclast pops up as well in books on ethics, postmodern philosophy, and Buddhist-Christian interfaith conversations, and invites references to "antiritual gesture" and "misplaced reification."[26]

The episode's classical rendering is "Danxia Burns a Buddha" (Ch. *Danxia shaofo*), a tale recorded in the *Jingde Era Record of the Transmission of the Lamp* (*Jingde chuandeng Lu,* 1004):

> When he [Danxia] was staying at the Huilinsi in very cold weather, the Master [Danxia] took a wooden statue of the Buddha and burned it. When someone criticized him for doing so, the Master said: "I burned it in order to get Buddha relics." The man said: "But how can you get relics from an ordinary piece of wood?" The Master replied: "If it is nothing more than a piece of wood, why should you upbraid me [for burning it]?[27]

Thereafter, the incident (apocryphal or not) was "name dropped" and explicated in medieval to early modern Chan *gong'an* collections and in the lectures, epistles, and poetry of eminent masters.[28] The Japanese Sōtō Zen master Dōgen (1200–1253), for instance, instructed his followers to respect and have faith in even the most humble of statues and the crudest of copied scriptures and to strictly avoid evil actions. As for Danxia, Dōgen explained that, although the master's act of burning a Buddha might appear to be evil, it was in fact a potent "means of showing the dharma" that aligns with Chan records that demonstrate Danxia's exemplary adherence to Buddhist precepts and his protection of temple proprieties. The incendiary act should be

understood, then, as a means of clarifying the Way performed by a master who had attained it.[29]

The later Japanese koan anthology *Entangling Vines Collection* (*Shūmon kattōshū;* no later than 1689) presents the Danxia scenario with a touch of embellishment:

> Once, when Zen master Danxia Tianran was visiting the temple Huilin si in the capital, it was so cold that he took a wooden Buddha image from the Buddha hall, set it afire, and warmed himself by the blaze. The priest happened to see this and scolded Danxia, saying, "How can you burn our wooden Buddha!" Danxia stirred the coals with his staff and said, "I'm burning it to retrieve the holy relics." The priest replied, "How could there be relics in a wooden Buddha?" "If there are no relics," Danxia answered, "then please give me the two attendant images to burn." The priest's eyebrows fell out.[30]

Again we have the deliberate incineration of an icon for the apparent purpose of bodily comfort. When challenged, Danxia reframed his act in terms of the veneration of Buddha relics, an otherwise orthodox practice, only to then turn the frame inside out—if there are no relics, then let me warm myself; and, by the way, burning three statues is better than one. The episode may also be read as a Chan encounter (Ch. *chanhui*) narrative (anachronistically, a Chan "happening") that manifests through contestation the right activity of the dharma.[31] In this sense, the script presents us with a Chan ancestor who charismatically outwits his interlocutor not merely through the "in your face" act of iconoclasm but also by applying the impeccable logic spun from the local monk's dull-witted response. Caught in Danxia's trap, the Huilinsi priest's "eyebrows fall out" because of his confusion over forms and signs and ultimate truth.[32] Moreover, by setting up a dialectical tension between the true body of the Buddha, which is formless, and the Buddha's sculpted form appearing in the material realm, and by then demonstrating a Chan master's awakened activity in response, the scenario presents something more provocative than desecration: a performance that creates and asserts, to borrow from Albert Welter, "a unique Chan persona . . . constructed to meet the demands of a new orthodoxy."[33]

That Danxia's destruction of an image would be represented pictorially and glossed with poetic encomia by monastics turns on its head the simplistic notion of Chan's rejection of images and language; the story of iconoclasm acts in its potent way not in spite of representation and expression but precisely through them. The question to ask regarding Danxia's burning a Buddha and other stories of Zen iconoclasm, then, is probably not

"are they too good to be true?" (did master so-and-so actually do that?) but "how good have they been for particular Zen aims?"

The episode of Danxia burning the Buddha is by no means the most prominent of Zen painting themes, overshadowed as it is by those of, say, Śākyamuni Emerging from the Mountains (J. *Shussan Shaka*), the Wall-Gazing Bodhidharma (J. *Hekikan Daruma*), and various manifestations of the thaumaturge Budai. Nevertheless, it appears in medieval monastic contexts and continued into the early modern Zen milieu in Japan before circulating into popular visual culture and, then, modern Japanese-style painting (Nihonga).[34] The episode's art-historically most famous representation is surely Yintuoluo's (14th c.) scraggly rendering inscribed by the Chan master Chushi Fanqi (1297–1371) (Plate 3):

> *At an old temple, in cold weather, he spent the night.*
> *He could not stand the piercing cold of the whirling wind.*
> *If it has no śarīra [holy relic], what is so special about it?*
> *So he took the wooden Buddha from the hall and burned it.*[35]

Yintuolou is a painter of obscure biography, but the Danxia painting is one of several surviving sections of a horizontal scroll depicting multiple scenes derived from Chan hagiography.[36] It is typically classified as a Chan encounter painting, or "Chan action painting" (Ch. *chanji tu; J. zenki zu*), the latter not pertaining to method (and, thus, not a precedent for modern "action painting") but the pictorialization of Danxia's awakened activity through which he embodies, performs, and instructs as a Chan master and, by extension, asserts Chan's superiority to other Buddhist denominations and religions.

Using a scenography conventional in Chan ink-figure painting, Yintuoluo situates Danxia and the Huilinsi monk facing each other outdoors in a shallow middle ground with minimal suggestion of receding space. Yintuoluo's middle-tone ink brushwork for the monks' faces, robes, and other forms is segmented and additive, and the tree is sketched out with scraggly lines and dabs. Despite such rough-and-ready, even "slightly outlandish," facture, the painter follows figural and arboreal painting conventions seen in Song and Yuan dynasty Chan painting, including the accent with dark ink of physiognomic features, collars, headgear, and implements.[37] The figures are separated on a diagonal by the roots of the tree that rises along the picture's right edge and curves back into the composition. The Huilinsi monk, who carries a gnarled staff that crosses over the trunk in a second diagonal, points with his left hand at the kneeling Danxia, who stares at his accuser over his left shoulder while warming his hands over the burning

image. Perhaps Danxia reacts to his opponent with a "sardonic grin."[38] The statue, a small, seated Buddha placed on the ground, appears through swirling flames and tendrils of smoke that trail off behind Danxia.

The painting's modern premiere may have taken place when it was photographically reproduced in 1904 in the Japanese art history journal *Kokka* (Flowers of the Nation). The work's appearance in *Kokka,* established in 1889 as an instrument of Japanese imperial history formation, helped secure its place in the modern canon of East Asian art and, by virtue of photography and the rapidly expanding realm of art publication, propelled it into the visual, epistemological, and ideological spaces of Asian art history as they were then being shaped in Japan (often nationalist, pan-Asianist) and the West (frequently orientalist, historicist).[39] The 1904 explanatory text for Yintuoluo's painting recounts the tale and suggests, among other things, that the distinctive, scrappy brushwork is typical of the amateur ink play of an eminent Chan monk or perhaps a means of expressing Danxia's liberated character (*gedatsu no fūshin*).[40] Some of this wording—with its emphasis on monkish eminence, liberation, and unorthodox brushwork, conceptions that appear in early modern Japanese painting treatises that refer to Buddhist painters—found its way into *A Gallery of Japanese and Chinese Paintings* (*Wakan meigasen*), published by the Kokka Company in 1908.[41] There Danxia is characterized in English as "a man of eccentric conduct and independent views" and the painting distinguished as being "among the most worthy of Yin-t'o-lo's works; amid its simple grace and apparently immature rendering there is evident a poetic feeling."[42] The painter's unpolished facture, like Danxia's behavior, therefore appears to reveal something beneath the surface, something distinctively Zen. European scholars took note of the painting shortly thereafter. In 1922, the translator and art critic Arthur Waley deemed the work exemplary of Zen paintings that take up "episodes in the lives of the great Zen teachers" and "reveal the grandeur of soul which lay hidden behind apparent uncouthness or stupidity."[43] This explanation, with its Romantic sensibility, may have enabled English-language readers to perceive Danxia's greatness as a Chan patriarch as being manifest in the awakened soul that compelled the incendiary act.

Meanwhile, we learn something of the painting's collection history in Japan, though not its Zen meaning, from the *Survey Report on Art Treasures* (*Kichō bijusuhin chōsa hōkoku*), published in 1930 by the Japan Art Association (Nihon Bijutsu Kyōkai):

Collection of Marquis Kuroda Nagashige

Painter: Yintuoluo with a square relief seal with twelve characters.
　　Inscription by Fanqi Chushi.

Ink painting on paper. H: 1 *shaku*, 1 *sun*, 5 *bun;* W: 1 *shaku*, 2 *sun*, 1 *bun*.

Accompanying documents: Scroll labels by Tan'yū and Kōgetsu; letter by Junsō.

This painting, along with the picture of Kanzan and Jittoku in the collection of the Marquis Asano, the picture of Hotei in the collection of Nezu Ka'ichirō, and others, was originally part of a single handscroll that was cut into sections. It is the most reliable of Yintuoluo's works.[44]

Here we find reference to the painting's authorship, material identity, and inscription; its premodern circulation and ownership in the early twentieth century; as well as to associated works and its premier status among them. The entry's reference to labels prepared for the painting during the seventeenth century by the professional painter Kano Tan'yū (1602–1674) and the Zen monk Kōgetsu Sōgan (1574–1643), as well as a letter, presumably of authentication, by the Zen monk Junsō Sōjo (d. 1700), intimate the painting's evaluation within premier early modern connoisseurship circles.[45]

By 1930, the painting had come to reside in the collection of Kuroda Nagashige (1867–1939), a member of the Japanese Parliament's House of Lords and the thirteenth head of the Kuroda family, a powerful daimyo house during the early modern period that amassed a significant corpus of art objects, including renowned works of Chinese and Japanese painting and calligraphy and objects associated with Chanoyu.[46] During the late nineteenth and early twentieth centuries, Nagashige, alongside other former daimyo family heads and members of the House of Lords, lent various paintings and calligraphies heretofore shown only in privileged, intimate settings to public exhibitions. Noted off and on in newspaper reporting during the first half of the twentieth century, the Kuroda Yintuoluo painting was exhibited at the Imperial Museum, Tokyo, in November 1939.[47] An heirloom work even in the seventeenth century, therefore, Yintuoluo's *Danxia Burns a Buddha* had found its way into the canon of Chinese painting preserved in Japan and into public exhibition, art reproduction, and art history. Having been acquired by the businessman Ishibashi Shōjirō (1889–1976) in 1944, the painting reached the apogee of modern recognition when it was designated a National Treasure of Japan, thus sealing its re-signification from a Chan visual and poetic exegesis to an object of modern, national identity.[48]

If Yintuoluo's painting secured pride of place as the quintessential fine arts depiction of the Danxia episode, thanks to its identification by Japanese scholars and inclusion in *Kokka* and ensuing publications, other,

FIGURE 9.
Sengai Gibon
(1750–1837),
*Danxia Burning a
Buddha.* Idemitsu
Museum of Arts,
Tokyo.

later works also garnered the attention of collectors and audiences in Japan and abroad, although not all were produced within the Chan or Zen institution. One was produced by the Zen monk Sengai (1750–1837), whose ribald response to the episode visualizes the master warming his buttocks before the flames rising from the burning icon, the face of which is juxtaposed with Danxia's posterior (fig. 9). Acquired by the corporate leader and art collector Idemitsu Sazō (1885–1981), the painting has Sengai's characteristic rapid brushstrokes, strategic detail, and tonal contrast.[49] D. T. Suzuki's translation of Sengai's accompanying poems offered English audiences deeper access to the late Tokugawa-period monk's response to the ancient episode:

> *The wind is high, the cold is penetrating;*
> *The fire must be stirred up in the hearth.*
> *If you call this "burning the Buddha,"*
> *You will see your eyebrows as well as your beard falling off.*
> > *The hip is warmed now,*
> > *The hard ice is melting.*
> > *Here is the Buddha.*[50]

Just how "humorous" this painting and its poems may be and what the functions of apparent vulgarity may be are matters open to debate owing to the episode's long-standing presence in Zen textual and visual discourse.[51] For his part, Suzuki notes that "Sengai, in his Japanese verse, has a pun on

the word *hotoke* which may mean Buddha, or, as a verb, to melt, to release, or to be free of bondage." Moreover, as Danxia is "a free man, is a Buddha, what retribution can come of one Buddha burning another Buddha, which in Tanka's case was no more than a wooden figure?"[52] Suzuki's "one Buddha burning another" may be a novel addition to the Danxia libretto, but it sticks to the Zen ideology of the continuous transmission of awakening, from Śākyamuni down to Danxia and eventually to the layman Suzuki, though I doubt that Suzuki himself ever literally burned a Buddha.

Paintings of Danxia had crossed into collections in North America by the early twentieth century, including an album leaf by the renowned, professional painter Katsushika Hokusai (1760–1849) that was acquired in 1904 by the prodigious American collector of Japanese art Charles Freer (1854–1919). Here a bearded man in loose tunic and trousers sits and warms his hands before a brazier in which flames consume the halo of a gilded wood statue, while the icon's lotus pedestal and an adze rest to its side.[53] In 1917, William Sturgis Bigelow (1850–1926), another impressive collector, donated a similar painting by Hokusai rendered on a folding fan to the Museum of Fine Arts, Boston; it suggests an image-format pun on the verbal expression "fanning the flames" (J. *hi o aoru*) (Plate 7).[54] As these paintings suggest, the Danxia tale had appeal in early modern painting in Japan outside of Zen monastic circles, no doubt as a venerable tale of "eccentric" behavior—Danxia being an entertaining figure whose iconoclasm was unthreatening or put no demands on the viewer other perhaps than that of fascination.[55] As for Charles Freer and William Sturgis Bigelow's acquisitions, they were surely prompted by the "Hokusai boom" and the painter's elegantly economic figuration rather than by religious or philosophical interest in Zen or Zen art per se.

That said, the Danxia story was not fully dislocated from the Zen institution; Zen Buddhism was becoming modern, and Danxia had a role to play, especially for lay and general audiences. In 1914, one could read the Zen master Shimada Shunpo's (1876–1975) vernacular rendition of the Danxia episode in *The Entangling Vines Collection: A Japanese Reading and Concise Interpretation* (*Kattōshū: Wakun ryakkai*).[56] Shaku Sōen, a participant in the 1893 World's Parliament of Religions in Chicago and the "first monk to teach Zen in the United States outside immigrant communities," introduced the episode to Japanese readers in his book *Quick Person, Fast Horse* (*Kaijin kaiba*, 1919) to illustrate the principle that "Fundamentally there is no ascent or descent (progress or regress)."[57]

That such "outreach" soon bore fruit is suggested by the Danxia episode's interpretation by two painters of distinctly different visual ambition and method who shared a lay affiliation with Zen: Yamamoto Shunkyo

(1871–1933), a leader of Kyoto-based Nihonga famous for grand landscapes indebted to the Maruyama-Shijō School, and the prolific "manga journalist," Okamoto Ippei (1886–1948), well known for his popular *Zen Cartoon Collection* (*Zen mangashū*). Yamamoto, drawn to Zen particularly during the last decades of his life, was a lay student of Hashimoto Shōtei (1852–1900), abbot of the Kyoto Rinzai Zen monastery Tenryūji, from whom he received the Buddhist name Ittetsu Koji (literally Layman Persistent) and artistic name En'yūsai, the term "*en'yū*" (Ch. *yuanrong*) referring to the consummate interfusion of all phenomena in ultimate reality.[58] His fervor for Zen, Yamamoto wrote in 1926 in the magazine *Zenshū* (The Zen Sect), led him to "purchase every book with Zen in its title" and to believe that "consummate interfusion should be thought of as the essence of the arts."[59]

In his sepia-hued *Discarding the Bones, Gathering the Marrow* (*Shakaku shūzui*), shown in 1924 at the first Tankōkai exhibition organized by the Mitsukoshi Department Store, Danxia stands in the forecourt of a monastic meditation hall, a hanging lantern and altar table visible within the building's interior (Plate 5).[60] The master, with long white eyebrows, black outer robe, and beige-and-ochre pieced *kesa,* stands calmly, with hands clasped behind his back and no sign of the Huilinsi monk, looking down at a burning statue of the Buddha canted to the right near his feet—as if nothing were more natural than an icon in flames.[61] Smoke wafts upward from the statue and around the monk in broad sweeps of golden pigment and scattered flecks of gold leaf, while mothlike dabs of white suggest floating ash. Unlike Yintuolou's scrabbly brushwork on paper, Yamamoto's rich mineral pigments and ink line on silk alternately evoke solidity and dematerialization, while physiognomic detail, emphasis on Danxia and the statue, and the painting's dimensions lend the scene psychological focus and a sense of theatrical grandeur.[62]

Here, as in Hokusai's paintings, the Danxia episode has moved outside monastic painting, calligraphy, and discourses on non-duality into a different visual-material dispensation, in this case that of 1920s Nihonga, with its dialectical relationship between "traditional" Japanese painting and Japanese modern reception of European painting. In format and scale, and lacking the picture-calligraphy-poetry triangulations of medieval and early modern Chan/Zen painting, *Discarding the Bones* participates in the rhetoric of modern history painting in Japan and its public exhibition, and perhaps intimates not simply Yamamoto's personal, lay Zen homage to Danxia but a recasting of the Chan ancestor into the drama of modern Japanese national aesthetics. Yamamoto's "neoclassicism" may also reflect the early twentieth-century Japanese imaginary of Chinese Buddhist antiquity and may perhaps adumbrate imperialist Japanese epistemological and material

FIGURE 10.
Okamoto Ippei
(1886–1948),
*Danxia Burns a
Buddha,* in *Zen
mangashū.* From
*Ippei zenshū dai
ikkan* (Tokyo:
Senshinsha,
1930), 25.

ambitions to control and possess the Chinese cultural past in the years leading up to Japan's full-scale invasion of China.[63]

Okamoto Ippei, perhaps echoing the Zen monk Sengai, depicted Danxia in ink warming his backside (with a "smart-ass" sort of facial expression) (fig. 10). The icon rests on its back with its head away from the viewer and on fire at its midsection.[64] Ippei and the feminist poet and novelist Okamoto Kanoko (1889–1939), who were married in 1910, began to study and practice Zen in 1921—with Arai Sekizen (1865–1927) at Sōjiji in Yokohama and Harada Sogaku (1871–1961) at Kenchōji in Kamakura—partly in response to their tumultuous marital life.[65] Thereafter, their visual and written work took up Buddhism and Zen in various ways. This included contributions to the nationally distributed magazine *Zen no seikatsu* (The Zen Life). Inaugurated in 1923, the magazine was edited by the Sōtō Zen master Yamada Reirin (1889–1979), who also taught Ippei and Kanoko.[66] At Yamada's invitation Kanoko became the magazine's poetry editor and Ippei provided the cover illustrations.

Ippei's depiction of Danxia is but one of his numerous single-frame illustrations of Chan, Zen, and contemporary Japanese figures à la Zen, but as a small piece of a large body of Zen-theme work, it suggests another visual mode of lay Zen response to the classical Zen past alongside Yamamoto's *Discarding the Bones.* For her part, Kanoko, as Maryellen T. Mori writes, "began writing 'Zen stories,' updated renditions of old parables and legends that she tried, with varying success, to infuse with psychological nuances and literary appeal; many of these were published in Buddhist journals. Some, while transcending the narrow didacticism of their original versions, instead became vehicles for propogating Kanoko's own vaguely Buddhist-inspired 'philosophy.'"[67] Ippei's Danxia and other Chan/Zen related illustrations and writings and Kanoko's literary work are not unique in prewar and war-period Japan, but they draw attention to networks of monastic and lay Zen in Japan during the first half of the twentieth century

and to resulting creative work, which circulated outside monastic contexts and contributed to the modern Zen milieu.

Perhaps, then, we might choose to see Danxia in Yamamoto and Oka-moto's versions as a new sort of "spiritual actor" whose incendiary action was more than merely an "outrageous" antic of antiquity but a modern re-enunciation—in these instances, by artists with lay Zen affiliations with two different Zen denominations, and in central and eastern Japan—of the dialectic of conventional and ultimate truth. At the very least, the circula-tion of the classical Chan theme into 1920s elite and popular visual cultures points towards the shifts and slippages that occur in modern Zen and Zen art and aesthetics—out of the cloister and susceptible to new expressions and important to new audiences.[68]

BURNING FOR THE WEST

The iconoclastic Zen-ness of Danxia's behavior emerged most prominently and globally, I suspect, in Japanese writings that instrumentalized icon-oclasm in discourses on Japanese uniqueness for Western audiences and Western representations of Japanese culture, notably the oddities and exotic outlandishness of Japan's religious and cultural past. Of the for-mer, it would not come as a surprise to discover that the first citation of the Danxia tale in English may have been made by Okakura Kakuzō in *The Book of Tea* (1906), not too long after the Yintuoluo painting's reproduction in *Kokka* (1904):

> Some of the Zen even became iconoclastic as a result of their endeavor to recognize the Buddha in themselves rather than through images and symbolism. We find Tankawosho breaking up a wooden statue of Buddha on a wintry day to make a fire. "What sacrilege!" said the hor-ror-stricken bystander. "I wish to get the Shali [relics] out of the ashes," calmly rejoined the Zen. "But you certainly will not get Shali from this image!" was the angry retort, to which Tanka replied, "If I do not, this is certainly not a Buddha and I am committing no sacrilege." Then he turned to warm himself over the kindling fire.[69]

This is by no means the only Zen episode that Okakura offered his readers as evidence of Japan's Chinese cultural heritage and national distinction, but Danxia's appearance in *The Book of Tea* gave it wide readership from the early twentieth century onward. Having no direct relationship to Chanoyu itself, Danxia in Okakura's rendition helps valorize Japanese tea culture's

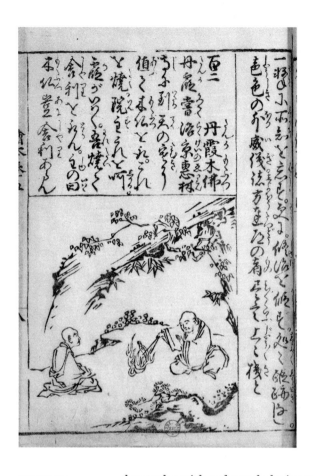

FIGURE 11.
"Danxia and the Wood Buddha," in *Japanese-Chinese Expanded Precious Mirror of Painting* (*Wakan zōho Ehon hōkan;* 1688). Bibliothèque nationale de France.

perspective towards religion, one that rings modern in its emphasis on inner experience and the aesthetic realization of the unfettered artistic life.

Danxia's iconoclasm was noted shortly thereafter by the French philosopher and sociologist Henri L. Joly (1839–1925), who included the tale in his *Legend in Japanese Art: A Description of Historical Episodes, Legendary Characters, Folk-Lore, Myths, Religious Symbolism* (1908). Here Danxia exclaims, "If your God is only of wood and has no *shari* [relics] it can only be a wicked God," and then proceeds to burn the Buddha. The Shingon patriarch Kūkai, Joly added, "is also said to have burnt some idols," and "Jittoku [the Chan monk Shide] once noticed two crows eating the food offerings set before a Buddha. He then took a stick and struck the image, saying: 'What sort of a God are you to let yourself by robbed?'" Japanese Buddhists, and their Chinese ancestors, one might thus imagine, were prone to such ("Protestant") iconoclasm. What Joly does not address, as his purpose is to emphasize the fascinating and bizarre, is Danxia's role in orthodox Chan/Zen discourse. To his credit, though, he does cite as a primary source the widely circulated printed painting subject manual *Precious Mirror of Painting* (*Ehon hōkan,* 1688), which suggests the Danxia theme's circulation in early modern visual culture in Japan prior to Hokusai's paintings (fig. 11). Unconcerned with this history, however, Joly's citation of Danxia points instead to the episode's flow into modern exoticist writing on Japanese culture.[70]

The Danxia tale assumed greater specificity and transnational edginess in Nukariya Kaiten's *The Religion of the Samurai: A Study of Zen Philosophy and Discipline in China and Japan* (1913). Nukariya, a Sōtō cleric, urged his European and North American readers to recognize Zen's iconoclastic posture as constituting the "real" Buddhism, in opposition to the Buddhism of Western critique:

Non-Buddhist people are used to call Buddhism idolatry, yet Zen can never be called so in the accepted sense of the term, because it, having a grand conception of Deity, is far from being a form of idol-worship; nay, it sometimes even took an iconoclastic attitude as is exemplified by Tan Hia, who warmed himself on a cold morning by making a fire of wooden statues. Therefore our exposition on this point will show the real state of existing Buddhism, and serve to remove religious prejudices entertained against it.[71]

Writing for Western audiences, some no doubt aware of Christian and Islamic histories of iconoclasm, Nukariya sought to assert authority over Buddhism and Zen from what we might define as a Japanese imperial, pan-Asianist position. His emphasis on Danxia's iconoclasm becomes part of this broader polemic—elevating the history and culture of Japan, and empowering Zen in particular, as "the best representative of the Buddhist countries"—and likewise suggests an affinity-making effort to establish Zen (and Buddhism generally) as non-idolatrous, rational beneath its outward oddity or alienness, and thereby comprehensible, acceptable, and perhaps alluring to modern audiences in the West.[72]

From the 1920s and 1930s, Danxia's iconoclasm became a favored Zen ancestor tale in scholarly and popular Anglophone books on Buddhism, Zen, Japanese culture, and Asian art written by interpreters of Asia such as D. T. Suzuki, the historian Hu Shih (1891–1962), the Japanese Zen monk Sōkei'an Sasaki Shigetsu (1882–1945), the art historian and philosopher Ananda K. Coomaraswamy, the British diplomat and colonial administrator Charles Eliot (1862–1931), the translator and scholar of Asian religions Kenneth James Saunders (1883–1937), and the Zen guru Alan Watts.[73] Writing in 1934, Coomaraswamy cited the Danxia episode in a discussion of the distinctions between symbolic and "imagist" (mystical) art in Asia, adding however that Danxia "used a wooden image of the Buddha to make his fire—not, however, as iconoclast, but simply because he was cold." Noting that "Indian parallels to Zen are naturally not lacking," Coomaraswamy referred to a Tamil poet, and then acknowledged that there were other examples to be found "in the Gospels, and in Eckhart and Blake." Coomaraswamy thus brought Danxia into a global discussion of mysticism and art, shaping a hybrid intervention similar to that seen in Suzuki's writings.[74]

In 1938, Alan Watts glossed the story with a favored Zen metaphor: "Zen was therefore the direct method of approach; it dispensed with external aids to religion as liable to lead people into confusion. Scriptures and doctrines were well so long as they were seen only as aids, and Zen masters likened them to a finger pointing at the moon; he is a fool who takes the

finger for the moon."[75] How many of Watts' readers grasped that Danxia's tale, not to mention Watts' own text, was merely an "external aid" is unclear; some perhaps took Danxia's act of destruction for Zen itself. In February of the same year, Sōkei'an lectured on the Danxia episode as a koan to a lay audience at the First Zen Institute of America in Manhattan, offering the following rendition and commentary:

> *When he visited Erin Temple* [Huilinsi], *the weather was extremely cold.*
> Sometimes there are very cold times there.
> *He took the wooden Buddha which was in the temple and made a fire to warm himself.*
> I think this was a very big temple, because he made a fire in the temple—on the stone floor.
> *The abbot saw this and upbraided him: "How did you dare burn up my wooden Buddha!" Tennen* [Tianran] *poked the ashes with his staff, saying: "I burned it in order to make some relics."*
> When the Buddha died he was cremated and many kings came to take his relics, or *sarira,* and almost fought. So these relics are very important in Buddhism. The Abbot fell into hell—not Tennen! Do you understand? If not, there is no use explaining.[76]

Sōkei'an's retelling follows the traditional plot but elides the Chan trope of the deluded priest's eyebrows falling out in favor of a reference to hell; the tropes and intertextuality of Chan discourse fall away here in favor of a more familiar bad end. But Sōkei'an eschews fuller explication in favor of a "Zenny" punch line—the "shock" of the obtuse, perhaps, administered at the end of a "shocking" story. Presumably Sōkei'an wanted his prewar Manhattan listeners to find their own realization of the medieval tale's meaning, something that, presumably, would require Zen meditation under his guidance. More than a matter of the inscrutable or quixotic, therefore, Sōkei'an's objective was, I surmise, to instigate Zen action on the part of his listeners.

In this regard, D. T. Suzuki's 1927 explication of the Danxia episode in 1927 is worth noting for its emphasis on Zen monastic training and caution regarding the "slippery ground" of antinomianism—as if he foresaw postwar counterculture fixation on iconoclastic behaviors as the soul or sum of Zen:

> Theoretically, the philosophy of Zen transcends the whole range of discursive understanding and is not bound by rules of antithesis. But this is very slippery ground, and there are many who fail to walk erect. When they stumble, the result is sometimes disastrous. Like some Medieval

mystics, the Zen students may turn into libertines, losing all control of themselves. History is a witness to this, and psychology can readily explain the process of such degeneration. . . . Therefore, the monastery life is minutely regulated and all the details are enforced in strict obedience to the spirit already referred to. Humility, poverty, and inner sanctification—these ideas of Zen are what saves Zen from sinking into the level of the Medieval antinomians. Thus we can see how the Zendo [meditation hall] discipline plays a great part in the teachings of Zen and their practical application to our daily life.

It is in relation to Zendō discipline in the monastery, therefore, that Suzuki recounts the Danxia episode, adding that however meritorious the monk's action may have been as a reflection of spiritual attainment, "such deeds as his are to be regarded as highly sacrilegious and to be avoided by all pious Buddhists. Those who have not yet gained a thorough understanding of Zen may go to all lengths to commit every manner of crime and excess, even in the name of Zen. For this reason, the regulations of the monastery are very rigid that pride of heart may depart and the cup of humility be drunk to the dregs."[77] In 1934, Suzuki would also link the Danxia iconoclastic act to the larger debate on the religious perception of transcendent form and aesthetic response:

> Neglect of form is generally characteristic of mysticism, Christian, or Buddhist, or Islamic. When the importance of the spirit is emphasized, all the outward expressions of it naturally become things of secondary significance. Form is not necessarily despised, but attention to it is reduced to a minimum, or we may say that conventionalism is set aside and individual originality is asserted in its full strength. But because of this there is a forceful tone of inwardness perceivable in all things connected with Zen.

Suzuki's interreligious framing is characteristic and notably modern, as is his turn to "individual originality" as a modality that expresses the transcendence of conventional form and manifests mystical perception of the "inward or spiritual."[78] Of course Suzuki's explanation of form and its subordination to spiritual experience is not quite adequate to the task of explaining the profusion of painted and sculpted icons found in Zen monasteries (beyond the incorrect notion that Zen communities merely tolerated "traditional" Buddhism images). But Danxia appears to have been useful to Suzuki in conveying to the West the ancestry and philosophical gravitas of Zen, and his emphasis on monastic training anchors his exegesis on form

and his own role as a lay authority able to access the inner workings of Zen monasticism and the path towards satori.

The preceding genealogy tells us only so much, of course, but at a minimum, it suggests how premodern representations of the Danxia tale moved the idea of Zen iconoclasm into and across the modern world in concert with canon formation, photographic reproduction, scholarly publication, the circulation of art objects, Japanese critiques of Western perceptions of Buddhism, developments in modern lay Zen in Japan and the West, and translations into modern Japanese and English for lay and non-practicing readers. This is part of the prehistory of postwar notions and representations of Zen's "crazy" masters and their reimagination as Kerouac's "crazy bhikkus." Moreover, one might see Danxia's iconoclasm as one of many overdetermined signifiers of Asian cultural and religious uniqueness deployed by Japanese intellectuals to refute European and North American presumptions to explain Japan, Zen, and Asia. In some instances, however, the acts of Chan and Zen patriarchs appear to have been taken at face value by audiences in the West, because they offered in their otherness compelling alternatives and role models for countercultural resistance and change. Whatever the recounting and representation of Danxia burning the Buddha meant in preceding centuries—within the Chan/Sŏn/Zen/Thiền institution and within visual cultures in Asia—it was now entangled with modern prospects, ambitions, media, and geopolitical encounters and tensions. Across this traverse, the tale would not dislocate entirely from formal Zen teaching and practice even as it assumed new potency in new sorts of Zen. Indeed, Danxia appears to be alive and well—still burning Buddhas.

4

THE LOOK AND LOGOS
OF ZEN ART

Mu-ch'i, with artless art, had plucked his fruits out of
a white eternity. In smoke he outlined them, and left.

—Ruth Stephan, *Various Poems* [1]

Some time ago a young man of Japan visiting New York
asked me to think about whose works should be shown
in an exhibition of paintings of American students of
Zen. This triggered a chain of thoughts that linked add
up to—What is Zen Art?

—Mary Farkas, "Zen and Art" [2]

In 1922, the British orientalist Arthur Waley (1889–1966) began his book, *Zen Buddhism and Its Relation to Art,* with a lament: "Books on the Far East often mention a sect of Buddhism called Zen. They say that it was a 'school of abstract meditation' and that it exercised a profound influence upon art and literature; but they tell us very little about what Zen actually was, about its relation to ordinary Buddhism, its history, or the exact nature of its influence upon the arts." [3]

Zen may be an extraordinary sort of Buddhism, Waley implies, and its impact on the arts remarkable, but the matter is in dire need of elucidation. His mission, then, was to inform readers what they should know about the effects of Zen upon art. We can allow Waley this ambition, but by no means did he have the final say. In the ensuing decades, books, exhibition catalogues, and articles by the truckload, followed by blogs, tweets, and the like, have sought to explain Zen and its relationship to the arts and

nearly everything else. Some are encumbered with "epistemological snags" and "historical confusions."[4] Others break down essentialism and infatuation—that's a hard act to pull off, for during the twentieth century, "Zen" and "Zen art" became nearly indispensable keywords, quotidian yet exotic and slightly numinous. Like "Tibetan Buddhism" and "Mindfulness" in more recent decades, they assumed incantatory power and acquired spiritual allure and consumer cachet, at least in advanced capitalist parts of the world. Indeed, "Zen" and "Zen art" are terms that imaginations seem to crave and run with, and they have remarkable carrying capacity. Explaining Zen's influence on art even seems like a rite of passage in certain communities, or a way to win a cool culture badge of honor.

This would perhaps be unremarkable were it not for the Zen tradition's long-standing promotion of wordlessness, anchored by the famous dictum attributed to Bodhidharma declaring Zen's independence from words and letters.[5] Independence did not mean outright rejection, however, and there has been no lack of words dispensed by Chan/Sŏn/Zen/Thiền monastics, lay advocates, and admirers over the centuries to describe and interpret Zen, an apparent contradiction that bugged the writer and public intellectual Arthur Koestler (1905–1983). "Inarticulateness is not a monopoly of Zen," he wrote, "but it is the only school which made a philosophy out of it, whose exponents burst into verbal diarrhea to prove constipation."[6] D. T. Suzuki, in reply to Koestler, explained that "When we wish to say that no words are needed, words are needed to prove it. We are so made and we cannot escape this fatality. Zen is not alone in this."[7] Historians of religion in turn have worked hard to interpret the voluminous Zen canon and to clarify Zen's verbose wordlessness in relation to discourse, performance, and ideology.

In any case, there seems to be plenty of Zen to go around, and wherever it turns up there tends to be voluble elucidation. This is likewise the case with Zen art. Hundreds of texts—premodern to present-day, produced within and outside the Zen institution—respond to works of Zen-associated painting, calligraphy, and sculpture; account for the work of premodern Zen painters and modern-contemporary Zen-inspired artists; and explain the function and presences of Zen art from ritual, spiritual, philosophical, and visual perspectives. Some outline the ways through which one can become a Zen artist and integrate Zen art into one's practice, of whichever sort it may be. With the rise of what I call "critical Zen art history," meanwhile, there have also been efforts to reconsider the "Zen art" rubric itself.[8]

However garrulous we may be about Zen art, it remains a domain of visual culture study that has not as yet been thoroughly thrashed by critiques of meta-narrative, positivism, and power, remains hobbled by rigid

definitions and reductive binaries, and is impoverished by feckless acceptance of ideologically shaped tropes and anachronisms. This chapter works to redress this shortfall by examining our lexicon and explanatory habits for Zen art.

WHAT DOES ZEN ART LOOK LIKE?

What makes art "Zen" and Zen art "art"? From where and when does it arise?—Southern Song dynasty China (1127–1279), Muromachi period Japan (1333–1573), London in the 1920s, or Manhattan in the 1950s? What has it meant to monks, nuns, rulers, literati, and lay Buddhists from the medieval era to the present? What about Japanophiles, Japanese nationalists, Beat poets, Ab Ex artists, art collectors, architects, and designers of commercial products? Is Zen art different from other clichés (Gong fu and Geisha), "Madame Butterfly" in a different key? Is it intrinsic to Asian aesthetics and culture, a Japanese construct of cultural uniqueness, or universal and endlessly adaptable? What does Zen art look like?

Zen art seems to shape-shift at will, especially during the twentieth century, but it is often said to inhere in specific objects and aesthetic qualities. Most writings about the art produced by Zen monks and nuns refer to particular formats (hanging scroll), mediums and supports (brush and ink, paper and silk), and styles (abstract and monochrome). The usual pictorial subjects include Śākyamuni, haggard from ascetic practice in the mountains; Bodhidharma scowling beneath bushy eyebrows (Plate 2); Linji and other severe Chinese masters (fig. 2); "uncommitted saints" (C. *sansheng*, J. *sansei*) such as Budai; and the allegorical ten ox-herding pictures (J. Jūgyū zu).[9] There are also calligraphic "Zen circles" (fig. 1), paintings of flora and fauna, and depictions of landscape vistas of China (Plate 1). Calligraphy, landscape garden design, as well as tea ceremony ceramics and architecture are also identified as Zen artistic domains. For the most part, "classical" Zen art of this ilk dating from the medieval to early modern eras is viewed as a quintessential cultural achievement of Japan; China and Korea are often relegated to antecedent status or are largely absent, unless one includes works from these cultures preserved in Japan.[10] Zen monastic painters and calligraphers, meanwhile, are frequently said to have been amateurs at heart. Aloof from "elite sensibilities" and commerce, they took up the brush solely to express their awakened states and offer followers embodiments of deep realization.[11]

Since the early twentieth century the visual forms, or de-forms to some viewers, of medieval and early modern paintings, calligraphies, and

landscape gardens produced or found in Zen temples and monasteries have transfixed numerous lay Buddhist and nonreligious artists and art audiences. Many viewers have come to view Zen art as narrowly indexical to Zen philosophical concepts such as nothingness as introduced by D. T. Suzuki and other Zen campaigners. Some studied with Zen monastic teachers in order to access the creative freedom understood to awaken through Zen meditation. During the postwar "Zen boom," discussed in Chapter 5, the distinction between the Zen temple or Zen center and the modern artist's atelier seems to have blurred in the minds of some. Modern artists who rejected conservative, academic concepts of representation in the European tradition were eager to draw upon Zen and Zen art whose essences were changeless, universal. Working from popular notions of Zen meditative calm, "in the zone" intuitive hipness, and minimalist aesthetics, late twentieth- and twenty-first-century commercial industries have generated dozens of Zen-styled products, some discussed in Chapter 8, that embody Zen or may confer a sort of Zen-itude. This may seem a long way from "classical" Zen art, but the distance from the ink paintings of the Chinese monk painter Muqi Fachang, for instance, to the elegant restraint of the "no brand" apparel and household goods sold by the Japanese company Muji—products whose "simplicity and emptiness yield the ultimate universality"—may be less than it initially appears.[12]

We usually expect Zen art to be rendered in a distinctive visual mien distinguished by abbreviation, reduction, and traces of spontaneous action that are said to originate purely from Zen awakening but are equally indebted to enduring traditions of painting and calligraphy in East Asia.[13] Whether it is the fractious, fluctuating calligraphy of the Japanese monk Ikkyū Sōjun or the "splashed ink" landscapes of Sesshū, Zen art is said to reject suave mimesis and deliberate composition in favor of the unmediated expressive manifestation of the state of no-mind or no-thought (J. *mu'nen*). As in the case of John Cage's iconic musical composition *4'33"* (1952), with its fortuitous ambient sounds, Zen art is typically defined as being aleatoric; it advances chance and rejects planned outcomes, iconography, and tradition-bound techniques of representation.[14] It is "representation as antirepresentation," in Hans Belting's view, forcing the viewer to find something in nothing, as in Nam June Paik's *Zen for Film* (1968), an "empty" one-hour film with no images.[15]

One might therefore observe that Zen art—at least in the modern view—is generally "what it is" by virtue of "what it isn't." It rejects rationalism and dispenses with the color, ornament, conventional subjects, as well as sacerdotal and magical powers of "traditional" iconic Buddhist art. When representational naturalism is acknowledged as part of Zen art, as

in formal portraits of Zen masters (J. *chinsō*), painstakingly wrought "realism" is often treated as a window into the enlightened consciousness of the vividly portrayed master.[16] Both visual abstraction and naturalism can be "Zen," it seems, as long as they express the state of Zen awakening. Thus, it is art to be appreciated with an aesthetic eye but also an inner eye that seeks Buddha nature.

Reductive or anachronistic as some of the preceding ideas may appear to some, they are held holy by others. Of more interest to me than dismantling them is inquiring after the terms, categories, and interpretive practices employed in modern commentary on Zen art. In this regard Arthur Waley is emblematic of early twentieth-century Western commentators on Zen art in his efforts to categorize Zen painting and extol its metaphysical nature. In *Zen Buddhism and its Relation to Art,* he introduces readers to two kinds of Zen painting that have come to dominate our expectations for Zen art. First are representations of flora and fauna in which the painter "attempted to identify himself with the object depicted, to externalize its inner Buddha" through the rapid transfer to paper of an intensely concentrated visualization "before the spell of concentration (samādhi) was broken." Second are paintings depicting episodes from the lives of Chan/Zen masters, which reveal "the grandeur of [the master's] soul that lay hidden behind apparent uncouthness or stupidity" (Plate 3).[17] In the first, we have the fusion of artist and object through spontaneous insight born of concentration, and in the second, the beloved figures—fierce, grizzled, or quirky—of Bodhidharma and sundry antinomian characters.

Waley's first category is embodied preeminently in the work of the Chinese painter Muqi, especially his *Six Persimmons* (fig. 6): "[Muqi] seems to have been the first to practice the swift, ecstatic type of monochrome which is associated with Zen. In hurried swirls of ink he sought to record before they faded visions and exultations produced whether by the frenzy of wine, the stupor of tea, or the vacancy of absorption. Sometimes his design is tangled and chaotic; sometimes as in his famous 'Persimmons,' passion has congealed into a stupendous calm."[18] In explanations such as this the relationship between Zen and art is conveyed in Romantic tones, floating free from monastic contexts, doctrine and ritual, and ideology. Aesthetic presence derives not so much from the Zen artist's biography, response to iconography, canons of form, or even "avant-gardist" originality but rather from the painter's spontaneous capture in particular visual effects of "visions and exultations." The painting is an unmediated double of the mind and, ultimately, as in *Persimmons,* the mind's attainment of "stupendous calm." According to Waley, therefore, artists under Zen's influence attained "a better understanding of the psychological conditions under which art is

produced than has prevailed in any other civilization." Zen art was, in turn, an instrument to "annihilate Time and see the Universe not split up into myriad fragments, but in its primal unity."[19]

Waley was not atypical of art historians in the early twentieth century in his Romantic rhetoric and tendency to exoticize Asian cultures as inherently mystical. His view was consonant with, and partly conditioned by, the language and interpretations of Meiji (1868–1912) and Taishō (1912–1926) era intellectuals such as Okakura Kakuzō and D. T. Suzuki. The sort of Zen they promoted was a remarkable fusion of Buddhist scholarship, Japanese lay Buddhist practice, European philosophy, and modern fascination with mysticism infused with nationalist rhetoric concerned with the uniqueness of Japanese culture.[20] In the case of Nishida Kitarō (1870–1945) and Suzuki, Zen works of art, as well as their proper understanding and explanation, were seen to derive from "pure experience" (*junsui keiken*), "absolute nothingness" (*zettai mu*), and the corollary states of *muga* (no self/ego), *mushin,* and *mu'nen.* Although these last three terms are not modern neologisms, they came to steer much of the discourse on Zen art as it spread internationally in the early twentieth century. They became "facts on the ground."[21]

In "Buddhist, Especially Zen, Contributions to Japanese Culture," published in 1934 amid growing nationalism in Japan and imperialist expansion in Asia, Suzuki identified *sumiye* (*sumi'e,* literally "ink picture") as the exemplary mode of Zen cultural praxis.[22] *Sumiye,* in his explanation, reveals the mystical experience of Zen nothingness. It is non-duality manifested in pictorial suggestion, irregularity, and unexpectedness as well as the expression of infinity and absolute being within the confines of a piece of paper. The *sumiye* painter engages in the spontaneous transfer of artistic inspiration without the intrusion of logic or deliberation; artist and brush fuse in such a way that the "brush by itself executes the work quite outside the artist, who just lets it move on without his conscious efforts."[23] *Sumiye* thereby rejects mimesis, for resemblance is subordinate to each brushstroke. Beauty arises when "every brush stroke . . . is directly connected with inner spirit not at all hampered by extraneous matters such as concepts, etc." As Suzuki later put it in *Zen and Japanese Culture* (1959), the *sumiye* artist paints to give "form to what has no form." This is not ultimately about "art," therefore, but about how the brushstroke pulls the viewer into the aura or charisma of the awakened artist.[24] The look of Zen art, in Suzuki's view, therefore, transcends conventional expectations of formal expression and, outside historical circumstance, is defined by the forms attained through the painter's state of *mushin,* even as form is a vehicle for perceiving this state. There are echoes of traditional Buddhist

doctrine and hermeneutics here, but not surprisingly this was rich grain for the modernist mill.

Waley and other Western art historians may have realized that their efforts to elucidate Zen art were a bit unstable, despite or precisely because of their scholarly credentials. They themselves did not usually claim to have attained Zen awakening or *mushin,* whereas Suzuki and other Japanese apologists often did, implicitly or explicitly, and employed their authority as spiritual insiders to explain a purportedly nonverbal, nondiscursive system of knowledge.[25] Without *kenshō,* it seemed, Zen art is understood inadequately or even mistakenly. Suzuki was compelled, for the sake of his audiences (and rhetorical agendas), to resort to words in order to describe the creation and perception of formless-form and *mushin,* but his status as native Zen practitioner and claimant to the experience of enlightenment enabled him to justify this expediency and gave his words seemingly unimpeachable authority. As the Japanese layman and Zen exponent Hisamatsu Shin'ichi later asserted to a Western audience, to really grasp the characteristics of Zen art you must abandon analytical thought and "first fully make [one's] own the religious substance involved."[26] In other words, if you haven't attained Zen mind, you cannot really see Zen art and probably should not talk or write about it.

How then did the nonpracticing, nonawakened, if sympathetic, scholar discuss Zen art? For much of the twentieth century, art historians did not generally traduce figures like Suzuki, but neither did they remain silent. Usually they glided by questions of religious function and significance, preferring to focus on artist biography and brush style and the evolution of representational form within East Asian culture. But when it came to the meaning of Zen art, many simply appropriated Suzuki's terms and philosophical explanations as authoritative and transhistorically valid and described Zen art as mystical experience made visual. Suzuki's Zen was, after all, what most of them had grown up with. The effect, however, was to embed within Western discourse on Zen art the agendas of Meiji and Taishō era intellectuals.[27]

On occasion, Western academic writers on Zen art have also adopted a rhetorical ploy to deal with the gap between historical inquiry and mystical experience. Waley, for instance, admitted that he might not have fully grasped the interaction between the "psychic disciple of Zen" and art, but he did not abandon scholarly prerogative: "If I *knew,* I might transmit to you my knowledge, but it would have to be by a direct spiritual communication, symbolized only by a smile, a gesture, or the plucking of a flower. I need not therefore apologize for having given a purely external and historical account of Zen, a creed whose inner mysteries are admittedly beyond

the scope of words."²⁸ Referring to Śākyamuni's silent transmission of the dharma "mind-to-mind" to Mahākāśyapa (J. Nenge mishō)—the originary narrative of Chan—Waley deployed the trope of mystical wordlessness as if to vaccinate himself against criticism.²⁹ Once he admitted to not being "in the know," he could be excused for resorting to words and thus claim a degree of authority over the explication of Zen art.

The art historian Hugo Munsterberg (1916–1995) likewise acknowledged the difficulty of interpreting Zen art. "Since . . . Zen itself cannot be explained in verbal or philosophical terms," he wrote in 1965, "it is very difficult to point to a specific thing and say, 'This is a Zen work.' . . ." "It is even more difficult," he added, "to discuss Zen meaning in the way that it is possible to talk about the meaning of a Christian work such as Grünewald's Isenheim altarpiece."³⁰ Munsterberg discloses that he does not know what Zen art really is as he is not a Zen master, but this does not prevent him from writing about the meaning of form in relation to wordlessness: "both the abstract form and the content of these pictures give expression to Zen in a way that words cannot do, for meanings which are beyond language become concrete in visual form."³¹

Certain sorts of meaning in Zen art, therefore, are available to the art historian, even one lacking Zen experience, though apparently without the ease that attends the interpretation of a Christian work such as the Isenheim altarpiece. That a European religious icon can be analyzed confidently as an object of rational inquiry, whereas the work of Zen art is inscrutable or can be understood only through experience of the esoteric suggests a garden-variety orientalism. Suzuki and others, meanwhile, sought to counter the West as the measure of all cultures by promoting—in what Yuko Kikuchi terms "reverse orientalism"—Zen Japan as superior to the rationalist West.³² In any case, for Munsterberg the look and meaning of Zen art may still be sought through the study of visual form, about which the art historian may have much to say.

ZEN ART ABSOLUTISM AND JAPAN

If we want Zen, we probably want to *see* it. Fortunately, there is plenty of Zen art to be seen. Modern commentators have even suggested that *all* of Japanese art and culture is influenced by and reveals Zen. Andrew Juniper gushed in 2003: "As Zen has been the guiding light for Japanese thought and philosophy for over one thousand years, it has also provided the moral and aesthetic underpinnings for all Japanese arts as they have evolved over the centuries."³³ If one goes to Japan, one apparently discovers the Zen art

mother lode, not only because of the evident availability of countless Zen art things but also because one supposedly encounters a culture intact in its Zen-ness without the tensions of postindustrial society. Japan, for some, is the empire of Zen art.

This totalized perception—a strain of Zen universalism—amounts to a sort of "Zen art absolutism," operating from a procrustean inherence or permeation model, in which Zen inhabits or seeps into, and then controls, all cultural forms and practices in Japan. Repeated almost incessantly during the latter half of the twentieth century and still something of a mantra today, the absolutism notion appears to have been instrumental to the efforts of Japanese religious leaders and intellectuals to establish New Buddhism (Shin Bukkyō) within world religion during the late nineteenth and early twentieth centuries and to represent a Japanese national subjectivity that could be used to explain Japan to the West and rival Euro-American cultures.[34] As a signifier of the modern Japanese nation, Zen-based culture became one of several arguments that helped Japan define its geopolitical space. Of course Zen is not the only manifestation of Japanese culture or psychology to be deployed in totalistic fashion to define and explain modern Japan and valorize Japanese cultural identity. Bushidō is another prime example, and one might consider, too, the transnational cult of anime. But Zen remains for some commentators Japan's traditional, fundamental self.

D. T. Suzuki is famous for having promoted this sort of exceptionalism, doing so arguably to revitalize Zen and Japanese cultural traditions and to advance Japanese interests abroad. "There appears to be an essential rapport between Zen and the Japanese character," Suzuki wrote in 1944, which "pervaded literature and the arts to become the very foundation of Japanese life."[35] He would later add that Zen is "the unique property of the Japanese," and that all of the traditional arts of Japan are at their core Zen or have been raised to their ultimate accomplishment through Zen.[36]

We should not overlook the fact that Suzuki was part of a crowd of Japanese intellectuals, well known to each other, who rushed to Europe and North America in the first decades of the twentieth century to explain Zen as indispensable to any effort to understand the Japanese and to assert, as Richard Jaffe puts it, the value of "Japanese culture in static and essential terms in contradistinction to European and American cultures, which increasingly were characterized as mechanical, overly technological, and, ultimately threatening to Japanese interests at home and abroad."[37] Indeed, we find the permeation trope in Okakura Kakuzō's *The Ideals of the East* (1903) and Nukariya Kaiten's (1867–1934) *The Religion of the Samurai* (1913). Nukariya is marvelously concise in stating the fusion of

Zen, Japanese culture, and modernity, including Japan's recent military victories. Zen, following its introduction in Japan as the faith of the samurai, "gradually found its way to palaces as well as to cottages through literature and art, and at last permeated through every fibre of the national life. It is Zen that modern Japan, especially after the Russo-Japanese War, has acknowledged as an ideal doctrine for her rising generation."[38] Shortly thereafter, the historian of religion Anesaki Masaharu explained to Western audiences in 1915 that Zen "Pervaded the lives of the people and moulded their perceptions in every branch of art,—in the composition of poems, the building of houses and furnishing of rooms; in methods of flower arrangement, of gardening, and even of preparing and drinking tea. Indeed, there is in Japan hardly a form of thought or activity that *Zen* has not touched and inspired with its ideal of simple beauty."[39] In 1928, the art historian Harada Jirō (1878–1963) simply stated that "The influence of Zen was irresistible in all branches of art."[40] Anesaki and other Japanese intellectuals were in effect translating art from the Zen monastic environment into Japanese culture writ large, an effort that depended upon the existence of the new category "Zen art" (Zen bijutsu). This may have been undertaken partly to engender comprehensibility and appeal for audiences not able or inclined to access the monastic realm while cloaking Japanese art generally with an aura of the mystical. Zen art in turn became instrumental to larger aims as a fulcrum of national aesthetics.

In 1913, the British poet and art historian Laurence Binyon (1869–1943) saw fit to mimic this totalizing rhetoric, writing that "Incalculable has been the influence of the Zen teaching in the moulding of the Japanese character, bearing fruit, as we ourselves have seen, to-day," while the art historian Langdon Warner (1881–1955) observed that "Zen habits of mind ran through the warp of Japan to subdue and harmonize the whole fabric."[41] For both Japanese and Western scholars in this period, therefore, Japan's finest culture was embodied in the elite traditional arts of painting, ceramics, Chanoyu, landscape design, and so forth—all informed by Zen. Zen had yet to be found in the modern art and architecture of Japan, but that too would come. In 1936, Alan Watts wrote of Zen's paradoxical importance to Japan, that it produced both the "otherworldliness" and quiet simplicity of Japanese Chanoyu, landscape gardens, and ink painting as well as "the alarming techniques of *jujutsu* and *kenjutsu* (fencing), and the stern principles of *bushido*—the Samurai's code of chivalry."[42] Once Zen was accepted as being unique to Japan *and* a "transreligious universal spirituality," it could be identified in creative activity anywhere, anytime, a phenomenon noted in Chapter 2.[43] Thus, R. H. Blyth asserted, "Wherever there is a poetical action, a religious aspiration, a heroic thought, a union of the nature within a man

and the Nature without, there is Zen." Don Quixote, he suggested, was "the purest example, in the whole of world literature, of the man who lives by Zen," and the Zen attitude was also consistently present in Shakespeare, Wordsworth, Dickens, and Stevenson.[44]

Over the course of the postwar decades, the inherence/permeation trope held sway in English-language publications on Zen. The Zen abbot Ogata Sōhaku, writing in *The Middle Way* in 1958, observed that "Fundamentally Zen is working internally through all phases of Japanese culture, and it is called *wabi* and *sabi*."[45] In 1959, "A Short Guide to Zen Buddhism," published in *The Sunday Times,* explained that in Zen "the solution lies here in the world of everyday existence" and that "In China and Japan it is reflected in all naturalistic forms of art."[46] In 1960 the scholar of philosophy Van Meter Ames (1898–1985), commenting on the Zen boom in the United States, noted a "general indifference" to Zen in Japan, "except as it is infused in the arts and customs of the people so natively and naturally as to scarcely be noticed."[47] Munsterberg initially resisted Zen's utter saturation of Japanese culture but subsequently promoted the idea that it had entered "every phase of Japanese life."[48] According to the art historian Jon Carter Covell (1910–1996), "Textiles, household articles, folk crafts, even toys" joined Japan's fine arts: all "echo a sub-conscious awareness of Zen directness and organic simplicity."[49] Nearing century's end and then beyond, Zen inherence and permeation maintained their usefulness not only in Japanese exceptionalist writing but equally in journalism and general-audience writing in Europe and North America, so much so that one might be forgiven for believing that Zen is the artistic unconscious of Japan and for expecting that Zen will not only come up in explanations of Japan's traditional and modern-contemporary arts but may be considered their essence and raison d'être.[50]

Zen art fait accompli? Not entirely. In 1959, commenting on D. T. Suzuki's *Zen and Japanese Culture,* R. J. Zwi Werblowsky suggested that Suzuki has "practically identified Zen with Japanese culture, and this identification has become an almost unquestioned dogma for many Western writers. . . . This may be a bit much to swallow, especially for people who believe that Shinto too may have something to do with the Japanese spirit."[51] The following year, Arthur Koestler—the postwar Zen-bashing curmudgeon par excellence—asked, with no lack of sarcasm, "How is it possible?" that Zen could have influenced "painting, landscape-gardening, flower arrangement, tea ceremony, firefly-hunting and similar nipponeries on the one hand—of swordsmanship, wrestling, Judo, archery, dive-bombing on the other."[52] In 1961, Ernest Becker argued that Zen's "influence on garden art, painting and poetry is more a *post facto* rationalization on the part of Zen

adherents than something historically real," only then to echo Werblowsky: "In Japan, Shinto is the mother of the arts."[53] Even scholars who rejected the notion that Zen had taken over everything artistic in Japan still distinguished it as a special category in art: "the arts under the influence of Zen religio-aesthetic ideals," Richard B. Pilgrim writes, "constitute a body of material worthy of separate treatment."[54]

Arguably, there are hard and soft sorts of Zen art. The former we might say includes objects having direct visual, ritual, and historical connections with monastic and lay Zen contexts. The latter might encompass works that, though distant in concentric circles from monastic and lay communities, suggest their Zen-ness through aesthetic qualities, folkways, appropriation, and attributed metaphysical and philosophical dimensions. To judge from a trenchant comment made by Van Meter Ames in 1961, this "soft" category became, in a sense, Zen itself: "the response to Zen in the West does not depend so much upon studying it as in appreciating the artistic heritage of Japan as it emanates from Zen."[55] Often this broader array of Zen-associated art and culture is deemed to be Zen by virtue of the appearance of aesthetic qualities identified as uniquely Zen or cultivated by poets and artists said to have been influenced by Zen: *shibumi* (astringent beauty), *wabi* (rusticity, imperfection), *sabi* (worn-ness, patination), and *yūgen* (mysterious elegance)—notoriously complex terms, whose origin and theory arguably lie less with Zen or Buddhism per se than with the literary theory of the imperial court.[56]

Today it is difficult to take seriously the totalistic assertions about Zen and Japanese culture that arose in the twentieth century. Not only have historians of religion alerted us to their underlying nationalism, but those of us concerned over the West's pigeonholing (in adulation or condemnation) of other cultures or attuned to postmodernist questioning of objectivity and grand narrative find the inherence/permeation trope overstated if not worse. Needless to say, there were and are artistic cultures in Japan not subservient to Zen, at the very least those which arose prior to the existence of anything that could be called the "Zen sect" or "Zen aesthetics" in Japan, but also those which arose during the modern era in relation to, for instance, Pure Land Buddhism.[57] Nevertheless, what made Zen absolutism possible and enduring was partly the modern creation of a "gated-community" adorned almost exclusively with art produced or found in Japan that is, by degree, visually restrained in style and display, non-illusionistic, small in scale, non-decorative, and non-professional. In such characterizations of Zen art, monochrome, simplicity, intimacy, and amateurism replaced extravagant ornament and bold, polychrome icons by professional artists for traditional Buddhist ritual and devotion.[58]

Such perceptions are at best oversimplifications. In the same way that Zen monasteries had multiple ritual, social, and economic activities, and not simply monks meditating, they had multiple sorts of spaces—not merely austere meditation halls and rustic tearooms, but buildings with diverse modes of ornamentation and representation that often conformed to broader Buddhist ritual. Icons heavy in gold and colorful mineral pigments, some colossal, have long been common in Zen monasteries, as are images of the bodhisattva Mañjuśrī enshrined in traditional monks' halls, the most orthodox site of meditation. Moreover, many buildings had wall and sliding-door paintings with themes that call forth long traditions of floral and figural painting not exclusive to Zen. Events at the core of monastic life, such as founders' memorials, required that Zen spaces be adorned with images as well as offerings well beyond "severe simplicity." Further, the notion that the art of Zen Buddhism is entirely or even predominantly from the hands of Zen masters excludes much of the art found within Zen monasteries. Portrait paintings and statues, sculptural icons, as well as sliding-door and wall paintings were in the majority of cases done by professional artists, and masters received artistic gifts of all sorts that had little to do with Zen imageries or expression.[59]

To argue that these sorts of "un-Zen-like" images were not truly Zen or were merely tolerated by Zen monks and nuns out of general respect for the Buddhist tradition is to do several things. First, such bracketing takes the Zen tradition's well-known anti-scriptural and iconoclastic rhetoric at face value without considering how entangled such positions have long been with theological debate and sectarian ideology as well as with particularized modern affirmations of such views in Japanese philosophical and religious writing.[60] Second, it purges the iconic, magical, and sacerdotal dimensions of Zen monastic life that the textual and material record and ongoing ritual practice make abundantly clear.[61] We might see this as an art historical absorption of Suzuki's reframing of Zen as mystical, personal experience, in turn singularizing particular categories of objects and response.[62] Third, the preceding sorts of narrow characterization of Zen art shut out interesting questions about the contingencies and imperatives of religious practice within which monks, nuns, and lay practitioners defined the place and significance of the visual arts. Overstatements such as those cited above, flavorful as they may be, are ultimately about the desire for difference, seeing Zen art as separate and unique even if it means partially blinding oneself. Arguably, they are also about forgetting, "a crucial factor in the creation of a nation" and its traditions, and about the fulfillment of fantasies of exotic essence operating both inside and outside the nation/tradition.[63]

THE "MAGNIFICENT SEVEN" OF ZEN ART

In 2005, the blog "Presentation Zen: Gates, Jobs, & the Zen aesthetic" pro-
posed that one could distinguish the PowerPoint presentation styles of the
computer titans Bill Gates and Steve Jobs (1955–2011) by "keeping key aes-
thetic concepts found in Zen in mind." Simply put, Jobs has Zen, Gates does
not. The "typical visuals" of Jobs, the blogger Garr Reynolds tells us, exem-
plify core Zen aesthetic concepts: "Simplicity; Subtlety; Elegance; Sug-
gestive rather than the descriptive or obvious; Naturalness (i.e., nothing
artificial or forced); Empty space (or negative space); Stillness; Tranquil-
ity; Eliminating the non-essential."[64] This would seem to fit Apple's sleek
styling, though not all readers of the blog were convinced of the virtues
of "Presentation Zen." Gates, some noted, became wealthier than Jobs.[65]
Be that as it may, this and other blogosphere synapses remind us of the
pervasiveness of the so-called Zen aesthetic and the terms said to help us
see it.

The modern explication and exultation of Asian art has involved an
array of headlining principles and keywords; scholars and others have their
favorites. As noted already, Zen art in particular has been associated with
simplicity, asymmetry, instantaneity, and suggestion, as well as the intuitive
grasp of essence and the fusion of subject-object within nothingness. These
are among Zen art's most potent "priming words." Through their repeti-
tion, especially during the postwar years, they have become, to borrow from
Donald S. Lopez Jr., "innate qualities, immune from history."[66] To use them
in reference to art is quite nearly to speak of "Zen art," almost regardless of
the artist, object, or context at hand.

Where does this litany come from? The author of "Presentation Zen"
cites the North American designer of Japanese gardens Koichi Kawana
(1930–1990). The unacknowledged presence, however, is Hisamatsu
Shin'ichi, the student of Nishida Kitarō, lay Zen practitioner and founder
of the lay society F.A.S. (Formless self-awakening itself/All humankind/
Suprahistorical history). A determined campaigner for Zen as a transcul-
tural truth of "Oriental nothingness" (*Tōyōteki mu*), Hisamatsu's pro-
nouncements on Zen art in English appear most grandly in *Zen and the
Fine Arts* (1971), published initially in Japanese in 1958 as *Zen to bijutsu*.[67]
There Hisamatsu argues that each work of Zen art, be it an ink painting,
work of calligraphy, Chanoyu, Noh drama, or garden design, is a creative
expression that emerged from the "unitary cultural complex" of Zen and
is distinguished by Seven Characteristics: Asymmetry, Simplicity, Austere
Sublimity or Lofty Dryness, Naturalness, Subtle Profundity or Profound
Subtlety, Freedom from Attachment, and Tranquility. These are, to put it

one way, the "Magnificent Seven" of Zen art: idealistic, bold, and disciplined (even macho), they ride in to save the day.

Hisamatsu was not the first Japanese intellectual or Japanophile to employ a set of terms to explain the essential characteristics of Zen and Zen art to the West, and his postwar lexicon followed intensive national efforts to name and explain Japanese art and culture generally, particularly in transnational spaces. *L'histoire de l'art du Japon,* prepared by Kuki Ryūichi and others for the 1900 Exposition Universelle in Paris, outlined eight qualities that define "The Natural Gifts of the Japanese: Their Taste in the Arts."[68] In 1928, in Pontigny, France, Ryūichi's son, the philosopher Kuki Shūzō (1888–1941), outlined four characteristics of Japanese painting: "the absence of exact perspective, the arbitrary composition, the importance of the line, and the preference for ink painting."[69] European audiences, armed with such lists of quintessential qualities, could now presumably respond to and speak correctly about Japanese art. For his part, D. T. Suzuki introduced eight characteristics of satori: Irrationality; Intuitive Insight; Authoritativeness; Affirmation; Sense of the Beyond; Impersonal Tone; Feeling of Exultation; and Momentariness.[70]

By the early twentieth century, a consensus regarding the language of Zen art had begun to emerge in the writings of Okakura, Ernest Fenollosa, Suzuki, Yanagi Sōetsu (1889–1961), and others.[71] Thereafter Western commentators and Zen adepts acquired and adjusted the litany. For Alan Watts the three major characteristics that exemplified "the cultural effects of Zen" were "absence of symmetry," "the use of emptiness," and "the instantaneous quality."[72] For Loraine Kuck (1894–1977), a "Zen garden" had to be "executed in an impressionistic, abridged, and symbolic manner [typically] made of sand and stone" and should present "splendid mysticism" and "pure harmony."[73]

Long before the twentieth century, however, Zen monks and nuns had developed terminology related specifically to monastic visual and material culture and expended considerable effort to categorize relics, images, texts, and implements.[74] And though one can find terms such as "simplicity" in use prior to the modern era, the now-familiar enumeration of *bundled* aesthetic qualities in the explication of Zen art is undoubtedly a modern practice. Hisamatsu, for his part, explained the virtues of Zen asymmetry, simplicity, and so forth by emphasizing not only the states of *mushin* and *mu'nen* and the freedom that, he argues, underlies the actions of the Zen artist but also the necessity that all seven characteristics of Zen art are "always interrelated." When one of the seven "stands alone, unrelated to the other six characteristics," he stipulates, "it remains unsuitable as a description of Zen culture."[75] Thus, the Seven "did not appear at random, scattered

here and there, but in a great unitary system."[76] It is this system, he implies, that differentiates Zen art and Japan from the West.

We might also note the "ten steps in the experience of truth in the DO [Way; J. *dō*]," which the Japanese philosopher Hasumi Toshimitsu (dates unknown) modeled after the ten vignettes of the ox-herding theme of Chan/Zen poetry and painting.[77] "All Japanese arts," he wrote in 1960, "must mount unswervingly by these [ten] steps," which lead ultimately to "repose in the Nothing," a concept drawn from Nishida.[78] Meanwhile, four qualities found throughout the arts of Japan embody this attainment of the Way: "intimate connection with the immanent world"; simplicity, the elimination of the inessential to grasp the Absolute; intuition; and "the relation of the Japanese to the intentional formation of ideas." "The way to the NOTH-ING is the innermost art of Japan, and out of it all formative art unfolds."[79] Reviewers were not always convinced. Hugo Munsterberg found Hasumi's knowledge of the visual arts wanting and his text rife with errors. Another cautioned: "this book offers Zen as naïve nationalism, sometimes suggestive of tourist propaganda," and concluded, "It cannot be taken seriously as art criticism."[80]

Ultimately, Hisamatsu's Seven Characteristics were to prove more influential and resistant to criticism. Why Hisamatsu settled on the number seven is unclear to me, but in hindsight it resonates with John Sturges' (1910–1992) contemporaneous Western film *The Magnificent Seven* (1960) and its seminal prototype, Kurosawa Akira's *Seven Samurai* (*Shichinin no samurai,* 1954). In both films, seven warriors, each different in persona and martial skill, join together to defend a village from bandits in a united expression of chivalrous, selfless conduct, whether samurai or cowboy—akin to Hisamatsu's concept of the unified, indivisible Seven Characteristics of Zen art. But what makes these seven characteristics Zen, Hisamatsu explains, is their fusion with "the Self-Awareness of the Formless Self."[81] Each of the seven is in fact rooted in this Formless Self, which manifests a generative set of seven qualities: No Rule (which produces Asymmetry); No Complexity (simplicity); No Rank (Sublime Austerity); No Mind (Naturalness); No Bottom (Profound Subtlety); No Hindrance (Freedom from Attachment); and No Stirring (Tranquility). Thus, the Zen mind, the Self without Form, necessarily produces and perceives the Seven Characteristics, and "each being an expression of this One, are each included, inseparably, in all the others."[82]

Having introduced this interlocking, self-regulating system, Hisamatsu's *Zen and the Fine Arts* offered readers a broad set of "appreciations" of works of painting, calligraphy, architecture, ceramic art, and so forth. Each masterpiece—be it Muqi's *Six Persimmons* (fig. 6), a medieval Noh

mask, a calligraphy by the monk Ikkyū, a sixteenth-century Raku teabowl, the seventeenth-century gardens at Katsura Rikyū, or a lacquer box by Hon'ami Kōetsu [1558–1637]—is presented by Hisamatsu as an embodiment of the Seven Characteristics and, hence, the Formless Self.

With its philosophical elucidation of the Formless Self and its aesthetic materialization and gallery of exemplifying art masterpieces from Japan, Hisamatsu's *Zen and the Fine Arts* would therefore appear to be an admirable and useful manifesto. To put it another way, the Seven offer tools for authentication—they enable us to identify a Zen work of art when or wherever it may turn up—and they respond to desires to understand, interpret, as well as own and even make Zen art. But this is precisely where Hisamatsu's art criticism is doubly interesting and problematic for the historian. Once one has learned to identify the seven qualities of Zen art— ideally with some degree of Zen realization, though this is not a prerequisite to a reader's response to Hisamatsu's formulation—one in theory can find Zen art anywhere outside Zen institutional, ritual, social, and artistic settings in any historical or cultural context. One can make claims for the Zen-ness of any work and, by extension, the Zen mentality of the maker and even user. If this is Hisamatsu's point, then it is also the case that it is historically of a piece with the ahistorical, decontextualized, and universal Zen developed by Nishida and Suzuki and others, whose essence lies in mystical experience rather than in the actual institutions, objects, and ritual practices of monastic and lay Zen communities. Indeed, Hisamatsu's Seven Characteristics are part of the modern Zen period drama of suprahistorical no-self and nothingness, one that may appear as anachronistic as it is nationalistic and is still granted considerable authority as a portrait of Zen across time and space, rather than as a richly formulated modern Zen.[83]

The great majority of readers of Hisamatsu's *Zen and the Fine Arts*, I would hazard, did not pursue the combination of formal study and meditation that he, Suzuki, and other Zen campaigners in fact were advocating. This, I suspect, contributed to the problem of "book Zen," divorced from meditation Zen, in which an encounter with Hisamatsu's philosophical and aesthetic exegesis of the Formless Self and Seven Characteristics, illuminating as it may be, might become all one needed to know in order to know Zen and Zen art.

NEW TERMS, NEW ART

Hisamatsu's "Magnificent Seven" never rode off into the sunset. Across the postwar years and late-century globalism into our age of hyperconnectivity,

art historians, critics, artists, Zen monks, and cultural commentators have continued to avail themselves of Hisamatsu's Seven as an authoritative frame for Zen art.[84] But as the popularity of Zen art proliferated, so too did its terminological structures; artists and critics seem unable to resist the urge to outlist or edit Hisamatsu. Visiting Kyoto in 1958, the painter Ad Reinhardt (1913–1967) jotted in his diary, "Zen-West? Eleven Elements. Zen elements?" comprising asymmetry, simplicity, agedness, naturalness, latency, unconventionality, quietness, freedom, humor, sexuality, and joy.[85] In *Zen Art for Meditation* (1973), meanwhile, the authors distill Zen into fifteen tenets including the interrelation of self and universe, the birth of form in emptiness, and so on.[86] In the 1990s, an independent filmmaker had laid out a mere six tenets for "Zen Filmmaking," with emphasis upon a freewheeling "Just do it" attitude. Ultimately, "in Zen filmmaking nothing is desired and thus all outcomes are perfect."[87]

Hisamatsu's Seven returned as an authoritative touchstone in *Zen in the Fifties* (1996), Helen Westgeest's study of postwar art and Zen. Comparing Hisamatsu's characteristics to the work, views, and methods of some of the most famous artists of the 1950s and 1960s, Westgeest found conspicuous resemblances that led her to propose "five striking parallels" to Hisamatsu's Seven: Emptiness and Nothingness; Dynamism; Indefinite and Surrounding Space; Direct Experience of Here and Now; Non-dualism and the Universal.[88] To the extent that Suzuki and Hisamatsu's writings and lectures as well as Awakawa Yasuichi's (1902–1977) widely read *Zen Painting* (1970) were significant in the postwar artistic world, Westgeest's parallels suggest a field of exchange, recalibration, and transformation—a postwar "period eye" that was informed heavily by the sort of modern Zen and Zen art these authors promoted.[89] That said, and although she gives texture to the reception and reinterpretation of (modern) Zen in the art world of the 1950s, she accepts Hisamatsu's criteria without questioning their historical, philosophical, and ideological specificity. Her approach is also uneven because postwar art is hardly a colony of Zen (which does not fully or fundamentally explain the grid, seriality, color field, multiples and readymade, and so forth), and postwar artists were also interested in psychoanalysis, radical leftist and anticapitalist politics, gender, and so on.[90]

Lest one imagine that the hubbub about Zen art and aesthetics would quiet down by millennium's end, Andrew Juniper's treatise on the aesthetic of *wabi-sabi,* the "artistic mouthpiece of the Zen movement," offered a new lexical thread. *Wabi-sabi,* aka Zen art, is distinguished by the organic, freedom of form, texture, ugliness and beauty, color, simplicity, space, balance, and sobriety.[91] Equally insistent is Michael Dunn's *Inspired Design: Japan's Traditional Arts* (2005), which seeks to explain the uniqueness of

the Japanese aesthetic sensitivity to beauty. For this purpose Dunn turns to several sets of terms: Yanagi Sōetsu's four "Design Rules" ("I. Honest to use—i.e., design following function. II. Of sound quality. III. Made without being forced, artificial, or self-imposing. IV. Made with the user in mind"); Hisamatsu's Seven; and the "five aesthetic considerations" of Itō Teiji (1922–2010) (suggestivity; simplicity; asymmetry; transience; and space.)[92] Dunn seems keen to throw as many pedigreed terms as he can into the lexical mix as if to infuse his explanations with the authority of the established art and aesthetic theories of prominent Japanese intellectuals. What many readers may not grasp is how implicated these native figures were in modern cultural production and nationalism, and that their respective lexicons were interpretive, creative responses to the past. More recently, Hisamatsu's Seven have found their way to Silicon Valley and business consulting contexts, adding to what R. John Williams refers to as "*Technê*-Zen and the Art of Late Capitalism."[93]

Rather than wordless silence, therefore, the look of Zen art has elicited in the modern era a repertoire of keywords, albeit in a rhetoric of withholding or denial: simplicity; monochrome; suggestion; spontaneity; and so on. There is something a bit dreary about this litany, however, with sound bites sufficing for history and modern authorities ruling over past, present, and future Zen art. Nevertheless, varied publications on painting and calligraphy and other works of visual-material culture tagged Zen continue to cite and celebrate simplicity, abstraction, spontaneity, and the like as hallmarks of Zen nothingness and no-mind.[94] Many do so without concern for or knowledge of the modern histories of such terms and concepts and what these histories may tell us about the visual arts and religious traditions in transnational circulation, appropriation, and transformation. Still we might allow that these sorts of terms and terminological practices can facilitate the identification and enjoyment of particular aesthetic qualities and offer a matrix for meaningful cultural or spiritual experience. That is perhaps sufficient for many who are drawn to Zen and Zen art and for certain Zen teachers. It may be perfectly valid and significant as a modern-contemporary Zen phenomenon.

Even so, the terms and discourses about Zen and Zen art and aesthetics we typically encounter derive not from an unvarying, wholly understood Zen past transmitted seamlessly to the present but in large measure from desires for timeless, pristine traditions, especially those that offer cultural and spiritual alternatives.[95] A few of us by instinct balk at the normative language of Zen art, however, specifically because of its imbrication with and animation of modern and contemporary nationalisms, and point to instances of secondary orientalism, reverse orientalism, and

occidentalism. Surely there is good reason to pay attention to the power of particular words, to be wary of the modern lexical tail wagging old Zhaozhou's dog.[96]

Moreover, we may wish to leave the door ajar, for it is arguably the case that Zen art, like many things Zen, has wandered off in new directions, and in doing so may prompt new lexical entries or overwrite clichés of Zen monochrome, simplicity, minimalism, and nothingness. Surely, to judge from hackneyed appropriations of *ensō,* Zen gardens, and the like, we have arrived already at Zen kitsch. What might we say, then, about Murakami Takashi's (b. 1962) large-scale paintings of the first Chan patriarch Bodhidharma exhibited at the Gagosian Gallery, New York, from May 1 to June 9, 2007 (Plate 8)?[97] Do they look like Zen art? Which terms capture their Zen-ness, if they have any?

Let me close, then, with Murakami's turn to the quintessential Zen pictorial subject, the half-figure representation of Bodhidharma (J. *Daruma*) cloaked in monastic robes and glaring at the viewer (Plate 2). To situate this new work, Gagosian informed viewers that Murakami had departed from his smiling psychedelic flowers, "toonish apocalypse," and *otaku* figures, and that his *Daruma* works fuse "tradition with a heterogeneous range of artistic and cultural inspirations."[98] One reviewer felt "as if he had accidentally entered one of the Metropolitan Museum [of Art]'s rooms of ancient Japanese art before reaching the contemporary wing."[99] Hardly, I think, but the quip does capture the unexpectedness of Murakami's display of a Buddhist subject in the Manhattan upper-stratosphere gallery setting.

In these large-scale works, kinesthetically evocative lines echo centuries of preceding Chan/Sŏn/Zen and literati imagery, while Bodhidharma's pose against a background of metalic leaf recalls folding-screen and sliding-door paintings by early modern professional painters in Japan (rather than brush-wielding monastics). Murakami's adoption of traditional Zen iconography and metallic-leaf surfaces suggests a return to his earlier Japanese style painting, but given the appropriations, "classical transgressions," and commercial contrivances that run through his subsequent work, we should not expect simple neoclassicism.[100] Indeed, alongside a caricature of painterly gesture—digitized rendering of the sort of brash brushwork we associate with Daruma paintings executed by Zen monks—we find high-gloss surfaces of saturated acrylic color, sleek planar spaces, reduction to pattern, and *manga-anime* allegiances that align with the artist's Superflat and *otaku* projects.[101] Those attuned to postwar art may think of Benday-like dots, à la Roy Lichtenstein (1923–1997), Clyfford Still–ian (1904–1980) edgy color swatches, and Morris Louis–like (1912–1962) rivulets of intense color.[102] How we relate Murakami's *Daruma* paintings to postwar art that

drew from Zen and Zen art, meanwhile, is an interesting question, but they hardly seem to advance the sort of avant-gardism found in works by Yoshihara Jirō and John Cage, among others, even with Murakami's reputation for transgressing (certain) boundaries.[103]

Matters might be simpler had Murakami professed to have experienced *mushin,* or if his paintings had been intended for Zen temples rather than the high-end art market.[104] That said, allusions to Zen could be found throughout the gallery above and beyond the traditional glaring patriarch, including references to ascetic practice in the show's Zen aphorism-like wall titles and the koan-like captions of individual works: "I am not me. I cannot become myself; I open my eyes but see no scenery. I fix my gaze upon my heart." In keeping with his agenda to "bring something spiritually and culturally Japanese to a wider audience"[105] Murakami orchestrated VIP tea ceremony events conducted with antique utensils in the gallery by Sen Sō'oku, the family head (*iemoto*) of the Mushakōji Senke tradition of Chanoyu. Why tea ceremony? The gallery and Murakami explained that tea, which sustains meditation, has traditionally been offered to images of Bodhidharma in Zen monasteries. Given the long-standing modern fusion of Zen and Chanoyu—notable, for instance, in Okakura Kakuzō's *The Book of Tea* (1906)—the performance of tea reinforced the implied Zen-ness of Murakami's work and perhaps for some blurred the gallery space as a "white cube" with a Zen temple or tea room. It was hardly surprising, therefore, that one review of the show was titled "The Warhol of Japan Pours Ritual Tea in a Zen Moment." To lend this performance added authenticity, Murakami donned kimono and *hakama,* purportedly for only the second time in his life, a self-fashioning that brings to mind Okakura Kakuzō's "Daoist" garb in Boston and Hasegawa Saburō's (1906–1957) appearance in kimono at the Museum of Modern Art in New York (1954).[106]

Is this the new look of Zen art? Is this "pop culture gets religion," or religion gets pop culture?[107] Daruma gets a Warholian makeover for the pop culturati? Zen painting meets Superflat? "Pop eye candy" or "Pop Dharma"? A performance of Japanese-ness to beguile exotic-hungry collectors? All of the above? Something else?[108] Some viewers declined to drink the Kool-aid:

> Even with the tea ceremonies, everything we know about Murakami is, frankly, not very Zen. Rather than direct simplicity what I get from the paintings is a sense of tight control, of a demand for absolute perfection, of megalomania. . . . It is meticulously realized factory production. Daruma is just another image to be appropriated and enlisted alongside the cast that Murakami has already created and spread around the world.[109]

For this critic the look of Zen art appears to remain tethered to simplicity and directness and to depend upon the visual effects of fortuitousness, imperfection, and ego-less humility. Murakami's factory works, in contrast, are merely part of the artist's new spring product line, as it were.

Fair enough, but perhaps there is something more going on in Murakami's appropriation than simply the presence or absence of true Zen or art world hype. I suspect—though I may give Murakami's strategies too much discursive heft—that by giving Daruma the Neo-Pop and Superflat treatment, and by appropriating postwar New York–based painting, Murakami may have sought to reclaim a subject seemingly colonized by Zen-enthusiast Western collectors, to unbind it from Western consumption as a synecdoche of traditional Zen Japan, and to challenge artists outside Japan who believe their art to be full of Zen.[110]

Is Murakami upsetting the Zen art applecart? Freeing Zen art from institutional and visual narrowness? Reasserting Japanese-ness within late-capitalist art globalism? Subverting Western consumption of Zen art? Whether or not Murakami is an essentialist, an appropriationist, an interventionist, or all of the above, his Daruma paintings take us back to the dilemma of defining Zen art. These paintings may not be the Zen art some of us are accustomed to; Zen purists may be within their rights in disclaiming them as having anything to do with Zen. That said, what artists, designers, and architects do with (conceptions of) Zen may shake up certain expectations and descriptions, prompting new terms for what makes a particular work of art, space, or thing "Zen." No doubt much of the familiar imagery, facture, and lexicon will stick fast, but perhaps we will come to deliberate over the Zen baroque or Zen art code switching. Apparently, we have already discovered "Zen Warholism."[111]

5

ZEN-BOOM "CULTURE WARS"

If some of what I am about to say does not accord with what you have heard or conceived about Zen, please understand that I am speaking about the sect of Mahayana Buddhism known as the Zen sect. I am acquainted with no other Zen.

—Ruth Fuller Sasaki, *Zen: A Method for Religious Awakening*[1]

This was long before Zen Buddhism had become a commonplace in suburbia. . . . Cocktail guests had not yet begun to ask each other Zen *koans*. . . . It was even possible to spend a whole evening talking to an old friend without having to hear about his *satori* (enlightenment) or having to argue about the relative merits of beatnik Zen, square Zen, and ladies Zen.

—Calvin Tomkins, "Zen and the Art of Tennis"[2]

In the years following World War II, politicians, public intellectuals, writers, artists, academics, religious leaders, "disaffected youth," and various other communities around the globe felt that something, or indeed everything, was seriously out of whack. For some, Zen offered the fix. This was a lot to ask of Zen, and as its advocates would readily admit, Zen did not fully transform the world over the coming decades. But the transnational interest in Zen that emerged during the 1920s and 1930s not only continued, it exuberantly expanded during the postwar years, a phenomenon known as the "Zen boom," a bomb metaphor not coincidental to this period.[3] Although Zen did not provoke global religious intoxication, heavy Zen vibrations pulsed across North America, Europe, Asia, and other areas of the world from the 1950s to the 1970s.

Born at the tail end of the baby boom, I did not experience the Zen boom firsthand, though I am aware of its nostalgic power. The boom has a story line precious to many, plotted with anecdotes about D. T. Suzuki; accounts of Zen training in monasteries and centers in Asia and the West; descriptions of daily life transformed by Zen concepts and practices (emptiness, void, chance, the integration of art and life); as well as recollections of "first contact" between avant-garde artists and Zen and of how Zen liberated art from European modernism. This is not to suggest that everyone was enthusiastic about it. Reminiscing in 2005, curator of Japanese art Rand Castile proclaimed: "I detest the invention of 'Zenboom.' That said, I took some of Alan Watts's seminars. This word should have died with him."[4] The term did not die, of course, and it seems right to reconsider this phenomenon, now a half-century and more since its heyday, not merely in terms of "what happened" but also of the rhetoric used by Zen teachers, lay practitioners, historians, artists, and cultural critics in their attempts to explain, caution, and understand.

It would be a Sisyphean task to review all of the writings, ephemera, and oral histories of the Zen boom, which was not strictly about Zen practice but was a social, cultural, and political phenomenon concerned with Zen's seemingly sudden everything, everywhere presence. As such, it has been chronicled, dissected, praised, and disparaged in every possible medium: books, articles, newsletters, interviews, lectures, letters, newspapers, television programs and film, exhibition catalogs, and, more recently, the websites and blogs of Zen communities, individual practitioners, Zen artists, Zen bashers, and lifestyle gurus. Book-based Zen itself became a trope of social commentary and parody. In 1959, Guy Talese reported, tongue in cheek, that Zen books were threatening to take over New York City, or at least the soda fountain at the Sheridan Square Chemists in Greenwich Village, an area "jumping with beatniks and simmering with Zen." More room had to be made for books on Zen. "Any book with the word 'Zen' on it sells fast here," the owner remarked, "We've sold 'The Way to Zen,' 'Zen Buddhism,' 'Buddhism Zen,' 'The Way of Zen,' 'Zen and Japanese Culture,' 'Zen Flesh, Zen Bones.'"[5] Thus, even if "books about Zen are like legs on a snake," as one novelist put it, the philosopher Van Meter Ames was rather on point when he put it in 1960 that, "For one who wants to study [Zen], there is no end of unwearied reading to be done."[6]

In a moment I will offer some additional snapshots of the Zen boom, followed by a more or less conventional chronotope and, then, more specific discussion of some of the period's authors, texts, and cultural works. My particular interest lies with the interdependent patterns of postwar rhetoric concerning Zen and Zen-associated art—the discourse rather than absolute

facts, and a discourse that was often tempestuous and unresolved, especially as it concerned the value of Zen and the authenticity of one sort of Zen over another. Arguably, postwar Zen was especially labile and provocative, and any serious reading in the subject makes it abundantly clear that responses to it ran the gamut from awe and approval, to suspicion, accusation, and jest. Part of this was due to the appearance of forms of Zen that, in the view of Zen authorities such as D. T. Suzuki, went off the rails.[7] But debates over Zen were also complicated by what these authorities themselves were doing with Zen and by their differing views of authentic Zen as they emerged from traditional sectarian contexts and were active in Zen reform in modern Japan. If to some extent postwar debates over Zen echoed medieval efforts in Chan and Zen to grapple "with doctrinal conundrums and confusions that sit at the heart of Buddhism," there were also new puzzles and muddles to consider.[8] To trace postwar Zen with an eye for such concerns and disputes is to find the edges uneven and sometimes sharp. But such roughness, as I have suggested, is part of what makes Zen one of the twentieth century's more notable, or notorious, religious, spiritual, intellectual, and cultural phenomenon. It may even be fair to say that a Zen "culture war" was being fought across the late 1950s and early 1960s.

ZEN BOOM SNAPSHOTS

Cold War, Rock-and-Roll, Civil Rights, Free Speech, and Zen Boom—the 1950s and 1960s encapsulated in a surfeit of phrasemes. Rather than an explosion, however, the postwar Zen boom seems more like pollination or a seeding across a wide geography in the Americas, Europe, and Asia. In the United States it moved inward from the coasts. In some places Zen was considered an "invasive species," while in others it yielded edenic groves.[9] The years 1957 to 1959 seem to have been especially fertile.[10]

It seems safe to suggest that the Zen of the early twentieth-century period, formative as it was, has for the most part been overshadowed today by a fascination with mid-century developments. Zen observers of the time themselves remarked on how different things had become by the 1950s. The British philosopher Gerald Heard (1889–1971) wrote in 1950 apropos Zen that, "A generation ago an educated man might have said, as Disraeli remarked of heraldry, that it was a subject of which even an informed person need not be ashamed to know nothing. Arthur Waley's and Alan Watt's [sic] essays [of the 1920s and 1930s] on the subject roused little more than a faint esthetic curiosity."[11] By 1951, however, the scene had begun to change, thanks in no small part to the reprinting of D. T. Suzuki's *Essays in Zen*

Buddhism and the lectures he gave at Columbia University and elsewhere. As the ordained Zen priest Philip Kapleau (1912–2004) put it in 1966, Suzuki's lectures "ignite[ed] the fuse that exploded into the Zen boom of the late fifties."[12]

Zen-boom Zen deepened Buddhist practice in transnational, transcultural encounter; it was about migration, translation, conversion, and realization. By the 1970s Zen had dramatically proliferated and differentiated, especially in North America and Europe.[13] Even if some believed that "The Zen Buddhist outside the monastic wall is a contradiction in terms," Zen assumed assertive yet diverse forms in dissimilar spaces, and in doing so it enabled an elasticity of practice and belief that fostered inventively intercultural Zen communities and individualist Zen faiths as well as what I term our Zenny zeitgeist.[14] The master and monk were no longer the only Zen figures to capture public attention, and new sorts of Zen followers were doing things that seemed contradictory to Zen. In his autobiography, *Zen Showed Me the Way* (1960), for instance, the transnational film star Hayakawa Sessue (1890–1983) defended his materialist and hedonist habits as appropriate to his Zen faith:

> Although I have found a true salvation in Zen, I do not consider myself ascetic in the monastic sense. Zen does not demand the hair shirt and the begging bowl. After all, to move in Zen is to live with life, not apart from it, or in opposition to its flow. I have a taste for the finer things, and since my profession has abundantly rewarded me, I have catered to my tastes. I see nothing wrong with this; there is only wrongness in attaching too much importance to the ephemeral, all that cannot and does not last.[15]

This was by no means the only sort of Zen under discussion and in circulation, however, for D. T. Suzuki and other Zen advocates offered Western audiences descriptions of monastic Zen in Japan.[16] But Zen was clearly on a roll, becoming as well an anarchist solution to modernity's repugnant and terrifying creations, in R. John Williams' words, the "'mad rationality' of the technocratic machine."[17] Zen found its way into jazz, anti-art, and even the postwar murder mystery.[18] With apology to Shakespeare, there was much ado about Zen nothingness in 1950s and 1960s New York, London, Paris, Tokyo, Berlin, and elsewhere, and, perhaps inevitably, Zen became radical hip and then bourgeois fashion; it became boutique and street. Zen-theme products began to be marketed in the 1960s, as I note in Chapter 8, adding personal styling and consumption to postwar global Zen practice, anti-establishment Zen, and so forth. In seemingly no time at all, postwar

Zen could be found in temples, churches, meditation centers, living rooms, art galleries, performance spaces, psychiatrists' offices, marketplaces, and various urban and wild spaces.

The general print media, quick to exploit curiosity, published background reporting on where Zen came from, commentary on belief and behavior, and "Zen interest stories."[19] Thanks to presentations on Zen in "such mass media as *Life, Time, The New Yorker, Mademoiselle, Esquire,* television, the radio, and tabloid newspapers," Mary Farkas noted in 1958, "everyone and his neighbor who is not quite satisfied with a conventional spiritual diet wants a taste of this more exciting fare."[20] Explaining Zen therefore became a matter of genuine interest to many and a topic of social comment and literary imagination.

In February 1957, the American magazine *Time* noted that a "Buddhist boomlet [is] under way in the U.S." and suggested that "Zen (meditation) is the form of Buddhism that is at the same time most appealing and appalling to the Western mind. It claims to be as practical as a Mack truck; it is certainly as anti-intellectual as a hooky-playing schoolboy, and often as humorous as a well-timed pratfall. But it also insists on the disconcerting necessity of saying yes and no at the same time."[21] Having a bit of fun in this passage, the author turns more serious with his reference to the *rencontre* that Zen set up with the West—its challenge to rationalism, social norms, and language itself. "A Short Guide to Zen Buddhism," appearing in 1959 in the London *Sunday Times*—a frequent venue for commentary on Zen—informed readers that "Zen is a paradoxical institution" and "a quasi-religious system devised to do away with religion." Zen, in which "there is no teaching whatsoever," therefore enters powerfully into secular life and makes it clear that "the solution lies here in the world of everyday existence, and not in the monastic or ascetic disciplines."[22] This is a characteristically Zen-boom explanation, reflecting counterculture rejection of normative religion and turn to Buddhism, modern pragmatism, and emphasis on the spiritualized quotidian, not to mention hyperbolic commentary.

Still, not all attempts at elucidation were entirely successful. A serious-minded BBC documentary on Zen in Japan, one critic wrote, was sure to have appeal, as "Zen is a fashionable word among assiduous panacea-collectors." That said, the film "didn't really get us very far. Just what exactly Zen *is* was not made crystal clear."[23] Whatever Zen was or wasn't, it also offered rich material for light satire. In a short fiction piece run in the *Sunday Times,* a literary critic was tasked with writing "an article about the influence of Zen-Buddhism on the beatniks" but suddenly realized that "He knew nothing of either." Making a trip to the library, he discovered to his dismay that "all the books on Zen-Buddhism were out."[24] The story hints at

both the popularity of Zen and the idea, noted already, that Zen could be understood through books rather than Zen practice.

The postwar Zen heyday also had its version of profiling, for if one were from Japan and living or traveling abroad one might well be expected to do Zen and be eager to engage foreigners interested in Zen. The Japanese artist Hasegawa Saburō (1906–1957), for instance, recalled that "In about one hundred days [in New York City] I was asked by about one hundred about Zen and at times they told me about Zen."[25] A bit of exaggeration perhaps but surely not pure fabrication. The philosopher Van Meter Ames, having returned from a Fulbright professorship in Japan, reported that he was "asked by nearly everyone I meet, 'What did you learn about Zen?'"[26]

Of course there was much more to the Zen boom than what such snapshots convey, but you can see what was happening. Zen was no longer singular, solely a religion, strictly a matter of quiet meditation, serious, and in or of Japan or Asia. As we shall see, such flourishing plurality and transnational exchange occasionally resembled a Zen free fall. At times it led to a free-for-all over Zen.

A ZEN-BOOM CHRONOTOPE

Postwar Zen grew out of a half-century of immigration and travel as well as religious reform and intercultural encounter localized initially at temples, meditation centers, and other teaching-practice spaces. In the Americas and in Hawai'i, these included temples established before World War II within Japanese American communities, whose members suffered discriminatory internment during the war. There is Hanapepe Zenshūji Sōtō Temple (established 1903) on the island of Kauai, for instance, and the Paia Myōshinji Rinzai Zen Mission (1932) on Maui; in Los Angeles, Zenshūji (1922); and in San Francisco, Sōkoji (1934).[27] There was also the Rinzai monk Nyogen Senzaki's (1876–1958) "Mentorgarten" and "Floating Zendō" in 1920s and 1930s San Francisco and Los Angeles; the Zen study and meditation group organized in New York by Hayakawa Sessue and Sōkei'an, founder of the First Zen Institute of America in Manhattan in 1930, which was later overseen by Ruth Fuller Sasaki and Mary Farkas.[28] Shortly before the attack on Pearl Harbor, the literary editor J. Ronald Lane Latimer (1909–1964) left Japan after studying Zen in Kyoto. The scholar R. H. Blyth, who had studied Zen with the Japanese Rinzai master Kazan Daigi in Korea during the 1920s and befriended D. T. Suzuki, was interned in Kobe, Japan, as a British enemy alien and in that context introduced Robert Aitken to Zen.[29]

The Zen communities that emerged outside Japan from the 1950s to 1970s owed much to prewar advocates and communities as well as postwar immigration, the transmission of Zen to European and North American disciples who trained in Asia after the war, and conversion in the West. The list, even abridged, grows long indeed, but bear with me. We might note the Sōtō Zen temples Zengenji and Busshinji in Brazil (1955); the Zen Studies Society, established in Manhattan in 1956 by Cornelius Crane (d. 1962), heir to a bathroom fixture fortune; the Cambridge, Massachusetts, Buddhist Association, established in 1957 by D. T. Suzuki, Hisamatsu Shin'ichi, Stewart W. Holmes, and John (d. 1994) and Elsie Mitchell (1926–2011); the Diamond Sangha in Honolulu, established in 1959 by Robert Aitken (1917–2010); the San Francisco Zen Center, established in 1962 by Shunryū Suzuki (1904–1971), and from 1967 its Tassajara monastery; the Rochester Zen Center, founded in 1966 by Philip Kapleau (1912–2004); and the Zen Center of Los Angeles, established in 1967 by Taizan Maezumi (1931–1995). The Chan monk Hsuan Hua (1918–1995) arrived in San Francisco in 1962 and established the City of Ten Thousand Buddhas to the north in Mendocino County. That year the Japanese monk Jōshū Sasaki (1907–2014) settled in Los Angeles and, in 1968, founded the Cimarron Zen Center (Rinzaiji). In 1964, the Korean Sŏn master Il Bung Kyung Bo (1914–1996) became a visiting scholar at Columbia University, and in 1972 Seung Sahn Haeng Won (1927–2004) began teaching in Providence, Rhode Island.[30] Jiyu Kennett (1924–1996) established the Sōtō Zen Mission Society, San Francisco, and Shasta Abbey Buddhist monastery in California in 1969 and 1970 respectively.[31] In 1971, Walter Nowick (1926–2013) opened the Moonspring Hermitage in Surry, Maine, later the Morgan Bay Zendo.

In Great Britain, there was the Buddhist Society, established in 1924 by Christmas Humphreys (1901–1983), an advocate for Suzuki and himself a prolific writer and lecturer on Zen, and the Zen meditation groups led by the Rinzai Zen teacher Irmgard Schloegl (1921–2007).[32] By the mid-1950s, there was a Rinzai Zen Buddhist Mission in Berlin run by a young German.[33] In the mid-1950s, Max Dunn (1895–1963), ordained by the American monk Robert Stuart Clifton (1903–1963), set up the Zen Buddhist Institute of Australia in Melbourne, while the Sydney Zen Centre, affiliated with Robert Aitken, was established in 1975. The Korean monk Samu Sŭnim arrived in Montreal in 1968. In 1969 the Vietnamese monk Thich Nhat Hanh settled in France. In 1970, after arriving in Paris in 1967, the Sōtō Zen monk Taisen Deshimaru (1914–1982), established the European Zen Association, and a meditation group guided by Jōshū Sasaki established the Zen Centre of Vancouver.

In Japan, reform movements led by monastics such as the Sanbōkyōdan (Three Treasures Association, established in 1954), and

communities organized by lay Zen teachers and philosophers such as Hisa-matsu Shin'ichi, refocused Zen towards new practices, philosophical dis-courses, and audiences. Some leaders spoke from within the Zen institution about the war period, the threats of the modern nation-state, and social jus-tice.[34] Zen also drew Japanese corporate attention: employees were sent to monasteries and temples for short periods of meditation training to mold disciplined, obedient, and conforming workers.[35]

If Japan was the distant heartland of Zen in the mid-century Amer-ican imagination, for some it was the land of direct experience. At the Rinzai monastery Daitokuji in Kyoto, there was Ruth Fuller Sasaki's circle at the subtemple Ryōsen'an; Western students studying with Kobori Nan-rei (1918–1992) at the subtemple Ryōkōin; and Americans staying at Zui-unken, a guest quarters established with support from the Japan-American Zen Association in 1960. Elsewhere in Kyoto, Morinaga Sōkō (1925–1995) taught Western students at Daishuin, Ogata Sōhaku (1901–1973) estab-lished the Zen Study Center at the subtemple Chōtokuin within Shōkokuji, and Kōzuki Tesshū (1879–1937) set up a practice place for foreigners at the monastery Myōshinji, which also housed Hisamatsu Shin'ichi's F.A.S. Soci-ety at the subtemple, Reiun'in. Foreigners also trained at the Sōtō School headquarters, Sōjiji, in Yokohama, the Rinzai monasteries Engakuji and Kenchōji in Kamakura, and the Rinzai temple Ryūtakuji in Mishima.[36]

Outside of monasteries and Zen centers there were countless public lectures and social gatherings concerned with Zen.[37] Most famous are D. T. Suzuki's lectures and seminars on Zen, Buddhism, and Daoism given in Hawai'i and at Columbia University sporadically between 1949 and 1957 and attended by various scholars, visual artists, composers, and others.[38] By identifying who was present at Suzuki's presentations, as many writers on the Zen boom are wont to do, one may, it seems, establish the Zen boom's kinship relations. The terms, concepts, and patriarchal stories introduced and explained in Suzuki's lectures and books on Zen seem to have been carried on the wind from stage and page into countless lives and into new forms of Zen practice and cultural work.

Suzuki was not alone on the Zen-boom lecture circuit and was joined by, among others, the abbot of the Japanese monastery Engakuji, Asahina Sōgen (1891–1979), who spoke in New York City and elsewhere in 1954.[39] In 1957, Hisamatsu Shini'ichi taught at the Harvard Divinity School, where he conversed with the Christian theologian and philosopher Paul Tillich (1886–1965). The following year, he co-taught a seminar with the philoso-pher Martin Heidegger (1889–1976) at Freiburg University and visited Carl Jung (1857–1961) in Zurich.[40] In 1958, Ruth Fuller Sasaki lectured at MIT, while in California Alan Watt hosted radio talks on Zen, Asian cultures,

and psychology on KPFA, Berkeley, ran a television series on KQED, and frequented Big Sur's transcultural spiritual retreat, the Esalen Institute.[41] Zen was also a topic at "off the grid" gatherings, including the 1967 "Houseboat Summit," featuring Watts, Gary Snyder, Allen Ginsburg, and Timothy Leary, at the Bay Area counterculture space SS *Vallejo,* docked in Sausalito, California.[42]

In postwar Japan, meanwhile, philosophers, artists, cultural critics, medical doctors, and others avidly discussed the modern value of Zen and Zen art as well as the Zen boom in North America and Europe.[43] Works of medieval and early modern art produced by Chan/Zen monastics or by professional painters for monastic contexts were frequently on view in Japan's national and private museums. Japanese artists were investigating Zen and Zen art in their own work (or found their work explained in terms of Zen critics), and adventurous audiences attended performances by members of the international avant-garde with Zen affinities.[44] Japanese scholars, curators, and government officials were active in the organization of overseas exhibitions that included works of premodern Chan/Zen art from Japanese collections as well as contemporary work said to demonstrate inherent or ongoing Zen creative achievements. Such exhibitions fanned existing interest in Zen and the allied brush arts and touched off new fascination with postwar Japanese artists.[45]

As a result, the postwar landscape acquired numerous creative texts, objects, spaces, and performances associated with Zen that sought to destabilize capital and social norms and upend the forms, institutions, and economies of literature and the arts. Moreover, a new sort of Zen writer or Zen artist emerged at this time, one who might have no connection to formal Zen training and indeed might eschew meditation altogether. Not all audiences were appreciative of their work and its purported Zen-ness, but the heady postwar decades have left us with a canon of new Zen-associated literature and visual art. Among literary works, none is more famous than Jack Kerouac's *The Dharma Bums* (1958), with its character Japhy Ryder (inspired by Gary Snyder) and his now iconic countercultural sermon:

> A world full of rucksack wanderers, Dharma Bums refusing to subscribe to the general demand that they consume production and therefore have to work for the privilege of consuming, all that crap they didn't really want anyway. . . . I see a vision of a great rucksack revolution, thousands or even millions of young Americans . . . all of 'em Zen lunatics who go about writing poems that happen to appear in their heads with no reason and also being kind and also by strange unexpected acts keep giving visions of eternal freedom to everybody and to all living creatures.[46]

FIGURE 12.
Nam June Paik
performing *Zen
for Head.* 1962.
Photo: Harmut
Rekort. Courtesy
Kunsthalle Bremen
© The Estate of
Nam June Paik.

Then there is the "triad" of indeterminate-fortuitous visual and performance works: Robert Rauschenberg's (1952–2008) "unpainted" *White Paintings* (1951), John Cage's aforementioned "silent" *4'33"* (1952), and Nam June Paik's (1932–2006) "empty" *Zen for Film* (1962–1964).[47] Add in Mark Tobey's (1890–1976) "White Writing" and Franz Kline's (1910–1962) "calligraphic" paintings; Inoue Yūichi's (1916–1985) "action calligraphies"; Paik's *Zen for Head* (1962) (fig. 12); and Ad Reinhardt's (1913–1967) *Black Paintings* of the 1960s. There were also Yoko Ono's 1960s event scores and paintings, as well as her performance *Striptease,* which in one reading, sought to strip the minds of her audience.[48] One curator has suggested that Isamu Noguchi "brought a Zen sensibility to abstract expressionism."[49] Some even see Zen in Kusama Yayoi's *Infinity Nets,* produced from the late 1950s.[50]

As already noted, the Zen boom engendered a capacious literature, and while much of it was apologetic, there was also serious scholarship, critically engaged analysis, and caustic comment. The most famous books of the boom—receiving critical review as well as dilating euphoria—were those of Suzuki, especially his *Essays in Zen Buddhism* (published in three volumes in 1927, 1933, and 1934; reprinted in 1949, 1950, and 1958), *An Introduction to Zen Buddhism* (1934, 1949), and *Zen and Japanese Culture* (1959). In 1956, the scholar of medieval history Lynn T. White Jr. (1907–1987) proposed that the publication of the first volume of Suzuki's *Essays in Zen Buddhism* in 1927 "will seem in future generations as great an intellectual event as William of Moerbeke's Latin translations of Aristotle in the thirteenth century or Marsiglio Ficino's of Plato in the fifteenth."[51] Suzuki's three-volume *Essays* are not collections of translations of Zen texts per se, and arguably they were seen as a great intellectual event not centuries later but in real time, or at least upon their mid-century republication by the Buddhist Society, London. White's reference to Moerbeke and Ficino, however, suggests the intercultural comparisons that Suzuki himself developed to explain Zen and that appear in various domains of the Zen boom.

Piling up around Suzuki's books—for some readers the final word on "wordless" Zen—were so many publications in Western languages that one becomes alternately astonished or weary. Books introduced and explained Zen and its institutional history; described monastic Zen training; provided translations of classical texts such as *The Platform Sutra of the Sixth Patriarch* (Ch. *Liuzu tanjing*) and Huangbo's (d. 850) *Essential Teachings on the Transmission of the Mind* (Ch. *Huangboshan Duanji chanshi chuanxin fayao*); offered teachings by modern lay Buddhists; recounted Zen training by foreigners in Japan; expounded on Zen humor; introduced Zen art; and addressed Zen's growth in the West.[52] There were also dialogic publications concerned with Zen-Christian interfaith studies and the interrelationship of Zen and psychoanalysis. European and North American scholars and critics with the requisite language abilities turned to the numerous publications on Chan/Sŏn/Zen history, philosophy, and practice written by scholars in East Asia. All sorts of readers in Japan and elsewhere perused publications such as the journals *Bokubi* (Ink Beauty, 1951–1963) and *Bokujin* (Ink Person, 1953–1962), produced by the postwar calligraphy movement, Bokujinkai (Ink Human Society), and those of the Gutai art collective, that contributed to debates about avant-garde art and Zen. There were also numerous newspaper and magazine pieces on the Zen scene, long-form profiles of Zen campaigners, book reviews, and dense academic articles. And long before the websites and blogs of Buddhist teachers and communities the newsletters of Zen centers were mailed across the globe.[53]

Although the postwar publishing surge is one measure of the interest Zen attracted, Suzuki and other Japanese Zen advocates were dubious about most if not all writings on Zen by Europeans and Americans, not to mention the extent to which real Zen was understood in the West. Asked by Hisamatsu in 1958 if he had met anyone in America who really understood Zen, Suzuki replied, "None. As yet." "Well," Hisamatsu continued, "is there anyone who shows promise?" "There's no one even like that," Suzuki admitted. "In that case," Hisamatsu concluded, "no one among the many people writing about Zen displays understanding." "No one, indeed," replied Suzuki. Probing further, Hisamatsu asked, "Is there even a book that, as a written explanation of Zen, is largely without mistakes?" Suzuki rejoined, "None, to the best of my knowledge." "What about [the writings of Eugen] Herrigel [1884–1955; author of *Zen in the Art of Archery*]?" Suzuki's reply was unyielding: "His writings approach Zen but are not Zen itself."[54] In part Suzuki may have been reluctant to let go of a racial-ethnic particularity to Zen—"There is something most characteristic of Zen which makes it a unique product of the Oriental mind"—but he did not entirely exclude the

possibility that Europeans and North Americans might attain and teach true Zen.[55] He admitted that a small number of Western students training in Japan showed promise.

Whether or not one accepts Suzuki's conclusion regarding the state of Zen in the West in 1958, the Zen cat was out of the bag. Admittedly Zen was by no means everywhere, in every postwar conversation, but its widening appeal led to manifold, and sometimes incommensurable, discoveries and cultural efforts that invited if not demanded explanation—laudatory, censorious, or satirical. At particular moments, however, there were signs that the boom might end. In 1960, a member of London's Arts Council reflected: "'You know,' he [said], a trifle wistfully, 'the play that consisted of two double-decker buses talking to one another for a couple of hours about Zen Buddhism has really had its day.'"[56] But if Zen grew tiresome to some, it became second nature to others, and there were also those who saw fit to continue to tangle over Zen's value or dangers and what sort of Zen was authentic.

WHY THE ZEN BOOM?

In his 1958 article "Zen in the Modern World," D. T. Suzuki observed that "Modern men are indeed groping in the dark which envelops the birth-pangs that usher in a new age in all fields of human activity."[57] For some it was Suzuki himself who brought the light. In an age "much preoccupied by our sufferings," Stephen Mahoney wrote that year in *The Nation*, "Suzuki's gospel has prospered. . . . Clearly, Zen offers a kind of hope."[58] As the Japanese Sōtō Zen scholar Masunaga Reihō (1902–1981) put it shortly thereafter: "Man, surrounded by machines, mass-communication, and organized systems, has become alienated from freedom and spontaneity. Zen seems unusually well-suited to break the deadlock facing modern man."[59]

Such comments were not entirely new—Zen drew attention during the interwar period from those in the West "buffeted as never before by foreboding waves of materialism and selfish aggrandizement."[60] But in the postwar period Zen was increasingly part of a new conversation about the "spiritual problem of Western man" and "the future of the world and the salvation of man, or whether man can be saved fast enough to ensure a future."[61] Indeed, to many it seemed that the promises of democracy and technology remained disastrously unfulfilled. Fordism, Taylorism, and a "fantastic system of stimulation of greed" were corroding human life; God had abandoned the world; and the future of the human species had been ransomed to the atomic bomb.[62] For some, Zen offered release

from psychological anxiety and spiritual despair. It was a path to a utopian "no-place" that differed from that envisioned by liberal humanism.

In geopolitical terms, Zen had become all the more accessible owing to the American occupation of Japan and the "Anpo" Treaty of 1951.[63] "Since the end of the war," the philosopher William Barrett (1913–1992) wrote in 1954, "I have been impressed by the fact that a number of American soldiers returning from the occupation of Japan have become interested in Zen Buddhism. . . . There was something in the spectacle of these good Methodist boys from the Middle West becoming fascinated by one of the most remarkable and typical expressions of the East that gave me pause, and summoned up the ancient image of conquering Rome being conquered by the gods of the peoples it had conquered."[64] Hyperbolic as this reverse-conquest image may be, it seeks to capture the transcultural nature of Zen and its reach into America's "heartland."

The sources of Zen's fascination were multiple. Alan Watts, in his well-known essay "Beat Zen, Square Zen, and Zen" appearing in the 1958 "Zen issue" of the *Chicago Review,* proposed:

> There is no single reason for the extraordinary growth of Western interest in Zen during the last twenty years. The appeal of Zen arts to the "modern" spirit in the West, the work of Suzuki, the war with Japan, the itchy fascination of "Zen-stories," and the attraction of a non-conceptual, experiential philosophy in the climate of scientific relativism—all these are involved. One might mention, too, the affinities between Zen and such purely Western trends as the philosophy of Wittgenstein, Existentialism, General Semantics, the metalinguistics of B. L. Whorf, and certain movements in the philosophy of science and in psychotherapy. Always in the background there is our vague disquiet with the artificiality or "anti-naturalness" of both Christianity, with its politically ordered cosmology, and technology, with its imperialistic mechanization of a natural world from which man himself feels strangely alien.[65]

Watts—dubbed by one contemporary observer "the brain and the Buddha of American Zen" and by another the "Norman Vincent Peale of Zen"—packs it in here, and in hindsight, such multifariousness, especially as it encountered American liberal religiosity and cosmopolitan spirituality, helped to ensure Zen's saturation and its diversity, or instability, in different sorts of practice, belief, and consumption.[66] Ultimately, Watts, through Zen, envisioned "the reintegration of man and nature" in the face of the destruction and alienation of modern life.[67]

Taking stock of the Zen scene in 1960, Van Meter Ames noted that
Zen presented a deity-free religion equipped with an "iconoclastic blasting
of superstition," and that much of the "secret fascination of Zen" resided in
its "combination of the intellectual and the intuitive, or, rather, in its intel-
lectual justification of the intuitive."[68] Many indeed leapt upon Zen intui-
tive, in-the-moment, spontaneous expression as catalytic to countercultural
rejection of institutions, social and political norms, and consumerism.[69] It
was not insignificant to Ames that Zen also offered one the mysterious East:
"the setting, the trappings, all the aura and oracles they could want." For
the young, he added, "there is something in Zen which is fresh and present
and has a future, in spite of being old on the other side of the world."[70] The
American philosopher Filmer S. C. Northrop (1893–1992) declared simply,
"What the world needs is Jefferson and Zen."[71]

Some were pleased to find that they could explore Zen meditation
within the framework of Christian faith without committing "the sin of syn-
cretism," and that Zen reconciled "humanism and mysticism, a transfigu-
ration of the world which is not an escape from it."[72] Others argued that
something was needed beyond science and technology, and as R. John
Williams expresses it, Zen emerged as a potent "therapeutic means" to
merge counterculture interest in Eastern mysticism with cybernetic compu-
tationalism and to achieve a non-duality of consciousness and technology,
mysticism and the machine.[73] In this regard, the avant-garde artist Nam
June Paik's "machine-based artistic languages," Sook-Kyung Lee observes,
appear to be "linked to a Zen-inspired belief that the innate qualities of
nature and technology would eventually and inevitably lead to their distinc-
tions being diminished."[74]

This was not the first instance in which Buddhism was viewed in spir-
itual and therapeutic terms in the modern West, and it would not be the
last.[75] But in the 1950s many felt that the modern world needed something
new and hopeful. Could Zen be it? Was meditation the way to get it? But
zazen became many things in the Zen boom, not simply a form of Buddhist
meditation. It could be a method for "psychic relaxation," its effect "sim-
ilar to that of psychotherapy: anxieties and other mental oppressions are
drawn out of the subconscious mind . . . and are dispelled."[76] But postwar
Zen could also do without *zazen* and focus instead on philosophical princi-
ples expressed in nonreligious rituals, creative work, and even in the main-
tenance of machines which, like the mechanic, might be perceived to hold
within them Buddha nature.[77] Or it might be an institutional, temple-based
Zen, notably in Asia and diaspora communities, focused on funerals and
ancestral rites and lay Buddhist devotion without meditation, even while
zazen leading to awakening remained "a basic truth upon which the sect

was based."[78] Zen was also employed by participants in the postwar literary and art scene, David Doris suggests, "as a tool to explore the frontiers of the unconscious, the unmitigated, spontaneous source of selfhood" and, as Alexandra Munroe puts it, as a "productive strategy for creating a radically new aesthetic program."[79] Art could be remade through Zen, and the artist's consciousness, reworked by Zen—Zen concepts if not meditation—yielded new marks, shapes, movements, spaces, and critiques of art. Zen offered something to many and many ways to get it.

The appeal of Zen was not merely the possibility of "transzendental" discovery or lifestyle enhancement. Zen was compelling and meaningful not strictly because it was exotic and opened up new possibilities for art.[80] Rather the Zen boom arose in close relationship to changes in global economic and political power configurations; to the physical movement of people in new and expanding networks; to developments in postwar intellectual thought and questions of subjectivity; to radical resistance to corporate liberalism; to new religious movements in the West and Asia; and to terrifying technological developments. In this regard, it is hardly surprising that Cold War nuclear references and metaphors appear in varied statements about the benefits of Buddhism and Zen. The Engakuji Zen abbot Asahina Sōgen, lecturing in New York City in 1954, observed that Zen training had much to offer Americans, and that "what was needed at this moment of history was an 'atomic leap of mind' to increase our spiritual progress to match our material progress."[81] As another writer observed in 1960, "If you were hep you simply couldn't hear enough about beatniks, Zen-Buddhists, junkies—all the revolts and movements born of the Bomb."[82]

Through its focus on intuition, "pure experience," and "absolute presentness," Zen authorized, as the historian Harry Harootunian puts it, "the primacy of the self searching for a pure, unmediated experience rooted in the everyday of a present no longer encumbered by the threatening world of Cold War politics, ideology, and power struggle." It offered a new modality of freedom that, he adds, "prioritized the realm of spirit, culture, thought, and consciousness over politics and economic life" and could hide the "unfolding threat of nuclear annihilation."[83] For those who refused to hide from this threat, Zen provided writers and activists such as Gary Snyder a "stabilizing spiritual practice that grounded their anti-authoritarian critiques both of American ways of knowing and U.S. hegemony"—a means to overthrow, in Snyder's words, "world-engineering-technocratic-utopian-centralization men in business suits who play world games in systems theory."[84] A number of postwar writers such as Henry Miller were drawn to Zen, Manuel Yang suggests, because it fostered a "radical conviviality," a "counter-institutional idea against the grain of modern industrial capitalism."[85] One

might suggest, too, following from Emilio Gentile, that Zen offered a path to renewed sacrality in the wake of the fascist and totalitarian sacralization of politics and political religion.[86]

In other words, the Zen boom, especially as it occurred in the United States, was the product of a tense concatenation: global ideological conflict, apocalyptic violence, and "corporatocracy"; strategically introduced Zen teachings and practices; fascination with Asian religions and cultures; as well as progressive experiments and transformations of postwar spirituality with their wellsprings in the late nineteenth century and interwar years. Arguably, it was through the agency of an expanding cast of individualist types—the immigrant monk, the globe-trotting Zen campaigner, the beatnik on the road, the counterculture guru and activist, and the radical artist—that the Zen boom boomed as it did. Through them freedom might be possible, the sacred could be reengaged, and new spiritual communities as well as cultural forms could emerge.[87] That Zen was not perceived mid-century to be merely a cult is suggestive of how much was at stake, the groundwork laid by Zen campaigners since the early twentieth century, and the adaptive energies applied to and with Zen by different communities.

ZEN-BOOM PARODY, BEAT CRITIQUE, AND THE DARKER SIDES OF ZEN

It would have been nice had Zen blossomed effortlessly with nothing more than jaunty intercultural exchange and ego-transcending solidarity that allowed everyone to actualize Buddha nature, or at least achieve well-being in the postwar world. But the Zen boom was not a fairy tale. Once it walked "out of the seclusion of the cloisters," as Suzuki put it, Zen had its share of bumps and run-ins. Squabbles broke out between Zenthusiasts and Zenophobes, between pundits and teachers, practitioners and historians, and across and within particular Zen-positive constituencies. Competing authorities vied to make the case for or against Zen; everyone, it seems, had a critic. Zen also drew its share of bemused observation and suave parody; it got more than a few laughs. If postwar, transnational Zen was transformative and salvific, it was also boisterous and even unruly in unanticipated and, for some, undesirable ways.

Why such ruction and lampoon? For one thing, there were seigneurial concerns over legitimacy and authenticity, colored by sectarianism, appropriation, and xenophobia. Was Zen of value to humanity or, as some argued, a threat to Western religion and liberalism? If Zen was of value, what was true Zen and true Zen culture? Who decided? Complicating, or enriching, matters

was the fact that transnational, postwar Zen exhibited a particular tendency to slip out of the control of Zen authorities. For while Zen had proliferated beyond monastic forms into modern lay movements that sustained meditation and other traditional practices, which Zen advocates such as Suzuki supported, it was also showing up in new formulations. There was Zen psychology, which could dispense with meditation and disaggregate koan from Zen training for use as a "psychological shock discipline," as Gerald Heard put it in 1950. He deemed Zen "an empiric method for mind control and the total command of attention," one that deftly avoided "religion's greatest weakness—its tendency to unsubstantiated metaphysics."[88] In the postwar years, Zen was also becoming an Asia-infused Sheilaism *avant la lettre,* with individualist spiritual re-enchantments and cultural and attitudinal expressions, and eventually became a mode of individualist conformity.[89]

Before long, Zen went "meta"; by 1960, Van Meter Ames noted, there was "increasing interest in the interest in Zen."[90] In 1967, R. J. Zwi Werblowsky grumbled that "it has become almost *de rigueur* for a writer on Zen to begin with a lament over the prevalent Zen 'fashion' and to bemoan the popularity of Zen among faddists, beatniks, *littérateurs* and drawing-room converts."[91] In a matter of years, then, Zen as an exotic religion, a clarion call for transformation in the face of modernity's ravages, and a crucible of creative revolution was joined by the banality of Zen. This unevenness was as much a part of the Zen scene as the translation and circulation of specific Zen teachings, the development of global Chan/Sŏn/Zen/Thiền lineages, and the emergence of Zen reform movements directed towards the general public.

If Zen was an "inspired kind of nonsense," as the British philosopher Maurice Cranston (1920–1993) concluded in 1959, it also became a handy trope for short-take commentary on the modern quotidian.[92] Writing about his addiction to the morning newspaper and frustrated with poor delivery, the columnist Patrick Campbell (1913–1980) reported his exchange with the unreliable paperboy as if it were a quixotic encounter with an inscrutable Zen master:

> His face is framed by the hood of his little duffle coat. It gives him a strange, ecclesiastical appearance, as though he were some sort of dwarf novitiate monk from an unimaginable order in the Himalayas.
>
> "What's gone wrong? What happened?"
>
> He must be a Zen Buddhist. My questions mean nothing to him. No flicker of expression crosses his face.
>
> "Why are you late? What's gone wrong?"
>
> "Nothing," he says, microscopically surprised, and walks away. "Where's your bicycle?" I shout after him. No reply.[93]

If the familiar exotic of Zen could be put to such use, it could also be deployed in the gender wars of the 1950s. "Evening classes in Zen," one British journalist suggested, could possibly cure the "ravening discontent" (a seasonal variation of the misogynistic notion of "female hysteria") that women supposedly succumb to each spring.[94] Neither of these brief uses of Zen is especially consequential on its own, but this sort of Zen name-dropping was clearly habit-forming.

Not surprisingly, Zen's sirenic attraction, idiosyncratic adoption, and race- and class-based appeal also prompted extended satire, found most notably perhaps in Calvin Tomkins' "Zen and the Art of Tennis" and J. D. Salinger's novella "Seymour: An Introduction," both published in *The New Yorker*. Salinger got his punches in with distinctive vigor:

> I'd much prefer, though, to leave Zen archery and Zen itself out of this pint-size dissertation—partly, no doubt, because Zen is rapidly becoming a rather smutty, cultish word to the discriminating ear, and with great, if superficial, justification. (I say superficial because pure Zen will surely survive its Western champions, who, in the main, appear to confound its near-doctrine of Detachment with an invitation to spiritual indifference, even callousness—and who evidently don't hesitate to knock a Buddha down without first growing a golden fist. Pure Zen, need I add—and I think I do need, at the rate I'm going—will be here even after snobs like me have departed.) . . . I'm profoundly attracted to classical Zen literature, I have the gall to lecture on it and the literature of Mahayana Buddhism one night a week at college, but my life itself couldn't very conceivably be less Zenful than it is, and what little I've been able to apprehend—I pick that verb with care—of the Zen experience has been a by-result of following my own rather natural path of extreme Zenlessness.[95]

Salinger's send-up, a reviewer suggested, blows "the whole of fashionable American Zen out of earshot with a short gong-stroke paragraph of pure comedy."[96] To do so, it plays with a variety of Zenny attitudes and behaviors, juxtaposing them with "pure Zen," which will outlast the Zen poseurs. Here in the comfortable space of *The New Yorker,* then, we find not only Salinger's fictionalized social commentary but also his alertness to the differentials of postwar Zen: that there is a more authentic Zen, presumably of Japan, which will endure, and a less authentic, Western Zen, which will likely disappear (it didn't).

All good fun, perhaps— a lighthearted riposte to the emerging Zenny zeitgeist. But criticisms of Zen in the West could cut far more deeply,

especially when it was linked with a new, and for some alarming, social group: the Beats and their dilettante admirers, who thumbed their noses at social, sexual, economic, and political norms. For these apparent louts, however, Zen was good for the fight against The Man, if not also good for relieving suffering and for fostering empathy beyond the consuming self. By 1959, however, "Beat Zen" had been criticized by the American Zen advocate Alan Watts—he was skeptical about Jack Kerouac and his crowd—and had become a "Zen interest story" in Europe. *The Sunday Times'* Washington correspondent Henry Brandon (1916–1993), for instance, reported to British readers that, for the Beat writers, poets, painters, and musicians of America, "Zen Buddhism is required reading, [the movement's] bible," and that they were for the most part "intellectual spivs rather than artists." "They are harbingers of a new spiritual sense of purpose," he allowed, but a purpose "that still needs definition and translation, or perhaps they are simply unemployables from a mass educational system."[97] In response to Brandon's article and others in the British press, D. T. Suzuki asked whether this "strange group of people relating themselves to Zen" might not in fact augur "change in the psychological climate in Western culture?" If so, Suzuki concluded, "There is no doubt that Zen is in some way responsible for it." For Zen, Suzuki explained, could release the modern rationalist and ego-bound self from "our restless pursuit after logic, intellection, or ratiocination of any form," to become the true Self (Buddha nature) that lives in direct experience and metaphysical unity rather than idea-bound Cartesian dualism.[98]

Paying close attention to the reception of Zen in Europe, North America, and Japan, Suzuki expressed concern over the mistaken reception of his writings and lectures and popular misinterpretations of Zen, especially the use of psychedelic drugs to attain a consciousness-altered state that some took to be commensurate with satori.[99] Like other participants in postwar "Beat critique," he cautioned against childishness and "temporary antics," adding that "spontaneity is not everything, it must be 'rooted.'" The Beats, he observed, were "still wandering over the surface of reality and have not yet come to the Self which is verily the spring of creativity." Zen, in contrast, "seeks first of all to reach the roots of our being," and that depends upon formal training with a teacher, meditation, and discipline.[100] Even so, Suzuki probably contributed to rootless Zen in America through his aphoristic and auratic statements about Zen's intuitive freedom. "Zen wants to live from within," he wrote in 1934, "Not to be bound by rules, but by creating one's own rules—this is the kind of life which Zen is trying to have us live."[101] Perhaps Suzuki's descriptions of the liberating insights resulting from disciplined, direct Zen practice were rather too enticing, leading some to mold themselves in relation to such descriptions cognitively or

emotionally rather than achieving them through meditation.[102] Meanwhile, while North America and Europe were spawning the Beats and other Zen rowdies, Suzuki was equally concerned with Japanese society given the disappearance of feudal warrior discipline and the corruption of its youth: "In recent days the character of our Japanese youth has become noticeably depraved. . . . In truth, there is no doubt that preventing the current decay of the youth and cultivating healthy character are of the greatest urgency." For Suzuki, the "path to rescue" began with "the zazen practice (*zazen kufū*) of the Zen denomination."[103]

Criticism of the Zen boom's "bad boys" soon became routine on both sides of the Atlantic. The American writer and social critic Edmund Wilson (1895–1972), troubled by the state of American society and the country's role in the world, had little patience for them: "In the case of the 'beat' generation, it is not surprising that they should be completely anti-social— they have gone in for Zen Buddhism and things like that, which divorce them from social reality."[104] The Korean American journalist Peter Hyun was more severe, branding the followers of Beat Zen (with reference to Jack Kerouac), "disheveled writers and jazz musicians, students, and café bums . . . social misfits or psychological delinquents—the noisy sleepwalkers on the Open Road." "Square Zen Buddhist"—traditionalists infatuated with Japanese Zen monastic practice—also drew his scorn: they are "half-baked, muddled apologists of the East in general and Zen Buddhism in particular, who derive a meek supply of spiritual pabulum from D. T. Suzuki and Co. of Japan. . . . They are, to my mind, even more ridiculous than 'Beat Zen' followers in as much as a pompous man is always more ridiculous than a rogue." He insisted that neither Beat nor Square Zen would solve the problems of the "sons and daughters of Oxford, Cambridge, Vassar, Bennington, Columbia, and Chicago," whom he described as "repressed victims of the struggle between East and West, between Christian idealism and Marxist materialism."[105] In *The Sunday Times,* Cyril Connolly lampooned: "'Art is love is jazz is work (sex) is pot (marijuana) = Zen,' hazarded Mort one evening and was rewarded with a burst of crazy silence."[106]

The Trappist monk Thomas Merton (1915–1968), well known for his interfaith studies of Buddhism, contributed his own warnings:

> Zen is at present most fashionable in America among those who are least concerned with moral discipline. Zen has, indeed, become for us a symbol of moral revolt. It is true, the Zen-man's contempt for conventional and formalistic social custom is a healthy phenomenon, but it is healthy based on freedom from passion, egotism, and self-delusion. A pseudo-Zen attitude which seeks to justify moral collapse with a few

rationalizations based on the Zen masters is only another form of bour-
geois self-deception. It is not a sign of healthy revolt, but only another
aspect of the same lifeless and inert conventionalism against which it
appears to be protesting.[107]

For all its potential, therefore, Zen had spawned something poten-
tially unhealthy and threatening. The correct course, Suzuki and others
emphasized, was to follow monastic tradition. Connolly was therefore grate-
ful to the writer Richard Rumbold (1913–1961) for his firsthand account of
Zen training in 1956 as a "lay brother" (J. *koji*) under the direction of Ogata
Sōhaku at the Kyoto Zen monastery Shōkokuji.[108] Others sought to clarify
where the Beats went wrong and find a silver lining. Reviewing Kerouac's
writings in the literary magazine *Prairie Schooner* in 1960, Margaret E.
Ashida observed that "The Beats err not in adapting the past contributions
of the East (and West) to new demands, but in leading others to believe
that their adaptation is identical with the source and not a metamorphosis
of it."[109] For Theodore Roszak (1933–2011), Zen antinomianism, despite its
potential for "adolescentization," might nevertheless empower those who
felt "justified discomfort with the competitive exactions and conformities of
the technocracy."[110]

As it turned out, however, the Beats were not the only problem.
A broader affliction had developed, one profiled in Calvin Tomkins' afore-
mentioned satire of Zen suburbia and diagnosed more seriously by the Ger-
man theologian Ernst Benz (1907–1978) as "Zen snobbism." Zen snobs, as
Benz defined them in *Zen in Westlicher Sicht: Zen-Buddhismus-Zen-Sno-
bismus* (Zen in Western Perspective: Zen Buddhism, Zen Snobbism, 1962),
affected Zen experience without Zen religious awakening and turned it into
shallow, privileged consumption:

> Besides the self-conceited consciousness of being initiated into esoteric
> sources of wisdom and salvation which are as eastern in origin as they
> can be, what marks off the Zen snobs is that they are inclined to reach
> for the fruits of this recognition—satori, or enlightenment—as quickly
> and effortlessly as possible, and then by an enormous material expense
> at once to compensate the want of preparation for the actual disciplinary
> efforts and to purchase the social prestige as well as the self-conscious-
> ness of exclusively possessing the highly cultivated object.

The blame for Zen snobbism, in Benz' view, lay firstly with modern Japa-
nese Zen advocates, especially Suzuki, whose makeover of Zen distanced it
from its Asian monastic and lay religious traditions, promoting it on the one

hand as the universal essence of all religion and philosophy and on the other as a psychology, philosophy, and rational system separate from religious mysticism.[111] Japanese Zen modernists, according to Benz, were peddling a secularized, false Zen.

There were plenty of Zen snobs, no doubt, but a number of scholars and social critics issued warnings about still darker sides of Zen. In the wrong hands, they argued, Zen threatened Western liberalism. In 1950, Gerald Heard cautioned: "In Zen the anxiety to avoid metaphysics and to be purely empiric can end in the forging of an instrument which may be used by a fiend. The individual may be freed from his personal greed and fear only to become the selfless tool of some insane national, class or sectarian fanaticism." Heard is writing just a few years after the Holocaust and Japan's surrender, and thus he hopes that "Zen will learn from this past dangerous development" and in turn "establish not merely that it is the essence but the discipline of all religions that can change not only conduct and character but consciousness."[112] In 1958, reviewing Christmas Humphreys's generally well-received *Zen Buddhism,* Maurice Cranston confessed: "I myself have mixed feelings about Zen. I mistrust its attitude to reason; I am uneasy about its indifference to ethics; I believe its influence in Japan has been inimical to liberalism."

The often controversial cultural anthropologist Ernest Becker, meanwhile, was out for blood. In *Zen: A Rational Critique* (1961), based on his doctoral dissertation, Becker aimed to show that "Zen really *is* a denial of life, a negation of the Western ethic of individuation and autonomy which was so laboriously fashioned by Mediterranean civilization and is still too precariously grasped."[113] Zen advocates such as Suzuki, he argued, claim "that Zen is not only in harmony with Western tradition, but is in fact in essence more Western than the Western Greek and Christian-Judaic traditions themselves. This would be amusing if it were accepted only among a handful of gullible poets harmlessly dispersed in espresso shops. But the idea has infected some unimpeachable Western professionals, and among them psychotherapists who possess a good deal of power over individuals."[114] Once it left the cafés and entered the psychiatrist's office, therefore, Zen was potentially even more harmful.

HU SHIH, D. T. SUZUKI, AND ARTHUR KOESTLER

So Zen was not an easy sell in all quarters. It made some people hot under the collar and even occasioned ad hominem attacks. Suzuki himself engaged in two fierce debates in the 1950s and 1960s, first with the historian Hu

Shih (1891–1962) and then with Arthur Koestler. The Hu–Suzuki exchange, published in 1953 in the journal *Philosophy East and West,* pitted the historical study of Chan (Hu) against the inaccessibility of Zen to historical examination due to its metaphysical transhistoricity (Suzuki).[115] Hu, using Chan for the Chinese context, rejected Suzuki's assertion that "Zen is above space-time relations, and naturally even above historical facts."[116] Suzuki, using the Japanese term Zen even when discussing the Chinese context, scolded: "It is not the historian's business to peer into" the intuitive grasp of the metaphysical.[117]

Rejecting the sufficiency of "library study" of objective historical facts about Zen, Suzuki insisted that "Zen must first be comprehended as it is in itself and then it is that one can proceed to the study of its historical objectifications as Hu Shih does. . . . Zen is to be grasped from within, if one is really to understand *what* Zen is *in itself.*" Zen, Suzuki explained, is "*prajñā*-intuition," which precedes and is distinct from all historical facts. Suzuki would reiterate this view in his disparaging review of the Jesuit scholar of Asian religions Heinrich Dumoulin's (1905–1995) *A History of Zen Buddhism* (1963), which failed, in Suzuki's view, to write its history by first understanding "what Zen is in itself." "History may reveal the form and lead to the essence of things," Suzuki wrote, "yet if the essence of things is not clearly grasped at first, its history may be more deformed than need be." "In order to write a good history of Zen," therefore, "the author must be fairly well prepared to penetrate the essence of Zen"—namely, by "looking into one's own Nature, or Self-nature, which is no other than Subjectivity itself. It is not a relative subjectivity in which the object stands as its antithesis, but the absolute subjectivity."[118] Unprepared in this regard, Dumoulin's effort to write a history of Zen was ill-advised. This was also the position taken by Hisamatsu Shin'ichi with reference to the historical study of Zen art. Lacking a basis in "vivid Zen realization" itself, the answers of art historians "are no more than external explanations given in terms of attending circumstances."[119]

For his part, Suzuki wished to offer a "'logical' presentation of Zen philosophy" that developed from traditional meditation and koan training leading to realization: doing Zen, not just thinking and talking about it.[120] Although Suzuki was therefore disapproving of critics in the West who attempted to comprehend Zen without direct experience, he also warned that "there are Eastern writers who claim to be followers of Zen who miss the same points. The fact of their being 'of the East,' or coming from the East, does not necessarily make them experts on or in Zen."[121]

In his exchange with Hu, Suzuki seems to have been eager to place himself on the "right side" of Zen's history, as it were, a history based on

one timeless fact, or essence.[122] But it would be unwise to ignore Suzuki's uses of more conventional Buddhist and Chan/Zen history; his writings were not always aphoristic or incantatory, or concerned strictly with the metaphysical. Alongside his rejection of histories written by historians who lacked knowledge of "Zen itself," Suzuki implied that he, having grasped *prajñā*-intuition, could turn correctly to historical facts in order to explain properly why, for instance, Zen is iconoclastic, profane, and revolutionary. Such aspects of Zen, he explained, were born not from an inherent desire for iconoclasm but from the Chinese transformation of Indian Buddhism, the Chinese mind's preference for the practical and this-worldly, and the Chinese realization of *prajñā*-intuition that animates the individual in the "absolute present" and transcends "idle discussions as to whether a thing is conventionally tabooed or not."[123] Suzuki therefore availed himself of history to locate in medieval China the awakening of Zen as *prajñā*-intuition, which is ultimately outside history.[124]

Facts were also important to Suzuki—those pertaining to patriarchs, monastic sites, texts, and episodes, gleaned from hagiography as well as modern scholarship—insomuch as they can be used to build the chronology from the "golden age" of medieval Chan to Zen in late medieval Japan, to early modern Japanese luminaries such as Hakuin, arriving finally, through unbroken "mind to mind" transmission of mystical experience, at the living Zen tradition of modern Japan. Meanwhile, as was often the case during the postwar period, the issue under debate—in this case the question of Zen and history—became a matter for lighthearted comment. Profiling Suzuki in 1957, Winthrop Sargeant observed that "In the course of his lifelong propagation of the doctrine, Dr. Suzuki has lived through a great deal of time and history, about which—although time and history are banished from the heart of Zen—he can recall a surprising amount."[125]

It is unsurprising that Suzuki and Hisamatsu's emphasis on individual intuitive experience of absolute subjectivity (Buddha nature) would seize the imagination. Relatively few sought out traditional monastic training, and though Suzuki and other Zen authorities largely rejected the idea that true satori could be achieved without a qualified teacher, they understood that not everyone could study under a credentialed master—in the West they were few and far between—or could travel to study at a temple in Japan.[126] For those who could, as Stephen Mahoney observed during the Zen boom, traditional Zen turned out to be exceedingly difficult: "American Zenists whose enthusiasm carries them to Japan seem to find it as painful as the rack."[127] It is equally true that only a minority of those drawn to Zen in the 1950s sought it out in the historian's musty archive or practiced the philologist's painstaking textual study and the art historian's analysis

of attribution, style, and context. Instead, the time was ripe in Europe and North America for a Zen of philosophical keywords and romantic narratives, a Zen of personal transformation in and through the everyday now, and a Zen that would upset cultural norms and redefine "art" and society. Arguably, both "Zen itself," experienced through formal monastic or modern lay practice with a teacher, *and* academic Zen history, experienced through modern scholarly practice, were Zen-boom outliers.

In what may have been a collegial gesture, however, Suzuki labeled both himself and Hu "great sinners, murderers of Buddhas and patriarchs" because they "indulge[d] in word- or idea-mongering."[128] This was a measured sin for Suzuki, as words and ideas served the cause of bringing more people towards the experience of Zen itself. Suzuki extended no such gesture to his harshest critic, Arthur Koestler, whose opinion pieces and book *The Lotus and the Robot* (1960) bluntly condemned Zen and Suzuki's explanations for "double-think," abandoning reason and morality, and "pseudo-mystical verbiage." Zen, in Koestler's view, not only had limited use in resolving the world's grim problems and averting atrocities, it was complicit in some of them.[129] As if this were not a sufficient *coup de plume*, Koestler suggested that Suzuki's "voluminous *oeuvre*" might be a "hoax of truly heroic dimensions." Zen à la Suzuki, in Koestler's view, had a particular "stink."[130] Given Koestler's stature, Suzuki and other Zen advocates could hardly remain silent. With not a little savoir faire, Suzuki endeavored to explain how Koestler had failed to truly comprehend Zen; he "seems not to be cognizant of 'the stink' radiating from his own 'Zen.'" In return, Koestler opted for insult: "It is time for the Professor [Suzuki] to shut up and for Western intelligentsia to recognize contemporary Zen as one of the 'sick' jokes, slightly gangrened, which are always fashionable in ages of anxiety."[131]

Koestler was not alone, of course, for other Europeans and Americans also challenged or rejected Suzuki's Zen. There was Ernest Becker, noted earlier, and R. J. Zwi Werblowsky, who took issue with Suzuki's valorization of monastic Zen. In fact, Werblowsky argued, there were relatively few monks in Japan during the postwar period and their training was rather limited. Thus, the problem with the image of rigorous monastic Zen promoted by Suzuki was that it concealed the "total context" of Zen in Japan.[132]

Zen in the West, therefore, was not Zen in Japan, and even the latter was not all it was made out to be. But these points were situated within a larger anxiety—expressed in the journal *Encounter,* where the Koestler-Suzuki tussle appeared—namely, the question of "what liberal humanism involves, and how it can be represented and discussed."[133] European and

North American criticism of Zen, Mike Grimshaw argues, was not merely a matter of griping about Zenny affectations or Suzuki's representations. "In a climate concerned with the promotion of a specific type of culture and cultural values against communism," Grimshaw argues, "Zen as the spiritual force of a nascent counterculture was viewed as a distinct threat, especially given its attraction among those who could be viewed as possible future elites." Regardless of whether Zen was a nihilistic spirituality or type of atheism, it "ran counter to what was deemed the liberal humanist project in a Cold War environment." Zen observers such as William Barrett, Grimshaw adds, "would also have been aware of the recent links of Zen and Japanese fascism and the manner in which authoritarian and anti-Semite fascists and conservatives were and often are attracted to Zen as part of a 'triumph of the will.'"[134] Grimshaw suggests, then, that "Koestler's warning is clear: the turn to Zen and Yoga is as potentially damaging to Western civilization as the alternative turn to Marxism, for they will merely increase the dangers of an already nihilistic society."[135] In the liberal West the argument against Zen scaled up dramatically beyond the Beats to Cold War confrontation.

ÉMIGRÉ AND AMERICAN ZEN LEADERS ON TRUE ZEN

Suzuki may have captured the limelight and brunt of attack, but Zen monastic leaders and their disciples also spoke to the conditions of postwar Zen. In solidarity with lay authorities such as Suzuki, they too cautioned against bookish, philosophical, psychological, and artsy sorts of Zen detached from formal training and meditation. The Zen-intoxicated Beats and drug-culture denizens were easy targets; they got Zen incorrect—naïvely or willfully so. But these modern monastics were themselves not of one mind when it came to the question of true Zen. Engaging in sectarian debate, they were not unlike their Dharma ancestors, albeit on a global stage with modern props and audiences.

With regard to typical Zen-boom shenanigans, the Rinzai Zen monk Nyogen Senzaki put it this way: "[American Zen] is running sideways writing books, lecturing, referring to theology, psychology, and what not. Someone should stand up and smash the whole thing to pieces."[136] While not assuming that American Zen would necessarily be the same as Japanese Zen, the Rinzai abbess Ruth Fuller Sasaki nevertheless voiced concern that "the teachings of the Zen sect have been laid open to a variety of interpretations, many of them personal and equally many far-fetched, and these interpretations have come in some quarters to be accepted as

standard for Zen."[137] Sasaki sought to distinguish the Zen she knew from those that had strayed from meditation and fundamental Buddhist teachings.[138] To foreign students training under her direction at Ryōsen'an in Kyoto, she cautioned:

> For, though coming here to study Zen is a dream well worth cherishing, like all dreams it can suffer a rude awakening when it is not based upon thorough acquaintance with reality. . . . Merely to want to have a strange and exotic experience is not a valid reason for attempting Zen study. . . . There are those who seem to believe that Zen has a "technique" that can be useful in fields outside that of religion—writing, art, psychiatry, for instance. . . . To some extent their belief is justified. However, I am personally inclined to think that the several arts in Japan usually associated with Zen—tea ceremony, archery, fencing, sumi painting, calligraphy, haiku—basically are neither expressions of Zen nor derived from it, as seems to be the popular opinion, but rather that the practitioners of these arts found in Zen discipline an aid to the more expert handling of their own individual art. . . . Others did not hesitate to take various Zen doctrines from their Buddhistic context and reinterpret them so as to make them conform to and justify purely Japanese cultural patterns. For this reason I cannot agree with the often expressed opinion that the occidental can best approach Zen through the study of one of the traditional arts of Japan.[139]

Here Sasaki pushed back, if somewhat obliquely, against Suzuki and Hisamatsu's transcendentalist fusion of Zen and the arts, and the resulting popularity of Zen and the Ways.[140] Objecting to the concept-based technique-ification and art-ification of Zen, she warned that some boundaries should not be blurred. Zen is first and foremost Buddhism, not art.

From her vantage point at the First Zen Institute of America in New York, meanwhile, Mary Farkas noted that Zen in America was moving in "two divergent directions": towards a Zen of religious practice involving *zazen* and *sanzen* overseen by Zen monastics—she termed this "Practicing Zen"—and a Zen that was "primarily of an intellectual nature"—"Reasonable Zen," she called it—which arose largely from Suzuki's writings and lectures. Farkas' preference for the practicing sort of Zen was not surprising, and she was horrified upon hearing of a "doctor who after attending a few lectures and reading a book he himself stated he had not understood told us he was utilizing Zen as a 'method' to treat psychiatric patients." Still, she assumed that the Zen craze would "go to its extreme and subside," and that there would be few who became serious about "Practicing Zen."[141]

A more developed critique came in Philip Kapleau's *The Three Pillars of Zen: Teaching, Practice, and Enlightenment* (1966).[142] "The attempt in the West to isolate Zen in a vacuum of the intellect, cut off from the very disciplines which are its *raison d'être*," Kapleau wrote, "has nourished a pseudo-Zen which is little more than a mind-tickling diversion of highbrows and plaything of beatniks." In a jab directed at Suzuki and Hu, Kapleau—one of the new generation of American teachers with formal Zen training—also rebuked "idea-mongering," which weakened the practical and experiential fundamentals of Zen.[143] Kapleau thus wrote *The Three Pillars* as a corrective that set "forth the authentic doctrines and practices of Zen from the mouths of the masters themselves—for who knows these methods better than they?—as well as to show them come alive in the minds and bodies of men and women of today."[144] As for Kapleau's authority to explain authentic Zen, the book's foreword lauded him as a true Zen master—not Beat, bourgeois, or high-society—who had spent "twelve years of ardent practice, three of these years in both Soto and Rinzai monasteries." The book's translations from Japanese, meanwhile, were equally to be trusted: "Every one of the translators has trained in Zen for a considerable time under one or more recognized masters and opened his Mind's eye in some measure."[145] "In some measure" may be a notable qualification, but the assertion of orthodoxy in the face of faux Zen is clear.

More specifically, Kapleau intended *The Three Pillars* to be "a manual for self-instruction" for those unable to train with a Zen master.[146] The book therefore provides illustrations of meditation postures, a description of intensive meditation periods (J. *sesshin*), and a Q&A section that addresses common challenges during *zazen*. With correct knowledge of the meditation and rituals of formal Zen training, Kapleau argues, the reader can begin authentic Zen practice free of distortion. Kapleau therefore took what we might call, using the contemporary lingo, a "Square Zen" perspective. "Two years of studying Zen philosophy brought no relief" to Kapleau from the "pain-producing pattern" of his life; as he put it, "I had to go to Japan to learn how to discipline myself in Zen."[147] Based on his training, Kapleau sought to convey to Western audiences a manner of pure Zen, one found in the teachings of the Japanese Zen master Yasutani Haku'un (1885–1973). Therein one found "No account of the history and development of Zen, no interpretations of Zen from the viewpoint of philosophy or psychology, and no evaluations of the influence of Zen on archery, judo, haiku poetry, or any other of the Japanese arts." Echoing Sasaki's earlier concerns, Kapleau explained that "such extraneous facts and speculations have no legitimate place in Zen training and would only gratuitously

burden the aspirant's mind with ideas which would confuse him as to his aims and drain him of the incentive to practice."[148]

Not all was well in the house of Zen, therefore, but Kapleau directed his polemic not only against the libertinism of Zen-affecting beatniks and others "quick to exploit the vaunted freedom of Zen as sanction for cults of libertinism," but also their upstream sources, namely Zen authorities such as Suzuki and Watts. Suzuki's writings, in Kapleau's view, produced a warped Zen. Stimulating as Suzuki's "theoretical approach to Zen may be for the academically-minded and the intellectually curious," Kapleau insisted that "for the earnest seeker aspiring to enlightenment it is worse than futile, it is downright hazardous"; for this approach left one ill prepared for *zazen* itself and hindered the aspirant "by clogging his mind with splinters of koans and irrelevant fragments of philosophy, psychology, theology, and poetry which churn about in his brain, making it immeasurably difficult for him to quiet his mind and attain a state of samadhi." Make no mistake, Kapleau, argues, the "heart of Zen discipline is zazen. Remove the heart and a mere corpse remains."[149]

If Kapleau appears to offer a "back to basics Zen" emphasizing meditation and free of Zen-boom distortion, this purifying intervention was also distinctly modern in its sectarian character. Anchoring *The Three Pillars* are translations of lectures and commentaries by Yasutani Haku'un, Kapleau's teacher and the founder of the Zen reform movement Sanbōkyōdan. Sanbōkyōdan's particularity as a modern lineage, distinguished by its emphasis on lay practice and combination of Sōtō and Rinzai elements, resided, Robert H. Sharf argues, in its "single-minded emphasis on the experience of *kenshō* [seeing one's true nature]" that in turn distinguished it "markedly from more traditional models found in Sōtō, Rinzai, or Ōbaku training halls."[150] *The Three Pillars* is therefore noteworthy not merely for its practical instructions on what to do—seated meditation—but equally for its chapter titled "Eight Contemporary Enlightenment Experiences of Japanese and Westerners," about people "living among us today, neither as monks nor unworldly solitaries but as business and professional men and women, artists, and housewives."[151]

If Kapleau's instructions for authentic Zen and testimonies of Zen experience encouraged some of the Zen-curious to sit down on the meditation cushion and seek *kenshō* through that means, others in the West no doubt preferred the meditation-free Zen of "extraneous facts" and the personal epiphanies of Zen-influenced arts. But regardless of the precise scale and nature of its impact, *The Three Pillars* suggests a new sort of Zen religious treatise composed to lure its readers away from newfangled Zen "heresies," taking advantage of modern publishing and the booming

Zen book market. At the very least, Kapleau's text reveals the rough and tumble of postwar Zen discourse in which credentialed Zen teachers challenged not only derivative and misguided forms of Zen (Beat and highbrow) but also the forms presented by competing Zen authorities.

CIRCUITS OF CRITIQUE AND THE DILEMMAS OF WESTERN ZEN

Calling out one's foes was not unusual in medieval and early modern Chan/ Sŏn/Zen, but in the postwar context we find circuits of critique that pitted especially diverse authorities and authenticities against each other. Alan Watts' Zen, for instance, was cornered if not dismissed by the Rinzai Zen monk Ogata Sōhaku, whose own Zen was challenged in turn by Christmas Humphreys as well as the Sōtō Zen scholar Masunaga Reihō.[152]

Ogata, in a remarkably terse review of Watts' *The Way of Zen*, appearing in *The Middle Way* in 1957, commented:

> The author seems to have studied all the literature related to Zen Buddhism except Zen sermons in Japanese called *Kanahogo*. The information he has given in the book is comprehensive and his translations of the quotations are generally accurate. . . . The author's success in the book could said to be like an artist's creation of a big cat in an attempt to draw a tiger. Those who wish to see the distant view of a thousand miles away should climb up further stairways. Nevertheless, the book will be the finest of all Zen books written by Western writers who have not gone for the special study of Zen under the guidance of a Zen master.[153]

Watts' book is good as far as it goes, Ogata implies, but it does not reach the necessary height, which requires training with a Zen master. This is the sort of thing that Watts deemed "Square Zen" and shied away from. He was by no means an orthodox Zen practitioner and was at times antagonistic towards the training advocated by Ogata as well as by Suzuki.[154] Rather, Watts seems to have turned Zen into various modes of philosophical-cultural being mixed with psychotherapy, Daoism, counterculture spirituality, and the East Asian brush arts. Perhaps Ogata's review stung at the time, but Watts would later describe the monk as "our 'contact man' in Kyoto," whom he had first met when Ogata was studying at the University of Chicago Divinity School and Watts was at Northwestern.[155] In this sense, they were perhaps more co-participants than absolute opponents in modern Zen.

However brief Ogata's review was and faint his praise for Watts' Zen, it drew a line in the sand between Japanese and Western Zen. The editor of *The Middle Way* where Ogata's review appeared was ready to redraw this line from the Western side. At issue, the editor suggested was "the problem of the Western, as distinct from the Chinese and Japanese approach to Zen." Thus, the editor asked Christmas Humphreys to review Watts' book "from the Western point of view." Humphreys was the obvious go-to person for this response. Not only was he the president of the journal's publisher, the Buddhist Society, he had edited a number of Suzuki's writings and had himself written on the question of study under Japanese Zen masters, the use of koan, and the creation of Western Zen: "we can make of Zen," he had written, "a western school of awareness which will equally spring from the Blessed One's Enlightenment. . . . Zen, which, I claim, is neither of the East nor the West in spirit, and has no form."[156]

Writing in *The Middle Way* in 1958, Humphreys commented on several publications by Suzuki, Ogata, Watts, and others in terms of Zen's transmission to the West. In Humphreys' view, "Western Buddhism stands at the cross-roads."[157] The problem is "urgent, and yet unsolved," he believed, and asked, "If we cannot borrow teachers from Japan to help us until we produce our own, can we fight our way through the darkness until the most mystically minded among us not only find the Way but are able to teach it to others?"[158] Humphreys believed that Western Zen would indeed succeed because it would be, indeed, Western:

> We shall not import these goods [Zen Buddhism's history, theory, doctrine, practice, texts, and so forth] and leave them permanently foreign, as Chinese restaurants, French fashions and American films. Rather we shall receive them, study them, test them, digest them, absorb their spirit and then reclothe them in our own idiom of thought and practice. Only in this way will they become the product and expression of our own minds, and thus a useful set of "devices" to enable us to find and express "our" Zen, that is Zen as we shall find it. . . . For the East has no monopoly of *satori,* and though *satori* is one, it may be expressed by those who achieve it in different ways, according to temperament.

For Humphreys—redirecting the universal of Zen truth away from Japanese exceptionalism—the mystical experience of awakening is not the property of Japanese Zen. It can be homegrown; it can be "our Zen." "How then," Humphreys asks, "does Watts assist his fellow-Westerners to achieve the same 'experience'?"[159]

Although Humphreys does not share Watts' antipathy for Japanese Zen institutions—and, in any case, the West will make its own—he comes to Watts' defense.[160] Watts "does not claim to have studied in Japan, nor to have had any training under a *roshi* in the U.S.A., but he still has the brilliant mind which gave us *The Spirit of Zen* at the age of nineteen, and he has learnt enough Chinese to read originals for himself."[161] Even if Watts' book is "'an artist's creation of a big cat in an attempt to draw a tiger,' [it] is yet for many of us a large and helpful cat. . . . In brief an excellent book for the Western student. It does not give him Zen; nor does any other book, but it may set his feet on the Way which leads to it."[162] All books, including those of Suzuki and Ogata, are inadequate, therefore, because Zen truth, at least in this perspective, is revealed only in mystical experience. But books can start the journey, which in Humphreys' view can lead to an authentic Western Way. Alas, in 1968 Humphreys would write again of his hope, as yet unfulfilled it appears, that the West would "find its own way to the heart of Zen . . . that Zen experience is not the monopoly of the East."[163]

What goes around comes around, for while Ogata was to Watts and Humphreys a critical Japanese, monastic voice seeking to explain real Zen to the West, his own representations of Zen were themselves questioned by the Dōgen scholar Masunaga Reihō, based at the Sōtō Zen affiliated Komazawa University, Tokyo. Masunaga, actively writing for audiences in Europe and America, found Ogata's *Zen for the West* (1959) painfully lacking in historical content, theoretical discourse, and attention to Sōtō Zen.[164] "The style may be welcomed by the 'Beat' generation," he admitted, "but the abuse of Zen by such a group must be avoided."[165] This is a conventional critique, but Masunaga also targeted the Rinzai-dominant explanations of Zen promoted by writings of Ogata, Suzuki, and their followers. "The Zen now best known in the West," Masunaga would write elsewhere in 1960, "is koan Zen and kenshō Zen. This Zen [Rinzai Zen] has departed from the original Zen and gradually become rigid and dogmatic. Western thinkers who enter Zen in order to find freedom may become enslaved by one-sided Zen."[166]

From Ogata on Watts to Humphreys on Ogata, and then to Masunaga on Ogata and Suzuki, followed not long thereafter by Kapleau on Watts and Suzuki, these circuits of critique may have left some of the Zen-curious to wonder: Who was one to trust? Whose Zen was true? Others may have already made their choices and cheered on their respective authorities. As a transnational Japanese Zen sectarianism played out (Rinzai, Sōtō, and San-bōkyōdan), Western Zen scrambled to define its own identity and authenticity. There were, of course, other traditions and authorities in the mix, if not the spotlight: Chinese Chan expanded globally from the 1960s with the

efforts of Hsuan Hua and others, and from the 1960s and 1970s Korean Sŏn masters opened up a third space of Zen.[167] Thus, for all the seeming singularity, or security, implied by the word "Zen," what was or was not Zen was a matter of serious debate. Rather than being the result of a single, clear transmission from Asia to West, modern and postwar Zen came through as polyvocal and with noticeable static.

In postwar Zen we therefore find doubt, sectarianism, apologetics, and attack as well as determined monastic practice, reform movements, and serious reflection upon what Zen promised for humanity. There were "fundamentalists" arguing for their sort of Zen purity and "reformers" drawing from the deep pool of the Zen past to open new streams.[168] There were vitriolic outbursts and satirical narratives. Debate rippled and roiled the postwar world flow of Zen (and still does).[169] This is not to suggest endless partisanship or unchanging perspectives. In 1979, Gary Snyder suggested that some had moved on from Zen-boom romanticism and frenzy: "We all realize by now that Zen is not aesthetics, or haiku, or spontaneity, or minimalism, or accidentalism, or Japanese architecture, or green tea, or sitting on the floor, or samurai movies (*laughter*). It's a way of using your mind and practicing your life and doing it with other people."[170]

At our present distance from the mid–twentieth-century fray we might see postwar Zen as a transnational "contact zone" for the West and Asia and a space (religious, philosophical, spiritual, creative, individual, and communal) in which to work through the quandaries of global modernity, religion after religion, the international avant-garde, and differential modernisms overshadowed by domestic political struggles and Cold War ideology and nuclear confrontation. Then, over the ensuing decades of the twentieth century, Zen continued to deepen and change in practice, explanation, and materiality, through its integration into contemporary religious life, the arts and popular culture, and corporate capitalism. As the twentieth century wound down, Zen seems to have become something of a cozy or quaint commonplace—today one rarely catches a whiff of the rhetorical gunpowder that accompanied Zen-boom era skirmishes. But recent criticisms of doctrinal slippage and sexual abuse within particular communities suggest that Zen has not lost its ability to threaten and rile as much as beguile. Meanwhile, many Zen teachers and practitioners as well as historians are eager to revisit unresolved Zen-boom debates regarding race, gender, and power in Zen communities, nationalism and cultural exceptionalism, and adaptation and authenticity. The Zen boom's vibrations have not entirely died out, and perhaps this will help us figure out how Zen—monastic, lay, old school, new school, neo-Beat, hardcore Zen . . . perhaps all of it—can make a difference in the present and help ensure a better human future.

ZEN INFLUENCE, INHERENCE, AND DENIAL
RECONSIDERING POSTWAR ZEN AND ART

What I do, I do not wish blamed on Zen, though without my engagement with Zen (attendance at lectures by Alan Watts and D. T. Suzuki, reading of the literature) I doubt whether I would have done what I have done. I am told that Alan Watts has questioned the relation between my work and Zen. I mention this in order to free Zen of any responsibility for my actions. I shall continue making them, however.

—John Cage, *Silence* [1]

More than I should admit, I find this statement by the avant-garde composer, performer, and visual artist John Cage to be refreshing (fig. 13). I take it to be sincere, and perhaps a bit stubborn and sly. Retrospective as it may be to Cage's work in the 1950s, his declaration acknowledges Zen's importance without misprision. Cage takes responsibility for his work, his actions: they are indebted to Zen of a sort, and Cage will not desist from this work. But critics should blame him, not Zen. Zen is absolved of wrongdoing.

We might treat Cage's release of Zen from responsibility as a gesture of respect to the tradition and its sages (ancient and modern), but his statement also opens an interpretive gap between Zen and art. It implies that the relationship is susceptibly malleable rather than narrowly causal or inherent. Cage deftly dismisses one mode of discourse (authenticity as defined by Zen authorities) and asserts another (reception and autonomy). If there is a tremor of Zen-influence anxiety in this, Cage denies Zen's control. At the

very least, he invites us not to take Zen for the entire answer to the question of his creative work and that of other postwar artists often associated with Zen.

Given Cage's stature, his declaration is arguably no small thing. Viewed by some as the father of postwar avant-garde Zen-inspired art, Cage's "silent," aleatoric composition *4'33"*, per-

FIGURE 13.
John Cage and
D. T. Suzuki (1962).
Photo: Yasuhiro
Yoshioka. Courtesy
of the John Cage
Trust.

formed in 1952 by David Tudor (1926–1996), has been touted as the genre's originary work. In the composition's first performance at the Maverick Concert Hall in Woodstock, New York, as described by James Pritchett, "the pianist David Tudor, sat at the piano, opened the keyboard lid, and sat silently for thirty seconds. He then closed the lid. He reopened it, and then sat silently again for a full two minutes and twenty-three seconds. He then closed and reopened the lid one more time, sitting silently this time for one minute and forty seconds. He then closed the lid and walked off stage."[2] Ever since, Cage is said to have guided younger artists as a "Zen master."

Of course Cage was not alone in the postwar "pantheon" of Zen-associated artists. Among others, the painter Mark Tobey and the visual and performance artist Emmett Williams (1925–2007), a founding member of the postwar art network Fluxus, have been lionized in part because of their (usually brief) experiences in Japanese Zen temples and (in fewer instances) sustained Zen meditation practice.[3] Other European and American artists, including Cage, lacked this overseas pedigree and were allergic to institutional Zen and meditation but still became leading figures in the postwar Zen-art scene.

Despite the apparent white maleness of postwar Zen-related art, artists who engaged with Zen in the 1950s and 1960s did not fit a single racial-ethnic, gender, or political category. Nor did they make the same sort of work or express the same relationship to the same kind of Zen. Indeed, the postwar "Zen artist" could also be identified among painters, sculptors, and others of Asian nationality or heritage. This might seem logical given Zen's East Asian origins, but critics who expected artists of Japanese or Japanese American identity to know Zen and make Zen art, slotting them into an ethnic-Zen tier, were projecting their own desires for otherness and, in

turn, ignored these artists' specific and multifarious contributions to global modernism and collaborative creative work.

In any case, there is little question that by the 1960s Zen had established varied presences in creative work and become a hot topic in art criticism. In North America, a great deal of discussion about Zen took place at literary and art spaces such as The Club, New York City, famously associated with Abstract Expressionism. There and elsewhere, Zen joined the expanding roster of consciousness and world-changing ideas, practices, and beliefs being taken up and debated in new art. After years spent in the midst of the avant-garde art scene, the critic Harold Rosenberg (1906–1978) observed that "Art in the service of politics declined after the war, but ideology has by no means relaxed its hold on American painting. Zen, psychoanalysis, action art, purism, anti-art have replaced the Marxism and regionalism of the thirties."[4] The work of contemporary Japan-based artists shown in galleries in Europe and North America, such as those of the Gutai Collective, also elicited comments on Zen, often in tandem with references to Dada and the Fluxus art network.[5] With all the talk of contemporary art and Zen, it is no surprise that popular authors of the time would take advantage of this enthralling pair-up. "It is the intentionless intention of Zen art," H. R. F. Keating noted in his novel *Zen There Was Murder,* "which has been seized on by the action painters, with their use of the accidents that occur as they work."[6]

By no means did every critic respond favorably to postwar Zen-associated creative work or the sorts of attitudes attributed by some to Zen art acolytes. In 1969, the music critic Max Harrison responded sardonically to those who took issue with his unfavorable review of work composed by Cage: "Curious: lately critics have begun receiving peevish answers to unfavorable notices of such concerts. Surely the perpetrators [of such peevishness], being so Zen, so detached, so impersonal, should be unconcerned."[7] Turning the Zen back on to the Zennists—someone who is truly Zen, this rhetoric avers, will not be cranky—is one of several strategies in the postwar court of opinion on Zen and art.

Alan Watts was less oblique in his censure of artists—Cage in particular—whom he considered guilty of using Zen to justify "sheer caprice in art":

Today there are Western artists avowedly using Zen to justify the indiscriminate framing of simply anything—blank canvases, totally silent music, torn up bits of paper dropped on a board and stuck where they fall, or dense masses of mangled wire. The work of John Cage is rather typical of this tendency. In the name of Zen, he has forsaken his earlier

and promising work with the "prepared piano," to confront audiences with eight Ampex tape recorders simultaneously bellowing forth random noises. Or he has presented silent piano recitals where the performer has a score consisting of nothing but rests, plus an assistant to turn the pages, to jolt the audience into become aware of the multiplicity of sounds that fill the musical void—the shifting of feet and rustling of programs, the titters of embarrassment, the coughing, and the rumble of traffic outside.[8]

The questioning of canonical form and convention may reside within orthodox Zen, Watts suggests, but the use of Zen to produce fortuitousness and randomness in art, for art's sake, is not Zen itself.[9] Watts was defending a certain sort of Zen orthodoxy against the artistic branch of the Beat movement, but the mediations and appropriations of Zen by artists such as Cage could be neither controlled nor erased no matter what Watts might have written or said. Indeed, what Watts may seem to have deemed a modern Zen "heresy," others have subsequently praised as a source of "salvation" for art. Moreover, Watts may have been more like Cage than he would have admitted: neither based their Zen specifically in formal seated meditation and orthodox lay Buddhist training and instead formulated new forms of Zen consistent with personal philosophical, spiritual, and creative visions, as well as preferred media and modes of expression.[10]

In any case, engrossing books and essays have been written about Cage, other postwar artists, and Zen; the Zen-ness of their lives and creative work; the "movement" they may have formed with Zen as its ideology; and their enduring importance to debates regarding visual form, labor, and creativity intersecting with spirituality and the transformation of consciousness. As important as these writings are, they lead me to wonder what sort of Zen is going on in postwar art and why? What are the claims made for and against art in and of the Zen boom? How does old Zen art relate to new Zen art? What makes an artist a Zen or "Zen-influenced" artist? Is an "influence model" up to the historical task at hand?

It may be fair to say that the idea of Zen's influence on the postwar avant-garde has settled irrevocably into art criticism and history. Revisiting the issue in the affirmative, Valerie Hellstein questions the tendency of scholars to downplay Abstract Expressionism's debt to Zen: "To say that Zen was not influential, had nothing to do with abstract expressionism, or that it was a passing fad overlooks the documentary evidence: between 1950 and 1955, at least ten evenings at The Club were devoted to Zen and its connections with music, theater, art, and psychoanalysis. In other words, the artists at The Club discussed Zen more than any other documented

topic—even more than existentialism."[11] Fair enough; we need not throw the Zen out with the bathwater. Zen is there in the archive, in the lives of artists, and, depending upon your point of view, in the art. But how do we take this conversation beyond a Zen did/didn't binary or a question of how much Zen influence there was relative to other inspirations? Might Cage's absolution of Zen help us reconsider the twentieth-century Zen-art nexus?

CAGE AND ZEN INFLUENCE

The idea that Zen influenced art has never ceased to be curious to me, not least because a gaggle of Zen advocates, art historians, cultural critics, and others have argued since the early twentieth century that Zen influenced *all* the arts of Japan.[12] Determining just how Zen accomplished this and how such influence is revealed in particular works of art has been a task taken up by scholars in both Asia and the West. Arthur Waley took a stab at it in 1922 in his *Zen Buddhism and Its Relation to Art,* wherein he sought to make clear "the exact nature of its [Zen's] influence upon the arts."[13] From the 1950s onward, we encounter repeated instances in which avant-garde artists such as Cage were celebrated for having been influenced by Zen. They were not just introduced to it, aware of it, or interested in it, their art became different and radical specifically because of Zen. With blinkered hindsight, it seems as if every artist, musician, or writer of critical acclaim during the postwar era was, at one point or another, under Zen's influence.[14] Decades later, the notion of Zen influence remains au courant, perhaps because Zen and the Zen-art nexus still invite fascination and the postwar avant-garde continues to preoccupy us.

Taking issue with the trope of Zen influence is surely a lost cause and one bound to provoke backlash. Why get hung up on the single word "influence"? Why such skepticism? As I've been told on multiple occasions by different sorts of Zen advocates and fans, "Zen *did* influence [add artist name here]. We know that because [he/she] read Suzuki and attended Suzuki's lectures. [He/she] even spent a couple weeks in a temple in Japan. And we can plainly discern the emptiness and nothingness of Zen in [his/her] work." More often than not, this is how the argument builds, until Zen influence becomes a foregone conclusion.

This is not to suggest that individual artists did not develop immersed, self- and world-scrutinizing relationships with Zen in the postwar period. Cage certainly did, even if his Zen was different from those of, say, poet and eco-activist Gary Snyder, monk and poet Philip Whalen, and D. T. Suzuki

himself. These differences in fact suggest a strong reason for skepticism regarding Zen influence. For, as I have already suggested, postwar Zen was by no means uniform: it could be monastic, lay, philosophical, bookish, or anarchist. In the West, many found Zen, as Van Meter Ames put it in 1960, not in formal Zen training but by "appreciating the artistic heritage of Japan as it emanates from Zen."[15] If postwar Zen was therefore multivalent (and partly for this reason contentious), then perhaps in simple terms there was no single Zen that influenced the visual, literary, and performance arts, and no single Zen art.

Perhaps, too, the issue at hand is the familiar tussle in modern Zen and its discourses between historical inquiry and hagiography, archive and aura, and intention and reception. Indeed, all too often discussions of Zen and postwar avant-gardes rush ahead with little consideration of the particular sort of Zen purportedly acting on a particular artist or with fine-grained inquiry into the historical and visual record.[16] To the extent that Zen-influence arguments are sketchy, shaped by both art- and Zen-world hagiographies, they are more about Zen "taste" than Zen "analysis" or "evaluation."[17] Meanwhile, for some critics it seems sufficient merely to pin "Zen" on a visual artist, composer, or choreographer in order to spotlight something radical and exotic about them and their art. And once Zen has been cited as the essential, predominant cause of art it can be difficult to change the conversation. Partly, this may be due to the magnitude or spectacle of what many of these artists did—rending and transforming visual representation, performance, social and political space, and so forth—and the desire of some of us to nail down what it was that led them to it. For some, Zen influence, with "Zen" unspecified, drives the nail home.

At the risk of sounding disciplinarily parochial, however, I think the matter looks rather different when we avail ourselves of Michael Baxandall's (1933–2008) classic postulation regarding the concept of influence in the interpretation of art: "Influence is a curse of art criticism primarily because of its wrong-headed grammatical prejudice about who is the agent and who the patient. . . . If one says that X influenced Y it does seem that one is saying that X did something to Y rather than Y did something to X. But in consideration of good pictures and painters, the second is always the more lively reality."[18] Perhaps this could be usefully applied to Zen and postwar art, and we might also consider the distributive and often unequal agencies at work in global cultural circulation and appropriation.[19] In his polemic against transcendentalist interpretations of the work of abstract painters James Elkins insists, referring to Wassily Kandinsky's (1866–1944) well-known writing on the spiritual in art, that "If I cast my lot with the 'nonspiritualists' it is not because I think Kandinsky wasn't spiritually

inclined. It is because what gives the art lasting importance is what it does
other than affecting the kind of spiritual communication Kandisky hoped
for." To borrow from Elkins, then, it may matter very little to some that
Cage's *4'33"* was influenced by Zen, if it even was, and this may matter
a great deal indeed.[20]

Without rejecting an important role for Zen in postwar artistic sub-
jectivities and creative work, I therefore find Zen influence to be thin gruel
for the study of artists and the capacity for works of art to provoke rather
than resolve. It is also worth considering the likelihood that the Zen-art
influence paradigm is a product of the Zen boom itself—not so much incor-
rect as symptomatic. It is part of the history of modern-contemporary Zen.
What, then, can we learn by poking this paradigm in relation to Cage and
other postwar artists?

I make no claim here to particular expertise in Cage or pre- or post-
war American art studies, but perhaps we may agree that one of Cage's
earliest epiphanic contacts with Zen and art took place as he listened to
Nancy Wilson Ross' 1939 lecture "The Symbols of Modern Art," delivered
at the Cornish School, Seattle. Ross clearly caught Cage's attention, even
though she referred to Zen in this instance only briefly.[21] From the 1950s on,
Cage spoke and wrote often about the transformative impact of Zen on his
thinking, his music, and his art-life integration. Among Cage's sources were
John Blofeld's (1913–1987) 1947 translation of the Chinese Chan master
Huangbo's (d. 850) *Essential Teachings on the Transmission of the Mind;*
D. T. Suzuki's writings, lectures, and personal communications; specific
concepts associated with Zen and various Zen master stories; as well as
Zen-associated art works and themes such as the garden at Ryōanji and the
Ten Oxherding Pictures.[22]

These and other contacts with Zen impressed Cage greatly, in multi-
ple ways, and there is little reason to ignore his repeated references to Zen in
his early 1950s performances, including "Lecture on Something" and "Lec-
ture on Nothing" at the Artist's Club, New York City, and *Theater Piece #1*
at Black Mountain College, North Carolina.[23] In "Lecture on Something,"
presented in 1951, he recounted his favorite Zen allegory, borrowed from
Suzuki: "Before studying Zen men are men and mountains are mountains.
While studying Zen, things get confused. After studying Zen men are men
and mountains are mountains." He added, in modernist mash-up, "If any
of you are troubled still about Orient and Occident, you can read Eckhart,
or Blyth's book on Zen in English literature, or Joe Campbell's books on
mythology and philosophy, or the books by Alan Watts. And there are natu-
rally many others."[24] During the question-and-answer period of "Lecture on
Nothing," as Cage recalled in 1961, he "gave one of six previously prepared

answers regardless of the question. This was a reflection of my engagement with Zen."[25]

Cage critics and biographers have these and other episodes and references well in hand. From my perspective the safe conclusion to draw, using a hermeneutic of suspicion *and* generosity, is that Cage's Zen, as he found and formed it, suited him quite well in his life and creative work. Sensible as this may sound, this sort of statement may give Cage more agency than some may be willing to grant him, and the issue one faces with a great deal of writing on Cage's work and Zen, then, is perhaps that of interpretive overreach or blinkered desire to narrow down the cause and fruition of Cage's work as singularly or principally Zen. This is suggested by statements that identify a Zen principle or trope (Zen awareness active in the present moment, for instance) and find it expressed directly, without remainder, in the artist's work: "Cage's notorious silence should be understood primarily as a product of this Zen availability to experience."[26]

When the historical record of purported Zen influence is not as detailed as one might wish, some authors find it tempting to infer it into being. "Could Cage have written that observation without Suzuki's lectures on the Heart Sutra?" the biographer Kay Larson asks. And, again: "Let's assume that Cage wanders into [the bookstore] Orientalia in mid-1950; perhaps alerted by [Gerald] Heard's review, he picks up Suzuki's *Essays in Zen Buddhism*. He opens to the first page. Here is what he reads: . . ."[27] Larson is working diligently to reconstruct Cage's milieu and creative process, but perhaps this is Zen-ful thinking.

It does not have to be this way, however, and certain Cage interpreters—notably musicologists—emphasize different aspects and histories of the artist's work and are skeptical of or entirely mum about Zen and its influence. This produces a sort of parallax effect—a recurring phenomenon of postwar Zen art criticism—in which a work of art may be simultaneously Zen and not Zen, a further indication of the sorts of differentials or slippages already noted. James Pritchett, who resists a Zen frame for Cage, has argued that Cage's *4'33"* had its origins in 1948 in a piece to be called *Silent Prayer* prior to the composer's encounters with Zen. His summation on the popular fame of *4'33"* entirely eschews comment on Zen: "It is a piece that has become a sort of icon of post-war culture, like Warhol's soup cans: a punch line for jokes and cartoons; the springboard for a thousand analyses and arguments; evidence of the extremity of a destructive avant-garde that appeared in the 1950s and 60s."[28] Pritchett makes clear, then, that there are ways to engage *4'33"* without Zen being primary or present at all. In fact, what concerns him most is not the Zen-influenced Cage but the "composing Cage." In this he challenges Cage critics who characterize him as "more

a philosopher than a composer" and who, in turn, fail to consider his compositional technique as well as his rhythmic and time structures, harmonic progressions, and other aspects of the music itself.

In the face of nearly constant rehearsal of Cage's indebtedness to Suzuki, the musicologist David W. Patterson argues that the "relationship between Cage's aesthetic and Suzuki's work" remains "highly speculative." One can almost hear fans of a Zen Cage crying foul over this, but Cage's own claim to have "studied" with Suzuki, and the frequent echoing of this idea in Cage criticism, Patterson notes, is barely supportable beyond a few verified encounters in New York and Japan.[29] Much clearer are Cage's borrowings from the "slim ninth-century Chinese Zen text *Doctrine of Universal Mind,* attributed to Huang Po."[30] Cage observers agree on the importance of this text, but few make much of the fact that one of Cage's most compelling encounters with Zen involved neither monastic or lay Zen training nor a book explaining Zen meditation but a philosophical text.[31]

At the very least, the Zen that influenced Cage, if that was what happened, was of a specific sort, one distinguished in large measure by philosophical concepts and evocative stories encountered in books and from other sources and not through training with a Zen master, experience inside a practicing Zen community, or even personal meditation. Nor did Cage directly borrow musical tuning, instrumentation, or rhythms found in Zen liturgy.[32] That he was into his own sort of Zen thing, even creating a new sort of Zen, seems likely in light of such statements as: "Distractions? Interruptions? Welcome them. They give you the chance to know whether you're disciplined. That way you needn't bother about sitting cross-legged in the lotus position."[33]

None of this disqualifies outright Cage's sort of Zen, and if anything he was probably in the majority dispensation of postwar Zen. But it does make one wonder about interpretations of Cage's work that posit, in Edward J. Crooks' words, "a reasonably faithful adoption of doctrines and traditions found during his ongoing study of Asian religions and philosophies" and that relate his "embracing of nothingness to his study of Zen." Crooks argues, instead, that Cage "assumed that there was an essence behind those [book- and lecture-derived] ideas that he could discover for himself without guidance," adding that he "showed no interest in the extensive rituals, intercessionary actions, and other devotional practices of Japanese Buddhism or any other religious or philosophical tradition he investigated."[34] Neither unexpected nor unique to Cage, this suggests the individualist and Romantic sensibilities prevalent in Buddhist modernism that reject institutional religion in the pursuit of self-discovery, transcendent (or radical) experience, and revelatory creative expression.

Pritchett, Patterson, and Crooks aim to flip the Zen-influence script à la Baxandall: the story line is not what a timeless Zen did to Cage but what Cage did to postwar Zen (and perceptions of premodern Zen) through his creative work.[35] Here is Pritchett again: "The relationship of Cage's composition to his study of Zen Buddhism was not one in which Zen 'influenced' him to act and think in certain ways: Cage's understanding of Zen was shaped as much by his compositional concerns as his composition was shaped by his interest in Zen."[36] Moreover, one-dimensional and sometimes euphoric discussions of Zen influence seem less reliable when we trace and probe Cage's multiple discoveries in, for instance, the work of Arthur Schoenberg (1874–1951), Meister Eckhart, Ananda Coomaraswamy, Huangbo, Suzuki, and the futurist Luigi Russolo (1885–1947), as well as in Daoist texts such as the *Yijing*. This leads Patterson to map out Cage's "elaborate" network of "East Asian rhetorical appropriations," in which the artist's borrowings "were not so much faithful transcriptions of ideas as they were carefully constructed intellectual subversions" in which "the basic elements and unifying structure of an idea are maintained, though the intended effect is first undercut and then reversed (i.e., subverted) by a motivation contrary to the idea's original purpose."[37] Ultimately, Patterson argues, "The most elemental facet of Cage's contact with Asian cultures is the way in which he studied, absorbed, and sifted through a variety of texts during the 1940s and 1950s, extracting with single-minded discrimination only those malleable ideas that could be used metaphorically to illuminate the artistic themes that were always the focus of his writings or reshaped to reinforce the tenets of his own modernist agenda."[38] Crooks sums it up this way: "Cage's texts do not necessarily inform the reader of what *Zen* wants, what *Indians* think, or what *Meister Eckhart* meant, more often they inform us of what *Cage* thought Zen wanted, what *Cage* thought Indians think, and what *Cage* thought Meister Eckhart meant."[39]

Appropriations of all sorts, needless to say, are a vital matter in twentieth-century art. But we should not conclude that all appropriations are the same or entirely benign. Indeed, in the post-Saidian worldview the "Zen turn" by Cage and other modern artists in the West presents a familiar case of decontextualizing orientalism. Ming Tiampo, for instance, observes that "From Paul Gauguin's (1848–1903) Tahitian escape to Surrealism's utopian internationalism to John Cage's devotion to Zen Buddhism, modernism was, as Said argues, inextricably entwined with the imaginations and international experiences of colonialism and imperialism."[40] Andreas Huyssen fleshes it out further: "The turn to Zen Buddhism, so central to Cage and much of the counter-culture of the 1960s, had been significant in that it functioned as the Eastern veneer of some alternative meaning, an

intellectual 'other' that breathed new life into the world of Dr. Strangelove. It provided the illusion of spirituality that had been drained from Western civilization."[41] Crooks is blunter still: "Cage absorbed the stereotypes and tropes of affirmative Orientalism and 'Eastern philosophy.' Combining these with contemporary American and European discourse on the Orient and the modernist desire for a universal language, he created his own syncretic theories of Oriental art and thought. His theories grew out of but were not identical to any earlier systems of thought. Yet, through a complicated set of historical, cultural, and circumstantial conditions, his vision gained the authority to represent Asia."[42]

So there is Zen in the Cageian creative palimpsest and work, but it arrived there less through a process of Zen acting upon Cage than of Cage's polytonal, and perhaps orientalist, appropriations—which gained the power, in the view of some, to speak for Zen and Zen art. Needless to say, the postcolonial perspectives of Crooks and others are discordant with an essentialist view that Cage's work, influenced by Zen, in turn manifests inherent, unchanging Zen principles (indeterminacy, no self, and so forth). But the holes that these perspectives poke in the Cage Zen myth may allow us to better see the ways in which Zen and art twined amid the postwar period's intellectual and cultural energies and politics.

Some writers do lean from influence toward agency—from what Nam June Paik termed, perhaps sardonically, "the old Zen-Cage thesis," to "Cage Zen," "Cageian Zen," and the "Cage Zen point of view."[43] Others treat Cage and others as mediators, which allows us to move away from a narrow discourse on authenticity to consider their creative work as—well—their creative work, neither beholden to nor a betrayal of Zen.[44] For, after all, Cage and others were, we might say, making art not "doing Zen." "Painters paint, dancers dance, musicians make music," as Arthur Koestler put it, "instead of explaining that they are practicing no-thought in their no-minds."[45] Alexandra Munroe is therefore right to propose that, while Cage and other artists may have had a "distorted view of Zen," their "mediated, even imagined concepts of Zen were central to their creative processes."[46]

Fair enough, but we might be cautious about touting mediation as a distinctively modern act. Every act, text, and representation is perhaps mediated and mediating, and arguably premodern monastic Chan/Zen was no less so than Suzuki Zen, and Suzuki Zen no less so than Cage Zen.[47] Munroe's comments also reveal how tricky the interpretation of postwar Zen-associated art can be. "In monastic forms of Zen Buddhism," she writes, "enlightenment passes through direct experience between the minds of master and student, without the mediation of religious texts or ritual." "Cage's Zen-inspired experiential methods," she adds, "established mental,

transformative interaction—a relational dynamic between the creator and recipient/viewer—as a crucial principle of neo-avant-garde art. In this formulation of Cage Zen, art is a catalyst for direct insight."[48] Before we know it, then, we may be drawn from artistic mediation of postwar Zen in the name of art per se back to the favored terms and concepts of the Zen boom itself. We should defend Cage from Watts' charge of distorted Zen in favor of an investigation of mediated Zen, but do we wish to reauthenticate Cage as truly Zen by using Munroe's analogy between insight emerging between artist and audience in Cageian art contexts and that traditionally valorized in monastic, master-student Zen? A problem internal to this analogy is its generalization of monastic Zen and its demotion, if not ignoring, of historical Chan/Zen's ritual and literary cultures, which were not entirely about unmediated mind-to-mind transmission. Munroe's analogy therefore appears to mimic one strain of modernist Zen rhetoric, namely its assertion of intuitive experience and enlightenment as a "special transmission outside words and scriptures," and it ignores the work of historians of religion who have challenged the modern anti-ritual, anti-textual, experience-dominant conceptions that have come to rule perceptions of Zen.[49] In Munroe's presentation, therefore, it is not sufficient to validate Cage's agency and his work as mediating Zen; Cage needs to be returned to authentic Zen through conflation with the very sort of Zen (monastic, meditation-based) that he declined.

Recourse to Zen orthodoxy shows up as well in the insertion of Cage into the Zen tradition through the use of monastic language (master, initiates, transmission, taking refuge in, and the like). Influenced by Zen, Cage apparently became a Zen master. "It is perfectly accurate and even interesting," Joan Retallack tells us, "to characterize John Cage as an American Zen master, as long as it is entirely clear that he was not a formally trained Zen Buddhist."[50] "As long as" is a monumental qualification, one that points to the dramatic recontextualization and transformation of Zen in the West even as it claims the authority of a traditional title. Then, not surprisingly, we read of Cage's transmission of Zen-influenced art making to more junior artists, in what became, we might say, an extra-monastic, postwar Zen art lineage, one with its own hagiographic topoi—from premodern Chan/Zen teachers, to modern Japanese monastics, to D. T. Suzuki, to Cage, and from Cage to, among others, Merce Cunningham and Fluxus artists such as Yoko Ono.[51] One composer and musicologist, a bit overly taken with the monastic metaphor, even tried to get Cage to agree that his teacher, Arnold Schoenberg, was "a kind of Zen master who had authority and power," a notion that Cage appears to have resisted.[52]

Some of us therefore wish to view Cage as a Zen disciple of D. T. Suzuki, who then became a Zen master himself, "credentialed" to teach

others. Of course this is flatly incorrect in any sense of orthodox Zen and Dharma transmission, and in some instances such characterizations are merely over-enthusiastic Zen gushing.[53] But this sort of naming—the transfer of monastic title and authority to a non-monastic or even lay Zen figure— should be recognized as a rhetorical and social creation of the Zen boom itself, part of a "new orthodoxy" of postwar Zen. In such terms, Retallack's "perfectly accurate" makes sense to the extent that we acknowledge the postwar creation of new Zen "patriarchs" in spaces outside the meditation hall as simultaneous with the spread of formal Zen training globally.[54] This urge to view Cage and others as Zen masters also suggests the postwar desire for and discovery of new gurus and cult figures, a pattern that eventually appeared in popular culture in the Shaolin monk Kwai Chang Caine in the television program *Kung Fu* (1972–1975) and, later, in the identification of the film character The Dude from *The Big Lebowski* (1998) as a Zen master.[55]

By no means do I wish my observations to diminish Cage's engagement with Zen. Rather, they seek to bring attention to the sort of Zen that was becoming possible and prevalent in the postwar period, the kind of creative work and statements that flowed with it, and the complex processes of Cage's subjectivation. The Zen and art that came about with Cage is marvelous, but it is its own marvel and not Zen or Zen art in any universal or essential sense, as some wish to see it. One can also see the influence game as it played out in relation to postwar art and Zen as an expression of the unequal power relations and white privilege of the art world. For however much Cage and other European and American avant-garde artists exploring Zen and other non-Western traditions may have been taken to task for their creative work in the terms of Euro-American modernism, Asian and Asian-heritage artists engaging international art spaces and movements in the 1950s and 1960s were caught in the bind of Cold War affirmative orientalism on the one hand and the cultural hegemony of Western avant-gardes and their advocates on the other. To put it bluntly, if you were from Asia and your creative work involved Abstract Expressionism, for instance, but also evoked a distinct sense of Zen, you probably drew praise from the Western critic elite and mainstream press; if your painting, installation, or performance lacked a Zen affect, then you might well be considered a wannabe New York School imitator. This overstates the point, and there were artists such as Isamu Noguchi who created complexly hybrid work that defied both essentialist and subordinate characterizations.[56] But the dynamics of postwar art suggests a sort of "New York School manqué syndrome," to borrow from Parta Mitter, in which non-Western artists, such as those of the Japanese Gutai group, were "enmeshed in a complex discourse of authority, hierarchy and power" and their contributions to modernism from the periphery

were labeled derivative within a Euro-American–centric discourse in which influence was a "key epistemic tool."[57]

We find this condensed in a critic's blunt statement on the 1958 Gutai exhibition at the Jackson Gallery in *Art News:* "A number of Japanese artists much influenced by New York Abstract-Expressionism, and much in awe of Europe, were introduced in a fancy exhibition that was generally disapproved of as derivative and trivial."[58] For the Gutai artists this condescending language of influence, awe, and triviality surely stung, and as Ming Tiampo points out, such views prompted the group's leader, Yoshihara Jirō, to argue against hierarchy and for the interconnectedness and common ground of the art world.[59] It is also worth noting that Western critics were for the most part unaware of the ongoing domestic debates taking place among artists and critics in Japan regarding traditional Japanese and modern art, art and Cold War economics and geopolitics, and modern artistic subjectivity.[60]

But resisting marginalization by the West through intercultural dialogue appears to have been easier said than done, especially given the passions of Euro-American Zenophilia. In the "Zen-enriched environment" of late 1950s and early 1960s New York, Alan Hockley writes, American reviews of the work of the Japanese artist Munakata Shikō (1903–1975) relied on "Zen conceptualizations to explain and characterize Munakata and his creative process." "Whether by accident or by design, but probably a combination of both," Hockley adds, "Zen Buddhism emerged as the framework most capable of accommodating the iconography and aesthetics of Munakata's art and his eccentric manners."[61] Efforts by a number of critics to resist this "Zen-speak" failed, as Hockley points out, and Munakata himself may have facilitated and participated in the Zen-ing rhetoric.[62] Consider too the artist Okada Kenzō (1902–1982), whose work, as Ming Tiampo writes, was deemed marginal to postwar Euro-American art movements, in turn leaving the artist with the vexing choice of either facilitating Western desires to see traditional Japanese and Zen qualities in his work—"use of empty space, nothingness, an evocation of the Zen that had been so popularized by figures like D. T. Suzuki and Alan Watts"—or refusing "to offer audiences the Orientalist rhetoric that they yearned for."[63]

The power relations of postwar art and Zen also emerge in a retrospective description written by the philosopher Arthur C. Danto (1924–2013) in 1995. "It was precisely in their focus on materiality and on action," Danto recalls, "that the Gutai artists exhibited the spirit of Zen, even if one gets the sense that they saw themselves as reenacting the impulses of the New York School on a larger scale and regarded themselves as transcending the barrier between East and West." Mind the gap, then, between Japanese

postwar art that embodied the "spirit of Zen" in Western reception and the ambitions of the artists producing such work, who claim their own categories and geopolitics. Danto goes on to recall the sentiment that Japanese artists should stick with the "spirit of Zen" as their means to consequential art and participation in global modernism rather than attempt to engage the New York School.[64] For Americans "beginning to steep themselves in Zen," he notes, "New York-style painting [done by Gutai artists] was the last thing they wanted from Japan." But Danto then adds the apposite convolution: that if the work of the Gutai artists was a pale approximation of that of the New York School, it "must have looked as inauthentic as New York Zen did" to Japanese critics.[65] This spins the matter of influence and borrowing around, for indeed the Zen affections and appropriations of European and American artists did not necessarily make the grade as far as certain Japanese critics were concerned. In 1976, the art historian Yamada Chisaburō (1908–1984) weighed in with censure of imitative approximation. Westerners "may think that their modern art has received immeasurable influence from Zen Buddhism and so on," he wrote, but "From our point of view, what they are talking about is certainly, in most cases, a *soi-disant* Zen, little resembling the teachings of orthodox Zen Buddhism."[66] Western soi-disant Zen—that of the Beats, Cage, and others—is the flip side, it appears, of Gutai soi-distant Abstract Expressionism.

We could go on talking about these convolutions of influence, agency, and criticism, but perhaps it is now time to set aside the notion of influence (and "catalyzed," "inspired," "steeped in," and so forth). For the Zen and art case, we might theorize a Zen-art ecotone—a zone of two adjacent ecologies in tension and interpenetrating in particular ways, dynamic and difficult to measure.[67] We might consider code switching—combining more than one language (art, Zen, varieties of each, and so forth) within a single gesture, performance, or object—and perhaps global "interpoetic" negotiations between art and Zen.[68] We might also treat Zen, as Thomas A. Tweed does, as one of multiple "found objects [that artists used] to assemble new cultural forms."[69] This might include other "iconoclasms" and "parallel" or "symbiotic" modernisms such as those of Dada and Marcel Duchamp, multiple sources of Asian philosophical and religious thought, and other modes of consciousness-altering/raising that drew attention amid postwar disillusionment and intervention and interwove with or blurred into postwar Zen and art. Tweed also proposes the lovely idea of "transcultural collage," a practice of "affixing some of this to some of that" within postwar global flows. Collage—an assertive technique of early twentieth-century modernism—by nature implies decontextualization and reassembly, vigorous action not passive receipt. The metaphors of found objects and collage

also help us step outside the rhetoric of authenticity: "For a cultural history of Buddhism in post-war U.S.," Tweed adds, "it does not matter that the received representations did not faithfully or fully portray the complexities of Zen as it had been practiced by monks and laity in Japanese temples for centuries."[70] What matters, in Ronald L. Grimes' view, is "to attend to the values that determine patterns of adaptation and modes of distortion."[71]

INHERENT ZEN

The crisscrossing circumstances of postwar Zen meant that influence was not the only rhetorical game in town. Certain critics argued for the inherent Zen of contemporary Asian artists. Not influenced by Zen but intrinsically Zen, it was argued, these artists produced the truest Zen art, which could only be approximated by European and American Zen-enthused artists. The sort of collapsing of art, race, ethnicity, and Zen into one another was not to the liking of all, however, and one might sense a bit of discomfort in Nam June Paik's later comment: "Now let me talk about Zen, although I avoid it usually, not to become the salesman for 'OUR' culture like Daisetsu Suzuki."[72] But others had no qualms about a Zen sales pitch, most notably Michel Tapié (1894–1987) and Haga Tōre (Tōru; 1931–) in their 1961 *Continuité et avant-garde au Japon* (Avant-garde art in Japan, 1962). For Tapié and Haga—the former a critic associated with Tachisme, Art Informel, and Fluxus, and the latter a Japanese scholar of comparative literature—Japanese avant-garde artists were innately Zen.[73]

Introducing artists of the Gutai art collective, the "Ikebana sculptor" Teshigahara Sōfu (1900–1979) and others, Tapié and Haga offered free-wheeling expositions on premodern Zen and Zen monk painters and calligraphers, Japanese culture (including Bushidō), European analogies to Zen experience, the postwar avant-garde, and more. Their statements regarding Zen-art praxis, as embodied in the work of the Japanese artists profiled in their volume, is especially incantatory. To put it one way, *Avant-garde Art in Japan,* which Ming Tiampo refers to as "Tapié's manifesto on avant-garde art in Japan," is a "primary text" of postwar art curation in a Zen mood, one focused not on the hegemony of Euro-American avant-gardes but on a counterargument against them.[74]

What interests me here is not the relative Zen-ness of the work of a particular Japanese artist introduced by Tapié and Haga but the manner in which the authors present their case, in part through recourse to Sesshū's *Splashed Ink Landscape* (1495) (Plate 1)—reproduced without

its accompanying prose and poetic inscriptions, implying that Zen art is just picturing.[75] That Tapié and Haga would include and comment on Sesshū's painting should come as no surprise. Rivaling the thirteenth-century Chinese monk painter Muqi's *Six Persimmons* (fig. 6), the *Splashed Ink Landscape* has been wildly popular in Japan and abroad throughout the twentieth century. Although it has not captivated all modern viewers—the English art critic Sacheverell Sitwell (1897–1988) was ambivalent about it—the painting has been enduringly lauded for its spontaneous, unmediated, and transcendental expression of emptiness or void.[76] Arguably, it has become a metonym for Zen painting and even Japanese painting as a whole.[77] That the scroll acquired such presence is due to its absorption into Japan's modern "art authorizing system," to borrow from Shimao Arata, operated by government officials, academics, and collectors, and materialized in public exhibition, photographic reproductions, and scholarly and popular publications.[78] The scroll first drew wide attention at the 1884 Domestic Competitive Painting Exhibition (Naikoku Kaiga Kyōshinkai) and was published in 1889 in *Shinbi taikan* (Survey of true beauty). After its sale by the Kyoto Zen monastery Shōkokuji in 1905, the painting entered the collection of the Imperial Museum, Tokyo. In 1952, just prior to the 450th anniversary of Sesshū's death (1956) and amid the "Sesshū boom" in Japan, the scroll was designated a National Treasure.

For Tapié, the painting had special importance as the premier work in the premodern "Haboku school," in which space is a "central preoccupation." The painting's "very structure, the essence," he explains, is "conceived of as a whole signified by a minimum of elements, the latter in turn being signified in a structural ambiguity carried to the controllable extreme of perceptual contemplation." It was the unfettering power of Zen that allowed the artist to push visual form towards the minimal and into fertile ambiguity at the limits of perception.

It quickly becomes evident that *Avant-garde Art in Japan* seeks to situate the *Splashed Ink Landscape* in implicit consanguinity with the work of postwar Japanese artists of varied ilk. At stake in this is not the question of whether or not Sesshū's painting directly inspired the volume's postwar artists but its auratic embodiment of premodern Zen and Zen art and, in turn, its function as a touchstone for an invented tradition sustained in the work of postwar Japanese artists. Put differently, Sesshū is cast as a patriarch of Japan's postwar artists, who receive from him "mind-to-mind," as it were, Zen artistic technique and subjectivity and in turn take their place on the international stage as Zen artists of impeccable lineage.

Tapié and Haga's exuberant essays make this seem possible through their mutually reinforcing endorsements. True avant-garde art in Japan,

Tapié tells us, drinks deeply from tradition, first-and-foremost Zen. Imbibing this ancient spiritual-cultural mix, contemporary artists in Japan acquire "paroxysmic means of free and intense expression." From Haga, meanwhile, we learn that:

> Traditions flow from the depths of history toward our artists, submerging them in their fatality. And yet it is this very fatality that they transform into their own necessity by means of their creations. This dialectical progress is exemplified today by their associations with one of the richest Japanese artistic traditions, that of Zen. Introduced into our country's spiritual life in the twelfth century, this severe discipline of inner negation opened an entirely other system in the thought and art of Japan at the same time that it formed a secret volcano of paroxysm in her soul. Indeed, it is Zen that has rekindled the creative fire in our avant-gardes which today assert themselves in the international field.

Sesshū's "Haboku lines" arise from "another level of reality," a Zen level, Haga argues, and it is because "Zen art is essentially expressionistic and irrational" that "our artistic elites go back to Zen, and it is in the subterranean current explored by Zen that they find their most enriching nourishment."[79]

There are many ways to take up Tapié and Haga's recourse to "paroxysm" and "irrationality," Haga's description of the dialectical process by which artists avoid the death hand of tradition but access its "subterranean current" to rekindle creativity, and so forth. At the very least, these explanations constitute very modern work on Zen art, a process of particularized revisioning of the past and its artifacts to valorize and distinguish the distinctness of the Japanese avant-garde within international contemporary art. Thus, while one might dismiss Tapié's and Haga's explanations for gushing essentialism—echoing earlier writings of Suzuki, Blyth, and others—their identification of Zen as the sine qua non of the Japanese avant-garde may be more than mere orientalist (Tapié) and nationalist (Haga) hype. As Ming Tiampo puts it, Haga "used the postwar Euro-American obsession with Zen to claim a place for Japanese artists."[80] In this sense, their explanation of Zen art was a strategic inverse orientalism, a means to intervene against, on the one hand, European and North American criticisms of Japanese artists as second-rate Abstract Expressionists, action artists, and so forth, and, on the other, Euro-American presumptions to "own" Zen and its artistic materializations. It was a means to argue for an "alternative modernism," one created by artists with, it is implied, unique access to a liberating mystical-artistic past.[81] Japanese

artists in the fictive art lineage extending from Sesshū and other premodern Zen painters, including Hakuin, are thus to be distinguished from Euro-American avant-gardes by virtue of trans-temporal Zen experience unique to Japan. Moreover, Zen art in Japan is seen as not strictly antiquarian but new and radical; old Zen art, indeed, leads to new Zen art. The overdetermined assertion here, however, is that Japanese avant-garde artists draw from the native source or inherent self, doing a "mind-meld," as it were, with Sesshū and other premodern artists. Western artists are, by implication, mere dilettantes at play in the field of Zen and art.

ZEN DENIAL

Given the cornucopia of juxtapositions and tensions arising in postwar Zen, it seems appropriate that the rhetorical patterns of Zen influence and Zen inherence would be joined by Zen denial. Indeed, John Cage was not the only artist who saw fit to deny, qualify, or subvert the characterization of his or her work as having been influenced by or being principally expressive of Zen. The painter Georges Braque (1882–1963), who was drawn to Zen and collaborated with the Zen luminaries Eugen Herrigel and D. T. Suzuki, nevertheless refused to admit Zen's influence: "Do these ideas of mine derive from Zen Buddhism? I don't think so. True, I have read a lot about Zen Buddhism, but I'm convinced that this philosophy hasn't influenced my way of thinking or my work. On the other hand, I have been deeply interested to find how closely certain tenets of Zen Buddhism correspond to views that I have held for a long time. For me this is reassuring, no more than that."[82] If an admission of Zen influence is unacceptable, denial, as we see here, may turn on the idea that Zen simply confirms the artist's already developed ideas and is not, as Suzuki argued, the "ultimate fact of all philosophy and religion."[83] For a European artist such as Braque, then, Zen just happened along. It may have offered an alternative way to say and do what was already being thought, but it had no primary claim.[84] Such reactions may reflect a broader rhetoric of "Asian denial," as Bert Winther-Tamaki terms it, which was articulated by a number of European and North American artists alongside Clement Greenberg's (1909–1994) rejection of Asian sources in Abstract Expressionism.[85]

Thus, Zen can stick in the craw but denial has spun the other direction, against what have been deemed false and orientalist Zen projections made by European and North American critics upon the work of Japanese artists active in the postwar decades. Such denial manifests itself in the anti-Zen defense of the Japanese painter Yoshihara Jirō's large-format Circle

Works (J. *en*), a phenomenon I encountered firsthand when the copyright holder of Yoshihara's *White Circle on Black* (1965), his son Shin'ichirō, refused to grant me permission to reproduce the painting in this book because he thought I wished to describe it as being expressive of Zen spirituality or philosophy.[86] I was determined to convince him that my intention was quite the opposite, to mollify such Zen-phobia, but to no avail.[87]

Produced during the last decade of his life, but with antecedents in his preceding "Informel Period" of the 1950s, Yoshihara's Circle Works suggest outward formal resemblances to *ensō* that might be backed up by mention of the artist's familiarity with monastic Zen calligraphy, including the work of the modern Rinzai monk Nantenbō, or, more dubiously, with expectations regarding the unity of his ethnicity and art. As scholars in Japan and abroad caution, however, we get very little traction with *White Circle on Black* and its siblings if we simply search for apposite Zen calligraphy ancestors. This is arguably self-evident given the basic fact that Yoshihara's circles are *paintings*—often large in dimension—that respond to critical debates regarding material, form, figure-ground facture, scale, and spirituality that have rather little to do with Zen or Zen monastic calligraphy (J. *bokuseki*). Reiko Tomii puts it this way: "The white-on-black circle may appear calligraphic at first glance. However, placed on a large canvas, it was made by no splashy instantaneous gesture; the painter slowly built the whole pictorial plane with the heavy materiality of oil paint, from which the white form vividly breaks out."[88]

Nor did Yoshihara title such works "ensō," though this is not to say that calligraphy including that by Zen monks did not matter to him. Far from it in fact, for the artist was among a number of internationalist Japanese artists—including Morita Shiryū (1912–1998), Inoue Yūichi (1916–1985), Hasegawa Saburō, and Yoshihara's colleagues in the Gutai art collective—who were fiercely engaged in the reconceptualization, rematerialization, and re-performance of East Asian calligraphy, testing the boundaries of language, line, form, and material in relation to new creative subjectivities and engaging Western Abstract Expressionist artists exploring Asian calligraphy, such as Franz Kline (1910–1962).[89] Moreover, while it might be tempting to pin Zen on comments the artist prepared for his 1967 Tokyo solo exhibition—namely, that within the nearly impossible challenge of drawing a circle in one perfect stroke resides "an infinite possibility left unknown, lurking from within a bottomless swamp," and that, facing his circle works, he perceived a dialogue between or fusion of self and image[90]— it is precisely in what Yoshihara meant by "infinite possibility" and the self that things become interesting, or perhaps awkward as far as a quick Zen interpretation goes. This seems especially true when read in relation to his

famous "Gutai Art Manifesto" ("Gutai bijutsu sengen"), which asserted the imperative to advance into the unknown and create pictures that do not distort matter but, like the work of Jackson Pollack (1912–1956) and George Mathieu (1921–2012), reveal "the scream of matter itself, cries of the paint and enamel." How, indeed, should we reconcile a desire to find traditional Zen and Zen calligraphy in Yoshihara's circle works with the manifesto's initial polemic burst?

> To today's consciousness, the art of the past, which on the whole presents an alluring appearance, seems fraudulent. Let's bid farewell to the hoaxes piled up on the altars and in the palaces, the drawing rooms and the antique shops. They are monsters made of the matter called paint, of cloth, metals, earth, and marble, which through a meaningless act of signification by humans, through the magic of material, were made to fraudulently assume appearances other than their own. These types of matter (*busshitsu*), all slaughtered under the pretense of production by the mind, can now say nothing. Lock up these corpses in the graveyard.[91]

For Haito Masahiko and other scholars, not surprisingly, Yoshihara's *Circles* and "Manifesto" align not through Zen or calligraphy per se but in their respective and forceful juxtaposition of matter and human spirit, concerns that cannot be collapsed into Zen. The "circle is an image that genuinely approaches the spirit," Haito writes, but it also "facilitates a contradictory state in which the traces of physicality and individuality compete with each other." This, Haito adds, offers a "spiritual depth that European viewers of the time could take as being 'Zen like' [J. *Zen teki*]."[92] Could take, but for Haito this is not the preferred response.

It therefore seems advisable to admit that Yoshihara's circle paintings may not easily be identified as a response to Zen calligraphy (nostalgic or otherwise) and, on the contrary, may be more revealing of the artist's determined participation in multiple discoveries and discourses operating in modern painting in Japan and internationally across the first half of the twentieth century. In Ming Tiampo's assessment, they seek to fulfill his "desire to take a place on the international stage and engage in the kind of artistic discourse in which national boundaries are broken down rather than reinforced."[93] The Zen of Yoshihara's circle works, if there is anything to it, therefore needs to be thought through in relation to decades of his creative work and efforts to establish Japanese art in the postwar period as a full participant in abstraction as it emerged as a transnational contact zone of new art and debate about it. Reiko Tomii sums it up nicely:

In 1959, Yoshihara wrote, "Gutai art does not practice Orientalism." Certainly, *Circle* was no Orientalist project. His initial interest may have been part Japanese (oriental), but the end result was authentic, transcending the facile dichotomy of East vs. West. In a broader context, his probe away from gestural abstraction paralleled the contemporary global tendency toward minimalism and hard-edged abstraction. In this respect, *Circle* embodies the state of "international contemporaneity" that characterized 1960s art.[94]

◎ ◎ ◎

Postwar Japanese film turns out to be another space in which we find entangling claims of Zen influence, inherence, and denial, which we might begin to unravel by tugging first at a comment attributed to the filmmaker Ozu Yasujirō (1903–1963). Responding to international reviews of his film *Late Spring* (J. *Banshun,* 1949), Ozu reportedly countered that foreign critics "cannot understand the life of salaried men, ephemerality, and the atmosphere outside of the story at all. That's why they say it [the film] is Zen."[95] Although it is risky to subpoena single statements such as this, Ozu's riposte suggests impatience with critics who lack direct knowledge of, or concern for, the conditions of postwar life in Japan and Ozu's filmmaking therein, preferring instead a philosophical-aesthetic fantasy of Zen Japan.

As is true for postwar visual art, the Zen-film case presents multiple philosophical, aesthetic, and social relationships. For instance, the actor Hayakawa Sessue—famous for his postwar roles in *Tokyo Joe* (1949) and *The Bridge on the River Kwai* (1957)—framed his 1960 autobiography around Zen and the "mastery of self" that lay Zen practice in Japan taught him, much to the benefit of his career: "Zen gives me a oneness with [the parts I play]. Through Zen I am able to empty my mind of all thoughts that may hinder my performance. What comes out of me comes intuitively, unconsciously, and everything seems natural."[96] Here, then, is a self-proclaimed Zen mode of acting in good standing with Zen-boom beliefs and nothing less, it would appear, than a Zen movie star. The front of Ozu's gravestone, further, displays the single Chinese character, *mu* (nothing/nothingness), a key concept in Zen discourse and a modern hypersignifier of Zen. Perhaps this is the ultimate of autobiographical Zen-filmmaker declarations, the "final word" on Ozu's Zen-ness.

Western film critics, meanwhile, have written paeans to the presence of Zen aesthetics and philosophy (but less so to social and historical

dimensions) in the films of Ozu, Kurosawa Akira (1910–1998), and other Japanese filmmakers. Paul Schrader, in his study of transcendental film style, argues that Ozu's "techniques are so similar to traditional Zen methods that the influence is unmistakable." "Like the traditional Zen artist," he adds, "Ozu directs silences and voids. . . . In Ozu's films it is also possible to detect a remnant of the thirteenth-century one-corner style. A static environment fills Ozu's frame while in one corner a distant action (boats, trains slowly moving, people conversing) occurs." Ozu's "Zen painterly" scenes that limit content to one corner in turn bring out "the quality of the void."[97] As an art historian, I would suggest that similarity in the formal and expressive qualities of works distant in context and medium is certainly beguiling, especially when presented under the presumptive operation of influence. But it may also be possible that the "one-corner style" and its expression of "void" to which Ozu purportedly refers—with its roots in Chinese ink landscape painting not principally Chan and frequently associated with album leaf paintings by or attributed to the Southern Song painting academy artist Ma Yuan (d. 1225)—is a "traditional Zen method" largely, if not exclusively, by virtue of the modern collapse of Sino-Japanese painting into Zen art. If Ozu's film is Zen in this regard, it is arguably a matter of this invented Zen art tradition. Little of this would matter to Schrader, I suspect, since premodern Chinese paintings with putatively "Zen" effects of meditative stillness, void, and quotidian there-ness establish a transhistorical continuum of Asia-as-Zen that allows Schrader in turn to authenticate Ozu as a modern Zen-film master in aesthetic-philosophical terms.[98]

It is not particularly surprising that recent critical film study has challenged this sort of culturalist homogenization of director, aesthetics, and nation-culture as well as the conclusion that the work of Ozu and other Japanese filmmakers manifests a "collective essence called the 'Japanese mind,'" whose epitome, for many writers, is Zen.[99] Better to pay close attention to, they argue, the power relations of film representation and criticism, the ideological constructions of national and world cinemas, and the "racial life of Buddhism" as these topics pertain to (and upend normative) definitions of Buddhist and Zen film. If Zen is present in Ozu's films even after such challenges, it is arguably a very particular sort of Zen-film formation. It is even possible that Ozu's "Zen" silences and voids, *pace* Schrader, may be less significant to Ozu's films than our understanding of how in the postwar decades Zen and film came together in transnational criticism.

But the forthright Zen-ing of Ozu endures. The film scholar Kathe Geist's 1997 reading of Ozu's shot of a train time board in *Tokyo Story* (J. *Tōkyō monogatari,* 1953) heads resolutely in this direction: "When we

first see it, it is blank, a literal tabula rasa, the very image of the 'void' so beloved in Buddhist aesthetics." "There are narrative and symbolic reasons for the shot of the board," she admits, "but no particular reason for it to start out blank, except as a kind of embodiment of *mu* [which she translates as 'void']."[100] Geist also describes a domestic scene in which "characters leave a room going in one direction and enter the next room from the opposite direction," seeing in this case "shades of Zen in his playing with directions." To support this interpretation, she turns to Alan Watts who, she notes, refers to "the *hosshin,* a type of koan, or Zen riddle, posed to students that begins by sending them off 'in the direction exactly opposite to that in which they should look,'" a technique she also identifies in Ozu's *Late Spring.*[101]

Although Geist's reading of Ozu's film sequences is incisive, her less convincing citation of Zen tropes (void) and authorities (Watts) in support of her formal analysis nevertheless reveals a recurring modality of Zen-affirmative art criticism that depends on resemblance aloof from social practice and contextual nitty-gritty and goes something like this: if Ozu's film techniques produce moments, spaces, and movements that look like Zen concepts or visual counterparts to koan, and the maker is Japanese and had even the most general interest in Zen, then the filmmaking must surely be Zen. "The aesthetics of Buddhism in Japan," she adds, "have changed with history, but its artifacts remain, as do its basic philosophical contours, which even today influence thought, behavior, and institutions in Japan." With this reductive statement, Geist largely sidesteps inquiry into the filmmaker's specific encounters with and responses to Zen, his apparent denial of Zen, and other approaches to Ozu's films. Committed as she is to this view, a potentially false resemblance to Zen void and the like in Ozu's films would be unthinkable.

Moreover, in making this case Geist is noticeably undeterred by David Bordwell's prior call for more suspicious inquiry into what "Japanese tradition" and "Zen aesthetics" might mean specifically to Ozu, and Bordwell's skepticism regarding "dispositional explanations." "Not all Japanese directors fit the 'Zen aesthetics' case," he points out, "so Ozu's living in Japanese society is not enough to cause its presence in his work." Moreover, "any such use of Zen in Ozu is not direct, let alone distinctly religious, but will be mediated by proximate historical practices." Unconvinced by the evidence other critics offer for Ozu's "unusual interest in traditional arts" or that he was "a devout Buddhist or that he had a keen interest in Zen," Bordwell nevertheless suggests that a Zen reading may not be incorrect in a given case, pending provision of evidence and proper historical and hermeneutic suspicions.[102]

Whether we like it or not, however, the "dispositional explanation"—with its thin contextual inquiry, reliance upon resemblance, and essentialist tendencies—is one of the "truths" of modern Zen art criticism, the product of a recognizable Zen worldviewing that prioritizes Zen's permeation into multiple media, including film, in distinction from other beliefs, systems, and ideologies. Put differently, those who argue for Ozu's "Zen-infused sensibility" and Zen filmmaking are not categorically incorrect.[103] The matter is more precisely that we should get the categories and interpretive processes straight and historicize them. We should ask whether or not silence, void, the "empty shot," "meditative moments around the nonhappening," and other (im)material features are ineluctably Zen, postwar Zen, or, as David Desser suggests, indicative of other modernist fascinations.[104] Perhaps they are just "Ozu-like," Desser adds, rather than Zen-like.[105]

It would certainly be fair to say that scholars such as Bordwell and others, myself included, maneuver in one direction of Zen denial (historical, analytical resistance to essentialist notions of Zen influence and inherence), but Geist moves in another. It appears that, for Geist, Ozu protested too much in his retort to foreign critics who found Zen in *Late Spring* and is thus not to be believed. "Not only is ephemerality (*mujo*) a Buddhist concept," she states, "but Ozu's dislike of having his work labeled as such is itself Zen-like. 'The basic position of Zen is that it has nothing to say, nothing to teach,' writes Alan Watts."[106] She therefore seems to say: I will discount your denial of Zen by pointing to how Zen your denial is; a Zen filmmaker would, by nature, reject being characterized as a Zen filmmaker.[107] Of course we might ask in turn: what if Ozu's understanding of Zen, of what is Zen-like, was not the same as Geist's, whose cited authority is Alan Watts? We might wonder, too, if Geist—implicitly denying Ozu's reference to "the life of salaried men, ephemerality, and the atmosphere outside of the story"—effects, to quote Karatani Kōjin, "a certain bracketing of the concerns of pedestrian Japanese, who live their real lives and struggle with intellectual and ethical problems inherent in modernity" in order to valorize an "aestheticentric" love of Zen Japan.[108]

Nonetheless, by denying Ozu his denial of Zen to establish his work's Zen-ness, Geist takes us further into the Zen-art discourse, and in fact this sort of Zen denial appears to have been in play for some time. In 1955, the expressionist painter Rudolf Ray (1891–1984) exhibited a series of portraits of D. T. Suzuki at Manhattan's Willard Gallery. A *Time* magazine review noted that

The final portrait was a handsome, delicately painted oil that looked like a faded Buddhist scroll suggesting blue mountains, red sky and

willow-green foreground. At this point, according to Ray, Suzuki and Zen Buddhism became one. Philosopher Suzuki, on hand to see his portrait for the first time, was not so sure. Said he: "I know nothing of these things. Therefore, I cannot say." Prompted by Painter Ray ("You have said that when you say you don't know, then you know"), Philosopher Suzuki bowed with a smile, politely admitted: "That too can be true."[109]

In the review's account of this exchange, Suzuki's initial reticence or refusal seems to give way, through partial acquiescence, to the sort of statement that would, if anything, enhance an impression that the demurring Zen subject is all the more Zen.

Something similar may have been present in Cage's search for the Zen in Marcel Duchamp, despite the fact that the latter, to follow Alexandra Munroe, "famously denied any interest in Zen whatsoever."[110] As Cage recalled,

> I asked [Marcel Duchamp] once or twice, "haven't you got some direct connection with Oriental thought?" And he always said no. In Zen, the student comes to the teacher, asks a question and gets no reply. Asks a second and third time, but no reply. Finally he goes off to another part of the forest, builds himself a house, and in three years runs back to the teacher and says "Thank you." Well, I heard recently that a man came to Marcel with a problem he hoped Marcel would solve. Marcel said absolutely nothing. After a while the problem disappeared and the man went away. It's the same teaching method as the Oriental one, and it's hard to find examples of it in the West.[111]

Although Cage admitted that there "weren't any specific oriental sources" in Duchamp's work, he also suggested that Zen came to Duchamp in a sort of osmosis through the Zen-like things said by others, including "Emerson, or Thoreau, who said yes and no are lies, or Schopenhauer, who said that the highest use of the will is the denial of the will."[112] But here again is the interesting logic: Duchamp's denial of "direct connection" to Zen or Daoism, his opposition to religion, and his "no reply" in the face of entreaty are apparently all the right signs of Oriental thought, including Zen, and just the sort of thing a Zen master purportedly does. Cage's own release of Zen from responsibility may likewise suggest this pattern; he may seem all the more Zen-like for putting some distance between his work and Zen. In one of postwar Zen's convolutions, then, the denial of Zen's influence or inherence may turn inside out to authenticate the presence of Zen.

"THE STROKE, WHATEVER IT IS, MOVES JUST TOO MANY THINGS"

Postwar artists in the West continued to encounter and sometimes dodge Zen-affirming interpretations of their work. In 1971, Mark Tobey, who spent a month in a Zen temple in 1939 and became famous for his "White Writings" inspired partly by Asian calligraphy, was asked by the Japanese critic Takemoto Tadao: "What attracted you most in Zen? Its relation to art? Was it, for example, the 'interior space,' or 'emptiness,' or 'accidental value'?" These are key concepts in postwar Zen art criticism, but Tobey, now eighty-one, demurred. "I don't put much stock in that," he responded. "I think I find these men, the monks, more interesting. I think they are real men. They were more interesting than the people who tried to make forms." Takemoto, still trying, replied, "But, your paintings may have the same point of departure as these Zen ideas." Tobey, at least at this late date in his career, would have none of this: "Well, I can't say that. I don't know, but what I do just seems normal to me now. The stroke, whatever it is, moves just too many things. I'm sorry, but a lot of Americans get ahold of these ideas, and I don't know what they do with them."[113]

Much like Cage's release of Zen from responsibility, Tobey's response to Takemoto brings fresh air into the Zen-art discourse. Tobey's works are icons of modernism in which, given his encounters with Zen and calligraphy in Japan, we might expect to find Zen philosophy and associated aesthetics. That being so, and this perhaps is Takemoto's sense, Tobey's paintings may not merely bridge between cultures but, more acutely, in their purported debt to Zen, demonstrate Zen Japan's unique contributions to twentieth-century avant-garde art. But Tobey, despite earlier affirming remarks about Asian philosophy and Zen, the way in which Asian calligraphic line liberated him from the West's emphasis on mass, and his contact with Japanese Zen masters and the writings of Suzuki and others, declined to confirm Zen's importance to his work. Perhaps he recanted or had simply moved on from Zen. More likely, as Bert Winther-Tamaki argues, he was never the sort to subsume himself under the influence of Asia but sought a "universal writing," albeit one secured in an American exceptionalist sensibility. Certain American reviewers, meanwhile, valorized his work as having emerged from a preceding formation into which his interests in Asian calligraphy and Zen were simply assimilated—a denial, as Winther-Tamaki puts it, of "Japanese incursions" into American identity.[114] Perhaps the question of Tobey's work bends not on the question of Zen or not Zen but the hinge of United States–Japan Cold War geocultural politics.

What, then, was true Zen and true Zen art in the postwar period? Who taught and explained Zen authentically, and who was doing Zen, and doing it correctly? How does Zen find its way into art; how do artists absorb, practice, express, appropriate, and mediate Zen in their creative work? Who acquires authority as a Zen artist, and which sort of Zen does their work arise from and express?

On the postwar ground and in its spheres of discourse the answers to such questions were multiple, sometimes at odds, and they changed. Some participants in the Zen boom took a side, and others seem to have taken several sides at once or over time. New forms of art associated with Zen and being made within avant-garde contexts by non-monastics and non-meditators joined old Zen art made within and for monastic contexts. Zen-influenced art became a term of postwar admiration. For some it was a label to exploit or claim, and for others it was something to shrug off, implying, as Cage seemed to, that they were being themselves as artists rather than being merely Zen. If there was commitment by artists around the world to Zen practice and insight, there was also orientalist appropriation and etherealizing projection as well as Cold War jostling for authority over Zen and its visual and material presences. Art was therefore part of the Zen "culture war" of the late 1950s and early 1960s. Perhaps we might say that the worlds of Zen and art, to borrow from Randall Jarrell, "understand each other worse, and it matters less, than either of them suppose."[115] Nevertheless, some of us are still trying to work out what and where these worlds are and what we might say about them.

7

WHAT'S SO FUNNY?

ZEN CARTOONS, ZEN HUMOR, AND BODHI-CHARACTERS

ACHILLES: That koan is very serious. I don't know how you got the idea that it is humorous.

TORTOISE: Perhaps Zen is instructive because it is humorous.

—Douglas Hofstadter, *Gödel, Escher, Bach*[1]

Can we ever know how, or why, people in the past laughed? What difference does it make that we barely can explain why we ourselves laugh?

—Mary Beard, *Laughter in Ancient Rome*[2]

What is a Zen cartoon? This is not an earth-shaking question, but as it concerns cartooning it might promise amusement. A case for asking the question—for taking Zen cartoons seriously as "small bits of symbolic behavior"[3]—might start from their not infrequent appearance, especially in English-language venues. It might build from the field of critical cartoon study and debates regarding cartoons in interreligious encounter and religious extremism. Anecdotally, Zen cartoons elicit considerable enjoyment. Pinned on a bulletin board, held in place by a refrigerator magnet, "liked" online, and marketed in reproduction by cartoon banks, they move more deeply into our lives than might be expected given their ostensibly ephemeral nature. Zen cartoons also raise the topic of Buddhism and humor, or perhaps Buddhist humor, and the claim that Zen is fundamentally humorous. I want to engage this claim and by doing so probe the relationship between Zen and popular culture. Having said that, the question "What is a

Zen cartoon?" requires work in order to be effective, like its kindred question "What is Zen art?"

A working definition of a Zen cartoon with enough slack to not trip us immediately might be a picture with or without caption, that addresses with humorous intent, and perhaps effect, Zen-related concepts and practices as well as people engaged with Zen—in distinction from other traditions and communities, religious or otherwise. As a form of in-group humor, and sometimes for the purpose of proselytism, cartoons appear in Chan/Sŏn/Zen communities and draw from their traditions' visual and literary past. Others are situated in spaces among or between traditions and cultures, with humor bridging, blurring, or confounding exchange between them. A Zen cartoon might appear in small-print publication, in syndication, online, and on spin-off goods (mugs, T-shirts, and the like).

The question's finer grain concerns particular Zen concepts and practices singled out for cartooning. As I have already suggested, there are multiple sorts of Zen; which are relevant to cartooning, and why? Further, we might want to know if Zen cartoons look "Zen," deploy graphic gestures that signify "Buddhist" or "Asian" religious or philosophical states and aesthetics, or create visual puns that work from Zen practices and concepts towards humor. Do Zen cartoons employ an "iconography" of figures or types, particular narratives of revelation, and apposite spaces in which (humorous) Zen events transpire? What triggers amusement in a Zen cartoon, and who is (or isn't) amused by it?

Of course, one might ask if Zen cartoons have anything at all to do with "actual Zen" as a religious practice or with Buddhism as a religion concerned firstly, in one definition, with the alleviation of suffering (Skt. *duḥkha*). Laughter can relieve suffering, but is this capacity necessarily Zen or Buddhist? Do Zen cartoons depend on the modern translation of Zen into spirituality and Zenny attitudes—away from monastic and ritual-based practices, communities, and traditions? Perhaps they produce cultural spaces not intrinsically concerned with Zen but something looser, more malleable, yet still Zen in certain senses, to some.

I raise such questions because I am comfortable neither with the outright dismissal of pop-Zen—treating it as "cultural junk," as one Zen teacher put it—nor with its uncritical consumption.[4] I hesitate to enforce strict borders between "pure" Zen, something spiritual, and what some deem derivatively cultural; their interrelationships seem more interesting and to the point. The Zen cartoon offers a space in which to consider such irresolution and interrelationship. But how, indeed, did Zen find its way into so many quadrants of popular culture, including cartooning? What did this do to Zen? Such questions suggest that it might be productive to treat

Zen cartoons as one of many modern-contemporary "contact zones" of reli-
gion, spirituality, race-ethnicity, and visual culture. One might also focus
on the persuasive force, if any, of Zen cartoons. Do they help us to better
understand Zen, or something else? Does mirth come at Zen's expense, or
does it enhance Zen's spiritual or religious value? Perhaps there is humor in
self-recognition. How many consumers of Zen cartoons practice meditation
and listen to the teachings of Zen monks and nuns, and how many read
books and magazines concerned with Zen, Buddhism, and Asia-inspired
spirituality? Or is the target audience of the Zen cartoon generally different?
Has Zen become a vernacular for exposing to satire other attitudes, behav-
iors, or beliefs? If so, should we be concerned about appropriation? Might
Zen cartoons be disrespectful to those with orthodox, sincere Zen practice
or a Zen spiritual habitus? Do "real Zen practitioners" simply ignore this
stuff or put it to good use? We might also take a step back and ask: What
does it mean to chuckle about or smile wryly at cartoons associated with a
religious tradition or spiritual path, one's own or those of others?

If these sorts of questions matter—even if they threaten the subject's
presumed fun—they make it difficult to dismiss Zen cartoons as inconse-
quential and ephemeral. Indeed, how they represent Zen may tell us some-
thing about Zen's reception and transformation and modern-contemporary
spiritual cultures. We might also give cartoonists their due. What does it
take to "get the Zen" into a cartoon, to capture in brief visual and verbal
gestures a recognized and interesting Zen motif, action, or predicament
(with orthodoxy and authenticity potentially beside the point), and to elicit
humor?

My proposal here is that we treat Zen cartoons as active repre-
sentations. Perhaps their diminutive size, which belies their "visceral
effectiveness," indicates that we might engage them as, to borrow from
Catherine Gallagher and Stephen Greenblatt, anecdotes within a larger
visual and textual history of Zen or Zen culture or, from Simon Critchley,
"small anthropological essays."[5] As such, and borrowing again from Galla-
gher and Greenblatt, Zen cartoons may "puncture" the usual or grand nar-
ratives and guide us towards a deeper sense of our Zenny zeitgeist.

ZEN CARTOONS IN *THE NEW YORKER*

By Zen cartoon, I refer here to one-panel pictures with or without captions.
I therefore bracket off comic strips, animation, and various sorts of graphic
work with Zen-associated content, as well as paintings by Japanese Zen
monks such as Hakuin Ekaku and Sengai Gibon (Plate 2, fig. 9).[6] Although

such paintings suggest to some viewers the ancestors of present-day Zen cartoons, they turn out—when studied in their historical and discursive contexts—to be surprisingly orthodox in religious theme and aim, more concerned with Buddhist soteriology than mirth per se.[7] The historian of Zen Yoshizawa Katsuhiro has been strongly critical of those who treat works by the Zen monk Hakuin as cartoons (*manga*) or comic pictures (*giga*):

> [The art historian] Takeuchi [Naoji, 1914–] may have described [Hakuin's paintings] as "jokes" out of a failure to understand their true meaning; in any event it is the case that their religious significance has never been examined from a historiographical standpoint. The most they have received are arbitrary interpretations at the hands of Hakuin aficionados. In any event, these paintings are not comics, but are profound religious messages expressed with all of Hakuin's powers of artistic creativity and technique. Attempts to understand them intuitively on the basis of aesthetic sensitivity or religious perception can never reveal their true inner meaning. Only familiarity with the entire body of Hakuin's work can provide the context necessary for discerning what these paintings are trying to convey.[8]

Yoshizawa is insistent: rather than paintings "inspired by a playful or humorous or even satirical intent," therefore, Hakuin's works are grounded in "the desire to express the most fundamental Mahayana principle of 'striving toward enlightenment above, working to save others below.'"[9]

My unscientific survey of Zen cartoons is based primarily on examples published in *The New Yorker* magazine, a venerable cartoon venue, with additions from the cartoonist Dan Piraro and others. Frequent *New Yorker* readers are familiar with its cartoon themes and the signature styles of individual cartoonists. Manhattanites and those who are fond of urban-affluent New York cultures—the customs, tribulations, and absurdities of life in New York, of a privileged demographic—are accustomed targets of its cartoon humor, which typically pokes fun at occupations (tycoon, banker, psychiatrist, socialite, parent, and so on) and mocks New York attitudes, affluence, trend, and scandal, while also setting up "humor" through racial-ethnic stereotypes and class-based scenarios.[10] Religion and spirituality also have recurring if largely uncontroversial presences in the magazine's cartoons (rather than on its covers), and tend to focus on Christian, Buddhist, and Hindu monks, judgment by Saint Peter at the Gates of Heaven, and the guru on the mountaintop. Whimsy derives often, and not unexpectedly given cartooning conventions, from an incongruously banal facet of contemporary life, a colloquial phrase, or an unexpected or even un-saintly behavior

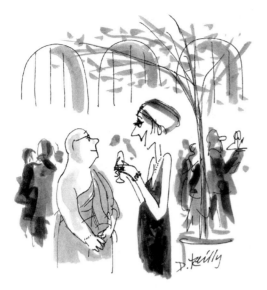

"I imagine serenity's pretty much the same, one season to the next?"

FIGURE 14. Donald Reilly, "I imagine serenity is pretty much the same, one season to the next." *The New Yorker,* July 7, 1977. Donald Reilly/The New Yorker Collection/The Cartoon Bank.

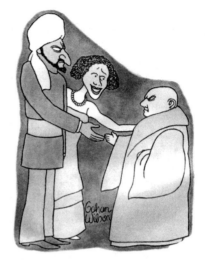

"Swami Ananda, here, has also discovered the secret of life!"

FIGURE 15. Gahan Wilson, "Swami Ananda has *also* discovered the secret of life." *The New Yorker,* March 13, 1978. Gahan Wilson/The New Yorker Collection/The Cartoon Bank.

introduced into a religious mis-en-scène. Although religious themed cartoons may focus on the cloister or meditation hall and mimic monastic garb and demeanor, they often stage the encounter or crossing of traditions and cultures. Sometimes they mock affluent, white spiritual pretension and privileged behavior (figs. 14, 15).

Beginning in the 1950s, and coinciding with the Zen boom, discussed in Chapter 5, *The New Yorker* and other mass media publications began to publish cartoons that work from notions of Zen monasticism, meditation, enlightenment, and philosophy; focus on the teaching Zen master, meditating monk, and convert or Zen curious follower (the first two categories often Asian in appearance, the last two frequently white); and hover in spaces suggestive of a monastic or Asian locale. Zen communities took note. In 1958, Mary Farkas commented in *Zen Notes,* the newsletter of the First Zen Institute of America, that "The *New York Times* delighted us as it appalled us with its cartoon of the matron who came into the library to 'Take a stab at Zen Buddhism.'" Not to be outdone, perhaps, the newsletter had its own cartoons drawn by William A. Briggs (fig. 16).[11]

For regular readers of *The New Yorker,* the appeal of a Zen cartoon may lie partly in a given cartoonist's style rather than a thoroughgoing "Zen" graphic style, such as one finds in design and advertising contexts. That said, some of the magazine's Zen cartoons use iconographies popularly

associated with Zen, such as the calligraphic circle (J. *ensō;* figs. 1 and 17). Others describe minimalist settings suggestive of meditation halls or Japanese temple architecture more generally.

A cartoonist may also work from the purportedly nonmaterialistic, minimalist lifestyle/aesthetic of Zen. The Zen master "hoarder," for instance, sits in a room immaculately devoid of clutter and chaos (fig. 18). A few simulate works of calligraphy with faux-Chinese characters (fig. 19).[12] Accuracy, as I note below, is not necessarily a high priority; it is the believable simulation that matters.

Few of these cartoons go for cutting satire or ridicule. They leave particular senses of Zen more or less intact, amusing and slightly exotic. Or, they turn scrutiny away from Zen practice itself to parody Zen's permeation into American culture. Some cartoons are admiring of their Zen characters; they appear warmly human. If some elicit quick amusement or a chortle, others may be quizzical. A sense of the enigmatic may be one intended effect—the abstruseness that is inherent, presumably, in a Zen sort of humor, evocative of a Zen master's apparently mystical, non sequitur utterances, or related to the racist stereotype of the "inscrutable Oriental." In other cases, a lack of comedic access may arise from a cartoonist's allusion to Zen practice and literature legible only to a narrower, practicing audience.[13]

In general, *New Yorker* Zen cartoons have a limited range of content and kit of humor-triggering devices. If you have no clue what meditation

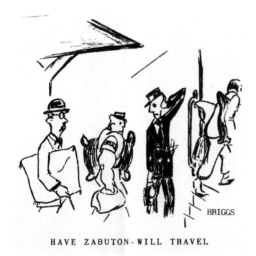

HAVE ZABUTON-WILL TRAVEL

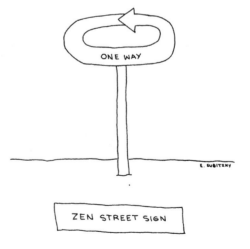

FIGURE 16. William A. Briggs, "Have Zabuton—Will Travel." *Zen Notes* 6, 8 (August 1959).

FIGURE 17. Ed Subitzky, "Zen street sign." Tricycle, *Buddha Laughing: A Tricycle Book of Cartoons* (New York: Bell Tower, 1999), 67.

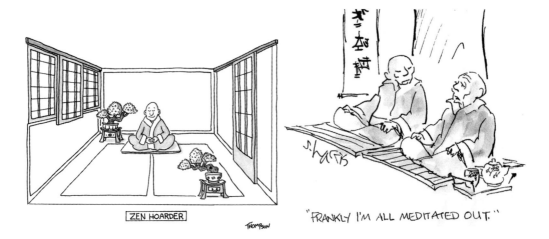

FIGURE 18. Mark Thompson, "Zen hoarder." *The New Yorker,* August 27, 2012. Mark Thompson/The New Yorker Collection/The Cartoon Bank.

FIGURE 19. Sidney Harris, "Frankly I'm all meditated out." Cartoon Stock.com.

is, what one is supposed to do in a meditation hall, or what the trope of Zen nothingness signifies (at least in popular culture), then the joke may elude you. But that which sets up Zen for comedic denouement, or suggests a particular "Zen" sort of humor, is fairly conventional. Occasional novelties aside, this is not an "A.D.H.D." domain of popular culture, with dis-focused switching among Zen-related themes. To assume a reader will "get" these cartoons—and the reason they pass editorial review—implies an audience primed to recognize certain Zen tropes and that anticipates the general manner in which they may be inflected in *New Yorker* humor.

Thus, we find Zen-associated concepts of emptiness, nothingness, no-thought, and nonattachment interpolated into contemporary colloquialisms, built up with wordplay, and situated in everyday cultures to yield a sense of the exotic in the familiar, irony hued with the transcendental, and sometimes a dilemma or struggle that suggests in a witty way the cartoonist's familiarity with Zen practice (figs. 20–23). In "Zen Crossword Puzzle," Dan Piraro (b. 1958), working outside *The New Yorker,* imagines a monk facing a wall-size Zen crossword puzzle with one white and one black square and a single prompt: "Across: 1. Nothing; Down: 1. Nothing."[14] Zen practitioners generally do not face a blank wall of this sort during meditation, but the "negative space" serves as the surface for contemplating the koan-like crossword puzzle. Piraro's "Zen Birthday Card," meanwhile, gives us a seated monk reading the card's caption, "Not thinking of you."[15]

Given their captions, Piraro's cartoons set up their category explicitly, but they also work from visual recognition of the figure of the Buddhist

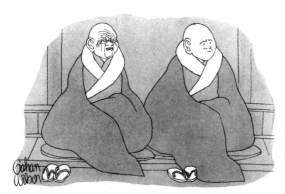

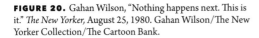

"Nothing happens next. This is it."

FIGURE 20. Gahan Wilson, "Nothing happens next. This is it." *The New Yorker,* August 25, 1980. Gahan Wilson/The New Yorker Collection/The Cartoon Bank.

"None of this seems to be doing me any good at all!"

FIGURE 21. Gahan Wilson, "None of this seems to be doing me any good at all." *The New Yorker,* October 24, 1994. Gahan Wilson/The New Yorker Collection/The Cartoon Bank.

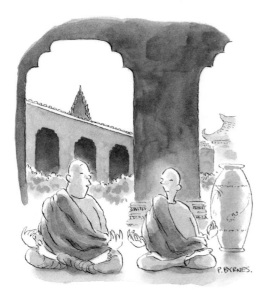

"Are you not thinking what I'm not thinking?"

FIGURE 22. Pat Byrnes, "Are you not thinking what I'm not thinking?" *The New Yorker,* January 15, 2001. Pat Byrnes/The New Yorker Collection/The Cartoon Bank.

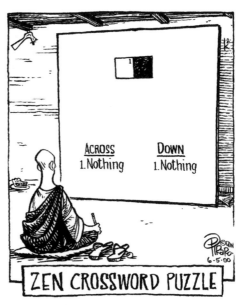

FIGURE 23. Dan Piraro, "Zen Crossword Puzzle." June 5, 2000. © Dan Piraro.

monk, with shaved head and robes, seated posture, and a space that implies meditation. A number of Zen cartoons differentiate the Asian and almost exclusively male Zen master from their male and female Western followers, often white, using a caricatured representation of Asian physiognomy and physique, verging towards renderings that recall racist anti-Chinese and anti-Japanese propaganda of the late nineteenth to twentieth centuries. Some appear to play off of the trope of the Happy or Laughing Buddha or the wizened and bearded Zen master as embodied in Master Po in the television series *Kung Fu* or, later, the *Star Wars* character Yoda.[16]

For a cartoonist, accuracy of portrayal may be a moderate threshold to cross. In Piraro's blog entry titled "The Sound of One Hand Inking" (punning on "What is the sound of one hand clapping?" the widely known modern formulation of a koan by Hakuin), the cartoonist responded to readers who criticized the inaccuracy of one of his cartoons depicting Moses:[17]

> Okay, I admit I don't know anything about Zen Buddhism, but the whole "nothingness" thing is a common conception and cartoons are often built on these, whether correct or not. . . . In spite of this flippant attitude toward history, I actually do try to be more accurate in my cartoons than do most cartoonists. I research historical costumes and such, to get things *mostly* right, and often look up what certain objects look like to add that extra bit of convincing detail, even though I'm perfectly capable of an approximation out of my own head. But if the accuracy conflicts with the joke, as it would have in the Moses cartoon, I toss it out and use the common misconception instead.[18]

Knowing nothing about Zen save for "nothingness," getting things "mostly right," or making use of the "common misconception" seem to be quite the point for the cartoonist, actually, as cartoons are not thick ethnographic records but purposefully thinner representations that, for better or worse, rely upon already appropriated and domesticated customs and images. The convincing details of the Zen subject and space—so far as they go, researched or known firsthand but not in too much detail—function as the focusing agents for the Zen-flavored send-up (of Zen or something else) that is the cartoon's main action. Depict a monk, a meditation space, or a Zen-associated concept, and you are on your way to a Zen cartoon.

Not surprisingly, the utterances and demeanor of the Zen master are perennial topics, often mashed up with clichés of Asian culture and "behind the scenes" glimpses. Gahan Wilson, for instance, stages a cartoon in a monastery kitchen, where the wrinkled master's authority is rendered through a culinary vernacular fused to yin-yang (fig. 24), while Ed Fisher gives us

"Enough yin. More yang."

FIGURE 24. Gahan Wilson, "Enough Yin. More Yang." *The New Yorker,* April 12, 1976. Gahan Wilson/The New Yorker Collection/The Cartoon Bank.

"As Jerry Brown says . . ."

FIGURE 25. Sidney Harris, "As Jerry Brown says . . ." *The New Yorker,* July 30, 1979. Sidney Harris/The New Yorker Collection/The Cartoon Bank.

a monkish figure confessing his inability to discern yin from yang.[19] Other cartoons attempt humor by shifting authority to an unexpected figure. Sidney Harris gives us a Zen monk who explains to a colleague, as if quoting an ancient Zen master or Buddhist scripture, that, "As Jerry Brown says . . . ," the authority cited here being California's governor during his first term (1975–1983), known for his study of Zen (fig. 25).[20]

Some Zen cartoons provoke amusement by insinuating a Zen-associated concept or character into a prosaic colloquialism, thereby rephrasing it to ironic, exotic, yet proximate effect while lampooning Zen's banality. "Forget the lawyers!" a caption to a cartoon by Frank Modell reads, "You tell him that my roshi will be in touch with his roshi!"[21] Others appropriate modern Zen clichés and proto-memes, most notably "Zen and the art of —," derived from Robert Pirsig's 1974 novel, *Zen and the Art of Motorcycle Maintenance: An Inquiry into Values,* and followed by countless subsequent appropriations of Persig's title—Zen and the art of corporate management, running, making a living, falling in love, stand-up comedy, casino gambling, knitting—ad nauseam.[22]

Warren Miller's 1991 "Zen and the Art of Bankruptcy" depends on an audience familiar with Persig's title (even if they have not read the book itself) or sundry appropriations (fig. 26). Miller's cartoon attempts nothing so large as that attributed to Pirsig's novel, but its humor may come from its "liberating" intrusion of a Zen or Zenny attitude into the rough-and-tumble of business and capital. The cartoon's performer is, I take it, a white-collar office worker or perhaps business owner who adopts a pseudo-yogic pose (a variation of the "Warrior Pose" or Vīrabhadrasanāsana?) and appears

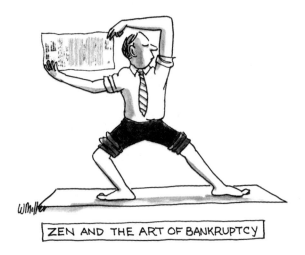

ZEN AND THE ART OF BANKRUPTCY

FIGURE 26.
Warren Miller,
"Zen and the Art
of Bankruptcy."
The New Yorker,
July 22, 1991.
Warren Miller/
The New Yorker
Collection/The
Cartoon Bank.

unworried despite the specter of financial ruin embodied in the document held aloft. That it is a pose unrelated to Zen meditation (even walking meditation) suggests the pop-culture propensity for mixing reductive metaphors of Asia, here Yoga and Zen.[23] Perhaps, too, the cartoon suggests an amusingly incongruous Wall Street reenchantment-via-ruin of the social "square," the target of much counterculture, antiestablishment scorn. A counterpart to Miller's cartoon might be Gahan Wilson's depiction of a lawyer or investment banker leaning back in his leather chair with a subordinate saying to him sycophantically, "Well, all I can say, sir, is that it's a darn good thing for Barton, Franklin, Battersby, Klempstein & Pierce that you decided not to become a Zen monk."[24]

It should provoke little surprise that Zen cartoons borrow the best-known koan in America, Hakuin's "What is the sound of one hand clapping?" In Mark Parisi's, "Ring Tone for Gurus," one bearded guru on a mountain laments to another, "I can't decide on a ringtone. . . . It's between a tree falling in the forest and one hand clapping"—a combination of Hakuin's koan and the now clichéd question posed by the philosopher George Berkeley (1685–1753), "If a tree falls in a forest, and there's no one there to hear it, does it make a sound?"[25] Here a banal decision of cell-phone life turns into something philosophically, absurdly more; how will either choice, the gag goes, alert you that someone's calling, and what might this realization mean? Then there are Paul Noth's plainclothes detectives who confront a guru meditating on a mountaintop, "You can tell us the sound of one hand clapping here or you can tell us downtown," and Dave Coverly's "Zen and The Art of Child Discipline," with a monk-parent instructing his child, "When you feel the urge to act badly, my son, ask yourself this: What Is the Sound of One Hand Spanking?"[26] Parisi's "Meditating Cats Question Sounds," meanwhile, takes the koan and popular "Zen cat" trope in a yucky direction: a cat-monk seated in meditation asks a pupil, "Ask yourself . . . What is the sound of a hairless cat coughing up a hairball?"[27] The caption for Jorodo's cartoon of a monk doctor writing out a prescription for a younger monk zings us with the vulgar: "Zen VD Clinic: You've got a dose of one hand clap."[28]

"You notice how these telephone pitches always come just when you're about to achieve satori?"

"You can't handle the meaning of life!"

FIGURE 27. Gahan Wilson, "You notice how these telephone pitches always come just when you're about to achieve satori?" *The New Yorker,* June 10, 1996. Gahan Wilson/The New Yorker Collection/The Cartoon Bank.

FIGURE 28. Gahan Wilson, "You can't handle the meaning of life!" *The New Yorker,* February 12, 2001. Gahan Wilson/The New Yorker Collection/The Cartoon Bank.

In many Zen cartoons, the place of meditation—seemingly timeless, a bit exotic, a place to quiet the mind—presents monks conversing in ways that contradict the expectation that the meditation hall is a place of undistracted ritual, rigorous discipline, and awakening. Less common are cartoons that suggest orderly practice and Zen equanimity or contentment; it is funnier to see meditation disrupted or made fraught by the non-Zen quotidian.

Gahan Wilson may be *The New Yorker* cartoonist most enamored of the Zen meditation hall as cartoon stage. Wilson's Zendō cartoons vaporize the space's expected rigor and gravitas through the intrusion of contemporary givens or by channeling aspects of Zen practice into the cultural mainstream or meme of the moment (fig. 27). In one case, Wilson rescripts the ritual of Dharma debate between a Zen master and disciple through a memorable (and variously appropriated) scene in Rob Reiner's film, *A Few Good Men* (1992), in which the lieutenant Daniel Kaffee (Tom Cruise), goads Colonel Nathan Jessup (Jack Nicholson) into saying, "You can't handle the truth" (fig. 28). Wilson's Zen master scolds a younger monk, "You can't handle the meaning of life!" I find the conflation a bit unnerving, but this is partly what the cartoonist wants, I suspect—to pull the viewer towards surprising but compelling relationships—the Zen meditation hall and the military courtroom; hierarchy and competition; and the superior testing the inferior. The rhetorical moves between one trope and another turn on notions of truth (factual, legal, existential, and spiritual), shuttling between master-disciple and monastic-military homosocial cultures. Perhaps it is

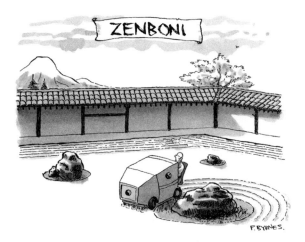

funny because such interrelations leave "pure" Zen (or actual Zen monastic discourse) behind, as they move into the space of popular culture, and then shift back to, well, a different sense of Zen.

Given the propensity of, if not need for, cartoonists to leverage the Zen familiar, it is also unsurprising that Zen rock gardens—mimicking the famous garden at the Kyoto Zen temple Ryōanji—are another preferred setting (fig. 3). The broad, raked gravel of Ryōanji's South Garden and other famous dry landscape gardens in Japanese Zen temples have functioned since the early twentieth century as nearly tabulae rasae for modern philosophical and aesthetic exclamations about Zen.[29] In cartoons, the Zen rock garden becomes a field in which the cartoonist may plant the unexpected, irreverent, and contemporary, even as humor or irony depends upon a stable set of conceptions about such gardens and their representation. Pat Byrnes' "Zenboni" gives us a Ryōanji-esque garden with a monk riding a Zamboni ice-rink resurfacing vehicle modified to create the distinctive raked patterns that mark the gravel surfaces of real gardens (fig. 29). One can imagine that this cartoon began in wordplay, followed by the switch from smoothing the surface to evocative marking, while the yin-yang logos adorning the machine again conflate tropes of Asia.

Leaving aside the fact that formal Zen meditation is conducted primarily in meditation halls rather than garden spaces, the insertion into Zen cartoon rock gardens of the boxy, predigital-age television or more up-to-date flat-screen monitor in place of a grouping of rocks, is an obvious cartoon disruption via purposeful intrusion—an "icon" of modern-contemporary image-consumption society, with its loud, commercialized fantasy realms of entertainment, placed discordantly into a space embodying pre-tech and quiet orthodox Zen or spiritually rich cultural tradition (figs. 30, 31); for the art-informed Diffee's cartoon might even bring to mind Nam June Paik's *TV Buddha* installations, in which seated figures—buddhas, other Buddhist figures, and Paik himself—watch (meditate on) live-feed images of themselves. But the set in Diffee's cartoon is unplugged, and the remote in the monk's left hand advances—what? Nothing perhaps, which brings to mind David Sipress' cartoon of two monks facing a television and captioned, "There's nothing on. Excellent, let's watch that."

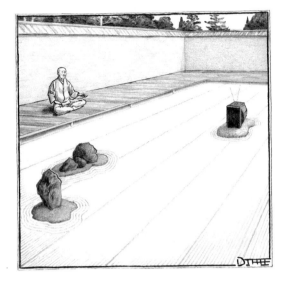

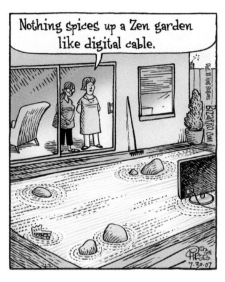

FIGURE 30. Matthew Diffee, Untitled. *The New Yorker,* December 17, 2007. Matthew Diffee/The New Yorker Collection/The Cartoon Bank.

FIGURE 31. Dan Piraro, "Nothing spices up a Zen garden like digital cable." July 30, 2007. © Dan Piraro.

In Piraro's hands, playing with the trope of nothing, the staid Zen garden, now located in a prosaic residential backyard rather than a temple, is apparently saved from tedium by the addition of exotic hyper-channel cable television; the garden has been displaced as the focus of attention by this latest purchase. There is also a homey Americana addition: a second group of rocks has been replaced by a piece of (apple?) pie.[30] Perhaps such cartoons juxtapose the idea of motile imagery with a garden's apparent physical and material stillness or fixity. Or perhaps they juxtapose the nothingness of the abstract or nonmimetic Zen garden, and the Zen awareness that may arise from meditating on it, with the television-age cliché, leveraged by Sipress, that there is nothing worth watching.

Meanwhile, the amusement of the unexpected intrusion, or perhaps a secret revealed, is captured playfully in Nonaka Toshihiko's cartoon on the theme of "trouble" *(komaru)*, published in 2007 in *Yomiuri shinbun,* one of Japan's major newspapers. Here, a master has caught a young monk tending a colorful flower in the otherwise conventional rock garden (fig. 32).[31] The dilemma—who, in fact, is "in trouble" (master or monk)—is perhaps a lighthearted koan of sorts that calls into question the "Zen-ness" of the Zen garden, generally thought to require monochrome and non-decorative features. In terms of thoroughly inappropriate Zen gardening practices, Piraro pulls out all the stops in his "First Day of Zen Garden School," in which a senior monk is shown covering his eyes in despair over his students' efforts:

"My Zen garden has been a total nightmare."

FIGURE 32. Nonaka Toshihiko, "Komaru (Trouble)." Published in *Yomiuri shinbun*, January 1, 2007. Photograph courtesy of Yomiuri Shinbun, Tokyo.

FIGURE 33. Bruce Eric Kaplan, "My Zen garden has been a total nightmare." *The New Yorker,* July 9, 2007. Bruce Eric Kaplan/The New Yorker Collection/The Cartoon Bank.

one is building a sand castle, another making "snow angels" in the sand, one is burying a treasure chest, and another steps on the tines of a rake and thwacks himself in the face (Plate 9). Bruce Eric Kaplan, meanwhile, is perhaps as bitingly sardonic as one can get. In his parody of well-to-do Manhattanite spiritual-cultural pursuits and cell-phone fixation, the Zen garden is anything but a space of meditative calm (fig. 33).

That the Zen garden—a place of apparently profound metaphysical and philosophical possibilities—turns into a kitty-litter box is perhaps due to the mistaken characterization of Ryōanji and other dry landscape gardens as "sand gardens" (they use crushed granite) and to the aforementioned Zen Cat trope (figs. 34, 35). The introduction of feces and bathroom behaviors may bring to mind, at least for some, the scatological language found in classical Chan/Zen literature.[32] But the Zen garden-as-litter box cartoon depends not on specialized Zen knowledge but an absurd poetry of juxtaposition. Equally true to cartoon proclivities is the cartoonist's addition of a secondary trope, namely that of Buddhist impermanence. In any case, those of us who live with cats may now look at their litter boxes a bit differently; those who own miniature "rake-it-yourself" Zen rock gardens, sold by museums as well as lifestyle and Asian-y goods retailers, may use them with new associations.

So, Zen cartoons may not be exclusively or finally about Zen, even if cartoonists capture something recognizable as Zen. The flavoring is Zen of a certain kind, but the main ingredient may be more familiar and entangled

FIGURE 34. Dave Coverly, "Zen Kitties." *Speed Bump*, February 6, 2009. Speed Bump © Dave Coverly/distr. by Creators.

FIGURE 35. Pat Byrnes, "Zen Litter Box." Pat Byrnes/ The New Yorker Collection/The Cartoon Bank.

in behaviors and attitudes that appear antithetical to what Zen practice presumably seeks or achieves. The cell phone's imposition strikes me as a fitting case in which the Zen cartoon serves as a medium for social commentary—technology's disruptive invasion of all moments of contemporary life and our fetishization of devices—even as it pokes fun at the seriousness of Zen practice.

Still, there is reason to allow for play in the interpretive line. What may seem like a derivative secularization or popular appropriation may strike some viewers as very much to the Zen point. Just how directly the humor references or targets Zen, and what sort of Zen, will depend of course on author and audience. If one holds to the notion that Zen focuses attention on the mundane as the site of awakening, then the cell phone might be a heuristic prop and the manner in which we respond to technology an opportunity for realization.[33] Perhaps the cell phone is simply an au courant proposition of the sacred-mundane juxtaposition leading, hopefully, to transcending such binaries and categories. If you have spent time in a Zen center you may respond knowingly to a cartoon's evocation and gentle satire of meditation groups and particular attitudes or experiences. Practitioners are not averse to parody, poking fun at Zen practices and customs in the West as well as the persona of the Roshi.[34] Perhaps, then, an outwardly humorous Zen cartoon could function as a serious Zen case, a scenario presented by a Zen teacher to a pupil that is structured with incongruity or the

incommensurable and that may have didactic, exegetical, or performative value in Zen training and discourse.[35] Within this thought experiment, we might expect that the through line of the Zen cartoon would lead somewhere different for the monastic and lay Zen practitioner than it would for someone familiar with Zen as a spiritual or cultural mindset or a *New Yorker* reader with no connection to Zen but open to cartoon humor. All of this, however, is of a relatively recent moment in Zen and begs the question, Why are Zen and Buddhism funny?

WHAT'S SO FUNNY ABOUT BUDDHISM AND ZEN?

Why is Zen fair game for cartooning, and an apparently safe game at that? Not all religions receive the same degree of attention in cartoons. Should we be concerned about the easy production and consumption of Zen cartoons? Are they significant to how we think about Zen, or not worth critical bother? Is there something enabling in Buddhism and Zen that encourages their appearance in cartoons, especially in the West? The short answer is yes, even if the question turns on the sort of Buddhism and Zen one has in mind. A fuller answer points to the idea of Buddhist humor, the cartoon in multireligious society, and what I call "Bodhi-characters" in the neo-pantheon of modern-contemporary Buddhism.

One might surmise that Buddhism is available for cartooning and other appropriations in Christian-majority North America partly because it is a minority religion that in certain regions and communities lies outside dominant conceptions of the sacred and true faith and is therefore available to parody or malign.[36] But I suspect this explanation is inadequate to the complexities inherent in the representation of religion in popular culture and insufficient to modern and contemporary histories of Buddhism. To overstate the case, Buddhism and Zen are humorous because they became modern. This is not to say that forms and moments of humor were absent in premodern Buddhism. Early Buddhist texts employed what we would call today "narrative embellishments, burlesques, witty retorts, puns, and comedies-of-errors" to address soteriological concerns at the heart of Buddhist doctrine, monastic practice, and devotion.[37] Doing so, their "humor" was not walled off from surrounding comedic cultures and may not be the sort of humor familiar to us today. There are numerous issues to consider, including how this earlier history intersects with and gives way to more recent conceptions of Buddhist humor. But two general phenomena seem relevant. The first is that Buddhism has in certain modern contexts been untethered from religion. It may be philosophy, a rationalist or scientific worldview, an

individual spiritual practice, or a lifestyle habitus—free of clergy, ordina-
tion, scripture, ritual, deities, icons, patriarchs, and miraculous narratives.
Neo-, spiritual, and secular transformations of Buddhism are often distin-
guished by their experiential dimensions, and in some cases by a correla-
tive "attitude-ification" of Buddhism through which complex traditions and
ritual practices are reduced to a state of mind or ethos, sometimes adorned
with Buddha-logo and Buddhist-branded products.[38] This attitude or mind-
set is not one attained necessarily or exclusively through sustained prac-
tice in explicitly Buddhist contexts. Zen-itude can be, and often is, without
zazen; it may be adopted at cognitive and emotional levels, with a sense of
affinity with values perceived to be Zen. Although some note that a "Zen
attitude" combines "intense concentration on the task at hand" with intui-
tive and spontaneous response in the moment, the practice and hard work
of centered awareness are often forgotten in popular representations.[39] It
may depend on a sense that certain existential or spiritual perspectives
(rather than belief in the cycle of rebirth, for instance, or the performance
of rituals directed towards particular powerful deities) are psychologically
and holistically beneficial. They may soothe rather than put us into con-
ditions of doubt or tension that have positive soteriological value.[40] As
I suggest later, this Buddha-tude/Zen-itude has generated character types
in modern-contemporary Western culture that have something to do with
the possibilities and reception of Zen cartoons.

A second phenomenon is Buddhism's relatively recent distinction
as a religion predisposed from its inception to humor and jest.[41] I do not
believe this holds broad validity for premodern contexts, even if there were
instances of strategically deployed comedy. This essentialist perspective
nevertheless leads to the identification of dispensations in which Buddhist
truth and realization are said to be expressed fundamentally as and through
humor, with a concomitant deemphasis of cosmology, scripture, scholas-
ticism, ritual, and so forth. These two modern inflections of Buddhism—
separation from religion and inherent humor—constitute enabling forces for
a number of Buddhism's popular representations, including Zen cartoons.

Caution is warranted, however, as humor is famously resistant to
definition and interpretation, especially in cross-linguistic/cultural contexts.
Take, for instance, the attempt made in 2011 by the Australian newscaster
Karl Stevanovic to tell the Fourteenth Dalai Lama a well-known "Bud-
dhist joke." The setup is "The Dalai Lama Walks into a Pizza Shop," and
the punch line is the Buddhist leader's order, "Can you make me one with
everything?"[42] The joke has a number of variations that work from the cliché
"A man walks into a bar" and concludes with the familiar colloquialism for
Buddhist nonduality, "one with everything" (fig. 36).[43] Its humor depends

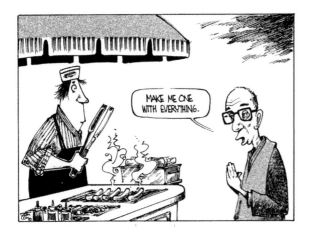

FIGURE 36.
John Cox, "Make
Me One with
Everything."
© John Cox,
2016.

on amphibolous play between a food item prepared with all the available toppings and the attainment of nonduality. Perhaps the newscaster presumed that telling the joke to the Dalai Lama himself—the best-known living Buddhist teacher in the West, who is worshipped by Tibetan Buddhists and others as a manifestation of the bodhisattva Avalokiteśvara—would produce a novel and possibly comedic denouement. Would the Buddhist leader laugh, offer a sage reply to a Western pop-culture representation of Buddhism, or tell a joke in return that illuminated Buddhist doctrine? Might his response validate Buddhist jokes as being more than pop-culture junk? Or would the Dalai Lama challenge the joke's representation of Buddhism and reject its humor?

At first the Dalai Lama did not appear to understand that a joke was in play, responding (once there was sufficient clarity of translation) with the seemingly off-point "Theoretically impossible." This came as a surprise to some observers in the West: "American Buddhists in particular, many of them with Jewish roots (e.g., Nes Wisker), are funny. And Buddhist monks are often the most lighthearted of all (in our experience). So it's odd that the Dalai Lama had never heard the most popular of a handful of ubiquitous 'Buddhist jokes.'"[44] But this remark may mistakenly presume that American Buddhists and the Dalai Lama necessarily share identical social worlds and get the same jokes.[45] One Buddhist's "ubiquitous" may not be another's, and in the end, the Buddhist leader's response shifted attention from the joke to the humorousness of the newscaster's misadventure, which found its place in the online "news anchor fail" genre.

At the very least, the episode suggests the complexities of intercultural encounter within the frame of humor and the potential disjuncture between popular representations and those of religious teachers and practitioners. But the assumption that telling a "Buddhist joke" to the Dalai Lama would be appropriate—casting him unawares as a participant in a comedic situation—may reveal something more specific to popular perceptions of the Dalai Lama and of Buddhism more generally. Namely, that the Dalai Lama, given his often remarked upon jovial public persona and laughter, would find such repartee copacetic.[46] Indeed, the preferred figures of Buddhist monastics in the West are often the warrior monk with mystical

powers or the lighthearted, trickster monk, rather than female monastics, lay Buddhists, and protesting activist monks.[47] For some Buddhists and others, then, what could be more Buddhist than the Dalai Lama laughing at a Dalai Lama joke?

Like other marquee topics in the humanities and social sciences, humor has its share of disciplinary approaches and intellectual grit, finding a home in linguistics, philosophy, history, anthropology, psychology, sociology, popular culture studies, and beyond. There is ample writing on humor—far too much for any one person to master, as Mary Beard puts it for the literature on laughter.[48] There are books, articles, and blog posts on humor's potential to "explode fraudulent, corrupt, and hypocritical ideas, individuals, and institutions"; on how humor's "life-giving and destructive values meet and intermingle"; on the "strategic deployment of humor as a political weapon"; on gender, race, and humor; on the "commercialization of humor"; and the "___ology/ics of humor."[49] Religion is a notable subfield of humor studies, even if, in the twentieth century, many writers relied upon the now criticized binary of sacred and profane and tended toward Romantic and universalizing interpretations as well as reductive comparisons between Christianity and other religions.[50] We now tend to resist master definitions and racial-ethnic categories (eschewing, for instance, the idea of a single Jewish humor). As a result of efforts to make humor and laughter "a bit messier, rather than tidy [them] up," as Beard urges, we are now likely to read of humor, belief, and doctrine intertwined with ideologies, institutions, and "economies" of orthodoxy and play; oscillations between humor in sacred and secular spaces; the piety and redemptive power of irreverence or its heresy; ritualization and pageantry in religious comedy; and humor's alternately transitory and durable presences in religious cultures.[51] Attention is likewise paid to religious caricature and its relationship to free speech and secular society, defamation, and interreligious conflict as well as humor's use in orientalist representations of Asian religions.

Richard Gombrich has argued that "There can be no doubt that the Buddha used allegory satirically," but the challenges of studying Buddhist humor may sum up in statements made respectively by the Indologist Oskar von Hinüber and historian of religion Gregory Schopen: "Many paragraphs which we are inclined to read with a smile today, may have been a deadly serious matter to those who originally wrote them down"; and "The joke, indeed, may be on us—those who quote texts and 'doctrine,' it seems, who come off looking ridiculous."[52] Buddhism in the past and also in the present,

they caution us, may be less funny than we assume. Or, we may need to work harder than we think to discern how Buddhist humor may have functioned in particular contexts and communities to scholastic and soteriological ends rather than as an end in and of itself. To that purpose, historians of religion who focus on Buddhism generally consider humor as subject-, site-, and time-specific rather than universal or timeless. It has particular values (didactic, ideological, and performative) and contexts (historical, herme-neutical, and sectarian). Humor is therefore treated methodologically the same way as the study of Buddhist relics, ordination, sectarian debate, and even modernity: by close reading of scripture and commentary, hagiogra-phy, ritual manuals, and historical documents in their original languages; critical study of institutional and local communities; inquiry into didactics, hermeneutics, performance, soteriology, and ideology; and with reference to various theoretical models in the humanities.[53] Scholars have pointed out that ancient Buddhist texts in Sanskrit and Pali sought to critique and regulate laughter as anathema to the Buddha's teachings and inappropri-ate in monastic settings. Others argue that early texts incorporate episodes that draw from literary conventions intended to trigger laughter, compose scenarios marked by incongruity, deploy representations of learned monas-tics as buffoons, and set up doctrinal puns and jokes (which only monastics get). A few suggest that a new and distinctive modality of Buddhist humor appeared with Chan and is apparent in patriarchal tales, koan scenarios, and paintings of Chan eccentrics. Humor is also identified in Tibetan monastic Buddhism in the figure of the trickster.

That humor is a vital part of the premodern Buddhist tradition, in specific contexts of discourse and practice, has ideological implications within modern discourse, for its presence offers an alternative to Western characterizations of Buddhism as austere and nihilistic. That Buddhists may be seen to joke, play, and dance is perhaps a positive "discovery" for the West, but it may also smack a bit of "model minority" characterization. And in the West, humor seems to overwhelm other dimensions of Buddhism, taking its place alongside dominant modern conceptions of mystical and therapeutic Buddhism and, recently, scientific Buddhism.[54]

"NOT LETTING THE NONSENSE OF THE WORLD GET TO YOU"

Let us remind ourselves that cartoons—despite their small frames and lim-ited visual palettes—may be sneering and hegemonic, and not just playfully satirical or empathetically amusing. To chuckle today at nineteenth- and

PLATE 1. Sesshū Tōyō (1431–1506), *Splashed Ink Landscape* (*Haboku sansui zu*) and detail. 1495. Ink on paper. Hanging scroll. 147.9 x 32.7 cm. Tokyo National Museum. National Treasure. Image: TNM Image Archives.

PLATE 2. Hakuin Ekaku (1685–1768), *Giant Daruma.* Hanging scroll. Ink on paper. 130.8 x 55.2 cm. Gitter-Yellen Foundation. Image courtesy of Manyo'an Collection, Gitter-Yellen Foundation.

PLATE 3. Yintuoluo (late 14th c.), *Danxia Burning a Buddha*. Chinese, Yuan dynasty, 14th c. Inscribed by Chushi Fanqi. Ink on paper. 35.0 x 36.8 cm. Ishibashi Foundation, Kurume City, Japan. National Treasure. Bridgestone Museum of Art, Ishibashi Foundation, Tokyo.

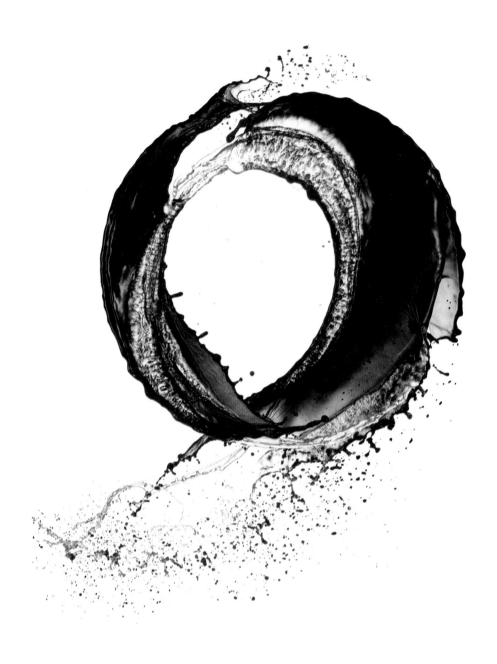

PLATE 4. Maruyama Shin'ichi (1968–). *Kusho #1,* 2006. Archival pigment print. © Shinichi Maruyama, courtesy of Bruce Silverstein Gallery, New York.

PLATE 5. Yamamoto Shunkyo (1871–1933), *Discarding the Bones, Gathering the Marrow*
(*Shakaku shūzui*). 1927. Color on paper. 171.0 x 93.0 cm. National Museum of Modern Art,
Tokyo. MOMAT/DNPartcom.

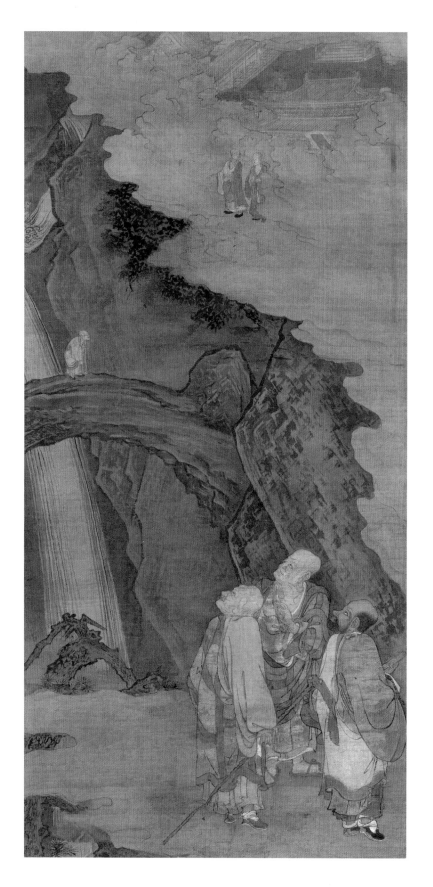

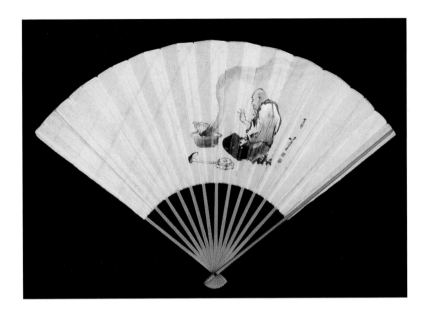

PLATE 7. Katsushika Hokusai (1760–1849), *Danxia Burning a Buddha*. Edo period, mid-Bunka era (1804–1818). Ink and color on mica-coated paper. Upper length: 43.8 cm; lower length: 17.2 cm; radius 16.6 cm. 18.391. Museum of Fine Arts, Boston. 18.391. Photograph © Museum of Fine Arts, Boston.

PLATE 8. Murakami Takashi, *That I may time transcend, that a universe my heart may unfold.* 2007. Acrylic and silver leaf on canvas mounted on board. 3 panels, each 95.5 x 111 inches. The Steven A. Cohen Collection. © 2007 Takashi Murakami/Kaikai Kiki Co., Ltd. All rights reserved.

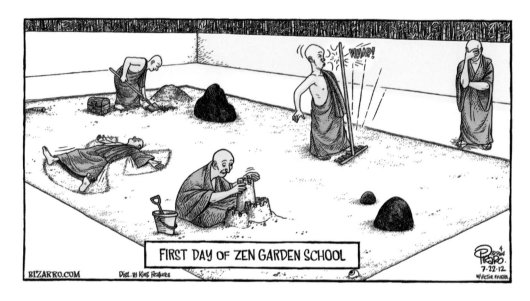

PLATE 9. Dan Piraro, with Victor Rivera, "First Day of Zen Garden School." July 22, 2012. Bizarro Comics. © Dan Piraro.

twentieth-century cartoons that vilify colonized and immigrant communities is no laughing matter.⁵⁵ To acquaint oneself with cartooning's provocative political agency, or at least ambition, take a look at the editorial cartoons of the French Revolution, Thomas Nast's (1840–1902) Progressive Era cartooning, and cartoon savaging of President George W. Bush. For racist representations of African-Americans, see cartooning before the civil rights era in, for instance, *The New Yorker*.⁵⁶ While satirical anti-Semitic, anti-Catholic, and anti-Muslim cartoons of religious figures appear from the late nineteenth and early twentieth centuries, the present potential for such cartoons to provoke not only deep offense but extreme violence has been clear since the 2005 publication of cartoons of the Prophet Muhammad in the Danish newspaper *Jyllands-Posten* and, in 2012, in the French magazine *Charlie Hebdo*.⁵⁷

As far as I know, professional cartoonists in America who take up Buddhist themes and visual content do not aim for such provocation—that Buddhism is perceived popularly to be a peaceful religion may have something to do with this—and have not been the targets of outrage or violence because of their work. Nevertheless, they may be sensitive to religious communities and alert to the possibility of offending. For instance, following publication of his 2008 "Peanut Buddha" cartoon, Dan Piraro commented:

> I'm not a *huge* fan of puns but I like them if they strike me a certain way or carry a good visual. This one [Peanut Buddha] seemed amusing enough to draw up and I liked the result, so I submitted it. Examples of some that I did not draw up: Almond Muhammad, Walnut Jesus, Pecan Vishnu. On a sad note, I got a couple of complaints from people who felt I was being insensitive to the religious beliefs of others. The kicker is that neither of these writers were Buddhists, they were just assuming that others might be offended. It is my impression that a big part of Buddhism is not letting the nonsense of the world get to you, which I guess is why no actual Buddhists complained.⁵⁸

Leaving aside the not insignificant question of who "actual Buddhists" might be for Piraro and his readers, the cartoonist's suggestion is that to be Buddhist means to be detached from "the nonsense of the world," including, it appears, cartoons that might potentially, in their representation of the Buddha in the service of humor, offend Buddhists, or at least raise concerns about sensitivity to religious belief.

I take Piraro to be sincere, and he is not alone in having this sense of Buddhism. That said, the notion that real Buddhists are unconcerned about popular culture and thus do not take offense from cartoons and other

representations becomes a bit flimsy once one notices protests by monastic and lay Buddhists, often in predominantly Buddhist countries, against entertainment and culture-industry appropriation of the Buddha's image and teachings.[59] Be that as it may, the concepts of rising above or being aloof from the world have become for many non-Buddhists, and some Buddhists, defining features of "actual" Buddhist consciousness and identity.

Indeed, one of the more consequential modern transformations of Buddhism, alongside its becoming a therapeutic and self-help matrix, involves its conceptualization by some as a religion or spirituality centered on the attainment of an attitude in which one is detached from worldly concerns in a state of "jazzee and nondeliberative" freedom wherein one makes one's own rules in the unconditioned realm of the absolute.[60] This modern attitudinal Buddhism might be traced partly to the impact of Romanticism (emphasizing individualism, interiority, and epiphanic, spontaneous response).[61] Notably, however, its articulation is evident not strictly in popular culture but in contemporary Buddhist lay and spiritual communities (some in the orbit of the magazine *Tricycle: The Buddhist Review*), whose members may focus on the insubstantiality of the self (Skt. *anātman*) to the exclusion or deemphasis of icons, rituals, and other soteriological concerns. A North American lay practitioner of Buddhism, for instance, explains that "The art of humor practiced by Buddhism is seeing the subtle delight in everything. It is having a feeling of lightness about oneself. The Buddhist does not take himself seriously for the core reason that he does not feel life to be serious. He sees life as a game and is always willing to play. The seriousness that can be found in the United States for example is a seriousness that is manifested out of the ego."[62]

From the standpoint of traditional religious Buddhist practice and belief, however, there may be conceptions more fundamental than that of rising above the nonsense of the world, including deeply rooted faith, that manifest in precisely regulated devotional actions and concern matters such as suffering and compassion as well as fear of rebirth in hell. For some Buddhist individuals and communities, these concerns may require offerings to deities, the taking of vows, repentance rites, readings of scripture, and so forth. An ethos or psychology of copacetic equanimity may hardly be efficacious, or at least primary, in such contexts. For some Buddhists, then, a Buddhism that is a spiritual or lifestyle habitus of breezy detachment is no longer true Buddhism but merely a popularized, psychological, or spiritual derivative, even as it may make use of sound bites taken from traditional Buddhist scripture and discourse.

In any case, this neo-Buddhist mentality or attitude finds representation in a cast of twentieth-century characters notable for what we might

call Zenny auras, utterances, and antics. These figures act out "Buddhist" or "enlightened" behaviors and attitudes in print, film, and digital media, and we may respond by recognizing (and perhaps even re-performing) the mindset embodied in such acts, which are often quirky and humorous in a particular modality of detachment joined by "an appetite for the Zany."[63] These characters are usually amusing in their counter-normative if not absurdist behaviors and non-sequitur–like responses that (appear to) intimate deeper philosophical and spiritual truths.

Among these Bodhi-characters, to give them a name, are the quirky "Dharma Bums" of Beat literature, surfer-stoner figures in film, The Dude in *The Big Lebowski* (1997), and others who perform heterodox acts of social renunciation with blissful, slacker, or idiosyncratic freedom of comportment.[64] They may be bemused or befuddled by the "real world," which they may avoid or trip up in, and utter gnomic phrases of seemingly Asian philosophical tenor (as much pop-Daoist as pop-Buddhist).[65] These Bodhi-characters are also generally domesticated; they tread on social norms and break certain rules, but their presences seem to be perceived as enviably, even fashionably, countercultural and exotically oddball rather than anarchist. In turn, they translate Zen into something that can be recognized, understood, and enjoyed by those with little inclination towards religion or spiritual practice. That most of these figures are white and male, Sharon A. Suh argues, demands that we recall what bell hooks refers to as "looking relations" and ask, "whose Buddhism do we see on the screen and why? Whose Buddhism is missing and why?" and, thereby, avoid a "blind spot regarding the politics of representation and the privilege afforded to white men and the power of their image."[66]

The Dude in *The Big Lebowski,* directed by Joel and Ethan Coen, is the most enduring post-Beat embodiment of the comedic and slovenly apathetic, mystical Zen attitude.[67] His staying power is due to the film's memorable plot absurdities and famous phrases—"The Dude is not in" and "The Dude abides"—which seem to come straight out of the Chan koan literature and become the Zenny punch lines of The Dude's slacker antics. Indeed, Zen as The Dude and other Bodhi-characters perform it is not about actual meditation practice and actual Buddhist discourse (in the sense of direct engagement with canonical and commentarial literatures), vows, or ritual. Instead, these figures perform for us a state of being that apparently manifests true Zen. The fact that there appears to have been little if any Zen in the Coen brothers' original concept matters little.[68] That The Dude, played by Jeff Bridges, is a fictional character is rather beside the point. He may be as real to some viewers as the medieval Chan/Zen masters, whose mystical, gnomic, disruptive, and possibly comedic performances inform pop culture.[69]

Not surprisingly, given the film's cult status, *The Big Lebowski* has spawned numerous publications, including Jeff Bridges and Zen teacher Bernie Tetsugen Glassman's *The Dude and the Zen Master* (2013). A combination buddy-book, paired autobiography, film memoir, and playful exegesis on The Dude's Zen-ness, it is also an introduction to Zen in "the parlance of the time," to borrow The Dude's words. Bridges recalls his film career, music, and activism, with various spiritual and philosophical observations thrown in, and asks Glassman for his interpretations and wisdom. Glassman, more laconic, describes his Zen training and teaching and distills Zen sayings, concepts, and practices linked, occasionally and after the fact, to the film. "The Dude is not in," Glassman explains, refers to a "pure state of no attachment whatever, nothing there."[70] The Dude has therefore taken on a Zen life of his own, with Glassman working hard to "convert" him to the cause of popularizing Zen.

One book reviewer, the astrophysicist Adam Frank, lauded Bridges and Glassman and vouched for The Dude as "a kind of intuitive Zen master," adding that, "Having experienced my own share of seven-day Zen intensives, I can vouch for the fact that a big chunk of Buddhism lies in a daily practice that can, sometimes, be intense. This book doesn't really touch that aspect of Zen but that's OK. Glassman and Bridge are trying to show us that the real truth is we have no other choice. We, like The Dude, must always learn to abide."[71] Here, then, is the issue: there are no formal instructions on meditation in Bridges and Glassman's book, and nothing on the discipline of daily practice, just as there is none of this sort of Zen in the film. Practice becomes something quotidian and aphoristic, without meditation, holding to belief in nonattachment, change, interconnectedness, abiding, and so on. We might refer to this as an applied Zen, but "that aspect of Zen" missing in the book (Frank's words), is for some precisely what Zen is and requires: the serious, sometimes arduous practice of meditation under the direction of a teacher and the cultivation of knowledge of the Zen tradition's texts, rituals, and histories. Indeed, one reader of Frank's review cried foul: "Adam Frank says that it's OK that *The Dude and The Zen Master* doesn't touch on the daily practice aspect of Zen that he (Frank) is most familiar with—that is because this book is the shallowest kind of pop-cultural philosophy."[72] Zen, in this contrary view, is not found in a Hollywood film character, in the valorization of a persona or ethos, or in the folksy conversations of Bridges and Glassman separate from formal practice.

This is not to argue that serious Zen does not happen "in the parlance of the time" (see Jundo Cohen's online Zazenkai, discussed in Chapter 8). It is also possible to interpret the absence of Zen meditation in The

Dude's "practice" as a sign of authenticity—true not to monastic and lay Zen religious training but to forms of Zen that have deemphasized meditation, especially postwar meditation-free sorts of avant-garde Zen.[73] Moreover, while some of us may resist labelling The Dude a "Zen master," with good reason I think, we may choose not to absolutely dismiss what he signifies as the "shallowest kind of pop-cultural philosophy." The Dude's Zenny antics, utterances, and obtuseness-masked-mysticism may conceivably be a gateway to actual practice and a different awareness (one presumably not attained from reefer, as in the film).

By taking the performances of The Dude-as-Zen master and other Bodhi-characters for Zen itself, however, we may be mistaking, as a well-known Zen metaphor puts it, the finger pointing at the moon for the actual moon. But the truth may be that many of us may find the quirky, exotic, iconoclastic character pointing at the moon more appealing than the moon itself, and we get to enjoy their performances with no obligations. Actual meditation, after all, is hard work not undertaken for entertainment, even if we may laugh later, "when we realize our futile attempts to escape the first noble truth" (namely, suffering as inherent to existence).[74]

Arguably, the reification of Zen into performance has been happening for some time, and we should note the ancestors of our twentieth-century Bodhi-characters in the premodern East Asian Buddhist tradition. They include the Chinese Chan "eccentrics" Budai (J. Hotei), Hanshan (J. Kanzan), and Shide (J. Jittoku), as well as medieval Chan/Zen masters portrayed in biographies and koan collections, where they frequently do outwardly humorous, outlandish things that in twentieth-century reception are often interpreted as literal manifestations of nonattachment and mystical freedom. For premodern monastic and lay Chan/Sŏn/Zen audiences, however, these were complexly rhetorical quasi-historical figures—not just antinomian weirdos—whose representations are today worthy of sophisticated theological, literary, and visual study, involving recognition of the intertextual/pictorial, soteriological, and ideological ambitions of their performances. In any case, I suspect that these Zen ancestors, in their modern reception, inform the conception of Zenny characters such as The Dude as well as masters and monks in Zen cartoons.

To acknowledge rather than merely dismiss our recent Bodhi-characters, therefore, we might treat them as part of a modern-contemporary "pantheon" of Buddhist or Buddhism-associated figures in spiritual belief and mainstream culture that emerged particularly in postwar North America.[75] The Dude and his cousins reside not at the top of this neo-pantheon—a position reserved for the Laughing Buddha, arguably the primary "deity" of modern popular Buddhism—but further below, perhaps as the followers

of the figure of the Oriental Monk (traditionally trained monastics as well as "monkish" modern lay reformers such as D. T. Suzuki), who serves a bridging role, as Jane Iwamura puts it, by traveling to the West to transmit wisdom and insight within a setting of orientalist reception and amid white anxieties about race and nation.[76]

Although orthodox Buddhist communities revere monks and nuns as sacred and powerful, modern nonreligious and popular communities tend to refigure the Buddha and Zen teacher from supranormal and divine to human and proximate, arguably in keeping with the development of individualized, spiritual Buddhisms in Western individualist, convert contexts. Indeed, since the 1950s the figure of the Buddhist monk has become increasingly familiar and approachable, no longer strictly an austere or wonder-working saint but a wise and compassionate teacher represented with endearing qualities and quirks, a figure who may offer amusingly quixotic responses to the unenlightened, and a figure of spiritual authority who may even be depicted caught in banal concerns that seem to throw into question nonattachment and the transcendental.

To circle back to the main topic at hand, then, if Zen can be reborn in pop-culture figures with Zenny attitude manifest in oddball or amusing utterances and antics, Zen cartoons may not seem especially odd. Given that Zen cartoons eschew the Buddha Śākyamuni, other buddhas, and bodhisattvas, perhaps we might rather view their recurring figures—Buddhist teachers, monks, American followers, and figures with Zen-like behaviors—as members of this neo-Buddhist pantheon.

BUDDHISM'S HUMOR, ZEN'S COMEDY

Alan Watts, criticizing the "regrettable tendency in the West to associate Religion with long faces, intense seriousness, gloom and morbid restrictions," explained in 1933 that Buddhism's intrinsically humorous nature arises from self-wisdom rather than "just the knack of being comic, nor yet a mere hilarious state of mind . . . [or] making fun of the oddities of other people." Wisdom, that is, that comes with the realization that the "Self is an error, an illusion, a dream," and "certainly not a thing to be taken seriously." A "Buddhist sense of humour," he suggests, can "teach us to laugh at the proud little thing which thought itself so great, at the comic bundle of worries which imagined itself the most important thing in the world—the self."[77] There is something to this, but since then, more than a few writers have argued that humor is not merely one expression of but is essential to, if not the essence of, Buddhist awakening. For instance, the blurb on the back of

Buddha Laughing: A Tricycle Book of Cartoons, declaims and puns: "Over the centuries, Buddhism has offered the world a clear-eyed, down-to-earth approach to life and death. This irresistible little book of teachings is no exception. It demonstrates that wisdom can—and often should—be taught through humor. *Buddha Laughing* is a healthy recipe for lightening up, the path to true en-*lighten*-ment."[78] From this perspective Buddhist humor may be amusing *and* soteriological, helping to us to attain a lightness of being in the world free from mood-lowering ego attachment.

Fair enough, but the wholesale characterization of a religion as humorous (or anything else) is worth challenging, provoking at least the retort "Which Buddhism are we talking about?" Arguably, the perception of Buddhism as fundamentally and distinctively humorous amounts to one of many stereotypes that invite "unmasking" and is akin to the notion that Buddhists are always nonviolent.[79] Moreover, there is the possibility that the characterization of Buddhism as inherently humorous is partly the effect of an orientalist and racist strategy of representing the other through alternately affirmative or demeaning qualities such as childishness or femininity.[80] At the same time, an appeal to Buddhism's humor as a convivial sign (everyone likes a good laugh, right?) may have been useful to Japanese nationalists seeking to introduce Buddhism to the West and alter otherwise negative perceptions of Asia and Buddhism.[81]

In any case, there is no reason to dismiss entirely the idea that wisdom may come through humor or to disparage outright a practice or belief that might lead one to delight in the world or avoid egocentrism and preoccupying rumination. But we should resist the somewhat insistent recommendation that Buddhists are inherently of "good humor." This is not to suggest that modern-contemporary Buddhists who emphasize humor are unmindful of foundational Buddhist teachings. "The primary rule of Buddhist humor," Perry Garfinkle writes in an article on Harold Ramis and his "underground Buddhist classic" *Groundhog Day* (1993), "is that you never laugh at someone else's expense. But, rather, laughter arises when we realize our futile attempts to escape the first noble truth [the truth of suffering, Skt. *duḥkha*]. Pointing to our common bumbling deluded nature—with humor—apparently relieves some of the suffering."[82] Whatever one might think of *Groundhog Day,* as a Buddhist film or not, Garfinkle's definition pitches Buddhist humor towards the soteriological—the removal of suffering arising from the delusions that come from attachment.[83] That this concern may be difficult to discern directly in many Zen cartoons and other popular representations is perhaps not surprising, and for that reason, we need to hone in on the role of humor in such ambiguous zones of spiritual-cultural representation and consumption.

What, then, of Zen in particular? Is it a denomination fundamentally distinguished by humor? Apparently so. In *Oriental Humour* (1959), R. H. Blyth suggested that "the essence of Zen is humour" and recalled, "When I first read Dr. Suzuki's *Essays in Zen* I laughed at every koan he quoted, and indeed the less I 'understood' the more I laughed."[84] Zen humor and laughter, then, reside in Zen koan, and laughter becomes a measure of (nonrational) comprehension. The Zen advocate Nancy Wilson Ross, meanwhile, introduced the humor section of the widely circulated *The World of Zen: An East-West Anthology* (1960) with a dose of overstatement: "It would not be possible to present a Zen anthology without devoting a section to humor, for Zen's zany wit is part of the indefinable quality which sets it apart from other religious philosophies. In Zen, laughter is not merely permitted, it is insisted upon."[85] Here Ross paraphrases Blyth ("laughter is not merely permitted but necessary")[86] and quotes him: "It is possible to read the Bible without a smile, and the Koran without a chuckle. No one has died laughing while reading the Buddhist sutras. But Zen writings abound in anecdotes that stimulate the diaphragm. Enlightenment is frequently accompanied by laughter of a transcendental kind which may further be described as a laughter of surprised approval."[87] Although Ross channels well-established notions of Zen's nonrational, ineffable nature, she alludes to the need to contextualize the zany *koan* as "assigned problems" within actual Zen training, rather than as free-floating Zen jokes; true Zen laughter and an understanding of the grinning "holy Zen 'lunatics,' Kanzan and Jittoku," arise within formal Zen.[88] "Laughter of a transcendental kind" is thus presumably a very special sort of laughter. Not simply funny, in a tossed-off or casual sense, Zen humor is therefore connected to Zen practice and catalytic to realization. As the religious studies scholar and Presbyterian minister Conrad Hyers (1933–2013) put it, Zen operates fundamentally through "a kind of comic midwifery in the Socratic sense of a technique for precipitating (or provoking) an inner realization of truth."[89] Allen Klein (the self-named "Jollytologist") gets the award for pithiness: Zen humor moves us "From Ha-Ha to Ah-Hah."[90]

As Klein's quip suggests, the real action as far as Zen humor goes is potentially well outside the critical study of the premodern Chan/Sŏn/Zen tradition and present-day monastic practice. It appears often in the mixture of Zen tropes with the foibles and predicaments of the human condition, often making use of a broader comedic vernacular and blending with other humor genres (such as "Jewish humor"). Take the genre of "Zen Jokes," and examples such as the following. "If there is no self, whose arthritis is this?" "Wherever you go, there you are. Your luggage is another story." "Zen is not easy. It takes effort to attain nothingness. And then what do you have? Bupkes."[91] Such jokes situate themselves at a level of cultural expression akin

to that of Zen cartoons; one can easily imagine their pictorial accompaniment. Without denying outright their potential to nudge someone towards religious and personal realization, one has to wonder whether the point is Zen itself or if Zen is a vehicle for something else, in essence inverting the rhetoric.

For some scholars, however, Zen's comedic action is so striking that it denotes an epochal change in Buddhism, one as distinctive as Zen's purported rejection of "traditional" Buddhist scriptures, iconographies, and rituals—a rather modern conception of Zen.[92] For the fullest promotion of this view, we turn to Conrad Hyers, whose prolific, enthusiastic writing on the subject suggests that we nickname him the postwar period's "Zen humor man." Given the fairly broad citation of his work across the second half of the twentieth century, it is conceivable that Hyers contributed to the creation and appeal of Zen cartoons.[93]

Trained in biblical studies, Hyers portrays Zen humor as a soteriological system rather than pop-culture effluvium that manifests most profoundly in the guffawing, quizzical utterances, scatological rejoinders, and Three Stooges–like clowning of the classical Chan patriarchs and "scattered saints." Cautious about the willy-nilly appropriations of Zen in the West and diversion from meditation, Hyers suggests that there is an authentic, stable Zen that, while ineffable, is explainable through classical texts that make clear Zen's fundamental truth in humor. Hyers was therefore surprised to find that Suzuki gave "comic elements in Zen and Zen art" only scattered attention.[94] For Hyers, then, humor is the under-acknowledged "other side" of Zen, which has been overshadowed by emphasis on Zen's philosophical side. Humor "*is* the odd way into Zen," he admits, but it is also "the odd way of Zen itself."[95] Needless to say, by extolling the comedic, Hyers pays scant attention to monastic ritual, meditation, and discourse, as well as the broader role of pan-Mahayana doctrine and cosmology in Zen.

In Hyers view, the comedic is present in Buddhism from nearly the get-go, and Zen takes Buddhist humor to its apogee. Zen humor may even be the apex of all forms of religious humor (just as, for some Zen campaigners, Zen is the ultimate, universal religion). "In no other tradition," he writes, "could the entire syndrome of laughter, humor, comedy, and 'clowning' be said to be more visible and pronounced than in Zen, where the comic spirit has been duly rescued from those miscellaneous and peripheral moments to which it is so commonly assigned and restricted. So much is this so that it is difficult to imagine authentic Zen, or to survey the unusual history of Zen, completely apart from the comic vision."[96]

Not to wildly (or further) overstate his case, Hyers acknowledges that not "all Zen masters are clown-figures or holy fools, or that all who

achieve awakening within the tradition of Zen do so in the context of comic techniques." True, indeed. But he is undeterred in his effort to convince his readers of the "comic spirit and style" present in a "remarkable procession of individualists—one might even say characters—who often appear to be as much at home in the comic as the sacred. In perusing their biographies, and their koans and mondos, one has the impression of being witness to a kind of Buddhist 'circus.'"[97] How this circus squares with institutional Zen contexts is an unexplored question, but Hyers gives us neither a how-to manual on monastic Zen humor nor a Buddhologist's fine-grained analysis of primary texts and contexts. Instead, he gives us a survey of Zen humor's origin and development and explanations of particular Zen humorists and Zen gags.

When did Zen humor begin? At the very beginning of Zen itself, Hyers explains, in the foundational myth of Zen transmission, wherein the Buddha Śākyamuni's disciple Mahākāśyapa smiled wordlessly after the Buddha held up a flower to his assembly (J. Nenge mishō) at Vulture Peak:

> The Buddha's silent gaze on Vulture Peak is the commencement of that propositionless communication of the innermost nature of things that is pivotal to Zen. . . . Yet the other aspect of the story is also important, and that is Kasyapa's smile of understanding—a smile that is carried through in the subtlest to the most raucous forms throughout the later development of Zen. This smile is the signature of the sudden realization of the "point," and the joyful approval of its significance. . . . It is this smile, historically authentic or not, which is the beginning and the end of Zen.[98]

Hyers does not go so far as to suggest that Mahākāśyapa's smile was in response to a joke told by the Buddha, but he does imply that the smile puts us on the road to Zen humor. This smile—manifesting "this sudden intuition of Truth, and this wordless transmission of the Dharma"—is not merely "carried through" across centuries in the Zen lineage but is, he suggests, the touchstone for a spectrum of expressive acts that manifest Zen's comedic praxis and humor-essence.[99] Hyers emphasizes, too, that humor's inherence and unified presence in Zen arises from the fusion of the comic and the mundane with the "collapse of the sublime." It is this which distinguishes Zen from the "abstract flights and ethereal delights" of India and the West and the "spiritual other-worldiness and mythological fantasy and philosophical grandeur of so many other cultures."[100]

Hyers therefore gives us Zen humor's genesis story, its life grounded in the mundane, and its uniqueness. He also gives us a cast of comedic

characters found in the tales of Tang and Song dynasty and Muromachi-
and Edo-period patriarchs and saints, some of whom appear in well-known
Chinese and Japanese paintings such as those depicting the "Three Laugh-
ers of Tiger Valley" (C. Huxi sanxiao; J. Kokei sanshō), whose euphoric
mirth and slapstick-like actions are said to harbor the sacred. There is some
truth to this; Hyers is not entirely dreaming in Zen. But his widely read
book *The Laughing Buddha* (1974) is now to be read best, I would say, as
a modernist Zen treatise, more spiritual than historical, and a primary text
of Buddhist modernism. Certainly, in our present moment of the historical
study of Buddhism and Zen, his work may seem essentialist and affirma-
tively orientalist, and one may wince at his uncritical reliance on Japanese
Zen campaigners in an effort to make the Zen humor case on such an ambi-
tious scale.[101] His analysis is therefore not entirely up to the task it takes on,
at least in the academy's present methodological terms, and lacks the sort
of suspicion now brought to bear on strategic appropriations and sectarian
constructions of orthodoxy. But Hyers was not a Buddhologist, trained to
study Zen through painstaking archival, philological, hermeneutical, and
anthropological work, and arguably his work sits at the border between
critical history and general audience writing. Thus he appears unconcerned
with some of the big postwar intellectual debates, including the question
of Zen history/mysticism taken up by Hu Shih and D. T. Suzuki, discussed
in Chapter 5, and with theoretical perspectives such as Eric Hobsbawm's
(1917–2012) "invented traditions," pious fabrications, and the like.[102]

Of course, my criticisms have the benefit of hindsight, and rather than
trouncing Hyers' work, I would therefore include it in Donald S. Lopez Jr.'s
A Modern Buddhist Bible (2003), a collection of exemplary modern texts
that helped make (and now reflect the formation of) some of the new types
of Buddhism that arose with modernity, which together, Lopez suggests,
might be seen as a new Buddhist sect.[103] At the very least, Hyers built his Zen
humor edifice in notably modern ways, including his reliance on a canon of
modern texts written by D. T. Suzuki and other Zen internationalists that
explain Buddhism and Zen.[104] We might note, too, that *The Laughing Bud-
dha* is an expansion of articles published in the journals *Philosophy East
and West, The Eastern Buddhist,* and *The Middle Way.*[105] These venues are
smack in the middle of modern transnational, comparative-philosophical
discourse on Buddhism and Zen and intellectual traditions East and West,
and are hued with Japanese cultural exceptionalism and Western expla-
nations of the other. To his credit, meanwhile, Hyers added to his reading
of modern texts on Zen his brief study in Japan and interviews with Zen
monks, albeit those noted for international proselytism and exchange.[106]
Last, we should not overlook the fact that Hyers' elevation of the comedic

in Zen was partly a reaction against the subordination of humor research in twentieth-century religious studies; the "prejudices, often shared by priest and scholar alike," he notes, "reflect a failure to understand the importance, in fact necessity, of the interplay of the sacred and the comic."[107] Hyers sought to defend the comedic in Zen against negative associations of religious humor with "sensuality and self-indulgence," "hollow, superficial, and finally empty levity of momentary delight," and "earthy, zany, and divisive associations." He suggests that, "if one requires a justification for the presence of the comic in Zen, one may see it as a species of *upaya* [skillful means], a device for bringing the Buddha-dharma into conscious awareness and existential realization."[108]

All of which is to say that Hyers' presentation of Zen and humor is not categorically incorrect but correctly modern (or, at least one sort of modern). I would hazard as well that Hyers' Zen humor was inspired not only by his readings of Zen internationalists like Suzuki but also by the Zen boom itself, in which the antics (comedy sketches) of the Zen patriarchs had already drawn the attention of Beat writers and others. Beneath this, meanwhile, were the already rooted attractions in modern American spirituality of antinomianism and exotic iconoclastic others, some of whom became comedic-spiritual role models.[109]

"NOTHING HAPPENS NEXT"

There is nothing necessarily or exclusively Zen about an outwardly silly or bizarre behavior pivoting us towards insight (the sort of insight, of course, being at issue). We might also ask: What sort of relationship do prevailing conceptions of Zen humor have to the fine-grained interplay of literary and visual devices, metaphor, and allusion in sophisticated discourses on awakening that operate historically in Zen institutional-monastic contexts? Or, is Zen humor—as we usually encounter it—more wholly modern and exterior to orthodox Zen? At the very least, we should note the recurring forms and spaces of humor related to Zen in the modern-contemporary world, be it the "slapstick qua Ah-hah!" humor of charismatic patriarchs, the "yuppy Zen humor" of a *New Yorker* cartoon, or the "postmodern Beat Zen humor" of *The Big Lebowski*.[110]

Perhaps one might dismiss Zen cartoons as being merely derived from "real" Zen and therefore relatively meaningless or merely part of the visual-cultural fluff of the Zenny zeitgeist. But to the extent that these cartoons speak for Zen at some level in the public sphere, and do so by touching on concepts and practices that bear some relation to Zen as a changing

tradition and are recognized by some as "authentically" Zen, they may be more consequential than they seem. Indeed, the substrates of Zen cartoons are often concepts, behaviors, and spaces that first drew attention outside cartooning and very much through the intertwining of Buddhism and modernity. Nothingness and related concepts, as well as the "sound of one hand clapping," were spotlighted in transnational modern discourse prior to becoming acceptable tropes for Zen cartooning. Thus, while things occur in Zen cartoons that may be unexpected or disjunctive to our perceptions of and expectations of Zen (making use of classic cartoon incongruity), these "happenings" depend on a Zen that we already recognize or perhaps identify with as well as the pictured content that incites such recognition and then may subvert or divert it. The cartoonist's trick, therefore, often seems to depend on citation of a legible, if not necessarily fine-grained, notion of Zen. The task may then be finding a particular visual and verbal way to bend either the expected otherness or the familiarity of Zen—a common-denominator Zen—in different, unexpected directions, to inflect it, perhaps, as is often the case in *New Yorker* cartoons, through Manhattanite customs or foibles.

Meanwhile, if much seems to be taken for granted in the modern-contemporary thus-ness of Zen as it appears in Zen cartoons, we may wish to distinguish between cartoons that appear to communicate humor through Zen themes or scenarios and those which communicate something we might wish to identify as a specifically Zen sort of humor. This would not necessarily be a mutually exclusive distinction, but my sense is that *New Yorker* Zen cartoons generally perform the former, situating and framing cartoon humor through "Zen" situations. Cartoonists and editors depend on these familiar conventions; obscure reference or ambivalent representation fails the cartoon form itself. It may be axiomatic, given the context, that the cartoonists cannot assume that their audiences are acquainted (nor may they themselves be acquainted) with the sorts of local humor one may find in formal monastic training and temple communities or the sophisticated performances and hermeneutics of humor that operate in Chan literary texts and are embodied in certain painting themes. Instead, appropriation and common-denominator culture are to be expected; they are in the cartooning genome. After all, we are not concerned primarily with representing what might transpire in an actual Zen meditation hall, where the incongruous sight of a monk talking on a cell phone might elicit a reaction quite distinct from amusement. Nor, it seems safe to add, are *New Yorker* Zen cartoons interested in proselytizing, asserting a pure or true Zen for the purpose of conversion or seeking soteriological benefit per se. What, then, are we laughing at or chuckling about? Are these cartoons

really about Zen? Although this begs the question "What is Zen?" for which there are multiple responses, what visual and rhetorical operations do we find in these image-texts?

To sum up a bit, we might note first the power of ironic juxtaposition, in which Zen cartoons operate through the intrusion or insertion of the vernacular, entertainment, technological, or commodity commonplace into the perceived space of the monastic or spiritual—a monk on a cell phone in the mediation hall, for instance, telling his listener that meditation is not helping (as it should). Such cartoons may then move through popular conceptions of Zen and Buddhism towards something else, the quirks or memes of popular cultures and the absurdities of privilege. Zen, in a set of popularly recognizable tropes, reflects the ridiculous behaviors or foibles of the non-Zen. Still, it is possible that such Zen cartoons may also deflate romanticized popular notions of Zen monastic life, meditation, and Zen-style culture by virtue of the presence of things, statements, and attitudes that, ideally, should not be there. A Zen cartoon reprinted in a sectarian or practice/belief community publication or on a website may produce a different set of responses, perhaps a knowing grin or chuckles at one's practicing self.

If cartoons in *The New Yorker* (rather than the magazine's covers and textual content) tickle rather than punch, this does not necessarily mean that they are quaint reflections of contemporary society. As cultural texts "embedded in particular material and social relations,"[111] their representations of race, gender, culture, class, and religion deserve careful analysis. Indeed, *New Yorker* cartoons have been undergirded or shadowed by Cold War politics and the War on Terror, by particular representations of non-Western and traditional/preindustrial cultures, and by privileged positions within globalism. At the very least, a cartoon may speak to many but not to all, and may also silence others. Are Zen cartoons complicit in unequal power relations, privilege, and racial and cultural stereotyping? If so, how and where? Should we be surprised?

To ignore such questions is to assume that Zen and its popular representations in *The New Yorker* and elsewhere are post-racial, post-ideological, and post-historical—and that cartoon aesthetics and rhetoric are simply about generating amusing, feel-good mass culture. I tend to think otherwise, given stereotyping of the obtuse but wise, mystical, laughing, or oddball Zen master and monk as admired others. It is important, then, to consider how racial, cultural, and religious differences may play out in such cartoons.

Although few readers of *The New Yorker* would assume that such cartoons present "real" Zen or "real" Asia, the magazine's cartoons verge

closely in some instances on disturbing representations.[112] One might observe that Asian characters generally do "Asian" things in Zen cartoons in a conventional equation of race with culture. Zen cartoons seem rarely to be about Asian Americans, however, typically representing white Americans engaged in Asian cultural practices or Asian figures in Asia or teaching white Americans. One might argue that Zen cartoons turn generally on the ethnocentrism of white Americans in their encounters with cultural difference.[113] I wonder how Aaron McGruder, of *Boondocks* (1996–2006) fame, the comedians Keegan-Michael Key and Jordan Peele, and other artists engaged directly with race and class would handle Zen and its humor.

A personal communication from the cartoonist Gahan Wilson, however, suggests that critical discourse of this sort might be joined by "ethnographic" inquiry into how cartoonists approach their Zen subjects: "I got interested in Zen way back when Suzuki's first books came out, studied many other authors' works as more material on Zen was published and eventually put in a long and very helpful stretch of regularly attending sessions at an excellent Zendo. The monks keep popping up in my cartoons because I am fond of the ones I met and because, like all other humans and human institutions, are fair game for a humorist."[114]

I find Wilson's mention of "fondness" appealing, for it suggests a set of interactions underlying the creative process that are situated in lived experience and may lend a degree of humanity to his cartoons that separate them from what could be the mere exploitation of Zen's popular familiarity or the indulgence of a Zen apologist. It is also true that some of us take quite seriously the Zenny zeitgeist's popular representations, and certain practitioners may appreciate the jovial insight of a Zen cartoon as pointing to something quite real in, and through humor easing the challenges of, Zen practice. This is to say that Wilson's cartoon "Nothing happens next. This is it" might be, at one level, a humorist's serious response to present understandings of Zen teaching and practice. It would probably therefore be unwise to deny the possibility of different modes of efficacy—just as has been the case, arguably, throughout the Buddhist tradition—including a Zen cartoon's capacity to lead us towards different sorts of laughter. The question might be how to situate Zen cartoons in relation to such potential efficacy without assuming their pure identity with a timeless or anachronistic explanation of Zen.

Thus, as "strange poems," to borrow from Michel Foucault (1926–1984),[115] Zen cartoons probably evoke and provoke in multiple ways: exploiting stereotypes; raising questions about elite notions of Zen and Zen art; subverting the expected or idealized through their inserting of prosaic social and cultural tropes into Zen; revealing various things about

how cartoonists and audiences understand, admire, or project onto Zen; and placing us often at the in-betweens of Zen, society, and humor. If Zen cartoons manage to destabilize both Zen *and* popular culture through their satire and humor, however we define it, perhaps they have more impact and value than we realize.

8

ZEN SELLS

Give up. Give up everything.

—Philip Whalen (1972), "1957–1977"[1]

In 1953, Ruth Strout McCandless (1909–1994), a student of the Zen masters Nyogen Senzaki and Nakagawa Sōen (1907–1984), observed: "In the West there are people who use the name of Zen to attract followers. Zen never advertises itself."[2] True Zen, she implies, never name-drops, puts itself up in neon, or purchases ad space. Perhaps, but self-promotion has been part of Zen for as long as there has been Zen, in terms of monastics asserting the authority of their teachings; monks and nuns courting royal, literati, and merchant patrons to secure titles, protections, and donations of icons, relics, lands, cash, and the like; charismatic masters performing public rites and miracles; and itinerant teachers proselytizing to expand lay adherence.[3] Modern and contemporary Zen communities may promote themselves in different spaces through different media, but they are not entirely unlike their ancestors.

McCandless, however, was responding specifically to Zen-boom behaviors that were suspicious if not entirely inconsistent with Zen religious teachings. I imagine her nodding in agreement with Mary Farkas, who took issue with the Japanese Shiseidō cosmetics company's "use of the name Zen for its perfume that sends you to Nirvana" (fig. 37).[4] As Farkas' comment suggests, capitalism had dug its claws into Zen. "Zen" attracted people to Zen practice and belief, but it also became an advertising byword—a magnet to attract customers.

Selling goods with or through Zen is not strictly a modern phenomenon, but the use of Zen—in name, design, and aura—to sell consumer products since the mid-twentieth century moves us into the realms of corporate advertising, neo-orientalism, and materialistic and aspirational

<e

FIGURE 37.
Shiseidō, *Zen.*
Advertisement,
New York Times,
Dec. 21, 1966, 9.

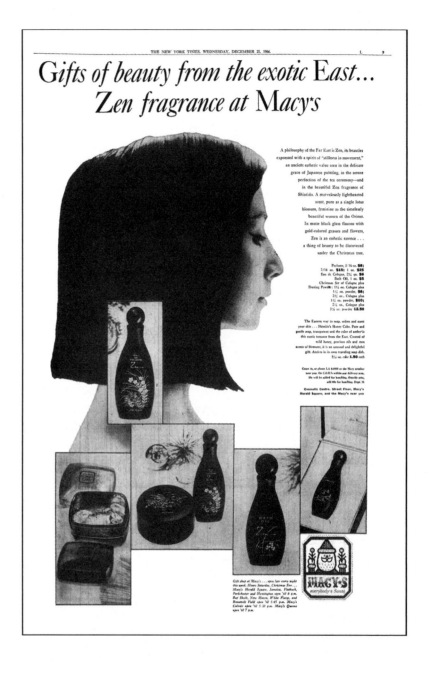

self-fashioning.[5] Much like "mindfulness" and "yoga," Joshua A. Irizarry notes, the commercial value of "Zen" comes partly from the term's status as a copyright-free signifier that accommodates multiple connotations and references.[6] "The word Zen at any time, in any place," one blogger writes, is sufficient, by virtue of its association "with anything that seems paradoxical, peaceful, or contemplative," to convince us to buy things. "It really doesn't

matter what you're selling here in America; if you can cover a few 'Buddhist' basics, people will buy your product simply because it appeals to our nature to covet other cultures' (misunderstood) spirituality."[7] Indeed, Zen-styled products have become so commonplace that practitioner-centered websites track and trounce them for absurdity, disrespect, and jarring contradiction with Buddhist teachings.[8] Even so, the bottom line since the 1960s is that Zen sells things well, to many sorts of consumers.

Some of us may deplore the appropriation of Zen by manufacturing, marketing, shopping, and "transaction fulfillment." But late capitalist consumer culture Zen may be the form in which most people today encounter it. Arguably, it is through retail items like Shiseidō's "Zen" fragrance rather than Zen communities and even books on Zen, that Zen has achieved its widest recognition and appeal—albeit as a fantasy Zen, a means to instant lifestyle enlightenment. The persuasiveness of "retail Zen" may now exceed even that of twentieth-century Japanese nationalist Zen and counterculture Zen.

But surely there is more than one sort of price to be paid for mass-consumer Zen as it submerges Buddhist ritual, ethics, communities, and even radical cultural possibilities under corporate branding, trend and spend, sweatshop labor, and planet-harming materialism. In response to the recent "corporate takeover" of "mindfulness," the Theravadin monk Bhikkhu Bodhi, Zen teacher David Loy, and management scholars Ronald E. Purser and Joseph Milillo, among others warn against its decontextualization from Buddhist ethics and soteriology. "Rather than applying mindfulness as a means to awaken individuals and organizations from the unwholesome roots of greed, ill will, and delusion," Purser and Loy write, mindfulness is "being refashioned into a banal, therapeutic, self-help technique that can actually reinforce those roots." Instead of guiding us towards Buddhist practices of right livelihood and right consumption, "McMindfulness," as Purser and Loy term it, reinforces consumer capitalism.[9]

There is probably no getting around the creation of Zen-brand consumer products, and no way to go back to a market-free Zen (if there ever was such a thing). Like "postural yoga" in distinction from the "complex yoga system" found within monastic practice, Zen has become a "transnational cultural product."[10] What, then, should we make of Zen in mass-produced consumer as well as artisanal cultures? What was the time lag between the global circulation of Zen and the marketing of Zenny commercial products?[11] What predicaments crop up with these Zen things, makers, and consumers? If Zen sells, then how do Zen things come into being and the market? How do they capture consumer attention? One answer lies with creative advertising teams that leverage "borrowed interest" in Zen and hone in on its exotic aura, the figure of the Zen monk, and Zen-associated aesthetics.

What, then, are the aspirations (Zen or otherwise) to which Zen things reach out? How do we identify and select Zen things within the limitless universe of goods; how do we make them "our own"? What relationships (visual, tactile, bodily, cognitive, and spiritual) do we form with these things (packaging and contents)? Presumably they fulfill us, but how, and for how long? Perhaps they also let us down. How much Zen stuff is enough? How do we adorn ourselves and our living spaces with Zen things alongside other cultural-ethnic-religious things; do we hold on to them longer than other things? Is Zen always in style? If Zenny lifestyle consumption distributes positive values, what are the social and ecological costs? Or might the commercial Zen script in fact teach us something truly Buddhist, if only by counterexample?

Retail Zen is arguably worth the sort of scrutiny we would bring to any other kind of Zen. But the sale of Zen-related material things is not limited to global corporations and mass markets. What about things used directly for Zen meditation and sold by Zen monastic and lay communities? Short of making our own meditation cushions (J. *zafu*), most of us who practice *zazen* buy at least some Zen-related stuff. As this suggests, retail Zen is arguably not just one sort of commerce, and the sorts of the things marketed for and through Zen are many. In fact, we might consider four broad categories of products and sellers: the retail of Zen-branded mass-market consumer products; the retail of meditation and spiritual practice goods by mass-market vendors; the application of Zen Buddhist teachings and principles to for-profit corporate business; and the adaptation of mainstream business operations by Zen communities to support practice and outreach, in which market-share, profit, and investor return are usually irrelevant.[12]

We should therefore consider not just corporate retail Zen and products related to personal comfort, lifestyle, or fashion but also the sale of products for serious meditation practice to consumers oftentimes affiliated with Zen communities. In fact it is not particularly unusual for Zen temples and communities to sell items for *zazen* and spiritual practice using contemporary merchandizing methods and platforms but guided by religious teachings merged with principles of corporate responsibility. Some offer a limited range of meditation supplies, first and foremost cushions; others have large selections. Some ironically engage materialist and image-driven consumption: the Rochester Zen Center sells "shirts and swag for the well-dressed meditator."[13]

We might also keep in mind that retailer and consumer may or may not share values or understanding of the sales transaction or of Zen. A mass-market vendor may offer meditation cushions as one of a million products it hopes to sell as quickly and as often as it can. Even so, a meditation

cushion purchased from Amazon or Walmart might still be used for disciplined practice. While a Zen community with a public retail business may sell its products to its adherents within a shared dispensation of teaching, belief, and practice, non-adherents may make the same purchases, in some instances using items in ways unrelated or even contradictory to the Zen community's dispensation. Indeed, one might purchase a cushion or mat as furniture and not for *zazen,* incense for ambiance not ritual, and a buddha statue not for a home altar but to decorate a mantlepiece or yard. The Buddhist communities, which may benefit from the sale of such products both financially and in terms of work-as-practice, may see such consumption for other purposes as still seeding the Dharma, and who is to say that a non-practicing owner will not one day return a meditation cushion or other item to its first-order function in practice-based Zen.

Has Zen managed to appropriate retail for Zen purposes? If so, how does this square with our understanding of Buddhism and Zen practice? Are products sold by Zen communities more authentic and safer from criticism than those available from Amazon? How does the consumption of Zen products for religious or spiritual ends negotiate the system of capitalist consumption? Leave it to the philosopher and social critic Slavoj Žižek to proclaim that "Western Buddhism, this pop-cultural phenomenon preaching inner distance and indifference toward the frantic pace of market consumption, is arguably the most efficient way for us fully to participate in capitalist dynamics while maintaining the appearance of mental sanity—in short, the paradigmatic ideology of late capitalism."[14] Žižek appears not to refer to serious Buddhist teachers and practitioners, many of whom might concur with his critique, so the question What should we make of both retail Zen and Zen retail? merits further inquiry.

BUYING ZENNY STUFF

Zen, like Christianity, has been commodified and "McDonaldized," resulting in conventional and quickly available categories of mass-produced commercial products and not a small amount of kitsch.[15] Never a day goes by without another product or marketing campaign that leverages Zen—a new item every week, and now on sale. The design can be edgy, ethereal, rustic, absurd, or cute. Materials run the gamut from weathered wood to anodized metal, porcelain to plastic. Retail Zen products go on, in, and around us; most have no inherent relationship to Zen practice or Buddhist teachings.

Start your day with coffee in a "Zenguin" mug decorated with a penguin holding a lotus flower accompanied by the caption "What is the sound

of one flipper flapping?" Then have a bowl of "Optimum Zen" cereal and feed your dog "Holistic Zensitive Blend" pet food. For lunch, have a salad with "Zen Blend," one of Earthbound Farm's "Power Greens." If your infant or toddler is fussy at mealtimes, purchase the "Zen Collection" high chair: "A balance between beauty and function . . . an upscale look with rich textures, earthy colors and beautiful wood accents to help create harmony in your home (especially at mealtime!)"[16] In the evening, have a glass of Ravenwood Winery's "Zen of Zin" or the premium sake, "Urakasumi Zen."[17] At day's end rest your head on a "Zen Chi Organic Buckwheat Pillow." Wake up the next morning to the sound of your "ZenAwake" iPhone alarm clock, and Zen consume all over again.

There are easily a dozen or more categories of retail Zen stuff out there, and there is even the (tongue-in-cheek) consumption practice known as "Zen shopping, the art of using someone else's preferences in order to shape your purchases":

> Step 1: Find a person who looks like they know what they're going to buy.
> Step 2: Follow said person to their destination, and take note of their purchases.
> Step 3: Purchase an item (or items) identical to that of the person (within your financial limit).
> Step 4: Return home and enjoy whatever purchases you have made, be they food, music, or literature, you must eat, listen to, or read every bit respectively.[18]

In other words, let go of your own shopping desires, detach from the purchase of particular things, and go (buy) with the flow.

In some instances the concept and advertising copy are imaginative and at others banal or neo-orientalist. Occasional irony breaks the pattern. Regardless, you can bank on the fact that Zen is not a fickle consumer trend but a reliable global lifestyle concept that utilizes, in different ways for varied markets, Zen-evocative materials, designs, and lingo. In Brazil, Cristina Rocha writes, the Zen consumption lifestyle arose with urban cosmopolitanism and "global flows of the imaginary of Zen and their creolization with the local Brazilian imaginary."[19] If you find yourself in Bangkok, pay a visit to the ZEN Lifestyle Trend Megastore at fashionable Ratchaprasong Intersection. Touted as "the definitive all-round retail hub" representing "all that is fun about Bangkok," ZEN would seem to have nothing to do with Zen as religion, spirituality, philosophy, and traditional or even radical art.[20] Instead, it is a lifestyle concept mall for the youthful, trendy creative, cool,

alternative, and enlightened. Level three is the "'Casual Women's Zone' sporting ultra-chic fitness and aerobic wear and gear, nonchalantly stylish smart-casual fashion, underwear and hair and nail bars." The "ZEN 'Women's Vanity Restroom' is an enlightening experience in its own right." One level up is the "metrosexual man's destination, featuring breezy smart, business and casual wear, as well as novel shoes, jewelry, accessories and high-end timepieces." "Funky Edgy ZEN," on level five, offers "designer denim and cutting-edge street fashion, international sportswear, swimwear and beach fashion—and don't forget the hip 'ZEN Tattoo and Body Art Studio.'"[21]

The Zen in the ZEN megastore may be nothing more than branding for goods and services that are indistinguishable from those of upscale malls globally, but like many Zen retail platforms its concept comes with a credo: "ZEN IS About our state of mind, our cultural and style preferences, our beliefs and our aspirations . . . ZEN IS About giving you a Zense of identity, Uniqueness, Happiness, Self-Esteem and Fulfillment . . . A peace of mind. Be Daring, Resourceful, Confident, Trend-setting, Expressive, Open, Be Special, Be proud to give the Best to Yourself, Be the One."[22] It may take some work to square this paean to hip and high-end, ultrachic and conformist-consumer individuality with orthodox Zen teachings, but the customer at ZEN can, it appears, purchase that "Zense" of life as art and be special by buying the best and, presumably, peace of mind. "Be the One" (rather than be one with everything?).[23]

It is easy to dismiss Zen-concept lifestyle marketing and Zenny goods, but we might consider the individual sales pitch and package design, which in some instances resorts to tried-and-true modern notions of Zen and Zen aesthetics and in others goes where Zen has not gone before. There are also ripples that emerge from these things once they enter the global flow. Nothing stays in one market or target audience for long, and Buddhist and Zen communities online are quick to respond. Counter-narratives and reappropriations are therefore part of modern-contemporary retail Zen.

Of course Zen is not the only Asian religion and cultural tradition to have been processed into marketing opportunities and objects of consumer desire.[24] "Mindfulness," is only the latest case. Even if, as Jeff Wilson points out,

> Technically, mindfulness itself can never be commodified, because the act of awareness cannot be literally packaged, bottled, transmitted, weighed, or measured. It lies outside of the material dimension and therefore cannot be simply stored on a shelf or shipped through the mail. . . . Given this conundrum, peddlers of mindfulness must take two indirect approaches: they must either sell auxiliary products designed

to introduce or augment mindfulness, or sell their expertise at teaching mindfulness and delivering the benefits of mindfulness.[25]

Wilson's analysis is instructive for the case of retail Zen, even if the line for some consumers between possessing the thing and believing that they have achieved some sense of the awareness it is said to embody or foster may not be entirely clear.

◎ ◎ ◎

The postwar trail of Zen-styled and themed products is easy to pick up. Mary Farkas, echoing McCandless' earlier comment, observed in 1958 that "Of course there are those who think Zen can be used as a gimmick in their business or profession. . . . Soon we will have Zen toothpaste and cigarettes, one must suppose."[26] Her prognostication was correct, even if it took several decades to appear: after vaping with a "ZEN CIG," a disposable electronic cigarette, brush your teeth with "GoSMILE Zen Toothpaste."[27] In 1960, one could drink "Midi," a blend of Cassis liqueur and rosé, advertised in *The Sunday Times* with the encouragement: "Dialectical Materialists dig Midi. Zen Buddhists maintain its necessity. . . . Buy yourself a bottle or two of Midi and align yourself with world interests."[28] Commies and Zennies like it, you will too. In 1966, when Farkas commented on "Zen" perfume, she also took issue with the "Zen macrobiotic (long-life) diet" promoted by George Ohsawa (born Sakurazawa Yukikazu, 1893–1966): "The Zen of Ohsawa's macrobiotic diet is . . . 'purely his own idea' as he said. . . . As Ohsawa came to New York at the time Zen was at the height of its popularity, his use of the word Zen in his promotion is as understandable as it is objectionable."[29]

Then, in 1964, the Japanese cosmetics company Shiseidō introduced its "Zen" fragrance line (fig. 37). Now sold as "Classic Zen," the company describes it this way: "This is a warm lingering fragrance that conveys a mysterious, unique quality that is not unlike the Oriental philosophy that inspired it. It is quiet, yet sensual, exotic and modern, tempting and sexy yet innocent. It is a blend of jasmine, rose, burnished woods, and soft mosses."[30] As for the fragrance's olfactory profile, the advertising copy uses terms that might have made Hisamatsu Shin'ichi—famous for his seven characteristics of Zen art—grumble. But "Zen" was introduced as a world-market product in the midst of the Zen boom, when Zen had become not simply an alternative religious, spiritual, or creative response to the oppressiveness of modern life but a popular notion and cultural trope—and thus ripe for commodification and redirection into bourgeois consumption and normative romantic behaviors. Indeed, American marketing copy for

the fragrance made the most of stereotypes of the mysterious Orient and its alluring women with sound bites on exotic Zen. One Macy's Department Store advertisement announced: "From Japan, the subtle glamour secrets of flower-like Asian and Eurasian beauties . . . the faintly clinging mystery of Zen," adding, "Introduce her to it with an exhilarating eau de cologne, a mist of dusting powder, an intriguing perfume." Or, buy them all and "go Zen all the way. She's bound to love it, and thank you for thinking of it."[31] Another ad amplified the fantasy:

> A philosophy of the Far East is Zen, its beauties expressed with a spirit of "stillness in movement," an ancient esthetic value seen in the deli- cate grace of Japanese painting, in the serene perfection of the tea cer- emony—and in the beautiful Zen fragrance of Shiseido. A marvelously lighthearted scent, pure as a single lotus blossom, feminine as the time- lessly beautiful women of the Orient. In matte black glass flacons with gold-colored grasses and flowers, Zen is an esthetic essence . . . a thing of beauty to be discovered under the Christmas tree.[32]

The copy explains Zen, locates it in Asia, and links it to domains of Japa- nese culture known best to potential customers—Japanese (ink) painting and Chanoyu (tea ceremony). "Zen," the ad suggests, continues this Zen philosophical-aesthetic tradition. The objectifying photography of Asian women in such ads merges this sort of "cultural" consumption with "the timeless beautiful women of the Orient," whose qualities are said be evoked by the fragrance and, presumably, transferred to the wearer (or may play into the fantasies of the purchaser). Reference to the product's discovery under a Christmas tree pulls us back to the "reality" of holiday sales and offers a solution to the presumably heterosexual male's "what to get her" gift dilemma. The perfume's bowling-pin-shaped flacon, while suggestive of modernist design (and perhaps mildly phallic), is surprisingly without con- ventional Zen-associated visual qualities (monochrome, abstraction, and the like), reflecting instead the (patently non-Zen) aesthetics of Japanese Kōdaiji style *maki'e* (sprinkled in picture) lacquer, notably floral and "fem- inine."[33] Such culturally saturated design, however un-Zen, no doubt set off the bottle from other brands with an exotic elegance and helped disguise the mass-manufactured container that it is.[34]

Even though Shiseidō has marketed several formulations—"Zen" smells different over time—the original version has had enduring appeal, and aficionados warm to the challenge of describing its Zen-ness. The blog- ger Barbara Herman argues that the name is not a gimmick but expresses Zen's "quiet harmony":

Bright, fruity, floral, spicy, warm, ambery—I am dazzled by how much
this perfume says in a whisper. Its drydown does not ignore what came
before it, but marvelously carries the colors of those notes until they all
resolve into a soft revery [sic]—like a camera's soft-focus image of a gar-
den. A Zen bouquet would find harmony in the disparate shapes, colors
and sizes of flowers, letting each flower be what it is, while allowing its
beauty to be offset by the completely different, yet perfectly imperfect,
flower next to it. Because of the interesting color combination, the sim-
plicity, and the ineffable sense that love went into its arrangement, it
would achieve the quality of wabi ("quirks and anomalies arising from
the process of construction, which add uniqueness and elegant to the
object") and sabi ("beauty or serenity that comes with age" or wear).
. . . Decadent and reserved, riotous and quiet, voluptuous and austere,
this perfume exemplifies the way that the wabisabi aesthetic so dear
to Zen Buddhist practice can make simple things seem grand, seem-
ingly nonsensical Koans speak volumes, or the mere calling attention to
nature more of an art statement than a self-conscious art construction.
Zen a quiet masterpiece.[35]

By being attentive, then, one can perceive the Zen-ness of "Zen," which
develops from a juxtaposition of scents (Top Notes; Heart Notes; Bottom
Notes) that resolve into the transcendent. If the Zen-associated principles
of weathered imperfection (*wabi-sabi*) have a fragrance, this seems to be
it; if penetrating a koan turns nonsense into realization, wearing or sensing
"Zen" may transform one into a person of Zen.

Effusive as Herman's description is, it makes the effort to link the
product to a chain of Zen-associated aesthetic concepts, psychological-
spiritual states, and practices. This is hardly unusual in the Zen-scape, but
one might wonder if the perfumer Josephine Catapano (1918–2012), com-
missioned by Shiseidō to create the scent, had similar concepts and states
in mind. Is Herman finding Zen in the fragrance by virtue of branding?[36] Or
is there an intrinsic olfactory Zen? (My personal olfactory recollections of
Zen temples are of top notes of incense, middle notes of tatami mats, and
hints of dust and mold.) In the marketplace, such questions matter little if
the branding and the desires it exploits set in motion the cycle of consump-
tion. That said, and despite her reach into the world of Zen (as she knows
it) to describe and recommend Shiseidō's perfume, Herman would be better
off not wearing it to her local Zen center for Dharma talks and meditation
sessions; the scent of "Zen" would disrupt Zen itself.[37]

Since the 1960s, retail Zen has spread into virtually every domain
of consumer culture—arguably to the point of banality. Although the

degree of proximity of a retail Zen product to the monastic tradition and its visual and material cultures is not worth fixating upon, especially if we consider Zen as polythetic, we might still pay attention to how a product's aura-making, marketing mechanisms, and consumer re-enchantment may make use of the clichéd other to create commercial difference and promote sales. Occasionally Zen product design gets inventive and connects to a personal backstory—the Zenny having some connection to Zen. Take, for instance, Nike's "Roshe Run" shoe (Roshe is from the Japanese *rōshi,* or senior teacher). Described by one blogger as an "undisputed favorite of fitness freaks and hypebeats alike," the shoe is touted for its design simplicity: "there's a reason the Nike Roshe Run stands out today— more for what it's *not* than for what it is."[38] If that's a hint of the shoe's Zen affect, its designer, Dylan Raasch, has provided us with the tale of the shoe's origin:

> Since I was young I have practiced meditation, so the concept of Zen and simplicity plays a big part in my life. The inspiration and name comes [*sic*] directly from the word "Roshi," which is a title given to a Zen master. And to me, nothing really epitomizes simplicity better than a Zen master. For legal reasons, we had to change the "i" to an "e," but it is still pronounced the same so it worked for me. From there, I designed the shoe to be as simple as possible by keeping only what was absolutely necessary. . . . I pictured the Zen master meditating in his Zen garden and used the shapes and color for inspiration. The bottom of the outsole uses the Nike natural motion waffle pattern, but I wanted them to look like stepping stones in the garden. The insole was designed to mimic a freshly raked Zen rock garden. The original iguana colorway played off the natural dark green moss and leaves and the off-white rocks of a Zen garden.[39]

Raasch's design sketch, meanwhile, gives us multiple views of the shoe in "iguana" color orbiting a black-robed monk seated in meditation and balanced on the page with a garden rock with surrounding raked gravel and a bonsai-like pine tree. Wrapped around the shoe, then, are a designer's account of meditation practice and resemblances to Zen aesthetics and culture, producing a style that is the-simpler-the-better, athletic or chill, up-or-down-tempo, and, it turns out, the wellspring of a seemingly endless product line.

Footwear bearing the Buddha's image provokes ardent protest from Buddhist communities, but the "Roshe Run" appears to have avoided this vulnerability thanks to its philosophical-aesthetic concept (profound

simplicity) and reference to nonfigurative material culture (Zen rock gardens; fig. 3) rather than the Buddha's image.[40] Zen, at least in its consumer product forms rather than its monastic or lay advocate contexts, often has no face. Meanwhile, it is inherent in the Nike global merchandizing context that Raasch's Zen design features are found in a product not intrinsically related to meditation. This is not to say that Zen teachers do not wear running shoes, and some lead retreats on running as meditation—whether or not "Roshe Run" shoes are on their feet is unclear.[41] But the "Roshe Run" concept is noteworthy for its efforts to shape- and material-shift a Zen rock garden into a shoe for an active, cool lifestyle: one metonym joins another. To put on this shoe, or to look down at one's feet, is, perhaps, to step into a Zen podiatric calm or the meditative tranquility of a Zen garden. To be seen wearing "Roshe Run" might show how Zen one is, assuming that viewers know its design story or pick up on its garden mimicry. If the shoe's "Zen-like features will surely keep heads turning," as one consumer remarked, this may make particular sense in the monochromatic "Black-Anthracite" style.[42] But will it work with the shoe in "Sport Turquoise/Poison Green-Summit White" or "Bright Citrus/Flash Lime/Laser Orange"?

Lest one assume that the shoe has escaped criticism, *The Worst Horse* blog panned the "Zen sneaker" from a Buddhist perspective. Referring to what I assume is Nike's record of exploitative labor practices and perhaps its resource consumption and post-consumer waste, the blog speculated: "Perhaps Nike will also take further inspiration from Buddhism-confluent lines and do what it can to halt its involvement in the propagation of suffering"[43]—the suffering, in other words, that Nike creates rather than eases with its production of the (otherwise comfortable) Zen-themed shoe, suffering (Skt. *duḥkha*) being a condition to end by understanding the Buddha's teachings on craving (Skt. *tṛṣṇā*) and the path to the cessation of suffering. From this perspective, however "reverential" the designer's attitude toward meditation and citation of Zen-associated forms may be, the product does not exist in Zenny empty space, free from its production, labor, and lifestyle consumption contexts.

One may grant *The Worst Horse* its Buddhist teaching moment. That said, customer reviews of the shoe line refer almost exclusively to lightness, style, versatility, price, and durability; fashion and comfort apparently trump Zen design and Zen ideas. This is not terribly surprising, though one might cringe a bit at customer reviews that boast, "I have 15 pairs of these Roshes," or "They are so comfortable that I'm now getting a different color every other week!" Hyperbole perhaps, but this is the realm of corporate marketing and fashion-hungry ghosts in our post-religion "religion of consumption."[44]

If Zen goes on you it also goes in you. Visit an upscale, organic, or holistic-themed super-market and you'll come across a dozen food products advertised with Zen and Buddho-spiritual notions of meditative, inner calm. For example, there's the aforemen-tioned "Optimum Zen," an organic cereal sold by Nature's Path Foods of British Columbia (fig. 38). Made with oats, ginger, and cranberry, it's quite delicious, and I became a fan, but the packaging alone may be worth the purchase price. The product name floats upon a star-burst background under a cor-porate logo and is surrounded by

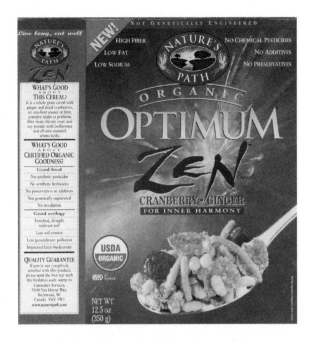

FIGURE 38.
Nature's Path
"Optimum Zen"
cereal packaging.

claims of high fiber, heart-health, and non-GMO content. "Zen" appears in quasi-East Asian calligraphic style and is tagged with the superscripted Trade Mark symbol. Distinguished from the psychedelic background by its indigo color and gold highlight, "Zen" is close in hue to the banner below that proclaims the product's purpose, namely "For Inner Harmony." The marketing seems clear enough: this is not a box of cereal "twigs" or granola, it's a Zen product that confers harmonious Zen benefits. The back panel copy, meanwhile, promises to help us "Enjoy a Zen Moment Every Day." This moment of Zen is that satisfying sense of synchronized mind, body, and spirit—"the peaceful sign of being in tune with yourself." Add images of a Zen rock garden and white, meditating female model (on the back panel), and it seems that eating fiber clumps and soy protein chunks is a spiritual, health-conscious journey of Asian inflection. If all this fails to make the sale, perhaps the packaging's quote from the Dalai Lama will tip the balance: "If you want to be happy, practice compassion."[45] One has to hand it to the box's creative team for their inventive enthusiasm, though it prompted one reviewer to riff, somewhat satirically: "We swallowed our first bite cau-tiously, afraid we might fall into a trance or begin levitating as the kibble hit our stomachs. But we were fine, fine. We continued to eat our breakfast and read the box, which provided five minutes of blissful diversion from current events (good for anyone's inner harmony)."[46] Reading cereal boxes in the morning hours may be a tiny but consequential moment in some of our lives as consumers, and arguably there is nothing unusual about product

marketing that leverages Buddhist and Zen-associated tropes—calmness, inner harmony, finding a "space of meditative calm," and so forth. What is perhaps noteworthy is the suggestion that one's true nature, as it were, can be achieved through consuming high fiber and cleansing ginger, long valued, we read, by Asian cultures. Eating "*Optimum* Zen"—the first word evokes result-oriented and efficient best practices—may produce optimum output, a particular sense of "emptiness." This is not the first time Zen and bodily processes have comingled, and healthy bowels make for productive meditation (Zen and the Art of Gastro-intestinal Maintenance, as it were).[47] That said, one might wonder if this vision of Zened high-fiber and a daily Zen moment was intended to play to Zen boom-nostalgic Boomers living through their "colonoscopy years," not to mention post-Zen boom health-conscious consumers of a certain race, affluence, and lifestyle, who get their Zen through brand-based fantasies.

Such is the world of retail Zen, and commercial scripts for products like "Optimum Zen" employ the generally trusted yet frequently derided advertising strategy of "borrowed interest": the use of a word, statement, person, imagery, behavior, mood, and so on determined to be of importance to a targeted market segment—but intrinsically unrelated to the product being advertised—that aims to capture consumer attention. It is a sort of bait-and-switch used to drive the marketing campaign to success.[48] The borrowed Zen con may also exploit the (con)fusion of tropes for Asia and Asian cultures: Zen and the Dalai Lama, Zen and Yoga, and Zen and Karma. In the (in)famous 2005 television commercial for Yoplait Whips, two women—white and African American girlfriends taking a spa holiday and consuming the creamy product—trade exclamations. One purrs, "Wow, chocolate Yoplait! This is like Zen, wrapped in karma, dipped in chocolate good."[49] The other replies, "Soaking in a chocolate bath good." Then, back and forth: "Chocolate body wrap good"; "Getting a foot massage, while shoe shopping"; "For chocolate-covered heels, good"; "This is like dating a masseuse good." Someone decided that Zen, karma, and chocolate are "les mots justes" for selling this otherwise mundane product (mass-market, neither exclusive nor rare) within an atmosphere of indulgent luxury with mingled stereotypes of Asian spirituality and a shower of gender clichés. Of course the product is not in any sense related to Zen precepts, ritual, religion, or spirituality per se. Rather, its Zen is that of health-conscious living, similar to "Optimum Zen" but in a different media and realm of consumer fantasy.[50]

In an act of reverse discourse, however, the Zen teacher Brad Warner reappropriated Yoplait's phrasing for his book title, *Zen Wrapped in Karma Dipped in Chocolate: A Trip through Death, Sex, Divorce, and Spiritual*

Celebrity in Search of the True Dharma (2009). A "big snarly ball of con-
fessional vomit," as Warner puts it, the book confronts the challenges of
meditating amid personal adversity and channels it into contemporary Zen
teaching.[51] For Warner, who received Dharma transmission in the Japanese
Sōtō tradition, the Yoplait commercial's solipsism is ripe for repurposing
into Buddhist teaching on nonattachment to the self: "We want to suck the
whole Universe into ourselves and carry it around in our bloated bellies,
giving back a little only if it will get us more than we give. In doing so we
experience misery upon misery. But when you give back without hope of
receiving anything in return, the reward is immeasurable. . . . Your duties to
parents, friends, and acquaintances, even enemies is your karma. So wrap
your karma in some Zen and dip it in chocolate then feed it to someone who
needs it."[52]

Warner—known for his "Hardcore Zen"—makes a compelling Bud-
dhist point, and we might smile at his appropriation of borrowed interest
Zen marketing for the purpose of teaching tradition-derived, practice-
oriented Zen. But Warner does not "purify" Zen of commerce, for his vehicle
is another commercial product, a book in the expanding Buddhist life-coach
publishing market. What we might take note of, then, is the interdepen-
dence of commerce and teaching or the call-and-response, push and pull,
within and against the Zenny zeitgeist.

HAUTE AND HIGH-PERFORMANCE ZEN

Most of us could not afford the sort of "artcentric" clothing shown by the
designers Viktor & Rolf in their "Zen-themed tableau-vivant of the world-
famous rock garden in Kyoto's Ryōanji" at the Paris Haute Couture Autumn/
Winter 2013 Collection Show (fig. 39).[53] Marking the designers' return
to Couture after thirteen years, the performance began with the Nether-
lands-based Horsting and Snoeren dressed in black, seated on the stage
back-to-back and cross-legged on cushions, and lit from above. After med-
itating for five minutes, the designers stood up and exited. The stage went
dark. Shortly thereafter, the lights came up accompanied by a minimalist
soundtrack of drum and cymbal that grew gradually with slightly menacing
electronica. Twenty predominantly white female models walked one-by-one
onto the stage, the floor of which simulated the Ryōanji garden's patterns of
raked gravel (fig. 3). Dressed in a black "technical silk that had the spongy
appearance of neoprene, and flat ropy sandals," the models moved to five
areas of the stage, where they clustered or sat or lay singly.[54] The designers
meticulously positioned each model, shaping sleeves and hems, turning the

models into the famous garden's rock groupings; fringe at the hems of certain garments evoked the thick, surrounding moss. Once the models were "turned to stone," the designers returned to center stage, faced each other with palms pressed together (J. *gasshō*), and bowed once before again exiting. The lighting dimmed, leaving a spotlight on each "rock" group.

The performance, which highlighted the designers' "conceptual" rather than "wearable side," apparently "drew thunderous applause."[55] With its runway reincarnation of Ryōanji's garden, meditation, and bowing, the Zen and Buddhist associations were obvious. Subsequent reporting responded with not unexpected Zen tropes. The designers, we read in one review, "felt a need to express a feeling of serenity and nothingness for which the simplicity of the rock garden in the Japanese Zen temple was a perfect match."[56] "Viktor & Rolf went Zen," another reviewer gushed, and sought "mindfulness and being in the moment. It was an exercise in minimalism—a word they used to describe the designs—and every piece was made in the same black material, treated to look like rocks and grass."[57] They "took a psychic journey to medieval Buddhist Japan," a critic burbled, and another declared that "The Duo zenned out before the show started," only to then bemoan the length of time the designers meditated on stage.[58] Still another exclaimed that the clever, high-concept show with its "instant Zen garden" was "a brainy chaser after a week of chiffon and crystals."

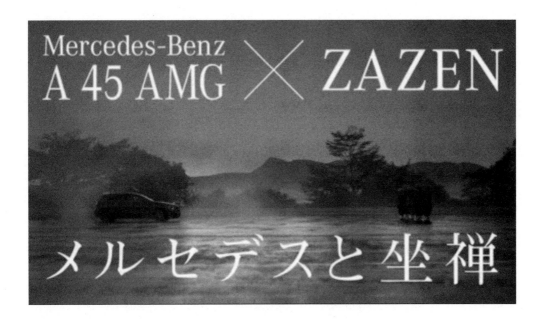

Mercedes-Benz
A 45 AMG ✕ ZAZEN

メルセデスと坐禅

"The word backstage," meanwhile, "was that half of the collection has already been snapped up by a collector."[59] You had to be there, I suppose, or have your finger on the Zen-fashion pulse.[60]

Clearly, Ryōanji has not lost its allure as a metaspace of Zen-associated minimalist design and mindfulness. Geisha, cherry blossoms, and Hokusai's *Great Wave* have already hit the runway in neo-orientalist frenzy, so why not the famous Zen rock garden?[61] Despite being somewhat clichéd (with miniature rake-it-yourself versions, cartoons, and other popular culture riffs), the garden and what it signifies is sufficiently high in aesthetico-spiritual value for Haute Couture. Or perhaps Viktor & Rolf's "Zen-themed tableau-vivant" was less a pious appropriation than a form of Zen camp, or even Zen voguing. That might lend a bit of frisson to the performance's otherwise ponderous appropriation, "high concept" fantasy of the other, and fashion-world hoopla.

Then there is high performance, luxury automotive Zen, as we discover in the short commercial film "Mercedes-Benz A 45 AMG X Zazen," released by Mercedes-Benz Japan in 2013 (fig. 40).[62] The film begins and ends in gray-black monochrome, playing with conventional Zen art tropes, but its plot does more than merely ply a visual Zen. As the practitioner and writer Rod Meade Sperry put it on the site, *Lion's Roar: Buddhist Wisdom for Our Time,* the commercial "seemed to pit Buddhist renunciates against, yes, a luxury car."[63] With its tone of indignation, Sperry's comment joined other reactions from Buddhist teachers and practitioners who, as we shall see, questioned the film content's intent and authenticity but also

FIGURE 40.
Screen shot. Mercedes-Benz Japan, "Mercedes-Benz A 45 AMG X Zazen."

considered its heuristic value. In global circulation, retail Zen can be appropriated by practice Zen.

As the film begins, morning rain has lifted, and a sleek, slate-colored A 45 AMG sits quietly on wet blacktop overlooking a fog-filled valley. The adjacent trees and distant hills are silhouetted against a cloud-ashen sky. Crickets hum; we are in the countryside. Five monks wearing robes and conical bamboo hats stand in a row and face the vehicle. Then, a close-up of the car and the monks, who raise their hands in unison to remove their conical hats, revealing brain-wave-monitoring headbands wrapped across foreheads and ear-clip heart-rate monitors. A bell rings. Water ripples in a basin. We are now inside a half-darkened temple, where the monks are chanting.[64] In the next shot a monk sits on the temple veranda, seen from the back, and the commercial's Japanese voice-over begins with English subtitles: "Zazen is supposed to soothe your spirit." Chanting continues in the background. The film then shifts to views of electroencephalograph (EEG) output readings tracking across computer screens in even, low intensity pulses, a monk with an EEG headband, and the monitoring team with its hardware set up under an awning.

Five monks arrange themselves in a circle on the blacktop, adjusting posture and robes and bowing. The leads from their monitoring devices trail back to the observation team. The voice-over and subtitles continue: "Maintain calm breathing and correct posture. And you will achieve [a] sense of tranquility. Keep your earthly desires in check and never relinquish your abiding faith. Then, you will finally see the truth ahead." The senior monastic looks out at the monks with an expression of confidence. One of the seated monks then hits a pair of clapping blocks (J. *hyōshigi*) to begin meditation. Silence. An incense stick burns, smoke rises upwards in a straight, unwavering line. Close-up views capture faces in deep concentration. Gray mist swirls past.

The monitoring team watches their screens, which display even EEG waves. Then, the driver of the A 45, parked at one end of the tarmac, starts the engine, given the okay by walkie-talkie from the monitoring station. The line of incense smoke wavers. The driver accelerates the vehicle towards the seated monks and turns to skid and drift in circles around them—engine and tire noise intrude, sheets of water are thrown up from the blacktop. This is the sort of power drift, donut stunt one sees at street-racing sideshows and that has been immortalized in the blockbuster film *Fast and the Furious: Tokyo Drift* (2006). Here, however, the careening vehicle encircles meditating monks, in unnerving proximity. Perhaps the circular drift is a reference to the *ensō,* calligraphic circles in traditional Zen imagery signifying emptiness, here "brushed" by the roaring vehicle. Then a shot in silent

slow motion shows the car behind the monks, followed by another of the vehicle's steering wheel and driver's gloves.

The senior monk looks on as the car roars and slides. We see again the faces of individual monks. Then there is a silent, still shot of the sun coming through the clouds. After one last spin, the car comes to a halt. One monk looks up with an expression of relief or defeat. Electronic music comes in. The team monitoring their brain waves and heart rates notes the large oscillations appearing on the monitors. The monks have failed to maintain equanimity; the car has distracted their minds, raised their pulses. The senior monastic frowns in displeasure and walks towards the monks to administer slaps of the *keisaku* (admonition stick). After a final shot of the car skidding in slow motion around the monks and overlaid text—"Fascination for all. Technology that moves the heart. Mercedes-Benz A 45 AMG"—a single monk stands before the car and bows.

According to Mercedes-Benz Japan, "The video was created to verify whether people can stay calm when A 45 AMG 4MATIC with the latest technology is driven close by. It delivers the characteristics of the car that can even shake the heart of the well-trained monks by its fascination, using metaphors as the dynamic driving with the A 45 AMG 4MATIC in a closed circuit for 'Action' and the monks doing Zazen for 'Silence.'"[65] The question posed by the film is therefore straightforward: Could the monks maintain the state of nothingness attained in silent *zazen?*[66] The answer is clear. The car is so thrilling and powerful that it distracts even disciplined monastic meditators. Car overcomes monk and meditating mind; at the film's end, the monk therefore bows in respect before the automotive "master."

Although the commercial was quickly removed from the Mercedes-Benz Japan website and official Youtube site, it was seen widely and hailed by some for its creativity. One writer in the automotive genre praised it as a big improvement over the earlier Mercedes-Benz "Chicken ad" touting the S-Class W222.[67] Viewers who found the Mercedes x Zazen commercial's story line or intention unclear nevertheless found the vehicle itself impressive. Most car enthusiasts had little to say about the Zen, although one reviewer joked, metaphorically cross-dressing popular culture in spirituality, "For drift fans, this, right here [the drift], is the real absolute truth of the cosmos."[68] Others saw through the film's conceit—"This is a fantasy about ZAZEN, not seated meditation itself." Some criticized use of the tired trope of "mysterious Japanese culture" to promote the image of Cool Japan.[69] One viewer in Japan asked, "What sect are these monks from, and how much money did they get for this?" To which a sympathetic reader replied: "They are Zen monks, but the commercial left me disgusted. If they are real monks, why would they appear in such a vapid commercial, making them

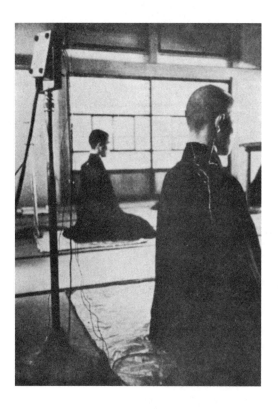

FIGURE 41.
EEG monitoring
of meditating
Japanese Zen
monks. In Akira
Kasamatsu and
Tomio Hirai,
"An Electro-
encephalographic
Study of the
Zen Meditation
(Zazen)," *Psycho-
logia: An Interna-
tional Journal of
Psychology in the
Orient* 12, nos.
3–4 (December
1969): 207.

look like fools? And which temple are they from? It all makes me hope they're fake monks. . . . I wonder if there isn't a bizarre misapprehension underlying this commercial—akin to the idea that Japan is a land of Superman-like Ninjas."[70]

How anyone could remain utterly calm or centered in meditation, given the cacophony, velocity, and threat of bodily harm should the driver err, is beyond me. How might we reconcile the power, noise, speed, and disruption with common modern perceptions of Zen aesthetic qualities, such as Hisa-matsu's Seven Characteristics of Zen, let alone traditional Zen teachings? What do we make of the commercial's whiff of "macho nonsense."[71] Given the vehicle's price point (pushing above US$50K), would these monks be likely consumers of this vehicle, or were they, like the majority of viewers, only to be transfixed in suspended, unfulfilled desire? If they were compensated for their performance, was the revenue a means to an end in a challenging era for Japan's Buddhist institutions, with their declining temple budgets and dwindling congregations?[72] Let us also keep in mind the crux of the commercial, its pitting of car against monk: a high-performance machine put to use as a hypermechanized device of distraction, to shake the heart of disciplined meditators, lure them into "fascination," and promote the product in a triumph of technology over tradition. This is about speed and motion over centered, still awareness, and materialism over contemplation and wisdom. Zen—often and in different ways appropriated into "cool culture"—is first exploited for its exotic religious, preindustrial cachet only to be defeated, supplanted by automotive cool.[73]

The film's conquering automotive concept depends not just on meditating monks, however, but on science—specifically, scientific research on Buddhist meditation, borrowing recent interest in the wiring-up of monastic meditators with brain-wave-monitoring devices.[74] This is not a new idea, for EEG and other physiological studies of meditating Zen monks are more than a half-century old (fig. 41). From the late 1950s Japanese physicians and psychiatrists conducted various studies of monks in monastic settings. Kasamatsu Akira (1910–1987) and Hirai Tomio (1927–1993) even produced

a documentary film, "The Science of Zazen."[75] This nexus of science and Zen meditation was celebrated in the 1960s and 1970s in medical and Buddhist literatures and attracted attention in Japan and the West within an emerging Zen-health movement concerned with the stresses of technologically advanced, automated, and corporatized life.

For the Zen institution, data regarding the high-amplitude alpha and theta waves that occur during the meditation of experienced monastics was scientific proof of the ancient practice's significance to the modern world. An enthusiastic effort to promote such physiological evidence shows up in a 1962 English-language booklet produced by the Tokyo headquarters of the Sōtō Zen denomination, titled *Zen: The Way to a Happy Life*.[76] Written for Western readers, the text promotes the value of Zen meditation in the "tumultuous and irritating life of the modern world."[77] Following "A Brief Guide to Technical Terms," with examples of the EEG waves that indicate when a person "keeps a tranquil mind," we learn that a number of Sōtō monks were "selected as subjects, and serial recordings were made in the course of their usual Zen practice. Electrodes were applied with collodion at the parietal and occipital regions of the subjects so that the applications would not disturb them in practicing Zazen." The results, we read, were impressive.[78]

Validated by science, traditional Zen meditation was therefore touted as the antidote to Western rationalism and science, and to further engage general readers, the booklet brought in the medical writer and Sōtō Zen lay practitioner Sugi Yasusaburō (1906–2002), who describes study of senior monks and lay practitioners at the Sōtō temple Kasuisai in Shizuoka Prefecture. In Sugi's view, the data shows that *zazen* "is the best method to calm or tranquilize the nerves consciously, and rectify the distortion of the interbrain and give mental stability." If this is Sugi's scientific voice, he added, in a burst of sectarian hyperbole: "The Soto Sect of Zen Buddhism, which most emphatically recommends the practice of Zazen, aims at the creation of perfect men who can steer themselves safely in the muddy whirl-pool of present-day life. It is the salvation of man. It will save mankind from the genocide or holocaust which is looming ahead."[79]

Whether or not the creative team that produced the Mercedes-Benz commercial was familiar with the studies conducted by Hirai, Kasamatsu, and others (and regardless of whether or not the commercial performance involved actual EEG readings), the team's responsibility was not to promote science, religious realization, or mental health through meditation. Rather, the "experiment" was conducted for the purpose of global luxury marketing, using high-production-value entertainment that depended upon the traditional, religious other. Rather than elevating Buddhist meditation, as is typically the case in mass-media reports on the study of monks, meditation,

and brain activity, *zazen* is shown to be exotic *and* imperfect in the face of hypermechanized automotive technology.

As creative as the A 45 AMG Zazen commercial may be, it is not the first instance in which Mercedes-Benz has marketed with Buddhist monks. In an earlier commercial for the maker's C-Class vehicles, a monk is shown behind the wheel of a sedan and swerving back and forth as he drives down a country road, alarming his passengers.[80] The commercial's punch line reveals that the monk's seemingly erratic driving was in fact an effort to avoid hitting insects. The monk's apparently "unhinged" laughter is actually delight over technology's value to the fulfillment of the Buddhist precept of not killing. The C-Class portrayal, availing itself of the trope of the "crazy master," therefore affirms a core Buddhist ethical teaching even while exploiting it to valorize the technology in the arena of marketing. The A 45 commercial, on the other hand, may be seen to diminish, even lampoon, Buddhist practice, and perhaps this is why the commercial was pulled after about a month: it may have been a borrowed interest fail.[81]

Of course *zazen,* at least in orthodox practice, does not primarily seek "meditative unity for man and machine," but this is the right melody for popular culture and techno-utopic marketing in tune with what R. John Williams refers to as *technê-zen* in postindustrial capitalism.[82] From viewers who practice Zen meditation in more traditional forms, however, we find responses to the A 45 commercial that reveal a bit of soul-searching. Some were disturbed by the appropriation of religious people and practice for commercial marketing. Others suggested that it is fundamentally wrong to promote elite consumption and materialist desire through representation of a practice that seeks nonattachment and realization that all things are imperfect, impermanent, and interconnected. Many responses turned on the matter of what "real Zen" is.

Whatever artistry or wow-affect the commercial's visual values may reveal or produce, its use of Zen works through a presumed affect of authenticity. For certain Buddhist-identifying viewers, however, there were red flags. Sperry asked: "Is it real? Is it phony? Hard to say for certain, but the last shot of the spot, which shows a monk *bowing to the car,* should promptly set off your Dubiosity Meter." "Based on the way their robes are worn," he added, "it's arguable that Tendai [denomination], and not Zen, monks are depicted in this ad."[83] Probing the issue, a comment on the blog of the Tsukuba, Japan-based Treeleaf Zendo, affiliated with the Sōtō Zen denomination, reported: "I couldn't help but notice that their Okesa [Skt. *kāṣāya;* J. *kesa*] were just tied and not tucked."[84] Evidence was then presented in the form of a photograph of Japanese, American, and Danish Tendai monks at the Tendai Buddhist Institute in Canaan, New York.[85]

Moving beyond sartorial accuracy, a comment to Sperry's post took issue with the commercial's portrayal of the senior monk's use of the *keisaku* to discipline the monks for failing to maintain concentration: applying the *keisaku* "for not measuring up to the task is an inappropriate representation of how it is used. . . . The use of the stick is about awakening, not about punishing or abusing."[86]

Such challenges went largely unnoticed among high-performance automotive aficionados, but within Buddhist circles the commercial struck a nerve, leading some to poke fun at its pretensions and push back in various ways. One practitioner opined on the Treeleaf Zendo blog that "Sitting in an old VW and truly being present with your hurting ass, your greasy rear-view mirror and the rusty dashboard. Opening into the falling that is awakening to true beetlehood. That's more like Zazen."[87] Another quoted from the song "Mercedes Benz," sung by Janis Joplin (1943–1970) in 1970:

> *Oh Lord, won't you buy me a Mercedes Benz?*
> *My friends all drive Porsches, I must make amends.*
> *Worked hard all my lifetime, no help from my friends,*
> *So Lord, won't you buy me a Mercedes Benz?*[88]

Critiquing elitist consumer marketing with a "hippy era" counterculture critique of consumerism might seem nostalgic were it not for the sharpness of the lyrics, and for the fact that Mercedes-Benz has licensed this very song repeatedly—ironically, perhaps, or at face value, assuming viewers were unfamiliar with the entire song and its original context.[89] The Treeleaf Zendo blog's discussion also prompted, perhaps inevitably, the reappropriation of the brand into the famous koan "Zhaozhou's Dog," the first case in Wumen Huikai's *Wumenguan* (Gateless Gate, 1228): "Q: Does a car have Buddha nature? A: Mu-cedes."[90] On the *Buddhist Art News* blog, meanwhile, the cautionary note issued by Mercedes-Benz Japan—"The driving scenes were filmed with a professional driver on a closed circuit. For your own safety, DO NOT attempt"—received the pithy retort: "On the other hand, for your own safety DO engage in Zazen!"[91]

On the Treeleaf Zendo blog, the A 45 commercial became a topic of more than casual critique. After an initial online exchange, Treeleaf Zendo's American teacher, Jundo Cohen, appropriated the commercial into his weekly "Live Zazenkai Netcast," which he renamed for the occasion the "Benzazenkai."[92] Joining the meditation session by live stream were nine practitioners, each wearing an abbreviated surplice (J. *rakusu*) and seated in their respective meatspace locations. Dressed in traditional robes, Jundo faced his webcam and opened with the following instruction:

Today is a day when I sometimes want to remind folks that, ah, Buddha is in all things and everywhere, seen and unseen, and sometimes we can get very serious about religious form, and Zen always had a way of telling us that there is a time to honor and respect the Buddhist statues, and there's a time also to see that everything, everything in the whole world, the whole world itself, is a Buddhist statue. Sometimes the beautiful, also the ugly, war and peace, if you can see through it, has a greater peace that represents all things. So today, inspired by that television commercial from Japan that I'm still trying to figure out, here's our Buddha for the day. Yes, our Buddha is the Mercedes-Benz. I was going to bring the whole Mercedes-Benz in here, but I would have to borrow one from a friend, and I couldn't figure out how to get it in the Zendō. So this will have to do. So our Buddha is the Mercedes-Benz, with two bodhisattvas on either side, "peace" and, of course, an *ensō*. What does it mean? I'll let you figure that out. Why don't we sit with that? Okay? I'm going to install our Buddha for today, and please know that even though it's sometimes hard to see Buddha may be in a Mercedes-Benz. He's there too. I'm not telling you to go out and buy one. This is not a commercial endorsement. There are better things to do with your money. My five-year-old car is just fine for me.

Despite the fact that the Benzazenkai relied on the same technology that disseminated the commercial, Jundo's triptych was decidedly low-tech: a piece of cardboard, cut from a box, onto which he had pasted three sheets of paper, one with a handwritten peace sign and the word "peace" in ink, the second a photocopy with the Mercedes-Benz logo and lettering, and the third an *ensō* brushed in ink in a traditional manner. Jundo then installed the "Buddha," with its rhyming forms, in front of the altar's shrine and Buddha statue, leaving space in front of it for traditional offering utensils (incense burner, candle, and flower vase). The Benzazenkai then continued with offerings, bows, prostrations, and recitation of the *Heart Sūtra*. This was followed by a reading of the *Dedication of Merit* (merit produced by the sūtra recitation) to the Buddha, the Sōtō School patriarch Eihei Dōgen, and other worthies; for "tranquility and well being for all creatures"; to "all victims of war and violence and natural events"; and so forth. Two periods of seated meditation ensued, combined with walking meditation and recitation of the *Four Vows and Verse of Atonement*. At the conclusion, Jundo again faced his webcam, held up the cardboard "Buddha," and offered his closing teaching: "Alright. Well, lovely. I guess, just a reminder today that there's something sacred in what we do that transcends, goes right through, both the sacred and profane, and a kind of wealth, I would say, riches, that

is more than you can measure. It's not a matter of A-Class, B-Class, C-Class, D-Class, or E-Class [referring to Mercedes-Benz vehicle categories]. Okay? By the way, this was not an endorsement of Mercedes-Benz."

In a blog post, Jundo reinforced his teaching on nonattachment, explaining that the Buddha is present not simply in beautiful statues but in myriad things that make the sacred present. True to traditional pedagogy, he offered his students a version of "Danxia Burns the Buddha."[93] Here, the classical Chan narrative comes into a twenty-first-century space and debate in a way that moves beyond simple rejection of the commercial film. Danxia helps co-opt it, make something meaningful out of it for a practice community, and perhaps turn it into something more truly Zen or a different sort of Zen.

The online coexistence of the A 45 film and the Treeleaf Zendo's discussion and Benzazenkai, the circulation of one representation of Zen from one space into another, and the proliferation of images are all parts of what Zen is now. These spaces are not, of course, identical or necessarily reconcilable. The reappropriation of the commercial into a global space of Zen practice—with attention to ancient/traditional exemplars, narratives, iconography, and ritual, as much as contemporary technology—suggests on the part of the Treeleaf Zendo an active engagement across multiple contemporary spaces in which "Zen" appears, including commercial spaces, and an effort to teach and practice Zen while engaged with the contemporary world. Not much of this is imaginable in a premodern context, but it seems native to the predicaments of Zen in our present world.

ZEN SELLS ZEN

One afternoon the Spring–Summer catalog of The Monastery Store appeared on the floor under my mail slot among bills, charitable donation requests, and supermarket flyers. Its cover combined a photograph of hand-carved wood statues of a Buddha against a sky-blue background with a logo bearing the vendor's name, "The Monastery Store," and the phrase "Support for Your Spiritual Practice at Home." Hesitating at the recycle bin, I realized that this was an example of Zen sells Zen.

The Monastery Store is part of the Zen Mountain Monastery (Doshinji), located a dozen or so wooded miles northwest of the famous village of Woodstock, now more hipster than hippy, in New York State's Catskill Mountains. The monastery is the epicenter of the Mountains and Rivers Order of Zen Buddhism (MRO), the Buddhist organization established by the American Zen master John Daido Loori (1931–2009).[94]

The store—visited online, in hard-copy catalogue, or on site—is a retail space unlike that occupied by the Zen-styled products found on a store shelf, in a magazine, or on the sites of ecommerce behemoths. Here, instead, is a Zen department store, as it were, operated by a nonprofit Zen monastic and lay Buddhist order, selling things for Zen practice and items representative of other Buddhist traditions and that respond to Asia-associated spirituality and holistic lifestyle markets. It is not the oldest Zen monastery in America, but it is one of the earliest and most extensive institutional Zen retailers.[95] What sort of business, then, is The Monastery Store, and what might it suggest about "Zen retail" in comparison with for-profit, corporate "retail Zen"?

To begin with, there is good reason, David M. Padgett argues, to take seriously the production, marketing, and sale of meditation cushions and other items, for "Buddhist Americans' consumption practices are, in conjunction with other factors, having a profound impact on the various ways that Buddhism in America is developing, how it is being perceived, imagined, and, finally, contested." Padgett acknowledges that the character of "Buddhist America" is hotly debated, but he makes a case for understanding American Buddhism as more than merely "rarified and immaterial" and "unrelated to the human traffic in *things*."[96]

As a primary site for the study of retail Zen in the shadow of global corporate capitalism and ecommerce click-consumption, The Monastery Store is operated not in terms of profit but Buddhist Right Livelihood and eco-awareness practices. Many of its products are actual tools for Zen meditation and compilations of Zen teachings from credentialed masters—no perfumes or running shoes à la Zen sold here. Even though the store employs some of the technology, business practices, and vernacular of megacorporate consumerism, its retail items are framed by narratives and values that are enduringly (though not fixedly) Zen and, not surprisingly, indicative of the histories and social constitution of American Zen.

When I visited the monastery on a weekday afternoon one June, residents were busy with daily work and preparations for upcoming fee-based retreats and visitor programs. The brick-and-mortar store is located in the monastery's Sangha House, not far from the main building that houses the meditation hall. The store occupies a rectangular room that is decidedly not "boutiqued out." Wood shelves with books and Buddhist statues line one wall, tables run down the center, and meditation cushions and benches sit on the floor along the opposite wall (figs. 42, 43). Clothing items are hung on the rear wall above a table with sale items. Simple cards provide information and pricing, such as, "Handcrafted Buddhas from Nepal. Price: $20 Code: SHK-NEPAL."

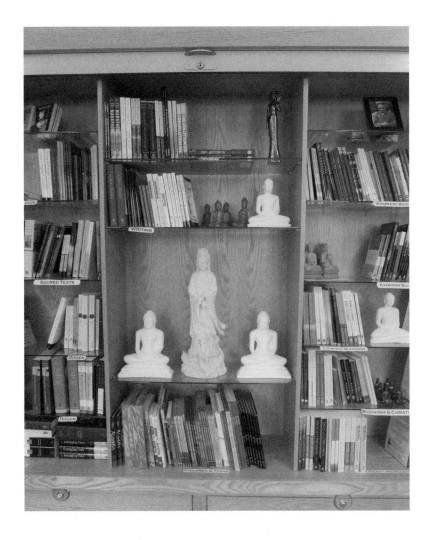

FIGURE 42.
Statues and Books.
The Monastery
Store, Zen Moun-
tain Monastery,
Mount Tremper,
NY. 2015. Pho-
tograph by the
author. Used by
permission of
Zen Mountain
Monastery, https://
zmm.mro.org.

The store offers items for home practice and study, beginners' sets, specialized instruments, and MRO logo-printed goods—ranging in price from three dollars (a roll of incense sticks) to twelve hundred (a calligraphy by Kazuaki Tanahashi). There are meditation cushions, statues, altars and supplies, *mālā* (prayer beads), monastic eating bowls (J. *ōryōki*), and utensils for Japanese tea ceremony. The store also offers numerous books on Zen and other topics; audio disks of Dharma lectures; and DVDs and audio books on Zen, other Buddhist traditions, religion, and spirituality. For eleven dollars you can also purchase the MRO Flash Drive: "2 gigabytes of storage to take your favorite Dharma talks with you wherever you go. With MRO logo printed on both sides."[97] Zen work clothing (J. *samu-e*) hangs alongside T-shirts and hoodies, some with graphics of Bodhidharma and the phrases "Just Sit" or "Think Not Thinking," as well as monk's shoulder bags

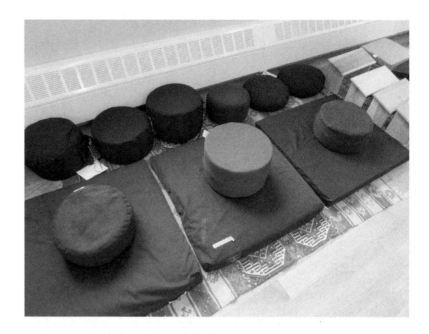

and bags for carrying meditation cushions. There is other MRO "swag"—
mugs, notecards, and the like—and at the front of the store, adjacent to the
credit card reader, sits a stack of parchment cards printed with the text of
the traditional "Evening Gāthā," five dollars each.[98]

On its website and in its catalog but less so on site, the store is orga-
nized into specific departments. New items are highlighted, sales and spe-
cials are announced, and goods are presented with practical descriptions
and, occasionally, the sort of chirpy, promotional pitches one encounters
in mainstream retail: "a cushion so soft and comfortable, you'll forget
you're sitting on the ground"; "If you think that pain during meditation is
just plain unnecessary, this is the cushion for you."[99] Not surprisingly, the
primary retail category is that of meditation cushions and mats (J. *zabu-
ton*) available in a range of styles, materials, and sizes—"From our classic
kapok zafu to the newest member of our cushion family, the Cloud."[100] The
website provides links to instructions for *zazen* and the store's "Zafu Med-
itation Cushion Donation Program."[101] The store assembles its cushions on
site, and the catalog adds: "All of our cushion shells and inserts are made
in the US within 250 mile radius of our Monastery, which keeps our trans-
port related energy use low."[102] Being mindful about one's cushion's carbon
footprint accords with the store's environmental ethic, which reflects Daido
Roshi's engagement with deep ecology and Buddhism.[103] We also learn that
each cushion type has been "developed, tested, and improved by monas-
tics, Monastery residents and other Buddhist practitioners with thousands

of combined hours of meditation experience."[104] This is not a verification of true relics, but as far as meditation cushions are concerned this would appear to be the height of quality control and authentication. The store's attestation also embeds its cushions in the lineage, teachings, and authority of the MRO, something not found when shopping at a mass-market retailer. The latter retail experience also lacks the store's request for tax-deductible donations of used cushions, mats, and other items that are given to practitioners of limited means, including students, former inmates, members of the military, and various practice groups. Through these donations the monastery links its retail store to a sharing or collaborative economy.[105] This helps connect the principle of Right Livelihood to its fraternal twin, as it were, "right consumption."

The Monastery Store also retails statues of the Buddha Śākyamuni (one whose robe is engraved with the characters of the *Heart Sūtra*), the bodhisattva Avalokiteśvara in several "transformation bodies" (J. *keshin*), Mahāprajāpatī (the Buddha's aunt and the first ordained Buddhist nun), the Chan patriarch Bodhidharma, and other deities. Produced in Nepal, Bali, the United States, and elsewhere, the statues vary in size, materials (bonded stone coated with a hand-painted bronze- or white-marble-like finish; cast bronze or ceramic; mahogany), styles (Japanese, Chinese, Tibetan, Nepalese), and price.[106] Catalog copy for these items offers guidance reflective of a particular mode of lay Zen that combines icons and individualized space and practice:

> To create a sacred space is to bring awareness and intention to your place of practice. In setting up a home altar, we encourage you to use elements that are meaningful to you. That's why it's important you have a connection with the central image on your altar—whether it's the seated Buddha in the classic meditation posture, a fierce Manjushri wielding the sword of wisdom, or a standing Kuanyin Bodhisattva expressing the boundless compassion of an enlightened being.[107]

One may also purchase an altar, incense bowl, altar cloth, vase, and so forth. The retail concept here aligns with Buddhist practice that incorporates visual images and the adornment of their spaces with traditional ensembles of offering utensils (J. *mitsugusoku*). One can even buy liturgical instruments: handheld bells (J. *inkin*), gong (*keisu*), fish drum (*mokugyo*), and wooden clapping blocks. These sorts of instruments are not sold by mainstream retailers, and in this respect The Monastery Store resembles businesses in Asia and in diaspora communities that specialize in Buddhist altars and implements for home use (J. *butsugu shō*).[108]

The creation of a home altar with a statue, offering utensils, and liturgical instruments may seem conservative or perhaps even "heretical" to forms of Zen that focus exclusively on meditation—a "Protestant Zen" free of devotional objects and ornamentation, if not a secular Zen devoid of all expressions and trappings of institutional religion. But Zen teachers in America have long recommended the incorporation of these sorts of things into domestic practice, reflecting what some might call a "traditionalist" Zen, wherein meditation, images, scripture, ritual, precepts, and lineage are inseparable.[109] In 1958, Ruth Fuller Sasaki wrote:

> I wish every western Buddhist could have a shrine in his home, no matter how small or how simple. Perhaps just a corner of a shelf in a bookcase. He need not even have an image in it, only a place and a small incense burner will do. I wish that every morning before he sits down to breakfast he would stand before that shrine, palms together. With his mind quiet and collected, let gratitude fill his heart, gratitude to his parents past and present, to his teachers past and present, and to all sentient beings past and present who have contributed and are contributing to sustain his existence. Let him bow to all these to whom he owes a debt of gratitude impossible to repay. Then let him light an incense stick and, still standing with palms together, recite in his heart or with his lips the Four Great Vows [of a bodhisattva (J. *shigu zeigan*)].[110]

The Monastery Store does not go quite so far in recommending a home altar, and Sasaki, whose text is not associated with retail, allows for the absence of an image. That said, Sasaki's recommendation speaks to the creation of personal sacred space, which the store emphasizes and extends through its suggestion that one select a statue that suits one's spiritual, doctrinal, or aesthetic preferences or place on the altar an object of personal importance. Given our present "trend toward secular mindfulness," as the MRO senior monastic and director of Dharma Communications, Vanessa Zuisei Goddard, put it, the monastery's more traditional approaches to the Dharma are not intended to exclude the choices of individual practitioners. The point, she emphasized, is to create a space that helps integrate meditation into daily life and that structures practice and extends it beyond the cushion. One might note, however, that the store does not offer or refer to certain items common in traditional home altars in Asia and in diaspora communities, notably those related to mortuary Buddhism such as "memorial tablets" (J. *ihai*) for deceased family members.[111] This suggests a modern redefinition of Zen towards individualized meditation and deemphasis of funerary and ancestral practices.

To augment one's meditation space one can purchase DVDs and audio recordings of Dharma discourses given by Daido Roshi, Geoffrey Shugen Arnold Sensei (the present head of MRO), and other teachers. There are also instruction manuals for *zazen* and other forms of practice, translations of medieval and early modern Chan/Zen texts, books written by Daido Roshi and other modern teachers including the Tibetan master Chögyam Trungpa (1939–1987) and Thomas Merton, and titles on writing and holistic living. One of the physical store's display tables presented a mélange of titles: copies of *Zen Mountain Monastery Liturgy Manual,* edited by Daido Roshi, stacked next to DVDs of the *Tibetan Book of the Dead,* narrated by Leonard Cohen, Jon Kabat-Zinn's "Mindfulness Meditation for Pain Relief," as well as "Bedtime Meditation for Kids" and "Holding Still to Free the Butterfly: Meditations for Squirmy Kids." One might raise an eyebrow: Is the store padding its inventory beyond items essential for meditation in order to tap into a broader market for Buddhist, Asian, and spiritual products, and to sell to the entire family? Perhaps this is simply a matter of spreading the Dharma by all means or products necessary. That said, postwar and contemporary Zen is often an "ecumenical" concoction of denominational, ritual, cultural, and material traditions. This is evident, too, in the monastery's programming, which includes rigorous monastic retreats and residencies as well as retreats for Yoga and other traditions not native to premodern Chan/Sŏn/Zen/Thiền but part of modern Asia-associated spiritual and body-practice cultures, especially in the global north. Practicing Zen is often omnivorous; so too retailing and consuming Zen.

◎ ◎ ◎

As a business, The Monastery Store is run by Dharma Communications (DC) Inc., the "Not-for-profit outreach and education arm of the Mountains and Rivers Order . . . and a right-livelihood enterprise."[112] Staffed by ten to fifteen senior monastics, full-time monastery residents, and volunteers, DC is a multitasking Zen media business and retail company. The nonprofit corporation, set up in 1991, manages the store, designs the MRO's websites, brochures, and flyers; runs a press that publishes the writings of Daido Roshi and other teachers as well as the *Mountain Record: The Zen Practitioner's Journal* and *Fire Lotus Temple;* operates WZEN.org; produces Zen instructional materials that bring "teachings to home practitioners"; and manages a large audio, video, and print archive.[113] Daido Roshi "loved media," Zuisei recalled, and he "was proud that the monastery was the first [among American Zen communities] to be on the web."[114]

As a nonprofit religious organization, DC is not required to report financial information, but its annual gross revenue, I am told, runs around one million dollars. Profits do not go to salaries or investors but fund DC's operations, including the radio station and publication of the *Mountain Record*. Its revenue has also supported construction of the Sangha House and, during a recent boom period, helped cover the health insurance of monastic residents. Staff work in a red-clapboard-sided building a short distance from the main compound. Just as I arrived at the building with my guide, the Creative Director, Shoan, a FedEx truck was backing up to the garage that serves as a shipping bay, which happened to hold 700-pound sacks of buckwheat hulls shipped from North Dakota that are used to stuff meditation cushions. Next door is the packing and shipping department, with shelves of inventory, boxes and other materials, and an online shipping system. The floor above includes comfortable offices, with small Buddhist statues placed on a number of desks (including that of the customer service staff member), and a small but comfortable meditation room.

Long before express delivery, The Monastery Store began with a humble mimeographed sheet, the ancestor of the *Mountain Record,* and an audiocassette recording of a practice session led by Daido Roshi. The tape offered an aural context for home practice—an early form of "distance Zen" now superseded in some communities by webcast—including a twenty-minute period of silent meditation. (Some customers returned the tape, Zuisei recalled, assuming that the extended silence meant it was defective.) Thereafter, the store quickly expanded its inventory and moved from mail order to ecommerce.[115] These days Zuisei selects the majority of the store's products, working with national and international distributors as well as local or regional artisans and sculptors in Thailand and Bali. Meditation cushions are assembled in the monastery using covers produced by a company in Massachusetts and materials such as memory foam, buckwheat, and cotton batting.[116] A longtime practitioner makes the store's meditation benches and travel altars. A resident makes some of the *mālā* and a local seamstress the altar cloths. Although the store has worked with particular makers for years, building strong small-business-to-business relationships, there are occasional supply chain hiccups. Producers sometimes fail to meet orders or raise prices too high. Pricing, Zuisei added, is transparent, reflecting the wholesale cost of the item, the cost of shipping to the store, and a small markup without the inflation that creates the fiction of "free shipping."

As a corporation, The Monastery Store's business health can be tracked in reports sold by business data companies; sales in 2015 were improving.[117] That said, the store holds to a small-business retail capacity,

eschewing an outright growth model. It holds its inventory on-site and, save for books it distributes through Shambhala Publications, does not use fulfillment companies. Although there is nothing in the monastery's teachings that rejects wide distribution, the additional volume that might come with selling through Amazon, for instance, would overwhelm the staff. Without a marketing department at her disposal, meanwhile, Zuisei does not have "big data" or precise demographic information on the store's customer base and occasional shoppers. That said, the store makes use of the MRO's mailing lists, developed partly with registration information from retreats and programs, and it may acquire lists from affinity organizations. The store's customer base—"community of consumption," to use Padgett's term—is a mixture of practitioners who attend sessions and retreats at the Catskill and New York City centers, affiliate groups, and those who practice at home or in institutional settings (campuses, community centers, prisons, and so forth) without direct teaching and training contacts. Tracking with broader demographics of American Zen, many are what Jan Nattier terms "elite Buddhists," with income that covers the costs of retreats and practice-related consumption. Or, as Padgett puts it, meditation cushions are "lifestyle choices as well as religious articles. They are the options for those who have options."[118]

Mail-order catalogues and websites routinely, if not necessarily, create story lines for products, situate them in exotic or envious locations with attractive and market-targeted models, articulate mission statements and values, and create fantasy worlds that promote consumption. If this is part of what David R. Loy and Jonathan Watts refer to as the "religion of consumption," with its disastrous impacts on communities, cultures, and the biosphere, how does DC present the Monastery Store?[119]

The store's catalog and website present a comfortably familiar retail space: attractive design, lively product explanation, item numbers and unit pricing, and product photography. There are the requisite phone, fax, and ecommerce tools, including "customers also viewed" data, reviews, shopping carts, secure payment, and customer support. The store also has a blog with articles on practice and related retail items. Explicit in the store's paper and online retail platforms is a running narrative that links customers and spaces of home practice with the monastery (represented in elegant photographs of meditation, community assemblies, and so on), networked into a larger virtual community through the MRO's websites, including the "Cyber Monk" website feature, with a form through which to send questions to a senior monastic.[120] There is nothing unusual these days about Buddhist cyber-communities, but The Monastery Store portal is impressively designed for the sale of meditation things and other items.[121]

That said, both Daido Roshi and Zuisei Goddard are clear about the challenges faced by DC in navigating between, on the one hand, "rampant American consumerism" and "simply selling more stuff" and, on the other, the "sincere need for products to support spiritual practice."[122] That need is addressed throughout the catalog and website; and interspersed within and between particular product departments are quotations from Zen luminaries: the Chan master Hongzhi Zhengjue (1091–1157), Dōgen, Hakuin Ekaku, and the order's own teachers. Customers are exhorted by Hakuin: "Don't think the commitments and pressing duties of secular life leave you no time to go about forming a ball of doubt. Don't think your mind is so crowded with confused thoughts you would be incapable of devoting yourself single-mindedly to Zen practice."[123] We also read that "The subtle art of chado [Japanese tea ceremony] offers us an opportunity to extend our zazen into the practice of serving others, as well as to explore the key aspects of the ceremony determined by Sen no Rikyu: rustic simplicity, directness of approach and honesty of self."[124] Whatever one might think of their historical or sectarian perspectives, these texts and explanations offer Zen "teaching moments" in the retail space. Off and on we also find the sentence, "Thank you for your practice," which suggests the interconnection of individual practice at home with the larger turning of the wheel of the Dharma but may also imply "Thank you for your purchase." Practicing is purchasing is practice. Rather than profit per se, then, the mission "is to help maintain and spread the Buddhist teachings of wisdom and compassion."[125] Or, as the store's manager Nathan Lamkin put it, business revenue is "*a* conversation but not *the* conversation."

One can list a set of key words—practice, support, work practice, and right livelihood—that frame The Monastery Store's retail operations and routine conversations at DC and that support a claim for Zen retail rather than retail Zen. What the store sells, in Zuisei's words, are items that embody a "practical, physical way to support practice." Supporting home practice matters, she added, because "we believe that the Dharma works." Lamkin added that the store offers only products that the residents of the monastery themselves would want to use in their own practice. Practice materializes in the physical store, above and beyond its retail items, most notably in the functioning altar placed along one wall with an icon of Avalokiteśvara, incense bowl, candle, and flowers (it simultaneously serves as a retail display for how to equip a home altar).

Instead of mass-market products directed at data-minded consumers, the store emphasizes—from logo to checkout—the concept of "support," implying the interrelational, rather than autonomous, nature of Zen practice and therefore community and compassion in the Dharma.[126] The monastery

directs support in particular to those who are homebound, incarcerated, or otherwise unable to visit the monastery or its affiliates for direct participation in programs, retreats, and residencies. Those who purchase support in the form of meditation-related items may participate in this system through the donation of used goods to other practitioners. This "relational practice" culture and its economics are built upon the monastery's Zen teachings, monastic organization, and engagement with contemporary society.

◎ ◎ ◎

The Monastery Store is perhaps unexceptional. Buddhist communities routinely support monastic and lay practice through the performance of religious services in return for donations as well as the sale of grave sites, talismans, worship goods, calligraphies, books, temple-made foods, and other products. Since the postwar decades, American Zen centers have operated a range of non-funerary and non-devotional businesses. Endless Knot, a meditation cushion and Zen robes business, was founded in 1972 at the Rochester Zen Center. The Tassajara Bakery, run by the San Francisco Zen Center, opened in 1976. On Vashon Island, Koshin Christopher Cain and Soshin Lidunn Cain, founders of the Puget Sound Zen Center, run Still Sitting Meditation Supply.

None of this is wholly surprising or contradictory to long-standing practices in premodern and modern Buddhisms. Of course there are teachings that promote understanding of the fundamental emptiness (Skt. *śūnyatā;* J. *kū*) of all things, the virtues of noncraving (Skt. *alobha;* J. *muton*), renunciation (Skt. *naiṣkramya;* J. *shutsuri*), life as a monk or nun (literally, mendicant, Skt. *bhikṣu, bhikṣuṇī;* J. *biku, bikuni*), and restrictions on property and money. Throughout Buddhism's history, however, monastic communities have not rejected outright the acquisition of property, entrepreneurship and systems of exchange, or the promotion of the benefits to business prosperity as well as kingship and territorial conquest that accrue to lay patrons from the veneration of and donations (Skt. *dāna;* J. *fuse*) to deities and gurus—all producing revenues that were crucial to temple economies.[127] Studies of Theravāda monasticism point to a dialectical relationship between the acquisition and renunciation of wealth, and Mahayana scriptures such as *The Lotus Sūtra* (Skt. *Saddharma-puṇḍarīkasūtra;* J. *Hokekyō*) present teachings that became fundamental to discourses on "this-worldly benefits" (J. *genze riyaku*) gained from devotional practice as well as from the pious performance of secular occupations, including those related to merchant activity.[128] Thus, members of Buddhist monastic communities did not spend all their time meditating, which was

far less central to monastic life than we have come to assume. Some were busy acting as what we would now call financial officers, fund-raisers, buyers, and salespeople.[129] This did not transpire, however, without complaints from rulers, Confucian and nativist critics, as well as Buddhist leaders regarding temple wealth, commercialization, and corruption—long before recent scandals arising from overzealous Buddhist fund-raising, jet-set monks, and the like.[130]

In premodern Chan/Sŏn/Zen, monastic codes regulated monks and nuns responsible for managing temple savings, income, fund-raising, estates, and the sale of surplus food.[131] Until confiscations during the second half of the nineteenth century, Japanese monasteries had conspicuous land holdings, and the most prominent among them also generated revenue through foreign trade, moneylending, and other commercial activities.[132] The Sōtō Zen monk Suzuki Shōzan (1579–1655), meanwhile, may have developed a protocapitalist ethics of work and business compatible with Buddhist devotion and salvation.[133] Modernity produced new permutations of the Buddhism–business relationship. Certain Zen monks "recognized the basic incompatibility of Zen and Capitalism" and worked to develop Buddhist socialism.[134] In his oft-cited essay "Buddhist Economics" (1966), meanwhile, E. F. Schumacher (1911–1977) saw in Buddhist countries, specifically Burma, an economics that, differing fundamentally from that of the West, was based, he believed, on principles of interconnectedness, nonviolence, and renewable resources. Buddhist economics, he argued, were local and sufficient rather than limitless in production and growth, and emphasized well-being rather than maximized profit. Schumacher pointed to Right Livelihood, "one of the requirements of the Buddha's Noble Eightfold Path" as evidence of the compatibility of economic activity and Buddhist ethics and practice.[135]

Schumacher's essay—reductive as its portrayal of Buddhism may have been—became a foundational text for later socially engaged Buddhism and Dharma economics that draw from or composite Buddhist teachings and blend them with ecological and progressive ethics in order to transcend capitalism and socialism.[136] "Five centuries before Christ entered the temple [and threw out the moneylenders]," Derek Wall argues, the Buddha "set up a philosophical system in opposition to the notion of economic (wo)man and the desire for even more consumer goods before the term 'economics' had been coined by Aristotle." Zen, he adds, like "slow food and allied italist practices," "minimizes need and provides an alternative road to affluence." It is therefore congruent with anarchist, Occupy, and ecosocialist perspectives.[137] In this sense, and despite reductive and perhaps overly imaginative characterizations of what the Buddha and early Buddhists did, Buddhism

and Zen offer, in the view of some, a means to intervene in global consumerism and the destruction and suffering it causes, making use of "analytical tools and practices that can assist in liberation from the environmental and socially oppressive nature of over-consumption."[138]

To generalize, Buddhist businesses often manifest webs of sacral-economic relations (teachers, makers, sellers, and practitioners), and conceptions of nonprofit work-retail, rooted in the interpretation of Buddhist teachings and the interaction of monastic and lay communities. Different relations operate, of course, between the consumer of Zen-branded goods and corporate producers and mass-market retailers. Equally different are twentieth- and twenty-first-century efforts to integrate Zen and Buddhist concepts of mindfulness into for-profit corporate business models unrelated to monastic and lay Buddhist communities, monastic precepts (Skt. *upasaṃpadā;* J. *jukai*), and so forth.[139] However sincere and compassionate such corporate efforts may potentially be, they are part of what we might call (perhaps generously) "capitalist applied Buddhism." In the technocratic-nirvana of Northern California, for instance, we have "Silicon Valley Zen," which the blog "ValleyZen" describes as a matter of "Simplifying a product—removing features—to make it more useful; Looking for the right solution, not the logical one; Acting today to be wrong, not tomorrow to be right."[140] A CEO, VP, or cubicle drone might gain a great deal from meditation-ritual-community-based Zen practice, and there is a modern history of corporate Zen retreats at temples and centers. But it strikes me that corporate "Zen-ification"—largely abstract appropriation of "beginner's mind" and "mindfulness," "iconoclastic" innovation, and a faux interdependence separate from Zen teaching contexts and meditation—is its own late-capitalist Zenny thing. Not surprisingly, there is a booming genre of Zen-infused business management publications and various business Zen gurus (part of a larger business-spirituality fad).[141]

The introduction of Zen into high tech is often linked to innovation-driving (and profit-increasing) corporate work-life-balance rhetoric, and is quite distinct from the ways in which religious teachers, philosophers, and economists work to rethink or dismantle capitalism, work, and consumption.[142] With its ultimate aim of profit and share price, corporate Zen takes what it wants and ignores the rest, including sustained meditation in a specific Zen community, ongoing instruction from a teacher in a particular Zen lineage, and Buddhist soteriological goals.[143] In a general sense, selective appropriation and refocusing are hardwired into modern-contemporary Zen, but the corporate version is hardly akin (in capital, resource consumption, labor, and global political power) to the countercultural appropriations of the Beats, the visual and performance avant-gardes

of the 1960s and 1970s, various multi-tradition spiritual communities, as well as recent Hard Core Zen followers and Dharma punks. I might feel less ambivalent were I to hear of a corporation that espoused not just the value of Zen thinking to innovation, market share, and stock price but the bodhisattva ideal of relieving the direct suffering of all sentient beings, not just those who can purchase things, receive corporate dividends, and reap capital gains.

In any case, The Monastery Store differs in obvious respects (personnel, tax status, work, and so forth) from multinational retail corporations that sell meditation supplies and Buddhist-Asian spirituality products but have no Buddhist denominational affiliation or doctrinally based business principles, and from the self-congratulatory "disruptive" notions of Silicon Valley Zen.[144] The Monastery Store also differs in tax category from for-profit meditation supply businesses—the privately held DharmaCrafts, for instance—which, while not affiliated with specific temples, may still self-represent in terms of Buddhist lineage, articulate a business model based on Right Livelihood, and advocate particular Buddhist practices such as donation.[145]

Dharma Communications describes its mission this way: "To help maintain and spread the Buddhist teachings of wisdom and compassion in two ways: I. By providing a training ground for work practice and right livelihood for Zen Mountain Monastery residents and volunteers, II. By offering finely crafted products that support your spiritual practice and have a low negative impact on the environment."[146] If some of this language sounds obligatory to IRS nonprofit activity categories, the phrases "work practice" and "right livelihood" (Skt. *samyagājīva;* J. *shōmyō*) link the statement to Buddhist teachings that play a central role in modern-contemporary practice-based Buddhist businesses.

The monastery defines Right Livelihood as "one of the principles of the Eightfold Path of the Buddha, and within the MRO it is expressed as work practice—work as sacred labor. In all of our activities and decisions, we strive to be guided by the Buddhist Precepts, or moral and ethical teachings." Today, the approximately thirty full-time monastery residents each have specific work practices, be it in the kitchen, the vegetable garden, the store, and so on, in addition to meditation practice and receiving instruction. As part of the Eightfold Path (Skt. *āryāṣṭāṅgamāga;* J. *hasshōdō*), Right Livelihood "involves abstention from engaging in occupations that are considered to be incompatible with morality because they bring harm to other beings, either directly or indirectly. . . . Right livelihood also involves abstention from any occupation that may cause oneself, or encourage others, to break precepts associated with right speech . . . and right action."[147]

The concept was introduced to the West early in its modern encoun-
ters with Buddhism. Dwight Goddard, in his 1930 *The Buddha's Golden Path,*
observed: "In our modern days, when economic competition is so keen and
relentless and our whole civilization based on material values, the importance
of the Fifth Stage of the Golden Path [Eightfold Path] is often overlooked. Any
vocation is considered to be 'right' if it provides a fair living and it is very
desirable if by it man becomes rich." In any profession, however, one may
become "smug and complacent and egoistic" and be tempted by quick profits.
"'To keep up with the Joneses' will probably be a constant, besetting urge,"
Goddard admits, but he points to the deeper benefits of limited consumption,
nonattachment to material things, and "concentration on the highest ideals
of the spirit."[148] To follow David Loy's more recent comments, Right Liveli-
hood implies that an alternative to our present religion of market capitalism
"would not require eliminating the market . . . but restoring market forces to
their proper delimited place within community social relations."[149]

Right Livelihood involves work, to be sure, but work, as the DC web-
page puts it, is "a gate of self-investigation and an opportunity to serve the
community at large."[150] Zuisei explained it with the question "How do we
work and wake up?" and Nathan, The Monastery Store's manager, added,
"We don't change when we walk between the meditation hall to the offices
of Dharma Communications." For the monastery's founder, Daido Roshi,
Zen practice "is not about isolating ourselves on some mountaintop, dwell-
ing in tranquility while rejecting the busy activity of the world, but, rather,
it is about manifesting the Buddhadharma in everything we do, so that the
secular is, indeed, the sacred. This is what we need to see in order for the
practice of work to function as an aspect of our Zen training." *Zazen,* there-
fore, "is not just sitting cross-legged on a pillow; it is growing a garden,
getting to work on time, getting the job done." "The foundation of work
practice," he adds, "is mindfulness, a state of consciousness in which the
body is relaxed, the senses are alert, and the mind is clear and focused on
the task at hand." It is essential to "really 'do what you are doing while you
are doing it'—in other words, to be fully present. To experience the breath in
zazen is to be the breath. To experience the work is no different." Work, he
writes, "emerges as an active function of zazen," and "The problems we face
in work function as our genjokoans, the koans of our everyday life. They can
be handled in the same manner as the koans we work with in zazen."[151] In
a common Zen pedagogical turn, Daido Roshi encapsulated his teaching in
a commentary on a statement made by his medieval Dharma ancestor, the
Sōtō Zen patriarch Dōgen: "'To carry the self forward and realize the secular
is delusion; that the secular advances and realizes the self is enlightenment.'
To 'carry the self forward' means to separate yourself. That the 'secular

advances' means to be one with the object of your attention. The secular world itself becomes your life, and its inherent liberation is constantly manifested."[152]

We might also gloss Right Livelihood as partly a matter of "first do no retail harm" to makers, workers, consumers, sentient beings, and the planetary ecosystem. Indeed, The Monastery Store's mission statements speak to efforts to reduce the business' carbon footprint, critically evaluate its sources of materials, and support fair trade and fair labor: "We believe that it's not enough to offer high quality products and services at a reasonable price—we strive to do so with full knowledge of how each of these are [sic] made, under what conditions, and how they affect our environment."[153] As social-ecologically responsible practices, these goals are hardly unique to Buddhist communities, but in contemporary conceptions of Buddhist market mindfulness, they are grounded in the ethical principles of the Eightfold Path and other teachings. Often they resonate with the progressive social and political views of many who are drawn to Buddhism.

In practical terms work practice at the store includes product selection and purchasing, catalog and website design, customer service, packing and shipping, and so on. On weekends, retreat participants assist residents in packing and labeling items for shipment as a practice of "caretaking," a concept explained in a Dharma talk given by Geoffrey Shugen Arnold, the head of the MRO: "Although we may think of a spiritual journey as being exotic or removed from ordinary life, actually, it is all about how we live this ordinary life. At its heart, this journey is quite simple. It's a journey of deep caring—of cultivating a mind and heart that care deeply for all things and living our life so that it is a manifestation of that caring . . . it means having the courage to admit that we care, and being willing to do everything we can to bring our life into alignment with that caring."[154] Preparing individual

orders is also an opportunity to distinguish the store's shipments from the other padded envelopes and boxes that appear on our doorsteps. Each item is hand-wrapped in a way that shows care has been taken, and the exteriors of shipping materials are adorned with fragments of ink calligraphy saved from the monastery's brush-practice programs (fig. 44). Cut from larger paper sheets into rectangles and impressed with the monastery's seal, these handwritten calligraphy fragments (individual characters tend to lose their ideographic legibility) are affixed to the sides of each package, giving them unique (and perhaps Zenny) decoration that stands out from conventional mailing labels and packing materials. Needless to say, this is hardly the sort of thing one finds on a box shipped from Amazon. By repurposing snippets of calligraphy into retail exchange, the adornment, I was told, helps build a community of practitioners: monastery residents, those attending retreats on site (who practice calligraphy and help with packing and shipping), and off-site customers. As Shoan put it, "We want to be as connected as possible with those who connect with us." "One can buy a *zafu* at Walmart," Zuisei noted, somewhat disparagingly, but those sold by The Monastery Store are of far higher quality, she said, and last for many years. What she was actually referring to, I sensed, was not strictly the matter of differentiating one product's manufacture and durability over another but distinguishing the nature of retail and consumption itself. The store's retail mission of supporting spiritual practice at home, training at the monastery, and spreading the Buddha's wisdom and compassion relies, therefore, upon normative manufacturing, supply chain, and retail operations, sometimes finding expression in familiar retail vernacular. But Zen business activity in this instance is guided by Buddhist teachings of ethical work, work practice, and ecology as articulated in the teachings of its founder, John Daido Loori, and, it is implied, his lineage ancestors extending all the way back, in classic Buddhist manner, to Dōgen. Buying Zen things from The Monastery Store is, perhaps, an act of consumption that brings one into this lineal community and into contact, at one level or another, with its teachings.

A Zen curmudgeon might dismiss this discussion of rightness, work, teaching, and realization as just so much idealism or worse. Capitalism is capitalism, one might argue, even in monk's robes, and some might label The Monastery Store as simply another space of privileged hypocrisy— namely, that its Buddhist retail operations are, ultimately, akin to those of Starbucks, Whole Foods, and so forth. We consume things reassured by

statements of ethical business practices and the notion that we are doing good by buying *these things* from *this* business, while we may end up ignoring the root causes of the suffering created by the very system of consumption that we in fact sustain.[155] Or perhaps one is merely disappointed: surely a Zen community would sidestep the snare of late capitalism, avoid familiar (soul-sucking) retail jargon, product styling, clickable consumption, and "This is the cushion for you!" sales exhortations. How far into this trap can the monastery step and not get caught?

There is much to suggest in the store's defense, for instance, its nonprofit status, its distinction from mega-retailers and non-denominational Asian- and Buddhist-themed retail stores, and its distancing from the sale of excessively "Buddhisty" commercial products. At the very least, the store's framing of its retail vernacular, styling, and mechanisms within Buddhist identity and practice—reference to monastery's rituals, training procedures, Buddhist teachings, and so on—suggests an active process of self-definition and the infusion of religious and spiritual principles into its products. If one is inclined to describe the store as a specialty "boutique" of Zen things, at least its retail theme—Zen practice and Buddhist teachings—appears always to be in season.

Nevertheless, the name "Monastery Store" provokes odd sensations. Literally and appositely a serious Zen space, lineage, and practice, it still has the ring of commercial branding. To be fair, "The Monastery Store" is not unique to the MRO, and it is akin to "The Abbey Store," the ecommerce and mail-order business operated by the Trappist monks of the Monastery of the Holy Spirit in Conyers, Georgia. In both cases the stores' distinction from non-religion-based businesses is suggested by a religious architectural metonym. Nevertheless, "The Monastery Store" also brings to mind the direct-marketing "Country Store," a folksy-fictive general store that sells homespun simplicity in bedding and casual clothing and other embodiments of country living to customers who are often, I suspect, urban, suburban, and exurban consumers.[156] Might a similar imaginary operate for someone who flips through The Monastery Store catalog or clicks through its website? To what extent does the store imbue retail items with a special Zen aura and affiliation above and beyond practical function—an aura with which a purchaser might self-identify, yearn for, and possess through the incorporation of *these* products into a home practice space and lifestyle? I could not help but wonder, however hyperbolically, about possible Zen ecommerce addiction: fervent beginners purchasing meditation cushions and statues while caught in the "awareness trap" of consumerism—the belief that the "solution to our *dukkha* is our next purchase," and the next, and so on.[157] Buy Zen stuff to be Zen.

Where is the line beyond which sincere Buddhist or Zen understandings of commerce become overwhelmed by consumption-driving rhetoric, production, and credit culture? Will the store upgrade to the newest, predictive tools for faster speed-to-market and customer gratification? DC probably needs to navigate not only between the shores of rampant American consumerism and support for sincere practice, to paraphrase Daido Roshi, but also the third shore of technology—enhanced "algorithmic marketing," for instance, that "provides real-time offers targeted to individual customers through a 'self-learning' process to optimize those interactions over time."[158] A site with such coding would presumably tell you which Zen things you should purchase before you know which items you desire. It is unlikely that the store would adopt "fast fashion," with retail items changing every ten weeks or so in response to trends in meditation supplies and sundry goods. But if the postwar period generated a hunger for instant Zen through psychedelics or "crash courses supposedly leading to enlightenment,"[159] it is possible that Zen retail may be creating a new dispensation of speedy spirituality through its purveyance of Zen things with next-day delivery. Perhaps the store should align itself instead with the "slow fashion" and "slow food" movements.

At the end of the shopping day, and no matter where one shops, "purity" of consumption, the absence of impact (human and planetary), is pure fantasy—the sort of delusion that Buddhist teachings about the autonomous self warn us against. Not surprisingly, then, the transformation of consumerism through Buddhist principles of interconnectedness and ethical practice appears to be as daunting a task as any local, nonprofit, anarchist, and human-scale challenge to capitalism and other domination model systems.[160] Students at UC Berkeley with whom I have raised these sorts of issues over the past several years offer a variety of responses and suggestions. Some readily adopt Buddhist perspectives and offer defenses of the monastery in distinction from megacorporate retail.[161] Together we brainstormed new products for The Monastery Store and honed in on the apparent contradiction or irony of shopping for products that may lead one to nonmaterialistic awakening but may also differentiate The Monastery Store from "McMindfulness."[162] One can do *zazen* on the floor, a tree stump, or the ground, we agreed, but purchasing the correct or better "tool" for *zazen* seems reasonable, provided one is mindful of the relationship between craving and suffering and aware of the commodification of Buddhism, fair-labor practices, and the ecological implications of consumption.

Acknowledging that the Internet has altered the way we do business and consume, and how we do Zen, some felt it was enough that the store has transformed a tiny space of the ecommerce universe—a small "karmic

reversal" of the colossal bad karma of consumer capitalism. We debated the truism that Zen and Buddhism always adapt—from India, to China, to Korea, to Japan, to the West, and beyond—and the possible slippery slope of cool styling and algorithmic marketing for Zen communities. Not many of us were ready to accept the idea that the Store is a "skillful means" (Skt. *upāyakauśalya;* J. *hōben zengyō*) fashioned for late-capitalism, tailored to spread the Dharma to sentient consuming beings.[163] Our discussion turned as well to methods by which the store might enhance its operations to further alter the system. A carbon offset option for each purchase, for instance, or perhaps the monastery and other nonprofit Buddhist and Buddhist-affinity businesses should create a Right Livelihood/Right Consumption label with third-party certification that would function in the marketplace akin to non-GMO and Organic labels, to educate, attract, and retain customers. Perhaps the monastery might make common cause with biospheric-egalitarian movements embodied in the Universal Declaration of the Rights of Mother Earth.

At the very least, The Monastery Store and related businesses suggest that there is more to "Zen sells" than simply Zenny products that leverage "borrowed interest" for mass consumption. There are multiple aspects of production, marketing, and consumption to consider: the scale of retail and business model; the relationship between the sort of thing, the type of advertisement, and the manner of Zen practice; price point and for-profit or teaching point and for-Dharma objectives; what one needs and wants and why; and what one can afford, and what one gives back. To the extent that Zen products enter our lives—through corporate retail, for-profit Right Livelihood businesses, monastic Zen retail, or all of them—we should pay attention to how these material things, how they are marketed, and how and why we obtain them, become rightly complicated in the overlap of religion, spirituality, and consumption.

CODA

"Where's Satori?"

"What?" I asked.

"[Your lecture title] says 'From Satori to Silicon Valley,'"
he explained. "I know where Silicon Valley is. But
where's Satori?"

—Theodore Roszak, *From Satori to Silicon Valley*[1]

Zen changes in different times and places and what it
has become here and now, I am not certain.

—John Cage, "An Autobiographical Statement"[2]

What would the world be like without Zen? Less religious or spiritual?
Less free of suffering? Less visually compelling or cool? Rest assured, it's
not likely to happen; Zen seems immune to fatal doubt. Indeed, there is so
much Zen this and Zen that. So many moments of Zen: meditation, reali-
zation, foodie, film, sports, comedy, and so on. On search-engine, crowd-
sourced, and personalized platforms, so many photographs of carefully
balanced worn river rocks and rippling pools; so many meditating figures
(the Buddha, monks, nuns, lay practitioners, but also frogs and cats); so
many splashed-ink landscapes; so many Zen-branded spas and products
designed with the matte, minimalist, or natural values of the Zen aesthetic—
soothing and inspiring, consumption with the illusion of not consuming.
Just when I think I have come across the most intriguing or alarming exam-
ple yet, it is almost immediately surpassed. I no longer try to keep up.

 Some of us have re-enchanted ourselves with Zen and Zen art and
aesthetics, even as the sorts of Zen and Zen art that first inspired us may

change. This fits the modern history of Buddhism, with its many appropri-
ations and recontextualizations of diverse traditions in transnational, colo-
nial, interreligious, scholarly, popular, and personal encounters. Some of
the newfangled, "incomplete," or "incorrect" sorts of Zen that emerged with
modernity and thereafter—which changed Zen—arose as forms of resistance
against what some viewed as the unbearable dilemmas and pathologies of
modernity, including religions and their institutions. It is also important to
catch in action the overlap of, the back-and-forth between, one sort of Zen
and another amid uneven processes of exchange and representation. And
given all the changes of the past one hundred and fifty years or so, John
Cage is admirable to admit his uncertainty regarding what Zen has become.
We should be equally uncertain, or insightfully skeptical, about what Zen
and Zen art were in the past.

In any case, Zen will endure: it will be taught, transmitted, and put
into practice, on the cushion and elsewhere. If we wish, many of us—but not
necessarily all of us—can practice Chan, Zen, Sŏn, or Thiền in institutional,
religious settings: locally, at a neighborhood temple or center; by traveling
to retreats led by credentialed teachers held nearly all around the globe; or
by signing in to webcast *zazenkai*. There will also be new Zen teachers, new
enunciations of age-old teachings, new communities, and new engagements
with social, spiritual, and political movements.

We can expect paintings and calligraphies created by premodern
monks such as Sesshū, Hakuin, and Sengai to continue to draw enthusias-
tic attention in Japan and elsewhere, in museum, art-market, and popular-
culture environments. Zen circles, pictures of "eccentric" Zen masters, and
Zen ink landscape paintings—be it in an heirloom masterpiece or a contem-
porary neoclassical, commercial, or "deviant" rendition—will intrigue many
of us for years to come (figs. 2 and 45). New historically based research
is being undertaken on medieval and early modern Chan, Sŏn, and Zen
visual cultures in East Asia. Who knows what we may discover in temple
storehouses, bring to light through new imaging technologies, and come to
terms with through close looking and reading allied with transdisciplinary
methods? Artists (monastic, lay, avant-garde, outsider) will keep making
visual work eliciting responses that point to Zen form, insight, process,
and appropriation. There will be new books offering instruction on Zen—
meditation or mindset—not to mention how-to books for Zen ink painting,
garden making, and just about any other art form; new coffee-table books,
calendars, note cards, and the like reproducing masterpieces of Zen paint-
ing and calligraphy; new replicas and send-ups of the Ryōanji rock gar-
den; new renditions of "Zen and the art of —"; new retail products for Zen
health, wealth, and glamour; and new Zen cartoons and tattoos.

One might think that by now the grand narratives of Zen and Zen art that gripped the postwar period would have eroded, but the permeation trope of Zen and the arts of Japan, as well as the explanations and auras of Suzuki and other modern Zen "saints," remain surprisingly au courant. By now nearly anyone, it seems, can become a Zenologist, be an online curator of Zen art, create a Zen circle, coin a new "Zenism," and so on. Zen will no doubt continue to be a bridge language, a global dialect. Like Frida Kahlo (1907–1957), Zen will persist in "international culture at variable points on a sliding scale between sainthood and a brand," or, like Edvard Munch's (1863–1944) *The Scream,* from "awe to burlesque."[3] Zen will surely endure as a way of seeing objects and the world, even as it may shift aspect.[4]

FIGURE 45.
The Sixth Patriarch Chopping Bamboo. Tattoo. BMEZINE, 2003. ©

Some of us will continue to find Zen and Zen art "out there" where and when we recognize it, and want it, mirroring our particular Zen selves and, in some cases, projecting ourselves onto others. Indeed, Zen will keep rushing along in transit from intention to reception, context to context, image to imagination. "You gotta be kidding," Jeff Bridges admitted. "We never talked about Zen or Buddhism while we were making [*The Big*] *Lebowski.* The brothers [writers and directors Ethan and Joel Coen] never said anything about that." If popular culture has therefore (mis)claimed this film as Zen, does it matter? Or is this precisely what popular culture does? The Zen teacher Bernie Glassman has doubled-down on the film's Zen-ness: "Yeah . . . just look at their name—the Koan brothers." "*The Big Lebowski* is filled with koans," he adds, "only they're in the 'parlance of our time,' to quote the Dude."[5] The boundary between pareidolia (perceiving an image or form where none exists) and the real may not always matter, and some of us ache for a post-religion, Zen "hierophany."

Like it or not, Zen practice communities, Zen speak communities, and Zen fashion communities coincide, though they may not easily coexist. But if the Zen goes on and on in different ways, I happen to think that this does not diminish the need to look twice, to sit (or walk, run) and think hard about nonthinking, nonattachment, and nothingness, Zen-associated visual and material things (fine art to everyday product), and the claims (global, national, denominational, personal) made for any part or all of this. Why such fascination with Zen and Zen stuff? What should we make of the fact that the varieties of Zen practices and Zen cultures available and still emerging do not always align or converge comfortably? Is any sort of Zen okay,

made acceptable by virtue of the doctrine of "skillful means"—that buddhas and bodhisattvas have extraordinary abilities to modulate their teachings for particular audiences? Does this mean that every Zenny exfoliation from "real Zen" and into entertainment, fashion, and consumer cultures may have the potential to help us on the way to insight and release from suffering?

It's possible. But there may be moments when a line is crossed in acts of unmindful consumption and racial-ethnic profiling or in bigheaded desires to have a "final understanding of the world," including Zen.[6] To my ear, something is "off" in John Updike's (1932–2009) 2004 review of the newly opened Museum of Modern Art, in which the renowned novelist, poet, and critic wrote, "The architect, Yoshio Taniguchi, is Japanese, and a riddling Zen reticence presided over the acres of white wall and white-oak floor." Much as I admire Updike, his syntax is too tight to avoid the implication that Taniguchi's architectural preferences arise from a cause-and-effect relationship between ethnicity and aesthetics—Japanese ergo riddling Zen. Perhaps Taniguchi did wish "to Zen" this bastion of modernism with reticent walls and floors, but modern architecture offers more than one source for such design, and Japanese architects of Taniguchi's generation, whatever their relationship to Zen, Zen temple architecture, and Zen aesthetics, could hardly be said to be ignorant of cosmopolitan modernisms. Unexplored by Updike—admittedly, his text is just a quick comment—are the tensions and exchanges that develop between nationality and art/aesthetics and the complexities of transnational cultural coproduction.[7]

In certain zones of the academy, meanwhile, Zen and Zen art and aesthetics are not entirely what they used to be (since the mid-twentieth century). Deconstruction, invented communities, shared fictions, gender, and postcolonial studies, to name a few interpretive frames, have put a squeeze on many of the normative ideas about Zen. That said, for every academic challenge—"You don't know what you're talking about, the history says otherwise"—there are responses like—"Who cares? I don't, because I like what I see and believe." Our conversations may perhaps go better if we acknowledge Zen's diversity—resisting knee-jerk rejection of those who follow a spiritual or art Zen rather than a religious or meditation Zen—*and* take seriously the frictions that heat up between institutionally based Zen teachers and practitioners, Zenologists in the academy and elsewhere, Zen-affinity artists, and Zenny lifestyle aficionados. A willingness to engage our differences seems necessary, as history tells us that, no, we can't always "just be Zen about it."

Arguably Zen has recently ceded its preeminence to Mindfulness, and in recent years Zen painting and calligraphy seem to have relinquished their privileged place in international exhibition culture to the "arts of the samurai"; perhaps Zen art has lost some of its earlier soft-power efficacy amid

resurgent Japanese nationalism.[8] Already in 1986, however, the historian Theodore Roszak sensed that the public might have forgotten or dismissed much of Zen-boom Zen. Then in 2002 the professor of religion and culture Ronald L. Grimes observed that his students tended to be less open to exploring Zen meditation and its creative possibilities: "They are desperate to be given explicit rules and directions, preferably coupled with marks that can be achieved following them. They are disoriented, even threatened by paradox, silence, simplicity, playfulness, and the other 'virtues' that made Zen and student life seem so obviously connected in the 1970s and 1980s."[9] But even with such social, cultural, and cognitive shifts, the Tibetan Buddhism boom since the 1990s, and the recent Mindfulness fad, Zen is not as yet, I sense, on an endangered list.

Forecasting the future of Zen in a general sense does not seem especially difficult. But perhaps it is time for a Zen and Zen art makeover? After all, isn't Zen about letting go of preconceived notions? Having read this far, you might agree that the fortunes of Zen and Zen art and aesthetics and their interpretation have not been entirely or necessarily assured. Perhaps, then, some of the modern tags of Zen art (simplicity, abstraction, tranquility, and the like) will be overwritten through the force of the imagination within our global capital-cultural metabolism. Much from earlier Zen and Zen art will surely stick around, but what may appear in the future in response to growing and unexpected human challenges—what will new Zen and new Zen art do with the dialectic of form and emptiness, the dance between conventional and ultimate truth? Who will make new sorts of Zen art and Zenny things, what will they look like, and how will we describe and use them? What sorts of euphoria and criticism may they produce? What about the fate of Zen art in our age of image "flow," to borrow from T. J. Clark, "meaning constant replacement, fading in and out of focus, speed-up and slow-down, instant magnification and miniaturization, a ludicrous and mind-numbing overkill of visual stimuli?"[10] What might Zen and Zen art be and do in the cultural and spiritual imaginaries of globalized "New Asia"?[11] What about our age of surveillance, big data, neo-Gilded Age inequality, and anthropogenic planetary destruction? If these conditions strike you as very much to the point for Zen and Zen art going forward, then the goal of Zen awakening may be alive and well. Or perhaps the political ambitions and messages of counterculture Zen and Zen-engaged avant-garde art (rowdy, bravely idealized as they may have been) really have faded away, or one has simply watched *The Big Lebowski* too many times. But perhaps there are reasons still to wonder about the fascination and fuss of Zen and Zen art and aesthetics and what they may teach us about the workings, and predicaments, of religion, spirituality, culture, technology, and capital.

NOTES

ABBREVIATIONS USED IN NOTES

PDB Robert E. Buswell Jr. and Donald Lopez Jr., eds., *The Princeton Dictionary of Buddhism* (Princeton, NJ: Princeton University Press, 2014)

T *Taishō shinshū daizōkyō* (Tokyo: Daizōkyōkai, 1924–1935)

INTRODUCTION

1. Kunzru, *Gods without Men,* 28.
2. Foulk, "Ensō," in *Digital Dictionary of Buddhism,* ed. Muller.
3. Suh, *Silver Screen Buddha,* 187.
4. On "translocative," see Tweed, "American Occultism"; on "denial of coevalness," see Fabian, *Time and the Other.*
5. Faubion, *An Anthropology of Ethics,* 95.
6. For premodern Chan and debate, see Gregory, *Tsung-mi.*
7. Lears, *No Place of Grace,* 32.
8. Huang, *Transpacific Imaginations,* 8.
9. B. M. Lee, *Forgetting the Art World,* 4.
10. Chakrabarty, "Afterword," 288.
11. On "projects of modernity," see Lopez, *A Modern Buddhist Bible,* ix.
12. See Mathur, *India by Design.*
13. Grateful Dead, *American Beauty,* side two, track ten (Warner Bros., Nov. 1, 1970).
14. "Nirvanic times" is from Rubin, *Psychedelic,* 8.
15. Rogers, "Zen and LSD," 150.
16. Masters and Houston, *Psychedelic Art,* 17; Johnson, *Are You Experienced?* 7, 13, 88.
17. Irons, "'Experience' Drug Alarms U.S. Doctors."
18. Werblowsky, "Some Observations," 318. See also Suzuki, "Religion and Drugs," and other articles in the October, 1971 issue of *The Eastern Buddhist.*
19. See Goldberg, dir., *A Zen Life* (37:00–38:23).
20. Farkas, "That Way—Danger."
21. Chadwick, "Psychoactivism," 116; Strassman, "DMT Dharma," 111.
22. Aitken, "LSD," 141.
23. Fadiman, *At Large and at Small.*
24. Bradbury, "Zen in the Art of Writing," 7, 8.
25. Hacking, *The Social Construction of What?* 21.
26. *PDB,* 256–257.
27. Ibid., 256–257; Foulk, "The 'Ch'an School.'"
28. Various authors adopt orthographic methods to distinguish monastic Zen (禅 and Zen) from modern, postwar Zen (zen and ZEN).
29. On the diversity of Chan meditation, see Sharf, "Mindfulness."
30. Becker, *Zen: A Rational Critique,* 21.

31. Salinger, "Seymour," 114.
32. Irizarry, "Putting a Price on Zen," 65.
33. O'Brien, "Zen 101."
34. Stewart, *The Daily Show,* Jan. 9, 2013.
35. Promey, "Taste Cultures," 254.
36. On American orientalism, see Park, *Apparitions of Asia.*
37. See Irizarry, "Putting a Price on Zen," 58.
38. See Michel et al. "Quantitative Analysis."
39. Law, "'Mindful' Ousts 'Zen'"; Wilson, *Mindful America.*
40. For "Zenthusiasts," see Humphreys, *Zen Buddhism,* 199.
41. ZPA-Berzerk, "Zenophobia," *Urban Dictionary.*
42. See Donna Karan's label, "Urban Zen"; Karan, "Our Story," *Urban Zen.*
43. Hisamatsu, "On Zen Art," 26.
44. Meditation was not the sole focus of monastic communities, and Guifeng Zongmi (780–841) articulated five motivations for Chan practice, not all of which concerned full awakening. Modern forms of Zen that deemphasize *zazen* are not exclusively Western. See Sharf, "Buddhist modernism"; Reader, "Zazenless Zen?"
45. I thank Richard M. Jaffe for suggesting "Zenism."
46. Suh, *Silver Screen Buddha,* 59.
47. Zizek, *On Belief,* 12–15.
48. On immigrant communities, see Asai and Williams, "Japanese American Zen"; Iwamura, *Virtual Orientalism,* 56–60; and Masatsugu, "'Beyond This World.'"
49. Heine, *Zen Skin, Zen Marrow.*
50. See Hickey, "Two Buddhisms"; Numrich, "Two Buddhisms Further Considered."
51. From Jack Kornfield's blurb to Chadwick, *Thank You and Ok!*
52. Ashida, "Frogs and Frozen Zen," 203.
53. Watts, *This Is It,* 101–102.
54. See Watts, "Beat Zen, Square Zen, and Zen," 5–9.
55. Masunaga, "Western Interest in Zen," 23–24.
56. See R. F. Sasaki, "Letter[s] from Kyoto," published in *Zen Notes;* Wienpahl, *Zen Diary;* Van de Wetering, *De lege Spiegel;* and S. Morinaga, *Novice to Master.*
57. Werblowsky, "Some Observations," 318.
58. Ibid., 320.
59. Zen-related books appear in Library of Congress Classifications including: B: Philosophy; BH: Aesthetics; BL: Religions, Mythology, Rationalism; BQ: Buddhism; HG: Finance; N: Fine Arts; PL: Languages and literatures of Eastern Asia; PR: English literature; PS: American literature; SB: Plant culture; and QA: Mathematics.
60. Tweed, "Night-Stand Buddhists," 79.
61. This is neither to suggest that communities do not believe in the authenticity of their form of Zen nor to imply that authenticity was unimportant in premodern Zen. Note Heze Shenhui's (684–758) condemnation of "Northern School (Chan)" (Bei zong) and Dahui Zongao's (1089–1163) criticism of "silent illumination Chan" (Mozhao Chan). *PDB,* 206, 349, 415, 549; Schlütter, *How Zen Became Zen;* Wu, *Enlightenment in Dispute;* Faure, *Chan Insights,* 261–266; Sharf, "Mindfulness."
62. Maruyama uses "strobe-light technology, allowing the artist to capture phenomena in most instances at 7,500th of a second, and, in the few close-up

images of droplets, at an astonishing 20,000th of a second." M. Berger, "Writing in the Sky."

63. The image evokes the calligraphy effect of "flying white" (Ch. *feibai; J. hihaku*), when the hairs of a drying brush disaggregate and leave ink striations through which appears the unbrushed surface.

64. Maruyama, "Statement."

65. A 2007 print of *Kusho #1* sold at auction for $18,750 in 2010. Phillips, New York, Lot 405, October 8, 2010.

66. Maruyama, "Statement."

67. M. Berger, "Writing in the Sky." Berger does not once mention Zen.

68. Williams, *The Buddha in the Machine,* 175.

69. Noguchi's sculpture is in the John B. Putnam Jr. Memorial Collection, Princeton University, Princeton, NJ.

70. Asian Art Museum, San Francisco, "Interactive Brush Painting Activity."

71. See "Enso Wave," Tiffiny Kaetzel, Knoxville, American Tattoo Studio, posted on https://www.pinterest.com/vbahure/enso/.

72. Warner, *Zen Wrapped in Karma,* xii.

73. See Jain, *Selling Yoga,* 171.

74. Schmidt, *Restless Souls,* xi–xii.

75. Loy and Watts, "The Religion of Consumption."

76. See Gutiérrez-Baldoquín, ed., *Dharma, Color, and Culture;* Chin, "Attack of the White Buddhists."

77. Jaffe, "Introduction," i.

78. See Sterling, *Zen Pioneer,* and Arai, *Women Living Zen.*

79. See Grieve, "A Virtual Bodhi Tree."

80. Zen and its cultural manifestations were not isolated from Buddhist modernism. See McMahan, *The Making of Buddhist Modernism.*

81. See Robson, "Formation and Fabrication"; Levine, "Critical Chan/Sŏn/Zen Art History."

82. From a conversation with James Ulak, May 24, 2012.

83. Chakrabarty, *Provincializing Europe,* 237, 239.

84. See Faure, *Unmasking Buddhism.*

85. Masuzawa, *The Invention of World Religions,* 10.

86. Premodern masters engaged in public discourse, but the stakes and spaces of argumentation are of course not identical to those of the twentieth century.

87. Sargeant, "Profiles: Great Simplicity," 52.

88. For this point I thank Richard M. Jaffe.

89. For the "Zen Gaze," see Belting, "Beyond Iconoclasm."

90. More specifically, to awaken to one's original nature and become a buddha (J. *kenshō jōbutsu*). *PDB,* 385.

91. See Pitelka, "Form and Function."

92. Tweed, "American Occultism," 273.

93. On disparate artifacts and "panoramic reading," see Ngai, *Our Aesthetic Categories,* 17–18.

94. Morgan, *Visual Piety,* xi.

CHAPTER 1: ZEN ART BEFORE NOTHINGNESS

1. Varnedoe derived "pictures of nothing" from William Hazlitt (1778–1830).

2. The scholar is Martin Powers, Professor of Chinese Arts and Cultures, University of Michigan.

3. Ross, "What Is Zen?" 64.

4. "Thunderous silence" is associated with Vimalakīrti's use of silence to demonstrate entrance into non-duality in *Vimalakīrti nirdeśa sūtra* ("Vimalakīrti's Instructions").

5. Winther-Tamaki, "The Asian Dimensions," 145.

6. See Murai and Lippit, "Beyond Tenshin."

7. See D. Satō, *Modern Japanese Art;* Aso, *Public Properties.*

8. See Tweed, *American Encounter,* 45; Triplett, "From the Archives."

9. App, "The 'Discovery' of Zen," 10, 12–14.

10. Ibid., 20–21.

11. Cieslik, "The Case of Christovão Ferreira."

12. App, *The Birth of Orientalism,* 138.

13. Ibid., 18–19, 138–139, 142, 144; Morita, et al., *Hoyaku Nippō jisho,* 356–359, 561; Cooper, *They Came to Japan,* 202, 316–317, 320–321; Cooper, ed., *João Rodrigues's Account,* 288–289, 305, 321, 357; Elison, *Deus Destroyed,* 339.

14. Cooper, *They Came to Japan,* 342–345.

15. Bickersteth, *Japan as We Saw It,* 297; Pier, *Temple Treasures of Japan,* 121. Terms such as "Zen-shū" and "Za-zen" appear, but not one corresponding to Zen art, in Hepburn, *Waego rinshūsei* (1867), and Satow and Masakata, *An English-Japanese Dictionary.* On nothingness in European philosophy, see Droit, *The Cult of Nothingness.*

16. See Numata, "Sesshu."

17. Alcock, *Art and Art Industries,* 4.

18. Sladen, *The Japs at Home,* 138–150; M. Yoshihara, *Embracing the East,* 26.

19. Stopes, *A Journal from Japan,* 266; Chamberlain, *A Handbook,* 299.

20. Stopes, *A Journal from Japan;* Baxter, *In Beautiful Japan.*

21. On Romanticism, see McMahan, *The Making of Buddhist Modernism,* chap. 5.

22. Jarves, *A Glimpse,* 52, 98.

23. The illustration appears to have been based on *Red-Robed Bodhidharma,* attributed to Sesshū (Idemitsu Museum, Tokyo). Tōkyō Kokuritsu Hakubutsukan, *Sesshū,* no. 108.

24. In 1958 Ruth Fuller Sasaki noted, "Most of you have heard of or read the famous verse descriptive of Zen attributed to Bodhidharma." Sterling, *Zen Pioneer,* 141.

25. Greey, *The Wonderful City of Tokio,* 174–176, 234–236.

26. This was not true in Japan, where specific painting subjects were linked to Chan/Zen Buddhist teachings, hagiography, and contexts.

27. See, for instance, Reed, *Japan,* and Hartmann, *Japanese Art.*

28. Chamberlain, *A Handbook,* 45.

29. Chamberlain, *Things Japanese,* 44–46.

30. Murayama, *Wakan meigasen,* no. 39.

31. By the early twentieth century, Zen had gained a reputation among European and American observers for mysticism and a "Protestant" "opposition to an excessive use of idols, sacred books, ceremonies, and religious externals." Parrot, "Buddhism in Japan."

32. Chamberlain, *A Handbook,* 48–49.

33. Dow, "A Course in Fine Arts," 117.

34. Dyer, *Dai Nippon,* 205.

35. See Suzuki, *Essays in Zen Buddhism* (Third Series), 289–331, 315, 337.

36. The Japanese Commission, *Official Catalogue,* 97–101.

37. Secretary of State, *Reports of the United States,* 163.

38. See Nunokawa, "Oscar Wilde in Japan."

39. Snodgrass, *Presenting Japanese Buddhism,* 43; Weston, *Japanese Painting,* 107–117.

40. Tokyo Kokuritsu Hakubutsukan, *Umi o wattata Meiji no bijutsu,* 103–104; Handy, *The Official Directory,* 131–132.

41. Snodgrass, *Presenting Japanese Buddhism,* 43.

42. Sharf, "The Zen of Japanese Nationalism," 112–116. See also Shaku, *Sermons of a Buddhist Abbot* and *Zen for Americans.*

43. This was not the painting dated 1495 now in Tokyo National Museum. Office of the Imperial Japanese Government Commission, *An Illustrated Catalogue,* no. 31.

44. Mutsu, *The British Press,* 17–18, 59–61, 73–74, 80–82, 161–163.

45. Commission Impériale du Japon. *L'histoire de l'art du Japon,* 13.

46. Ibid., 146.

47. Ibid., 106–107.

48. Wilde, *Intentions,* 42.

49. At century's turn Zen was described as a "doctrine of abstraction" and an "austere discipline." Brinkley, *Japan,* 61, 62; de Gruchy, *Orienting Arthur Waley,* 16–33.

50. See *Kyōtofu kaku shaji hōmotsu mokuroku: Atago-gun* (1880s–1890s). Muqi's *Six Persimmons* was reproduced in Matsudaira Sadanobu, *Shūko jisshū* (1800) and copied by painters of the Kano school. For Muqi, see Gotoh Bijutsukan, *Mokkei.*

51. See Onshi Kyōto Hakubutsukan, *Daitokuji meihō shū;* Kyōtofu, "Kyōtofu jiin jūhō chōsa."

52. For Soseki, see Morrell and Morrell, *Zen Sanctuary,* 139–140; Seo, *The Art of Twentieth-Century Zen,* 59.

53. Guth, *Art, Tea, and Industry,* 77, 159; Tanaka, "Sengo bijutsuhin idō 36."

54. Yoshizawa, *Hakuin,* 16; Marx et al., *Zenga.* For prewar discussion of Zenga, see Okamoto, "Hakuin no gazen ni tsuite" (1938), in *Okamoto Kanoko zenshū,* 10:294–300.

55. On Zen gardens, see S. Yamada, *Shots in the Dark.*

56. Weston, *Japanese Painting,* 232.

57. Okakura, *Ideals of the East,* 50.

58. Ibid., 176.

59. See Suzuki, *Nihonteki reisei.*

60. Okakura, *Ideals of the East,* 179–181.

61. Okakura, *The Book of Tea,* 67.

62. Okakura, *Ideals of the East,* 179–181.

63. Okakura, *The Book of Tea,* 69–71.

64. Snodgrass, *Presenting Japanese Buddhism,* 270.

65. On Anesaki's lack of Zen affiliation, I thank Richard M. Jaffe.

66. On ritual, see Foulk, "The Denial of Ritual."

67. On Okakura and Emerson, I am indebted to Salzwedel, "(Emersonian) Nature in East Asiatic Painting"; Murai, "Okakura's Way of Tea."

68. Anesaki, *Buddhist Art,* 48, 53, 57.

69. Ibid., 54, 55, 62.

70. Japan occupied Taiwan, the Penghu archipelago, the Liaodong Penninsula, and Manchuria after the Sino-Japanese war (1894–1895) and annexed Korea in 1910.

71. Binyon, *Painting in the Far East,* 167.

72. Bohrer, *Orientalism and Visual Culture,* 3.

73. Ibid.; see also Hatcher, *Laurence Binyon*, 184.
74. See Levine, *Daitokuji*, Epilogue.
75. See Fenollosa, "Introduction," in Museum of Fine Arts, Boston, *A Special Exhibition*, 5, 8, 17–18.
76. Fenollosa, *Epochs of Chinese and Japanese Art*, 2:4.
77. Ibid., 2:1.
78. Ibid., 2:7.
79. Ibid., 2:5.
80. Ibid., 2:36, 51, 64.
81. Ibid., 2:81–83.
82. Ibid., 2:80–81.
83. Generally, Fenollosa's aim was to explain the universality of art and Okakura's the unity of Asia. See Weston, *Japanese Painting*, 264.
84. Fukui, "A Landscape by Bunsei," 221, 222.
85. Huston Smith, "Foreword," in Kapleau, *The Three Pillars of Zen*, xiii.

CHAPTER 2: MAKING ZEN MODERN

1. Humphreys, "Zen Comes West," 126.
2. I am indebted here to Jaffe, "Introduction"; Tweed, "American Occultism."
3. Suzuki, *Essays in Zen Buddhism* (First Series), vi. "Sayings" refers to "discourse records" (Ch. *yulu*; J. *goroku*). For Suzuki's criticism of certain Zen masters and goal of making Zen accessible, see Jaffe, "Introduction," lvi.
4. In premodern East Asia, there were multiple political developments and cultural processes that brought Chan/Sŏn/Zen into non-monastic spaces, often in relation to literati spheres. See Poceski, "Lay Models of Engagement," and Halperin, *Out of the Cloister*. There were multiple modern Zen movements, and prominent Japanese Zen monks and scholars such as Shaku Sōen, Shimada Shunpo (1876–1975), and Sugawara Jiho (1866–1956). See Sharf, "The Zen of Japanese Nationalism," 7–10; Sharf, "Sanbōkyōdan"; Uchiyama and Okumura, *The Zen Teachings of Homeless Kodo*.
5. See Suzuki, *The Training of a Zen Buddhist Monk*, and Shimada Shunpo, *Zendō seikatsu*.
6. Jaffe, "Introduction," xii, liii.
7. See Jaffe, "Introduction," xvi–xix; Victoria, *Zen at War;* Auerback, "A Closer Look at Zen at War"; and K. T. Satō, "D. T. Suzuki and the Question of War." For "Zen nationalism" *avant la lettre*, see Kokan Shiren (1278–1346) *Genkō shakusho*, in Bielfeldt, "Kokan Shiren."
8. Suzuki, "A Reply from D. T. Suzuki," 56.
9. For Suzuki's Zen practice, see Jaffe, "Introduction," xix–xxv. On the stick, see Wittern, "Thirty Blows"; Rumbold, "Catching the Mood," 26–27.
10. On Suzuki's independence from the Zen establishment and rejection of the role of Zen teacher, see Jaffe, "Introduction," xxiv, xlix. Hisamatsu's 1960 essay, "Seven Characteristics of Zen Art," was introduced hyperbolically by the editor as "The only treatise on 'Zen and Art' ever written by a Zen Master."
11. Jaffe, "Introduction," xxvi.
12. According to Kirita Kiyohide, Suzuki believed that contemporary Zen should emphasize the Bodhisattva Vow to save all sentient beings through Great Mercy and Great Compassion. Kirita, "D. T. Suzuki," 70.
13. See Watsuji Tetsurō, *Shamon Dōgen* (1926), translated in Bein, *Purifying Zen*.
14. Goddard, *A Buddhist Bible*, 11.

15. See Suzuki, "Eckhart and Zen Buddhism"; Suzuki, *Mysticism*. On Suzuki's debts to William James and others, see Jaffe, "Introduction to the 2010 Edition," xxi; Tweed, "American Occultism."

16. Meister Eckhart is also cited by the Sri Lankan-British philosopher and advocate for Indian art, Ananda K. Coomaraswamy (1877–1947) in *The Transformation of Nature*, 61.

17. Kostelanetz, *Conversing with Cage*, 247.

18. Snyder describes practice in Japan in *Earth House Hold*, 44–53. On bringing Zen out of the monastery, see Snyder, *The Real Work*, 16.

19. Jaffe, "Introduction," xxxix, xl.

20. For Suzuki's chronology, see Jaffe, "Introduction." For Zen monks studying in America, see Amakuki, *Zensō ryūgaku*.

21. McMahan, *The Making of Buddhist Modernism*, 125. For Suzuki's advocacy of Rinzai Zen, see Jaffe, "Introduction," xlix.

22. On koan, see Suzuki, *Essays in Zen Buddhism* (Second Series).

23. See Suzuki, "Zen: A Reply to Van Meter Ames."

24. On Suzuki and the degeneration of Chan in China, see Jaffe, "Introduction," xvi.

25. Ibid.

26. Suzuki, *Japanese Spirituality*, 17–18, 21, 23, 46.

27. Ibid., 94–95.

28. For wartime Buddhist ultranationalism, see Edwards, "Forging Tradition," 304–305; Victoria, *Zen at War*.

29. Jaffe, "Introduction," xxxix, xli, l.

30. Werblowsky, "Some Observations," 320–321. Werblowsky quotes from Suzuki, *Zen and Japanese Culture*, 63.

31. Blyth, *Zen in English Literature*, vii. On Blyth, see *A Modern Buddhist Bible*, ed. Lopez, 106–107.

32. Blyth, *Zen in English Literature*, illustration facing page 412.

33. Van Meter Ames, echoing Blyth, suggested that Zen was present all along in American thought, "though not by the name." Ames, "Zen to Mead," 27.

34. Schiller, *Zen*.

35. Jaffe, "Introduction," xiii.

36. Nancy Wilson Ross, quoted on the back cover of the third printing of Suzuki, *Zen and Japanese Culture* (1973).

37. Nagatomi, review of Suzuki, *Zen and Japanese Culture*; Gardner, review of Suzuki, *Zen and Japanese Culture*.

38. Gardner, review of Suzuki, *Zen and Japanese Culture*.

39. Soper, review of Suzuki, *Zen and Japanese Culture*.

40. Werblowsky, "Some Observations," 320; Patterson, "Cage and Asia," 64.

41. Suzuki, "Zen in the Modern World," 452.

42. Gould and Vrba, "Exaptation."

43. Brown, "The Zen of Anarchy," 207, 212.

CHAPTER 3: DANXIA BURNS A BUDDHA

1. Nukariya, *The Religion of the Samurai*, 76.

2. Not all "scandalous" behaviors are benign. See Downing, *Shoes Outside the Door*; Oppenheimer, *Zen Predator*.

3. For "norm-overturning" behaviors see also DiValerio, *The Holy Madmen of Tibet*.

4. "[Hitting with a] stick and shouting" (C. *banghe*; J. *bōkatsu*). *PDB*, 95; Cleary, *The Blue Cliff Record*, 57.

5. Cleary, *The Blue Cliff Record*, 31; Krichner, *The Record of Linji*, 92; *PDB*, 121.
6. Hoffman, *Every End Exposed*, 69.
7. Sanford, *Zen-Man Ikkyū*, 51–52.
8. Gregory, *Tsung-Mi*, 19. There have long been Buddhist tussles over language, material-visual forms, and their "heresy" as illusion. Halperin, *Out of the Cloister*, 84.
9. Iwamura, *Virtual Orientalism*, 38–41; Melby et al., *The Zen of Steve Jobs*, 66; Suh, *Silver Screen Buddha*, 60, 63.
10. Besserman and Steger, *Crazy Clouds*, 3, 16.
11. Gluskin, "Zen Rebel."
12. See Warner, *Hardcore Zen*.
13. Wright, *Philosophical Meditations*, 213.
14. Suh, *Silver Screen Buddha*, 60.
15. The appeal of Zen iconoclasm may have something to do with the "performative aesthetic of zaniness" in late capitalism. See Ngai, *Our Aesthetic Categories*, 1, 12, 185.
16. Watts, *An Outline of Zen Buddhism*, 48.
17. Watts, "Beat Zen," 8.
18. Werblowsky, "Some Observations," 323.
19. Faure, *Visions of Power*, 264–267, and *The Rhetoric of Immediacy*, 177–178.
20. Sharf, "Whose Zen?" 43.
21. Grimes, "Zen and the Art of Not Teaching," 160.
22. Hakuin, *Wild Ivy*, 23–24, 133–134. I thank Richard M. Jaffe for this reference.
23. McMahan, *The Making of Buddhist Modernism*, 141, 142–144. See also Lussier, *Romantic Dharma*, and "Preface." On "modernity's idolizing of the charismatic, exalted master" see Gilhus, *Laughing Gods*, 125. On role models, see Morreall, *Comedy*, 61.
24. Yuanwu Keqin's commentary to the seventy-sixth case in *The Blue Cliff Record* notes that the toponymic Danxia received the name "Tianran" from Mazu Daoyi (709–788) after climbing onto a statue of Mañjuśrī in the Monks' Hall, to which Mazu responded, "My son is so natural." Cleary, trans., *The Blue Cliff Record*, 339. Hagiographies of Danxia appear in the *Patriarch Hall Collection* (*Zutang ji*, 952), *Song Dynasty Biographies of Eminent Monks* (Zanning, *Song gaoseng zhuan*, 988), and *Jingde Era Transmission of the Lamp* (*Jingde chuandeng Lu*, 1004). See Welter, *Monks, Rulers, and Literati*, 82–83; Jia, *The Hongzhou School*, 26–28. For mountains associated with Tianran, see Kinoshita, "Tankazan."
25. My first encounter was in Kapleau, *The Three Pillars of Zen* (1966), 236, 421.
26. Heine and Wright, *Zen Ritual*, 4; Loy, *Healing Deconstruction*, 13; W. I. Cohen, *Ethics in Thought and Action*, 140; Callaway, *Zen Way, Jesus Way*, 112; Elinor, *Buddha and Christ*, 104.
27. *T* 2076_.51.0310c13–16. Translated in Shimizu, "Six Narratives," 8. See also Shimada Shūjirō, "Indara no Zen'e zu."
28. See Baoye Miaoyuan, ed., *Xutang heshang yulu, T* 2000_.47.0988c13.
29. Dōgen, *Shōbōgenzō zuimonki*, 124–126; Masunaga, *A Primer of Sōtō Zen*, 55.
30. Kirchner, trans., *Entangling Vines*, 29, 158.
31. *Chanhui* refers to a meeting for the explication of Chan but grew into a genre in which the Chan master bests (and converts) his interlocutor. Levine and Lippit, *Awakenings*, 130.
32. See "Cuiyan's Eyebrows," in Cleary, *The Blue Cliff Record*, 53–57.
33. Welter, "Lineage and Context," 143.

34. See, for instance, Hasegawa Sakon (active first half of the 17th c.), *Spiritual Exercises of Zen (Chan) Monks,* inscribed by the Daitokuji monk Takuan Sōhō (1573–1645), in Rosenfield and Shimada, *Traditions of Japanese Art,* 197.

35. Translation from Fontein and Hickman, *Zen Painting and Calligraphy,* 38.

36. The scroll was divided following arrival in Japan. Yintuoluo is referred to as an Indian monk in Japanese sources such as *Kundaikan sōchōki* (16th century) and Hasegawa Tōhaku (1539–1610), *Tōhaku gasetsu* (Talks on painting). See Wakimoto, "Zuhan kaisetsu"; Shimizu, "Six Narrative Paintings."

37. For Yintuoluo's brushwork, see Levine and Lippit, *Awakenings,* 88.

38. Fontein and Hickman, *Zen Painting and Calligraphy,* 38.

39. "Den Indara hitsu Tanka shō mokubutsu zu." On *Kokka* and the development of art history in Japan, see D. Satō, *Modern Japanese Art,* 153–160.

40. "Den Indara hitsu Tanka shō mokubutsu zu."

41. See reference below to *Precious Mirror of Painting.* For early modern painting treatises, see Lippit, *Painting of the Realm.*

42. Murayama, *Wakan meiga sen,* no. 29.

43. Waley, *Zen Buddhism,* 23–24. See also Sirén, *Chinese Painting,* 146–147.

44. Nihon Bijutsu Kyōkai, *Kichō bijusuhin chōsa hōkoku,* no. 1.

45. Kōgetsu and Junsō (d. 1700) were respectively the 156th and 231st abbots of Daitokuji. See Lippit, *Painting of the Realm,* 142–149; Levine, *Daitokuji,* pt. 3.

46. Paintings and calligraphies in Kuroda Nagashige's collection were reproduced in various early twentieth-century art publications including Shōbikai, *Meiga seikan.* The Fukuoka Art Museum preserves part of the Kuroda collection.

47. "Kokka sangatsu gō"; "Kanko yodan"; "Sōgen no meihin."

48. In 1998, the painting entered the collection of the Ishibashi Museum of Art, Kurume, Japan.

49. Idemitsu Shōsuke, "Chichi, Idemitsu Sazō."

50. Suzuki et al., *Sengai the Zen Master,* 86–87.

51. On Zen and humor, see Chapter 7.

52. Suzuki et al., *Sengai the Zen Master,* 87.

53. Katsushika Hokusai, *Burning a Buddhist Image,* F1904.210, Freer Gallery of Art and Arthur Sackler Gallery, Washington, DC.

54. Museum of Fine Arts, Boston, *Museum of Fine Arts, Boston Forty-second Annual Report,* 90.

55. On eccentricity in early modern visual culture, see Rosenfield et al., *Extraordinary Persons;* Rosenfield, "Hokusai."

56. Shimada Shunpo, *Kattōshū,* 54–55.

57. Shaku Sōen, *Kaijin kaiba,* 158–159. Sōen taught Zen in San Francisco in 1905–1906. McMahan, *The Making of Buddhist Modernism,* 64; Jaffe, "Introduction," xxiii.

58. *PDB,* 1041–1042.

59. Yamamoto, "Zensō kara eta kyōkun," quoted in Mori, "Yamamoto Shunkyo shiron," 25.

60. The painting's title refers to discourses on the true location/acquisition of Buddha nature, beyond external materialization, and harkens back to the monk Huineng, who received Bodhidharma's "marrow" and became the second Chan patriarch. Heine, *Zen Skin, Zen Marrow,* 22–26. For Yamamoto's lay Zen practice, see Mori, "Yamamoto Shunkyo shiron." Yamamoto's artist seals, impressed on the painting, are engraved with a variation of the last two phrases of a verse composed by the Song dynasty Caodong master Touzi Yiqing (1032–1083): "Flourishing, perishing; clouds go, clouds come. He has

no country, is utterly free from dust. On the peak of Mount Sumeru, rootless plants; without feeling the spring breeze, the flowers bloom of themselves." Cleary, *Classics of Buddhism and Zen,* 4:561.

61. Shiga Kenritsu Kindai Bijutsukan, *Yamamoto Shunkyo,* 24.

62. That Yamamoto indicated that the painting be displayed with light hitting it at an angle suggests an interest in the luminous effects of gold, something not usually associated with Zen painting (see ibid.). This was not the first instance in which Yamamoto depicted a classic Chan tale. In *Hōjin issō,* exhibited in 1901 at the Seventh New and Old Fine Arts Exhibition (Shinko bijutsuhin ten) and signed with his layman's name, Yamamoto depicted Deshan Xuanjian burning his commentaries on the *Diamond Sutra* in a horizontal composition of similar setting but with two startled disciples behind the master. Its rough ink strokes and wash for the monk's robe are absent in the Danxia painting but closer in form to premodern Chan/Zen figure painting. Reproduced in ibid., fig. 10.

63. For Nihonga artists and Buddhist themes, see Weston, *Japanese Painting.* For Japanese claims over the study of Chinese Buddhism and its cultures, see comments by the scholar-monk Mochizuki Shinkō (1869–1948) in Mochizuki, "Preface."

64. Okamoto Ippei, *Ippei zenshū,* 1:25. Okamoto inscribed the cartoon with the phrases, "Grasp the flameless (burning) torch, face the smokeless fire," referring to a state of non-duality and found in Chan texts such as Baoye Miaoyuan, *Xutang heshang yulu.* Iriya and Koga, *Zengo jiten,* 371. "Manga journalist" is from Inouye, "Theorizing Manga," 22.

65. Kanoko initially turned to Christianity and then to the teachings of Shinran and wrote numerous essays on Buddhism. See M. T. Mori, "The Splendor of Self-Exultation."

66. Yamada was prominent in pre- and postwar efforts by Japanese monastics to popularize Zen in Japan. He served from 1960 to 1964 at Zenshūji in Los Angeles as the Sōtō denomination bishop of North America, certified dharma transmission to Japanese monks who became active in the West, including Taizan Maezumi and Dainin Katagiri, and became the seventy-fifth abbot of Eiheiji.

67. M. T. Mori, "The Splendor of Self-Exhaltation," 87.

68. For a postwar acquisition (1979), see Kusumi Morikage (1620–1690), *Two Zen Masters, Danxia and Puhua,* Sanso Collection.

69. Okakura, *The Book of Tea,* 67–68.

70. Joly, *Legend in Japanese Art,* 360.

71. In a related criticism, Nukariya commented, "It is hardly justifiable to cover the whole system of Buddhism with a single epithet 'pessimistic' or 'nihilistic.'" Nukariya, *The Religion of the Samurai,* xviii, xx–xxi. European criticism of Buddhist "idols" has an old history, seen in reports of missionaries and others from the sixteenth century onward.

72. Nukariya positioned his exegesis on Zen in relation to the West and the "New Buddhism" of reformers in Japan. Nukariya, *The Religion of the Samurai,* xix–xx.

73. Hu, "Development of Zen Buddhism," 500; Sir Charles Eliot, *Japanese Buddhism,* 168; Spiegelberg, *The Religion of No-Religion,* 38; Suzuki, *The Zen Doctrine of No-Mind,* 100; Saunders, *A Pageant of Asia,* 299–300.

74. Coomaraswamy, *The Transformation of Nature,* 28n25, 192; Coomaraswamy, "Introduction," 120–121.

75. Watts, *The Spirit of Zen,* 49.

76. Sasaki, "Twenty-five Zen Koans," 10.
77. Suzuki, *Essays in Zen Buddhism* (First Series), 315–317.
78. Suzuki, *Essays in Zen Buddhism* (Third Series), 304.

CHAPTER 4: THE LOOK AND LOGOS OF ZEN ART

1. Stephan, *Various Poems,* 39.
2. Farkas, "Zen and Art."
3. Waley, *Zen Buddhism,* 7.
4. Ivy, *Discourses of the Vanishing,* 1.
5. See Chapter 1.
6. Koestler, "Neither Lotus nor Robot," 58.
7. Suzuki, "A Reply from D. T. Suzuki," 55.
8. See Shimizu, "Zen Art?"; Sharf, "The Zen of Japanese Nationalism"; Lachman, "Art" and "Chan Art"; and Levine, *Daitokuji.*
9. On the Zen "pantheon," see Lippit, "Awakenings."
10. On the elevation of Japanese Zen, see Sharf, "The Zen of Japanese Nationalism," 121, 128, 135.
11. Addiss, *The Art of Zen,* 204; Seo, *The Art of Twentieth-Century Zen,* 15.
12. Muji, "What Is Muji?"
13. Chan painting drew from the "untrammeled" tradition (Ch. *yipin*), "plain drawing" style (Ch. *biamiao*), and literati painting of the Song and Yuan dynasties. See Pan, *Painting Faith,* chap. 3.
14. For Cage, see Chapter 6.
15. Belting, "Beyond Iconoclasm," 391–393, 399.
16. See Levine, *Daitokuji,* pt. 1.
17. Waley, *Zen Buddhism,* 23.
18. Ibid., 22–23.
19. Ibid., 22.
20. See Sharf, "The Zen of Japanese Nationalism."
21. Robert H. Sharf has used this phrase in relation to modern notions of Zen and Zen art.
22. Suzuki, *Essays in Zen Buddhism* (Third Series), 289–331, 315, 337.
23. Ibid., 307.
24. Ibid., 309; Suzuki, *Zen and Japanese Culture,* 17, 31, 36.
25. See Faure, *Chan Insights,* 89, 135; Morinaga, *Secrecy,* 1, 8–10.
26. Hisamatsu, "On Zen Art," 24. Hisamatsu studied with the Rinzai monk Ikegami Shōsan (d. 1928). Not a Zen master in the institutional sense, Hisamatsu was instead part of a modern group of Zen advocates who, as "adjunct Zen teachers," developed lay-popular Zen in association with monastic Zen.
27. On Taishō cultural nationalism, see Kikuchi, *Japanese Modernisation,* 76–80.
28. Waley, *Zen Buddhism,* 22, 26.
29. See Welter, "Mahākāśyapa's Smile."
30. Munsterberg, "Zen and Art," 198.
31. Munsterberg, *Zen and Oriental Art,* 36.
32. See R. King, *Orientalism and Religion;* Kikuchi, *Japanese Modernisation,* xvii, chap. 4.
33. Juniper, *Wabi Sabi,* 15.
34. Snodgrass, *Presenting Japanese Buddhism,* 266.
35. Suzuki, *Japanese Spirituality,* 46–47.
36. Suzuki, *Zen and Japanese Culture,* 345–346; Sharf, "The Zen of Japanese Nationalism," 129–133.

37. Jaffe, "Introduction," xxxi. Note also Ōhasama Shūei (1883–1946), author of *Zen: Der lebendige Buddhismus in Japan* (1925), and Hisamatsu, whom I discuss shortly.

38. Nukariya, *The Religion of the Samurai,* xxii.

39. Anesaki, *Buddhist Art,* 53–54.

40. Harada, *The Gardens of Japan,* 4.

41. Binyon, *Painting in the Far East,* 119; Warner, *Enduring Art,* 100. See also Sansom, *Japan,* 336; Kuck, *One Hundred Kyoto Gardens,* 112.

42. Watts, *The Spirit of Zen,* 111.

43. See Sharf, "Whose Zen?" 46; Snodgrass, *Presenting Japanese Buddhism,* 266.

44. Blyth, *Zen in English Literature,* vii, viii. On "philosophical and pragmatic cognates" between European poets and Zen, see Lussier, "Preface," v.

45. Ogata, "Zen and Culture," 131.

46. Rankin, "A Short Guide," 31.

47. Ames, "Current Western Interest in Zen," 26, 29.

48. Munsterberg, "Zen and Art," 198; Munsterberg, *Zen and Oriental Art,* 29.

49. Covell, "Zen Gleanings," 11.

50. For the trope's late twentieth-century repetition, see Sterngold, "Experiencing the Spirit of Zen."

51. Werblowsky, "Some Observations," 320n9.

52. Koestler, *The Lotus and the Robot,* 242–243.

53. Becker, *Zen: A Rational Critique,* 19.

54. Pilgrim, *Buddhism,* 39.

55. Ames, "Current Western Interest in Zen," 29.

56. These terms have modern histories traceable in, for instance, Suzuki, *Zen and Japanese Culture;* Hisamatsu, *Zen and the Fine Arts;* and Juniper, *Wabi Sabi.*

57. See Porcu, *Pure Land Buddhism.*

58. Watts, *The Spirit of Zen,* 91; Munsterberg, *Zen and Oriental Art,* 35; Seo, *The Art of Twentieth-Century Zen,* 15.

59. See Levine, *Daitokuji;* Levine and Lippit, *Awakenings.*

60. On iconoclasm, see Faure, *Rhetoric of Immediacy,* 177–178. Modern emphasis of Zen's rejection of image veneration finds one source in Watsuji Tetsurō, *Shamon Dōgen* (1926). See Bein, *Purifying Zen,* 82–83.

61. See Mujaku Dōchū's (1653–1745) encyclopedia, *Zenrin shōkisen,* and gazetteer of the monastery Myōshinji, *Shōbōzanshi.* See also publications by Matsuura Hidemitsu, Bernard Faure, T. Griffith Foulk, and Gregory Levine.

62. D. T. Suzuki did, nevertheless, introduce monastic iconography in his 1935 *Manual of Zen Buddhism.*

63. Renan, "What Is a Nation?" 11.

64. Reynolds, "Presentation Zen."

65. Merholz, "Zen is not for value judgments."

66. Lopez, *Prisoners,* 10.

67. Sharf, "The Zen of Japanese Nationalism," 132–133. Hisamatsu introduced his ideas during lectures in the United States in 1958 and in "Seven Characteristics of Zen Art" (1960), "On Zen Art," 32–33, "Zen to shogei," and "Zen to Tōyō bunka." See also Farkas, "Zen and Art."

68. Commission Impériale du Japon, *L'histoire de l'art du Japon,* 4–5.

69. See Light, *Shuzo Kuki,* 51–57, 96–97; Hokenson, *Japan, France, and East-West Aesthetics,* 338–340. In 1928, Tsuzumi Tsuneyoshi (1887–1981) coined the term Rahmenlosigkeit ("framelessness") to distinguish Japanese art. In 1943, Yashiro Yukio (1890–1975) proposed four qualities essential to

Japanese art. Yashiro, *Nihon bijutsu no tokushitsu,* 2:187. See Inaga, "Is Art History Globalizable?"

70. Suzuki, *Essays in Zen Buddhism* (Second Series), 28–34. Efforts to distill cultures into sets of characteristics appear in the reformist/nationalist projects of European-trained intellectuals across Asia. Note the "seven universal elements" to mystical experience posited by Sarvepalli Radhakrishnan (1888–1975). Radhakrishnan, *An Idealist View of Life,* 66–78.

71. Okakura, *Ideals of the East,* 178–181; Suzuki, "Buddhist, Especially Zen, Contributions"; Anesaki, *Art, Life, and Nature,* 11, 13, 22, 23. For Yanagi, see Kikuchi, *Japanese Modernisation,* 7–9, 198–202.

72. Watts, *Zen,* 35–37.

73. Kuck, *The Art of Japanese Gardens,* 223, 225. Kuck was influenced by D. T. Suzuki and Shigemori Mirei (1896–1975). Katahira-Manabe, "Review: *The Art of Japanese Gardens,*" 60.

74. See Mujaku, *Shōbōzanshi* and *Zenrin shōkisen.*

75. See Hisamatsu, "Seven Characteristics," 32–33, 64.

76. Hisamatsu, *Zen and the Fine Arts,* 37.

77. Hasumi, *Zen in Japanese Art* (1962), published in German in 1960. For the ox-herding theme, see Ueda and Yanagida, *Jūgyūzu.*

78. Hasumi, *Zen in Japanese Art,* 81–83.

79. Ibid., ix–xi.

80. Munsterberg, Review of Hasumi, *Zen in Japanese Art;* E.H.S., Review of Hasumi, *Zen in Japanese Art,* 282.

81. Hisamatsu, *Zen and the Fine Arts,* 45.

82. Ibid., 28–38, 53–59.

83. Ibid., 53.

84. Ogata Sōhaku, for instance, drew directly from Hisamatsu in, *Zen for the West,* 26.

85. Quoted in Westgeest, *Zen in the Fifties,* 81–82.

86. Holmes and Horioka, *Zen Art for Meditation,* 12, 16–18.

87. Shaw, "Just Do It!"

88. Westgeest, *Zen in the Fifties,* 17–23.

89. See Awakawa, *Zen Painting;* Addiss, "Provisional Dualism"; Winther-Tamaki, *Art in the Encounter of Nations,* 22, 40, 49–50.

90. Westgeest, *Zen in the Fifties,* 150. For Hisamatsu as an uncritically cited authority, see also Divelbess, "Zen and Art," 36–37; Stevens, "Zen Brush," 27.

91. Juniper, *Wabi Sabi,* ix, 103–120.

92. Dunn, *Inspired Design,* 17, 23–25, 30–31.

93. See Kataoka and Fenwick, "7 Principles of Zen Aesthetics"; Williams, *The Buddha in the Machine,* 189.

94. See Woodson and Chong, *Zen;* Wirth, *Zen no Sho.*

95. See Vlastos, "Tradition."

96. For "Zhaozhou's Dog," see the First Case of *Wumen's Gate* (Ch. *Wumenguan*). Numata Center, *Three Chan Classics,* 71–72.

97. Gagosian Gallery, New York, "Takashi Murakami." See Vogel, "The Warhol of Japan."

98. Gagosian Gallery, New York, "Takashi Murakami." Murakami has revisualized other Buddhist iconographies; see his *500 Arhats* (2012).

99. Tully, "Master of the Universe," 164.

100. "Classical transgressions" is from Matsui, "Toward a Definition of Tokyo Pop."

101. Daruma's eyes bring to mind Murakami's *Tan Tan Bo,* other characters, and his "Eye Love Monogram" for Louis Vuitton. For "Superflat," see Ivy, "Review

of *Little Boy*"; Weisenfeld, "Reinscribing Tradition," 185–187; Murakami Takashi, "Superflat Trilogy," 153, 155.

102. I thank Aileen Tsui for comments on Murakami's 2007 works.

103. See Belting, "Beyond Iconoclasm."

104. Large works apparently sold for over one million dollars to collectors including the hedge fund executive Steven A. Cohen. See Vogel, "The Warhol of Japan."

105. Ibid.

106. See Winther-Tamaki, *Art in the Encounter of Nations,* 33, 41.

107. Kang, "Style and Substance."

108. See "Pop Dharma"; O'Shea, "NYC/Murakami's Moment"; Kanai, "Sick and Tired"; Swartley, "For the Pop Culturati."

109. Wakefield, "Review of Murakami Takashi."

110. Murakami's Superflat has been described as a "nationalist challenge to the hegemony of modern Western art by asserting standards of creation and appreciation derived purely from Japanese resources"; Matsui, "Beyond the Pleasure Room," 226. Murakami's Superflat theory echoes the meta-explanation purveyed by Zen campaigners such as D. T. Suzuki.

111. See Amp, "Zen Warholism." I thank Andrew Shanken for proposing "Zen baroque."

CHAPTER 5: ZEN-BOOM "CULTURE WARS"

1. Reprinted in Stirling, *Zen Pioneer,* 162.

2. Tomkins, "Zen and the Art of Tennis," 24.

3. See "Buddhist Boomlet," in "Zen" (1957) *Time* (magazine); "Zen buumu," in Suzuki and Hisamatsu, "Taidan" (1959), 16; and "The Zen 'Boom' Is On," in Ames, "Current Western Interest in Zen," 25. Chan's spread was likened to a blossoming five-petal flower (i.e., five Chan houses; C. *Wu jia*). See Lanxi Daolong's (1231–1278) inscription on the Kōgakuji painting of *Bodhidharma,* in Fontein, Hickman, *Zen Painting & Calligraphy,* no. 20.

4. Castile, "Letter to the Editor."

5. Talese, "Zen Selling Better Than Sodas."

6. Keating, *Zen There Was Murder,* 6–7; Ames, "Current Western Interest in Zen," 31.

7. Zen authorities took issue with misconceptions in the 1920s. Meanwhile, leaders of other Buddhist denominations such as the Jōdo Shinshū priest Zuiken Inagaki Saizō (1885–1981) disparaged Zen. Inagaki, "Letters from Zuiken," 1, Oct. 1, 1971; and parts 3 and 6.

8. Sharf, "Mindfulness," 952.

9. The metaphor derives from "grove of meditation" (Ch. *chanlin;* J. *zenrin*), connoting the Chan institution and tradition.

10. One must be cautious with any chronology and map, given what they leave out and omit. For these key years, see Kobori, "A Dialogue" (1957, 1958); the "Zen issue" of the *Chicago Review* (1958); Ross, "What Is Zen?" and "Beat—and Buddhist" (1958); "Zen: Beat and Square," *Time* (1958); Linssen, *Living Zen* (1958); Kerouac, *The Dharma Bums* (1958); Arthur Koestler's trips to Japan (1958); Ruth Fuller Sasaki's lecture at MIT (1958); the Ninth International Congress for the History of Religions, Tokyo (1958); Keene, "What Is Japanese Art?" (1959); Suzuki's *An Introduction to Zen Buddhism* (reissued in 1959); Fingesten, "Beat and Buddhist" (1959); "Zensation," *Time* (1959); and Ogata, *Zen for the West* (1959).

11. Heard, "On Learning from Buddha"; Ames, "Current Western Interest in Zen," 24.

12. Kapleau, "Report from a Zen Monastery," 77.

13. For Zen, globalization, and Japan's recent "spiritual boom," see Borup, "Easternization of the East?"

14. Hyun, "Beat Zen, Square Zen," 56.

15. Hayakawa, *Zen Showed Me the Way*, 184.

16. See Suzuki, *Manual of Zen Buddhism* (1935).

17. Williams, *The Buddha in the Machine*, 176.

18. Jazz musicians linked to Zen include Dizzy Gillespie (1917–1993), Tony Scott (1921–2007), and Tony Kinsey (b. 1927). See "Two Worlds of Jazz" and Scott, *Music for Zen Meditation* (1965). See Keating, *Zen There Was Murder* (1960).

19. Zen-boom Zen was initially recognized by most as Japanese; "Chinese Zen" and "Korean Zen" came later.

20. Enen, "Zen in New York."

21. "Zen," *Time* 69, no. 5 (Feb. 4, 1957), 67.

22. Rankin, "A Short Guide."

23. See Wiggin, "Crime and Punishment."

24. "A Glass of Rather Bad Sherry," 28.

25. Quoted in Winther-Tamaki, *Art in the Encounter of Nations,* 40. On Japanese American artists perceived as experts on Zen and Japanese art, see Winther-Tamaki, "Overtly, Covertly," 122.

26. Ames was based at the Sōtō Zen affiliated Komazawa University.

27. Tanabe and Tanabe, *Japanese Buddhist Temples.*

28. Senzaki, "Mentorgarten Dialogue"; Ford, *Zen Master Who?* 71–74; Besserman and Steger, *Crazy Clouds,* 157–181; Hayakawa, *Zen Showed Me the Way,* 183; "In Transition: Mary Farkas"; Stirling, *Zen Pioneer;* Kirchner, "Editor's Prologue," in *The Record of Linji.*

29. Graham, "Modernism's Mystery Man"; Fields, *How the Swans Came to the Lake,* 201.

30. See Yu, "The Growth of Korean Buddhism"; Low, "Seung Sahn"; Placzek et al., "Buddhism in British Columbia," 16; Spuler, *Developments in Australian Buddhism,* 17–20; Coupey, *Sit;* Batchelor, *The Awakening of the West,* 120–123, 131–137, 205–223; Croucher, *A History of Buddhism in Australia,* 50–51.

31. Tworkov, *Zen in America,* chap. 1; Wright, "Humanizing the Image," 243–245; Rocha, *Zen in Brazil;* Kirchner, "Zen Centers."

32. Suzuki visited the Buddhist Society in 1953, 1954, and 1958; Hisamatsu and Ogata Sōhaku in 1958. Humphreys, *Sixty Years of Buddhism,* 56, 60, 61; Koné, "Zen in Europe," 139–161; Kay, *Tibetan and Zen Buddhism,* pt. 3.

33. See *Zen Notes* 3, no. 7 (July 1956): n.p.

34. See Sharf, "Sanbōkyōdan"; Ives, "True Person" and *Imperial-Way Zen.*

35. Victoria, "Japanese Corporate Zen."

36. See Nanzan Institute for Religion and Culture, "Chronology for 1960"; R. F. Sasaki, "Letter[s] from Kyoto," Nov. 8, 1961; Austin, *Zen and the Brain,* 59–69, 107–110; Rumbold, "Catching the Mood"; Jaffe, "Introduction," xxiv.

37. This was happening before World War II. See Nancy Wilson Ross' 1939 lecture, "The Symbols of Modern Art," noted in Chapter 6.

38. In 1950, Suzuki taught at the University of Hawai'i. See Tokiwa, *Eight Lectures on Chan.*

39. See Suzuki, "D. T. Suzuki's English Diaries," 30–55; Danto, "Upper West Side Buddhism," 54–55; Jaffe, "Introduction," xxxvi; Pearlman, *Nothing and*

Everything, 169; Asahina, "A Message" and "Living Zen"; "Zen History Is Made in New York"; and "A Zen Master in Our Midst."

40. Ives, "True Person," 235n2; Heidegger and Hisamatsu, "Die Kunst und das Denken"; and Muramoto et al., "The Jung-Hisamatsu Conversation."

41. Stirling, *Zen Pioneer;* KPFA, "KPFA Participants: Alan W. Watts"; Watts, "The Life of Zen"; Kripal, *Esalen.*

42. Launched in 1879, the *Vallejo* was purchased and repaired by the artists Jean Varda and Gordon Onslow Ford and architect Forest Wright; Alan Watts bought a share in 1961. See "A Message from the Hippie-Elders."

43. See Sugi, "Ōbei ni mebaeru Zen" and "Zen to kenkō"; Suzuki and Hisamatsu, "Taidan"; Hisamatsu, "Zen to shogei."

44. Note performances given in Tokyo in 1962 by John Cage, David Tudor, Yoko Ono, Ichiyanagi Toshi, and Kobayashi Kenji. Cage's visits to Japan famously provoked a state of "Cage Shock."

45. See *Japanese Painting and Sculpture* (1953), which traveled from Japan to U.S. venues; *Abstract Japanese Calligraphy,* at the Museum of Modern Art, New York (1954); work shown by the Bokujinkai at Gallerie Collette Allendy, Paris (1955); paintings by the Zen monk Sengai Gibon (1750–1837) exhibited by Idemitsu Sazō in Oakland, California (1956); Gutai exhibitions in Kyoto, Osaka, and Tokyo, and at the Martha Jackson Gallery, New York (1957–1958), in Turin, Italy, and Tokyo (1959), and in Amsterdam and Paris (1965); Kurt Brasch's traveling Zenga exhibition (1959–1960), and *Zen Painting and Calligraphy,* at the Museum of Fine Arts, Boston (1970). See Shimizu, "Japan in American Museums"; Winther-Tamaki, *Art in the Encounter of Nations,* chap. 3; Tiampo, *Gutai;* Winther-Tamaki, "Asian Dimensions"; Museum of Modern Art, "Press Release"; Yamashita, "Reconsidering Zenga," 22; Aviman, *Zen Paintings,* 4–6.

46. Japhy's shack had "the complete works of D. T. Suzuki." Kerouac, *Dharma Bums,* 18, 97–98.

47. Daniels, "John Cage and Nam June Paik," 109–110, 114; Roberts, "*White Painting*"; Larson, *Where the Heart Beats,* 233–235, 269–271, 302–306; and Munroe, "Buddhism," 203.

48. Yoshimoto, *Into Performance,* 40, 84, 99; Munroe and Hendricks, *Yes. Yoko Ono,* 17, 64–89.

49. Vadnie, "The Zen of Isamu Noguchi." See also Pierre Alechinsky's film *Calligraphie Japonaise* (1956) and Ruth Stephan's film *Zen in Ryoko-in* (1971).

50. Gomez, "Kusama, in Her Words."

51. White, *Frontiers of Knowledge,* 304–305.

52. In the West, publication of studies of Chan/Zen was well ahead of the translation of primary texts. By 1961, Ruth Fuller Sasaki could cite nineteen of the latter. Sasaki, "A Bibliography of Translations."

53. The First Zen Institute of America began publication of *Zen Notes* in 1954. For several newsletters, see Primary Source Media, *American Religions Collection: Series 2.*

54. Suzuki, Hisamatsu, "Taidan," 28, 29.

55. Suzuki, "A Reply from D. T. Suzuki," 58.

56. "Atticus among the Angels."

57. Suzuki, "Zen in the Modern World," 455.

58. Mahoney, "The Prevalence of Zen," 312.

59. Masunaga, "Western Interest in Zen," 757.

60. Goddard, *A Buddhist Bible,* viii. Goddard practiced at the Kyoto Zen monastery Shōkokuji in 1928.

61. Barrett, "The Great Bow," 64, 65; Connolly, "Conversation with Aldous Huxley."

62. Snyder, "Buddhist Anarchism," published in *Journal for the Protection of All Beings* (1961) and revised as "Buddhism and the Coming Revolution," in Snyder, *Earth House Hold,* 90–93.

63. The Naturalization Act of 1965 enabled more Buddhist teachers and communities to enter the United States.

64. Barrett, "The Great Bow," 62.

65. Watts, "Beat Zen," 5.

66. Mahoney, "The Prevalence of Zen," 311; Roszak, *The Making of a Counter Culture,* 132.

67. Watts, "Beat Zen," 5–6. In 1958, Nancy Wilson Ross suggested that Zen garnered attention partly as a result of "the grave warnings of psychologists in general about the unhappy effects of ignoring the deeper levels of the human consciousness." Ross, "What Is Zen?" 117.

68. Ames, "Current Western Interest in Zen," 29.

69. This was the flip side of Zen as empirical and scientific. See Sharf, "The Zen of Japanese Nationalism," 111.

70. Ames, "Current Western Interest in Zen," 26, 31; Masatsugu, "'Beyond This World of Transiency,'" 436.

71. Ames, "Current Western Interest in Zen," 25. The venue was the Third East–West Philosopher's Conference (1959). See also Ames, "Zen to Mead," 27.

72. Werblowsky, "Some Observations," 321; Connolly, "Conversation with Aldous Huxley."

73. Williams, *The Buddha in the Machine,* 179–180.

74. S-K. Lee, "*Videa 'n' Videology,*" 28.

75. "American nervousness," Tom Lutz's phrase for George M. Beard's (1839–1883) "neurasthenia," drew many to Buddhism (and still does). See Lutz, *American Nervousness;* Tweed, *The American Encounter with Buddhism.*

76. Rankin, "A Short Guide."

77. For Cage's "proper discipline" being music rather than *zazen,* see Larson, *Where the Heart Beats,* 207.

78. Reader, "Zazenless Zen?" 8.

79. Doris, "Zen Vaudeville," 127; Munroe, "Buddhism," 199.

80. Tokiwa, "Dr. Shin'ichi Hisamatsu's 'Postmodernist Age,'" 17.

81. See "Zen History Is Made in New York."

82. "A Glass of Rather Bad Sherry." Huston Smith recalled that Suzuki "made Buddhism burst like a bomb on America." See Goldberg, dir., *A Zen Life: D. T. Suzuki* (1:51–2:01).

83. Harootunian, "Postwar America," 45, 46, 51, 53, 55.

84. Brown, "The Zen of Anarchy," 223, 224.

85. Yang, "Zen Buddhism," 72.

86. Gentile, *The Sacralization of Politics.* On Beat sacralization of life, see Prothero, "On the Holy Road," 214.

87. On liminal figures and the monk, see Prothero, "On the Holy Road," 210; Iwamura, *Virtual Orientalism.*

88. Heard, "On Learning from Buddha."

89. See Schmidt, *Restless Souls;* Niedzviecki, *Hello, I'm Special.*

90. Ames, "Current Western Interest in Zen," 23.

91. Werblowsky, "Some Observations," 315.

92. Cranston, "Mixed Feelings about Zen."

93. Campbell, "A Shot through the Letter-Box." For Chan encounters (*chanhui*), see Chapter 3.

94. Hugh-Jones, "Victims of Spring."
95. Salinger, "Seymour," 114–115; Tomkins, "The Zen of Tennis."
96. Raymond, "Salinger Kicks in the Door."
97. Brandon, "Beat Generation." On the Beats, see Yamada Shōji, *Tōkyō bugiugi,* chap. 5; Brown, "The Zen of Anarchy"; Prothero, "On the Holy Road."
98. Suzuki, "Zen in the Modern World," 452–453, 459.
99. For Suzuki's concern regarding misinterpretation, see Sueki and Grace, "Introduction," xvii–xviii.
100. Suzuki, "Zen in the Modern World," 454.
101. Suzuki, *An Introduction to Zen Buddhism,* 64.
102. Watts observed in 1972 that his "easy and free-floating attitude to Zen was largely responsible for the notorious 'Zen boom' . . . and led to the frivolous 'beat Zen' of Kerouac's *Dharma Bums,* of Franz Kline's black and white abstractions, and John Cage's silent concerts." Watts, *In My Own Way,* 262.
103. Suzuki, "A Recommendation for Quiet Sitting" (1900), in Suzuki, *Selected Works,* 2.
104. Brandon, "The Critic in Isolation."
105. Hyun, "Beat Zen," 56–57.
106. Connolly, "Square's-Eye View."
107. Merton, *Zen and the Birds of Appetite,* ix, 101.
108. Connolly, "A Fight against Fear and Failure"; Rumbold, "Catching the Mood"; Plomer, *A Message in Code,* 219–246.
109. Ashida, "Frogs and Frozen Zen," 200.
110. Roszak, *The Making of a Counter Culture,* 134–135, and amplified in *From Satori to Silicon Valley,* 11–12.
111. See Sakamoto, "Review of Ernest Benz, *Zen in Westlicher Sicht,*" 126.
112. Heard, "On Learning from Buddha."
113. Becker, "Zen Buddhism."
114. Becker, *Zen: A Rational Critique,* 13, 14.
115. Hu, "Ch'an"; and Suzuki, "Zen: A Reply to Hu Shih." See also Faure, *Chan Insights,* 89–92.
116. Hu, "Ch'an," 4, quoting from Suzuki, *Essays in Zen Buddhism* (First Series), 189. See also Maraldo, "Is There Historical Consciousness within Ch'an?" On Suzuki's Zen as being "apart from its historical setting," see Jaffe, "Introduction," xiv.
117. Suzuki, "Zen: A Reply to Hu Shih," 25, 26, 31, 34, 39 (italics in original).
118. Suzuki, Review of Heinrich Dumoulin, S.J., *A History of Zen Buddhism,* 124.
119. Hisamatsu, "On Zen Art," 32.
120. Suzuki, "A Reply," 56; Suzuki, "Zen: A Reply to Van Meter Ames," 349; Jaffe, "Introduction," xxxvi, liii.
121. Suzuki, "A Recommendation for Quiet Sitting" (1900), in Suzuki, *Selected Works,* 2. On the Hu and Suzuki perspectives, see Wright, *Philosophical Meditations,* ix–x.
122. Hu had supporters, including Dumoulin.
123. Suzuki, "Zen: A Reply to Hu Shih," 41.
124. In another turn to history, Suzuki noted that Heinrich Dumoulin had failed to consider texts identified at Dunhuang that allowed scholars to trace "to an even greater extent than before the course of development Zen thought took from the 6th to 8th centuries." Suzuki, "Review of Heinrich Dumoulin, S.J., *A History of Zen Buddhism,*" 123.
125. Sargeant, "Profiles," 48–49.

126. For spontaneous awakening, see Courtois, *An American Woman's Experience;* Ikemoto, "Zen Enlightenment."

127. Mahoney, "The Prevalence of Zen," 312. On *zazen* perceived as difficult, see Reader, "Zazenless Zen?"

128. Suzuki, "Zen: A Reply to Hu Shih," 30.

129. Fader, "Arthur Koestler's Critique."

130. Koestler, "A Stink of Zen." "To remain caught up in ideas and words about Zen is, as the old masters say, to 'stink of Zen.'" Watts, *The Way of Zen,* 127.

131. Suzuki, "A Reply from D. T. Suzuki," 58; Koestler, "Neither Lotus nor Robot," 59; Humphreys, "No Stink of Zen."

132. Werblowsky, "Some Observations," 323–326.

133. Grimshaw, "Encountering Religion," 32, 33–34, 35.

134. In his introduction to *Zen Buddhism: Selected Writings of D. T. Suzuki* (1956), Barrett stuck with a transcendentalist view of Zen. See Barrett, "Zen for the West." On this point I thank Richard M. Jaffe.

135. Grimshaw, "Encountering Religion," 34, 50, 51.

136. Senzaki and McCandless, *The Iron Flute,* 126.

137. Stirling, *Zen Pioneer,* 162.

138. R. F. Sasaki, "Letter[s] from Kyoto," Dec. 26, 1957.

139. Sterling, *Zen Pioneer,* 185.

140. See Leggett, *A First Zen Reader,* 215–236.

141. Enen, "Zen in New York."

142. Note, too, the Sōtō Zen teacher Jiyu Kennett, who challenged philosophical Zen and envisioned a Western Zen. See Kennett, *Zen Is Eternal Life,* xxxi, 22.

143. Huston Smith, "Foreword," and Kapleau, "Editor's Preface," Kapleau, *The Three Pillars of Zen,* xiv, xvi.

144. Kapleau, *The Three Pillars of Zen,* xv–xvi.

145. Ibid., xviii.

146. Kapleau notes the scarcity of qualified Zen masters and lack of concrete information on meditation; ibid., xviii, xvi, 3.

147. Kapleau, "Report from a Zen Monastery," 77.

148. Kapleau, *The Three Pillars of Zen,* 4.

149. Ibid., 90–91.

150. Sanbōkyōdan's impact in the West, according to Sharf, "has been far out of proportion to its relatively marginal status in Japan." Sharf, "Sanbōkyōdan," 417.

151. Kapleau, *The Three Pillars of Zen,* 199.

152. Ogata's publications in English include *A Guide to Zen Practice* (1934) and *Zen for the West* (1959).

153. Ogata, Review of Alan Watts, *The Way of Zen,* 116.

154. Watts, who abandoned study with Sōkei-an after an argument, later wrote: "It is believed in some circles that I have seriously misrepresented Zen by failing to bring out, and indeed even questioning, the importance of the discipline of *za-zen.*" Furlong, *Genuine Fake,* 69–70; Watts, *In My Own Way,* 261; Pope, "Contributions," 191–192.

155. Watts, *In My Own Way,* 347.

156. See Humphreys, *Zen Buddhism,* 194–195, 197, 211.

157. Humphreys, "Zen Comes West," 126.

158. Ibid., 128.

159. Ibid., 126, 128.

160. See ibid., 130.

161. Ibid., 129.
162. Ibid., 130.
163. Humphreys, *Sixty Years of Buddhism,* 78–79.
164. See Masunaga, *The Sōtō Approach to Zen* (1958); *Zen beyond Zen* (1960); *Zen for Daily Living* (1964); and *A Primer of Sōtō Zen* (1971).
165. Masunaga, "Review of Ogata, *Zen for the West.*"
166. Masunaga, "Zen of Vital Freedom," 7.
167. See Low, "Seung Sahn."
168. On the past as a pool of resources, see Chakrabarty, *Provincializing Europe,* 246.
169. Debates now often center on how Zen can be inclusive and respond to homelessness, inadequate medical care, and anthropogenic destruction.
170. Snyder, *The Real Work,* 153.

CHAPTER 6: ZEN INFLUENCE, INHERENCE, AND DENIAL

1. Cage, *Silence,* xi.
2. Pritchett, "What Silence Taught John Cage."
3. Tobey spent a month in the "Foreigner's Mediation Hall" at Enpukuji, and Williams resided at a Sōtō temple for two months in 1976. Brill, *Shock and the Senseless,* 125; Winther-Tamaki, "Asian Dimensions," 147.
4. Rosenberg, "Painting Is a Way of Life," 126.
5. Gutai Dadaism is praised for its "extremely Zen quality" in Haga, "The Japanese Point of View," in Tapié and Haga, *Avant-garde Art in Japan,* n.p.
6. Keating, *Zen There Was Murder,* 74.
7. Harrison, "Recitals"; Schonfeld, "Indeterminate Cage."
8. Watts, *This Is It,* 94.
9. See Ruth Fuller Sasaki's criticism of the "art-ification" of Zen, noted in Chapter 5.
10. On Zen as a means for Cage to express Zen philosophical ontological ideas through music, see Larson, *Where the Heart Beats,* 207, 277.
11. Hellstein, "The Cage-iness of Abstract Expressionism," 62–63.
12. See Chapter 4.
13. Waley, *Zen Buddhism,* 7.
14. Sargeant, "Profiles," 74.
15. Ames, "Current Western Interest in Zen," 29.
16. For caution regarding Zen influence, see McCormick et al., "Exhibition as Proposition."
17. My wording borrows from Jameson, *Postmodernism,* 298–299.
18. Baxandall, *Patterns of Intention,* 58–62. See also Mitter, *The Triumph of Modernism,* 8.
19. Guth, *Hokusai's Great Wave,* 9.
20. Elkins, *On the Strange Place of Religion,* 80, 82.
21. Larson, *Where the Heart Beats,* 79; Crooks, "John Cage's Entanglement," 105–107. Cage was not the first music-world figure to discover Zen. The conductor Sergiu Celibidache (1912–1996) was drawn to Zen in 1940s Berlin.
22. *Huangboshan Duanji chanshi chuanxin fayao, T* 2012a.48.379–384; Huang Po, *The Huang Po Doctrine of Universal Mind,* trans. Blofeld. In his composition *Indeterminancy,* Cage read anecdotes and Zen stories. See also Larson, *Where the Heart Beats,* 196–202, 255–257; Addiss and Kass, *John Cage.*
23. For Cage's references to Zen and Suzuki, see *Silence,* ix, xi, 6, 32, 40, 67, 70, 88, 93, 143, 161, 193, 260, 262, 266, 272. See also Crooks, "John Cage's Entanglement," 114–115; Larson, *Where the Heart Beats,* 219–224, 235–236.

24. "Lecture on Something" (published in *It is,* 1959), in Cage, *Silence,* 143.

25. Cage, *Silence,* ix.

26. Higgins, *Fluxus Experience,* 85.

27. Larson, *Where the Heart Beats,* 153, 284.

28. See Pritchett, *The Music of John Cage,* 59–60. Pritchett makes no mention of Zen in "What Silence Taught John Cage" and "Five Statements on Silence by John Cage." Scholars and critics of postwar avant-garde art may shun comment on Zen when it might otherwise (for some) be expected. See, for instance, discussions of Nam June Paik's *Zen for Head* and *Zen for Film* in Armstrong, "Fluxus and the Museum" and Jenkins, "Fluxfilms."

29. Patterson, "Cage and Asia," 62–64. On exaggeration of the artist's study of Zen, see Crooks, "John Cage's Entanglement," 174, 255.

30. In 1961 Cage listed ten books important to his thought and work, the sixth being Huangbo's text; Suzuki's books did not appear. John Cage, "List No. 2," in *John Cage,* ed. Kostelanetz, 139. On Huangbo's text and Suzuki's "speculative" relationship to Cage, see Patterson, "Cage and Asia," 65–66.

31. In hindsight, *The Huang Po Doctrine of Universal Mind* (1947) seems like a good choice for the acquisition of concepts, rhetoric, and for the affect of auratic Zen ideas. On Blofeld's response to Huang Po's limited comment on meditation, see Wright, *Philosophical Meditations,* 208.

32. A "clear distinction must be made," Patterson argues, between "influences [from Asia, on Cage] that are purely musical and those that are philosophical." Patterson, "Cage and Asia," 49.

33. Cage, *A Year from Monday,* 11.

34. Crooks, "John Cage's Entanglement," 31–32, 264.

35. The composer and musicologist Peter Dickinson shifted the balance somewhat, suggesting that Cage "*lets* Zen influence" (italics mine). Dickinson, "Noise and Silence," 1026.

36. Pritchett, *The Music of John Cage,* 74.

37. These appropriations distributed into different aspects of Cage's work; Zen served his music conceptually, the *Yijing* technically. Patterson, "Cage and Asia," 51.

38. Patterson, "Cage and Asia," 60, 61, 69. See also Haskins, *John Cage,* 58; Jensen, "John Cage," 97.

39. Crooks, "John Cage's Entanglement," 275.

40. Tiampo, *Gutai,* 8.

41. Huyssen, "Back to the Future," 149.

42. Crooks, "John Cage's Entanglements," 283.

43. Lee and Rennert, *Nam June Paik,* 119.

44. Munroe, "Buddhism," 199. For concern regarding the invocation of mediation, see McCormick et al., "Exhibition as Proposition," 38.

45. Koestler, "Neither Lotus nor Robot," 58.

46. Munroe, "Buddhism," 200.

47. Mediation (mediacy/immediacy) has a specific history in Chan discourse. See Faure, *The Rhetoric of Immediacy,* 4.

48. Munroe, "Buddhism," 202.

49. See ibid., 207. Munroe fails to acknowledge adequately the scholars Bernard Faure, T. Griffith Foulk, and Robert H. Sharf.

50. Cage and Retallack, *Musicage,* xl. Munroe reinforces this view in "Buddhism," 201. See also Dickinson, "Noise and Silence," 1027; Roth, *Difference/Indifferent,* 66.

51. Note, for instance: "Cage took refuge in Zen that, through him, was transmitted

to [Merce] Cunningham," in Dickinson, *Cage Talk,* 20. For critique of the "master-student" view, see Crooks, "John Cage's Entanglement," 253.

52. Dickinson, *Cage Talk,* 31–32.

53. On Fluxus having a more direct connection to Cage than to Zen, see Brill, *Shock and the Senseless,* 126.

54. Gary Snyder has also been referred to as a Zen master. See Werblowski, "Some Observations," 317n3; Goodyear, "Zen Master."

55. On the Asian monk or monkish figure, see Iwamura, *Virtual Orientalism.*

56. On the refusal or failure of European and North American critics to recognize artists such as Isamu Noguchi for seizing control of their relationships to Asian cultures and creating hybrid identities, see Lyford, *Isamu Noguchi's Modernism,* 191.

57. Mitter, *The Triumph of Modernism,* 7.

58. T.B.H., "Reviews and Previews," quoted in Tiampo, *Gutai,* 107.

59. See Tiampo, "'Under Each Other's Spell.'"

60. See Adachi, "Avant-garde Debates."

61. Hockley, "The Zenning of Shikō Munakata," 77, 79.

62. Ibid., 85.

63. See Tiampo, *Gutai,* 111.

64. That the *Gutai Art Manifesto,* written by Yoshihara Jirō, makes no reference to Zen is suggestive of another aspect of parallax in postwar art criticism (in which American critics often found Zen in Gutai). Note, too, the reception of work in the first Gutai exhibition in Japan (1955), when Japanese critics and audiences sought to make sense of the group's emerging "international contemporaneity" (J. *kokusaiteki dōjisei*) rather than the Zen-ness of its works. See Yoshihara, "Gutai bijutsu sengen"; Tomii, "'International Contemporaneity' in the 1960s"; Tomii, "Gutai's Phase Zero." On parallax and ethnic stereotype, see also Lyford, *Isamu Noguchi's Modernism,* 184–191, chap. 6; Winther-Tamaki, *Art in the Encounter of Nations,* 22; and Kuwabara, "Surechigai no taiwa," 40–48.

65. Danto, "Art," *The Nation,* Jan. 2, 1995, 26. Danto wrote on the occasion of the exhibition, *Japanese Art after 1945: Scream against the Sky* (Guggenheim Museum, New York).

66. C. F. Yamada, *Dialogue in Art,* 269.

67. Austin Salzwedel brought this concept to my attention.

68. For interpoetic, see Tiampo, *Gutai,* 5–6. See also Levin, "Action Painting," 119.

69. Tweed, "Buddhism, Art, and Transcultural Collage," 195.

70. Ibid., 203, 213.

71. Grimes, "Zen and the Art," 158.

72. Doris, "Zen Vaudeville," 126.

73. On "inherent Zen in Japan," see Westgeest, *Zen in the Fifties,* 198–200.

74. Tiampo, *Gutai,* 93. For French art and Zen, see Westgeest, *Zen in the Fifties.*

75. Such cropping (material, visual, textual, and epistemological) may "liberate" the painting from what are, for most postwar viewers (in Japan and elsewhere), inaccessible texts and allow the scroll to be seen as *painting* (in tension with premodern East Asian visual-textual cultures). For the scroll in its fifteenth-century context, see Lippit, "Of Modes and Manners."

76. Sitwell, *The Bridge of the Brocade Sash,* 198.

77. See Nōshōmushō Hakurankai-gakari, *Dai nikai Kaiga Kyōshinkai koga shuppin mokuroku,* 29; Shimao, "Kenkyū shiryō," 50. English-language publications up to 1962 that reproduce or discuss the painting include Terry,

Masterworks of Japanese Art, 90; Watts, *The Way of Zen,* facing page 191; Ross, *The World of Zen,* 337; Hasumi, *Zen in Japanese Art,* 60.

78. Shimao, "Sesshūga denrai shiryō," 47–48. See also Satō, *Modern Japanese Art,* chap. 4.

79. Haga, "The Japanese Point of View," in Tapié and Haga, *Avant-garde Art in Japan,* n.p.

80. Tiampo, *Gutai,* 94.

81. For Tapié's rejection of derivativeness, see Tiampo, *Gutai,* 138–139. For inverse orientalism, see Borup, "Zen and the Art of Inverting Orientalism."

82. Braque's interest in Zen is noted in Kawakita, "Burakku to Tōyō." I thank Kristopher Kersey for this reference. Braque illustrated *Le tir à l'arc* (1960), a selection of excerpts from the French translation of Herrigel's *Zen in der Kunst des Bogenschiessens* (1948) with an introduction by Suzuki. See Danchev, *Georges Braque,* 16, 100–101; and Richardson, *G. Braque,* 24. See also Franz Kline's denial of the influence of Asian calligraphy, discussed in Winther-Tamaki, *Art in the Encounter of Nations,* 45; Danto, "Art," *The Nation,* Feb. 2, 1995, 288.

83. Jaffe, "Introduction," xli.

84. This recalls the possibly apocryphal episode in which Martin Heidegger, having been asked about reading one of Suzuki's books, responded, "If I understand this man correctly, this is what I have been trying to say in all my writings." Barrett, "Zen for the West," xi.

85. See Winther-Tamaki, "The Asian Dimensions" and *Art in the Encounter of Nations,* 56–62.

86. Yoshihara Jirō, *White Circle on Black,* oil on canvas, 182.0 x 227.5 cm, The National Museum of Modern Art, Tokyo (000524).

87. Yoshihara Shin'ichirō, comment passed on to me by Iketani Shin'ichirō, Nihon Bijutsuka Renmei, e-mail correspondence, Tokyo, Jan. 26, 2016.

88. Tomii, "Two Legacies." See also Haito, "'En' to sono ato," 187.

89. On the importance of calligraphy to Yoshihara's work, see Osaki, "Yoshihara Jirō to sho."

90. Yoshihara, "Koten no tame no bunshō," reprinted in Ashiya Shiritsu Bijutsukan, *Botsugo 20 nen Yoshihara Jirō ten,* 205; translation adapted from Tomii, "Two Legacies."

91. Yoshihara, "Gutai bijutsu sengen," trans. Tomii.

92. Haito, "'En' to sono ato," 187.

93. Tiampo, *Gutai,* 80.

94. Tomii, "Two Legacies." Three of Yoshihara's circle works appeared in New York in 1966 as part of the 1st Japan Art Festival, a quasi-governmental, commercial exhibition installed in a space designed by the architect Tange Kenzō (1913–2005) inside the "rather un-oriental steel and glass" Union Carbide Building. The festival, which did not receive uniformly glowing reviews, was one of multiple events during the 1960s through which the Japanese avant-garde sought to garner international attention. See Glueck, "Japan Art Fete Opens"; Canaday, "Nice Try"; Kawakita, *The 1st Japan Art Festival,* 4–9.

95. Quoted in Geist, "Buddhism in *Tokyo Story,*" in *Ozu's Tokyo Story,* ed. Desser, 102. Yoshida Kiyu challenges the view that Ozu's films are "extremely Japanese," arguing that his intention was to examine "the true nature of what cinematic expression should be." Yoshida, *Ozu's Anti-Cinema,* 21. For the discovery of latent or subliminal Buddhism in film, see Sluyter, *Cinema Nirvana,* and Rios, *The Road to Whatever.*

96. After the war, Hayakawa was ordained a Zen priest. Hayakawa, *Zen Showed Me the Way* (adapted from *Hayakawa Sesshū: Musha shugyō sekai o yuku,* 1959), 136, 235.
97. Schrader, *Transcendental Style,* 28–29, 38.
98. I build here from Mitsuhiro Yoshimoto, *Kurosawa,* 10–16, 74.
99. Suh, *Silver Screen Buddha,* 20–23.
100. *Wu* is more typically translated by scholars of Buddhism as "nonbeing," "nonexistent," and "nothingness" signifying early Chinese Buddhist conceptions of a "preconceptual reality that transcended dichotomous existence." *PDB,* 998–999.
101. Geist, "Buddhism in *Tokyo Story,*" 101, 110, 114, 115.
102. Bordwell, *Ozu,* 27, 28.
103. Atkinson, "*Late Spring.*" We should unpack the notion of a Zen-infused sensibility and learn how it formed.
104. Atkinson, "*Late Spring.*"
105. Desser, *Ozu's Tokyo Story,* 5, 23.
106. Geist, "Buddhism in *Tokyo Story,*" 102. Geist is not the only critic to cite Watts. See Schrader, *Transcendental Style,* 27–29, 33–34; Anderson, "Two Inches," 149, 150. For use of "Zen-like," see also Danto, "Art," *The Nation,* Feb. 27, 1995, 284.
107. Chan/Sŏn/Zen masters may purposively destabilize meaning and refuse the terms of discourse, but they may present teachings without the sort of denial-as-reveal that Geist reductively treats as Zen.
108. Karatani, "Uses of Aesthetics," 146.
109. "Art: Pictures of the Soul."
110. Munroe, "Buddhism," 200.
111. Roth, *Difference/Indifference,* 75.
112. Ibid., 75.
113. C. F. Yamada, *Dialogue in Art,* 305.
114. On Tobey's skepticism regarding Zen and American artists and his resistance to Asia's influence, see Winther-Tamaki, *Art in the Encounter of Nations,* 51.
115. Jarrell, *Pictures from an Institution,* 175.

CHAPTER 7: WHAT'S SO FUNNY?

1. Hofstadter, *Gödel, Escher, Bach,* 237.
2. M. Beard, *Laughter in Ancient Rome,* ix.
3. Gallagher and Greenblatt, *Practicing New Historicism,* 26.
4. Yasuda, "Zen and Culture."
5. Gallagher and Greenblatt, *Practicing New Historicism,* 26, 49, 67; Critchley, *On Humour,* 65.
6. See the "Zen manga" of Okamoto Ippei (1886–1948) in Okamoto Ippei, *Ippei zenshū;* Nishimura and Satō, *Unsui;* Salajan, *Zen Comics I, II;* Groenig, "She of Little Faith"; Melby et al., *The Zen of Steve Jobs;* Wang and Guo, *The Patriarch of Chan;* and Tokō, *Bōzu days,* discussed in Porcu, "Down-to-Earth Zen." Note illustrations—drawn by the monk Satō Zenchū and not intended for humor—accompanying Shimada Shunpo, *Zendō seikatsu* (1914).
7. Suzuki began writing about Sengai in the 1930s, "valorizing Sengai's humor, free-spiritedness, and independence"; Jaffe, "Introduction," xxxiv. The Zen scholar Furuta Shōkin (1911–2001) files Sengai's painting of *Danxia Burns a Buddha* under "Humor in Zen"; Furuta, *Sengai,* 28. For interpretation of

Sengai's paintings as "witty and droll" but evoking Zen nonduality and freedom, see Idemitsu Bijutsukan, *Tanjō 260 nen, Sengai.*

8. Yoshizawa, "The Interest in Hakuin's Art"; Yoshizawa, *Hakuin,* 266; Yoshizawa, *The Religious Art of Zen Master Hakuin,* 44.

9. Yoshizawa, *The Religious Art of Zen Master Hakuin,* 189; Aviman, *Zen Paintings.*

10. The magazine's circulation in 2015 was over 1 million copies with an audience of nearly 4.5 million people, most of them middle- to upper-class, over the age of forty, college-educated, and politically liberal to progressive; *The New Yorker,* "Media Kit." On race and representation, see Thibodeau, "From Racism to Tokenism," and J. Y. Lee, *Defining* New Yorker *Humor,* 215–219.

11. See Enen, "Zen in New York"; Briggs, "Have Zabuton." Hisamatsu Shin'ichi took note of Zen cartoons in 1958. See Suzuki and Hisamatsu, "Taidan," 17.

12. Orientalist approximations imply a dominant audience for whom signs of otherness generate a "believable" context for humor.

13. A cartoon by Harley Schwadron plays off the koan "What is your original face before your parents conceived you?" *Tricycle* magazine, *Buddha Laughing,* 26. For "Original face" (Ch. *benlai mianmu;* J. *honrai no menmoku*), see *PDB,* 104.

14. See also Ed Subitsky, "Zen Vacuum Cleaner (no attachments)," in *Tricycle* magazine, *Buddha Laughing,* 30.

15. Piraro, "The Sound of One Hand Inking."

16. On representation of the Oriental Monk, see Iwamura, *Virtual Orientalism,* chap. 4; Suh, *Silver Screen Buddha.*

17. Hakuin's koan (*Sekishu onjō*) has been known in the West since at least the early twentieth century. See Saunders, *Buddhism in the Modern World,* 65.

18. Piraro, "The Sound of One Hand Inking." Italics in original.

19. Fisher, *The New Yorker,* July 5, 1982.

20. See Chira, "Kamakura Journal."

21. Frank Modell, in *Tricycle* magazine, *Buddha Laughing,* 73.

22. See Williams, *The Buddha in the Machine,* 174–198, 229–237. Prior to Pirsig's title, there was Herrigel, *Zen in the Art of Archery* (1953) (*Zen in der kunst des bogen-schiessens,* 1948), and Bradbury, "Zen in the Art of Writing" (1958).

23. See also Roz Chast, "The Zen of Finance," in *Buddha Laughing,* ed. *Tricycle* magazine, 16.

24. *The New Yorker,* Jan. 26, 2009.

25. Parisi, *Zen cartoon, #2008–03–04.*

26. Paul Noth, *The New Yorker,* April 27, 2009; Coverly, "Speed Bump."

27. Parisi, *Zen cartoon, #2013–05–28.* For the Zen Cat trope, see Beard and Barrett, *Zen for Cats.*

28. Jorodo, "Zen clinic."

29. See Yamada, *Shots in the Dark.*

30. Pie also appears in Piraro, "Zen Crossword Puzzle" (fig. 25).

31. I thank Yamada Shōji for sending me this cartoon.

32. See *Wumenguan,* Case 21, in *Three Chan Classics,* ed. Numata Center, 87.

33. Emphasis on Zen awakening centered in the everyday mundane is evident in the writings of D. T. Suzuki. See Jaffe, "Introduction," xliv. For critique, see Sharf, "Whose Zen?" 50.

34. See Salajan, *Zen Comics I, II; Tricycle* magazine, ed., *Buddha Laughing;* Moon, *The Life and Letters of Tofu Roshi.*

35. By case I refer to koan (Ch. *gong'an*). See Sharf, "How to Think with Chan Gong'an"; Heine and Wright, eds., *The Koan.*

36. Of 35,000 adult Americans interviewed for the 2014 Pew Forum on Religion and Public Life U.S. Religions Landscape Survey, 0.7% self-identified as Buddhist, 30% as Baby Boomer generation, 44% as white; Pew Forum on Religion and Public Life, Religions Landscape Survey, 2014.
37. Clarke, "Locating Humor," 328.
38. On Buddhism's modern "Protestantization" (a term coined by Gananath Obeyesekere), neo-Buddhism, and Secular Buddhism, see McMahan, *The Making of Buddhist Modernism*, 70; Faure, *Unmasking Buddhism;* and Batchelor, "A Secular Buddhism." For the modern conception of Zen awakening as intuited experience, see Sharf, "Experience," and "Buddhist Modernism"; Shields, *Critical Buddhism,* chap. 3. On the Buddhist ingredients of the "American concoction of meditation," see Leigh Schmidt, *Restless Souls.* The slide of Zen from practice to attitude seems to coincide with the shift from the consumption of commodity to the consumption of brand. See Klein, *No Logo.*
39. W. I. Cohen, *Ethics in Thought and Action,* 138.
40. On stress induction (not reduction), see Lopez, "The Scientific Buddha."
41. Characterizations of Buddhism as humorous appear in Western writings from at least the early twentieth century. See O. Edwards, *Japanese Plays,* 164.
42. Nine Network, "I Wakeup with Today," June 9, 2011.
43. The setup may originate in Palmer, "The Consummately Dry Martini."
44. Seven and Dorrian, "Buddha Jokes."
45. On shared social worlds and the cultural specificity of laughter, see Critchley, *On Humour,* 4; M. Beard, *Laughter in Ancient Rome.*
46. Although the newscaster's presumption strikes me as disrespectful, the Dalai Lama may be a partial cocreator given his global efforts to rearticulate Buddhism with nontechnical keywords and short-form narratives.
47. See Kristof, "The Dalai Lama Gets Mischievous"; Whalen-Bridge, "Angry Monk Syndrome."
48. M. Beard, *Laughter in Ancient Rome,* 37.
49. See Lewis, *Cracking Up,* 155, 156, 159; Gilhus, *Laughing Gods,* 139; Raskin, *The Primer of Humor Research,* 1.
50. See Hyers, *Holy Laughter.*
51. M. Beard, *Laughter in Ancient Rome,* x.
52. Gombrich, *How Buddhism Began,* 80. I thank Richard Jaffe for this reference. Hinüber, "Everyday Life," 29; Schopen, "The Learned Monk," 203, 224; M. Beard, *Laughter in Ancient Rome,* chap. 3.
53. See Schopen, "The Learned Monk"; Clarke, "Locating Humor," 311–313.
54. Faure, *Double Exposure,* 143–149; Lopez, "The Scientific Buddha"; Faure, "A Grey Matter."
55. See American World War II representations of the "evil Jap," General Tōjō Hideki (1884–1948).
56. See Thibodeau, "From Racism to Tokenism." On the "Ethicity and Ethnicity of Humour," see Critchley, *On Humour,* chap. 5.
57. See Keane, "Cartoon Violence"; Carvajal and Daley, "Proud to Offend."
58. Piraro, "Pulling Your Legume."
59. Note protest against Philippe Caland, dir., *Hollywood Buddha* (2003) and the "Buddha Bikini Scandal" (2004). "'Degrading' Film Angers Buddhists"; Shields, "Sexuality."
60. Iwamura, *Virtual Orientalism,* 50.
61. See McMahan, *The Making of Buddhist Modernism,* chap. 5.
62. Berowitz, "The Importance of a Sense of Humor."
63. Suh, *Silver Screen Buddha,* 62.

64. See ibid., Introduction, Chapter 3.
65. Bridges and Glassman, *The Dude and the Zen Master;* Bridges, "Saying What Can't Be Said"; Comentale and Jaffe, *The Year's Work,* 1, 20, 273, 357.
66. Suh, *Silver Screen Buddha,* 3, 64.
67. "Slovenly apathetic" was suggested to me by Namiko Kunimoto.
68. Bridges and Glassman, *The Dude and the Zen Master,* 1.
69. "Dudeism"; Suh, *Silver Screen Buddha,* 66.
70. Bridges and Glassman, *The Dude and the Zen Master,* 94.
71. Frank, "Astrophysicist and Zen Practitioner."
72. Austin Gallaher, comment posted to Frank, " Book Review: 'The Dude and the Zen Master.'"
73. See Chapters 5 and 6. I thank Richard M. Jaffe for his comment on authenticity.
74. In the orthodox Buddhist sense, existence as subject to rebirth (Skt. *saṃsāra*). Garfinkle, "And If He Sees His Shadow. . . ."
75. This "pantheon"—a term I use loosely to accommodate the breadth of representations in modern-contemporary Buddhisms—overlaps with that of monastic and devotional Buddhist contexts but lacks deities, such as Śākyamuni and the bodhisattva Manjuśri (the latter enshrined in Zen meditation halls).
76. Iwamura, *Virtual Orientalism,* 20, 136. Full discussion of the Happy or Laughing Buddha is not possible here, but the rotund, jovial figure—religious icon, pop-culture Asian kitsch, and originally the thaumaturge Budai (J. Hotei, literally "Cloth Sack"), a tenth-century Chan Buddhist monk known for bizarre and wonder-working behaviors and identified as an avatar of the Future Buddha Maitreya (Ch. Mile)—has contributed to the stereotype of good-natured or humorous Buddhism. Budai's identification in English as the Laughing Buddha can be traced to at least the early twentieth century; see Stewart, *The Laughing Buddha* (1925). The modern overdetermination of Buddhism's smiling, humorous identity—as located in Budai as well as the Dalai Lama (the two most-well known "faces of Buddhism," especially in the West)—is symptomatic of the West's "flirting with the East." As Invild S. Gilhus might put it, the ebullient, Laughing Buddha embodies "a new type of religious ideal in today's Western world"—and perhaps in parts of Asia as well; Gilhus, *Laughing Gods,* 122–125. Arguably, the Laughing Buddha, as a Western "truth" of Buddhism and Asia, primes our expectations for how a Buddhist figure should appear, adumbrating the modern shift of Buddhist figures from supernatural or awesome deities to humanistic, earthly teacher-cum-philosopher-cum-counterculture beings and the sort of characters who tell and laugh at jokes as behaviors primary to Buddhism. We have Zen cartoons in some small way because of the appeal of the Laughing Buddha.
77. Watts, "Buddhism and Humour," 92, 93, 94.
78. *Tricycle* magazine, *Buddha Laughing.*
79. See Jerryson and Juergensmeyer, *Buddhist Warfare;* Faure, *Unmasking Buddhism,* 93–99.
80. On "childlike" Japan, see Guth, "Hasegawa's Fairy Tales."
81. Perhaps Japanese Zen campaigners were familiar with Sigmund Freud's (1856–1939) *Jokes and Their Relation to the Unconscious* (1905). On Buddhist humor, orientalism, and psychoanalysis, I thank Noriko Murai.
82. Garfinkle, "And If He Sees His Shadow. . . ."
83. On the possibilities of Buddhist film, see Suh, *Silver Screen Buddha.*
84. Blyth, *Oriental Humour,* 87.

85. Ross, *The World of Zen,* 183.
86. Blyth, *Oriental Humour,* 90.
87. Ibid., 89.
88. Ross, *The World of Zen,* 184.
89. Hyers, "Humor in Zen," 270.
90. Klein, "Zen Humor."
91. "Zen Humor," *Lots of Jokes.*
92. See Clarke, "Locating Humor," 312. For a claim for Zen's particular disposition toward humor, see Clasquin, "Real Buddhas Don't Laugh."
93. Hyers is quoted in, for instance, Clasquin, "Real Buddhas Don't Laugh," 99; Doris, "Zen Vaudeville," 121.
94. Hyers, *The Laughing Buddha,* 15.
95. Ibid., 14 (italics in original).
96. Ibid., 14–15.
97. Ibid., 39.
98. Ibid., 24–25. For the origin story, see Welter, "Mahākāśyapa's Smile."
99. His interpretation—Zen is humorous; Zen begins in Mahākāśyapa's smile; the smile embodies Zen comedic urge, etc.—resembles a Möbius strip.
100. Hyers, *The Laughing Buddha,* 23.
101. His authorities include D. T. Suzuki, R. H. Blyth, Heinrich Dumoulin, Ogata Sōhaku, Alan Watts, George Rowley, Hugo Munsterberg, and Nyogen Senzaki.
102. For the Hu-Suzuki debate, see Chapter 5. On "invention of tradition" and Japan, see Vlastos, *Mirror of Modernity.*
103. Lopez, *A Modern Buddhist Bible.*
104. By mid-century, books and articles written by non-monastic or lay authors and based on modern Japanese explanations of Zen and Buddhism were a normative genre.
105. See Hyers, *The Laughing Buddha,* 9.
106. For Hyers' informants in Japan, see ibid., 10.
107. Ibid., 15.
108. Ibid., 16, 17. In modern-contemporary explanations of Buddhism, nearly anything, it seems, can be *upāya,* especially in service to interpretation.
109. See Chapter 3; Suh, *Silver Screen Buddha,* 61–66.
110. I thank Noriko Murai for suggesting "yuppy" and "postmodern Beat" categories of Zen humor.
111. C. Klein, *Cold War Orientalism,* 6.
112. Certain Zen cartoons re-inflect existing stereotypes and suggest white appropriation of the Zen other for the purpose of self-referential humor (though some might object that such cartoons simply address the "human condition").
113. See Thibodeau, "From Racism to Tokenism," 490.
114. Gahan Wilson, personal communication by e-mail, March 8, 2009.
115. From Michel Foucault, "The Life of Infamous Men" (1979), quoted in Gallagher and Greenblatt, *Practicing New Historicism,* 66.

CHAPTER 8: ZEN SELLS

1. Whalen, "1957–1977," 3.
2. Senzaki and McCandless, *Buddhism and Zen,* 6. McCandless studied with Sōen at Ryūtakuji and was an editor and translator for Senzaki.
3. Note monastic pursuit of Imperial Robes (Ch. Ziyi; J. Shi'e) and State Preceptor (Ch. Guoshi; J. Kokushi) titles. See Kieschnick, *The Impact of Buddhism,* 100–103.

4. Farkas, "Let's Not Get Carried Away."

5. Merchants located in the "town outside the temple gate" (J. *monzenmachi*) in Japan have long used their location and the temple name to sell goods and services to pilgrims and tourists.

6. Irizarry, "Putting a Price on Zen," 63.

7. Oliver, "Fuck Buddhism!"

8. Sperry, *The Worst Horse;* Stein, "Zen Sells."

9. Purser and Milillo, "Mindfulness Revisited," 15, 16; Purser and Loy, "Beyond McMindfulness."

10. Jain, *Selling Yoga,* ix.

11. On time lag, see MacKenzie, *Orientalism,* xiv.

12. Gift, barter, and sharing economies also employ Zen principles.

13. Rochester Zen Center, "Shirts and Swag." See the online stores of The Zen Center of Los Angeles, Yokoji Zen Mountain Center, and Sonoma Mountain Zen Center. Zen temples and centers also hold silent auctions and other benefit events.

14. Žižek, *The Puppet,* 26; Williams, *The Buddha in the Machine,* 197–198.

15. Ritzer, *The McDonaldization of Society.*

16. Fisher-Price, "Fisher-Price Zen Collection."

17. Thanks to Richard M. Jaffe for Urakasumi.

18. AraChN!D, "Zen Shopping."

19. Rocha, *Zen in Brazil,* 127–128.

20. Zen Lifestyle Trend Megastore, "ZEN."

21. "Zen at CentralWorld Bangkok."

22. Zen Lifestyle Trend Megastore, "ZEN"; "Zen Department Store."

23. For conformist individuality, see Niedzviecki, *I'm Special.*

24. See Langford, *Fluent Bodies,* 263–264; Carrette and King, *Selling Spirituality,* chap. 3.

25. Wilson, *Mindful America,* 136–137.

26. Enen, "Zen in New York."

27. Mashing up Zen and the cliché of "x is the new y," another retailer exclaims, "Vapor is the New Zen." See "Zen Ecig"; "eCig Zen."

28. "For the Gourmet."

29. Farkas, "Let's Not Get Carried Away." On Sakurazawa, see Brandt, "You Are All Sanpaku."

30. Shiseidō, "Classic Zen Eau de Cologne."

31. See Macy's Department Store, "Uncommon Scents" and "Macy's Far East Festival"; "Americans Translate Japan into a Perfume"; "Shiseidō Zen Perfume."

32. Macy's Department Store, "Gifts of Beauty from the Exotic East."

33. Shiseidō's copy refers to the flacon's contemporary rendering of Kōdaiji-style lacquer and the fragrance's expression of Japanese tradition and Oriental mystery. Shisedō, "Zen."

34. Later the packaging shifted to more modernist design.

35. Herman, "Yesterday's Perfumes."

36. See also Herman's description of Bulgari's 1992 *Au Thé Vert au Parfumée.* Herman, *Scent and Subversion,* 216–217.

37. Zen centers request that participants be fragrance free. The eighth of the Ten Precepts (J. *jikkai*) for Buddhist novices stipulates, "not adorning oneself with garlands, perfumes and ointments." See "Jikkai."

38. Muething, "The Zen Origins."

39. Phillips, "Exclusive."

40. Protests were organized in 2012 against California-based Icon Shoes.
41. Formal walking meditation (J. *kinhin*) does not require running shoes. Vanessa Zuisei Goddard, of the Mountains and Rivers Order of Zen Buddhism, leads "Running as Meditation" retreats.
42. Chinelasone, Pal Desert, CA, April 7, 2013, posted on Nike, "Nikeid Nike Roshe Run One Men's Shoe."
43. Sperry, "Nike's New Zen Sneaker." The sneaker is apparently produced in Nike contract factories in Vietnam. See Muething, "The Zen Origins."
44. See jedisunrider, Orange County, Jan. 18, 2014; ARACELY, pico rivera, california, Jan. 18, 2014; and Chinelasone, Pal Desert, CA, April 7, 2013, posted on Nike, "Nikeid Nike Roshe Run One Men's Shoe." "Religion of consumption" is from Badiner, *Mindfulness in the Marketplace*, xiii.
45. Zen and Tibetan Buddhism are thrown together here as "Buddhism."
46. Taylor, "Zen: Now Part of a Complete Breakfast."
47. Echoing Linji and other Chan ancestors, Ikkyū quipped, "The scriptures from the start have been toilet paper." In an Edo-period "Ikkyū Tale" (*Ikkyū banashi*), Ikkyū "consecrated" an icon by urinating on it. Arntzen, *Ikkyū*, 90–95; Sanford, *Zen-Man Ikkyū*, 291–295.
48. The strategy can provoke outrage. See the 2011 Super Bowl Groupon commercial, which attempted to use interest in preserving Tibetan culture.
49. "Yoplait."
50. Among countless Zen-branded spas, there's "Onzen, the Spa," in my neighborhood, with its calligraphic Zen-style circle for "O."
51. B. Warner, *Zen Wrapped in Karma*, 224.
52. B. Warner, "Zen Wrapped in Karma."
53. Takahashi, "Paris Fashion Models Pose"; Mok, "Fashion Reveal: Zen."
54. Phelps, "Fall 2013 Couture."
55. Ibid.; Takahashi, "Paris Fashion Models Pose."
56. Takahashi, "Paris Fashion Models Pose."
57. Foreman, "Viktor & Rolf's Return."
58. Carter, "Turning Japanese"; St. James, "Viktor & Rolf."
59. Phelps, "Fall 2013 Couture."
60. Viewed online, and despite the interest of the collection's fabric and tailoring, I found the event dull and troubling (mindfulness on the runway and female models composed as rocks).
61. See John Galliano's 2007 collection for Christian Dior. Morton, "Spring/Summer 2007 Couture."
62. I thank Yamada Shōji for alerting me to the film, which runs for 2:45 minutes. Released prior to the Tokyo Motor Show, it was posted on Mercedes-Benz Japan's web page. Reviews and comments appeared on websites devoted to automotive culture, advertising, Japanese popular culture, and Buddhist practice. See "Zazen vs. Mercedes A45 AMG"; "Merusedesu ga zazen o kumu sōryō."
63. Sperry, "Video: Mercedes Benz Tests Buddhist Monks."
64. The text may be a version of *Hokke jōbutsu ge*. For this I thank Ryosuke Ueda and Mark Blum.
65. Media Site Mercedes-Benz Japan, "'A 45 AMG 4MATIC.'"
66. "Merusedesu ga zazen o kumu sōryō."
67. Oagana, "Japanese A 45 AMG ad"; Oagana, "Mercedes-Benz 'Chicken' Commercial."
68. Baseel, "Mercedes Benz measures the Brains Activity."
69. See comments posted by nakaniii@hatena, mamimp@hatena, and mr_mayama@hatena, on *Neto nabi*, Nov. 15, 2013.

70. See comments posted by "steveballmer2," Oct. 26, 2013, and "nonori_ss," Nov. 16, 2013, Yahoo Japan, *Chiebukuro*.

71. The phrase is from Nussbaum, "Cool Story, Bro," 78.

72. On temple struggles, see Nelson, *Experimental Buddhism*.

73. Note the Pine-Sol commercial titled, "Meditation" (Clorox Co., 2005), in which a meditating-levitating Asian American male actor is disturbed by the fresh smell of the product as his wife mops floor. I thank Todd A. Roe for mentioning this commercial.

74. Koch, "Neuroscientists and the Dalai Lama"; Austin, *Zen and the Brain* and *Zen-Brain Reflections*; Faure, "A Grey Matter"; Lopez, "The Scientific Buddha."

75. Kasamatsu and Hirai, "Science of Zen."

76. Headquarters of the Soto Zen Sect, *Zen*.

77. Ibid., 29–30.

78. Ibid., 30–31.

79. Ibid., 37–39.

80. "Mercedes Benz Monk Ad."

81. Mercedes-Benz is not alone in linking *zazen* to high performance automotive design. In 2005, the Swiss automotive design firm Rinspeed and Bayer MaterialScience produced the concept car "zaZen," designed by Frank M. Rinderknecht. "The interior is an invitation to meditative unity for man and machine," Rinderknecht states. "Everything has been reduced to essentials, hence the name of the concept car, the 'zaZen.' . . . After all, Zen . . . is a special form of insight that is only attainable if you are prepared to give up preconceived ideas." See Rinspeed, "Rinspeed zaZen"; Hanlon, "zaZen shows new ways."

82. Williams, *The Buddha in the Machine*, 189–198.

83. Sperry, "Video: Mercedes Benz tests Buddhist monks." The commercial includes the disclaimer: "This film has been made with the cooperation of Buddhist monks. Interpretation of the meanings/aims, the postures of Zazen differs between denominations and temples."

84. Bobman4671, comment posted on Treeleaf Zendo, "Mercedes Benz X Zen."

85. The altar arrangement in the film's temple sequence includes implements unusual in Zen contexts but common in the Shingon, Tendai, and Jōdo Shinshū denominations. I thank Ryōsuke Ueda for this observation.

86. Lee, comment posted Nov. 23, 2013, to Sperry, "Video: Mercedes Benz Tests Buddhist Monks."

87. Hans Chudo Mongen, comment posted on Treeleaf Zendo, "Mercedes Benz X Zen."

88. "Mercedes Benz," Janis Joplin, Michael McClure, and Bob Neuwirth, 1970.

89. Mercedes-Benz, "Welcome 2011 Super Bowl."

90. Juki, comment posted Treeleaf Zendo, "Mercedes Benz X Zen."

91. "Zen meditation vs. Mercedes-Benz."

92. Treeleaf Zendo is affiliated with the lineage of the Japanese master Gudō Wafu Nishijima (1919–2014) and Tōkei'in, Shizuoka. J. Cohen, "Live Zazenkai Netcast."

93. For Danxia, see Chapter 3. J. Cohen, "Post to *Treeleaf Zendo Forum*," Nov. 15, 2013.

94. The monastery was established in 1980. Its logo depicts the main building, constructed in the 1930s as the chapel of the Catholic Camp Wapanachki. The MRO includes monastic and lay training centers, the Zen Environmental Studies Institute, the National Buddhist Prison Sangha, The Monastery Store, and an on-demand radio station (WZEN.org).

95. MRO Store merchandise is more extensive than those of the Los Angeles Zen Center store and San Francisco Zen Center store. For analysis of Dharma-Crafts, a for-profit meditation supply business, see Wilson, *Mindful America,* 136–139. As far as I am aware, there is no Buddhist equivalent of the Association for Christian Retail.

96. Padgett, "'Americans Need Something to Sit On,'" 62, 63.

97. Dharma Communications, *The Monastery Store,* 47.

98. "Let me respectfully remind you: Life and death are of supreme importance. Time swiftly passes by, and opportunity is lost. Each of us should strive to awaken . . . awaken. Take heed. Do not squander your life." The verse, which appears in the *Platform Sutra of the Sixth Patriarch* (*Liuzu tanjin*) and *Baizhang's Pure Rules* (*Baizhang qinggui*), is conventionally inscribed on a wood "sounding board" hung in Zen temples.

99. Dharma Communications, *The Monastery Store,* 7.

100. Dharma Communciations, "The Monastery Store."

101. Ibid.

102. Ibid.

103. See Loori, *Being Born as the Earth,* "The Precepts and the Environment," and "River Seeing the River"; James, *Zen Buddhism and Environmental Ethics.*

104. Dharma Communciations, "The Monastery Store."

105. Dharma Communications, *The Monastery Store,* 8, 9.

106. The selection reflects a modern-contemporary pan-Buddhist sensibility.

107. Dharma Communications, *The Monastery Store,* 12.

108. See Nelson, "Household Altars." Numerous companies in Japan sell images, altars, and altar utensils online to temples and homes. Many of the items they sell are not sold in temples.

109. R. F. Sasaki, "Letter[s] from Kyoto," Dec. 26, 1957; Shunryū Suzuki, "Zazen, Rituals, and Precepts."

110. R. F. Sasaki, "Letter[s] from Kyoto," Dec. 26, 1957.

111. Tablets are engraved with the deceased's Buddhist name.

112. Dharma Communications, "Our Mission."

113. See Coffey, "Dharma Communications." Zen Mountain Monastery (EIN 14–1622356; Public Charity) is a nonprofit, registered in 1982, category X50 Buddhist (Religion, Spiritual Development). Dharma Communications is a Media, Communications organization (A30) and religion-related N.E.C. (X90), EIN 14–1742118 (supporting organization, unspecified type).

114. Quotations from Vanessa Zuisei Goddard and details of the operations and philosophy of the Monastery Store and Dharma Communications are from a phone interview conducted on July 16, 2014. On June 4, 2015, I visited the monastery and spoke with Shoan Ankele, Creative Director of Dharma Communications and *Mountain Record* editor, and Nathan Lamkin, Store Manager.

115. Early recordings include Loori et al., *Zen Practice at Home* and *Mountains and Rivers.* Loori's books include: *Eight Gates of Zen: Spiritual Training in an American Monastery* (1992) and *Zen Mountain Monastery Liturgy Manual* (1998).

116. For cushion makers in the United States, see Padgett, "'Americans Need Something to Sit On,'" 65–67.

117. On June 7, 2015, the business data company Dun & Bradstreet revised its Supplier Evaluation Risk for Dharma Communications, Inc., to 4 down from 6. The following day Dharma Communication's Financial Stress Score improved from 1,445 to 1,457. E-mail alerts from Dun & Bradstreet, http://www.dnb.com.

118. Padgett, "'Americans Need a Place to Sit,'" 71–72, 74, 75; Nattier, "Who Is a Buddhist?" 189.

119. Loy and Watts, "The Religion of Consumption," 62.

120. Zen Mountain Monastery, "Cybermonk."

121. See Taylor, *Buddhism and Postmodern Imaginings,* 89–107; Greider, "Academic Buddhology and the Cyber-Sangha"; Prebish, *Luminous Passage,* 203–232; Hershock, *Buddhism in the Public Sphere,* 85–101.

122. Daido Roshi paraphrased in Coffey, "Dharma Communications."

123. Dharma Communications, *The Monastery Store,* 37.

124. Ibid., 63.

125. See Dharma Communications, "Our Mission."

126. "Relational practice" is suggested by relational aesthetics in Jackson, *Social Works,* 1, 30–35.

127. On "icon unveiling" (J. *kaichō*), another revenue source, see Reader and Tanabe, *Practically Religious,* 212–215.

128. See Sizemore and Swearer, *Ethics, Wealth and Salvation,* 1; Reader and Tanabe, *Practically Religious.*

129. See Sharf, "Buddhist Modernism"; Silk, *Managing Monks,* 11–12; Scott, *Nirvana for Sale?*; Borup, *Japanese Rinzai Zen;* Collcutt, *Five Mountains.*

130. See Covell, *Japanese Temple Buddhism;* Scott, *Nirvana for Sale?* 2–3; Gecker, "Wirapol Sukphol." Richard M. Jaffe pointed out to me that the True Pure Land cleric Chikū (1634–1718) was critical of temple commercialization.

131. See Yifa, *The Origins of Buddhist Monastic Codes in China.*

132. Collcutt, *Five Mountains,* 251–253; Borup, *Japanese Rinzai Zen.*

133. According to Nakamura Hajime (1912–1999). See Nakamura, "Suzuki Shōzan."

134. Victoria, "Japanese Corporate Zen," 67–68. See also Shields, "Radical Buddhism"; Ives, *Imperial-Way Zen.*

135. Schumacher, "Buddhist Economics."

136. Note, too, Gary Snyder's writings, including "Buddhist Anarchism," revised as "Buddhism and the Coming Revolution," in Snyder, *Earth House Hold.* See also King, *Socially Engaged Buddhism,* chap. 5. For Buddhist critiques of capitalism and consumer culture, see James, *Zen Buddhism and Environmental Ethics;* Badiner, *Mindfulness in the Marketplace;* and Queen, *Engaged Buddhism in the West.*

137. Wall, *Babylon and Beyond,* 4, 190–191; S. B. King, *Socially Engaged Buddhism,* 96–99.

138. Kaza, "Overcoming the Grip of Consumerism," 24.

139. Not mentioned here are small, family-owned businesses run with Buddhist principles and often linked to lay communities.

140. Kataoka and Fenwick, *Valley Zen.*

141. See Williams, *The Buddha in the Machine,* 189–198, 227–228; Grieve, "A Virtual Bodhi Tree," 99–103, 104–106; Berger, "What Zen Taught Silicon Valley."

142. In 2013, Google invited the Zen teacher Thich Nhat Hahn to its headquarters. See Tan, *Search Inside Yourself;* Confino, "Google Seeks out Wisdom."

143. "Mindfulness divorced from its soteriological context runs the risk of being co-opted and exploited for maintaining the status quo rather than effecting transformative change." Purser and Milillo, "Mindfulness Revisited."

144. There are nonprofit Buddhist businesses, such as the Tricycle Foundation, Wisdom Publications, and Pariyatti Press, that stress the goals of alleviating suffering, providing access to Buddhist teachings, promoting scholarship, and preserving and sharing Buddhist cultures.

145. Dyan Eagles, the founder of DharmaCrafts (est. 1979) refers to her study at the Cambridge Zen Center, founded in 1973 by students of the Korean master Seung Sahn. Eagles, "Dharmacrafts."
146. Dharma Communications, "Our Mission."
147. *PDB*, 762–763.
148. Goddard, *The Buddha's Golden Path*, 60–61, 62–65. The Zen teacher Philip Kapleau discussed labor and meditation in "Report from a Zen Monastery," 80. See also Whitmyer, *Mindfulness and Meaningful Work;* Baumann, "Work as Dharma Practice."
149. Loy, "The Religion of the Market," 279n2.
150. Dharma Communications, "Dharma Communications."
151. "Actualized case," or, more colloquially, the "kōan of everyday life." *PDB*, 317.
152. Loori, *The Eight Gates of Zen,* chap. 8; Loori, "The Sacredness of Work."
153. Dharma Communications, "Environmental Policy." See also Coffey, "Dharma Communications." The Monastery Store does not use third-party certifiers for fair trade and labor.
154. I thank Shoan Ankele for sharing an unpublished transcript of a talk given in spring 2013 at the Zen Center of New York City.
155. See Price, "Slavoj Zizek."
156. See Potpourri Group, Inc., *Country Store.*
157. Loy, *Money, Sex, War, Karma,* 98.
158. Goff et al., "Need for Speed."
159. Werblowsky, "Some Observations," 335.
160. See Badiner, *Mindfulness in the Marketplace,* 41–48, 135.
161. I am grateful to various students in courses taught at UC Berkeley since 2000.
162. Purser and Loy, "Beyond McMindfulness."
163. See *PDB*, 942–943.

CODA

1. Roszak, *From Satori to Silicon Valley,* i.
2. Cage, "An Autobiographical Statement."
3. Schjeldahl, "Native Soil," 78.
4. I allude to Neer, "Connoisseurship."
5. Bridges and Glassman, *The Dude and the Zen Master,* 1–2.
6. Heuman, "Context Matters," 44.
7. Updike, "Invisible Cathedral."
8. See Pitelka, "Review Article." For Zen in recent popular culture in Japan, see Porcu, "Down-to-Earth Zen."
9. Roszak, *From Satori to Silicon Valley;* Grimes, "Zen and the Art of Not Teaching," 162.
10. Tuma, "In Conversation: T. J. Clark."
11. Wee, "'We Asians?'"

CHARACTER GLOSSARY

Anesaki Masaharu 姉崎正治

Anpo jōyaku 安保条約

Arai Sekizen 新井石禅

Asahina Sōgen 朝比奈宗源

Ashikaga 足利

Awakawa Yasuichi (Kōichi) 淡川康一

baimiao 白描

Baizhang qinggui 百丈清規

Banshun 晚春

benlai mianmu 本來面目

bijutsu 美術

biku 比丘

bikuni 比丘尼

Biyan lu 碧巖録

Bokubi 墨美

Bokujinkai 墨人会

bokuseki 墨蹟

Budai 布袋

Bunsei 文清

Bushidō 武士道

butsugu shō 仏具商

Byōdōin 平等院

Caodong 曹洞

Chan 禅

chanhui 禅会

chanhui tu 禅会図

chanji 禅機

chanji tu 禅機図

chanlin 禅林

Chanoyu 茶の湯

chinsō 頂相

Chixiu Baizhang qingui 勅修百丈清規

Chōtokuin 長徳院

chuandeng lu 傳燈録

Chushi Fanqi 楚石梵琦

Dahui Zonggao 大慧宗杲

Daigu Sōchiku 大愚宗築

daihi 大悲

daihitsu 代筆

daiji 大慈

daiji 大事

Daishuin 大珠院

Dai Tōa Kyōei Ken 大東亜共栄圏

Daitokuji 大徳寺

Danxia shaofo 丹霞焼仏

Danxia Tianran 丹霞天然

Daruma 達磨

dashi, see *daiji*

Deshan Xuanjian 徳山宣鑒

Dōgen Kigen 道元希玄

Edo 江戸

Ehon hōkan 絵本寶鑑

Eiheiji 永平寺

en 円

Engakuji 円覚寺

Enni Ben'en 圓爾辨圓

ensō 円相

en'yū 円融

En'yūsai 円融斎

Faqin 法欽

feibai 飛白

Fukui Rikichirō 福井利吉郎

Fukushōji 福昌寺

Furuta Shōkin 古田紹欽

fuse 布施

gakugyō-ichinyo 学行一如

gedatsu no fūshin 解脱の風神

Genkō shakusho 元亨釈書

genshō genmetsu 幻生幻滅

genze riyaku 現世利益

giga 戯画

gong'an 公安

Gong fu 功夫

goroku 語録

Guanyin 漢音

Gudō Wafu Nishijima 愚道和夫西嶋

Guifeng Zongmi 圭峰宗密

Guoshi 国師

Gutai 具体

haboku 破墨

haboku no hō 破墨之法

Haboku sansui zu 破墨山水図

Haga Tōru 芳賀徹

hakama 袴

Hakuin Ekaku 白隠慧鶴

Han Shan 寒山

Hanshin zō 半身像

Harada Daiun Sogaku 原田大雲祖岳

279

Harada Jirō 原田治郎

Hasegawa Saburō 長谷川三郎

Hasegawa Sakon 長谷川左近

Hasegawa Tōhaku 長谷川等伯

Hashimoto Gahō 橋本雅邦

Hashimoto Seisui 橋本静水

Hashimoto Shōtei 橋本昌禎

hasshōdō 八正道

Hasumi Toshimitsu 蓮見俊光

Hayakawa Sessue (Sesshū) 早川雪洲

Heian 平安

Hekiganroku, see Biyan lu

Hekikan Daruma 壁觀達磨

Heze Shenhui 菏澤神會

Hirai Tomio 平井富雄

Hisamatsu Shin'ichi 久松真一

hōben zengyō 方便善巧

Hōjin issō 法塵一掃

Hokekyō 法華経

Hokke jōbutsu ge 法華成仏偈

Hon'ami Kōetsu 本阿弥光悦

Hongzhi Zhengjue 宏智正覺

Hongzhou 洪州

honrai no menmoku, see benlai mianmu

Hōōden 鳳凰殿

Hotei, see Budai

Hsuan Hua 宣化

Huangbo 黄檗

Huangboshan Duanji chanshi chuanxin fayao 黃檗山斷際禪師傳心法要

huanyuan 還源

Huilinsi 慧林寺

Huiming 慧明

Huineng 慧能

Huxi sanxiao 虎溪三笑

hyōshigi 拍子木

Ichiyanagi Toshi 一柳慧

Idemitsu Sazō 出光佐三

iemoto 家元

ihai 位牌

ihō 遺法

Ikegami Shōsan 池上湘山

Iketani Shin'ichirō 池谷慎一郎

Ikkyū banashi 一休咄

Ikkyū Sōjun 一休宗純

Il Bung Kyung Bo 一鵬京保；일붕경보

Imakita Kōsen 今北洪川

Indara 因陀羅

inkin 引磬

Inoue Yūichi 井上有一

inshōsei 印象性

Iriya Yoshitaka 入矢義高

Ishibashi Shōjirō 石橋正二郎

Itō Teiji 伊藤ていじ

Itsumadegusa 壁生草

Ittetsu koji 一徹居士

jikkai 十戒

Jingang jing 金剛経

Jingde chuandeng lu 景德傳燈録

Jittoku 拾得

Jōdo 浄土

Jōdo Shinshū 浄土真宗

Josetsu 如拙

Jōshū Sasaki 承周佐々木

jukai 受戒

Jūgyū zu 十牛図

Junsō Sōjo 順叟宗助

junsui keiken 純粋経験

kaichō 開帳

Kaijin kaiba 快人快馬

Kamakura 鎌倉

kangen, see huanyuan

Kannon, see Guanyin

Kanō 狩野

Kanō Sansetsu 狩野山雪

kanōsei 可能性

Kanō Tanyū 狩野探幽

kanshōsei 感傷性

Kanzan, see Han Shan

Kaō 可翁

Karatani Kōjin 柄谷行人

karesansui 枯山水

Kasamatsu Akira 笠松章

Katsura Rikyū 桂離宮

Katsushika Hokusai 葛飾北斎

Kattōshū: Wakun ryakkai 葛藤集：和訓略解

Kawabata Gyokushō 川端玉章

Kazan Daigi 華山大義

keisaku 警策

keisu 磬子

Kenchōji 建長寺

kenshō 見性

kenshō jōbutsu 見性成仏

kesa 袈裟

keshin 化身

kinhin 経行

Kirita Kiyohide 桐田清秀

kōan, see gong'an

Kobori Nanrei 小堀南嶺

Kōgakuji 向嶽寺

Kōgaku Sōen 洪嶽宗演

kōgei 工芸
Kōgetsu Sōgan 江月宗玩
koji 居士
Kokan Shiren 虎関師錬
Kokei sanshō, see Huxi sanxiao
Kokka 国華
kokusaiteki dōjisei 国際的同時性
Kokushi, see Guoshi
kokusui 国粋
komaru 困る
Kongōkyō, see *Jingang jing*
Kōzuki Tesshū 神月徹宗
kū 空
Kuki Ryūichi 九鬼隆一
Kuki Shūzō 九鬼周造
Kundaikan sōchōki 君台観左右帳記
Kuroda Nagashige 黒田長成
Kuroji ni akai en 黒地に赤い円
Kurosawa Akira 黒澤明
Kusumi Morikage 久隅守景
Kwan Um (Kwanŭm), see Guanyin
Lanxi Daolong 蘭渓道隆
Liang Kai 梁楷
Li Longmian 李龍眠
Linji 臨濟
Liuzu tanjing 六祖壇經
Lu 律
luohan 羅漢
Luoyang 洛陽
makki no sho 末期の書
manga 漫画
Maruyama-Shijō 円山四条
Maruyama Shin'ichi 丸山晋一
Masaki Takayuki 正木孝之
Masuda Takashi 益田孝
Masunaga Reihō 増永霊鳳
Matsudaira Sadanobu 松平定信
Matsuyama 松山
Ma Yuan 馬遠
Mazu Daoyi 馬祖道一
Meiji 明治
Mile 彌勒
Minchō 明兆
mitsugusoku 三具足
Mitsukoshi 三越
Mochizuki Shinkō 望月信亨
mokugyo 木魚
Momoyama 桃山
monzenmachi 門前町
Morinaga Sōkō 盛永宗興
Morita Shiryū 森田子龍
Mozhao Chan 黙照禅

mu 無
muga 無我
Mujaku Dōchū 無著道忠
Munakata Shikō 棟方志功
munen 無念
Muqi Fachang 牧谿法常
Murakami Takashi 村上隆
Muromachi 室町
Mushakōji Senke 武者小路千家
mushin 無心
muton 無貪
Myōshinji 妙心寺
Nagai Hyōsai 永井瓢斎
Naikoku Kaiga Kyōshinkai 内国絵画
　共進会
Nakagawa Sōen 中川宋淵
Nakahara Nantenbō 中原南天棒
Nakamura Hajime 中村元
Nanquan Puyuan 南泉普願
Natsume Sōseki 夏目漱石
Nenge mishō 拈華微笑
Nezu Ka'ichirō 根津嘉一郎
Nihon Bijutsu Kyōkai 日本美術協会
Nihonga 日本画
Nihonjinron 日本人論
Nihonteki reisei 日本的霊性
Ningbo 寧波
Ninshitsu 忍室
Nippō jisho 日葡辞書
Nishida Kitarō 西田幾多郎
Noh 能
Nonaka Toshihiko 野中甫彦
nōtan 濃淡
Nukariya Kaiten 忽滑谷快天
Nyogen Senzaki 如幻千崎
Ōbaku, see Huangbo
Ogata Sōhaku 緒方宗博
Okada Kenzō 岡田謙三
Okakura Kakuzō 岡倉覚三
Okamoto Ippei 岡本一平
Okamoto Kanoko 岡本かの子
ōryōki 応量器
otaku おたく
Otogawa Kōbun Chino 乙川弘文知野
Ozu Yasujirō 小津安二郎
Pingshi Ruzhi 平砥石如
pomo 破墨
Raku 楽
rakusu 絡子
Reiun'in 霊雲院
Rinzai, see Linji
Rinzaiji 臨済寺

Ritsu, see Lu
Rokuso dankyō, see *Liuzu tanjing*
Rokuso zu 六祖図
rōshi 老師
Ryōanji 龍安寺
Ryōkōin 龍光院
Ryōsen'an 龍泉庵
Ryūtakuji 龍澤寺
sabi 寂
Sakurazawa Yukikazu 桜沢如一
samu-e 作務衣
Samu Sŭnim 삼우스님
Sanbōkyōdan 三宝教団
sansei 散聖
sansheng, see *sansei*
sanzen 参禅
satori 悟
Satō Zenchū 佐藤禅忠
Seisen 聖戦
sekishu onjō 隻手音声
sekitei 石庭
Sengai Gibon 仙厓義梵
Sen no Rikyū 千利休
Sen Sō'oku 千宗屋
sesshin 攝心
Sesshū Tōyō 雪舟等楊
Sesson Shūkei 雪村周継
Seung Sahn Haeng Won 崇山行願;
 숭산행원
Shakaku shūzui 捨骼拾髄
Shaku Sōen 釈宗演
Shaolinsi 少林寺
shibumi 渋み
Shichifukujin 七福神
Shichinin no Samurai 七人の侍
Shi'e 紫衣
shigu zeigan 四弘誓願
Shimada Shūjirō 島田修二郎
Shimada Shunpo 島田春浦
Shimao Arata 島尾新
Shinbi taikan 真美大觀
Shin Bukkyō 新仏教
Shingon 真言
Shiseidō 資生堂
Shitou Xiqian 石頭希遷
Shoaku makusa, Shūzen bugyō 諸悪
 莫作 衆善奉行
Shōbōgenzō zuimonki 正法眼蔵随聞記
Shōbōzanshi 正法山誌
shōchōsei 象徴性
Shoin zukuri 書院造
Shōkokuji 相国寺

shōmyō 正命
Shūbun 周文
shukke Zen 出家禅
Shūmon kattōshū 宗門葛藤集
Shussan Shaka 出山釈迦
shutsuri 出離
sōdō 僧堂
Sōjiji 総持寺
Sōkei'an Sasaki Shigetsu 曹渓庵
 佐々木指月
Sōkōji 桑港寺
Sŏn, see Chan
Song 宋
Song gaoseng zhuan 宋高僧傳
sōshokusei 装飾性
Sōtō, see Caodong
Sugawara Jiho 菅原時保
Sugi Yasusaburō 杉靖三郎
sumie 墨絵
Suzuki (Teitarō) Daisetsu 鈴木貞太郎
 大拙
Suzuki Shōsan 鈴木正三
Suzuki Shunryū 鈴木俊隆
Taisen Deshimaru 泰仙弟子丸
Taishō 大正
Taishū Zen 大衆禅
Taizan Maezumi 大山前角
Takakusu Junjirō 高楠順次郎
Takemoto Tadao 竹本忠雄
Takeuchi Naoji 竹内尚次
Takuan Sōhō 沢庵宗彭
Tange Kenzō 丹下健三
Tanka shōbutsu, see Danxia shaofo
Tanka shōbutsu no hanashi 丹霞焼仏
 の話
Tankōkai 淡交会
Teikoku Hakubutsukan 帝国博物館
Tendai 天台
Teshigahara Sōfu 勅使河原蒼風
Tetsuzan Sōjun 鉄山宗鈍
Tōfukuji 東福寺
Tōhon 等本
Tokugawa 徳川
Tōkyō monogatari 東京物語
Touzi Yiqing 投子義青
Tōyō bijutsu 東洋美術
Tōyō bijutsu taikan 東洋美術大観
tōyōteki mu 東洋的無
Tsuruzawa Tanshin 鶴澤探眞
Uji 宇治
Umehara Takeshi 梅原猛
wabi 侘

Wakan meigasen 和漢名画選
wu, see *mu*
Wu Daozi 呉道子
wu jia 五家
Wumenguan 無門関
Wumen Huikai 無門慧開
wuxing foxing 無性仏性
Xia Gui 夏珪
Xianzi 蜆子
Xutang heshang yulu 虚堂和尚語録
Xutang Zhiyu 虚堂智愚
Yamada Chisaburō 山田智三郎
Yamada Reirin 山田霊林
Yamamoto Shunkyo 山元春挙
Yamazaki Taikō 山崎大耕
Yanagi Sōetsu 柳宗悦
Yangshan Huiji 仰山慧寂
Yashiro Yukio 矢代幸雄
Yasutani Haku'un 安谷白雲
Yi jing 易經
Yintuoluo, see Indara
yipin 逸品
Yōga 洋画
Yomiuri shinbun 読売新聞
Yoshihara Jirō 吉原治良
Yoshihara Shin'ichirō 吉原眞一郎
Yoshizawa Katsuhiro 芳澤勝弘
Yuan 元
Yuanwu Keqin 圜悟克勤
yūgen 幽玄

yulu, see *goroku*
Yunmen Wenyan 雲門文偃
zabuton 座布団
zafu 座布
zaike Zen 在家禅
zazen 座禅
zazenkai 座禅会
zazen kufū 座禅工夫
Zen, see Chan
Zendō 禅堂
zen'e, see *chanhui*
zen'e zu, see *chanhui tu*
Zenga 禅画
Zenji 禅師
zenki, see *chanji*
zenki zu, see *chanji tu*
Zen mangashū 禅漫画集
Zen no fude 禅の筆
Zenpitsu 禅筆
zenrin, see *chanlin*
Zenshū 禅宗
Zenshūji 禅宗寺
Zen to bijutsu 禅と美術
zettai mu 絶対無
Zhaozhou 趙州
Ziyi, see Shi'e
Zuihōin 瑞峰院
Zuiken Inagaki Saizō 瑞険稲垣最三
Zuiunken 瑞雲軒

BIBLIOGRAPHY

Adachi, Gen. "Avant-garde Debates over Japanese Tradition in the 1950's with a Focus on the Role of Isamu Noguchi." In *Artistic Vagabondage and New Utopian Projects: Transnational Poïetic Experiences in East-Asian Modernity (1905–1960)*, ed. Shigemi Inaga, 103–117. Kyoto: Uno Printing, 2011.

Addiss, Stephen. *The Art of Zen: Paintings and Calligraphy by Japanese Monks 1600–1925*. New York: Harry N. Abrams, 1989.

———. "Provisional Dualism: Robert Motherwell and Zen." In *Robert Motherwell on Paper: Drawings, Prints, Collages,* ed. David Rosand, 59–81. New York: Harry N. Abrams, 1997.

Addiss, Stephen, and Ray Kass. *John Cage: Zen Ox-Herding Pictures*. New York: George Braziller, 2009.

"A Glass of Rather Bad Sherry." *The Sunday Times* (London), Sept. 4, 1960, 28.

Aitken, Robert. "LSD and the New American Zen Student." *The Eastern Buddhist,* n.s. 4, 2 (October 1971): 141–143.

Alcock, Sir Rutherford. *Art and Art Industries in Japan*. London: Virtue and Co., 1878.

Amakuki, Sessan. *Zensō ryūgaku kotohajime*. Kyoto: Zenbunka Kenkyūjo, 1990.

"Americans Translate Japan into a Perfume." *New York Times,* March 11, 1966, 51.

Ames, Van Meter. "Current Western Interest in Zen." *Philosophy East and West* 10, nos. 1/2 (April–July 1960): 23–33.

———. "Zen to Mead." *Proceedings and Addresses of the American Philosophical Association* 33 (1959–1960): 27–42.

"A Message from the Hippie-Elders: The Houseboat Summit—1967." https://www.youtube.com/watch?v=lKi4z0JPfFs (accessed Oct. 20, 2015).

Amp, Alicatte. "Zen Warholism." *Amp* (blog) May 23, 2007. http://amppower.blogspot.com/2007_05_01_archive.html (accessed Feb. 25, 2012).

Anderson, Lindsay. "Two Inches off the Ground." In *Ozu's Tokyo Story,* ed. David Desser, 145–154. Cambridge: Cambridge University Press, 1997.

Anesaki, Masaharu. *Art, Life, and Nature in Japan*. Boston: Marshall Jones Company, 1933.

———. *Buddhist Art in Its Relation to Buddhist Ideals*. New York: Houghton Mifflin, 1915.

App, Urs. *The Birth of Orientalism*. Philadelphia: University of Pennsylvania Press, 2010.

———. "The 'Discovery' of Zen." *Zen bunka kenkyū kiyō* 24 (December 1998): 1–23.

AraChN!D. "Zen Shopping." Post on May 11, 2009, *Urban Dictionary*. http://www.urbandictionary.com/define.php?term=Zen+Shopping (accessed July 3, 2014).

Arai, Paula K. R. *Women Living Zen: Japanese Sōtō Buddhist Nuns*. Oxford: Oxford University Press, 1999.

Armstrong, Elizabeth. "Fluxus and the Museum." In *In the Spirit of Fluxus,* ed. Simon Anderson et al., 12–21. Minneapolis, MN: Walker Art Center, 1993.

Arntzen, Sonja. *Ikkyū and the Crazy Cloud Anthology: A Zen Poet of Medieval Japan*. Tokyo: University of Tokyo Press, 1986.

"Art: Pictures of the Soul." *Time,* April 18, 1955. http://content.time.com/time /magazine/article/0,9171,866223,00.html (accessed Aug. 11, 2015).

Asahina Sōgen. "Living Zen," *Zen Notes* (August 1954): n.p.

———. "A Message to Sokei-an's Zen Students." *Zen Notes* 1, no. 7 (July 1954): n.p.

Asai, Senryō, and Duncan Ryūken Williams. "Japanese American Zen Temples: Cultural Identity and Economics." In *American Buddhism: Methods and Findings in Recent Scholarship,* ed. Duncan Ryūken Williams and Christopher S. Queen, 20–35. Richmond, Surrey: Curzon Press, 1999.

Ashida, Margaret E. "Frogs and Frozen Zen." *Prairie Schooner* 34, no. 3 (Fall 1960): 199–206.

Ashiya Shiritsu Bijutsukan. *Botsugo 20 nen Yoshihara Jirō ten.* Ashiya-shi: Ashiya Shiritsu Bijutsukan, 1992.

Asian Art Museum, San Francisco. "Interactive Brushpainting Activity." http:// education.asianart.org/brushpainting/ (accessed Jan. 28, 2016).

Aso, Noriko. *Public Properties: Museums in Imperial Japan.* Durham, NC: Duke University Press, 2013.

Atkinson, Michael. "*Late Spring:* Home with Ozu." *Current,* April 17, 2012. http:// www.criterion.com/current/posts/421-late-spring-home-with-ozu (accessed Jan. 22, 2016).

"Atticus among the Angels of the Theatre." *The Sunday Times* (London), July 17, 1960, 33.

Auerback, Micah. "A Closer Look at Zen at War: The Buddhist Chaplaincy of Shaku Sōen in the Russo-Japanese War (1904–1905). In *Buddhism and Violence: Militarism and Buddhism in Modern Asia,* ed. Vladimir Tikhonov and Torkel Brekke, 152–171. New York: Routledge, 2012.

Austin, James H. *Zen and the Brain: Toward an Understanding of Meditation and Consciousness.* Cambridge, MA: MIT Press, 1998.

———. *Zen-Brain Reflections: Reviewing Recent Developments in Meditation and States of Consciousness.* Cambridge, MA: MIT Press, 2006.

Aviman, Galit. *Zen Painting in Edo Japan: Playfulness and Freedom in the Artwork of Hakuin Ekaku and Sengai Gibon.* Farnham, Surrey: Ashgate Press, 2014.

Awakawa, Yasuichi. *Zen Painting.* Trans. John Bester. Tokyo: Kodansha International, 1970.

"A Zen Master in Our Midst." *Zen Notes* 1, no. 9 (September 1954): n.p.

Badiner, Allan H., ed. *Mindfulness in the Marketplace: Compassionate Responses to Consumerism.* Berkeley: Parallax Press, 2002.

Baoye Miaoyuan, ed. *Xutang heshang yulu.* T 2000_.47.0984a04–1064b20.

Barrett, William. "The Great Bow (Review), *Zen in the Art of Archery,* by Eugene Herrigel, D. T. Suzuki." *Encounter* (April 1954), 62–65.

———. "Zen for the West." In *Zen Buddhism: The Selected Writings of D. T. Suzuki,* ed. William Barrett, vii–xx. Garden City, NY: Doubleday, 1956.

Baseel, Casey. "Mercedes Benz Measures the Brain Activity of Zen Monks to Evaluate Their New Car [Video]." *Rocket News 24,* Nov. 15, 2013. http://en.rocketnews24 .com/2013/11/15/mercedes-benz-measures-the-brains-activity-of-zen-monks -to-evaluate-their-new-car%E3%80%90video%E3%80%91/ (accessed March 10, 2014).

Batchelor, Stephen. *The Awakening of the West: The Encounter of Buddhism and Western Culture.* London: Harper Collins, 1994.

———. "A Secular Buddhism." *Journal of Global Buddhism* 12 (2012): 87–107.

Baumann, Martin. "Work as Dharma Practice: Right Livelihood Cooperatives of the FWBO." In *Engaged Buddhism in the West,* ed. Christopher S. Queen, 372–393. Boston: Wisdom Publications, 2000.

Baxandall, Michael. *Patterns of Intention: On the Historical Explanation of Pictures.* New Haven, CT: Yale University Press, 1985.

Baxter, Katharine Schuyler. *In Beautiful Japan: A Story of Bamboo Lands.* New York: The Hobart Co., 1904.

Beard, Henry, and Ron Barrett. *Zen for Cats.* New York: Villard, 1997.

Beard, Mary. *Laughter in Ancient Rome: On Joking, Tickling, and Cracking Up.* Berkeley: University of California Press, 2014.

Becker, Ernest. *Zen: A Rational Critique.* New York: W. W. Norton & Co., 1961.

———. "Zen Buddhism, 'Thought Reform' (Brainwashing), and Various Psychotherapies: A Theoretical Study in Induced Regression and Cultural Values." Ph.D. diss., Syracuse University, 1960.

Bein, Steve. *Purifying Zen: Watsuji Tetsurō's* Shamon Dōgen. Honolulu: University of Hawai'i Press, 2011.

Belting, Hans. "Beyond Iconoclasm: Nam June Paik, the Zen Gaze, and the Escape from Representation." In *Iconoclash: Beyond the Image Wars in Science, Religion, and Art,* ed. Bruno Latour and Peter Weibel, 390–411. Karlsruhe and New York: ZKM and MIT Press, 2002.

Berger, Maurice. "Writing in the Sky." In Shinichi Maruyama, *KUSHO,* n.p. New York: Bruce Silverstein Gallery, 2008.

Berger, Warren. "What Zen Taught Silicon Valley (and Steve Jobs) about Innovation." *Co.Design,* April 9, 2012. http://www.fastcodesign.com/1669387/what-zen-taught-silicon-valley-and-steve-jobs-about-innovation (accessed July 5, 2014).

Berowitz, Adam. "The Importance of a Sense of Humor." *The Examiner,* April 29, 2010, http://www.examiner.com/article/the-importance-of-a-sense-of-humor-1.

Besserman, Perle, and Manfred Steger. *Crazy Clouds: Zen Radicals, Rebels and Reformers.* Boston: Shambhala, 1991.

Bickersteth, Mary Jane. *Japan as We Saw It.* London: Sampson Low, Marston, and Co., 1893.

Bielfeldt, Carl. "Kokan Shiren and the Sectarian Uses of History." In *The Origins of Japan's Medieval World: Courtiers, Clerics, Warriors, and Peasants in the Fourteenth Century,* ed. Jeffrey P. Mass, 295–317. Stanford, CA: Stanford University Press, 1997.

Binyon, Laurence. *Painting in the Far East: An Introduction to the History of Pictorial Art in Asia, Especially China and Japan.* London: Edward Arnold, 1913.

Blyth, R. H. *Oriental Humour.* Tokyo: Hokuseidō Press, 1959.

———. *Zen in English Literature and Oriental Classics.* Tokyo: Hokuseido Press, 1942.

Bohrer, Frederick N. *Orientalism and Visual Culture: Imagining Mesopotamia in Nineteenth-Century Europe.* Cambridge: Cambridge University Press, 2003.

Bordwell, David. *Ozu and the Poetics of Cinema.* Princeton, NJ: Princeton University Press, 1988.

Borup, Jørn. "Easternization of the East? *Zen* and *Spirituality* as Distinct Cultural Narratives in Japan." *Journal of Global Buddhism* 16 (2015): 70–93.

———. *Japanese Rinzai Zen Buddhism: Myōshinji, a Living Religion.* Leiden: Brill, 2008.

———. "Zen and the Art of Inverting Orientalism: Religious Studies and Genealogical Networks." In *New Approaches to the Study of Religion,* vol. 1, ed. Peter Antes et al., 451–487. Berlin: Verlag de Gruyter, 2004.

Bradbury, Ray. "Zen and the Art of Writing." In Ray Bradbury, *Zen and the Art of Writing.* Santa Barbara, CA: Capra Press, 1973.

Brandon, Henry. "Beat Generation." *The Sunday Times* (London), June 15, 1958, 19.

———. "The Critic in Isolation: Edmund Wilson." *The Sunday Times* (London), Feb. 1, 1959, 11.

Brandt, Kim. "You Are All Sanpaku: Zen Macrobiotics and Postcolonial Nationalism." *In Japan's Cultural Miracle: Rethinking the Rise of a World Power, 1945–1965,* chap. 4. New York: Columbia University Press, forthcoming.

Bridges, Jeff. "Saying What Can't Be Said." Foreword to Bill Green, Ben Peskoe, Will Russell, and Scott Shuffitt, *I'm a Lebowski, You're a Lebowski: Life, The Big Lebowski, and What Have You,* xiii–xiv. New York: Bloomsbury Publishing, 2007.

Bridges, Jeff, and Bernie Glassman. *The Dude and the Zen Master.* New York: Blue Rider Press, 2013.

Briggs, William A. "Have Zabuton—Will Travel," *Zen Notes* 6, no. 8 (August 1959): n.p.

Brill, Dorothée. *Shock and the Senseless in Dada and Fluxus.* Hanover, NH: Dartmouth College Press, 2010.

Brinkley, Captain F. *Japan: Its History Arts and Literature,* vol. 2. Boston and Tokyo: J. B. Millet Company, 1901.

Brown, James P. "The Zen of Anarchy: Japanese Exceptionalism and the Anarchist Roots of the San Francisco Poetry Renaissance." *Religion and American Culture: A Journal of Interpretation* 19, no. 2 (Summer 2009): 207–242.

Buswell Jr., Robert E., and Donald Lopez Jr., eds. *The Princeton Dictionary of Buddhism.* Princeton, NJ: Princeton University Press, 2014.

Cage, John. "An Autobiographical Statement" (1990). *Southwest Review* 76, no. 1 (1991): 59–76.

———. *Silence: Lectures and Writings, 50th Anniversary Edition.* Middletown, CT: Wesleyan University Press, 2011.

———. *A Year from Monday: New Lectures and Writings.* Middletown, CT: Wesleyan University Press, 1967.

Cage, John, and Joan Retallack. *Musicage: Cage Muses on Words, Art, Music.* Hanover, NH: University Press of New England, 1996.

Callaway, Tucker N. *Zen Way, Jesus Way.* Rutland, VT: C. E. Tuttle, 1976.

Campbell, Patrick. "A Shot through the Letter-Box." *The Sunday Times* (London), April 16, 1961, 13.

Canaday, John. "Nice Try. Too Bad It Didn't Work." *New York Times,* April 3, 1966, X22.

Carrette, Jeremy R., and Richard King. *Selling Spirituality: The Silent Takeover of Religion.* London: Routledge, 2005.

Carter, Lee. "Turning Japanese: Viktor & Rolf Fall 2013 Couture." *BlouinArtInfo,* July 6, 2013. http://www.blouinartinfo.com/news/story/927033/turning-japanese -viktor-rolf-fall-2013-couture# (accessed July 27, 2015).

Carvajal, Doreen, and Susan Daley. "Proud to Offend, Charlie Hebdo Carries Torch of Political Provocation." *New York Times,* Jan. 7, 2015.

Castile, Rand. "Letter to the Editor." *Impressions* 27 (2005–2006): 128.

Chadwick, David. "Psychoactivism." In *Zig Zag Zen: Buddhism and Psychedelics,* ed. Allan H. Badiner, 115–123. San Francisco, CA: Chronicle Books, 2002.

———. *Thank You and Ok! An American Zen Failure in Japan.* Boston: Shambhala, 2007.

Chakrabarty, Dipesh. "Afterword: Revisiting the Tradition/Modernity Binary." In *Mirror of Modernity: Invented Traditions of Modern Japan,* ed. Stephen Vlastos, 285–296. Berkeley: University of California Press, 1998.

———. *Provincializing Europe: Postcolonial Thought and Difference.* Princeton, NJ: Princeton University Press, 2000.

Chamberlain, Basil Hall. *A Handbook for Travellers in Japan.* London: John Murray, 1891.

———. *Things Japanese: Being Notes on Subjects Connected with Japan for the Use of Travellers and Others.* London: K. Paul, Trench, Trübner & Co., Ltd., 1891.

Chin, Justin. "Attack of the White Buddhists." In Justin Chin, *Mongrel: Essays, Diatribes, and Pranks,* 113–118. New York: St. Martin's Press, 1999.

Chira, Susan. "Kamakura Journal: Zen, Jerry Brown and the Art of Self-Maintenance." *New York Times,* Jan. 28, 1987.

Cieslik, Hubert. "The Case of Christovão Ferreira," *Monumenta Nipponica* 29, no. 1 (Spring 1974): 1–54.

Clarke, Shayne. "Locating Humor in Indian Buddhist Monastic Law Codes: A Comparative Approach." *Journal of Indian Philosophy* 37, no. 4 (2008): 311–330.

Clasquin, Michael. "Real Buddhas Don't Laugh: Attitudes Towards Humour and Laughter in Ancient India and China." *Social Identities* 7, no. 1 (2001): 97–116.

Cleary, Thomas, trans. *The Blue Cliff Record, Compiled by Ch'ung-hsien, Commented upon by K'o-ch'in.* Berkeley: Numata Center for Buddhist Translation and Research, 1998.

———. *Classics of Buddhism and Zen: Volume 4.* Boston: Shambhala, 2001.

Coffey, Drew Hodo. "Dharma Communications: A History." *Mountain Record: The Zen Practitioner's Journal* 21, no. 4 (Summer 2003). http://www.mro.org/mr/archive/21-4/articles/dchistory.html (accessed July 1, 2014).

Cohen, Jundo. "Live Zazenkai Netcast," Nov. 15, 2013. Treeleaf Zendo, http://www.treeleaf.org/forums/showthread.php?11639-November-15th-16th-2013-Treeleaf-Weekly-Zazenkai&p=115400&viewfull=1#post115400 (accessed March 12, 2014).

———. Post to "Treeleaf Zendo Forum." Nov. 15, 2013, http://www.treeleaf.org/forums/showthread.php?11639-November-15th-16th-2013-Treeleaf-Weekly-Zazenkai&p=115402&viewfull=1#post115402 (accessed March 12, 2013).

Cohen, Warren I. *Ethics in Thought and Action: Social and Professional Perspectives.* New York: Ardsley House, 1995.

Collcutt, Martin. *Five Mountains: The Rinzai Zen Monastic Tradition in Medieval Japan.* Cambridge, MA: Council on East Asian Studies, Harvard University, 1981.

Comentale, Edward P., and Aaron Jaffe. *The Year's Work in Lebowski Studies.* Bloomington: Indiana University Press, 2009.

Commission Impériale du Japon. *Histoire de l'art du Japon.* Paris: Maurice de Brunoff, 1900.

Confino, Jo. "Google Seeks out Wisdom of Zen Master Thich Nhat Hanh." *The Guardian,* Sept. 5, 2013. http://www.theguardian.com/sustainable-business/global-technology-ceos-wisdom-zen-master-thich-nhat-hanh (accessed Aug. 6, 2015).

Connolly, Cyril. "Conversation with Aldous Huxley." *The Sunday Times* (London), Oct. 19, 1958, 10.

———. "A Fight against Fear and Failure." *The Sunday Times* (London), May 17, 1964, 37.

———. "Square's-Eye View of the Beats." *The Sunday Times* (London), April 24, 1960, 17.

Coomaraswamy, Ananda K. "Introduction to the Art of Eastern Asia," *The Open Court* XLVI (1932). Republished in Roger Lipsey, *Coomaraswamy· Vol 1—Selected Essays, Traditional Art and Symbolism,* vol. 1, 101–127. Princeton, NJ: Princeton University Press, 1977.

———. *The Transformation of Nature in Art.* Cambridge, MA: Harvard University Press, 1934.

Cooper, Michael. *João Rodrigues's Account of Sixteenth-Century Japan.* London: The Hakluyt Society, 2001.

———, ed. *They Came to Japan: An Anthology of European Reports on Japan, 1543–1640.* Berkeley: University of California Press, 1981.

Coupey, Philippe, ed. *Sit: Zen Teachings of Master Taisen Deshimaru.* Chino Valley, AZ: Hohm Press, 1996.

Courtois, Flora. *An American Woman's Experience of Enlightenment without a Teacher, Verified by Hakuun Yasutani Roshi.* Los Angeles: Zen Center of Los Angeles, 1970.

Covell, Jon Carter. "Zen Gleanings." Unpublished manuscript, 1973.

Covell, Stephen G. *Japanese Temple Buddhism: Worldliness in a Religion of Renunciation.* Honolulu: University of Hawai'i Press, 2005.

Coverly, Dave. "Speed Bump," Oct. 1, 2004. http://www.thecomicstrips.com/store /add.php?iid=8437 (accessed April 7, 2014).

Cranston, Maurice. "Mixed Feelings about Zen." *The Sunday Times* (London), Feb. 9, 1959, 7.

Critchley, Simon. *On Humour.* London: Routledge, 2002.

Crooks, Edward J. "John Cage's Entanglement with the Ideas of Ananda Coomaraswamy." Ph.D. diss., University of York, 2001.

Croucher, Paul. *A History of Buddhism in Australia, 1848–1988.* Kensington: New South Wales University Press, 1989.

Danchev, Alex. *Georges Braque: A Life.* New York: Arcade Publishers, 2005.

Daniels, Dieter. "John Cage and Nam June Paik 'Change your mind or change your receiver (your receiver is your mind).'" In *Nam June Paik,* ed. Sook-Kyung Lee and Susanne Rennert, 107–125. London: Tate Publishing, 2010.

Danto, Arthur C. "Art." *The Nation,* Jan. 2, 1995, 26–29.

——. "Art." *The Nation,* Feb. 27, 1995, 284–288.

——. "Upper West Side Buddhism." In *Buddha Mind in Contemporary Art,* ed. Jacquelynn Baas and Mary J. Jacob, 49–61. Berkeley and Los Angeles: University of California Press, 2004.

"'Degrading' Film Angers Buddhists." *BBC News,* Sept. 13, 2004, http://news.bbc .co.uk/2/hi/south_asia/3651684.stm.

de Gruchy, John W. *Orienting Arthur Waley: Japonism, Orientalism, and the Creation of Japanese Literature in English.* Honolulu: University of Hawai'i Press, 2003.

"Den Indara hitsu Tanka shō mokubutsu zu." *Kokka* 173 (October 1904): 85–86.

Desser, David, ed. *Ozu's Tokyo Story.* Cambridge: Cambridge University Press, 1997.

Dharma Communications. "Dharma Communications." http://monasterystore.org /dharma-communications/ (accessed Jan. 19, 2016).

——. "Environmental Policy." http://www.dharma.net/monstore/mission.php (accessed July 3, 2014).

——. "Our Mission." http://monasterystore.org/our-mission/ (accessed July 27, 2015).

——. "The Monastery Store." http://monasterystore.org/zafu/ (accessed July 29, 2015).

——. *The Monastery Store, Spring–Summer 2014 Catalog.* Mount Tremper, NY: Dharma Communications, 2014.

Dickinson, Peter, ed. *Cage Talk: Dialogues with and about John Cage.* Rochester, NY: University of Rochester Press, 2006.

——. "Noise and Silence," review of *Silence* and *A Year from Monday* by John Cage, *The Musical Times* 109, no. 1509 (November 1968): 1026–1027.

DiValerio, David. *The Holy Madmen of Tibet.* Oxford: Oxford University Press, 2015.

Divelbess, Diane. "Zen and Art." In *Zen in American Life and Letters,* ed. Robert S. Ellwood, 33–49. Malibu, CA: Undena Publications, 1987.

Dōgen. *Shōbōgenzō zuimonki: Sayings of Eihei Dōgen Zenji, Recorded by Koun Ejō.* Translated by Shohaku Okumura, assisted by Daitsū Tom Wright. Kyoto: Kyōto Sōtō Zen Center, 1990.

Doris, David T. "Zen Vaudeville: A Medi(t)ation in the Margins of Fluxus." In *The

Fluxus Reader, ed. Ken Friedman, 91–135. Chichester, West Sussex: Academy Editions, 1998.

Dorrian, Steven and Amber. "Buddha Jokes: Do Dalai Lamas Laugh?" *Wisdom Quarterly,* June 15, 2011, http://wisdomquarterly.blogspot.com/2011/06/buddhist-jokes-do-dalai-lamas-laugh.html (accessed Feb. 5, 2016).

Dow, Arthur Wesley. "A Course in Fine Arts for Candidates for the Higher Degrees." *The Bulletin of the College Art Association of America* 1, no. 4 (September 1918): 117.

Downing, Michael. *Shoes Outside the Door: Desire, Devotion, and Excess at San Francisco Zen Center.* Washington, DC: Counterpoint, 2001.

Droit, Roger-Pol. *The Cult of Nothingness: The Philosophers and the Buddha.* Chapel Hill: University of North Carolina Press, 2003.

"Dudeism." www.dudeism.com (accessed July 15, 2015).

Dumoulin, Heinrich, S. J. *A History of Zen Buddhism.* Translated by Paul Peachey. New York: Pantheon Books, 1963.

Dun & Bradstreet. http://www.dnb.com (accessed June 7, 2015).

Dunn, Michael. *Inspired Design: Japan's Traditional Arts.* Milan: Five Continents Editions, 2005.

Dyer, Henry. *Dai Nippon, The Britain of the East, A Study in National Evolution.* London: Blackie & Son, 1904.

Eagles, Dyan. "Dharmacrafts." www.dharmacrafts.com (accessed July 30, 2015).

"eCig Zen." http://ecigzen.com (accessed Jan. 15, 2015).

Edwards, Osman. *Japanese Plays and Playfellows.* New York: John Lane, 1901.

Edwards, Walter. "Forging Tradition for a Holy War: The 'Hakkō Ichiu' Tower in Miyazaki and Japanese Wartime Ideology." *The Journal of Japanese Studies* 29, no. 2 (Summer 2003): 289–324.

E.H.S. Review of Hasumi Yoshimitsu, *Zen in Japanese Art: A Way of Spiritual Experience.* In *Journal of the American Oriental Society* 82, no. 2 (April–June 1962): 282.

Elinor, Robert. *Buddha and Christ: Images of Wholeness.* Cambridge: Lutterworth Press, 2000.

Eliot, Sir Charles. *Japanese Buddhism.* London: E. Arnold & Co., 1935.

Elison, George. *Deus Destroyed: The Image of Christianity in Early Modern Japan.* Cambridge, MA: Council on East Asian Studies, Harvard University, 1973.

Elkins, James. *On the Strange Place of Religion in Contemporary Art.* New York: Routledge, 2004.

Enen. "Zen in New York." *Zen Notes* 5, no. 10 (October 1958): n.p.

Fabian, Johannes. *Time and the Other: How Anthropology Makes Its Object.* New York: Columbia University Press, 1983.

Fader, Larry A. "Arthur Koestler's Critique of D. T. Suzuki's Interpretation of Zen." *The Eastern Buddhist,* n.s. 8, no. 2 (Autumn 1980): 46–72.

Fadiman, Anne. *At Large and at Small: Familiar Essays.* New York: Farrar, Straus & Giroux, 2007.

Farkas, Mary. "Let's Not Get Carried Away." *Zen Notes* 13, no. 9 (September 1966): n.p.

———. "That Way—Danger." *Zen Notes* 9, no. 10 (October 1962): n.p.

———. "Zen and Art." *Zen Notes* 12, no. 1 (January 1965): n.p.

———. "Zen, The Living Buddhism of Japan." *Zen Notes* 12, no. 6 (June 1965): n.p

Faubion, James D. *An Anthropology of Ethics.* Cambridge: Cambridge University Press, 2011.

Faure, Bernard. *Chan Insights and Oversights: An Epistemological Critique of the Chan Tradition.* Princeton, NJ: Princeton University Press, 1993.

——. *Double Exposure: Cutting across Buddhist and Western Discourses.* Translated by Janet Lloyd. Stanford, CA: Stanford University Press, 2004.

——. "A Grey Matter: Another Look at Buddhism and Neuroscience." *Tricycle: The Buddhist Review* 22, no. 2 (Winter 2012), http://www.tricycle.com/feature /scientific-buddha.

——. *The Rhetoric of Immediacy: A Cultural Critique of Chan/Zen Buddhism.* Princeton, NJ: Princeton University Press, 1991.

——. *Unmasking Buddhism.* Chichester, UK: Wiley-Blackwell, 2009.

——. *Visions of Power: Imagining Medieval Japanese Buddhism.* Princeton, NJ: Princeton University Press, 2000.

Fenollosa, Ernest F. *Epochs of Chinese and Japanese Art: An Outline History of East Asiatic Design.* New York: Stokes, 1913.

Fields, Rick. *How the Swans Came to the Lake: A Narrative History of Buddhism in America.* Boston: Shambhala Publications, 1986.

Fingesten, Peter. "Beat and Buddhist." *Christian Century,* Feb. 25, 1959, 226–227.

Fisher-Price. "Fisher-Price Zen Collection." http://www.fisher-price.com/fp .aspx?st=900004&e=storeProduct&pid=43982 (accessed July 3, 2014).

Fontein, Jan, and Money L. Hickman. *Zen Painting and Calligraphy.* Boston: Museum of Fine Arts, 1970.

Ford, James Ishmael. *Zen Master Who? A Guide to the People and Stories of Zen.* Boston: Wisdom Publications, 2006.

Foreman, Lisa. "Viktor and Rolf's Return to Couture for Fall 2013: Going Zen." *The Daily Beast,* July 3, 2013. http://www.thedailybeast.com/articles/2013/07/03 /viktor-rolf-s-return-to-couture-for-fall-2013-going-zen.html (accessed June 3, 2014).

"For the Gourmet." *The Sunday Times* (London), July 17, 1960, 33.

Foulk, T. Griffith. "The 'Ch'an School' and Its Place in the Buddhist Monastic Institution." Ph.D. diss., University of Michigan, 1987.

——. "The Denial of Ritual in the Zen Buddhist Tradition." *Journal of Ritual Studies* 27, no. 1 (2013): 47–58.

——. "Ensō." In A. Charles Muller, ed., *Digital Dictionary of Buddhism,* http://www .buddhism-dict.net/cgi-bin/xpr-ddb.pl?q=%E5%9C%93%E7%9B%B8 (accessed Aug. 3, 2015).

Frank, Adam. "Book Review: 'The Dude and the Zen Master.'" *All Things Considered,* Jan 16, 2013, http://www.npr.org/2013/01/16/169543638/book-review-the -dude-and-the-zen-master (accessed Jan. 19, 2013).

Fukui, Rikichiro. "A Landscape by Bunsei in the Boston Museum." *The Burlington Magazine for Connoisseurs* 41, no. 236 (November 1922): 218, 221, 223, 227.

Furlong, Monica. *Genuine Fake: A Biography of Alan Watts.* London: Heinemann, 1986.

Furuta, Shōkin. *Sengai: Master Zen Painter.* Tokyo: Kōdansha, 2000.

Gagosian Gallery, New York. "Takashi Murakami: Tranquility of the Heart, Torment of the Flesh—Open Wide the Eye of the Heart and Nothing is Invisible" (press release), April 19, 2007. http://www.gagosian.com/exhibitions/may-01-2007 --takashi-murakami (accessed February 24, 2012).

Gallagher, Catherine, and Stephen Greenblatt. *Practicing New Historicism.* Chicago: University of Chicago Press, 1997.

Gardner, K. B. Review of D. T. Suzuki, *Zen and Japanese Culture. The Burlington Magazine* 102 (1960): 459.

Garfinkle, Perry. "And If He Sees His Shadow. . . ." *Shambhala Sun,* July 2009, http:// www.shambhalasun.com/index.php?option=content&task=view&id=3379.

Gecker, Jocelyn. "Wirapol Sukphol, Jet-Set Buddhist Monk Shocks Thailand with

Religious Scandal." *Huffington Post,* July 18, 2013. http://www.huffingtonpost
.com/2013/07/18/thailand-riveted-by-jetse_n_3615742.html (accessed July 3, 2014).

Geist, Kathe. "Buddhism in *Tokyo Story.*" In *Ozu's Tokyo Story,* ed. David Desser,
101–117. Cambridge: Cambridge University Press, 1997.

Gentile, Emilio. *The Sacralization of Politics in Fascist Italy.* Translated by Keith
Botsford. Cambridge, MA: Harvard University Press, 1996.

Gilhus, Ingvild S. *Laughing Gods, Weeping Virgins: Laughter in the History of Reli-
gion.* London: Routledge, 1997.

Glueck, Grace. "Japan Art Fete Opens Here Tuesday." *New York Times,* March 19,
1966, 24.

Gluskin, Dawn. "Zen Rebel—Join the Movement." *Dawnsense,* Dec. 4, 2014. http://
www.dawngluskin.com/2014/12/04/zen-rebel/ (accessed Oct. 9, 2015).

Goddard, Dwight. *The Buddha's Golden Path: A Manual of Practical Buddhism
Based on the Teachings and Practices of the Zen Sect, But Interpreted and
Adapted to Meet Modern Conditions.* London: Luzac & Co., 1930.

———. *A Buddhist Bible: The Favorite Scriptures of the Zen Sect, History of Early
Buddhism, Self-Realization of Noble Wisdom, The Diamond Sutra, The Prajna
Paramita Sutra, The Sutra of the Sixth Patriarch.* Thetford, VT, 1932.

Goff, Joshua, et al. "Need for Speed: Algorithmic Marketing and Customer Data
Overload." *McKinsey & Company,* May 2012. http://www.mckinsey.com/client
_service/marketing_and_sales/latest_thinking/need_for_speed_algorithmic
_marketing_and_customer_data_overload (accessed July 11, 2014).

Goldberg, Michael, dir. *A Zen Life: D. T. Suzuki.* Toronto: Marty Gross Film Produc-
tions, 2006.

Gombrich, Richard F. *How Buddhism Began: The Conditions Genesis of the Early
Teachings.* London: Athlone Press, 1996.

Gomez, Edward M. "Kusama, in Her Words." *The Brooklyn Rail,* April 2, 2012.
http://www.brooklynrail.org/2012/04/art_books/kusama-in-her-own-words.

Goodyear, Dana. "Zen Master: Gary Snyder and the Art of Life." *The New Yorker,*
October 20, 2008, 66–75.

Google Books Ngram Viewer. https://books.google.com/ngrams (accessed Jan. 10,
2015).

Gotoh Bijutsukan. *Mokkei: Shōkei no suibokuga.* Tokyo: Gotoh Bijutsukan, 1996.

Gould, Stephen Jay, and Elizabeth J. Vrba. "Exaptation—A Missing Term in the Sci-
ence of Form." *Paleobiology* 8, no. 1 (Winter 1982): 4–15.

Graham, Ruth. "Modernism's Mystery Man." *Poetry Off the Shelf,* Sept. 23, 2013,
http://www.poetryfoundation.org/article/246458 (accessed Dec. 6, 2015).

Greey, Edward. *The Wonderful City of Tokio or Futher Adventures of the Jewett
Family and their Friend Oto Nambo.* Boston: Lee and Shepard Publishers, 1883.

Gregory, Peter N. *Tsung-Mi and the Sinification of Buddhism.* Honolulu: University
of Hawai'i Press, 2002.

Grelder, Brett. "Academic Buddhology and the Cyber-Sangha: Researching and
Teaching Buddhism on the Web." In *Teaching Buddhism in the West: From the
Wheel to the Web,* ed. Victor Sōgen Hori et al., 212–234. London: RoutledgeCur-
zon, 2002.

Grieve, Gregory Price. "A Virtual Bodhi Tree: Untangling the Cultural Context and
Historical Genealogy of Digital Buddhism." In *Buddhism, The Internet, and Digi-
tal Media: The Pixel in the Lotus,* ed. Gregory Price Grieve and Daniel Veidlinger,
93–113. New York: Routledge, 2015.

Grimes, Ronald L. "Zen and the Art of Not Teaching Zen and the Arts: An Autopsy."
In *Teaching Buddhism in the West: From Wheel to the Web,* ed. Victor Sōgen
Hori et al., 155–169. London: RoutledgeCurzon, 2002.

Grimshaw, Mike. "Encountering Religion: Encounter, Religion, and the Cultural Cold War, 1953–1967." *History of Religions* 51, no. 1 (August 2011): 31–58.

Groenig, Matt. "She of Little Faith." *The Simpsons,* episode 6, season 13, 2001.

Guth, Christine M. E. *Art, Tea, and Industry: Masuda Takashi and the Mitsui Circle.* Princeton, NJ: Princeton University Press, 1993.

———. "Hasegawa's Fairy Tales: Toying with Japan." *RES: Anthropology and Aesthetics* 53/54 (Spring–Autumn, 2008): 266–281.

Gutiérrez-Baldoquín, Hilda, ed. *Dharma, Color, and Culture: New Voices in Western Buddhism.* Berkeley, CA: Parallax Press, 2004.

Hacking, Ian. *The Social Construction of What?* Cambridge, MA: Harvard University Press, 2000.

Haito, Masahiko. "'En' to sono ato." In Osaka Shiritsu Kindai Bijutsukan Kensetsu Junbishitsu, *Yoshihara Jirō ten: Tanjō 100 nen ki'nen,* 187. Osaka: Asahi Shinbun, 2005.

Hakuin Ekaku. *Wild Ivy: The Spiritual Autobiography of Zen Master Hakuin.* Translated by Norman Waddell. Boston: Shambhala, 1999.

Halperin, Mark. *Out of the Cloister: Literati Perspectives on Buddhism in Song China, 960–1279.* Cambridge, MA: Harvard University Asia Center, 2006.

Handy, P., ed. *The Official Directory of the World's Columbian Exposition.* Chicago: W. B. Conkey Company, 1893.

Hanlon, Mike. "zaZen shows new ways to automotive enlightenment." *Gizmag,* Dec. 20, 2005. http://www.gizmag.com/go/4939/ (accessed March 9, 2014).

Harada, Jirō. *The Gardens of Japan.* Translated by C. Geoffrey Holme. London: Studio Ltd., 1928.

Harootunian, Harry. "Postwar America and the Aura of Asia." In *The Third Mind: American Artists Contemplate Asia, 1860–1989,* ed. Alexandra Munroe, 45–55. New York: Guggenheim Museum Publications, 2009.

Harrison, Max. "Recitals." *The Musical Times* 110, no. 1520 (October 1969): 1055.

Hartmann, Sadakichi. *Japanese Art.* London: G. P. Putnam's Sons, 1904.

Haskins, Rob. *John Cage.* London: Reaktion Books, 2012.

Hasumi, Toshimitsu. *Zen in Japanese Art: A Way of Spiritual Experience.* London: Routledge & Kegan Paul, 1962.

Hatcher, John. *Laurence Binyon: Poet, Scholar of East and West.* Oxford: Clarendon, 1995.

Hayakawa, Sessue. *Zen Showed Me the Way to Peace, Happiness, and Tranquility.* London: Allen & Unwin, 1960.

Headquarters of the Soto Zen Sect. *Zen: The Way to A Happy Life.* Tokyo: Headquarters of the Soto Zen Sect, 1962.

Heard, Gerald. "On Learning from Buddha," *New York Times,* June 4, 1950, BR3.

Heidegger, Martin, and Shin'ichi Hisamatsu. "Die Kunst und das Denken. Protokoll eines Colloquiums." In *Japan und Heidegger: Gedenkschrift der Stadt Messkirch zum hundersten Geburstag Martin Heideggers,* ed. Hartmut Buchner, 211–215. Sigmaringen: J. Thorbecke, 1989.

Heine, Steven. *Zen Skin, Zen Marrow: Will the Real Zen Buddhism Please Stand Up?* Oxford: Oxford University Press, 2008.

Hellstein, Valerie. "The Cage-iness of Abstract Expressionism." *American Art* 28, no. 1 (Spring 2014): 56–77.

Hepburn, James C. *Waego rinshūsei* (1867). http://www.meijigakuin.ac.jp/mgda/index.html (accessed Feb. 24, 2012).

Herman, Barbara. *Scent and Subversion: Decoding a Century of Provocative Perfume.* Guilford, CT: Lyons Press, 2013.

———. "Yesterday's Perfumes: A Blog for Vintage Perfumaniacs," Oct. 14, 2009.

http://yesterdaysperfume.typepad.com/yesterdays_perfume/2009/10/shiseido-zen-1964.html (accessed May 1, 2014).

Herrigel, Eugen. *Zen in the Art of Archery.* New York: Pantheon Books, 1953.

Hershock, Peter D. *Buddhism in the Public Sphere: Reorienting Global Interdependence.* London: Routledge, 2006.

Heuman, Linda. "Context Matters: An Interview with Buddhist Scholar David McMahan." *Tricycle: The Buddhist Review* (Winter 2013): 44.

Hickey, Wakoh Shannon. "Two Buddhisms, Three Buddhisms, and Racism." *Journal of Global Buddhism* 11 (2010): 2–25.

Higgins, Hannah. *Fluxus Experience.* Berkeley: University of California Press, 2002.

Hinüber, Oskar von. "Everyday Life in an Ancient Indian Monastery." *Annual Report of the International Research Institute for Advanced Buddhology at Soka University* 9 (2006): 3–31.

Hisamatsu Shin'ichi. "On Zen Art." *The Eastern Buddhist* 1, no. 2 (September 1966), 28–32. Published originally as "Zen geijutsu no rikai." In Hisamatsu Shin'ichi, *Tōyōteki mu.* Kyoto: Kōbundō, 1939.

———. "Seven Characteristics of Zen Art by Hoseki Shin'ichi Hisamatsu." *It is* 5 (Spring 1960): 62–64.

———. *Zen and the Fine Arts.* Translated by Gishin Tokiwa. New York: Kodansha International, 1971.

———. "Zen to shogei." *Zen Bunka* 14 (January 1959): 11–15.

———. "Zen to Tōyō bunka." *Zengaku kenkyū* 34 (November 1940): 1–8.

Hockley, Alan. "The Zenning of Shikō Munakata." *Impressions* 26 (2004): 77–87.

Hoffman, Yoel. *Every End Exposed: The 100 Koans of Master Kidō with the Answers of Hakuin-Zen, Translated, with a Commentary.* Brookline, MA: Autumn Press, 1977.

Hofstadter, Douglas. *Gödel, Escher, Bach: An Eternal Golden Braid.* Hassocks, Sussex: Harvester Press, 1979.

Hokenson, Jan. *Japan, France, and East-West Aesthetics: French Literature, 1867–2000.* Madison, WI: Fairleigh Dickinson University Press, 2004.

Holmes, Stewart W., and Chimyo Horioka. *Zen Art for Meditation.* Rutland, VT: Charles E. Tuttle Co., 1973.

Hu Shih. "Ch'an (Zen) Buddhism In China, Its History and Method." *Philosophy East and West* 3, no. 1 (April 1953): 3–24.

———. "Development of Zen Buddhism in China." *The Chinese Social and Political Science Review* 15 (April 1931): 475–505.

Huang Po (Huangbo). *The Huang Po Doctrine of Universal Mind: Being the Teaching of Dhyana Master Hsi Yun as Recorded by P'ei Hsiu, a Noted Scholar of the T'ang Dynasty.* Translated by Chu Ch'an (John Blofeld). London: Buddhist Society, 1947.

Huang, Yunte. *Transpacific Imaginations: History, Literature, Counterpoetics.* Cambridge, MA: Harvard University Press, 2008.

Hugh-Jones, Siriol. "Victims of Spring." *The Sunday Times* (London), March 29, 1959, 13.

Humphreys, Christmas. "No Stink of Zen: A Reply to Koestler." *Encounter* (December 1960), 57–58.

———. *Sixty Years of Buddhism in England (1907–1967): A History and a Survey.* London: The Buddhist Society, 1968.

———. *Zen Buddhism.* London: William Heinemann, 1949.

———. "Zen Comes West." *The Middle Way* 32, no. 4 (February 1958): 126–130.

Huyssen, Andreas. "Back to the Future: Fluxus in Context." In *In the Spirit of Fluxus,* ed. Simon Anderson et al., 141–151. Minneapolis: Walker Art Center, 1993.

Hyers, Conrad M., ed. *Holy Laughter: Essays on Religion and the Comic Perspective.* New York: Seabury Press, 1969.

——. "Humor in Zen: Comic Midwifery." *Philosophy East and West* 39, no. 3 (1989): 267–277.

——. *The Laughing Buddha: Zen and the Comic Spirit.* Wolfeboro, NH: Longwood Academic, 1989.

Hyun, Peter. "Beat Zen, Square Zen: An Eastern Dissent." *Encounter* (July 1959), 56–57.

Idemitsu Bijutsukan. *Tanjō 260 nen, Sengai: Zen to yūmoa.* Tokyo: Idemitsu Bijutsukan, 2010.

Idemitsu Shōsuke. "Chichi, Idemitsu Sazō to Sengai." *Sadō zasshi* 62, no. 2 (February 1998): 22–27.

Ikemoto, Takashi. "Zen Enlightenment without a Teacher: The Case of Mrs. Courtois, an American." *Psychologia: An International Journal of Psychology in the Orient* 14, no. 2 (1971): 71–76.

Inaga, Shigemi. "Is Art History Globalizable? A Critical Commentary from a Far Eastern Point of View." In *Is Art History Global?* ed. James Elkins, 249–279. London: Routledge, 2007.

Inagaki, Zuiken Saizō. "Letters from Zuiken Sensei to the Reverend Jack Austin." *The Teaching of Zuiken,* http://www.nembutsu.info/horai/letters_ja1.htm (accessed Dec. 14, 2015).

Inoue, Shin'ichi. *Putting Buddhism to Work: A New Approach to Management and Business.* Translated by Duncan Ryuken Williams. Tokyo: Kodansha International, 1997.

Inouye, Rei Okamoto. "Theorizing Manga: Nationalism and Discourse on the Role of Wartime Manga." *Mechademia* 4 (2009): 20–37.

"In Transition: Mary Farkas (1911–1992)." *Tricycle* (Fall 1992), http://www.tricycle.com/transition/mary-farkas (accessed March 11, 2016).

Iriya Yoshitaka and Koga Hidehiko. *Zengo jiten.* Kyoto: Shibunkaku Shuppan, 1991.

Irizarry, Joshua A. "Putting a Price on Zen: The Business of Redefining Religion for Global Consumption." *Journal of Global Buddhism* 16 (2015): 51–69.

Irons, Evelyn. "'Experience' Drug Alarms U.S. Doctors." *The Sunday Times* (London), Aug. 18, 1963, 2.

Ives, Christopher. *Imperial-Way Zen: Ichikawa Hakugen's Critique and Lingering Questions for Buddhist Ethics.* Honolulu: University of Hawai'i Press, 2009.

——. "True Person, Formless Self: Lay Zen Master Hisamatsu Shin'ichi." In *Zen Masters,* ed. Steven Heine and Dale S. Wright, 217–238. Oxford: Oxford University Press, 2010.

Ivy, Marilyn. *Discourses of the Vanishing: Modernity, Phantasm, Japan.* Chicago: University of Chicago Press, 1995.

——. Review of *Little Boy: The Arts of Japan's Exploding Subculture.* Edited by Takashi Murakami. New York and New Haven, CT: Japan Society and Yale University Press, 2005. *The Journal of Japanese Studies* 32, no. 2 (2006): 498–502.

Iwamura, Jane N. *Virtual Orientalism: Asian Religions and American Popular Culture.* Oxford: Oxford University Press, 2011.

Jackson, Shannon. *Social Works: Performing Art, Supporting Publics.* New York: Routledge, 2011.

Jaffe, Richard M. "Introduction." In Daisetsu Teitarō Suzuki, *Selected Works of D. T. Suzuki Volume 1: Zen,* ed. Richard M. Jaffe, xi–lvi. Berkeley: University of California Press, 2014.

——. "Introduction to the 2010 Edition." In Daisetz T. Suzuki, *Zen and Japanese Culture,* vii–xxviii. Princeton, NJ: Princeton University Press, 2011.

Jain, Andrea R. *Selling Yoga: From Counterculture to Pop Culture.* Oxford: Oxford University Press, 2015.

James, Simon P. *Zen Buddhism and Environmental Ethics*. Aldershot, UK: Ashgate, 2004.

Jameson, Frederic. *Postmodernism, or, The Cultural Logic of Late Capitalism*. Durham, NC: Duke University Press, 1991.

The Japanese Commission. *Official Catalogue of the Japanese Section, and Descriptive Notes on the Industry and Agriculture of Japan*. Philadelphia: The Japan Commission, 1876.

Jarrell, Randall. *Pictures from an Institution: A Comedy*. New York: Alfred A. Knopf, 1955.

Jarves, James J. *A Glimpse at the Art of Japan*. New York: Hurd and Houghton, 1876.

Jenkins, Bruce. "Fluxfilms in Three False Starts." In *In the Spirit of Fluxus,* ed. Simon Anderson et al., 122–139. Minneapolis: Walker Art Center, 1993.

Jensen, Marc G. "John Cage, Chance Operations, and the Chaos Game: Cage and the *I ching*." *The Musical Times* 150, no. 1907 (Summer 2009): 97–102.

Jerryson, Michael K., and Mark Juergensmeyer, eds. *Buddhist Warfare*. New York: Oxford University Press, 2010.

Jia, Jinhua. *The Hongzhou School of Chan Buddhism in Eighth- through Tenth-Century China*. Albany: SUNY Press, 2006.

"Jikkai." *Digital Dictionary of Buddhism*. http://www.buddhism-dict.net/cgi-bin/xpr-ddb.pl?q=%E5%8D%81%E6%88%92 (accessed July 23, 2015).

Johnson, Ken. *Are You Experienced? How Psychedelic Consciousness Transformed Modern Art*. Munich: Prestel, 2011.

Joly, Henri L. *Legend in Japanese Art: A Description of Historical Episodes, Legendary Characters, Folk-Lore, Myths, Religious Symbolism*. London: John Lane, 1908.

Jorodo. "Zen clinic." Search ID: jdo 0202, Cartoonstock.com (accessed July 9, 2014).

Joskovich, Erez. "Genjō kōan" (article). In Muller, ed., *Digital Dictionary of Buddhism*. http://www.buddhism-dict.net/cgi-bin/xpr-ddb.pl?q=%E7%8F%BE%E6%88%90%E5%85%AC%E6%A1%88 (accessed July 30, 2015).

Juniper, Andrew. *Wabi Sabi: The Japanese Art of Impermanence*. Boston, Rutland, and Tokyo: Tuttle Publishing, 2003.

Kageyama Kōichi. "Yoshihara Jirō 'Kuroji ni akai en'": Mugen ni fukuzatsu na imeji, Inui Yoshiaki." *Artscape,* Aug. 15, 2009, http://artscape.jp/study/art-archive/1207412_1983.html.

Kanai, Gen. "Sick and Tired of Murakami Takashi." In *Gen Kanai Weblog,* May 7, 2007. http://www.kanai.net/weblog/archive/2007/05/07/19h26m04s (accessed Oct. 15, 2015).

Kang, Stephanie. "Style and Substance: Pop Culture Gets Religion; Whether Reverent or Ironic, Christianity Has Become Cool; 'Homeboy' T's Speak to Teens." *The Wall Street Journal,* May 5, 2004, B1.

"Kanko yodan (chū) (Bijutsu Kyōkai no tenrankai)." *Asahi shinbun,* May 26, 1907, 5.

Kapleau, Philip. "Report from a Zen Monastery. 'All Is One, One is None, None is All' . . ." *New York Times,* March 6, 1966, 76–78, 80–81, 84.

——. *The Three Pillars of Zen: Teaching, Practice, and Enlightenment*. New York: Harper & Row, 1966.

Karan, Donna. *Urban Zen*. https://www.urbanzen.com/pages/our-story (accessed Nov. 21, 2015).

Karatani, Kōjin. "Uses of Aesthetics: After Orientalism." Translated by Sabu Kohso, *boundary 2* 25, no. 2 (Summer 1998): 145–160.

Kasamatsu, Akira, and Tomio Hirai. "An Electroencephalographic Study of the Zen Meditation (Zazen)." *Psychologia: An International Journal of Psychology in the Orient* 12, no. 3–4 (December 1969): 205–225.

——. "Science of Zen." *Psychologia: An International Journal of Psychology in the Orient* 6, no. 1–2 (March–June 1963): 86–91.

Katahira-Manabe, Miyuki. "Review: *The Art of Japanese Gardens* by Loraine E. Kuck." *The Journal of the North American Japanese Garden Association* 1 (2013): 60–61.

Kataoka, Drue, and Bill Fenwick. "7 Principles of Zen Aesthetics." In *Valley Zen: At the Intersection of Zen, Modern Life and Technology* (blog), http://www.valleyzen.com/about-valley-zen.htm (accessed July 1, 2014).

Kawakita Michiaki, ed. "Burakku to Tōyō." *Atorie* (Oct, 1952): 3–11.

——. *1st Japan Art Festival.* Tokyo: Japan Art Festival Association, 1966.

Kay, David N. *Tibetan and Zen Buddhism: Transplantation, Development, and Adaptation.* London: RoutledgeCurzon, 2004.

Kaza, Stephanie. "Overcoming the Grip of Consumerism." *Buddhist-Christian Studies* 20 (2000): 23–42.

Keane, David. "Cartoon Violence and Freedom of Expression." *Human Rights Quarterly* 30, no. 4 (2008): 845–875.

Keating, H. R. F. *Zen There Was Murder.* London: Victor Gollancz, 1960.

Keene, Donald. "What Is Japanese Art?" *Art News* 58, no. 1 (March 1959): 40–43.

Kennett, Jiyu. *Zen Is Eternal Life.* Emeryville, CA: Dharma Press, 1976.

Kerouac, Jack. *The Dharma Bums.* New York: Viking Press, 1958.

Kieschnick, John. *The Impact of Buddhism on Chinese Material Culture.* Princeton, NJ: Princeton University Press, 2003.

Kikuchi, Yuko. *Japanese Modernisation and* Mingei *Theory: Cultural Nationalism and Oriental Orientalism.* London: RoutledgeCurzon, 2004.

King, Richard. *Orientalism and Religion: Postcolonial Theory, India and 'The Mystic East.'* London: Routledge, 1999.

King, Sallie B. *Socially Engaged Buddhism.* Honolulu: University of Hawai'i Press, 2009.

Kinoshita Masao. "Tankazan: Tanka shōbutsu no kochi." *Zen bunka* 99 (December 1980): 50–52.

Kirchner, Thomas Y., trans. *Entangling Vines: Zen Koans of the Shūmon Kattoshū.* Kyoto: Tenryūji Institute for Philosophy and Religion Kyoto, 2004.

——, ed. *The Record of Linji.* Translated by Ruth Fuller Sasaki. Honolulu: University of Hawai'i Press, 2008.

——, comp. "Zen Centers of the World: Country Index." International Zen Research Institute, Hanazono University, http://iriz.hanazono.ac.jp/zen_centers/country_list_e.html.

Kirita, Kiyohide. "D. T. Suzuki on Society and the State." In *Rude Awakenings: Zen, the Kyoto School, and the Question of Nationalism,* ed. James W. Heisig and John C. Maraldo, 52–74. Honolulu: University of Hawai'i Press, 1994.

Klein, Allen. "Zen Humor: From Ha-Ha to Ah-Hah." http://www.allenklein.com/articles/zenhumor.htm (accessed March 11, 2016).

Klein, Christina. *Cold War Orientalism: Asia in the Middlebrow Imagination, 1945–1961.* Berkeley: University of California Press, 2003.

Klein, Naomi. *No Logo.* New York: Picador, 2002.

Kobori Sōhaku Nanrei. "A Dialogue: A Discussion between One and Zero." *The Eastern Buddhist,* o.s. 8, no. 3 (1957): 43–49, and n.s. 8, 4 (1958): 35–40.

Koch, Christof. "Neuroscientists and the Dalai Lama Swap Insights on Meditation." *Scientific American,* June 6, 2013. http://www.scientificamerican.com/article/neuroscientists-dalai-lama-swap-insights-meditation/ (accessed March 12, 2014).

Koestler, Arthur. *The Lotus and the Robot.* New York: The MacMillan Co., 1961.

——. "Neither Lotus nor Robot." *Encounter* (February 1961), 58–59.

——. "A Stink of Zen: The Lotus and the Robot (II)." *Encounter* (October 1960), 13–32.

"Kokka sangatsu gō," *Asahi shinbun,* March 23, 1916, 6.

Koné, Alioune. "Zen in Europe: A Survey of the Territory." *Journal of Global Buddhism* 2 (2001): 139–161.

Kostelanetz, Richard. *Conversing with Cage.* New York: Limelight Editions, 1988.

——, ed. *John Cage: An Anthology.* New York: Da Capo Press, 1991.

KPFA. "KPFA Participants: Alan W. Watts." *KPFA Folio,* Oct. 12, 1958, 1, 12.

Kripal, Jeffrey J. *Esalen: America and the Religion of No Religion.* Chicago: University of Chicago Press, 2007.

Kristof, Nicholas. "The Dalai Lama Gets Mischievous." *New York Times,* July 16, 2015, http://www.nytimes.com/2015/07/16/opinion/nicholas-kristof-dalai-lama-gets-mischievous.html?ref=opinion (accessed July 16, 2015).

Kuck, Loraine E. *The Art of Japanese Gardens.* New York: John Day Co., 1940.

——. *One Hundred Kyoto Gardens.* London: Kegan Paul, Trench, Trubner & Co., 1936.

Kunzru, Hari. *Gods without Men.* New York: Vintage Contemporaries, 2011.

Kuwabara Sumio, "Surechigai no taiwa: Nichibei bijutsu kōryū no kōzō." In Kuwabara Sumio, *Bijutsu ronshū: Nihon hen,* 36–49. Tokyo: Okisekisha, 1995.

Kyōtofu. "Kyōtofu jiin jūhō chōsa" (1941–1945). Kyōto Furitsu Sōgō Shiryōkan, Kyoto.

Kyōtofu kaku shaji hōmotsu mokuroku: Atago-gun (1880s–1890s). Tōkyō Kokuritsu Hakubutsukan Shiryōkan (microfilm 6831 204).

Lachman, Charles H. "Art." In *Critical Terms for the Study of Buddhism,* ed. Donald S. Lopez Jr., 37–55. Chicago: University of Chicago Press, 2005.

——. "Chan Art." In *Encyclopedia of Buddhism,* ed. Robert E. Buswell Jr., 1:125–130. New York: Thomson Gale, 2004.

Langford, Jean. *Fluent Bodies: Ayurvedic Remedies for Postcolonial Imbalance.* Durham, NC: Duke University Press, 2002.

Larson, Kay. *Where the Heart Beats: John Cage, Zen Buddhism, and the Inner Life of Artists.* New York: Penguin Press, 2012.

Law, P. B. "'Mindful' Ousts 'Zen' as Top Buddhist Buzzword." *Buddhist Humor,* http://www.buddhisthumor.org/pblaw_fictions.html#mindful.

Lears, T. J. Jackson. *No Place of Grace: Antimodernism and the Transformation of American Culture.* Chicago: University of Chicago Press, 1981.

Lee, Barbara M. *Forgetting the Art World.* Cambridge, MA: MIT Press, 2012.

Lee, Judith Yaross. *Defining* New Yorker *Humor.* Jackson: University Press of Mississippi, 2000.

Lee, Sook-Kyung. "*Videa 'n' Videology* Open Communication." In *Nam June Paik,* ed. Sook-Kyung Lee and Susanne Rennert, 27–34. London: Tate Publishing, 2010.

Lee, Sook-Kyung, and Susanne Rennert, eds. *Nam June Paik.* London: Tate Publishing, 2010.

Leggett, Trevor. *A First Zen Reader.* Tokyo, Rutland, VT: C. E. Tuttle, 1960.

Levin, Gail. "Action Painting: Perspectives from Two Sides of the Atlantic." *Art Journal* 67, no. 4 (Winter 2008): 119–121.

Levine, Gregory. "Critical Zen Art History." *Journal of Art Historiography* 15 (December 2016). https://arthistoriography.wordpress.com (accessed April 9, 2017).

——. *Daitokuji: The Visual Cultures of a Zen Monastery.* Seattle: University of Washington Press, 2005.

Levine, Gregory, and Yukio Lippit, eds. *Awakenings: Zen Figure Paintings in Medieval Japan*. New York: Japan Society Gallery in Association with Yale University Press, 2007.

Lewis, Paul. *Cracking Up: American Humor in a Time of Conflict*. Chicago: University of Chicago Press, 2006.

Light, Stephen. *Shuzo Kuki and Jean-Paul Satre: Influence and Counter-influence in the Early History of Phenomenology*. Carbondale: Southern Illinois University Press, 1987.

Linssen, Robert. *Living Zen*. London: Allen & Unwin, 1958.

Lippit, Yukio. "Awakenings: The Development of the Zen Figural Pantheon." In *Awakenings: Zen Figure Paintings in Medieval Japan,* ed. Gregory Levine and Yukio Lippit, 35–51. New York: Japan Society Gallery in Association with Yale University Press, 2007.

———. "Of Modes and Manners in Japanese Ink Painting: Sesshū's *Splashed Ink Landscape* of 1495." *The Art Bulletin* 94, no. 1 (March 2012): 50–77.

———. *Painting of the Realm: The Kanō House of Painters in the Seventeenth Century*. Seattle: University of Washington Press, 2012.

Loori, John Daido. *Being Born as the Earth: Buddhism and Ecology* (video). Lewisburg, PA: n.p., 1992.

———. *The Eight Gates of Zen: Spiritual Training in an American Zen Monastery*. Mount Tremper, NY: Dharma Communications, 1992.

———. "The Precepts and the Environment." In *Buddhism and Ecology: The Interconnection of Dharma and Deeds,* ed. Mary Evelyn Tucker and Duncan Ryūken Williams, 177–184. Cambridge, MA: Harvard University Center for the Study of World Religions, 1997.

———. "River Seeing the River." In *Dharma Rain: Sources of Buddhist Environmentalism,* ed. Stephanie Kaza and Kenneth Kraft, 141–150. Boston: Shambhala Publications, 2000.

———. "The Sacredness of Work." In Dharma Communications, *Mountain Record of Zen Talks* (1988). Reprinted in Claude Whitmyer, ed., *Mindfulness and Meaningful Work: Explorations in Right Livelihood,* 31–35. Berkeley, CA: Parallax Press, 1994.

———. *Zen Mountain Monastery Liturgy Manual*. Mount Tremper, NY: Mountains and Rivers Order, 1998.

Loori, John Daido, Maureen Jisho Ford, and Robert Tokushu Senghas. *Zen Practice at Home* (sound recording). Mount Tremper, NY: Dharma Communications, 1980.

Lopez Jr., Donald S., ed. *A Modern Buddhist Bible: Essential Readings from East and West*. Boston: Beacon Press, 2002

———. *Prisoners of Shangri-La: Tibetan Buddhism and the West*. Chicago: University of Chicago Press, 1998.

———. "The Scientific Buddha: Why Do We Ask That Buddhism Be Compatible with Science?" *Tricycle: The Buddhist Review* 22, no. 2 (Winter 2012), http://www.tricycle.com/feature/scientific-buddha (accessed Jan. 15, 2016).

Low, Sor-Ching. "Seung Sahn: The Makeover of a Modern Zen Patriarch." In *Zen Masters,* ed. Steven Heine and Dale S. Wright, 267–285. Oxford: Oxford University Press, 2010.

Loy, David R. *Healing Deconstruction: Postmodern Thought in Buddhism and Christianity*. Atlanta: Scholars Press, 1996.

———. *Money, Sex, War, Karma: Notes for a Buddhist Revolution*. Boston: Wisdom Publications, 2008.

——. "The Religion of the Market." *Journal of the American Academy of Religions* 65, 2 (Summer 1997): 275–290.

Loy, David R., and Jonathan Watts. "The Religion of Consumption: A Buddhist Perspective." *Development* 41, no. 1 (March 1998): 61–66.

Lussier, Mark S. "Preface." In John G. Rudy, *Romanticism and Zen Buddhism*, xi. Lewiston, NY: The Edwin Mellon Press, 2004.

——. *Romantic Dharma: The Emergence of Buddhism into Nineteenth-Century Europe*. New York: Palgrave Macmillan, 2011.

Lutz, Tom. *American Nervousness, 1903: An Anecdotal History*. Ithaca, NY: Cornell University Press, 1991.

Lyford, Amy. *Isamu Noguchi's Modernism: Negotiating Race, Labor, and Nation, 1930–1950*. Berkeley: University of California Press, 2013.

MacKenzie, John M. *Orientalism: History, Theory, and the Arts*. Manchester, UK: Manchester University Press, 1995.

Macy's Department Store. "Gifts of Beauty from the Exotic East . . . Zen Fragrance at Macy's." *New York Times*, December 21, 1966, 9.

——. "Macy's Far East Festival." *New York Times*, September 7, 1966, 27.

——. "Uncommon Scents . . . Unforgettable Gifts." *New York Times*, December 12, 1966, 17.

Mahoney, Stephen. "The Prevalence of Zen." *The Nation*, Nov. 1, 1958, 311–315.

Maraldo, John C. "Is There Historical Consciousness within Ch'an?" *Japanese Journal of Religious Studies* 12, nos. 2/3 (1985): 141–172.

Marie, Annika. "Ad Reinhardt: Mystic or Materialist, Priest or Proletarian?" *The Art Bulletin* 96, no. 4 (December 2014): 463–484.

Maruyama, Shin'ichi. "Statement." *Maruyama Shin'ichi*. http://www.shinichimaruyama .com/statement (accessed December 6, 2015).

Marx, Eberhard, et al. *Zenga: Malerei des Zen-Buddhismus in Japan, 17.–19. Jahrhundert*. Berlin: Haus am Waldsee, 1959.

Masatsugu, Michael K. "'Beyond This World of Transiency and Impermanence': Japanese Americans, Dharma Bums, and the Making of American Buddhism during the Early Cold War Years." *Pacific Historical Review* 77, no. 3 (August 2008): 423–451.

Masters, Robert E. L., and Jean Houston. *Psychedelic Art*. New York: Grove Press, 1968.

Masunaga, Reihō. *A Primer of Sōtō Zen: A Translation of Dōgen's Shōbōgenzō zuimonki*. Honolulu: East–West Center Press, 1971.

——. Review of *Zen for the West* by Ogata Sōhaku. *Contemporary Religions in Japan* 1, no. 3 (September 1960): 68–69.

——. *The Sōtō Approach to Zen*. Tokyo: Layman Buddhist Society Press, 1958.

——. "Western Interest in Zen." *Indogaku Bukkyōgaku kenkyū* (*Journal of Indian and Buddhist Studies*) VII, no. 2 (March 1960): 753–757.

——. "Zen of Vital Freedom." *Komazawa Daigaku kenkyū kiyō* 18 (March 1960): 1–13.

Masuzawa, Tomoko. *The Invention of World Religions: Or, How European Universalism Was Preserved in the Language of Pluralism*. Chicago: University of Chicago Press, 2005.

Mathur, Saloni. *India by Design: Colonial History and Cultural Display*. Berkeley: University of California Press, 2007.

Matsui, Midori. "Beyond the Pleasure Room to a Chaotic Street: Transformations of Cute Subculture in the Art of the Japanese Nineties." In *Little Boy: The Arts of Japan's Exploding Subculture*, ed. Murakami Takashi, 209–239. New York and New Haven, CT: Japan Society and Yale University Press, 2005.

———. "Toward a Definition of Tokyo Pop: The Classical Transgressions of Takashi Murakami." In *Takashi Murakami: The Meaning of the Nonsense of the Meaning,* ed. Amanda Cruz et al., 20–29. New York: Harry N. Abrams, 1999.

McCormick, Seth, et al. "Exhibition as Proposition: Responding Critically to *The Third Mind.*" *The Art Journal* 68, no. 3 (Fall 2009): 30–51.

McMahan, David L. *The Making of Buddhist Modernism.* Oxford: Oxford University Press, 2008.

Media Site Mercedes-Benz Japan. "'A 45 AMG 4MATIC' *orijinaru Web mu-bi-kōkai.*" *Daimler, Media Site Mercedes-Benz Japan.* http://media.daimler.com /dcmedia-jp/0-1119-1231664-81-1647551-1-0-0-0-0-0-0-1231603-0-1-0-0-0-0-0 .html (accessed March 12, 2014).

Melby, Caleb, Forbes LLC, and Jess3, *The Zen of Steve Jobs.* Hoboken, NJ: John Wiley & Sons, 2012.

Mercedes-Benz. "Welcome 2011 Super Bowl." http://www.youtube.com/watch?v =MSQCbWmJ8kU (accessed March 12, 2014).

Mercedes-Benz, Japan. "Press Information: The Mercedes-Benz A 45 AMG 4MATIC Web Video." http://www.mercedes-benz.jp/news/release/2013/20131107_e.pdf (accessed Jan. 15, 2016).

———. "Zazen vs. Mercedes A45 AMG." http://www.mojvideo.com/video-mercedes -benz-a-45-amg-2014-vs-zazen/de5e997f3f0cdc7748d8 (accessed Feb. 1, 2016).

"Mercedes Benz Monk Ad Australian Actor Kim Chan.flv." http://www.youtube .com/watch?v=ldC6kC_G80E (accessed March 9, 2014).

Merholz, Peter. "Zen is not for value judgments." *Peterme.com,* November 20, 2005 (accessed Dec. 4, 2011). http://www.peterme.com/archives/000644.html (accessed Feb. 24, 2012).

Merton, Thomas. *Zen and the Birds of Appetite.* New York: New Directions, 1968.

"Merusedesu ga zazen o kumu sōryō no mae ni sassō tōjo, nōha sokutei ga 'mu' no kyōchi de nani ga okita no ka o tsuini akiraka ni." *Gigazine,* Nov. 15, 2013. http:// gigazine.net/news/20131115-mercedes-zazen/ (accessed March 14, 2014).

Michel, Jean-Baptiste, et al. "Quantitative Analysis of Culture Using Millions of Digitized Books." *Science* 331, no. 6014 (Dec. 16, 2010): 176–182.

Mitter, Partha. *The Triumph of Modernism: India's Artists and the Avant-garde, 1922–1947.* London: Reaktion Books, 2007.

Mochizuki Shinkō. "Preface." In Tonomura Taijirō, *Tenryūshan sekkutsu,* no pages. Tokyo: Kaneo Bun'endō, 1922.

Mok, Amanda. "Fashion Reveal: Zen." *The Fashionide,* Sept. 6, 2013. http:// fashionide.com/viktor-rolf-couture-fall-winter-2013-paris/ (accessed June 1, 2014).

Moon, Susan. *The Life and Letters of Tofu Roshi.* Boston: Shambhala, 1988.

Morgan, David. *Visual Piety: A History and Theory of Popular Religious Images.* Berkeley: University of California Press, 1998.

Mori, Maryellen T. "The Splendor of Self-Exhaltation: The Life and Fiction of Okamoto Kanoko." *Monumenta Nipponica* 50, no. 1 (Spring 1995): 67–102.

Mori, Yoshinori. "Yamamoto Shunkyo shiron." *Zokei geijutsugaku ronshū* 4 (March 1988): 17–34.

Morinaga, Maki Isaka. *Secrecy in Japanese Arts: "Secret Transmission" as a Mode of Knowledge.* New York: Palgrave Macmillan, 2005.

Morinaga, Soko. *Novice to Master: An Ongoing Lesson in the Extent of My Own Stupidity.* Translated by Belenda A. Yamakawa. Somerville, MA: Wisdom Publications, 2002.

Morita Takeshi et al., eds. *Hoyaku Nippō jisho.* Tokyo: Iwanami Shoten, 1989.

Morreall, John. *Comedy, Tragedy, and Religion.* Albany: SUNY Press, 1999.

Morrell, Sachiko K., and Robert E. Morrell. *Zen Sanctuary of Purple Robes: Japan's Tōkeiji Convent since 1285.* Albany: SUNY Press, 2006.

Morton, Camilla. "Spring/Summer 2007 Couture, Christian Dior." *Vogue,* Jan. 22, 2007. http://www.vogue.co.uk/fashion/spring-summer-2007/couture/christian-dior (accessed July 27, 2015).

Muething, Ted. "The Zen Origins of the Nike Roshe Run." *Slow Commerce,* Feb. 6, 2015. http://www.slowcommerce.com/blog/2015/2/5/the-zen-origins-of-the-nike-roshe-run (accessed Jan. 30, 2016).

Mujaku Dōchū. *Shōbōzanshi.* Kyoto: Myōshinji Tōrin'in, 1921.

———. *Zenrin shōkisen.* Edited by Yanagida Seizan. Kyoto: Chūbun Shuppansha, 1979.

Muji. "What Is Muji?" http://www.muji.com/us/about/ (accessed Jan. 2, 2016).

Muller, A. Charles, ed. *Digital Dictionary of Buddhism.* http://buddhism-dict.net/ddb. Edition of 2014/12/31.

Munroe, Alexandra. "Buddhism, and the Neo-Avant-Garde: Cage Zen, Beat Zen, and Zen." In Alexandra Munroe, ed., *The Third Mind: American Artists Contemplate Asia, 1860–1989,* 199–215. New York: Guggenheim Museum Publications, 2009.

———, ed. *The Third Mind: American Artists Contemplate Asia, 1860–1989.* New York: Guggenheim Museum, 2009.

Munroe, Alexandra, with John Hendricks. *Yes. Yoko Ono.* New York: Japan Society, 2000.

Munsterberg, Hugo. Review of Hasumi Yoshimitsu, *Zen in Japanese Art: A Way of Spiritual Experience.* In *Journal of Asian Studies* 22, no. 2 (February 1963): 217–218.

———. "Zen and Art," *Art Journal* 20, no. 4 (Summer 1961): 198–202.

———. *Zen and Oriental Art.* Rutland, VT: Tuttle & Co., 1965.

Murai, Noriko. "Okakura's Way of Tea: Representing Chanoyu in Early Twentieth-Century America." *Review of Japanese Culture and Society* 24 (December 2012): 70–93.

Murai, Noriko, and Yukio Lippit, eds. "Beyond Tenshin: Okakura Kakuzō's Multiple Legacies." *Review of Japanese Culture and Society* 24 (December 2012).

Murakami Takashi. "Superflat Trilogy: Greetings, You Are Alive." In *Little Boy: The Arts of Japan's Exploding Subculture,* ed. Murakami Takashi, 150–163. New York: Japan Society, 2005.

Muramoto, Shoji, et al., trans. "The Jung-Hisamatsu Conversation." In *Awakening and Insight: Zen Buddhism and Psychotherapy,* ed. Polly Young-Eisendrath and Shoji Muramoto, 105–118. New York: Taylor & Francis, 2002.

Murase, Miyeko. "An Introduction to Japanese Calligraphy in the Barnet and Burto Collection." In *The Written Image: Japanese Calligraphy and Painting from the Sylvan Barnet and William Burto Collection,* ed. Miyeko Murase et al., 11–23. New York: The Metropolitan Museum of Art, 2002.

Murayama, Jungo, ed. *Wakan meigasen.* Tokyo: Kokkasha, 1917.

Museum of Fine Arts, Boston. *Museum of Fine Arts, Boston Forty-second Annual Report for the Year 1917.* Boston: T.O. Metcalf, Co., 1918.

———. *A Special Exhibition of Ancient Chinese Buddhist Paintings, lent by the Temple Daitokuji of Kioto, Japan.* Boston: Museum of Fine Arts, Boston, 1894.

Museum of Modern Art. "Press Release: First Showing of Abstract Japanese Calligraphy at Museum of Modern Art," June 23, 1954. http://www.moma.org/momaorg/shared/pdfs/docs/press_archives/1849/releases/MOMA_1954_0070_65.pdf?2010 (accessed May 28, 2014).

Mutsu, Hirokichi, ed. *The British Press and the Japan-British Exhibition of 1910.* London: Curzon, 2001.

Nagatomi, Masatoshi. Review of D. T. Suzuki, *Zen and Japanese Culture. Harvard Journal of Asiatic Studies* 22 (December 1959): 294.

Nakamura, Hajime. "Suzuki Shōzan 1579–1655, and the Spirit of Capitalism in Japanese Buddhism." *Monumenta Nipponica* 22 (1967): 1–14.

Nanzan Institute for Religion and Culture. "Chronology for 1960." https://nirc .nanzan-u.ac.jp/nfile/3277 (accessed Dec. 14, 2015).

Nattier, Jan. "Who Is a Buddhist? Charting the Landscape of Buddhist America." In *The Faces of Buddhism in America,* ed. Charles S. Prebish and Kenneth K. Tanaka, 183–195. Berkeley: University of California Press, 1998.

Neer, Richard. "Connoisseurship and the Stakes of Style." *Critical Inquiry* 32, no. 1 (Autumn 2005): 1–26.

Nelson, John K. *Experimental Buddhism: Innovation and Activism in Contemporary Japan.* Honolulu: University of Hawai'i Press, 2013.

——. "Household Altars in Contemporary Japan: Rectifying Buddhist 'Ancestor Worship' with Home Décor and Consumer Choice." *Japanese Journal of Religious Studies* 35, no. 2 (2008): 305–330.

Neto nabi. Nov. 15, 2013. http://netnavi.appcard.jp/e/14e3b (accessed March 16, 2014).

The New Yorker. "Media Kit." http://www.condenast.com/brands/new-yorker /media-kit (accessed July 25, 2015).

Ngai, Sianne. *Our Aesthetic Categories: Zany, Cute, Interesting.* Cambridge, MA: Harvard University Press, 2012.

Niedzviecki, Hal. *Hello, I'm Special: How Individuality Became the New Conformity.* San Francisco, CA: City Lights Books, 2006.

Nihon Bijutsu Kyōkai, ed. *Kichō bijusuhin chōsa hōkoku.* Tokyo: Nihon Bijutsu Kyōkai, 1930.

Nike, Inc. "Nikeid Nike Roshe Run One Men's Shoe." http://reviews.nike.com/9191 /511881/nike-roshe-run-mens-shoe-reviews/reviews.htm (accessed March 19, 2014).

Nine Network. "I Wake Up with Today," Nine Network, Australia, video clip uploaded June 9, 2011, http://www.youtube.com/watch?v=xlIrI8oog8c (accessed Dec. 23, 2012).

Nishimura, Eshin, and Giei Satō. *Unsui: A Diary of Zen Monastic Life,* ed. Bardwell L. Smith. Honolulu: University Press of Hawai'i, 1973.

Nōshōmushō Hakurankai-gakari, ed. *Dai nikai Kaiga Kyōshinkai koga shuppin mokuroku.* Tokyo: Nōshōmushō, 1884.

Nukariya, Kaiten. *The Religion of the Samurai: A Study of Zen Philosophy and Discipline in China and Japan.* London: Luzac & Co., 1913.

Numata, Yorisuke. "Sesshu," *The Japan Magazine,* April 1917, 756–759.

Numata Center for Buddhist Translation and Research, ed. *Three Chan Classics: The Recorded Sayings of Linji, Wumen's Gate, The Faith-Mind Maxim.* Berkeley, CA: Numata Center for Buddhist Translation and Research, 1999.

Numrich, Paul D. "Two Buddhisms Further Considered." *Contemporary Buddhism* 4, no. 1 (2003): 55–78.

Nunokawa, Jeffrey. "Oscar Wilde in Japan: Aestheticism, Orientalism, and the Derealization of the Homosexual." *Positions* 2, no. 1 (1994): 44–56.

Nussbaum, Emily. "Cool Story, Bro." *The New Yorker,* March 3, 2014, 78–79.

Oagana, Alex. "Japanese A 45 AMG ad Involves Drifting and Zen Buddhist Monks." *Autoevolution.com,* Nov. 7, 2013. http://www.autoevolution.com/mercedes-blog /japanese-a-45-amg-ad-involves-drifting-and-zen-buddhist-monks-video-70534 .html (accessed March 9, 2014).

——. "Mercedes-Benz 'Chicken' Commercial Is Hilarious but Unoriginal." *Autoevo-*

lution, Sept. 23, 2013. http://www.autoevolution.com/mercedes-blog/mercedes
-benz-chicken-commercial-is-hilarious-but-unoriginal-video-67497.html
(accessed March 9, 2014).

O'Brien, Barbara. "Zen 101: An Introduction to Zen Buddhism." http://buddhism
.about.com/od/chanandzenbuddhism/a/zen101.htm (accessed March 9, 2016).

Office of the Imperial Japanese Government Commission to the Japan-British Exhi-
bition. *An Illustrated Catalogue of Japanese Old Fine Arts Displayed at the
Japan-British Exhibition, London 1910.* Tokyo: Shimbi Shoin, 1910.

Ogata Sōhaku. *A Guide to Zen Practice.* Kyoto: Bukkasha, 1934.

——. Review of Alan Watts, *The Way of Zen* (1957). *The Middle Way* 31 (1957): 116.

——. "Zen and Culture." *The Middle Way* 32, no. 4 (February 1958): 131–132.

——. *Zen for the West.* London: Rider & Co., 1959.

Ōhazama, Shūei, and August Faust. *Zen: Der lebendige Buddhismus in Japan.*
Gotha: F. A. Perthes, 1925.

Okakura, Kakuzō. *The Book of Tea.* New York: Fox Fuffield & Co, 1906.

——. *Ideals of the East with Special Reference to the Arts of Japan.* London: John
Murray, 1903.

Okamoto, Ippei. *Ippei zenshū.* Vol. 1. Tokyo: Senshinsha, [1930]1990.

Okamoto, Kanoko. *Okamoto Kanoko zenshū.* Vol. 10. Tokyo: Tōjusha, 1975.

Oliver, Brent. "Fuck Buddhism!" *Zen Bastard,* Nov. 16, 2010, http://zenbastard
.blogspot.com/2010/11/fuck-buddhism.html (accessed March 12, 2014).

Onshi Kyōto Hakubutsukan, ed. *Daitokuji meihō shū.* Kyoto: Onshi Kyōto Hakubut-
sukan, 1933.

Oppenheimer, Mark. *Zen Predator of the Upper East Side.* Washington, DC: The
Atlantic Books, 2013.

Osaki Shin'ichirō. "Yoshihara Jirō to sho." In Ashiya Shiritsu Bijutsukan, *Botsugo
20 nen Yoshihara Jirō ten,* 179–84. Ashiya-shi: Ashiya Shiritsu Bijutsukan, 1992.

O'Shea, Jamie. "NYC///Murakami's Moment. . . ." *Supertouch* (blog), May 3, 2007.
http://www.supertouchart.com/2007/05/03/nycmurakamis-moment/ (accessed
Oct. 15, 2015).

Padgett, David M. "'Americans Need Something to Sit On,' Or Zen Meditation Mate-
rials and Buddhist Diversity in America." *Journal of Global Buddhism* 1 (2000):
61–81.

Palmer, C. B. "The Consummately Dry Martini." *New York Times Sunday Magazine,*
April 6, 1952, 41.

Pan, An-yi. *Painting Faith: Li Gonglin and Northern Song Buddhist Culture.* Leiden:
Brill, 2007.

Parisi, Mark. "Zen Cartoon," #2008–03–04; Zen Cartoon #2013–05–28, http://
www.offthemark.com/cartoons/zen/ (accessed Jan. 15, 2015).

Park, Josephine Nock-Hee. *Apparitions of Asia: Modernist Form and Asian Ameri-
can Poetics.* Oxford: Oxford University Press, 2008.

Parrott, Frederick. "Buddhism in Japan: The Clash of Two Religions." *The Japan
Weekly Chronicle,* March 18, 1909, 431.

Patterson, David W. "Cage and Asia: History and Sources." In *John Cage,* ed. Julia
Robinson, 41–60. Cambridge, MA: MIT Press, 2011.

Pearlman, Ellen. *Nothing and Everything: The Influence of Buddhism on the Ameri-
can Avant-Garde 1942–1962.* Berkeley, CA: Evolver Editions, 2012.

Pew Forum on Religion and Public Life, Religions Landscape Survey, 2014. http://
www.pewforum.org/religious-landscape-study/religious-tradition/buddhist/
(accessed Jan. 12, 2016).

Phelps, Nicole. "Fall 2013 Couture: Viktor & Rolf," *Vogue,* July 3, 2013. http://www
.vogue.com/fashion-shows/fall-2013-couture/viktor-rolf (accessed Jan. 19, 2016).

Phillips, Aron. "Exclusive: The Story behind the Nike Roshe Run." *HowToMakeIt .com* April 16, 2012. http://www.howtomakeit.com/2012/04/exclusive-the-story -behind-the-nike-roshe-run/ (accessed Nov. 21, 2015).

Pier, Garret C. *Temple Treasures of Japan.* New York: Frederic Fairchild Sherman, 1914.

Pilgrim, Richard B. *Buddhism and the Arts of Japan.* 2nd ed. Chambersburg, PA: Anima Books, 1993.

"Pine Sol Meditation." www.adforum.com/creative-work/ad/player/6711642 (accessed April 4, 2014).

Piraro, Dan. "Pulling your Legume." *Bizarro Blog!* Sept. 17, 2008. http://www .bizarrocomics.com/?p=231 (accessed Nov. 15, 2012).

———. "The Sound of One Hand Inking." *Bizarro Blog!* May 20, 2009. http:// bizarrocomics.com/2009/05/20/the-sound-of-one-hand-inking/ (accessed July 13, 2015).

Pitelka, Morgan. "Form and Function: Tea Bowls and the Problem of Zen in *Chanoyu.*" In *Zen and Material Culture,* ed. Pamela D. Winfield and Steven Heine. Oxford: Oxford University Press, forthcoming.

———. "Review Article: Should Museums Welcome Parody?" *Early Modern Japan* (2011): 58–61.

Placzek, James, et al. "Buddhism in British Columbia." In *Buddhism in Canada,* ed. Bruce Matthews, 1–29. London: Routledge, 2006.

Plomer, William ed. *A Message in Code: The Diary of Richard Rumbold (1932–61).* London: Weidenfeld & Nicolson, 1964.

Poceski, Mario. "Lay Models of Engagement with Chan Teachings and Practices among the Literati in Mid-Tang China." *Journal of Chinese Religions* 35 (2007): 63–97.

"Pop Dharma: Japan's Warhol Goes Buddhist with a New Body of Work." *Trycicle: The Buddhist Review* 17, no. 1 (Fall 2007). http://www.tricycle.com/parting -words/pop-dharma (accessed Oct. 15, 2015).

Pope, Alan. "Contributions and Conundrums in the Psychospiritual Transformation of Alan Watts." In *Alan Watts—Here and Now: Contributions to Psychology, Philosophy, and Religion,* ed. Peter J. Columbus and Donadrian L. Rice, 183– 202. Albany: SUNY Press, 2012.

Porcu, Elisabetta. "Down-to-Earth Zen: Zen Buddhism in Japanese Manga and Movies." *Journal of Global Buddhism* 16 (2015): 37–50.

———. *Pure Land Buddhism in Modern Japanese Culture.* Leiden: Brill, 2008.

Potpourri Group, Inc. *Country Store.* http://www.countrystorecatalog.com/Default .aspx (accessed Aug. 18, 2014).

Prebish, Charles S. *Luminous Passage: The Practice and Study of Buddism in America.* Berkeley: University of California Press, 1999.

Price, Andrew. "Slavoj Zizek on the Hypocrisy of Conscious Consumerism." http://magazine.good.is/articles/slavoj-zizek-on-the-hypocrisy-of-conscious -consumerism (accessed July 4, 2014).

Primary Source Media. *American Religions Collection: Series 2: Nontraditional American Religions: Eastern Religions: Buddhism, Shintoism and Japanese New Religions.* Part 4, Zen Buddhism. Woodbridge, CT: Primary Source Media, 2006.

Pritchett, James. "Five Statements on Silence by John Cage: Questions, Hypotheses, Second Thoughts." In *The Piano in My Life: James Pritchett on Music and Writing.* http://rosewhitemusic.com/piano/writings/five-statements-on-silence-by-john -cage/ (accessed Dec. 14, 2015).

———. *The Music of John Cage.* Cambridge: Cambridge University Press, 1993.

——. "What Silence Taught John Cage: The Story of *4'33.*" In *The Piano in My Life: James Pritchett on Music and Writing.* http://rosewhitemusic.com/piano/writings/silence-taught-john-cage/ (accessed Dec. 14, 2015).

Promey, Sally. "Taste Cultures: The Visual Practice of Liberal Protestantism, 1945–1965." In *Practicing Protestants: Histories of Christian Life in America, 1630–1965,* ed. Laurie F. Maffly-Kipp et al., 250–294. Baltimore: Johns Hopkins University Press, 2006.

Prothero, Stephen. "On the Holy Road: The Beat Movement as Spiritual Protest." *The Harvard Theological Review* 84, no. 2 (April 1991): 205–222.

Purser, Ron, and David Loy. "Beyond McMindfulness." *The Huffington Post,* July 1, 2013. http://www.huffingtonpost.com/ron-purser/beyond-mcmindfulness_b_3519289.html (accessed Nov. 22, 2015).

Purser, Ronald E., and Joseph Milillo. "Mindfulness Revisited: A Buddhist-Based Conceptualization." *Journal of Management Inquiry* 1, no. 22 (January 2015): 3–24.

Queen, Christopher S., ed. *Engaged Buddhism in the West.* Boston: Wisdom Publications, 2000.

Radhakrishnan, Sarvepalli. *An Idealist View of Life.* 2nd ed. London: Unwin Books, 1937.

Rankin, Ian. "A Short Guide to Zen Buddhism." *The Sunday Times* (London), June 28, 1959, 31.

Raskin, Victor, ed. *The Primer of Humor Research.* Berlin and New York: Mouton de Gruyter, 2008.

Raymond, John. "Salinger Kicks in the Door." *The Sunday Times* (London), March 3, 1963, 30.

Reader, Ian. "Zazen-less Zen? The Position of Zazen in Institutional Zen Buddhism." *Japanese Religions* 14, no. 3 (December 1986): 7–27.

Reader, Ian, and George J. Tanabe Jr. *Practically Religious: Worldly Benefits and the Common Religion of Japan.* Honolulu: University of Hawai'i Press, 1998.

Reed, Edward J. *Japan: Its History, Traditions, and Religions, with the Narrative of a Visit in 1879.* London: John Murray, 1880.

Renan, Ernest. "What Is a Nation?" In *Nation and Narration,* ed. Homi K. Bhabha, 8–22. London: Routledge, 1990.

Reynolds, Garr. "Presentation Zen: Gates, Jobs, and the Zen Aesthetic." *Presentation zen* (blog), Nov. 5, 2005. http://presentationzen.blogs.com/presentationzen/2005/11/the_zen_estheti.html (accessed Feb. 24, 2012).

Richardson, John. *G. Braque.* New York: New York Graphic Society, 1961.

Rinspeed. "Rinspeed zaZen." http://www.rinspeed.eu/info_Rinspeed-zaZen_8.html (accessed Dec. 6, 2015).

Rios, Cara. *The Road to Whatever: A Pop Culture Approach to Buddhism.* New York: iUniverse, Inc., 2009.

Ritzer, George. *The McDonaldization of Society.* Los Angeles, CA: Sage, 2015.

Roberts, Sarah. "*White Painting* [three-panel]." *Rauschenberg Research Project,* July 2013, San Francisco Museum of Modern Art. https://www.sfmoma.org/artwork/98.308.A-C (accessed Feb. 5, 2016).

Robson, James. "Formation and Fabrication in the History and Historiography of Chan Buddhism." *Harvard Journal of Asiatic Studies* 71, no. 2 (2011): 311–349.

Rocha, Cristina. *Zen in Brazil: The Quest for Cosmopolitan Modernity.* Honolulu: University of Hawai'i Press, 2006.

Rochester Zen Center. "Shirts and Swag for the Well-dressed Meditator." http://www.cafepress.com/rochesterzencenter (accessed July 4, 2014).

Rogers, Arthur H. "Zen and LSD: An Enlightening Experience." *Psychologia: An International Journal of Psychology in the Orient* 7, nos. 3–4 (December 1964): 150–151.

Rosenberg, Harold. "Painting Is a Way of Life." *The New Yorker,* Feb. 16, 1963, 126–137.

Rosenfield, John M. "Hokusai and Concepts of Eccentricity." In *Hokusai Paintings: Selected Essays,* ed. Gian Carlo Calza and John T. Carpenter, 17–30. Venice: International Hokusai Research Center, 1994.

Rosenfield, John M., with Fukuko Cranston and Naomi Noble Richard. *Extraordinary Persons: Works by Eccentric and Nonconformist Japanese Artists of the Early Modern Era in the Collection of Kimiko and John Powers.* Cambridge, MA: Harvard University Art Museums, 1999.

Rosenfield, John M., and Shūjirō Shimada. *Traditions of Japanese Art: Selections from the Kimiko and John Powers Collection.* Cambridge, MA: Fogg Art Museum, Harvard University, 1970.

Ross, Nancy Wilson. "Beat—and Buddhist." *New York Times,* October 5, 1958.

———. "What Is Zen?" *Mademoiselle,* January 1958, 64–65, 116–117.

———, ed. *The World of Zen: An East-West Anthology.* New York: Random House, 1960.

Roszak, Theodore. *From Satori to Silicon Valley: San Francisco and the American Counterculture.* San Francisco: Don't Call It Frisco Press, 1986.

———. *The Making of a Counter Culture: Reflections on the Technocratic Society and Its Youthful Opposition.* Berkeley: University of California Press, 1969.

Roth, Moira. *Difference/Indifference: Musings on Postmodernism, Marcel Duchamp, and John Cage.* Amsterdam: G+B Arts International, 1998.

Roth, Moira, and William Roth. "John Cage on Marcel Duchamp: An Interview." *Art in America* (November–December 1973): 72–79.

Rubin, David. *Psychedelic: Optical and Visionary Art since the 1960s.* San Antonio, TX: San Antonio Museum of Art, 2010.

Rumbold, Richard. "Catching the Mood of the Universe: A Personal Experience of Zen Buddhism." *Encounter* (January 1959), 19–29.

Sakamoto, Hiroshi. "Review of Ernest Benz, *Zen in Westlicher Sicht. Zen-Buddhismus-Zen-Snobismus* (1962). *The Eastern Buddhist* 1, no. 1 (September 1965): 126–132.

Salajan, Ioanna. *Zen Comics.* Rutland, VT: C. E. Tuttle, 1974.

———. *Zen Comics II.* Rutland, VT: C. E. Tuttle, 1982.

Salinger, J. D. "Seymour: An Introduction." *The New Yorker,* June 6, 1959, 42–119.

Salzwedel, J. Austin. "(Emersonian) Nature in East Asiatic Painting." M.A. thesis, Graduate Theological Union, Berkeley, CA, 2015.

Sanford, James H. *Zen-Man Ikkyū.* Chico, CA: Scholars Press, 1981.

Sansom, George B. *Japan: A Short Cultural History.* New York: Appleton-Century-Crofts, 1962.

Sargeant, Winthrop. "Profiles: Great Simplicity, Dr. Daisetz Teitaro Suzuki." *The New Yorker,* August 31, 1957, 34–53.

Sasaki, Ruth Fuller. "A Bibliography of Translations of Zen (Ch'an) Works." *Philosophy East and West* 10, no. 3/4 (October 1960–January 1961): 149–166.

———. "Letter[s] from Kyoto." Dec. 26, 1957, in *Zen Notes* 5, no. 2 (February 1958): n.p.

———. "Letter[s] from Kyoto." Nov. 8, 1961, in *Zen Notes* 8, no. 12 (December 1961): n.p.

———. *Rinzai Zen Study for Foreigners in Japan.* Kyoto: The First Zen Institute of America in Japan, 1960.

Sasaki, Sōkeian. "Twenty-five Zen Koans, Selected and Translated by Sokei-an Sasaki. Fifth Koan (Saturday, February 5, 1938)." *Zen Notes* 54, no. 4 (Fall 2006): 7–11.

Satō, Dōshin. *Modern Japanese Art and the Meiji State: The Politics of Beauty.* Translated by Hiroshi Nara. Los Angeles, CA: Getty Research Institute, 2011.

Satō, Kemmyō Taira. "D. T. Suzuki and the Question of War," trans. Thomas Kirchner. *The Eastern Buddhist* 39, no. 1 (2008): 61–120.

Satow, Ernest Mason, and Ishibashi Masakata. *An English–Japanese Dictionary of the Spoken Language.* London: Trubner, 1876; reprint, Tokyo: Benseisha, 1970.

Saunders, Kenneth J. *Buddhism in the Modern World.* London: Society for Promotion of Christian Knowledge, 1922.

———. *A Pageant of Asia: A Study of Three Civilizations.* Oxford: Oxford University Press, 1927.

Schiller, David. *Zen: Surprising Sayings, Parables, Koans, and Haiku* (page-a-day calendar). New York: Workman Publishing, 2007.

Schjeldahl, Peter. "Native Soil." *The New Yorker,* May 25, 2015, 78–79.

Schlütter, Morten. *How Zen Became Zen: The Dispute over Enlightenment and the Formation of Chan Buddhism in Song-Dynasty China.* Honolulu: University of Hawai'i Press, 2010.

Schmidt, Leigh E. *Restless Souls: The Making of American Spirituality.* Berkeley: University of California Press, 2012.

Schonfeld, Victor. "Indeterminate Cage." *The Musical Times* 110, no. 1522 (December 1969): 1244.

Schopen, Gregory. "The Learned Monk as a Comic Figure: On Reading a Buddhist Vinaya as Indian Literature." *Journal of Indian Philosophy* 35, no. 3 (2007): 201–226.

Schrader, Paul. *Transcendental Style in Film: Ozu, Bresson, Dreyer.* Berkeley: University of California Press, 1972.

Schumacher, E. F. "Buddhist Economics." In *Asia: A Handbook,* ed. Wint Guy, 695–701. London: Anthony Blond, 1966.

Scott, Rachelle M. *Nirvana for Sale? Buddhism, Wealth, and the Dhammakāya Temple in Contemporary Thailand.* Albany: SUNY Press, 2009.

Secretary of State. *Reports of the United States Commissioners to the Universal Exposition of 1889 at Paris.* Washington, DC: Government Printing Office, 1891.

Senzaki, Nyogen. "Mentorgarten Dialogue." *Chicago Review* 12, no. 2 (Summer 1958): 37–40.

Senzaki, Nyogen, and Ruth Strout McCandless. *Buddhism and Zen.* New York: Philosophical Library, 1953.

———. *The Iron Flute: 100 Zen Koans.* Rutland, VT: Tuttle, 1961.

Seo, Audrey, with Stephen Addiss. *The Art of Twentieth-Century Zen: Paintings and Calligraphy by Japanese Masters.* Boston: Shambhala Publications, 2000.

Shaku, Sōen. *Kaijin kaiho.* Tokyo: Nisshinkaku, 1919.

———. *Sermons of a Buddhist Abbot.* Edited and translated by D. T. Suzuki. Chicago: The Open Court Publishing Co., 1906.

———. *Zen for Americans.* LaSalle, IL: Open Court Press, 1913.

Sharf, Robert H. "Buddhist Modernism and the Rhetoric of Meditative Experience." *Numen* 42, no. 3 (1995): 228–283.

———. "Experience." In *Critical Terms in Religious Studies,* ed. Mark C. Taylor, 94–116. Chicago: University of Chicago Press, 1998.

———. "How to Think with Chan Gong'an." In *Thinking with Cases: Specialist Knowledge in Chinese Cultural History,* ed. Charlotte Furth et al., 205–243. Honolulu: University of Hawai'i Press, 2007.

——. "Mindfulness and Mindlessness in Early Chan." *Philosophy East and West* 64, no. 4 (October 2014): 933–964.

——. "Sanbōkyōdan: Zen and the Way of the New Religions." *Japanese Journal of Religious Studies* 22, no. 3/4 (1995): 417–458.

——. "Whose Zen? Zen Nationalism Revisited." In *Rude Awakenings: Zen, the Kyoto School, and the Question of Nationalism,* ed. James W. Heisig and John C. Maraldo, 40–51. Honolulu: University of Hawai'i Press, 1994.

——. "The Zen of Japanese Nationalism." In *Curators of the Buddha: The Study of Buddhism Under Colonialism,* ed. Donald Lopez Jr., 107–160. Chicago: University of Chicago Press, 1995.

Shaw, Scott. "Just Do It! The Art of Zen Filmmaking." *Filmmaking.net,* May 1, 2006. http://www.filmmaking.net/articles/show_article.asp?id=34 (accessed March 11, 2016).

Shields, James Mark. *Critical Buddhism: Engaging with Modern Japanese Buddhist Thought.* Farnham, Surrey: Ashgate, 2011.

——. "Radical Buddhism, Then and Now: Prospects of a Paradox." *Silva Iaponicarum* 23–26 (2010): 15–34.

——. "Sexuality, Blasphemy, and Iconoclasm in the Media Age: The Strange Case of the Buddha Bikini." In *God in the Details: American Religion in Popular Culture,* ed. Eric Mazur and Kate McCarthy, 80–101. Abingdon, Oxon.: Routledge, 2010.

Shiga Kenritsu Kindai Bijutsukan. *Yamamoto Shunkyo.* Ōtsu: Shiga Kenritsu Kindai Bijutsukan, 2000.

Shimada Shūjirō. "Indara no Zen'e zu." In Shimada Shūjirō, *Chūgoku kaigashi kenkyū,* 161–173. Tokyo: Chūō Kōron Bijutsu Shuppan, 1993.

Shimada Shunpo, comp. *Kattōshū: Wakun ryakkai.* Tokyo: Kōyūkan, 1914.

——. *Zendō seikatsu.* Tokyo: Kōyūkan, 1914.

Shimao Arata. "Kenkyū shiryō: Sesshūga denrai shiryō Kindai hen (kō)." *Tenkai toga* 2 (March 1998): 45–63.

Shimizu, Yoshiaki. "Six Narrative Paintings by Yin T'o-lo: Their Symbolic Content." *Archives of Asian Art* 33 (1980): 6–37.

——. "Zen Art?" In *Zen: In China, Japan, East Asian Art,* ed. Helmut Brinker et al., 73–98. Bern: Peter Lang, 1985.

Shiseidō. "Classic Zen Eau de Cologne." http://www.shiseido.com/classic-zen-eau -de-cologne/0730852501201,en_US,pd.html?q=Zen& (accessed June 9, 2014).

——. "Zen." http://www.shiseido.co.jp/sw/products/SWFG070410.seam?shohin _pl_c_cd=091701 (accessed Nov. 22, 2015).

"Shiseidō Zen Perfume" (advertisement) *Vogue,* Nov. 15, 1972, 47.

Shōbikai, ed. *Meiga seikan.* Tokyo: Shōbikai, 1917.

Silk, Jonathan. *Managing Monks: Administrators and Administrative Roles in Indian Buddhist Monasticism.* Oxford: Oxford University Press, 2008.

Sirén, Osvald. *Chinese Painting: Leading Masters and Principles.* Vol. 2. London: Lund Humphries, 1956.

Sitwell, Sacheverell. *The Bridge of the Brocade Sash: Travels and Observations in Japan.* Cleveland, OH: The World Publishing Company, 1959.

Sizemore, Russell F., and Donald K. Swearer, eds. *Ethics, Wealth and Salvation: A Study in Buddhist Social Ethics.* Columbia: University of South Carolina Press, 1990.

Sladen, Douglas. *The Japs at Home.* London: Ward, Lock & Bowden, 1895.

Sluyter, Dean. *Cinema Nirvana: Enlightenment Lessons from the Movies.* New York: Three Rivers Press, 2005.

Snelling, John, ed. *The Early Writings of Alan Watts: The British Years: 1931–1938, Writings in Buddhism in England.* Berkeley, CA: Celestial Arts, 1987.

Snodgrass, Judith. *Presenting Japanese Buddhism to the West*. Chapel Hill: University of North Carolina Press, 2003.

Snyder, Gary. *Earth House Hold: Technical Notes and Queries to Fellow Dharma Revolutionaries*. New York: New Directions, 1969.

———. *The Real Work: Interviews and Talks, 1964–1979*. New York: New Directions, 1980.

Sōgen, Asahina. "Living Zen." *Zen Notes* 1, no. 8 (August 1954): n.p.

———. "A Message to Sokei-an's Zen Students." *Zen Notes* 1, no. 7 (July 1954): n.p.

———. "Zen History Is Made in New York." *Zen Notes* 1, no. 7 (July 1954): n.p.

"Sōgen no meihin, Teishitsu hakubutsukan, tsuitachi kara chinretsugae," *Asahi shinbun*, Nov. 1, 1939, 8.

Soper, Alexander. Review of D. T. Suzuki, *Zen and Japanese Culture*. *Artibus Asiae* 23, no. 2 (1960): 139–140.

Sperry, Rod Meade. "Nike's New Zen Sneaker." http://theworsthorse.com/2013/06/dharma-burger-nikes-new-zen-sneaker/ (accessed March 7, 2014).

———. "Video: Mercedes Benz tests Buddhist monks against new car (and vice-versa)/ With small update." *Lion's Roar: Buddhist Wisdom for Our Time,* Nov. 15, 2013. http://www.lionsroar.com/video-mercedes-benz-tests-zen-monks-against-new-car-and-vice-versa/ (accessed July 27, 2015).

———. *The Worst Horse,* http://theworsthorse.com. Redirects to http://www.lionsroar.com/author/rod-meade-sperry/ (accessed Jan. 15, 2016).

Spiegelberg, Frederic. *The Religion of No-Religion*. Stanford, CA: J. L. Delkin, 1948.

Spuler, Michelle. *Developments in Australian Buddhism: Facets of a Diamond*. London: RoutledgeCurzon, 2003.

Stein, Todd. "Zen Sells: How Advertising Co-opted Spirituality." *Shambhala Sun* 8, no. 2 (November 1999). http://www.lionsroar.com/zen-sells-how-advertising-has-co-opted-spirituality/ (accessed Jan. 15, 2015).

Stephan, Ruth. *Various Poems*. New York: Gotham Book Mart, 1963.

———. *Zen in Ryoko-in*. United States: Audio Brandon, 1971. Pacific Film Archive, University of California, Berkeley.

Sterling, Isabel. *Zen Pioneer: The Life and Works of Ruth Fuller Sasaki*. Emeryville, CA: Shoemaker & Hoard, 2006.

Sterngold, James. "Experiencing the Spirit of Zen." *New York Times,* Dec. 29, 1991. http://www.nytimes.com/1991/12/29/travel/experiencing-the-spirit-of-zen.html?pagewanted=all&src=pm (accessed Feb. 24, 2012).

Stevens, John. "Zen Brush: The Development of Zen Art." In *Zen Mind Zen Brush: Japanese Ink Paintings from the Gitter-Yelen Collection,* ed. the Art Gallery of New South Wales, 21–28. Sydney: Art Gallery of New South Wales, 2006.

Stewart, James L. *The Laughing Buddha: A Tale of Love and Adventure in Western China*. New York: Fleming H. Revell, 1925.

Stewart, Jon. "Jeff Bridges." *The Daily Show*. Season 18, Episode 41, Jan. 9, 2013. http://thedailyshow.cc.com/videos/fppsqa/jeff-bridges (accessed July 17, 2015).

St. James, Mark. "Viktor and Rolf Fall 2013 Couture." *Marquis of Fashion,* July 4, 2013. http://www.marquisoffashion.com/viktor-and-rolf-fall-2013-couture/ (accessed July 27, 2015).

Stopes, Mary C. *A Journal from Japan: A Daily Record of Life as Seen by a Scientist*. London: Blackie & Son, 1910.

Sueki, Fumihiko, and Stefan Grace. "Introduction." In *The Hekigan Roku (Pi-yen Lu): Translated by Daisetz T. Suzuki*. Separate volume: The Annual Report of Researches of The Matsugaoka Bunko, no. 26, ed. Matsugaoka Bunko Foundation, x–xxi. Kamakura: The Matsugaoka Bunko Foundation, 2012.

Sugi Yasusaburō. "Ōbei ni mebaeru Zen no chie." *Daihōrin* 24, no. 5 (April 1957): 14–20.

———. "Zen to kenkō—Tokushū-Zen no tankyū to tokushitsu." *Nihon oyobi Nihonjin*, 11, no. 1 (January 1960): 48–50.

Suh, Sharon A. *Silver Screen Buddha: Buddhism in Asian and Western Film.* London: Bloomsbury Publishing, 2015.

Suzuki, D. T. "Buddhist, Especially Zen, Contributions to Japanese Culture." In *Essays in Zen Buddhism* (Third Series), 289–331. London: Luzac & Co., 1934.

———. *Buddhist Philosophy and Its Effects on the Life and Thought of the Japanese People.* Tokyo: Kokusai Bunka Shinkōkai, 1936.

———. "D. T. Suzuki's English Diaries." *Zaidan hōjin Matsugaoka Bunko kenkyū nenpō*, 19–28 (2005–2014).

———. "Eckhart and Zen Buddhism." In *The Field of Zen: Contributions to The Middle Way, the Journal of the Buddhist Society, by Daisetz Teitaro Suzuki,* ed. Christmas Humphreys, 62–66. London: The Buddhist Society, 1969.

———. *Essays in Zen Buddhism* (First Series). London: Luzac & Co., 1927.

———. *Essays in Zen Buddhism* (Second Series). London: Luzac & Co., 1933.

———. *Essays in Zen Buddhism* (Third Series). London: Luzac & Co., 1934.

———. *An Introduction to Zen Buddhism.* Edited by Christmas Humphreys. London: Rider, 1969.

———. *Japanese Spirituality.* Translation of *Nihonteki reisei* (1944) by Norman Waddell. Tokyo: Japan Society for the Promotion of Science, 1972.

———. *Manual of Zen Buddhism.* London: Rider & Co., 1935.

———. *Mysticism: Christian and Buddhist.* New York: Harper, 1957.

———. *Nihonteki reisei.* Tokyo: Shunjūsha, 1961.

———. "Religions and Drugs." *The Eastern Buddhist,* n.s. 4, no. 2 (October 1971): 128–133.

———. "A Reply from D. T. Suzuki." *Encounter* (October 1961), 55–58.

———. Review of Heinrich Dumoulin, S.J. *A History of Zen Buddhism* (1963). *The Eastern Buddhist* 1, no. 1 (September 1965): 123–126.

———. *Selected Works of D. T. Suzuki, Volume 1,* ed. Richard M. Jaffe. Berkeley: University of California Press, 2014.

———. *The Training of a Zen Buddhist Monk.* Kyoto: The Eastern Buddhist Society, 1934.

———. "Zen: A Reply to Hu Shih." *Philosophy East and West* 3, no. 1 (April 1953): 25–46.

———. "Zen: A Reply to Van Meter Ames." *Philosophy East and West* 5, no. 4 (1956): 349–352.

———. *Zen and Japanese Culture.* Princeton, NJ: Princeton University Press, 1970.

———. *The Zen Doctrine of No-Mind: The Significance of the Sūtra of Hui-neng (Wei-lang).* London: Rider, 1949.

———. "Zen in the Modern World." *Japan Quarterly* 5, no. 4 (1958): 452–461.

———. "The Zen Sect of Buddhism." *Journal of the Pali Text Society* (1906–1907), 8–43.

Suzuki Daisetsu and Hisamatsu Shin'ichi. "Taidan: Amerika no Zen o kataru." *Zen bunka* 14 (January 1959): 16–29.

Suzuki, Daisetz T., et al. *Sengai the Zen Master.* Greenwich, CT: New York Graphic Society, 1971.

Suzuki, Shunryū. "Zazen, Rituals, and Precepts Cannot Be Separated." In *Wind Bell: Teachings from the San Francisco Zen Center, 1968–2001,* ed. Michael Wenger, 39–46. Berkeley, CA: North Atlantic Books, 2002.

Swartley, Ariel. "For the Pop Culturati, Patterns That Say Tokyo Cool." *New York*

Times, April 22, 2001. http://www.nytimes.com/2001/04/22/arts/art
-architecture-for-the-pop-culturati-patterns-that-say-tokyo-cool.html
?pagewanted=all&src=pm (accessed Oct. 15, 2015).

Takahashi, Makiko. "Paris Fashion Models Pose as Zen Rock Garden." *Asia &
Japan Watch* July 6, 2013. http://ajw.asahi.com/article/cool_japan/style
/AJ201307060034 (accessed May 16, 2014).

Talese, Gay. "Zen Selling Better Than Sodas, 'Village' Store Scraps Fountain." *New
York Times,* Sept. 12, 1959, 11.

Tan, Chang-Meng. *Search Inside Yourself: The Unexpected Path to Achieving Suc-
cess, Happiness (and World Peace).* New York: HarperOne, 2012.

Tanabe, George, and Willa Tanabe. *Japanese Buddhist Temples in Hawai'i: An Illus-
trated Guide.* Honolulu: University of Hawai'i Press, 2012.

Tanaka Hisao. "Sengo bijutsuhin idō 36: Kubusō Tarō, Masaki Takayuki no shūshū."
Geijutsu shinchō 26 (December 1975): 118–123.

Tapié, Michel, and Tore Haga. *Avant-garde Art in Japan.* New York: Harry N.
Abrams, 1962.

Tayama Hōnan, ed. *Zenrin bokuseki.* Ichikawa: Zenrin Bokuseki Kankai, 1955.

Taylor, James L. *Buddhism and Postmodern Imaginings in Thailand: The Religios-
ity of Urban Space.* Burlington, VT: Ashgate, 2008.

T.B.H. "Reviews and Previews: New Names This Month." *Art News* 57 (November
1958): 17.

Terry, Charles S., ed. *Masterworks of Japanese Art, based on the definitive six-
volume Pageant of Japanese Art edited by staff members of the Tokyo National
Museum.* Rutland, VT: Charles E. Tuttle Co., 1956/1958.

Thibodeau, Ruth. "From Racism to Tokenism: The Changing Face of Blacks in *New
Yorker* Cartoons," *Public Opinion Quarterly* 53 (1989): 482–494.

Tiampo, Ming. *Gutai: Decentering Modernism.* Chicago: University of Chicago
Press, 2010.

———. "'Under Each Other's Spell': Gutai and New York." In *"Under Each Other's
Spell": Gutai and New York,* ed. Ming Tiampo, 3–11. East Hampton, NY: Pol-
lock-Krasner House and Study Center, 2009.

Tokiwa, Gishin. "Dr. Shin'ichi Hisamatsu's 'Postmodernist Age.'" *FAS Society Journal*
(1997): 17, http://www.fas.x0.com/writings/fasj/fj97postmoderne.html (accessed
March 11, 2016).

———, ed. *Eight Lectures on Chan by Daisetz Teitaro Suzuki.* Kamakura: Matsugaoka
Bunko, 2011.

Tōkyō Garō. *Yoshihara Jirō koten.* Tokyo: Tōkyō Garō, 1967.

Tōkyō Kokuritsu Hakubutsukan, ed. *Umi o wattata Meiji no bijutsu: Saiken! 1893
Shikago koronbusu sekai hakurankai.* Tokyo: Tōkyō Kokuritsu Hakubutsukan,
1997.

Tōkyō Kokuritsu Hakubutsukan, Kyōto Kokuritsu Hakubutsukan. *Sesshū: Botsugo
500 nen tokubetsuten.* Tokyo: Mainichi Shinbun, 2002.

Tomii, Reiko. "Gutai's Phase Zero: When Pollock Came to Osaka (1951)." Public lec-
ture, University of California, Berkeley, October 8, 2013.

———. "'International Contemporaneity' in the 1960s: Discoursing on Art in Japan
and Beyond." *Japan Review* 21 (2009): 123–147.

———. "Two Legacies of Yoshihara Jirō: Gutai and Circle." In *Sotheby's* (blog), Sept.
9, 2015. http://www.sothebys.com/en/news-video/auction-essays/full-circle
-jiro-yoshihara-collection/2015/09/two-legacies-yoshihara-jiro-gutai-circle
.html (accessed Jan. 3, 2016).

Tomkins, Calvin. "Profiles: Figure in an Imaginary Landscape, John Cage." *The New
Yorker,* Nov. 28, 1964, 120–121.

——. "Zen and the Art of Tennis." *The New Yorker,* Aug. 8, 1959, 24–26.

Treeleaf Zendo. "Live Zazenkai Netcast," Nov. 15, 2013. http://www.treeleaf.org /forums/showthread.php?11639-November-15th-16th-2013-Treeleaf-Weekly (accessed March 12, 2014).

——. "Mercedes Benz X Zen." *Treeleaf Zendo Forum,* Nov. 20, 2013. http://www .treeleaf.org/forums/showthread.php?11635-Mercedes-Benz-X-Zazen (accessed March 14, 2014).

Tricycle magazine, ed. *Buddha Laughing: A Tricycle Book of Cartoons.* New York: Three Rivers Press, 1999.

Triplett, Katja. "From the Archives of the Museum of Religion at Marburg University: R. Otto and Zen." *Center for the Study of Japanese Religions Newsletter* (SOAS), 16–17 (January 2008): 12–14.

Tully, Judd. "Master of the Universe: Artist, Curator and Brand Promoter Takashi Murakami Is Lord of an Empire That Knows No Borders or Creative Limitations." *Art & Auction* (October 2007): 162–171.

Tuma, Kathryn. "In Conversation: T. J. Clark with Kathryn Tuma." *The Brooklyn Rail: Critical Perspectives on Arts, Politics, and Culture,* Nov. 2, 2006. http:// www.brooklynrail.org/2006/11/art/tj-clark (accessed Aug. 4, 2015).

Tweed, Thomas A. *The American Encounter with Buddhism, 1844–1912: Victorian Culture and the Limits of Dissent.* Bloomington: Indiana University Press, 1992.

——. "American Occultism and Japanese Buddhism: Albert J. Edmunds, D. T. Suzuki, and Translocative History." *Japanese Journal of Religious Studies* 32, no. 2 (2005): 249–281.

——. "Buddhism, Art, and Transcultural Collage: Toward a Cultural History of Buddhism in the United States, 1945–2000." In *Gods in America: Religious Pluralism in the United Statues,* ed. Charles L. Cohen and Ronald L. Numbers, 193–227. New York and Oxford: Oxford University Press, 2013.

——. "Night-Stand Buddhists and Other Creatures: Sympathizers, Adherents, and the Study of Religion." In *American Buddhism: Methods and Findings in Recent Scholarship,* ed. Duncan Ryūken Williams and Christopher S. Queen, 71–90. Richmond, Surrey: Curzon Press, 1999.

Tworkov, Helen. *Zen in America: Five Teachers and the Search for an American Buddhism.* New York: Kodansha America, 1994.

"Two Worlds of Jazz." *The Sunday Times* (London), Sept. 11, 1960, 37.

Uchiyama, Kosho, and Shohaku Okumura. *The Zen Teaching of Homeless Kodo.* Somerville, MA: Wisdom Publications, 2014.

Ueda Shizuteru and Yanagida Seizan. *Jūgyūzu: Jiko no genzōgaku.* Tokyo: Chikuma Shobō, 1992.

Updike, John. "Invisible Cathedral: A Walk through the New Modern." *The New Yorker,* Nov. 15, 2004, 106.

Vadnie, Rebecca Swain. "The Zen of Isamu Noguchi: Aesthetics of East and West Merge in His Art." *Orlando Sentinel,* Jan. 13, 2006. http://articles.orlandosentinel .com/2006–01–13/entertainment/NOGUCHI13_1_isamu-noguchi-sculptures -aesthetics.

Van de Wetering, Janwillem. *De lege spiegel; Ervaringen in een Japans Zenklooster.* Amsterdam: De Driehoek, 1971.

Varnedoe, Kirk. *Pictures of Nothing: Abstract Art since Pollock.* Washington, DC: National Gallery of Art, 2006.

Victoria, Brian D. *Zen at War.* New York and Tokyo: Weatherhill, 1997.

Victoria, Daizen [Brian]. "Japanese Corporate Zen." *Bulletin of Concerned Asian Scholars* 12, no. 1 (January–March 1984): 61–68.

Vlastos, Stephen. "Tradition: Past/Present Culture and Modern Japanese History." In *Mirror of Modernity: Invented Traditions of Modern Japan,* ed. Stephen Vlastos, 1–6. Berkeley: University of California Press, 1998.

Vogel, Carol. "The Warhol of Japan Pours Ritual Tea in a Zen Moment." *New York Times,* May 7, 2007, http://query.nytimes.com/gst/fullpage.html?res =9D02E3DC1E3EF934A35756C0A9619C8B63&pagewanted=all (accessed Feb. 24, 2012).

Wakefield, Jack. "Review of Murakami Takashi, 'Tranquility of the Heart, Torment of the Flesh: Open Wide the Eye of the Heart and Nothing Is Invisible.'" In http://www.saatchi-gallery.co.uk/blogon/2007/05/takashi_murakami_at _gagosian_n.php (accessed July 30, 2014).

Wakimoto Sokurō. "Zuhan kaisetsu: Indara-hitsu Tanka shōbutsu zu (Tōkyō Kōshaku Kuroda Nagashige-shi zō)." *Bijutsu kenkyū* 14 (February 1933): 28–29.

Waley, Arthur. *Zen Buddhism and Its Relation to Art.* London: Luzac & Co., 1922.

Wall, Derek. *Babylon and Beyond: The Economics of Anti-Capitalist, Anti-Globalist and Radical Green Movements.* London: Pluto Press, 2005.

Wang, Meizhi, and Haoyun Guo. *The Patriarch of Chan: The Life of Bodhidharma.* Hacienda Heights, CA: Buddha's Light Publishing, 2013.

Warner, Brad. *Hardcore Zen: Punk Rock, Monster Movies and the Truth about Reality.* Somerville, MA: Wisdom Publications, 1994.

———. "Zen Wrapped in Karma Dipped in Chocolate." *Hardcore Zen,* Oct. 10, 2006. http://hardcorezen.info/zen-wrapped-in-karma-dipped-in-chocolate/807 (accessed March 12, 2014).

———. *Zen Wrapped in Karma Dipped in Chocolate: A Trip through Death, Sex, Divorce, and Spiritual Celebrity in Search of the True Dharma.* Novato, CA: New World Library, 2009.

Warner, Langdon. *The Enduring Art of Japan.* Cambridge, MA: Harvard University Press, 1958.

Watts, Alan W. "Beat Zen, Square Zen, and Zen." *Chicago Review* 12, no. 2 (1958): 3–11.

———. "Buddhism and Humour." *Buddhism in England* (September–October 1933). Reprinted in *The Early Writings of Alan Watts, The British Years: 1931–1938, Writings in Buddhism in England,* ed. John Snelling, 89–95. Berkeley, CA: Celestial Arts, 1987.

———. *In My Own Way: An Autobiography, 1915–1965.* New York: Pantheon Books, 1972.

———. "The Life of Zen." https://archive.org/details/AlanWatts-TheLifeOfZen-Kqed -1959 (accessed Dec. 2, 2015).

———. *An Outline of Zen Buddhism* (1932). Reprinted in *The Early Writings of Alan Watts: The British Years: 1931–1938, Writings in Buddhism in England,* ed. John Snelling, 38–54. Berkeley, CA: Celestial Arts, 1987.

———. *The Spirit of Zen: A Way of Life, Work and Art in the Far East.* London: John Murray, 1936 (reprinted 1948).

———. *This Is It: And Other Essays on Zen and Spiritual Experience.* New York: Random House, 1960.

———. *The Way of Zen.* New York: Pantheon, 1957.

———. *Zen.* Stanford, CA: James Ladd Delkin, 1948.

Wee, C. J. W.-L. "'We Asians?' Modernity, Visual Art Exhibitions, and East Asia." *boundary 2* 37, no. 1 (2010): 91–126.

Weisenfeld, Gennifer. "Reinscribing Tradition in a Transnational Art World." In *Asian Art History in the Twenty-First Century,* ed. Vishakha N. Desai, 181–198. Williamstown, MA: Sterling and Francine Clark Art Institute, 2007.

Welter, Albert. "Lineage and Context in the Patriarch's Hall Collection and the Transmission of the Lamp." In *The Zen Canon: Understanding the Classic Texts,* ed. Steven Heine and Dale S. Wright, 137–180. Oxford: Oxford University Press, 2004.

———. "Mahākāśyapa's Smile: Silent Transmission and the Kung-an (Koan) Tradition." In *The Koan: Texts and Contexts in Zen Buddhism,* ed. Steven Heine and Dale S. Wright, 75–109. Oxford: Oxford University Press, 2000.

———. *Monks, Rulers, and Literati: The Political Ascendancy of Chan Buddhism.* Oxford: Oxford University Press, 2006.

Werblowsky, R. J. Zwi. "Some Observations on Recent Studies of Zen." In *Studies in Mysticism and Religion Presented to Gershom G. Scholem,* ed. E. E. Urbach et al., 317–335. Jerusalem: Magnes Press, 1967.

Westgeest, Helen. *Zen in the Fifties: Interaction of Art between East and West.* Zwolle: Waaners Publishers, 1996.

Weston, Victoria. *Japanese Painting and National Identity: Okakura Tenshin and His Circle.* Ann Arbor: Center for Japanese Studies, University of Michigan, 2004.

Whalen, Philip. "1957–1977: Selections from the Journals Part II." *Lost & Found: The CUNY Poetics Document Initiative,* ser. 1, no. 4 (Winter 2009).

Whalen-Bridge, John. "Angry Monk Syndrome on the World Stage: Tibet, Engaged Buddhism, and the Weapons of the Weak." In *Buddhism, Modernity, and the State in Asia: Forms of Engagement,* ed. John Whalen-Bridge and Pattana Kitiarsa, 163–207. New York: Palgrave Macmillan, 2013.

White Jr., Lynn T. *Frontiers of Knowledge in the Study of Man.* New York: Harper & Brothers, 1956.

Whitmyer, Claude, ed. *Mindfulness and Meaningful Work: Explorations in Right Livelihood.* Berkeley, CA: Parallax Press, 1994.

Wienpahl, Paul. *Zen Diary.* New York: Harper & Row, 1970.

Wiggin, Maurice. "Crime and Punishment." *The Sunday Times* (London), March 31, 1963, 39.

Wilde, Oscar. *Intentions: The Decay of Lying, Pen, Pencil, and Poison; The Critic as Artist, the Truth of Masks.* Portland, ME: Thomas B. Mosher, 1904.

Williams, R. John. *The Buddha in the Machine: Art, Technology, and the Meeting of East and West.* New Haven, CT: Yale University Press, 2014.

Wilson, Jeff. *Mindful America: Meditation and the Mutual Transformation of Buddhist Meditation and American Culture.* Oxford: Oxford University Press, 2014.

Winther-Tamaki, Bert. *Art in the Encounter of Nations: Japanese and American Artists in the Early Postwar Years.* Honolulu: University of Hawai'i Press, 2001.

———. "The Asian Dimensions of Postwar Abstract Art: Calligraphy and Metaphysics." In *The Third Mind: American Artists Contemplate Asia, 1860–1989,* ed. Alexandra Munroe, 145–157. New York: Guggenheim Museum, 2009.

———. "Overtly, Covertly, or Not at All: Putting 'Japan' in Japanese American Painting." In Cynthia Mills et al., eds. *East–West Interchanges in American Art,* 112–125. Washington, DC: Smithsonian Institution Scholarly Press, 2011.

Wittern, Christian. "Thirty Blows if You Succeed, Thirty Blows if You Fail." *Zenbunka kenkyūsho kiyō* 25 (November 2000): 1–14.

Woodson, Yoko, and Doryun Chong. *Zen: Painting and Calligraphy, 17th–20th Centuries.* San Francisco, CA: Asian Art Museum, 2001.

Wright, Dale S. "Humanizing the Image of a Zen Master: Taizan Maezumi Roshi." In *Zen Masters,* ed. Steven Heine and Dale S. Wright, 243–245. Oxford: Oxford University Press, 2010.

———. *Philosophical Meditations on Zen Buddhism.* Cambridge: Cambridge University Press, 1998.

Wu, Jiang, *Englightenment in Dispute: The Reinvention of Chan Buddhism in Seventeenth-Century China*. Oxford: Oxford University Press, 2008.

Yahoo Japan. *Chiebukuro Q&A*. http://detail.chiebukuro.yahoo.co.jp/qa/question_detail/q12116409062 (accessed March 12, 2014).

Yamada, Chisaburō F., ed. *Dialogue in Art: Japan and the West*. New York and Tokyo: Kōdansha International, 1976.

Yamada, Shōji. *Shots in the Dark: Japan, the West, and Zen*. Chicago: University of Chicago Press, 2009.

———. *Tōkyō bugiugi to Suzuki Daisetsu*. Kyoto: Jinbun Shoin, 2015.

Yamashita Yūji. "Reconsidering 'Zenga'—In Terms of America, in Terms of Japanese Art History." In Yamashita Yūji et al., *Zenga—The Return from America: Zenga from the Gitter-Yelen Collection,* 19–28. Tokyo: Asano Laboratories, 2000.

Yanagida Seizan, ed. *Sodōshū*. Kyōto: Chūbun Shuppansha, 1984.

Yang, Manuel. "Zen Buddhism as Radical Conviviality in the Works of Henry Miller, Kenneth Rexroth, and Thomas Merton." In *Encounter Buddhism in Twentieth-Century British and American Literature,* ed. Lawrence Normand and Alison Winch, 71–87. London: Bloomsbury, 2013.

Yashiro Yukio. *Nihon bijutsu no tokushitsu*. 2nd ed. 2 vols. Tokyo: Iwanami Shoten, 1962.

Yasuda Joshu Dainen Roshi. "Zen and Culture." *Zanmai* 8 (1976), http://www.wwzc.org/dharma-text/zen-and-culture.

Yifa, *The Origins of Buddhist Monastic Codes in China: An Annotated Translation and Study of the Chanyuan Qinggui*. Honolulu: University of Hawai'i Press, 2002.

"Yoplait—So Good—Chocolate." SplendAd.com, http://www.splendad.com/ads/show/832-Yoplait-So-Good-Chocolate (accessed March 12, 2014).

Yoshida, Kiyu. *Ozu's Anti-Cinema*. Translated by Daisuke Miyao and Kyoko Hirano. Ann Arbor: Center for Japanese Studies, University of Michigan, 2003.

Yoshihara Jirō. "Gutai bijutsu sengen." *Geijutsu Shinchō* 7, no. 12 (December 1956): 202–204. Translated by Reiko Tomii. http://web.guggenheim.org/exhibitions/gutai/data/manifesto.html (accessed Jan. 31, 2016).

———. "Koten no tame no bunsho." In Tōkyō Garō, *Yoshihara Jirō ten*. Tokyo: Tōkyō Garō, 1967. Reprinted in *Botsugo 20 nen Yoshihara Jirō ten*, ed. Ashiya Shiritsu Bijutsukan, 205. Ashiya-shi: Ashiya Shiritsu Bijutsukan, 1992.

Yoshihara, Mari. *Embracing the East: White Women and American Orientalism*. Oxford: Oxford University Press, 2003.

Yoshimoto, Midori. *Into Performance: Japanese Women Artists in New York*. New Brunswick, NJ: Rutgers University Press, 2005.

Yoshimoto, Mitsuhiro. *Kurosawa: Film Studies and Japanese Cinema*. Durham, NC: Duke University Press, 2000.

Yoshizawa Katsuhiro. *Hakuin: Zenga no sekai*. Tokyo: Chūō Kōronsha, 2005.

———. "The Interest in Hakuin's Art." In "Toward a Hakuin Studies," 2003. International Research Institute for Zen Buddhism, http://iriz.hanazono.ac.jp/frame/k_room_f1a.en.html.

Yoshizawa Katsuhiro, with Norman Waddell, *The Religious Art of Zen Master Hakuin*. Berkeley, CA: Counterpoint, 2008.

Yu, Eui-Young. "The Growth of Korean Buddhism in the United States, with Special Reference to Southern California." *Pacific World: Journal of the Institute of Buddhist Studies* 4 (1988): 82–93.

"Zazen vs. Mercedes." http://www.mojvideo.com/video-mercedes-benz-a-45-amg-2014-vs-zazen/de5e997f3f0cdc7748d8 (accessed March 7, 2014).

"Zen." *Time,* Feb. 4, 1957, 65–67.

"Zen: Beat and Square." *Time,* July 21, 1958, 49.

"Zen at CentralWorld Bangkok." *Bangkok Shopping.* http://www.bangkok.com/shopping-mall/zen.htm (accessed June 24, 2014).

"Zen Department Store." http://www.zen.co.th/Home/ (accessed June 24, 2014)

"Zen Ecig." http://www.zencig.com/en/ (accessed July 21, 2014).

"Zen History Is Made in New York." *Zen Notes* 1, no. 7 (July 1954): n.p.

"Zen Humor." *Lots of Jokes.* www.lotsofjokes.com/zen_humor.asp (accessed Aug. 12, 2012).

Zen Lifestyle Trend Megastore. "ZEN." http://www.zen.co.th/parallax-about/ (accessed July 22, 2015).

"Zen Meditation vs. Mercedes-Benz." *Buddhist Art News,* Nov. 15, 2013. http://buddhistartnews.wordpress.com/2013/11/15/special-movie-a-45-amg-x-zazen-now-playing-on-the-web/ (accessed March 10, 2014).

Zen Mountain Monastery. "Cybermonk." http://zmm.mro.org/cyber-monk/ (accessed July 9, 2014).

Zen Notes. First Zen Institute of America, 1954–. http://www.firstzen.org/ZenNotesOnLine.php (accessed Dec. 2, 2015).

"Zensation." *Time,* Feb. 23, 1959, 52.

Žižek, Slavoj. *On Belief.* London: Routledge, 2001.

———. *The Puppet and the Dwarf: The Perverse Core of Christianity.* Cambridge, MA: MIT Press, 2003.

ZPA-Berzerk. "Zenphobia." *Urban Dictionary,* Nov. 10, 2005. http://www.urbandictionary.com/define.php?term=Zenphobia (accessed July 4, 2014).

INDEX

Bold page numbers refer to figures.

advertising: borrowed interest strategy, 208–209, 274n48; promotional value of Zen, 195–197, 200–204, 206–209, 211–214, 215–219; television, 208–209, 211–214, 215–219, 275n73

aesthetics: Japanese, 84, 89, 92–93, 203, 256n69; package design, 201, 203, 207; of PowerPoint presentations, 88; Zen, 9–10, 86, 88–94, 153, 205, 242, 275n81

Aitken, Robert, 102, 103

Alcock, Sir Rutherford, 28

Ames, Van Meter, 85, 86, 98, 102, 110, 113, 135

Anesaki Masaharu, *Buddhist Art in Its Relation to Buddhist Ideals,* 36–37, 38, 84

Anjirō, 27

App, Urs, 27

Apple Computer, 88

Arnold, Geoffrey Shugen, 225, 234

art, Japanese: modern, 142–144, 146–148; Nihonga, 35, 67; relationship to Zen, 123, 134; Western perceptions, 28–29. *See also* aesthetics; art, Zen

art, Western: Abstract Expressionism, 106, 132, 133, 142–143, 148, 149; Asian influences, 148; modernist, 17, 56–57, 142; New York School, 142, 143, 144; twentieth-century, 25

art, Zen: absolutism, 83, 86; in Ashikaga period, 32, 33, 35–36, 38; canon, 34, 38, 49, 63, 64; in China, 35, 39, 62; cultural importance in Japan, 77, 82–86; defining, 15–18, 23, 37, 96; exhibitions, 21, 34, 39, 105, 260n45; explaining, 75–77, 81, 82, 84, 134; in future, 243; ink paintings (*sumiye*), 27, 30–31, 33, 36, 49, 77, 78, 80, 145–146; interest in, 11, 77–78, 240, 241, 242–243; landscape painting, 39, 77; look of, 77–82, 91; National Treasures of Japan, 34, 64, 146; popularity in Japan, 35, 105; in postwar period, 92, 131–134, 146–148, 157; premodern, 34, 49, 77, 78, 105, 145–146; qualities, 33, 78–79, 86, 88–94; recent, 1–3; religious meanings, 161; representational, 78–79; scholarship on, 21, 26, 76–77, 81–82, 86, 240, 242; Suzuki on, 31, 35, 51, 80–81, 123; use of term, 9; Western poetry and, 49–50

art, Zen, Western perceptions: evolution, 25–26, 40–41; of Japanese artists, 143–144; Jesuit missionaries, 27; in nineteenth and early twentieth centuries, 28–33, 36–41, 79–80, 81–82, 84–85; in postwar period, 41, 143–144; questioning, 86–87; spiritual interpretations, 38–39, 81

artists: of Asian background, 19, 131–132, 142–143, 145–148; denial of Zen influence, 148–151, 154, 155, 156; Japanese, 148–151, 154; professional, 87; students of Zen, 78

artists, Zen: criticism of, 132–133; defining, 16; influence of Zen, 134–136, 140–141, 144–145; inherent Zen, 145–148; insights from concentration, 79–80; Japanese, 143–144, 146–148; lineages, 147–148; monks, 28, 30–31, 33, 35, 40, 77; in postwar period, 105–106, 132–134, 142–143; spontaneity, 79–80; transmission among, 141–142, 265n51. *See also* Cage, John; Gutai art collective

Asahina Sōgen, 104, 111

Ashida, Margaret E., 117

Asian Art Museum, San Francisco, 18

Asian stereotypes. *See* racial stereotypes

Australia, Zen in, 103

authenticity, 11–12, 14, 20, 23, 112, 199, 216–217

Awakawa Yasuichi, *Zen Painting,* 92

awakening. *See* satori

Barrett, William, 109, 122

Baxandall, Michael, 135

Beard, Mary, 177

Beat Zen, 13, 14, 53, 115–117, 181, 262n102
Becker, Ernest, 7–8, 85–86, 118, 121
Bein, Steve, 44
Belting, Hans, 78
Benz, Ernst, 117–118
Berger, Maurice, 17
Berkeley, George, 168
Besserman, Perle, 56
Bhikkhu Bodhi, 9, 197
Bigelow, William Sturgis, 66
Big Lebowski, The, 8, 56, 142, 181–183, 241
Binyon, Laurence, *Painting in the Far East,* 38, 84
Blofeld, John, 136
Blue Cliff Record, The (Ch. *Biyan lu;* J. *Hekigan roku*), 55
Blyth, R. H., 49–50, 84–85, 102, 136, 186
Bodhi-characters, 180–184
Bodhidharma (J. Daruma): *Daruma,* 29, **29**; *Giant Daruma* (Hakuin), 77, 160–161, **Plate 2**; images, 27, 29–30, 77, 79, 94–96, 223; offerings to, 95; on wordlessness, 76
bookish Zen, 12, 13, 15, 91, 98
Bordwell, David, 153, 154
Bradbury, Ray, 6
Brandon, Henry, 115
Braque, Georges, 148, 267n82
Brazil: Zen consumption, 200; Zen temples, 103
Bridges, Jeff, 8, 181, 182, 241
Briggs, William A., 162, **163**
Brown, James P., 53
Brown, Jerry, 167
Budai (J. Hotei), 29, 55, 77, 183, 271n76
Buddha: paintings, 37; relics, 60, 61; Śākyamuni, 7, 48, 66, 77, 82, 188, 223. *See also* "Danxia burns the Buddha" story
Buddhism: home altars, 224; modern conceptions, 174–175, 180; multiplicity, 20; New, 83; practices, 180, 182–183; Pure Land, 47, 86; scholarship on, 22, 178; Western perceptions, 11, 27, 34. *See also* Chan Buddhism; Zen
Buddhist Society (London), 103, 106, 127, 259n32
Bunsei, *Landscape,* 41, **41**
businesses, Zen teachings and, 93, 104, 231–232. *See also* advertising; consumer capitalism; Monastery Store; Right Livelihood; technology

Byōdōin, Uji, Amida Hall, 32
Byrnes, Pat, **165**, 170, **170**, **173**

Cage, John: avant-gardism, 95; criticism of, 132–133, 141; Duchamp and, 155; *4'33,* 1, 78, 106, 131, 136, 137; *Indeterminacy,* 264n22; in Japan, 260n44; "Lecture on Nothing," 136–137; "Lecture on Something," 136; nature of Zen influence, 130–131, 134, 136–142, 262n102; study of Asian cultures, 139, 140, 265n30; Suzuki and, 44, 51, **131**, 136, 138, 139, 141–142; on Zen, 46, 240
calligraphy, 16, 34, 59, 77–78, 149. *See also enso*
Campbell, Patrick, 113
Canada, Zen in, 103
capitalism. *See* businesses; consumer capitalism
cartoons, Zen: audiences, 160, 164, 174, 191, 192; cat trope, 168, 172, **173**; deeper meanings, 190–191, 193–194; defining, 158–159, 160; functions, 160, 192–194; humor, 166–174; iconography, 162–163, 166–167; look of, 158–159; persuasive force, 160; potentially offensive, 179–180; stereotypical figures, 163, 166, 179, 184, 192–193, 272n112; themes, 162–173, 191–192; visual and rhetorical operations, 192–194. *See also New Yorker* cartoons
Carus, Paul, 46
Castile, Rand, 98
Catapano, Joseph, 204
Chakrabarty, Dipesh, 22
Chamberlain, Basil Hall, *Handbook for Travellers in Japan,* 30, 31
Chan Buddhism: art, 35, 39, 62; eccentrics, 183; encounter narratives, 61; historical study of, 119–120; Hongzhou school, 55, 56; humor, 178; monks' conduct, 55–56; origins, 7, 82; patriarchs, 29–30, 178, 189; spread, 7, 48, 128–129; Suzuki on, 47–48, 119, 120, 262n124. *See also* Bodhidharma; Zen
Chanoyu, 27, 35, 95
China, Southern Song painting, 35, 39, 152. *See also* Chan Buddhism
Christianity: missionaries, 26–28; monasteries, 236; Zen and, 104, 107, 109, 110
Chushi Fanqi, 62

Clark, T. J., 243
Clifton, Robert Stuart, 103
Coen, Ethan and Joel. See *Big Leb-owski, The*
Cohen, Jundo, 217–219
Cold War, 45, 111, 142, 156. *See also* postwar period
Collins, William, "Ode to Evening," 49–50
Conceptual Zen, 13–14
Connolly, Cyril, 116, 117
consumer capitalism, 195, 197, 199, 235–236
consumption, Buddhist teachings and, 197, 201–202, 229–231, 233–234, 235–238. *See also* advertising; products
Coomaraswamy, Ananda K., 71, 139
corporations. *See* businesses
counterculture, 53, 56, 105, 110, 122
Covell, Jon Carter, 85
Coverly, Dave, 168, **173**
Cox, John, 175, **176**
Crane, Cornelius, 103
Cranston, Maurice, 113, 118
Critchley, Simon, 160
Crooks, Edward J., 138, 139, 140

Daidō Bunka, *Ensō,* **2**
Daigu Sōchiku, 59
Daily Show, The, 8
Daitokuji (Kyoto), 39, 104
Dalai Lama, 175–177, 207, 270n46
Danto, Arthur C., 143–144
"Danxia burns the Buddha" story, 60–62, 69–74, 219; images, 61–69, **65**, **68**, 70, **70**, **Plates 3, 7**
Daruma. *See* Bodhidharma
DC. *See* Dharma Communications
Deshan Xuanjian, 55, 254n62
Desser, David, 154
de Torres, Cosme, 27
Dewey, John, 45
Dharma Communications (DC) Inc., 226–229, 232, 233, 237, 276n117. *See also* Monastery Store
Diffee, Matthew, 170, **171**
Dōgen Kigen, 14, 44, 60–61
Doris, David T., 111
Dow, Arthur Wesley, 31
Duchamp, Marcel, 144, 155
Dumoulin, Heinrich, 119, 262n124
Dunn, Max, 103
Dunn, Michael, 92–93

eccentricity. *See* iconoclasm
Eckhart, Meister, 45, 47, 71, 139

economics, Buddhist, 230–231. *See also* consumer capitalism; Right Livelihood
Eightfold Path, 230, 232, 233, 234
Eliot, Charles, 71
Elkins, James, 135–136
Emerson, Ralph Waldo, 45, 155
emptiness (*kū*), 5, 25, 59, 92, 134, 146, 164, 229
Encounter, 121–122
enlightenment, 16–17, 81, 125, 141, 186. *See also* satori
ensō (calligraphic circles), 1, 16, 18, 77, 149, 163, 212
Entangling Vines Collection (Shūmon kattōshū), 61
Entangling Vines Collection, The: A Japanese Reading and Concise Interpretation (Kattōshū: Wakun ryakkai), 66
ethics, 118, 197, 230, 232. *See also* Eightfold Path; Right Livelihood
Europe, Zen in, 103
Exposition Universelle (Paris), 32, 33, 89

Farkas, Mary, 6, 101, 102, 123, 162, 195, 202
F.A.S. Society, 88, 104
Faubion, James D., 3
Faure, Bernard, 58
Fenollosa, Ernest F., 38–41, 89
Ferreira, Cristóvão, 27
Few Good Men, A, 169
films: actors, 151; *The Big Lebowski,* 8, 56, 142, 181–183, 241; documentaries, 101, 214–215; *Groundhog Day,* 185; *Seven Samurai (Shichinin no samurai),* 90; Zen influences seen, 92, 151–154
First Zen Institute of America, 6, 72, 102, 123, 162
Fisher, Ed, 166–167
Fluxus art network, 131, 132, 141, 145
Frank, Adam, 182
Freer, Charles, 66
Frois, Luis, 27, 28
Fukui Rikichirō, 41

Gagosian Gallery, New York, 94–95
Gallagher, Catherine, 160
Gallery of Japanese and Chinese Paintings, A (Wakan meigasen), 63
gardens, Zen: cartoon depictions, 170–172, **170–172**, **Plate 9**; designers, 88; interest in, 77–78; Maruyama on, 16–17; miniature,

172; modernist design and, 35; at monasteries, 28; of Ryōanji, **3**, 136, 170, 172, 209–210, 211
Garfinkle, Perry, 185
Gates, Bill, 88
Geist, Kathe, 152–153, 154
Gentile, Emilio, 112
Ginsburg, Allen, 105
Glassman, Bernie Tetsugen, 8, 182, 241
global Zen, 7–8, 10, 11, 21, 53
Goddard, Dwight, 44–45, 233, 260n60
Goddard, Vanessa Zuisei, 224, 226, 227, 228, 235
Gombrich, Richard F., 177
Grateful Dead, 5
Great Britain: Buddhist Society, 103, 106, 127, 259n32; Zen in, 103
Greenberg, Clement, 148
Greenblatt, Stephen, 160
Greey, Edward, 29–30
Gregory, Peter N., 56
Grimes, Ronald L., 58, 145, 243
Grimshaw, Mike, 122
Groundhog Day, 185
Guifeng Zongmi, 13, 56, 57
Gutai art collective, 107, 132, 142–143, 144, 145, 149–150, 260n45, 266n64

Haga Tōre (Tōru), 145–148
Haito Masahiko, 150
Hakuin Ekaku, 35, 43, 228; *Giant Daruma,* 77, 160–161, **Plate 2**; "What is the sound of one hand clapping?", 166, 168; *Wild Ivy (Itsumadegusa),* 58–59
Harada Jirō, 84
Harootunian, Harry, 111
Harris, Sidney, **164**, 167, **167**
Harrison, Max, 132
Hasegawa Saburō, 95, 102, 149
Hashimoto Shōtei, 67, 68
Hasumi Toshimitsu, 90
Hawai'i: Suzuki's lectures, 104; Zen temples, 102
Hayakawa Sessue, 100, 102, 151
Heard, Gerald, 99, 113, 118, 137
Heidegger, Martin, 104, 267n84
Heine, Steven, 11
Hellstein, Valerie, 133–134
Herman, Barbara, 203–204
Herrigel, Eugen, 107, 148, 267n82
Hinüber, Oskar von, 177
Hirai Tomio, 214–215
Hisamatsu Shin'ichi: F.A.S. Society, 88, 104; on historical study of Zen

art, 119; on mysticism, 10; popularization of Zen, 22, 44, 104, 255n26; in United States, 103, 104; on Western understanding of Zen, 107; *Zen and the Fine Arts,* 88–92, 93; on Zen art, 16, 81
Histoire de l'art du Japon, L', 33, 34, 89
Hockley, Alan, 143
Holmes, Stewart W., 103
Hotei. *See* Budai
Hsuan Hua, 103, 129
Hu Shih, 71, 118–120, 121, 124
Huang, Yunte, 3–4
Huang Po (Huangbo), 107, 136, 138, 139, 265nn30–31
Huiseng, 253n60
humor: Bodhi-characters, 180–184; in Buddhism, 174–178, 180, 184–185, 271n76; cultural barriers, 176; jokes, 175–177, 178, 186–187; perceived in Zen paintings, 160–161; scholarship on, 177, 178, 186, 187–190; in Zen, 174, 186–190. *See also* cartoons
Humphreys, Christmas, 103, 118, 126, 127–128
Hunter, Robert, 5
Huyssen, Andreas, 139
Hyers, Conrad M., 186, 187–190
Hyun, Peter, 116

iconoclasm: "Danxia burns the Buddha" story, 60–74, 219; discourses for Western audiences, 69–71; in modern art, 56–57; of Zen, 54–57, 58–60, 70–74, 87
Idemitsu Sazō, 35, 65
Ikkyū Sōjun, 55, 78, 274n47
Il Bung Kyung Bo, 103
imperialism: Japanese, 35, 48, 67–68, 80, 249n70; Western, 38, 46
inherent Zen, 145–148
Inoue Yūichi, 106, 149
Irizarry, Joshua A., 8, 196
Itō Teiji, 92–93
Iwamura, Jane N., 184

Jaffe, Richard M., 19, 20, 44, 45, 46, 47, 50, 83
Jain, Andrea R., 19
James, William, 45, 46
Japan: art authorizing system, 146; Ashikaga period, 32, 33, 35–36; corporations, 104; fascism, 122; imperialism, 35, 48, 67–68, 80, 249n70; intellectuals, 37–38, 44,

45–47, 80, 83, 93; militarism, 47;
missionaries, 27–28; moderniza-
tion, 34; modern Zen, 46; muse-
ums, 34; nationalism, 80, 242–243;
Pure Land Buddhism, 86; spiritu-
ality, 47, 48; US occupation, 109;
Western students of Zen, 104, 108,
117, 120, 123, 124, 264n3; youth,
116; Zen as specific to, 47–48, 49,
84, 107–108. *See also* art, Japanese;
Japanese culture
Japan Art Association (Nihon Bijutsu
Kyōkai), 63–64
Japan-British Exhibition (London),
32–33
Japanese Americans, 102, 131–132
Japanese culture: exceptionalism,
6, 47, 189; modernity, 20, 83–84;
uniqueness, 69, 74, 80, 83; Zen
influences, 35, 36–37, 47–48,
82–86. *See also* art, Japanese; art,
Zen
Japonisme, 10, 28, 34
Jarrell, Randall, 157
Jarves, James, 29
*Jingde Era Record of the Transmis-
sion of the Lamp* (*Jingde chuan-
deng Lu*), 60
Jobs, Steve, 56, 88
Joly, Henri L., 70
Jorodo, 168
Josetsu, 30; *Catfish and Gourd,* 33
Jōshū Sasaki, 103
Jung, Carl, 104
Juniper, Andrew, 82, 92

Kandinsky, Wassily, 135–136
Kaplan, Bruce Eric, 172, **172**
Kapleau, Philip, 100, 103, 124–126
Karatani Kōjin, 154
Kasamatsu Akira, 214–215
Katsushika Hokusai: *Danxia Burning
a Buddha,* 66, **Plate 7**; Freer paint-
ing, 66; *Great Wave,* 211; Western
views of, 28, 66
Kawabata Gyokushō, 32
Keating, H. R. F., 132
Kennett, Jiyu, 103, 263n142
kenshō (seeing into one's true nature),
5, 48, 81, 125, 128
Kerouac, Jack, 51, 74, 115, 117; *The
Dharma Bums,* 13, 56, 105, 181,
262n102
Kikuchi, Yuko, 82
Klein, Allen, 186
Kline, Franz, 106, 149, 262n102
koans, 14, 128; in *The Big Lebowski,*

241; *hosshin,* 153; humorous, 186;
psychological use, 113; training, 23,
52; "What is the sound of one hand
clapping?", 166, 168
Koestler, Arthur, 76, 85, 121, 122, 140
Koichi Kawana, 88
Kokka (Flowers of the Nation), 63, 64
Korea. *See* Sŏn Buddhism
Kornfield, Jack, 12
Kōzuki Tesshū, 104
kū. See emptiness
Kuki Ryūichi, 33, 89
Kuki Shūzō, 89
Kung Fu, 142, 166
Kuroda Nagashige, 63, 64
Kurosawa Akira, 152; *Seven Samurai*
(*Shichinin no samurai*), 90
Kusama Yayoi, *Infinity Nets,* 106

Lamkin, Nathan, 228
Larson, Kay, 137
Laughing Buddha, 166, 183, 271n76
La Vallée Poussin, Louis de, 50
Lears, T. J. Jackson, 3
Leary, Timothy, 105
Lee, Sook-Kyung, 110
Liang Kai, 35; *The Sixth Patriarch
Chopping Bamboo* (*Rokuso zu*), **2**
liberalism, Western, 118, 122
Linji Yixuan, 55, 77
London *Sunday Times,* 101–102
Loori, John Daido, 219, 222, 225, 228,
233–234, 235, 237
Lopez, Donald S., Jr., 88, 189
Loy, David R., 19, 197, 227, 233
LSD, 5–6

Ma Yuan, 35, 152
Macy's Department Store, **196**, 203
"Magnificent Seven" characteristics of
Zen art, 88–92, 93
Mahoney, Stephen, 108, 120
marketing. *See* advertising; products
Maruyama Shin'ichi: *Kusho #1,* 16,
17–18, 246n62, 247n63, 247n65,
Plate 4; on Zen gardens, 16–17
mass media, 101–102, 107. *See also*
advertising; cartoons; popular
culture
Masunaga Reihō, 13–14, 108, 126, 128
Masuzawa, Tomoko, 22
McCandless, Ruth Strout, 195, 272n2
McMahan, David L., 45, 59
meditation (*zazen*): art influenced by,
33, 78; audiotapes, 226; cartoon
themes, 162, 163–166, **164**, 168–
169, **169**; cushions, 198–199, 221,

222–223, **222**, 226, 227; diverse meanings, 110; EEG monitoring, 212, 213, 214–216, **214**; importance, 23, 57, 125; practice, 12, 13, 37, 43, 182–183; Suzuki on, 43, 46, 47, 52; training for workers, 104; Western practitioners, 26, 124

Mercedes-Benz Japan, advertising, 211–214, **211**, 215–219, 275n83, 275n85

Merton, Thomas, 116–117, 225

Middle Way, The, 85, 126–127, 189

Milillo, Joseph, 197

Miller, Warren, 167–168, **168**

Minchō, 28, 30, 33

mindfulness, 9, 197, 201–202, 231, 233

Mitchell, John and Elsie, 103

Mitter, Parta, 142

Modell, Frank, 167

modernity: humor and, 174–175; Japanese culture and, 20, 83–84; Zen boom and, 108–112, 240

modern Zen: art world and, 92, 135; attitudes, 175, 180; debates, 19–20; drug scene and, 5–6; English poetry and, 49–50; exaptation, 53; hybridity, 45–47; iconoclasm, 56–57, 59–60, 74; in Japan, 46; landscape, 1–4; misrepresentation of Zen, 52, 117, 141; nationalism and, 47–48; philosophical emphasis, 10, 12–13, 120–121, 138, 174–175, 180; selective appropriation, 231–232; Suzuki's influence, 42–43, 44–47, 51–53; Western advocates, 44–45. *See also* Zen boom

moment of Zen, 8, 207–208

monasteries, Zen: buildings, 28, 87; foreign students, 104; gardens, 28; icons, 87; non-Zen artworks, 87; offerings to Bodhidharma, 95; in United States, 103, 219–220, 229; wealth, 229–230

Monastery Store, Zen Mountain Monastery: customers, 227, 236; differences from for-profit businesses, 220, 226–229, 236–238; mail-order catalog, 219, 220, 222–223, 227–228, 236; meditation cushions, 221, 222–223, **222**, 226; products, 220–225, 226, 237; retail space, 220–222, **221**; right livelihood practices, 220, 225, 226–227, 228, 232–236, 238; shipping department, 226, 234–235, **234**; website, 220, 222, 227–228, 236, 237–238

monastics: in ads, 212–214, 215–217, 275n83; cartoon depictions, 162, 164–167, 168, 169, 170, 171–172; criticism of Zen boom, 122–123; discipline, 57–58, 73–74; EEG monitoring, 212, 213, 214–216, **214**; financial activities, 229–230; nuns, 19, 20, 89; painters, 28, 30–31, 33, 35, 40, 77; in postwar Japan, 121; practices, 87; regulations, 54, 72–73; reverence for, 184; Rinzai Zen, 32, 122–123, 149; roles, 12; self-promotion, 195; stereotypes, 176–177, 184; Tendai, 216; Western missionaries and, 27; Zen aesthetics and, 89. *See also* meditation; Zen masters

Morgan, David, 24

Mori, Maryellen T., 68

Morinaga Sōkō, 104

Mountains and Rivers Order of Zen Buddhism (MRO), 219, 221, 223, 225, 232, 234, 275n94

mu. See nothingness

Muhammad, cartoon depictions, 179

Muji, 78

Munakata Shikō, 143

mu'nen. See no-thought

Munroe, Alexandra, 111, 140–141, 155

Munsterberg, Hugo, 82, 85, 90

Muqi Fachang, 35, 78; *Guanyin, Gibbons, and Crane*, 33, 34; *Six Persimmons*, 34, **34**, 79, 90, 146

Murakami Takashi: Superflat art, 94, 96, 258n110; *That I may time transcend, that a universe my heart may unfold*, 94–96, **Plate 8**

Museum of Fine Arts, Boston, 36–37, 39, 41, 260n45

Museum of Modern Art, New York, 95, 242

mushin. See no-mind

music, jazz, 100, 259n18. *See also* Cage, John

Nagai Hyōsai, 35

Nakagawa Sōen, 195

Nam June Paik, 110, 140, 145; *TV Buddha*, 18, 170; *Zen for Film*, 78, 106; *Zen for Head*, 106, **106**

Nast, Thomas, 179

nationalism: Japanese, 80, 242–243; modern Zen and, 47–48

National Treasures of Japan, 34, 64, 146

Native Zen, 14

Natsume Sōseki, 35

Nattier, Jan, 227

Nature's Path Foods, "Optimum Zen" cereal, 200, 207–208, **207**
New Buddhism (Shin Bukkyō), 83
New Yorker: circulation, 269n10; fiction, 114
New Yorker cartoons: audiences, 174, 191, 192, 269n10; common themes, 161; humor, 163–164; iconography, 162–163; political and cultural contexts, 192; racist, 179; religious themes, 161–162, **162**; Zen themes, 162–164, **164–165**, 166, **167–173**, 169–170, 191
Nietzsche, Friedrich, 3
Nike, "Roshe Run" shoe, 205–206, 274n43
Ninshitsu, 27
Nishida Kitarō, 25, 35, 80, 88, 90, 91
Noguchi, Isamu, 106, 142; *White Sun,* 18
no-mind (*mushin*), 16, 25, 78, 80–81, 89, 93
Nonaka Toshihiko, 171, **172**
Northrop, Filmer S. C., 110
Noth, Paul, 168
nothingness (*mu*), 25, 27, 41, 80, 88, 91, 164
no-thought (*mu'nen*), 78, 80, 89, 164
Nowick, Walter, 103
nuclear weapons, 111
Nukariya Kaiten, *The Religion of the Samurai,* 70–71, 83–84, 254n71
nuns, 19, 20, 89. *See also* monastics
Nyogen Senzaki, 102, 122, 195

Ōbaku Zen, 7, 125
Ogata Sōhaku, 85, 104, 117, 126–127, 128
Ohsawa, George, 202
Okada Kenzō, 143
Okakura Kakuzō, 10, 95; *The Book of Tea,* 26, 35–36, 40, 69–70, 95; Hōōden decoration, 32; *The Ideals of the East,* 35, 83; influence, 26, 40–41; tales of Zen masters, 56; on Zen art, 35, 36, 37, 39, 80, 89
Okamoto Ippei: *Danxia Burns a Buddha,* 67, 68, **68**, 69; magazine covers, 68
Okamoto Kanoko, 35, 68
Ono, Yoko, 106, 141, 260n44
"Optimum Zen" cereal, 200, 207–208, **207**
orientalism: aesthetic, 28; in art history, 38, 63; modern art and, 139–140, 142; reverse, 82, 93–94, 147

Otogawa Kōbun Chino, 56
Ozu Yasujirō, 151–153, 154, 267n95

Padgett, David M., 220, 227
Parisi, Mark, 168
Patterson, David W., 51, 138, 139
perfumes. *See* Shiseidō
Philadelphia Exposition, 31–32
Philosophy East and West, 119
Pier, Garrett Chatfield, *Temple Treasures of Japan,* 41
Pilgrim, Richard B., 86
Piraro, Dan, 164, **165**, 166, 170, 171–172, **171**, 179, **Plate 9**
Pirsig, Robert, *Zen and the Art of Motorcycle Maintenance,* 17, 167
popular culture: Bodhi-characters, 180–184; Buddhist imagery, 179–180; relationship to Zen, 95, 159–160; television, 142. *See also* cartoons; films
postwar period: art, 25, 56–57, 142; Cold War, 45, 111, 142, 156; cultural influence of Zen, 25; drug scene, 5–6; Western perceptions of Zen art, 41, 143–144; writings on Zen, 85; Zen art, 92, 131–134, 157. *See also* modern Zen; Zen boom
pragmatism, 45, 101
Precious Mirror of Painting (Ehon hōkan), 70, **70**
"Presentation Zen: Gates, Jobs, & the Zen aesthetic," 88
Pritchett, James, 131, 137, 139
products: books, 15, 209, 221, 225, 240; clothing, 205–206, 209–211, 221; food, 200, 202, 207–208; mass-market, 198–201; meditation and spiritual practice goods, 198–199, **222**, 232; sold by Zen communities, 198, 199, 229, 236; Zen-inspired, 78, 85, 100, 197–200, 202–208, 240; Zen shopping, 200. *See also* advertising; consumption; Monastery Store
psychology, Zen, 113, 123
Pure Land Buddhism, 47, 86
Purser, Ronald E., 197

Raasch, Dylan, 205–206
racial stereotypes: in cartoons, 163, 166, 179, 192–193, 272n112; of Japanese, 33, 242
Ramis, Harold, 185
Rauschenberg, Robert, *White Paintings,* 106
Ray, Rudolf, 154–155

Reilly, Donald, **162**
Reiner, Rob, 169
Reinhardt, Ad, 92; *Black Paintings,*
 106
retail Zen. *See* advertising; consumption; products
Retallack, Joan, 141, 142
Reynolds, Garr, 88
Right Livelihood, 220, 225, 230,
 232–236, 238
Rinzai Zen: criticism of, 128; foreign
 students, 104; history, 7; monastics,
 32, 122–123, 149; Suzuki and, 14,
 43, 46, 50; in West, 44, 102, 128.
 See also Hakuin Ekaku
Rocha, Cristina, 200
Rochester Zen Center, 198, 229
Rodrigues, João, 27
Rogers, Arthur H., 5
Romanticism: of art historians, 29,
 31, 38, 40–41, 50, 79, 80; iconoclasm and, 59; Western art, 47
Rosenberg, Harold, 132
Ross, Nancy Wilson, 25, 50–51, 136,
 186
Roszak, Theodore, 117, 243
rule breaking, 54–56
Rumbold, Richard, 117
Ryōanji, Kyoto, South Garden, **3**, 136,
 170, 172, 209–210, 211
Ryōsen'an, 104, 123

Said, Edward, 139
Salinger, J. D., 7–8; "Seymour: An
 Introduction," 114
Samu Sŭnim, 103
Sanbōkyōdan (Three Treasures Association), 103–104, 125, 263n150
San Francisco Zen Center, 103, 229
Sargeant, Winthrop, 22, 120
Sasaki, Ruth Fuller, 102, 104,
 122–123, 223
satori (awakening), 27, 48, 89, 115,
 120
Saunders, Kenneth James, 71
Schloegl, Irmgard, 103
Schmidt, Leigh Eric, 19
Schopen, Gregory, 177
Schrader, Paul, 152
Schumacher, E. F., 230
"Science of Zazen, The," 214–215
Sen Sō'oku, 95
Sengai Gibon: *Danxia Burning a
 Buddha,* 65–66, **65**, 160–161;
 paintings, 35, 260n45
Sesshū Tōyō: Fenollosa on, 40;
 paintings, 28, 30, 32, 33, 36, 78;

Splashed Ink Landscape (*Haboku
 sansui zu*), 16, 30–31, 49–50,
 145–146, 147, **Plate 1**
Sesson Shūkei, 36
Seung Sahn Haeng Won, 103
Seven Samurai (*Shichinin no samurai*), 90
Shaku Sōen, 32, 34, 46, 56, 66
Sharf, Robert H., 45, 58, 125
Shimada Shunpo, 66
Shimao Arata, 146
Shinto, 85, 86
Shiseidō, "Zen" fragrance, 195, **196**,
 197, 202–204, 273nn33–34
shopping, Zen, 200. *See also* consumption; products
Shūbun, 30, 33
Silicon Valley Zen, 231–232, 277n142
Sipress, David, 170, 171
Sitwell, Sacheverell, 146
Smith, Huston, 41
snobbism, Zen, 117–118
Snodgrass, Judith, 32
Snyder, Gary, 46, 105, 111, 129,
 266n54
Sōkei'an Sasaki Shigetsu, 56, 71, 72,
 102
Sŏn Buddhism, 7, 103, 129. *See also*
 Chan Buddhism; Zen
Soper, Alexander, 51
Sōtō Zen: foreign students, 104;
 history, 7; meditation practice, 215;
 patriarchs, 14, 44, 60–61
Sperry, Rod Meade, 211, 216–217
spontaneity, 10, 58, 78, 79–80, 110,
 115
Square Zen, 13, 14, 116, 124, 126
Steger, Manfred, 56
Stevanovic, Karl, 175
Stewart, Jon, 8
Stieglitz, Alfred, 17
Sturges, John, *The Magnificent
 Seven,* 90
Subitzky, Ed, 163, **163**
Sugi Yasusaburō, 215
Suh, Sharon A., 10, 181
Sunday Times, The, 85, 115, 116, 202
Survey Report on Art Treasures
 (*Kichō bijusuhin chōsa hōkoku*),
 63–64
Suzuki, D. T. (Suzuki Daisetsu Teitarō): on Beat Zen, 115; Braque and,
 148; "Buddhist, Especially Zen,
 Contributions to Japanese Culture,"
 80; on Chan Buddhism, 47–48,
 119, 120, 262n124; critics, 50–51,
 121, 124, 125; debates with Hu and

Koestler, 118–120, 121; early life and education, 46; engagement with Western thought, 45–47, 50, 51; *Essays in Zen Buddhism,* 15, 42–43, 99–100, 106, 137; influence, 4, 20, 26, 35, 42, 44–47, 51–53, 99–100, 189; influence on artists, 134, 136, 138, 141–142; *An Introduction to Zen Buddhism,* 106; *Japanese Spirituality,* 47, 83; on Japanese youth, 116; lectures, 22, 99–100, 104, 115; on LSD, 5; photographs, **42**, **131**; portraits, 154–155; on satori, 89; scholarship, 19; seen as modern, 22, 44, 51; tales of Zen masters, 56, 71, 72–74; teachings, 14, 23, 25, 43, 78, 80, 87, 91; translation of Sengai verse, 65–66; in United States, 99–100, 103; on universalism of Zen, 48–49; Western perceptions, 44; on Western understanding of Zen, 107–108, 115; on wordlessness, 76; *Zen and Japanese Culture,* 50–51, 80, 83, 85, 106; on Zen art, 16, 31, 35, 51, 80–81, 123; on Zen boom, 99; as Zen insider, 50, 81; "Zen in the Modern World," 108; Zen masters and, 43–44; as Zen reformer, 43, 44, 46
Suzuki, Shunryū, 103
Suzuki Shōzan, 230
Suzuki Zen, 14

Taisen Deshimaru, 103
Taizan Maezumi, 103, 254n66
Takemoto Tadao, 156
Talese, Gay, 98
Taniguchi, Yoshio, 242
Tapié, Michel, 145–148
tattoos, 201; *ensō,* 18; *The Sixth Patriarch Chopping Bamboo,* **241**
teachers, Zen: American, 124–126; artists as students, 78; online, 8; unorthodox conduct, 56; women, 19; in Zen boom, 103 104, 120 121. *See also* Zen masters
tea culture, 27, 35, 69–70, 95
technology: cell phones, 168, 173; ecommerce, 220, 226, 227, 236, 237–238; living with, 17; Silicon Valley Zen, 231–232, 277n142; Zen boom and, 110, 111
temples: in Brazil, 103; product sales, 198; scents, 204; in United States, 102; wealth, 229–230; Zen, 12, 26. *See also* Ryōanji

Teshigahara Sōfu, 145
Thailand, ZEN Lifestyle Trend Megastore, 200–201
Thich Nhat Hanh, 103, 277n142
Thompson, Mark, 163, **164**
Thoreau, Henry David, 45, 155
Tiampo, Ming, 139, 143, 145, 147, 150
Tibetan Buddhism: Dalai Lama, 175–177, 207, 270n46; humor, 178; interest in, 243
Time magazine, 101, 154–155
Tobey, Mark, 131, 156, 264n3; "White Writing," 106
Tomii, Reiko, 149, 150–151
Tomkins, Calvin, "Zen and the Art of Tennis," 114, 117
Transcendentalism, 37, 38, 40–41, 45, 59
Treeleaf Zendo blog, 216–219, 275n92
Tricycle: The Buddhist Review, 18, **18**, **163**, 180
Tsuruzawa Tanshin, 32
Tweed, Thomas A., 15, 24, 144–145

Ukiyoe, 30
United States: Japanese Americans, 102, 131–132; occupation of Japan, 109; Zen monasteries, 103, 219–220, 229
universalism, 48–49, 50, 83, 91
Updike, John, 242

Varnedoe, Kirk, 25
Viktor & Rolf, 209–211, **210**

wabi-sabi, 51, 85, 86, 92, 204
Wakan meigasen (Selection of Famous Japanese and Chinese Paintings), 30–31
Waley, Arthur, 63; *Zen Buddhism and Its Relation to Art,* 41, 75, 79–80, 81–82, 134
Wall, Derek, 230
Warner, Brad, 208–209
Warner, Langdon, 84
Watsuji Tetsurō, 35, 41
Watts, Alan W.: on Beat Zen, 115; "Beat Zen, Square Zen, and Zen," 13, 109; on Cage, 132–133, 141; critics, 125, 126–127, 263n154; on humor, 184; on koans, 153; *An Outline of Zen Buddhism,* 57–58; quotations, 154; role in Zen boom, 22, 104–105, 126; Suzuki and, 51; tales of Zen masters, 56; *The Way of Zen,* 126–128; on Zen aesthetics, 89; on Zen boom, 98, 262n102;

on Zen iconoclasm, 71–72; on Zen influence in Japan, 84
Watts, Jonathan, 19, 227
Welter, Albert, 61
Werblowsky, R. J. Zwi, 14–15, 48–49, 51, 58, 85, 113, 121
Westgeet, Helen, 92
White, Lynn T., Jr., 106
Wilde, Oscar, 32, 34
Williams, Emmett, 131, 264n3
Williams, R. John, 17, 93, 100, 110, 216
Wilson, Edmund, 116
Wilson, Gahan, **162**, **165**, 166, **167**, 168, 169–170, **169**, 193
Wilson, Jeff, 201–202
Winther-Tamaki, Bert, 25, 148, 156
women: advertising images, 203, 208; lay teachers, 19; misogyny, 114; nuns, 19, 20, 89
World's Columbian Exposition (Chicago), 26, 32
world's fairs, 26, 31–33, 35
World's Parliament of Religions, 26, 32, 46

Xavier, Francis, 26–27

Yamada Chisaburō, 144
Yamada Reirin, 68, 254n66
Yamamoto Shunkyo: *Discarding the Bones, Gathering the Marrow* (*Shakaku shūzui*), 67–68, 69, 253–254n60, **Plate 5**; *Hōjin issō,* 254n62; study of Zen, 66–67
Yamazaki Taikō, 45
Yanagi Sōetsu, 89, 93
Yang, Manuel, 111
Yasutani Haku'un, 124, 125
Yintuoluo, *Danxia Burning a Buddha,* 62–64, **Plate 3**
yoga, 167–168, 196, 197
Yomiuri shinbun, 171, **172**
Yoplait, 208–209
Yoshihara Jirō, 95, 143; Circle Works, 148–151, 267n94; "Gutai Art Manifesto" ("Gutai bijutsu sengen"), 149–150, 266n64; *White Circle on Black,* 18, 149
Yoshihara Shin'ichirō, 149
Yoshizawa Katsuhiro, 161

zazen. See meditation
Zen: author's position, 21–22, 23; discourses, 22–23, 76, 81, 98–99; diversity, 1, 7–9, 12, 19, 23, 242; in future, 240–243; historical study of, 119–120; lay practitioners, 34, 35; lineages, 7, 12; meanings, 3–4, 6–10; promotion in West, 26; reform movements, 125; self-promotion, 195; typologies, 11–15; ubiquity, 9, 10–11, 100–101, 239–241; use of term, 9–10, 76; Western perceptions, 45, 248n31; wordlessness, 76, 82. *See also* modern Zen; monastics
Zen art. *See* art, Zen
Zen Art for Meditation, 92
Zen boom: in arts, 78, 105–106, 111, 133–135, 142, 146–147, 157; banality, 113–114; Beat Zen, 13, 14, 53, 115–117, 181; books, 98, 101–102, 105, 106–108, 126–128; chronotope, 102–108; critics, 116–118, 121–127, 195; debates, 99, 112–113, 118–120, 126–129; discourses, 22–23, 98–99; diversity of practice and belief, 7–8, 104, 110–111, 113, 129, 135; effects in Japan, 20; factors in, 108–112; global interest, 97, 99, 100–102, 107; lecturers, 104–105, 111; mass media coverage, 101–102, 107; negative aspects, 115–118; parodies, 101–102, 112, 114, 117; political context, 11, 45, 111; Suzuki's influence, 99–100, 104, 108, 115–116, 117–118, 123; Westerners studying in Japan, 13, 104, 108, 117, 120, 123; Zen-inspired products, 202–203
Zen Cat trope, 168, 172, **173**
"Zen Desktop Page-a-day Calendar," 50
Zenism, 10, 37, 241
ZEN Lifestyle Trend Megastore, Bangkok, 200–201
Zen masters: Cage as, 141–142; cartoon depictions, 162, 166–167, 169; eccentrics, 183; episodes from lives, 79; lay, 8, 12, 44; portraits, 78–79; products inspired by, 205; Suzuki and, 43–44; unorthodox conduct, 54–56, 58–59, 70. *See also* teachers
Zen Mountain Monastery (Doshinji), 219, 226, 228–229, 232, 275n94. *See also* Monastery Store
Zen no seikatsu (The Zen Life), 68
Zen Notes, 162, **163**
Zenny zeitgeist, 10–11, 100, 160, 193, 209
Zen Studies Society, 103
Zhou Jichang, *The Rock Bridge at Mount Tiantai,* **Plate 6**
Žižek, Slavoj, 11, 199

ABOUT THE AUTHOR

Gregory P. A. Levine is professor of the art and architecture of Japan and Buddhist visual cultures at the University of California, Berkeley. His previous publications include *Daitokuji: The Visual Cultures of a Zen Monastery* (2005); "The Faltering Brush: Material, Sensory Trace, and Non-duality in Chan/Zen Buddhist Death Verse Calligraphies," in *Sensational Religion: Sensory Cultures in Material Practice,* ed. Sally M. Promey; and "Buddha Rush: A Story of Art and Its Consequences," in *BOOM: A Journal of California.*